Biography COPLEY John
A revolution in color
:the world of John Singleton
Copley /
Kamensky, Jane,

A REVOLUTION IN COLOR

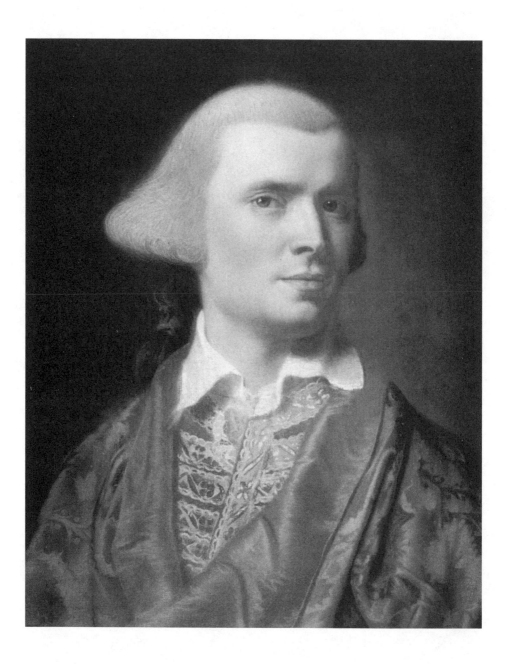

A Revolution in Color

The World of
John Singleton Copley

JANE KAMENSKY

W. W. NORTON & COMPANY

Independent Publishers Since 1923

New York London

For information about permission to reproduce selections from this book,
write to Permissions, W. W. Norton & Company, Inc.,
500 Fifth Avenue, New York, NY 10110

For information about special discounts for bulk purchases, please contact
W. W. Norton Special Sales at specialsales@wwnorton.com or 800-233-4830

Manufacturing by Quad Graphics, Fairfield
Book design by Dana Sloan
Production manager: Louise Mattarelliano

ISBN 978-0-393-24001-6

W. W. Norton & Company, Inc.
500 Fifth Avenue, New York, N.Y. 10110
www.wwnorton.com

W. W. Norton & Company Ltd.
15 Carlisle Street, London W1D 3BS

1 2 3 4 5 6 7 8 9 0

For Lorrie Neill Kamensky,
and in memory of Donald Louis Kamensky

Great Revolutions in Government, are generally attended with great Calamity to Individuals.

> —*Elisha Hutchinson to Margaret Hutchinson,*
> *January 1776*

Many of the Shades of the Portraits, both of Persons & Times, I confess are very dark: that is not my Fault. My Business was to draw true Portraits.

> —*Peter Oliver,* Origin and Progress of the
> American Rebellion, *1781*

The same truth that guides the pen of the historian should govern the pencil of the artist.

> —*Benjamin West to John Galt, ca. 1816*

⌒ Contents ⌒

Preface 1

CHAPTER ONE: The Provincial Eye 9

CHAPTER TWO: A Dazzling of Scarlet 39

CHAPTER THREE: The Imperial Eye 76

CHAPTER FOUR: A Son of British Liberty 111

CHAPTER FIVE: The Marriage Plot 149

CHAPTER SIX: The Tyranny of Liberty 183

CHAPTER SEVEN: Luxury in Seeing 221

CHAPTER EIGHT: The American War 254

CHAPTER NINE: Waging Peace 290

CHAPTER TEN: Daughters and Sons 328

CHAPTER ELEVEN: Betsy Copley's Smile 369

Epilogue 394

Acknowledgments 402

Illustrations and Credits 406

A Note on Sources 412

Abbreviations Used in the Notes 414

Notes 417

Index 505

A Revolution in Color

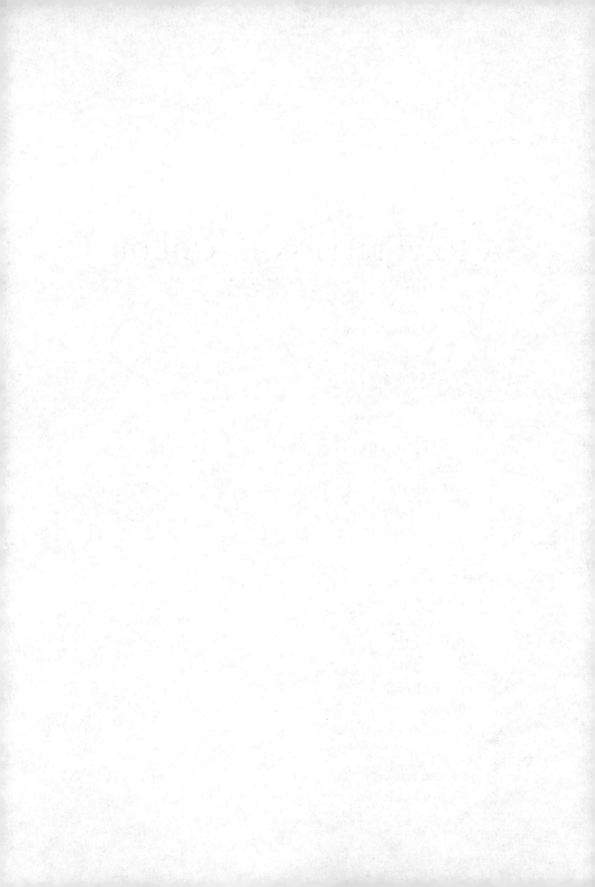

HEN YOU WALK through the heavy glass doors of the Americas wing in Boston's Museum of Fine Arts, you come face to face with the men and women who made the American Revolution. Paul Revere greets you, head on, just inside the entrance. His iconic likeness—unwigged, shirtsleeved, silver teapot in hand—hangs low enough that his big brown cow eyes meet yours with neither modesty nor condescension. Revere's is the honest, direct gaze of an honest, direct man: an American gaze. Vitrines holding examples of the silversmith's craft surround the portrait of the self-made maker. His famous Liberty Bowl stands on a platform just in front of it, like a chalice proffered by a preacher. In the 1950s, the churchiness of the presentation was franker; the portrait and the bowl were placed upon a pedestal with a couple of steps before it, suitable for genuflecting, flanked by American and Massachusetts flags. But even today, in a new and less earnest century, *Paul Revere* forms the center panel of an American altarpiece.[1]

Behind Revere, on the left, hang a quartet of his fellow revolutionaries. John Hancock, the stalwart merchant, sits at his desk, reckoning, the quill that will ink his bold signature on the Declaration of Independence poised in his right hand. Samuel Adams—the maltster's son turned politician—stands in a homespun crimson suit, drawn up to his full, modest height, eyes alight with patriotic zeal. Dr. Joseph Warren, the physician, pores over a set of anatomical drawings that seem to prefigure his death and resurrection as the martyr of Bunker Hill. Mercy Otis Warren, the sister of one liberty man and the wife of another, appears

lost in thought as she stands before a burbling fountain, displaying the contemplative bent of the intellectual who will write the Revolution's first major history. The portraits were painted separately, in the 1760s and early 1770s, tumultuous years in the world beyond their gilded frames. They were meant for separate fates, in firelit parlors in middling homes, in a bustling entrepôt at the edge of an empire. Viewed together centuries later, in the chilly splendor of a great museum, through the glaring light of hindsight, they become a patriotic pantheon: American originals, painted by another of their breed. The labels identify the artist as "John Singleton Copley, American, 1738–1815."

The MFA owns the largest collection of Copley's work in the world: scores of paintings spread across four galleries and myriad works on paper tucked away in the department of prints and drawings, where they can be viewed by appointment, under low light. But though Copley's legacy is more vivid in Boston than in most other places, just about any major museum in the United States will tell you a version of the same story. At the Met in New York or the Art Institute of Chicago, at the National Gallery in Washington or the De Young Museum in San Francisco, in Detroit and Toledo and Lawrence, Kansas, and Crystal Bridges, Arkansas, and on around the vast continental nation that Copley never imagined, his work is classed as American art, with labels that add greater and lesser degrees of mystery: "American, active in Britain," "American, died in London." Whatever the label, Copley's brush is pressed into much the same service: a conjurer's work, creating our mind's eye picture of the nascent American republic, of which he emerges, on those walls, as court painter.

Nothing would have surprised Copley more.

A cautious man in a rash age, John Singleton Copley feared the onrush of the colonial rebellion against Great Britain. Like many people of his place and time, he called the rebels' revolution a civil war. And like many people who had lived through civil wars before him, and who have endured them since, he thought the safest side was no side at all. Copley painted John Hancock, whom he knew well and grew to despise. But by the time Hancock signed the Declaration, the painter was long gone

from the country that document called into being. In the spring of 1774, during the brief interval between Boston's "tea party" and the outbreak of fighting in Lexington and Concord, Copley sailed to London, capital of the only nation he had ever known, leaving behind the second-tier British port city in which he had spent nearly four decades. John Singleton Copley had lived half his life in Britain's American provinces. He would never set foot in the United States.

British museums, which own the greatest of his works, classify him differently. "John Singleton Copley, R.A. . . . British School," runs the text inscribed on the frame of *The Death of Major Peirson*, my very favorite of all his paintings, which hangs in the Tate, hard by the Thames. The heroic canvas depicts a passage in Britain's American War that falls outside the standard narrative of the American Revolution: a battle that took place in an obscure corner of Europe, that featured no North American combatants, and that ended in British victory.

To explore Copley's American Revolution is to treat that war, and its world, with fresh eyes. In the United States, where the War of Independence functions as a national origins story—a "founding"—we tend toward histories peopled by Patriots and Tories, victors and villains, right and wrong. Such tales, for all their drama, are ultimately flat: morality plays etched in black and white, as if by engravers who have only ink and paper to depict all the shades of a subject. But like the paintings Copley produced so painstakingly, the revolutionary world was awash in an almost infinite spectrum of color. Allegiance came in many shades. Some pigments were durable, others fugitive and shifting. The age of revolutions takes on a prismatic quality when we try to view it through Copley's slate-colored eyes, eyes that saw deeply, and revealed many truths, not all of which we now hold to be self-evident.

⁓

My title also refers to Copley's work, which began, in his tender years, as a trade. As he grew in both mastery and drive, it became a calling. As a painter of portraits and, once he escaped the confines of Boston, of

the more elevated genres of history, religious art, and classical allegory, Copley worked in the upper echelons of the color trades, which included everyone from the farmers who grew the madder root from which the day's most popular bricky reds were made, to the collectors of burnt ivory that produced the richest blacks, to the merchants who trafficked in powdered pigments from around the globe and the shopkeepers who sold them at retail, to the many kinds of painters who worked with those stuffs: housepainters and sign painters and clock painters and wallpaper screeners, and on up the ladder of occupations to the painters of landscapes, human faces, and the higher reaches of Art.

A preposterously ambitious poor boy from a preposterously ambitious place, Copley glimpsed that ladder early and climbed it relentlessly—never resting, never satisfied—for seven decades, on two continents, through four global wars. His life in color is a story of striving, a species of ambition seen, even then, as peculiarly American: hard-edged, uncloaked, impolite. Like many stories of striving, Copley's is also a story of ever-increasing scale, both on and off the canvas. Boston was a place to paint small, to paint faces: art destined to hang in little clapboard houses, pictures that spoke to families. *Paul Revere* is a bit more than two feet wide, and a hair less than three feet high. In London, Copley's compass grew, and with it his works. The pictures got big, many times the size of *Revere*. His largest and most complex paintings—sometimes, though not always, his best—were meant to rivet exhibition-goers, to hold a palace wall, to fill a tent.

But unlike so many rags-to-riches tales of American ambition—a genre that began to circulate toward the end of Copley's life and that dominates our national imagination still—Copley's is a story of profound and crippling disappointment, agonies born of both self and circumstance. His was a rueful revolution, long on second guesses and short on second chances. Though his work could be daring and innovative, he was a man of indecision, a character that might have sat more easily in an era less consumed with the urgency of choosing one's destiny. The age of revolutions was an urgently forward-facing moment. Copley, by contrast,

had what the people of his day called a bivious gaze, forever alternating between glancing over his shoulder and peering at what was ahead of him. It was a painful way to be in a go-ahead world, though by no means a singular one.

Copley's bivious vision endures because he worked as a visual intellectual. His life and work invite us to *see* the age of revolutions in all its myriad complexity. Visual metaphors were central to Copley's way of imagining and organizing his complex world. He wrestled with the tensions between figure and field, the portrait and the crowd, the modern and the antique. He was often accused of paying too much attention to details at the margins of a scene, finishing all parts of a picture equally and thus making it "difficult for a beholder to guess which object the painter meant to make his main subject," as one reviewer in London noted in 1777.[2] When the background got too vivid, the story grew muddy. Deemed an artstic failing, Copley's tendency to dwell on and in the verges is also a gift, drawing our attention to overlooked aspects of a story too often cast in spotlight and shadow.

Background matters to the story of Copley's revolution, which centered less on the struggle of rebel colonists against the British crown than on family politics, the labor of art, and the dark undersides of liberty, including chattel slavery, which Copley both practiced and theorized. The history that becomes visible through his eyes is no easy story of the progress of America, but rather a stuttering series of rises and falls and eddies, all worked out on canvas, in a palette that remains startlingly fresh.[3]

That vividness is one reason painters are good to think with. But there are others, too. Like most who practiced his trade, Copley was a middling man. He shows us those above him on the ladder of hierarchy in their true colors. He also looks, often anxiously, at the echelons of society below, which he narrowly escaped, through a combination of gumption and good luck. He remained, all his life, obsessed with rising above and afraid of falling back, properties visible in many of his works, and in the unusually large corpus of letters he left behind. A strenuous autodidact,

Copley had gorgeous penmanship and terrible spelling. (I have left original spelling throughout; it is part of the story.) His letters are full of self-searching, a degree of introspection that may be common to most *Homo sapiens*, but is seldom accessible to historians who study people of lower middling status. Copley's correspondence offers a rare glimpse of the development of an artist's sight and insight, as well as a history of the early American eye.

And then, of course, there are the pictures, hundreds of them, painted on both sides of the ocean that defined the outer limits of his imagination. On the page and on canvas, Copley worked out his life in plain sight, in ways that, almost miraculously, remain visible still, some two centuries after his death.

A canvas by Copley hangs in my office, on loan from my university's art museum. It's an early portrait, painted ca. 1759–60, when the painter was just twenty-one or twenty-two years old. The sitter, Miss Dorothy Murray, was younger still, fifteen or sixteen when she sat for her picture. The painting is a frozen moment from a vanished time: a glimpse of some morning or early afternoon—most of the year, the light wasn't strong enough after that—on which two young people came together in a sunlit room, on the second story of the house Copley had recently purchased on Boston's Cambridge Street, where he lived with his fragile mother and his much younger half brother, Harry. For some years already, he had been the family's sole support, painting for his life. They were, both of them, painter and sitter, quite ordinary folks: the Scottish merchant's daughter, the Irish tobacco seller's son, aspiring, together, through the extraordinary act of portraiture.[4]

It is not an exceptional portrait; indeed, but for the subsequent fame of its painter, it is not really even a museum-quality work. Copley cannot quite manage the arms yet, much less the hands. The disposition of the body in space remains a mystery to him. *Dorothy Murray* wasn't especially well fabricated and hasn't, over the years, been especially well tended. It has

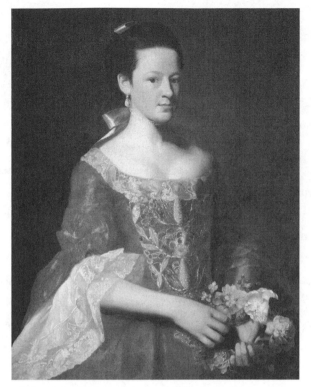

Copley, DOROTHY MURRAY, *ca. 1759–61* [Plate 1]

lost a lot of paint. The figure is wooden, the brushwork halting, the overall effect somewhat folky, or "primitive." In all these ways, it could pass for an unusually fine work by some itinerant hack—by Joseph Badger, maybe. But oh, that face! Fresh as youth, fresh as yesterday: a woman on the verge.

Living with it as closely as it was meant to be lived with, daily, without stanchions or guards, without companions or a wall label, I have come to see a special poignancy in the canvas, which is perched in every way on the precipice of becoming—the young lady blooming, the painter's talent unfurling, the Seven Years' War soon to end in a total, unexpected victory that would prove both exhilarating and cataclysmic for Britain's empire. The collision of all of these things is ineffable, and unique. There is nothing scientific, even social scientific, about such encounters. The experiment cannot be repeated to test the results.

A biography is in many ways like a portrait. The genre traffics in the

individual, the irreproducible, the extraordinary. Had Copley not burst the frame of his times by painting what and how he did, and especially when he did, it is unlikely that the material would have survived to allow me to tell his story—and unlikelier still that you would want to read it. A hundred ordinary people, armed with a hundred paintbrushes, toiling for a hundred years, would be hard pressed to paint something half so transcendent as *Dorothy Murray*, let alone *Paul Revere* or *The Death of Major Peirson*.

And yet, much as Copley made a world with his brush, his place and times also made him. Most people of the day were, as he was, creatures of kin and community, homemade and marriage-made more than self-made. Family ties mattered at least as much as political allegiances. And like Copley, most "Americans" were both military and ideological noncombatants when the war came. In a polygonal conflict that was at once a struggle for colonial independence, for native territorial sovereignty, for British imperial coherence, for European hegemony, for African American freedom, and much more, many deemed it best to do what Copley urged Harry: to forswear arms and pledges, to keep his own counsel, to wait and see how it all came out. The American Revolution looks different seen through his eyes, looking west from London: a sidelong glance at a sideways war, the conflict that made and unmade him. The closer we get to such ambivalent characters—both the ones in Copley's own household and the ones he painted—the more our easy verities about the period dissolve.

American historians of the American Revolution, no less than the rest of our fellow nationals, tend to believe fervently in the notion of choice, liberalism's first commandment. Colonials chose sides; some chose right and others chose wrong. But as Copley saw it, the sides—of the war, of the ocean—chose him. To recover such stories, in all their vexing multiplicity, is to contemplate a different American war, and maybe a different America as well.

Jane Kamensky
Woodstock, Vermont
December 2015

⌇ Chapter One ⌇

THE PROVINCIAL EYE

JOHN SINGLETON COPLEY grew up facing the sea, heaving heart of Britain's growing blue-water empire. He lived with his mother in three rooms of a small wooden house along Boston's Long Wharf, an arm of land that jutted into the harbor, as if reaching for London thousands of miles across the ocean. The clapboard buildings that lined one side of the wharf were attached, side to side. The windows on the north faced the older and denser part of the town, where the streets had names like Ship and Fleet and Fish. Boats moored on the south side of the wharf, just a few feet from the Copleys' front door. Facing that way from the second-floor window, the boy would have seen masts and sails, shipyards and ropewalks. He fell asleep to the twang of halyards and woke to the shouts of sailors and hawkers, and strumpets trudging home from the taverns to sleep.[1]

Every now and again, on the king's birthday, or on a feast day declared in honor of a military victory, Jack (as he was known) would have heard celebratory blasts from Castle William, where a hundred mounted cannon guarded the king's island fortress, the empire's might on display even there, at the mouth of a harbor at the edge of the British imagination.[2] Jack and his mother lived in a world where war was the rule, peace the exception. On the day he was born, 3 July 1738, the *Boston Gazette* reprinted an article from the *Jamaica Courant*, which excerpted a letter from Paris, which offered a clutch of prognostications. For 1738: "War will be declar'd throughout the whole World."[3]

The prophecy was not fulfilled that year, but it would be, several times, during the boy's long life.

Like many trading centers, Jack Copley's Boston was a shockingly cosmopolitan place: the "Metropolis of New England . . . the largest, most populous and flourishing Town in the British Dominions in America," as a map printed there in 1743 put it. The plan's cartouche featured Neptune, god of the sea, on one side, and Mercury, god of commerce, on the other.[4] The king's colors dotted the harbor, fluttering from a forest of masts made of tall white New England pine, on hundreds of ships every year.[5] Jack was born in summer, the best season for sailing as it was for painting. Dockworkers busied themselves unloading cargoes from Antigua and Surinam and Honduras, from Lisbon and the Canary Islands, from Rhode Island and Connecticut, and filling the hulls of ships bound for London and Jamaica and Newfoundland. Merchants advertised Carolina indigo and German steel and Madeira wine and Irish linen. There was also, on the last page of the *Gazette* on the day of Jack's birth, as on most days, an anonymous notice offering for sale a human being: a "healthy strong Negro Boy," aged about fifteen. That boy or his parents or their parents likely came from West Central Africa, via the Caribbean, where Boston merchants traded fish and lumber for sugar and cotton and sometimes slaves.[6] The Copleys, too, set themselves up as traders in faraway goods. From a storefront below their little flat, Jack's mother sold "the best *Virginia* Tobacco, Cut, Pigtail, and spun, of all Sorts, by Wholesale or Retail, at the cheapest Rates."[7]

The Boston of Jack's boyhood was also, in roughly equal measure, a parochial place, wary of strangers and aggressively pious, even by the standards of its day. A hundred years before his birth, the founders of the Massachusetts Bay colony had proclaimed, with a confidence all the more poignant for its absurdity, that they would create, in this new England, a shining city on a hill for all Christendom to emulate. A century later, Boston was home to some seventeen thousand souls gathered in sixteen churches, most of them of a stringent Calvinist stripe.[8] From sundown on Saturdays until dawn on Mondays, ferries stopped and shops closed tight.

Even a stroll across the Common or along the waterfront was forbidden on the Lord's Day.[9] On Sundays and fast days, the boy and his mother woke to a symphony of bells. The *Gazette*'s little group of prophecies forecast that in 1748, the year Jack turned ten, "Jesus Christ will come to Judge the World."[10]

⁓

Jack's mother, the widow Copley, cannot have wanted this life, counting coins and reckoning debts behind a shop counter, so very far from the place she grew up. The former Mary Singleton was born—wellborn— in Ireland, the second daughter of John Singleton, squire of Quinville Abbey, a Georgian manor nestled in the emerald hills of county Clare. Descendants of English gentry from Lancashire, the Singletons had lived in southwest Ireland for three generations by the time of Mary's birth, around 1710. She must have been raised with accomplishments befitting a young lady of her station, for she wrote, all her life, with a fine, clear hand, and a correctness of spelling that only the most avid and astute female reader could boast.[11]

But even fathers who cared about the education of young ladies—as few enough did—rarely settled lands upon their daughters, whose husbands determined their way in the world. Mary's older sister, Anne, made a fitting match within the Anglo-Irish gentry.[12] Mary faced different choices. In the early 1730s, she met Richard Copley from Ballyclough, a village about sixty miles to the south. Family tradition holds that the Copleys, too, were an ancient clan, Yorkshiremen, with an English lineage stretching back to the Crusades. There were whispers of a baronetcy descending through some other branch of the family; Richard's father may have served as an alderman in Limerick, the county seat.[13] But neither title nor office nor land nor fortune nor much in the way of calling trickled down to Richard Copley. And so, he did what young men with more ambition than means had done for generations: he wed as well as he could. No record of the marriage survives. But in late 1732, Richard and Mary Copley baptized a short-lived daughter, Sarah, in the Cathedral of

St. Mary's in Limerick.[14] A few years later, Copley scooped up his bride and sailed for the colonies.

Anglo-Irish like the Copleys composed but a small stream within the great human tide swirling around the Atlantic in the 1730s. The best estimate holds that roughly 11,800 migrants left Ireland for Britain's North American provinces over the course of that decade.[15] Relatively few of them fastened on New England, which offered neither open lands nor open arms. The ever-proliferating descendants of the dissenting English Protestants who had displaced the region's native peoples in the 1630s dominated Boston's population, which also included several hundred enslaved Africans, a goodly number of French Huguenots, and a smattering of German-speaking Pietists. A small influx of Irish had arrived in the 1710s.[16] The Copleys belonged to the town's second and larger wave of Irish immigration, people who journeyed not singly or in families but by the dozen, the score, the hundred. At least 800 Irish émigrés landed in Boston between late 1736 and 1739, when the wave broke as suddenly as it had swelled.[17]

When the Copleys got there, England had been at peace since 1713. Deprived of the wages of imperial war, Boston's economy had limped along for more than two decades. Town officials begged the province to help them offset the spiraling cost of the poor.[18] Disease stalked the quays and alleys. Smallpox killed hundreds in 1730, and diphtheria reached epidemic proportions between 1735 and 1737. In 1736, burials outnumbered births. For all these reasons, the place for which the Copleys set sail had every cause to be even warier than usual of newcomers wanting work and bread.[19]

Migrants from Ireland attracted special scrutiny. More than a half century after Cromwell's bloody conquest, the Kingdom of Ireland remained roughly 80 percent Roman Catholic. For Britons, the hatred of popish despotism was powerful glue, binding together an otherwise disparate people. Anglicans like the Copleys were vastly outnumbered in the southern counties; Mary Singleton's county Clare counted fewer than seven hundred Church of Ireland families amidst some ten thou-

sand Catholic households.[20] The day's stereotypes, which mixed religious animus with a potent cultural prejudice, held that the Irish were prone to drink and violence: uncivilized, untamable. Boston tradesmen advertised to recover a steady stream of Irish runaways—black-haired, blue-eyed lads, some of whom spoke with "the Irish Brogue."[21] From Dorchester came a report of "Irish Men" turned brigand, stabbing a yeoman as he drove his sheep through the sleepy country village of Milton.[22] In September 1738, when Jack was three months old, four Irish prisoners led a break from the gaol on Queen Street, accompanied by a one-armed "Indian Fellow" and an enslaved man named Jocco: the Irish at the vanguard of what appeared to Boston city fathers a diverse and growing underworld.[23]

The Copleys left behind scant record of their first years in New England. They were not warned out as indigents or posted as runaways; they committed no crimes; they purchased no property and joined no church. They were not among the wretched offscouring of Ulster crammed into the hold of the *Seaflower*, whose starved and haunted passengers became so desperate that they ate six of their dead during the long voyage from Belfast to Boston.[24] As the children of landed Anglo-Irish, the Copleys would have felt little affinity with the Ulster Scots, and none with the Gaelic-speaking peasants from their neighboring counties. The Copleys were hardly the sorts of "poor and indigent Countrymen" whose circumstances Boston's Charitable Irish Society—organized the year before Jack's birth, on Saint Patrick's Day—strove to ameliorate. But neither were they among those prosperous Irish tradesmen dispensing alms.[25]

What had pulled them across the vast and furious ocean to the ragged edges of the realm, a crossing Mary Singleton Copley never wanted to repeat, for the rest of her long life? Many—perhaps the majority—of those who journeyed when they did came in the service of Samuel Waldo, leader of a company of Boston merchants claiming title to 100,000 acres "in the Eastern Parts" of Massachusetts (now Maine), halfway between Boston and Nova Scotia, where the tall fir trees grew that made such peerless ship's masts. Eager to resettle these vast tracts of Penobscot

country, Waldo sailed to Britain to recruit likely migrants among the Anglo- and Scots-Irish. He promised free passage and generous grants of land: one hundred acres, freehold, to any settler who would "Build a House of at least Eighteen Foot Square" upon arrival, "Clear & Subdue" at least four acres of that lot, and remain to work the property (or have it worked for him) for two years more.[26] Land in the plantations proved a powerful lure for the latter sons of lesser gentry, especially for those without craft or calling—for such men as Richard Copley.

Tantalizing fragments support such a conjecture. In March 1742, when Jack was nearing age four, Samuel Waldo petitioned the Massachusetts legislature to organize a second township within his patent, invoking the names of forty-five men said to dwell there. He listed a Richard Copley second among them.[27] Only one other record of Copley's life in New England exists: about nine months before Waldo filed his petition, Richard Copley "of Boston . . . Tobacconist" sued a mariner to recover a debt of £180. There is every reason to suppose that these two Richard Copleys—the only adult male Copleys in the province—were the same man.[28] The odds of some connection between the Copleys' migration and the Waldo recruiting scheme run very high.

Whether the family ever actually journeyed to the "Eastern Parts" of the province is less certain. Perhaps they sailed up the coast to the Waldo patent soon after their Atlantic crossing, and Jack was born there, in a cabin of rough-hewn logs. That would account for the lack of a record of his baptism either in Ireland or in Boston. Or perhaps the couple and their infant son established themselves in Boston and then headed out to claim their grant several years later, in the early 1740s, when relations between the New England invaders and the indigenous Penobscots grew marginally more peaceable. Maybe, indeed, Richard Copley was calling in his debts in the summer of 1741 in anticipation of such a move. Perhaps more children were born to them there, in that place with neither church nor parish registry, children who died young. Or maybe Richard Copley lit out for those remote territories alone, leaving his wife and son in the ramshackle house on Long Wharf. If he did not quickly die at

the eastward, as many others did, he certainly fled the site by spring of 1744, when war with France and its native allies again loomed and, one of Waldo's agents reported, the settlers grew so "Exceedingly afraid of ye Indians" that they abandoned the Lower Town. "I thought Your Irish People of better Courage but ye Greatest Part prove absolute Cowards," he said.[29] Or perhaps Richard Copley was of stouter heart than the agent allowed, and he hired out to soldier, only to perish among the nameless hundreds of New Englanders who fought along the western front of the War of Austrian Succession. That would account for the lack of any other trace of his life in Boston, including a record of his death, which took place some time before the spring of 1748.[30]

Whether Richard Copley's years in New England followed one of these paths, or some other, yet more tangled, this much seems certain: his refined young bride had little say in the matter. The former Mary Singleton had left behind everything she knew: her church, her kin, the manor house that held her father's library, where she learned to read and write beyond the meager expectations of her sex. And then, too soon, she fetched up as a widow, and still, even after some years, a stranger, in a chilly town as far from her home it was beneath her station.

The widow Copley made something of the three modest rooms she shared with her son, Jack. In the smallest of them, a storage space holding two chests, she hung green curtains. (The men who inventoried her late husband's household goods called it "the Green Chamber.") The Copleys' only bed sat in the larger "Yellow Chamber," likely named for the hangings that surrounded the bedstead. Her feather bed and its curtains and blankets were worth nearly as much as everything else in the tiny flat combined. Textiles concentrate value in small, lightweight parcels; perhaps these were the movables John Singleton settled upon his daughter when she married, the trousseau she brought across the sea from county Clare.

There were other gestures toward refinement in that yellow room: a costly framed looking glass, six "prints & pictures," a dozen "Bound Books." By the bed, near the mirror and the pictures, stood an "Old

Desk," a place fit for tallying sums that never added up to much. Maybe a place for sketching.[31]

~)

If he walked out the front door and turned left, Jack Copley could meander down the wharf for near half a mile, to the great winch that lifted the heaviest cargoes. When he reached the end, he confronted the expanse of water stretching across the harbor, clotted with islands, toward the open ocean and, somewhere out there beyond measure, the shores of his parents' faraway homeland.

We will not be able to see through his eyes until the year 1753, when, at age fifteen, he picked up a brush; or to hear him until nearly a decade after that, in 1762, date of the earliest of his surviving letters; or to see him before 1769, when he first portrayed himself. But we can imagine him there, at the tip of the wharf, facing east.

Make the year 1745. Jack is seven years old, recently breeched, as New Englanders call the moment when boys first don trousers, a halting step into a world of men. He is a small child who will become a slight man, pale and fine-featured. He stammers, a disfluency that would have started very early, and will stay with him. The stammerer is a sensitive child, "of weak Nerves" and "a great Degree of Sensibility," explains the author of a treatise on "nervous diseases" published just before Jack was born. But stutterers are also "quick Thinkers," whose minds outrun their tongues. They "feel Pleasure or Pain the most readily," and tend to possess a "most lively Imagination." The diagnosis fits: Jack's sensibility is as acute as his speech is halting. His slate-gray eyes, the color of New England seas, take in his busy world.[32]

Jack sees a town that teems with soldiers and sailors. Britain is again at war with France, which costs Boston many young lives but is very good for business. Shipbuilders, blacksmiths, seamstresses, whores, and everybody else who works the wharves or supplies the army is busier than they've been in three decades. Great fortunes are gained. A bookseller named Thomas Hancock turns privateer, and makes enough that

he sends away to London for a chariot.[33] In this war, which the king calls
the War of Austrian Succession and the colonists know as King George's
War, New Englanders have played a direct, even heroic role, taking the
French fortress of Louisbourg, at the tip of Cape Breton Island, and thus
securing Britain's access to the North Atlantic fisheries and the St. Law-
rence waterway. In December, when Massachusetts governor William
Shirley returns to Boston after touring the fallen fortress, he is greeted
with a trooping of colors. Perhaps Jack is there, among the myriad boys
crowding the Long Wharf to watch the parade of redcoats, listening to
the cacophony of bells that ring all day long, to celebrate the stunning
achievement of "*Britain's* loyal Sons," Boston's loyal sons.[34]

But Jack is in many ways unlike the town's other loyal sons. He has
no siblings in a place where families of six or eight or even ten children
are the rule. His parents hail from overseas in a place where most people
have deep local roots. His father is absent, and very likely dead, in a place
where paternal authority over the household provides the model for good
government, mirroring, in miniature, the governor's authority over the
legislature, the king's sovereignty over his subjects, and God's dominion
over all creation.[35] With no father to chasten him and no brothers to
guide him through the rough, plebeian world of the wharf; with a mother
who knows she was fit for better, and may often have said so: Jack Copley,
it seems fair to suppose, is guarded, a keen-eyed, watchful boy.

It is tempting to give this watchful boy an artist's pensive and melan-
choly temperament, maybe even to add a dash of the all-American boot-
strapper's can-do, get-ahead gumption. "Without instruction or master
he drew and painted and 'saw visions' of beautiful forms and faces," Jack
Copley's granddaughter wrote of her by then illustrious ancestor shortly
after the centennial of the United States. "The usual story is told of his
beginning to draw at a very early age, with the first materials he could lay
his hand upon, when other boys were engaged in sport or in learning to
read and write." The "coarse drawings" he made on his nursery walls, "and
the rough sketches in his school-books, for which he was often reproved,"
represented "the dawning of his genius," she said.[36]

This "usual story" represents a particular kind of fiction: an origins myth for American Art. Like most origins myths, it owes more to fancy than to fact. Jack Copley's Boston was no seedbed of American character but rather a British town, indeed an *English* town. In his young life there was little sport and—as the artist's uncertain spelling attests—less schooling. Certainly there was no nursery. Only that yellow chamber, shared with a fretful mother given to melancholy, about whose health Jack would worry for decades to come.

And yet, and yet: in the eighteenth century as today, the boy was father to the man, his talents and aspirations formed in that household, on that wharf, in those early years, now hidden from our view. Young man Copley may or may not have doodled on the little flat's walls. But he nurtured there and then a blend of caution and ambition that would both propel and check his progress, push-me, pull-you style, his whole life long.

In May 1748, as a late spring and an uneasy peace came to Boston, the widow Copley married for the second and last time. Married better, it seems—better, certainly, for her only child, the boy Jack, who was soon to turn ten. Peter Pelham, like Mary Copley and her first husband, was an incomer. He had journeyed to Boston from Britain, arriving in Massachusetts by 1727, with a wife and two London-born boys in tow. A third was born two years later, and Mrs. Pelham died soon after, bitter reminder that healthy women were never closer to death than when giving birth. It took five years for Pelham to find a second wife, a helpmeet for a widower with three young sons. Margaret Beath Lowry appears to have shared his Anglo-Irish ancestry. She delivered him a daughter and a fourth son, in rapid succession, before she too perished. And so, when Pelham was wed for the third time, to the widow Copley, he was the father of five living children, ranging in age from Peter III, already married at twenty-six, to young Thomas, born in the spring of 1737, about a year before Mrs. Copley's only son.

Unlike Richard Copley, then, Peter Pelham came with a busy household. But also unlike Copley, Pelham had a trade: he had apprenticed as a portrait painter and an engraver in mezzotint, a technique of great fineness and subtlety, capable of teasing velvety blacks and liquid grays from inked copper plates. His London commissions included engravings of famous faces ranging from the king-slayer Oliver Cromwell to the head of a new royal dynasty, George I.[37]

Pelham's training, along with his knack for self-promotion, quickly earned him patrons in Boston. Shortly after he arrived in town, he secured a commission to paint the aging Puritan divine Cotton Mather, lauded as "perhaps the *principal Ornament* of this Countrey, & the *greatest Scholar* that was ever bred in it."[38] Months after Pelham pinned him to canvas, Mather enriched the painter by dying. Almost immediately, Pelham offered for sale, by subscription, an engraving taken from his portrait, a Mather memento that could be had for the extraordinary price of five shillings—three down, two payable upon delivery. Wholesalers

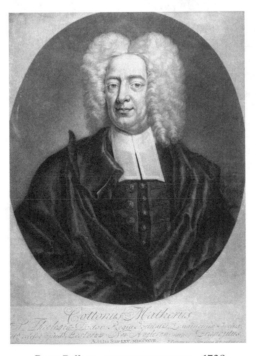

Peter Pelham, COTTON MATHER, *1728*

who bought twelve copies were promised a thirteenth "*Gratis*": a baker's dozen. Pelham's medium was unfamiliar enough to Boston buyers that he felt obliged to explain that the plate from which he would pull the image, suitable for framing, spanned "14 Inches by 10, which is the Common Size of most Plates in *Metzotinto*, by the said *Pelham*, and others."[39]

Likenesses of other local luminaries followed sporadically over the years—clergymen, mostly: Boston's celebrities.[40] But the commissions were too few to add up to a living. By the time the Copleys arrived, Pelham had reinvented himself several times over. He tried his luck as a concert promoter and dancing master, a daring venture in a town that, as one traveler noted, did not "admit of plays or music-houses."[41] The public concerts Pelham began to advertise in 1731 were among the first in Britain's American colonies. In late 1732, he added a monthly dancing assembly to the bill of fare. The innovation provoked controversy. "I could not read this Advertisement without being startled and concern'd at the Birth of so formidable a Monster in this part of the World," wrote one moralist in the *Boston Gazette*. Since his critic clearly did not know what was meant by "that monsterous word assembly," Pelham responded, "I shall take the liberty of informing of him . . . by an *Assembly* in *England* is only meant a Society of Gentlemen and Ladies, who meet in an Evening to Divert themselves, Soberly, Honestly, Innocently and Agreeably."[42] Not soberly enough for Boston, it turned out.

After the assembly folded, Pelham advertised his services as a teacher of everything from the manly clerical skills of writing and ciphering to the feminine arts of needlework and painting on glass. Two months before Mrs. Copley gave birth to Jack, Pelham moved his school, where both "*Gentlemen and Ladies in Town and Country*" could board, to Leverett's Lane, just off King Street, which flowed into the Long Wharf.[43] There he offered classes in writing and arithmetic in the evening, "from Candle-light till nine o'clock," for the benefit of those young scriveners "confin'd in Business in the Day Time."[44] Beginning in 1743, Pelham's eldest son, also named Peter, added to this curriculum instruction "on the *Harpsicord* or *Spinet*" three nights each week.[45]

The widow Copley may first have encountered the widower Pelham through lessons for her son, though her straitened finances cannot have left much for Jack's formal schooling. But the intimate scale of Boston afforded plenty of other ways for the pair to meet. Pelham's move to Leverett's Lane placed him just steps from the Copleys' tobacco shop; perhaps he took a pipe now and again. And Pelham belonged in some fashion to Boston's community of Irish émigrés. His name appears among the twenty-six "Gentlemen, Merchants, and Others of the Irish Nation" who founded the Charitable Irish Society. His second London-born son, Charles, acted briefly as its secretary; officers of the society were required to be "natives of Ireland, or Natives of any other Part of the British Dominions of Irish Extraction."[46] Pelham imported an Irish indentured servant, one John Dear, who promptly ran away.[47] Across the ocean, Pelham's sister Helena served in the retinue of an Anglo-Irish gentlewoman, "some times . . . in Irland and sometimes in England," she wrote, lamenting the rough crossing that the Irish Sea unfailingly provided.[48] At the very least, then: Irish "Extraction," Irish connections, Irish sympathies, whether inborn or acquired. Perhaps those sympathies extended to the widow Copley, who may well have qualified as an object of the Charitable Irish Society's benevolence after her first husband died.

Regardless of how they first met, Peter Pelham and Mary Copley had decided to join forces by late April 1748, when they published their intention to marry. Shortly thereafter, the widow Copley tallied her late husband's modest assets, with Pelham and another artisan—a peruke maker—serving alongside her as administrators. They filed their accounting of Richard Copley's worldly goods with the court on 18 May.[49] Four days later, the Reverend William Hooper, whose portrait Pelham would soon paint and engrave, blessed the marriage of Mrs. Copley and Mr. Pelham with full Anglican pomp, at Boston's Trinity Church.[50] When the news reached London, Pelham's father told his son he was "Extreamly well Pleasd that god has blest you with so Choice a Companion, which is the greatest Pleasure and Comfort of life." He wished the couple "health

and Prosperity," as well as "Patiance till I am called home," at which point his namesake, his "Dearest son," would receive a generous bequest.[51]

But the largesse of Peter Pelham Sr., a "gentleman," was impossibly far off. Peter Jr. and his new bride, the former Mary Singleton Copley, needed to make do in Boston. By July the couple had merged households. It is not clear whether any of Pelham's children lived with them: Peter III was married; Charles, aged twenty-two, and William, nineteen, could both have been lodgers elsewhere. Depending on family circumstances, even Penelope, at thirteen, may have been bound to service in another Boston household. Eleven-year-old Thomas was young for binding out or apprenticeship, and likely lived with his father and new stepmother. If so, young Jack Copley would have had a sibling for the first time in his ten years. Mrs. Mary Pelham advertised that the former widow Copley now sold her wares from her new home, and Mr. Peter Pelham advised the public that his school near the Town House was still taking pupils, and that customers might now find all sorts of "*Virginia* Tobacco," and "also Snuff," for purchase "at his Dwelling House."[52]

Jack's new home was set in Lindall's Row, barely more than an alley that began opposite the humble wooden Quaker Meeting House and ended, a block later, at the harbor. Their neighbors included dram sellers and a rooming house, businesses that took advantage of the site's proximity to the docks.[53] Pelham kept hustling at his several trades; when he died, all too soon, he would be known in official documents as a "schoolmaster," not as a painter or engraver.[54] Had he not needed his new wife's trading income, the widow Copley would not have kept at her business as she grew big with child in the autumn of 1748. The following winter, Henry Pelham—fated to be the couple's only surviving child and Jack Copley's only blood sibling—was baptized in Trinity Church.[55]

Hawking snuff along with prints, music, and dancing lessons, the Pelhams were figures out of the bustling underworld of William Hogarth's engravings more than the polite environs of Samuel Richardson's novels. They were middling folk who worked hard, with their hands. Yet

in its way, the Pelham household was also something of a cultural hub, and the move to Lindall's Row would greatly have enlarged young Copley's visual and intellectual world. His parents' little collection of books, pictures, and prints joined the myriad others essential to his stepfather's varied trades—schoolbooks, manuals on letter writing and penmanship, treatises on painting, as well as English and European mezzotints from which Pelham borrowed backgrounds and poses. There would have been musical scores, play scripts, translations of the classics. Down the street, in the space Pelham rented for his schoolroom, stood the keyboard on which his son Peter taught young pupils to fumble through Bach and Handel.[56] And of course, the elder Peter Pelham also owned a range of artists' materials—charcoals and brushes, pigments and oils and varnishes, stretched canvas and copper plates and engravers' burins and inks and nibs, a specialized printing press: materials that must have been quite wondrous to a ten-year-old boy beginning to contemplate the world of trades that might bring him manly competence.[57]

The house on Lindall's Row belonged to a burgeoning network of Boston artisans: painters, printers, booksellers, frame makers, and more. Many of these craftsmen were incomers to the colonies, born, like the Pelhams, in Britain's home islands. In the generations preceding Copley's, painters, especially, were almost always exotic imports to North America. Trained in drawing schools in Edinburgh or London, they fled the more crowded art markets of more cosmopolitan capitals and chanced the provinces, where they might satisfy the vanity of local grandees who were hungry to hang their likenesses, and possessed comparatively few ways to satisfy that appetite. Some British émigré painters made careers as itinerants, traveling from town to town and setting up their easels for all comers. Others ensconced themselves in ports like Boston, New York, Philadelphia, and Charleston, places whose scale and relative sophistication sometimes provided enough patrons that an extraordinarily talented or driven craftsman might eke a living out of art.

John Smibert was one of the latter. Born in Edinburgh in the rev-

olutionary year of 1688, he trained as a housepainter before moving to London to study with Godfrey Kneller, the German-born painter whose intimate, conversational style of portraiture took Britain by storm in the early decades of the new century. Smibert then spent several years in Italy, where he could see and copy the works of the Renaissance masters firsthand, a rare privilege among British artists of his generation. He crossed the Atlantic in 1728, in the retinue of the Anglican divine George Berkeley, who had recruited him to serve as an instructor in art at the college he planned to found in Bermuda. Berkeley's venture proved as ill starred as it was ambitious, and Smibert instead settled in Boston, where he quickly established himself as the preeminent artist in New England.[58]

To Peter Pelham, who had made his way in Boston for barely two years when Smibert turned up in town, the Scottish painter's arrival represented both unbeatable competition and unparalleled opportunity for artistic collaboration. Smibert was the better painter—"infinitely more skillful than any artist who had yet appeared in the colonies," the art historian Jules Prown writes.[59] Few who could sit to Smibert would choose Pelham instead. But since Smibert's patrons included Boston's good and great, some of their portraits had the potential to circulate beyond their parlors, as valued engravings, public art. Between 1735 and 1750, Pelham engraved six plates from Smibert's portraits: four men of the cloth, and two heroes of the victory over the French at Louisbourg. "J: Smibert pinx: – P: Pelham fecit"—Smibert painted it, Pelham made it—became a common inscription on some of the most elegant works on paper produced in the colonies.[60] Their collaboration sometimes ran in the other direction as well: when Pelham engraved a large-scale plan of Louisbourg, Smibert published and sold it.[61]

Though Smibert's outsized skills as a painter meant that he did not want for customers to sit to him, the colonial market for art remained small, the portrait a luxury purchased by no more than one in a hundred. To make a living painting something other than houses required a healthy dose of ingenuity as well as a tendency toward self-promotion, even

brashness. Shop signs, advertisements, open talk of prices and volume discounts: these were lowly commercial ploys, tactics British connoisseurs and critics considered debasing to Art. Some theorists deemed portraiture suspect on these grounds, carrying as it did the taint of exchange on its very surfaces. In portraiture, the painter's venality answered the sitter's vanity. Warts and jowls could be erased for profit.[62] But how much easier to make such pronouncements from London than to eke out one's competence in Boston! Bishop Berkeley, who had retreated to Ireland, assured Smibert that Dublin was "a great trading city . . . four times as populous as Boston, and a hundred times as rich," with "more faces to paint, and better pay for painting, and yet nobody to paint them."[63]

Moored by family, church, and inclination, Smibert remained on Boston's much lesser Queen Street. Where Pelham's commercial instinct operated horizontally—he spread himself laterally through the arts, adding music and dancing and needlework and glass painting to portraiture and engraving—Smibert's ambition was vertical: he would traffic in everything from the raw materials of painting to its afterlives on paper. As he explained to one of his Scottish correspondents, he tested the market for "colours" and discovered "that there is considerable demand & something to be got by [selling] them" in Boston. Buoyed by the experiment, he sent away to London "for a Cargo of goods proper for this country." When they arrived, he set up shop, becoming the first dedicated vendor of artists' materials in all of British America.[64]

Smibert's shop found ready patrons, Pelham almost certainly included. He stocked "the best M[e]zzotinto, Italian, French, Dutch and English Prints, in Frames and Glasses or without, by Wholesale or Retale at reasonable Rates," and, on occasion, more "Valuable Prints Engrav'd by the best Hands after the finest Pictures in Italy, France, Holland and England done by *Raphael, Michael Angelo, Poussin, Rubens,* and other [of] the greatest Masters," some of them "very rare, and not to be met with except in private Collections." He sold pigments, "dry or ground, with Oils and Brushes": red lake (both "the Common midling sort" and the pricier "good" grade), Frankfurt black, and Prussian blue by the pound;

stretched canvases, palettes, and paint knives by the dozen; and fan paper by the ream. Boston had "many women that paints Fanns for . . . country use," who bought both colors and paper from his shop, Smibert explained. Some of them must have been Pelham's former pupils.[65]

Smibert's store, like Pelham's school, formed a brightly colored strand in Boston's thickening web of culture, a place where aspiring artists and artisans might purchase essential stuffs and widen their visual horizons. Even more important to the training of the provincial eye was Smibert's painting room, which showcased the artist's own work along with his extensive collection of prints, canvases, and casts. Located on the second floor of the Queen Street house, its walls lined with sumptuous green cloth, the studio was fitted out like a cabinet of wonders and remained, for decades, the closest thing North America had to a public collection of fine art. When Dr. Alexander Hamilton, an Edinburgh-born physician, made his progress through the colonies in 1744, a visit to "Mr. Smibert, the limner" counted as an essential stop on the refined traveler's Boston itinerary. In his journal, Hamilton described Smibert's "fine pictures," along with his "collection of good busts and statues, most of them antiques, done in clay and paste."[66] The painter's best works hung alongside his copies of some of the most celebrated paintings by the Renaissance and modern masters: imitations (and intimations) of the treasures heaped up in Florence and Rome. Here aspiring artists could see (Smibert's version of) the dazzling ultramarine blues that punctuate Poussin's somber *Continence of Scipio*, or the acres of scarlet cloth that nap Van Dyck's *Cardinal Bentivoglio*. And Smibert's was surely the only place in post-Puritan Boston to gaze upon not one but two nude representations of the goddess of love: a copy of Titian's odalisque *Venus and Cupid*, reclining in soft-bellied splendor, as well as a cast of the Venus de' Medici, famed the world over as an exemplar of feminine perfection.[67] To stop in at Smibert's was to imaginatively project oneself across the great ocean, and back through the centuries. For Jack Copley and for many others with keen eyes and questing spirits, Smibert's was that rare space, in a world of black and white, where one could think in color.[68]

By the time Jack was absorbed into the Pelham household, Smibert was sixty, at the ragged end of his career. For all its pretensions to the higher realms of thought and the professions, painting required grueling physical labor—a younger man's game. "I need not tell you that I grow old, my eyes has been some time failing me," Smibert wrote to a longtime friend in 1749. Though he was "stil heart whole," he had stopped taking portraits.[69] But perhaps he offered instruction to the young and eager, passing on his hard-earned knowledge of color and varnish and composition: the mysteries of his craft. Certainly Jack and other apprentices in art nourished connections to Smibert, his shop, and his collections, all the while jockeying to succeed him as the town's leading face painter.

Robert Feke, who hailed from Long Island, was working in Boston in the late 1740s.[70] Picking up the kinds of commissions Smibert was no longer able to execute, Feke impressed contemporaries as a "most extraordinary genius" who "does pictures tolerably well," despite "having never had any teaching," as Dr. Hamilton wrote upon meeting him in Rhode Island.[71] Feke had painted in New York, Philadelphia, and Newport, and brought a range of sights and insights to Boston: new ways of thinking about iconography and pose, a fresh, vivid palette, and a heightened attention to the intricacies of cloth and the luminosity of skin. Copley probably met him and certainly knew his work, especially his portraits of men in Governor Shirley's circle, some of whom Feke rendered at full length, with all the pomp of state portraiture, which was rare in the colonies.[72]

Also chasing the aging Smibert's coattails was young John Greenwood. Born in Boston in 1727, Greenwood was about a decade Jack's elder. The son of a merchant who had graduated from Harvard, Greenwood had more resources than the Copleys or the Pelhams. But his father died when he was fifteen, and either out of inclination or necessity Greenwood then apprenticed to a painter and engraver, learning to incise decorative items like bookplates, coats of arms, and tavern signs.[73] In 1748, the year of the Copley-Pelham nuptials, Greenwood published his first effort at mezzotint, an engraving technique that only Peter Pelham could have taught him. The two men partnered on at least one other project as

well; Pelham engraved Greenwood's portrait of the preacher and historian Thomas Prince in 1750. Copley and Greenwood knew each other well in later life, and it seems likely that they met at this early juncture, when Jack was just past ten and Greenwood entering his third decade. A tall, elegant young man, reasonably talented and plainly ambitious, Greenwood would have made a natural object of emulation.[74]

To call this handful of painters, engravers, color dealers, and printsellers an art scene would exaggerate its scale, its concentration, and its visibility. But with Pelham, Smibert, Feke, and Greenwood, along with several other, lesser painters all working in Boston around midcentury, the town was then more crowded with genius—the walls of its parlors literally more *colorful*—than had been the case a dozen years before, when young Jack Copley first drew breath. The relative plentitude of artistic means appears to have heightened the local hunger for portraits. Feke and Greenwood both painted steadily in those years. And as the people of Massachusetts developed a taste for the likenesses of local luminaries, engravers grew busier as well. Working from his own originals as well as paintings by Smibert and Greenwood, Peter Pelham engraved as many plates in 1750–51 as he had in the previous two decades combined.[75]

As Jack approached the end of childhood and began to think, as middling boys must do, about learning a proper trade, making one's way in art would have seemed more profitable, or at least more plausible, than ever before. It was a common thing to follow a parent's calling. Peter Pelham had the specialized tools to make such a move logical, even urgent for one of his children, lest costly supplies bought dear in one generation gather dust in the next. Pelham's older sons—Copley's stepbrothers—were otherwise pulled or prodded, Peter toward music and Charles toward the schoolroom. So in 1750, it may have seemed quite obvious to those living in the little house on Lindall's Row that Jack would slowly, steadily cultivate his talents, guided by his stepfather's hand, through an apprenticeship no less rigorous for being a matter of custom rather than contract, lasting five or six or seven years, as such arrangements usually did.

Sometime in those early years, Jack learned to wield a brush and an engraver's burin. (Young "Joints and Fingers" should be made "used to the Pencil" while still "pliable," one trade manual warned, for "when a Child grows old, before he is taught to handle these delicate Instruments, the Muscles are not easily moved.") Perhaps he readied Pelham's ink, steeping oak galls with gum spirits and diluting the resulting syrup with a mild acid—typically urine—to achieve the right consistency. He may have inked his stepfather's plates and locked them into the press. Perhaps he prepped Pelham's palette, fetching pigments from Smibert's shop— burnt ivory for black, powdered lead for white, vermillion for the truest red, ochres and umbers for the browns of nature, no good blue that a common painter could afford—and grinding them finer on a smooth stone before scumbling them with linseed oil to make paint. Perhaps Pelham taught the boy to outline his drapery with charcoal, or to lay down a wash of bister to dead color his primed canvases. Maybe he schooled his stepson's eye, pointing out the planes and angles and tricks of light that add up to a unique human face, teaching the boy to peer hard and true, and then to soften what he saw when he played it back on canvas—neither lying baldly enough to lose the likeness, nor telling such an unvarnished truth to lose the commission. Perhaps, by the beginning of 1751, the twelve-year-old Jack was coming along quite nicely in the painting way, growing with each small step into Pelham's shoes.[76]

And then the boy's world once again tilted on its axis. In May, his mother gave birth to a daughter, named Helena, after her new husband's sister. Seven months later, Peter Pelham died.[77] Barely three and a half years after the family formed, the Copley-Pelham household was thrown into turmoil, without a clear means of support. Henry (called Harry) was not yet three, and Helena (called Maria) still a nursling. Pelham had owned no property that could be leased or sold. He died intestate, and no inventory of his goods was filed; his estate was likely quite modest. Pelham's father, nearing eighty, outlived him; the promised bequest from London—some two hundred pounds, it turned out—would never reach Boston.[78] If Mary Pelham continued retailing tobacco, her income from

the trade would have been meager. Of Pelham's sons from his first marriage, only Charles was in a position to contribute to the wherewithal of his father's widow and her young children.[79] And Charles's largesse, too, was limited to whatever surplus he could earn by running his father's on-again, off-again school. The sadness and strain felt by all on Lindall's Row must have deepened the following spring, when Mary Pelham buried Helena, just one day short of the anniversary of the baby's baptism.[80]

Beyond the Copley-Pelham family, the losses to the world of art in Boston multiplied. John Smibert had died several months before Peter Pelham. Robert Feke left Massachusetts for Newport and then Philadelphia; by late 1751 or early 1752, he too would be dead.[81] John Greenwood took advantage of Boston's deep connections to the Caribbean trade and set sail for Suriname, a Dutch colony on the northern coast of South America, where he hoped rich sugar planters might pay well to preserve their likenesses. Boston's cultural fabric, grown so much denser and more vivid during the 1740s, was once again tissue-thin.

Much weight rested on the still slender shoulders of Jack Copley, thrust at age thirteen into the role of male head of his fragile, twice-broken household. "You are now taken from the Company of *giddy Boys*, to that of *serious Men*," counseled an advice manual directed to youth about to embark upon their apprenticeships. "You are therefore to *conclude* the *Boy*, and *begin* the Man."[82]

~

The early 1750s were difficult for many in Boston. The town's population, long stagnant, dropped, counting about a thousand fewer people than at the time of Jack's birth. Taxes were high—the cost, in large part, of poor relief. Indigent families found themselves warned out of the town in record numbers.[83] The "Cry of Poverty has been for a long Time growing upon us," noted one pamphleteer. Much like the critic of Peter Pelham's dancing assemblies, he worried about the combination of luxury and meanness. For "if we are *poorer* than we were thirty Years ago," he said, "we are also at the same Time *finer*. Our Ornaments have encreased

with our Poverty With an ill Grace must that Tradesman Complain of hard Times, and the Difficulty of getting a Livelihood, whose Wife and Daughters are cover'd with Scarlet and Velvet."[84] As remedy, the writer advocated the building of a workhouse, a "manufactory" where the ragged and idle—including children—would weave linen cloth, "earning, instead of begging, their daily bread."[85] Jack Copley, too, embraced industry—made it, in fact, his gospel. But his industry would be the handmaiden of luxury; he would seek his pay from those ladies robed in scarlet and velvet, and the silk-suited merchants who were their husbands and fathers.

Soon after Pelham died, Jack started to hone his craft in earnest. He gathered up the materials nearest to hand: tools he could put to use, prints from which he could quote, kinsmen from whom he could beg the many hours of time-is-money needed for a sitting. Among the first

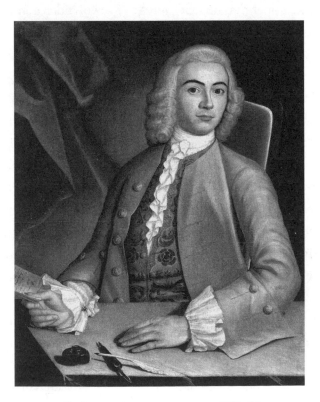

Copley, CHARLES PELHAM, *ca. 1753–54*

subjects he painted from life were two of his adult stepbrothers, whose similar faces testify to either a very strong family resemblance or to the artist's rudimentary skill at catching a likeness. Jack portrayed the thirty-year-old Charles Pelham seated behind a cloth-covered table reminiscent of Smibert's and Greenwood's poses, in a warm, rosy palette that owed much to Feke. But the picture revels in the stuff of everyday life—a pen-knife and a freshly cut quill, a shining glass bottle filled with jet black ink, pearly linen ruffles punctuated by a gleaming gold button, a figured silk waistcoast—a level of attention to surfaces that would soon come to distinguish the young painter's developing style.[86]

Jack also tried his hand at engraving. In 1753, at the age of fifteen, he offered for sale a mezzotint bust of the recently deceased Reverend William Welsteed, longtime pastor of the New Brick Church. Parts of his *Welsteed* so closely replicate Peter Pelham's 1744 engraving of the Reverend William Cooper that he may well have reworked his stepfather's old plate, incising the surname of one Reverend William over that of another. *J. S. Copley pinxt et fecit*, reads the inscription below the oval portrait, the first record of his name in print.[87]

Both the *Welsteed* engraving and Jack's studies of his stepbrothers were well-plotted steps along a career ladder, investments in a competence as much a calling. And the effort paid off: before the end of 1753, he received a pair of portrait commissions from paying customers: a baker's daughter and her husband, who had that year been named a Boston constable. He painted Bethia (Torrey) Mann's likeness first, basing her pose and costume on an English mezzotint depicting Princess (later Queen) Anne, a print upon which Greenwood and Feke had also drawn. With its vaguely classical dress, swanlike neck, and falling strand of pearls, the princess's pose ennobles the sitter, who had lived, until her marriage, on Water Street, just around the corner from the Pelhams. The fifteen-year-old painter's skill lagged his and his patron's ambitions; Mrs. Mann's hands look as if they are made of pine.[88] But by the time he completed the companion portrait, Jack's brush had grown more fluent. While both sitters wear masklike planar faces, Joseph Mann's hands are subtler, more

convincing illusions. The artist signed and dated both pictures, following a relatively recent practice among artisans determined to claim the trade of painting as a "liberal" rather than a mere "mechanick" or manual art. Indeed, in the span of a few months separating the two canvases, Jack experimented with his signature, switching from italics to roman capitals, turning his name on Joseph Mann's likeness into a legible calling card.[89]

But if J. S. Copley was working to build a business painting for money, he also worked, when he could, during those tender early years, in the service of Art. As Pelham, Smibert, and the treatises in their libraries would surely have told him, artistic genres were arrayed in a steep, hierarchical pyramid. Histories, allegories, and classical scenes—things for which few in Boston had much appetite—occupied the topmost reaches. Among Copley's first works are three mythological scenes, each translated, painstakingly, from print into paint: large, complex pictures that had no intended buyers. The sixteen-year-old who transcribed *Galatea*,

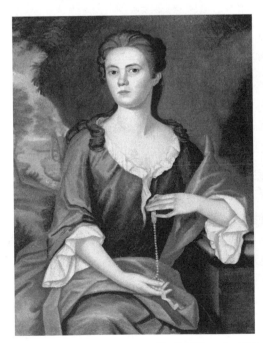

Copley, MRS. JOSEPH MANN *(Bethia Torrey), 1753* *Copley*, JOSEPH MANN, *1754*

Neptune, and *The Forge of Vulcan* would fain be a seeker after immortality and no mere copyist.

Two of the three tell sea stories. In *Galatea* (ca. 1754), the sea nymph described in Ovid's *Metamorphoses* rules over the waves, returning to her realm after a brief dalliance with an earthly lover, Acis. Dolphins and naiads surround her. Neptune, astride a horse, calms the seas. *The Return of Neptune*, which appears to date from nearly the same moment, also shows a watery apotheosis, with the eponymous god pulled forward in his half shell by a quartet of mighty steeds, like some merchant grandee rumbling down the streets of Boston in his chariot and four.

Seen in one light, the pictures are mere juvenilia: earnest and clumsy, products of a still inexpert hand working doggedly to produce a line-for-line copy. Here is imitation, not imagination, in other words—and not terribly fluent imitation at that. But Copley's deviations from the originals, though minor, are telling. He robes the nude Galatea in a shift and mantle that resembles nothing so much as *Mrs. Joseph Mann* in dishabille, with the addition of a goddess's golden belt—evidence either of a Boston boy's discomfort with the nude female form, or of his desire to gain practice painting drapery. To *Neptune*, he adds a lowering sky and a distinct horizon, east facing, sunrise peeking above the waves: the early-morning view from Long Wharf.

And he added color—vivid, even lurid color—to each engraving's black-and-white palette. If copying was rote work, this dimension of the translation from print to oil was improvisational, a no longer boy at play with a paint box. There would have been formulas (shared by Smibert and Pelham? by Greenwood? intuited from Feke?) and doubtless some book learning. But by and large we see the painter's eye let loose on the world around him, and on worlds he can only imagine. The seas are slate: New England seas. The flesh tones, too, gesture toward the local palette in all its breadth, from whites so near to alabaster that they appear sculptural, to ruddier complexions that might serve sailors well, to a deeper bronze and wooly hair on one of Galatea's minions that takes the scene from the ancient Mediterranean to the Atlantic society with slaves in

which Copley lived. Delicate dawn pink lines Neptune's clamshell carriage. Nymphs offer Galatea a coral branch of startling red and an oyster filled with luminous white pearls. Copley robes Galatea in a cerulean worthy of the Virgin Mary, as vivid a pigment as one could buy in Boston. Perhaps Smibert had told him of the pulsating intensity of ultramarine, worth a king's ransom, almost unknown in the colonies but visible in great expanses in Italy. Here is a Boston teenager imagining himself in Florence, in Rome, in Athens—so terribly far from Lindall's Row.

With these two canvases, the young Jack Copley, striving with an empty purse, attempted to paint himself into an artistic lineage both wide and deep. The great Raphael had represented Galatea's triumph in an enormous fresco in the Farnese Palace in Rome in 1512; Poussin rendered his own version a century later. Copley surely knew of these; prints after the Raphael fresco circulated widely, and could well have been among those Smibert sold. The Dutch print upon which Copley based his own attempt followed a later original, by the Venetian painter Gregorio Lazzarini. Copley's canvas, then, bore the impress of ancient Greece, sixteenth-century Rome, seventeenth-century Paris, eighteenth-century Venice and the Netherlands: millennia of travel through time, across tongues, packed into two dimensions and shipped to the Long Wharf, carted to Smibert's printshop or Pelham's studio, and thence to Copley's easel.[90]

Despite their polyglot accents and their cosmopolitan family trees, Copley's *Galatea* and *Neptune* also boasted a proud and unmistakably British pedigree, with connections to Georg Friedrich Handel, that most English of German composers. Throughout Copley's youth, as the Hanoverian dynasty focused its territorial ambitions and its military and economic might across the Atlantic, Handel's music served as the soundtrack of a growing and increasingly confident blue-water empire, a realm made and maintained by naval might. His oratorio *Acis and Galatea*, sung in English with a libretto most likely written by John Gay, was for many years one of the most popular operatic attractions in London. Any English gentleman of the day would have associated Galatea

not only with Greek myth but, through Handel, with the rise of British sea power and the culture that celebrated it.[91]

So, too, *Neptune*: the French engraving after an Italian original upon which Copley based his painting was drawn from a large-scale theatrical transparency, one of eighteen panels that decorated the enormous pavilion erected in London's Green Park to celebrate the Treaty of Aix-la-Chapelle, which ended the War of Austrian Succession. For months after the treaty was signed, the Boston papers carried news from London describing the spectacular fireworks planned for the day it took effect. *Neptune* belonged to an elaborate frieze of martial and maritime images ringing the viewing pavilion, before which loomed a mast stretching fifty feet into the air—a mast, perhaps, of New England pine—topped with an enormous wooden sun: the Hanoverian sun rising over Britain's empire. On a damp evening in April 1749, throngs packed the park to gape as the sun was set alight to the joyous noise of cannons firing and rockets bursting overhead, while "a hundred of the best musicians" played the Royal Fireworks Suite, which Handel had written for the occasion.[92] Perhaps Peter Pelham, Boston's music master, transposed to the spinet the strains of the horns and the trumpets raised in martial fanfare, just as Copley translated the engraving of the *Neptune* transparency into oil on canvas.[93]

When Copley painted *Neptune*, he celebrated Britain's glory. Yet he may have read in the newspapers of the grumbling that accompanied the celebration. The pageantry goaded the public "to rejoice for the *Breaking of a bad Peace*," wrote one English pressman in an essay reprinted in Boston, where those who had spent both blood and treasure to gain Louisbourg mourned the treaty that returned the fortress to France.[94] The *Boston Evening Post* carried a column by a London satirist who mocked the "giddy Croud" dazzled by the fireworks display. Who could afford such luxuries? "It is generally known that the Public Debt is Eighty Millions," the writer pointed out. Fashioned of wood tricked out like stone, the pavilion in Green Park was a hollow and vainglorious display, a "singular Instance of Folly." Thus it struck many as perversely fitting when sparks

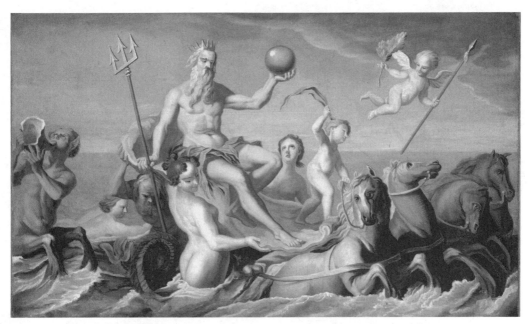

Copley, THE RETURN OF NEPTUNE, *ca. 1754* [Plate 2]

from the fireworks set it ablaze. Total loss was averted only when frantic laborers cut away the burning wing, topped by *Neptune.* The incendiary limb severed from the body: hardly a comforting metaphor for Britain and its dependencies.[95]

Art and politics came together, then, in *Neptune,* a composition that heaped up strata of meaning, much as the fledgling artist built the image upon canvas, from a wash of primer to the final coat of varnish. Encoding those meanings comprised what the English portraitist George Allen called "the thinking Part of Painting." And from that thinking part stemmed the painter's claim to join poets, philosophers, and other "liberal" artists, rather than to stand alongside carpenters and tobacco sellers. Art's "first essential and requisite is Genius," wrote Allen in the disquisition on the subject he published in 1747. He counseled painters not to become "meer Appliers to the Pencil, those laborious Machines whose Employments is to fix on one Cloth; what they see standing before them on another."[96] But genius could not put food on the table. Along with his soaring encomia to the painter's intellect, Allen offered a proverb said to

have originated with the greatest of all Greek painters, Apelles, in the fourth century BCE: *"No Day without a Line."*[97] The mind's eye needed the trained hand.

Jack Copley did not want for diligence. Some would soon say that he suffered from an excess of it. The danger, as he came to see it, was less the overfaithfulness of the observer—that watchful boy at the end of the wharf at the edge of the empire—than the absence of sufficiently elevated and challenging material to observe. Smibert's legacy, Pelham's tutelage, Feke's canvases—indeed, even their deaths: all these were advantages to the Boston artist on the make in the 1750s.

Yet Copley, restless and longing, even so young, tended rather to count his trials than his blessings. The "mere dictates of Nature" were not enough, he would write a decade later, when he had become convinced that his talent was larger than his milieu. "I think myself peculiarly unlucky in Liveing in a place into which there has not been one portrait brought that is worthy to be call'd a Picture within my memory."[98]

A DAZZLING OF SCARLET

ATER, MUCH LATER, after he had at last reached Italy, Copley shared with a fellow English painter a formula for making a glaze. "The Receipt for Varnish is as follows," he told Ozias Humphry, with some pride in a method he (wrongly) considered his own creation: "take of the Whitest Gum Sandrick, two pounds to a gallon of Rectified spirits of wine, & to every half pint near upon two Spoonfuls of the Balsam of Fir, if you find it too thick add more spirits of Wine."[1]

Painting was a business of recipes and routines, some of them shared as guild knowledge and others guarded as trade secrets, the stuff of rumor and whispers. There were formulas for making varnish and blending colors, geometries governing composition, ratios for perspective, tricks even for stretching and softening canvas: procedures large and small that turned mere matter into High Art. But what recipe confected an artist? Charles Du Fresnoy, a French painter and author of one of the most widely regarded treatises on painting for over a century, listed this set of ingredients in 1668:

> The Qualities requisite to form an excellent Painter, are, a true discerning Judgment, a Mind which is docible, a noble Heart, a sublime Sense of things, and Fervour of Soul; after which follow, Health of Body, a convenient Share of Fortune, the Flower of Youth, Diligence, an Affection for the Art, and to be bred under the Discipline of a Knowing Master.[2]

When he began to paint in earnest, in the mid-1750s, Copley possessed much of what Du Fresnoy recommended. Youth he had in excess; his age still constituted an obstacle to his business. His health was sufficient to the trade's considerable physical demands. None could question the affection for Art that would drive a teenager to attempt *Galatea* and *Neptune*. Even at so tender an age, Copley evinced a relentless determination to progress at the easel and thus to improve rather than merely maintain the modest situation of his household. In a world that valued competence—a sense of sufficiency, of adequacy—he would have only excellence.

"Fervour of Soul," which we might call ambition, Copley possessed in hyper-abundance, both the immediate sort, born of necessity, and the slower-burning variety that success only stokes, the insatiable hunger to reach beyond one's grasp, to ascend, to transcend: the *Galatea* kind of ambition. Now understood as a defining element of the get-ahead, go-ahead American character, ambition carried in Copley's day a taint of wickedness. Which is not to say that British Americans lacked "fervour." To the contrary; the society of the provinces was, by the standards of its time, highly mobile. Tenants, and even, on occasion, slaves, became landholders; shopkeepers turned merchants; farmers' sons fetched up as ministers. But for every striver who reached for a higher rung on the social ladder than the one upon which his father's feet had come to rest, and for every Benjamin Franklin who trafficked in rags-to-riches tales, there remained scores of moralists who fretted about the consequences of ambition: a destructive, unruly passion that tended as much to the sin of envy as to the virtue of enterprise. Once loosed, ambition was hard to corral. As Copley's half brother, Henry Pelham, later noted, "neither the light of Natural Religion, the dictates of Reason, the positive Commands of Christianity, nor even a Regard to present Happyness are effectual to curb the licentious Ambition, the Pride and Averice of Man."[3] Nonetheless, Copley evinced from a very early age a desire to do not just well enough but better than anyone else, ever, at least in the colonies. This sense of purpose was both fueled and tempered by family feeling. "What

ever my ambition may be to excell in our noble Art," he later wrote, "I cannot think of doing it at the expence of not only my own happyness, but that of a tender Mother and Young Brother whose dependance is intirely upon me."[4] About Mary Pelham's tenderness and Henry Pelham's youth and their entire dependence upon him Copley did not exaggerate.

Driven from without as well as within, Copley worked steadily, tirelessly. Like the hero of William Hogarth's famed 1747 engraving series *Industry and Idleness*, Copley would be the virtuous apprentice rewarded for his toil, not the flighty soul waiting on inspiration. As he came of age both socially and artistically, he recalled his "diligence for Years past": those "many hours of severe study" that gave him "a foundation to build upon" at the easel. The "design I have always had in v[i]ew," he wrote, was "improveing in that charming Art which is my delight, and gaining a reputation rather than a fortune." Reputation came first: he was insistent on this point. "Tho if I could obtain the one while in the persuit of the other," he continued, "I would willingly use great diligence for the acquireing of both."[5] *Diligence*, another of Du Fresnoy's necessary ingredients: Copley was a stern self-governor, a hardworking craftsman, unafraid to appear effortful.

But what of Du Fresnoy's insistence that an excellent painter must "be bred under the Discipline of a Knowing Master"? Peter Pelham had been knowing enough; his fleeting presence in young Copley's life gave his stepson the tools of craft—the only capital he inherited—and also forged an enduring web of connections in Boston's community of artist-artisans. John Smibert's collections offered some sense of the goals and accomplishments of European academic traditions in the arts. The portraits by Greenwood and Feke that hung in Boston parlors provided further specimens of the handling of paint, the hardest thing to learn from prints.

The arrival of Joseph Blackburn in Boston in 1755 presented both heightened example and heightened competition for the teenager who had begun to make his way on canvas. Blackburn was likely from London; some formal academic training underlay his fashionable style of portraiture, which was brighter and lusher than the more restrained ele-

gance that Smibert had learned at Kneller's hand. Blackburn sailed to the North American mainland via Bermuda, where he made a name for himself among the island elite. His New England sitters praised not only his knack for painting faces—he modeled flesh much more effectively than had his predecessors—but also his ability to portray the stuffs of everyday life: "to make such extreme fine lace and satin," as one Massachusetts woman wrote in 1757.[6] Blackburn's devotion to representing fabrics has led some art historians to speculate that he may have worked in England as a drapery painter, clothing the heads painted by greater artists: a kind of sous-chef in the assembly line of Art. A line cook in London was a master in Boston, and Copley quickly began to absorb both the details and the substance of Blackburn's stylistic vocabulary.

Yet connections and example were not schooling; Copley had no master of the sort whose presence seemed so easy and obvious a necessity in Du Fresnoy's ancien régime Paris. The early deaths of Copley's father and stepfather, the contours of culture in Boston, indeed, the provincial condition itself all conspired to force Copley to navigate by his own compass. His years of "severe study" proceeded, to a significant degree, at his own masterless hand, and certainly without an academy or even a less formal drawing school where he and other journeymen, similarly diligent and fervent, might progress together, much as Pelham and Smibert had done in the 1710s, when they studied with Godfrey Kneller at his academy on Great Queen Street in London. Kneller's operation, founded in 1714, had been Great Britain's first—English artists then, and after, bemoaned the country's backwardness in comparison with France and the Italian states, where government-sponsored academies of the fine arts had august lineages reaching back centuries.[7] Since Kneller's day, several other drawing schools had popped up in the lanes and alleys around Leicester Square, in London's West End. By the 1750s, as Copley worked to train his hand and eye in Boston, London artists had begun to lobby for the creation of an academy that would bring drawing, painting, and sculpture under the ever-spreading wings of the Hanoverian state.[8]

Even without the king's imprimatur, the most haphazard drawing

school had several advantages over solitary study. London academies like Kneller's and, later, William Hogarth's, on St. Martin's Lane, concentrated the wisdom of experts and channeled the aspirations of young acolytes, whose achievements and even failures could goad the others to greater heights. Academies heaped up materials as well as talent. Prints, books, and copies; pigments, formulas, and plaster casts; easels, brushes, burins, inks, even specialized lighting fixtures: drawing schools created three-dimensional libraries of the base stuffs that could be turned, almost alchemically, into art. There was no such storehouse within three thousand miles of Copley's Lindall's Row, but at least the closest approximation could be found just blocks away, at Smibert's on Queen Street. Smibert's nephew continued to run the color shop, and the family kept the studio open to aspiring artists and curious travelers for nearly three decades after Smibert's death in 1751.[9]

Of course, a pilgrimage to Smibert's did not provide even the best and most fervent of pupils with comrades, much less with live models. Anyone who aspired to depict figures had to master human anatomy, an essential prerequisite for the painter of histories, allegories, and any other genre that arrayed images of people in space. Face painters likewise had to become architects of the body: heads needed shoulders, and the subjects of full-lengths had to read as if their silks and linens scaffolded real skeletons. For centuries, academic curricula had insisted that anatomy was best mastered by direct confrontation with a nude human form. Drawing and doctoring grew up together; apprentice artists and aspiring physicians alike learned in the dissection theater. One young British painter training in the 1770s asked his brother whether he'd read in the newspapers about the recent execution of two murderers at Tyburn. "We had the body of one of them at the acadamy . . . and now I begin to know somthing of Anatomy," he wrote. "We had but two lectures on it because they might have the body fresh to cast a plaster anatomical figure from to be placed in the acadamy to be drawn from." Artists drew from life as well as from death; "life class" had been a staple of painters' formal training at least since the Renaissance. Life class, like dissection, took place in

the round—amphitheater style, if the setting was formal enough, though a clutch of chairs ringing a model would do. Just so long as students could encircle the form, sketch books in hand, gazing from their different vantage points at changing patterns of light and shadow as a leg was raised or a head turned, a muscle contracted or weight shifted.[10]

And like dissection, life class was a fraught enterprise, rife with sexual and social tension. Models found themselves posed, prodded, inventoried, their every wart and wrinkle recorded. Students were awestruck and titillated by turns. By the early nineteenth century, life-drawing classes would become a favored subject for graphic satire, especially when the models were women, and looking verged on lechery. Female artists, even those accomplished enough to earn a place in an arts academy, were deemed unfit for life class, for which their sensibilities were too delicate. To be shut out of life class was a major impediment to an artist's education; a lack of fluency with human anatomy inevitably sapped one's figures of accuracy and energy. Their categorical exclusion from life class is one reason that women artists often specialized in still life, mosaic, and other lowly mimetic genres. They were not trained to paint bodies, let alone histories.[11]

In the American provinces, with no academies and thus no life classes, every prospective artist had to improvise. In Rhode Island, the aspiring painter Gilbert Stuart and a friend who wanted to be a physician once bribed a "strong muscle blacksmith . . . to exhibit his person for their study."[12] Perhaps Copley sought a similar arrangement with one of the powerfully built men who loaded crates onto ships from the winches at the end of Long Wharf, or one of the enslaved carters who pulled goods through Boston's cobbled streets. Perhaps the strolling women who sold sex along the narrow lanes near the waterfront were happy enough to be paid merely to pose. Perhaps Copley called upon the fine mirror that had hung in his mother's yellow chamber and sketched himself. ("*Speculum pictorum magister,*" Du Fresnoy advised: "The Looking-glass the Painter's best Master.")[13] But mostly, absent bodies in three dimensions, he fell back on what was available to him in two.

In 1756, when Copley was eighteen years old, he made as close a study

of human anatomy as he could, working from the printed page. He relied upon—quite literally drew on—at least three treatises on the subject to create his own group of eight folio-sized pages of annotated drawings interleaved with three of explanatory text. Two of the books from which Copley worked were antique. The Flemish scientist Andreas Vesalius published his *De Humani Corpus Fabrica* in Basel in 1543; the Dutch painter and engraver Jacob Van Der Gracht drew heavily upon Vesalius when he compiled his *Anatomie der wtterlicke deelen van het Menschelick Lichaem*, first printed in The Hague in 1634.[14] The rarity of these works— enormous, expensive, lavishly illustrated folios—is hard to overstate. It is not at all clear how Copley got hold of them. Harvard College did not count the titles among its near 5,000-volume library, nor did they find a place in the library of the Mather family, the largest private collection in British North America. Copley's third source, the 1723 London edition of an older Italian book originally printed for the French academy in Rome, was only slightly more common; even in England, it turned up in the cabinets of scholars and noblemen.[15] It seems impossible that Pelham could have afforded any of them, and only slightly more likely that Smibert would have owned them—unless, perhaps, they were extravagant gifts from Bishop Berkeley.

However he turned them up, Copley had them near enough at hand to trace their intricate plates as he made his copies. Working in graphite and red chalk, he drew the musculature that extended from scalp to toes. Five plates diagram standing figures at full length; another maps front and back views of the head and torso; a series of arms and hands (right, left, extended, contracted) and another of legs (left and right, front and back) get pages of their own. He labeled his figures in ink, producing a key to inventory each muscle and sinew. Copley devoted the final page of the group to a line drawing, in ink, of the fabled Venus de' Medici. He labeled the dimension of every one of the bones implied by the picture of the statue from which he worked: a study in the perfect proportions that the finest classical sculptures were believed to exemplify.[16] Where *Galatea* and *Neptune* have a clumsy, halting quality, the anatomical

Copley, Measured study of MEDICI VENUS, *1756* *Copley, Book of Anatomical Studies, Plate X, 1756*

drawings are vigorous and confident, with fluid lines and the intricate crosshatched shading of etched plates.

If Copley's drawings were as faithful as he could make them, he adapted the accompanying text quite freely, in his gorgeous script. He must have had help, perhaps from a physician or other learned neighbor, as he rendered Latin words in English, spelling better than he usually did. He compressed cumbersome phrasing, and shifted labels to heighten the drawings' utility. Under "Muscles of the Thigh," for example, he notes the "Sartorious so called because Taylors use it in bringing one Leg and thigh over the others to sit cross Legg'd," a pose he had not yet attempted to catch in one of the portraits that he painted, every other month or so, for an increasingly broad array of New England patrons.[17] Copley—or perhaps

his mother—stitched the bible-sized pages into a booklet, and there is some evidence that he used it in his growing portrait practice, keeping it near his easel, along with his pastels and paint box and a wooden figure, or "layman," on which he could arrange drapery.[18]

Treatises that mapped the hierarchy of genres and other lineaments of art were only slightly easier to come by in Boston than the illustrated texts upon which Copley based his anatomical drawings. Not a single book on painting, sculpture, architecture, or drawing was published in the American provinces before some of them declared their independence in 1776. Copley's letters disclose that, by the early 1770s, he had read carefully—indeed, had committed to memory—a handful of French, Italian, and English tracts on art. But several of these were published or translated only in the 1760s, and so could not have guided Copley's "severe study" earlier in his career. Surviving booksellers' catalogs—themselves rare—make clear how very few art books printed in England were offered for sale in Britain's American colonies: exactly one before 1760. Nor did the library at Harvard, a cabinet of wonders to which Copley might conceivably have gained access, offer much guidance. Only in 1773 did the college library acquire two treatises on painting, tucked among the works of divinity, history, and classical literature that overwhelmingly dominated both the collection and the curriculum.[19]

Books by two French university-trained painters, Charles Du Fresnoy and his sometime translator Roger de Piles, rank high among the older titles likely to have made it to Boston in the sea stores of Pelham or Smibert, and thus as almost certainly the first such texts to which Copley would have been exposed. Du Fresnoy's epic poem *De Arte Graphica* was published in Latin in 1668, quickly translated into French, and issued in English a generation later. De Piles also parlayed his work as a translator and annotator of Du Fresnoy into several successful publications of his own. His 1699 treatise *L'Abrégé de la vie des peintres . . . avec un traité du peintre parfait* saw its first English printing in 1706, as *The Art of Painting and the Lives of the Painters*; two more London editions followed before Copley picked up a brush.[20]

These books made for heady reading. Du Fresnoy modeled *De Arte Graphica* on Horace's *Ars Poetica*, and its very first lines announced the kinship of painting and poetry, "two Sisters, . . . so like in all things." Both of these "Divine Arts" had "rais'd themselves to Heaven" in the service of religion. Both had plumbed the depths of "all past Ages" in the service of history. Historical and religious painting operated at the junction of book learning and the mind's eye. They demanded a degree of invention that elevated them above still life, landscape, or even portraiture—genres where the content of art appeared before painter. Painters, like poets, must temper observation with imagination, and vice versa. "Be not so strictly ty'd to *Nature*, that you allow nothing to Study," Du Fresnoy warned. "But on the other side, believe not that your *Genius* alone . . . can afford you wherewithal to furnish out a beautiful Piece, without the Succour of that incomparable School-mistress, *Nature*." Copley must have been comforted by Du Fresnoy's claim that even Titian had "no better Rule for the distribution of the Lights and Shadows, than his Observations drawn from a *Bunch of Grapes*."[21]

Both Du Fresnoy and de Piles prescribed a course in the study of antiquities that few readers in Paris or London, and certainly no Bostonian, could hope to approximate. But at the same time, they promoted a relatively recent understanding of artistry as a product if not of supernatural inspiration then at least of sublime natural inheritance. Talent could be channeled but not made. "Genius is the first thing we must suppose in a Painter; 'tis a part of him that cannot be acquired by study or labour," runs the first line of de Piles's first chapter, as if to say, *reader, if you have not genius, set down this book.* Or: *reader, if you have faith in your own yet undiscovered genius, read on.* Genius could not be purchased or learned; it was "a present which nature makes to a man at the hour of his birth."[22] Du Fresnoy and de Piles taught Copley to see his gifts as an inheritance.

Talent should not be confused with mere dexterity. The painter's genius resided in the mind, "rather in your Eyes, than in your Hands," Du Fresnoy explained.[23] Great art, Copley read, required not just sharp

sight but true vision: insight into the human condition, past, present, and future. This notion of the seat of artistic genius is one reason why painters' self-portraits—including those Copley would later make—more often call attention to an artist's high forehead and piercing gaze than to brushes, palettes, or paint-flecked fingertips.

If painting was inspired by a "light of the mind," as de Piles put it, what use diligence? "'Tis in vain for the Painter to sweat over his Works," Du Fresnoy wrote; "too much Assiduity" risked "blunting the Sharpness of your Genius, and abating . . . its Vigour."[24] Sometimes talent flourished best in the absence of discipline, one of Copley's correspondents hinted. The Boston-born craftsman William Johnston wrote Copley a capsule biography of the Dutch genre painter Jan Steen, the son of a brewer who had painted in an alehouse. Steen "drank the greatest part of his own Liquor," Johnston said, deducing that "if Genius did not often supply the place of study & application, one could not well conceive how a man who was almost always Drunk, could produce such excellent performances."[25]

Such tales prescribed a volatile blend of inspiration and industry. But they also imparted to their readers, perhaps especially to those provincial readers with few pictures to see, and who perforce hung on every word, a sense of membership in the family of Art. Here was a genealogy of genius, a chain of masters and disciples stretching from ancient Greece through the Renaissance, and sometimes beyond. English translations of Du Fresnoy appended biographies of the modern masters working in Italy, France, Germany, and the Netherlands. A few English painters join the expanded list included in the 1716 printing. Artists' lives must have sold well, for the third English edition of de Piles's *Art of Painting*, published in 1750, was largely a biographical project, cataloging "the Lives and Characters Of above 300 of the most Eminent Painters": saints' lives for a new cultural pantheon. To these the translator appended "An Essay towards an English School of Painters." An astute reader, as Copley surely was, may have noticed that the great majority of those claimed for the "English School," from Hans Holbein to Godfrey Kneller, had been born and trained in Europe.[26]

The Art of Painting traced the arc of genius across space and time, north and west from classical Athens. The belief that human progress followed the path of the sun was both long and widely held. *Translatio imperii*: as early as the fifth century, scholars posited that imperial power traveled or "translated" inexorably westward, as new empires rose from the ashes of vanquished realms. *Translatio studii*: learning and the arts—culture—echoed the heliotropic progress of civilization. For writers of the European Enlightenment, the sun rose in Greece, grew high in Rome, and finally, after a long eclipse in the Middle Ages, resumed during the Renaissance its journey across Europe.[27] The French art theorists whose works had such importance in Copley's world tracked the sun no farther than Paris. The invention of the so-called English school tugged the light of art and culture about as far west as Bath.

But by the late 1720s, some Britons had begun to posit that the westward progress of civilization might, in the fullness of time, leap the ocean. Bishop Berkeley, Smibert's patron, was the best-known proponent of the idea that art and empire must together reach their zenith on the western side of the Atlantic. His 1726 verses "On the Prospect of Planting Arts and Learning in America," occasioned by the Bermuda College project, were already well known when they were printed for the first time in 1752. The poem's final quatrain rhapsodized,

> Westward the Course of Empire takes its Way;
> The four first Acts already past,
> A fifth shall close the Drama with the Day;
> Time's noblest Offspring is the last.[28]

Copley may well have read Berkeley and de Piles together. And there were plenty of other places to take in the same message. In 1730, a Massachusetts writer purported to have discovered a stone in a field in Plymouth engraved with a similar couplet: "The Eastern World enslav'd, its Glory ends; / And Empire rises where the Sun descends." The portentous Plymouth rock was a fiction, it turned out. But that fiction proved popu-

lar and enduring. John Smibert jotted the lines in the back of his account book, along with several other variations on the same theme. Perhaps Smibert showed his carefully collected examples of an Americanized *translatio studii* to a young Copley.[29] Certainly Copley had meditated on the theme by 1762, when he confided to a Swiss correspondent his hopes that "America which has been the seat of war and desolation" would "one Day become the School of fine Arts."[30]

Translatio bellii: France and England had again moved the theater of their ongoing conflict west, to North America. By 1762, when Copley wrote, this latest war had raged for more than seven years. Copley was not wrong about the "desolation" it visited upon much of the continent. But in ways he could not yet see, the French War (as the colonists called this latest in a succession of similarly titled conflicts) brought Copley closer than he had ever come to possessing another of the ingredients on Du Fresnoy's list of painterly attributes: a convenient Share of Fortune.

The second war to convulse the colonies during Copley's young life came hard on the heels of the first. The peace brokered at Aix-la-Chapelle in 1748—the peace whose gaudy London celebration, crowned by the image of *Neptune* that Copley later copied, had ended in ashes—never amounted to much on the ground. Within two years, the French were building a new line of fortifications in the American interior, and New England leaders had begun to lobby Whitehall to seize control of Acadia.[31] Before the year 1755 ran out, British America was at war from Newfoundland to Virginia.

By the time the conflict that came to be called the Seven Years' War ended, eight years later, roughly a third of the adult men in Massachusetts had served under arms.[32] They died by the hundreds, of war wounds, accidents, and disease. Whether the fighting was going badly (as it did for the first three years) or brilliantly (as it did in 1758 and thereafter), life in the army was far deadlier than even the most pestilential season

in the preindustrial city. One historian estimates that Boston alone lost three hundred men over the course of the conflict, about 10 percent of those who enlisted, compounding the even greater losses suffered by the same generation less than a decade before, in King George's War.[33] At home as on the frontlines, war meant hunger and want. The almshouse on Boston Common filled with those too poor to scrape by, the majority of them women and children. Refugees streamed into Boston. Governor William Shirley's campaigns in maritime Canada set in motion the violent expulsion of the Acadians, or "French neutrals," as New Englanders called them. "About a thousand of them arrived in Boston, just in the beginning of the winter, crowded almost to death," Thomas Hutchinson later recalled.[34] Most of the Acadians were hounded on, forcibly dispersed throughout the mainland British provinces, and ultimately to Louisiana, where they came to be known as "Cajuns." But others stayed, bound to service or consigned to the workhouse, sick, exiled, and desperate.

Yet if war brought death and privation to many, it brought opportunity to others. Then as now, war carried the promise of profit in exchange for peril. "War is declared in England—Universal joy among the merchants," wrote one New York diarist in July 1756. The North American theater filled with British soldiers and sailors, whose number grew more than tenfold in the space of two years, from two thousand men in 1755 to more than twenty thousand at the end of 1757. By 1760, their ranks would double again. Every one of those British regulars, and their provincial brothers in arms, needed food, clothing, shelter, and transit. Middling people in the port towns did well: innkeepers made money watering horses and liquoring soldiers. Butchers and bakers, farriers and farmers, laundresses and laborers, seamstresses and seamen all fetched inflated wages. Those at the top of the social ladder did still better. Thomas Hancock, whose fleet of ships ferried troops and supplies from Boston Harbor to the eastern end of the Bay of Fundy and returned with their holds packed full of Acadian deportees, raked in more than £100,000 over the course of the war. Other leading Boston merchants likewise made fortunes, from the military contracts that Governor Shirley and his successors doled out like

sugarplums, and from the grayer markets afforded by smuggling and privateering, boon companions of wartime disruption.[35] The sorts of people who bought luxury goods—who bought portraits, for example—found themselves with money to spend in the late 1750s.

There was glory at stake as well as fortune. Preachers thundered patriotism from their pulpits. "Our *French* Neighbours . . . lay Claim to our Lands and are building Fortifications even within our Territories: And shall we set down still, till they drive us out of our Houses?" asked the Reverend Isaac Morrill, in a sermon called *The Soldier Exhorted to Courage*, which was rushed to print shortly after he delivered it to a group of raw recruits training near Boston. "No surely, it becomes us to arise," for men to "go forth in the Service of their KING . . . in the Defence of his Country." Arise they did, at least at first.[36] Many Boston boys of Copley's age—he was seventeen when the fighting began and would turn twenty-five before the peace was signed—enlisted, pulled by the call of king and country, pushed by the need for pay. Copley's father, Richard, may well have responded to similar calls during the last war—may even have died, unmarked, in battle on that bleak northern frontier. His son did not mobilize for this one, deciding, no doubt, that his widowed mother and six-year-old brother could not do without his support. He would serve at the easel, painting swords and muskets and uniforms rather than donning them himself.

Redcoats abounded, a veritable scarlet sea. Historians have tended to emphasize the tensions provoked by the buildup of British forces in North America during the 1750s and the 1760s. Since the English Civil War, if not before, many writers on liberty had deemed a "standing army"—a professional force that served in peacetime as in war, for pay more than patriotism—the handmaiden of tyranny.[37] The presence of so many thousands of British regulars so suddenly on the ground in North America between 1755 and 1763 brought the tyranny of Britain's standing army into sharp relief, the argument goes. Their presence served as a constant reminder of the differences between colonial and metropolitan views on crucial matters of governance and defense. Mutual suspicions smoldered

during the war, caught fire after the peace, and finally turned to confla-
gration between Britain's professional redcoats and American volunteer
militias at Concord and Lexington in 1775.[38]

But, as it so often does, reading American history backward from the
vantage point of independence flattens our understanding of the world
before the Revolution—and, indeed, of that conflict itself. The Seven
Years' War marked the apogee of empire, not the beginning of its disinte-
gration. Throughout much of British America, during much of that war,
the sight of a regular's red coat was comforting, even thrilling—especially
in New England, far from the worst of the fighting. During the difficult
first years of the conflict, New England provincials and British regulars
together eked out some of the empire's only victories. Locals did not mus-
ter as eagerly in 1756 and 1757 as they had at the beginning of hostilities,
but in 1758 the crown began to pour enough money, men, and matériel
into the American front that even the most skeptical New Englanders
had to extoll the British army's prowess. A Boston poet praised those

Intrepid Heroes—Britains loyal Band!
Who valiant fought on this important Land . . .
A nobler Emulation ne'er was known,
Nor British Valour ever better shown.

He signed himself Philo-Bellum.[39]

The warm red glow of British valor spread well beyond the front lines.
Ordinary colonists mapped out new routes to patronage and preferment
within the expanding British fiscal-military state. A portrait in uniform
was both a tool in that quest and a reflection of its success, enacting
a dawning imperial manhood by robing the sitter in the fabric of the
nation. A New England–born officer depicted in the vibrant red that
had been identified, since Cromwell's day, with the British army was no
backward provincial but England incarnate. "Men of scarlet," Samuel
Johnson called the legions who left Britain to soldier around the globe.[40]
The coat did not quite make the man. By itself, "a red coat has as little

virtue in it as a green apron," said one London writer reprinted in the *Boston Evening Post* in April 1758. "It is not the apron that can make the gunsmith; neither can the regimental inspire the man that wears it by commission." But if true patriotism came from within, surfaces nonetheless mattered. Boston men planning "to engage in this Year's Expedition for the total Reduction of CANADA" were instructed to report to Daniel Jones's shop, at the sign of the Hat & Helmet, where they would find an ample stock of "Uniform English Gold and Silver Lace for Hats," along with enough scarlet broadcloth to outfit a battalion. An artist seeking to capture the effect on canvas could repair to the Painter's Arms on Queen Street, where John Gore stocked nine types of red pigment—more varieties than of any other color—including the pricey vermillion that an officer's raiment demanded.[41]

In an economy that remained poised between the place-seeking world of the gift and the impersonal discipline of the market, the military portrait could purchase favor. In the wake of the 1745 siege of Louisbourg, John Smibert had painted its heroes: William Shirley, the governor who dreamed of conquering the Gibraltar of North America, and William Pepperrell, whose valor had earned him the provinces' only baronetcy, both decked out in officer's battle dress, with a legion of brass buttons marching in formation down their lapels. Because portraits of military heroes had public as well as private significance, Peter Pelham had engraved Smibert's likenesses for sale.[42] Now, as a new campaign against French positions in Nova Scotia loomed, Shirley's supporters pressed Smibert's portrait into public service once again. In August 1754, Thomas Hancock reminded the Boston town meeting that he and "a considerable number of Gentlemen, Merchants and others" had paid to have Shirley's "Picture drawn at their Expence" following his triumph in King George's War. They now wished "to make the Town a present of the said Picture to be hung up in Faneuil Hall," where it would serve "as a Memorial of Publick Respect and Gratitude to him for his aforesaid Services."[43] Such a gift answered old obligations and begat new ones. Townsfolk who gazed on the portrait during their business in the hall were reminded of

the debt they owed Shirley for their security, and of the beneficence of Thomas Hancock and his fellow merchants. And every time he saw his own likeness, Shirley would have recalled that he, in turn, owed favors to men like Hancock, who had done so much, in 1745 and since, to help him put his best face forward.

The vogue for portraits of men at arms had boosted the fortunes of Peter Pelham and John Smibert in the twilight of their careers, and it propelled Copley at the dawn of his, a scant decade later. A *rage militaire* gripped New England after General Edward Braddock's defeat in Pennsylvania in 1755. Those heightened passions, and the prospect of enlarged fortunes, may be part of what drew Joseph Blackburn to Boston that same year. As the senior, more established painter, Blackburn got the more elevated commissions. Major General John Winslow, who commanded the expeditions to Nova Scotia in 1755, sat to Blackburn some time after his ghastly success expelling the "French neutrals" from Acadia. When Major General Jeffrey Amherst sailed into Boston Harbor in 1758, fresh from victory in Louisbourg, he found time to sit to Blackburn before continuing his march west.[44] The portrait, an intimate kit-kat, hung in the Hancock mansion, just above the Common where the troops encamped. It was likely commissioned by Thomas Hancock, whose supply ships had purchased glory for Amherst, whose victories made Hancock rich in turn.[45]

But there was enough demand for scarlet cloth rendered in vermillion paint that young Copley, too, benefited from a new momentum in his painting room. In 1755, when he was just seventeen or eighteen, he painted Captain Joshua Winslow, a merchant turned solider whose service during the 1745 siege of Louisbourg earned him a commission in the British forces in Nova Scotia. Winslow held a relatively modest title as paymaster and commissary; his distant kinsman John Winslow far outranked him. But Joshua Winslow's particular role provisioning the troops for these new campaigns meant that he had favors—lucrative contracts—to dispense. Hanging in his quarters at Fort Lawrence, Winslow's portrait in uniform would have served as a subtle reminder of his valuable

connections. Copley's three-quarter-length portrait lavishes attention on the young officer's silver lace and pulsing red coat, a uniform more elaborate than the one he likely wore. The painter seemingly delights in the play of light upon shining surfaces, from the buff-colored sateen pulled taut across Winslow's ample waist to the golden braid and tassel dangling from his silver-hilted sword.[46]

The following year, Copley painted a closely related picture of William Brattle, scion of one of the most prominent families in Cambridge. In 1733, in the middle of the long peace before the last war, Brattle had published a pamphlet entitled *Sundry Rules and Directions for Drawing Up a Regiment*, doling out the wisdom he had gained as a young major in the Middlesex County militia. By 1745, the modest expertise Brattle demonstrated, combined with the eminence of his family, was enough to garner him an appointment as commander of the forces at Castle Wil-

Copley, JOSHUA WINSLOW, *1755*

liam, in Boston Harbor, where he drilled his men in preparation for a French invasion that never came. A decade later, as the province again plunged into war, Brattle took on renewed prominence, joining the governor's council in 1755. That same year, he married for the second time and moved to a grand house on King Street, steps from Copley's modest home on Lindall's Row. As his personal, military, and commercial fortunes rose in tandem, Brattle commissioned Copley to portray him in a fanciful uniform nearly identical to the one in *Joshua Winslow*.[47] A colonel when he sat to Copley, Brattle ascended quickly through the ranks of the provincial militia as the campaigns in Nova Scotia advanced: a man with rank to display and favors to dispense.

Both Brattle and Joshua Winslow were Boston born. But as Copley established a reputation among military men, his work was seen by some of the British officers who served with their provincial counterparts. George Scott probably encountered Joshua Winslow when Scott commanded Fort Lawrence in 1753–54.[48] The following year, Scott led a battalion in Governor Shirley's campaign to deport the Acadians and destroy the remnants of their villages. Captain Scott stayed on to pacify the scorched peninsula, serving with enough distinction that his superiors gave him an important command over an elite cadre of light infantrymen. In the 1758 expedition against Louisbourg, Scott's performance earned him the rank of major. Shortly before the promotion took effect, he found himself in Boston, at the baptismal font in King's Chapel, where he stood with one of his fellow soldiers to sponsor the baby of a third, a child named Edward Cornwallis Moncrief, after the royal governor of Nova Scotia.[49]

Copley likely painted Scott on that visit to town, crafting a portrait that references the victorious campaigns of the summer before. Unlike the fanciful, half-imagined costumes of Winslow and Brattle, Scott appears in the meticulously rendered uniform of his parent regiment, the Fortieth Foot. His costume is tailored for the American theater: the jacket cut short to allow free movement in dense underbrush; the bayo-

Copley, MAJOR GEORGE SCOTT, *ca. 1755–58* [Plate 3]

net stout, for hand-to-hand combat; even the cartridge box tricked out for foul-weather fighting. Scott holds a leather cap of his own design, smaller and more protective than the standard officer's tricorn. But it is not just the detail Copley lavished on the drapery that separates *Major George Scott* from the Winslow and Brattle portraits. In the space of just two or three years, the painter had made dramatic technical leaps in the handling of materials, form, and the human face. Copley's Scott appears a man, where his Winslow seems a mask. From the stubble of his heavy beard to the shimmer of his carefully tended fingernails, *Scott* testifies to a painter's mastery as well as a soldier's: diligence rewarded. At the level of his craft, if not yet in the status of his clientele, Copley

had surpassed Smibert, Feke, even Blackburn. Scott was proud of the likeness; he gave it to General John Winslow, a present that surely benefited the giver.[50]

The perverse good fortune that the war brought to Copley did not stop with military men and their brides. He painted jurists, officeholders, bureaucrats: placemen whose comfortable berths in the swelling ranks of provincial officialdom grew softer as the conflict ground on. Jonathan Belcher, the son of the Massachusetts governor whom Shirley had maneuvered out of office, went to Halifax in 1754 as the chief justice of a newly impaneled supreme court in a newly christened city. Two years later, Copley painted Belcher and his young bride, daughter of a prominent Boston merchant himself growing fat on the spoils of war. Dressed in fine beige silks and lace, wrapped in a tissue-thin fichu of military red shot through with gold thread, Mrs. Belcher stands before a fountain composed of a sea sprite riding a dolphin: a quotation from Copley's *Galatea*, and thus a gesture toward Britain's blue-water empire. The allusion to Britain's majesty in the portrait of her husband is less subtle: sporting a barrister's wig that descends past his shoulders, the judge appears in the fur-trimmed red robes of the magistracy, a man of scarlet perched upon the throne of justice.[51]

Copley also garnered commissions from the war's fortune seekers and fortune makers: in 1757, Thomas Ainslie, a Scottish-born merchant who entered the ranks of officialdom in Nova Scotia by supplying the expeditions. That year or the following: Andrew Oliver, provincial secretary of Massachusetts, as well as a considerable merchant, growing wealthier each year the war lasted. And, likely in 1758, Copley garnered what was arguably the greatest plum of all: a commission to capture the likeness of Thomas Hancock, whom this war, combined with the last, had made the richest man in the colony. Copley rendered him in pastels, a fashionable medium still new to the provinces, and also in a miniature painted on copper, an intimate format favored by spouses and other loved ones in far-flung families. For the rise of empire tended to disperse family members—some by

choice, many more in chains—more widely around the Atlantic basin than ever before. Thomas Ainslie planned to send his portrait home, "to please a fond Parent" whom he had left behind near Glasgow. Since the canvas "goes in a Man of War," he added, "I hope She will receive it Safe."[52]

The families of several of Copley's wartime patrons intertwined. William Brattle was kin by marriage to Thomas Hancock. The Olivers and the Belchers intermarried. But within the intricate web of connections linking Boston's elite, one particular strand was especially vivid in the Copley patronage network of the 1750s: a striking number of these wartime commissions linked back, by blood or marriage or shared military service, to Samuel Waldo, the land speculator whose ventures in Penobscot country may well have brought Copley's parents from Ireland to North America. A commander in the 1745 siege of Louisbourg, the great proprietor known by the 1750s as Brigadier General Waldo was once again having a very good war. Abigail Allen Belcher was Waldo's niece, as was Ann Tyng, another early Copley sitter, whose husband, a British army officer, had served under Waldo. Joshua Winslow was distantly related to Waldo. Waldo's son married into the Oliver family. In the gift economy of wartime, perhaps the great proprietor extended some tiny modicum of his vast largesse—now lost words of recommendation—to the prodigious young son of one of the hopeful settlers who had crossed the ocean in exchange for the promise of a hundred acres carved from Waldo's tens of thousands.[53]

Like Waldo's war, and New England's war more broadly, Copley's war pulled northward and eastward; a significant number of his sitters in the 1750s came from New Hampshire and Nova Scotia. And though he had only just reached the age of maturity, his patrons—even the most elevated among them—came to him. For the patterns of wartime meant that, more than ever, Boston served as a regional hub of empire in matters of culture and commerce, politics and military affairs. As red coats and red robes transformed the palette of the town, the young painter prospered.[54]

The young Copley and the patrons who dreamed of a greater, more east-ward-yearning, more British New England were hardly the only ones to unite "art and arms," as the period saying went. In London, painters and printers, writers and architects, built new fortunes and erected new neighborhoods upon the money that flowed so freely during what one anonymous writer called "the heat of the war."[55] In provincial English cities from Bristol to Kingston to Charleston, the war nourished both the consumption and the production of culture. Just as Joseph Blackburn flourished in Newport, Boston, and finally Portsmouth, painting those grown fat and famous on the spoils of war, so the London-trained portrait painter John Wollaston, who had sailed to New York City between the wars, in 1749, found great demand for his work in Maryland, in Virginia, and especially in Philadelphia, whose wartime economic boom scaled far greater heights than that of Boston.[56]

Any number of artisanal careers—Benjamin Franklin's included—blossomed into a kind of Atlantic celebrity in the heady atmosphere of midcentury Philadelphia. Indeed, Copley had a doppelgänger there, though the disparateness of the American provinces means that he did not know it quite yet. Benjamin West was born in 1738, just a few months after Copley, in Springfield, Pennsylvania, a swampy hamlet a day's ride and a world away from Philadelphia. His parents, like the Copleys, were immigrants—less unusual in the mid-Atlantic than it was in New England. John West, Benjamin's father, kept a tavern, first in Springfield and later, for most of West's childhood, in the larger village of Newtown. A retrospective mythology grew up around West's talent, as it would around Copley's. The boy West, too, was said to draw on nursery walls, eventually begging scraps from his mother's sewing basket to use for canvas, and pulling hair from his cat's tail to improvise a brush. Unlike Copley, West was not a city boy, so his tale of dawning genius carried elements of frontier mythology. Shawnee and Delaware headmen were

said to have taught him how to make red and yellow pigments, the kind they used to paint their faces for battle.[57]

West, like Copley, picked up a brush early (cat's tail or no), by the age of nine, if we can trust his recollection. Like Copley, he was diligent, his "attention . . . directed to every point necessary to accomplish me in the profession of painting," he later wrote. And like Copley, West had a poor boy's odd good fortune. In the early 1750s, a dry goods merchant who stayed at his father's tavern took an interest in the talented youth, sending him paints and brushes and a set of engravings by Hubert-François Gravelot, who had illustrated the French translation of *Tom Jones*. Much in the manner of Fielding's hero, West soon found himself on a picaresque journey toward the metropolis.[58] In Philadelphia, he met a portraitist, the Bristol-born itinerant William Williams, who lent him treatises on art, including Du Fresnoy's *Art of Painting*. Back at his father's tavern, West said, he slept with the books "under my pillow by night."[59] He began to take portraits of the children of some of the wealthier burghers in the village. His first efforts were clumsy: crude primitives. But the hunger for likenesses was keen enough that even such halting efforts found favor. By early 1756, West had parlayed these humble local commissions into an invitation to paint in the town of Lancaster, a backwoods Athens in the middle of the province.

When West got there, Lancaster stood at the edge of a war zone. The Seven Years' War devastated western Pennsylvania as it did nowhere else on the continent. The British having proved poor protectors, Delaware and Shawnee warriors joined the French. The colony whose Quaker founders had never created a militia began to hemorrhage. In November 1755, William Allen, chief justice of Pennsylvania's highest court and soon to become West's most powerful patron, told one of his trading partners that Indian warriors had "ravaged the back parts of this Province, & laid it waste with Fire & Sword." He scarcely exaggerated. Lancaster teemed with refugees. The proprietors made plans to dig moats and build drawbridges at the ends of Queen and King Streets.[60] The seventeen-year-old

West rode into town at what would seem a less than propitious time for a fledgling itinerant limner in search of customers.

Yet he found in Lancaster a boomtown as well as a battleground. Lancaster gunsmiths were charging more for their wares than were Philadelphia importers. The most innovative and skilled among them, William Henry, was appointed armorer to the king's forces, a contract worth as much as £500. Henry paid West for portraits of himself and his wife. He also commissioned and likely designed an ambitious allegory, *The Death of Socrates*, which West executed with help from an illustrated history in Henry's library, much as Copley, the year before, had painted *Galatea* and *Neptune* from European prints.[61]

Lancaster was the kind of place where artisans collected the classics. That made it a natural stop for William Smith, an Anglican preacher touring the backcountry to drum up support for his scheme to create public grammar schools. Smith, a Scottish émigré, harbored unconventional ideas about the nature of genius. In 1753, he had argued that those fitted for "the learn'd Professions" and those "design'd for Mechanic Professions" alike required a liberal education. The next year, Benjamin Franklin invited Smith to teach in Philadelphia's Academy and Charitable School. In 1755 the Academy became Pennsylvania's first college, and William Smith became its provost. So committed was Smith to cultivating untutored genius that he took under his tutelage that creature of the woods, Benjamin West.[62]

During his second sojourn in Philadelphia, which began in late 1756 or early 1757, West traveled in lofty circles. He worked on his painting under Wollaston, who returned to the city in 1758. He studied at Smith's College, a cultural, spiritual, and intellectual hothouse. Though West did not matriculate, he spent his days with young poets and philosophers fated to become merchants and lawyers and statesmen. He sketched them at cards and painted their sisters and fiancées; they lauded his talents in print. "We are glad of this opportunity of making known to the world, the name of so extraordinary a genius as Mr. West," noted the preface to a group of poems published in February 1758 in the *American*

Magazine and Monthly Chronicle for the British Colonies, a new periodical that was the brainchild of William Smith. West "was born in Chester county in this province, and without the assistance of any master, has acquired such a delicacy and correctness of expression in his paintings, joined to such a laudable thirst of improvement, that we are persuaded, when he shall have obtained more experience and proper opportunities of viewing the productions of able masters, he will become truly eminent in his profession."[63] The magazine's September issue again rhapsodized about West's "sacred *Genius*" at the end of a longer poem singing Wollaston's praises:

> Nor let the muse forget thy name O West;
> Lov'd youth, with virtue as by nature blest!
> If such the radiance of thy early Morn,
> What bright effulgence must thy Noon adorn?[64]

Could Copley, in Boston, have heard that West's sun, too, was rising, some three hundred miles to the south? The *American Magazine*—itself an outgrowth of the Seven Years' War—had deep local roots in the internecine struggles of Smith and Justice Allen to seize power in the Pennsylvania legislature, but it also had broad, continental ambitions. "Our readers are a numerous body, consisting of all parties and persuasions, thro' *British America*," the editors insisted.[65] And indeed, hundreds of subscribers from Jamaica to New England to Britain paid to receive the magazine during its thirteen-month run. In Boston it went to several ministers, a Harvard professor, and the printing house of Edes & Gill, publishers of the *Boston Gazette*. Such men were tastemakers and information hubs, people whose opinions circulated widely, in clubs and coffeehouses and in print. Periodicals often passed through multiple sets of hands, finding as many as twenty readers for every subscriber. Boston newspapers reprinted several stories—largely on the progress of the war—from the celebrated "new *American Magazine*."[66] Given his interest in reading every scrap he could find about the liberal

arts, and especially painting, it seems far from impossible that Copley would have seen the verses.

It is less likely that West yet knew of Copley, whose genius no poet in the less belletristic world of Boston had lauded in print.[67] In this sense, the *American Magazine* was an exception that proves a rule: if the Seven Years' War was a powerful cultural and economic engine, it was not always an integrating one. Well into the 1760s, Boston merchants had firmer ties to Halifax, and to Kingston, and certainly to London, than to New York or Philadelphia. Along the Atlantic seaboard of North America, a sense of shared purpose remained rare. A conference held in Albany, in the summer of 1754, had tried to forge an intercolonial agreement around matters of common purpose, including defense. The effort failed, utterly. Despite Benjamin Franklin's famous "Join or Die" graphic—created to promote the Albany Congress's doomed Plan of Union—the *dis*union of these disparate provinces remained the order of the day. To the extent that Britain's victory in the long, grinding imperial war tied provincials living in the American colonies together, it knit them into a shared patriotic fabric less as Americans than as Britons. When men like Smith referred to British America, they meant to emphasize the first word.

It is an exaggeration, but only a slight one, to say that the war that made British America also made John Singleton Copley and Benjamin West, both of whom grew to manhood during those starving, booming years. The war did not make them artists. The chemical reaction of talent and diligence did that. But war was the crucible in which those volatile elements combined to forge the rudiments of a trade, maybe even a calling.

~

The year 1758 marked a decisive turning point in Britain's hydra-like conflict with France and its European and Native allies. Acting as de facto commander in chief, William Pitt, minister for the empire's southern division, devised bold new military tactics for North America and the war's many other fronts—in the Caribbean, Europe, Africa, India, and

on around the globe. He trusted the provincial governors and was greeted with trust in kind. Louisbourg fell to Amherst's forces at the end of July. In October, Shawnee and Delaware leaders treated with the province of Pennsylvania and agreed to sever their alliance with the French. Before the year was out, the British had retaken Pennsylvania's Fort Duquesne, which was renamed Fort Pitt, in honor of the man who turned the tide.

The year 1758 marked a turning point in Copley's life as well. He turned twenty that July, an age that closed the curtain on that vague, amorphous period known in his day as "youth." Even in a time without such sharp, factory-made transitions as high school graduation or a legal drinking age, a young man's third decade seemed newly and decisively adult. But if Copley felt the transition to manhood keenly, he did not write about it. And indeed, in many ways, he had been acting the part of male head of household for far too long already, since Peter Pelham died, in 1751, when Copley was just thirteen. Mary Singleton Copley Pelham did not remarry after her second husband's death, a striking choice in a world where households were productive units, wives found themselves in great demand, and few widows stayed single for long. The burgeoning painting business of her older son, Jack, appears to have been the sole support of Mrs. Pelham and her younger son, Henry (called Harry), who turned nine the year Jack turned twenty. No evidence puts the family anyplace but Lindall's Row in the tumultuous years between 1751 and 1758; the remnant of Copley-Pelhams appears to have continued to live in the quarters Peter Pelham rented, among candlemakers and dockworkers.

And then, in December 1758, young John Singleton Copley did something that neither his father nor his stepfather, much less his widowed mother, had managed to do: he bought property, a house in the rapidly developing western part of town, "commonly called New-Boston," as the newspapers put it, where Boston's famously crooked streets succumbed to the dawning logic of the grid.[68] The house Copley purchased from the widow Sarah Jackson stood on Cambridge Street just past the corner of Hanover. It was a neighborhood in which speculators were investing;

Andrew Oliver owned one of the adjoining lots. The deeds and mortgage Copley signed describe land and a dwelling worth nearly £300, three times greater than the value of his father's entire estate. He put about half down in cash, counting on his trade to make up the rest in a short span of time.[69]

Copley's was a substantial urban lot, roughly a quarter of an acre.[70] The house upon it was average by the standards of its day. It stood two stories tall, with three rooms upstairs and three below. There were several small outbuildings: a "Kitchen, Wood-house and Stable, a large Yard and good Water, a large and good Garden with Variety of Fruit." The painter would have taken one of the second-floor rooms, where the light was better, as his studio. He also purchased a strip of land ten feet wide from his neighbor to the north, a good way to ensure against encroaching shadows, as other migrants from denser parts of town built up the newer precincts. Copley may also have bought some of the previous owner's movables at auction: after her husband died, the widow Jackson sold off the family's "Beds, Bedding, Case Draw[ers], Tables, some very handsome Chairs, Kitchen Furniture," and a "very handsome Silver Coffee Pot and Stand, with some other Plate."[71] Here was instant gentility, available on the cheap, to a new homeowner at the tender age of twenty.

The legal documents formalizing the purchase call Copley "Painter," which is the way most correspondents addressed him, though on occasion, some who wrote to him at his new home "Near the Orange Tree," a tavern in the area, still directed their letters to "Mr. Copley, Limner."[72] Of these two ways of labeling his trade, "painter" was the more elevated. When Smibert died, the papers lauded him as "an ingenious and celebrated Painter"; by contrast, Boston's self-taught Joseph Badger, whose wares were cheaper and patrons humbler, was called simply "Limner" in his brief death notice.[73] Limners—the word descended from *luminer*, as those who painted the decorative or illuminated elements of medieval manuscripts were called—took likenesses. On occasion, they hawked their wares like any other retailer. "George Mason, Limner from London, Begs leave to inform the Public, That he draws Faces in Crayons,

from one to two Guineas each," ran a notice in the *Boston Gazette*.[74] But "painter," too, covered a range of occupations. "David Mason, Painter, in Queen-Street" decorated and hung wallpaper. Advertisements seeking to recover Richard Bryant, an escaped Irish convict servant, called him "a Painter by Trade"; he painted houses.[75]

Both "painter" and "limner" were humbler titles than Copley might have wished—more artisanal than artistic. Both labels hinted at a core fact of his trade. Even the most "celebrated painter" wanted independence—autonomy—in the full eighteenth-century sense. A person who took likenesses served the rich as well as the muse. An eminent sitter "condescended to sit for his Picture," as the *Boston Gazette* reported one London jurist had done. The men who commissioned the judge's likeness "gave Orders to Mr. Reynolds, an eminent limner, to paint the same." However eminent, however celebrated, painters and limners took orders far more often than they gave them.[76]

While sitters condescended to have their portraits taken, painters seduced their sitters, teasing a patron's character into the room and then pinning it to canvas. Such familiarity—a choreographed minuet that seemed, however briefly, to suspend social rank—was hardly unique to painters and their clients. Copley's was an era of bespoke refinement. Many luxury tradesmen, and at least a few tradeswomen, were practiced at the delicate art of flattering the wealthy. Tailors, goldsmiths, architects, and garden designers all needed to project a measure of gentility while they showed their drawings and silks and sample books to men and women of taste. All worked with their hands to feather opulent nests that were quite unlike the places they themselves lived. Their labor was somebody else's leisure. Thus their persons and their workplaces needed to be tidy and respectable, if not elegant. The portraitist had to act and even feel the part, the art theorist Jonathan Richardson had written in his well-known *Essay on the Theory of Painting*: "as his Business is chiefly with People of Condition, he must Think as a Gentleman, and a Man of Sense, or 'twill be impossible for him to give such their true, and proper Resemblances."[77]

But if the business of portraiture in some ways resembled other luxury trades, sitting for one's picture was in crucial respects very different from ordering a garden folly or being fitted for a fine silk dress. The process unfurled much more slowly, and took place almost entirely face-to-face. The limner's art rested upon conversation; a portrait required a polite, comfortable exchange of words throughout hours, even days. A good painter, wrote the essayist William Hazlitt, needed to be able to "fling in a few adroit compliments," and to "expatiate on his art" through a store of "lively and characteristic anecdotes." The famed London portraitist Joshua Reynolds was known as a particular master of "secret whisperings" and "confidential, inaudible communications": counterfeit intimacies that kept patrons at ease during sessions that were tedious and strenuous by turns.[78] The duration of portraiture was only part of its distinctiveness, though. For the portraitist required not only sociability—a fluency of the tongue—and vision—a fluency of the eye—but also *insight*—a fluency of the heart. It took a keen intuition to bring a sitter to a convincing simulacrum of life. "A Portrait-Painter must understand Mankind, and enter into their Characters, and express their Minds as well as their Faces," Richardson urged. For "Painting not only shews us how Things appear, but tells us what they are."[79]

The portraitist trafficked in Platonic essence, yet he was also a conjurer, casting illusions on the wall of a cave. The likeness was an audacious counterfeit, explained *The London Tradesman*, a manual for the parents of aspiring artisans published in 1747, when Copley was nine. "Its Eyes speak the Passions, its Gesture describes the inward Perturbation of the Mind, and the whole Picture needs but to speak to perswade us of it is [*sic*] real Existence; yet it is all a Shadow, a mere *Deception Visus*" confected from powders and oils.[80]

The limner's flickering shadow was meant not only to trick but also to reveal and, above all, to endure. A likeness held in perpetual presence men and women "out of our reach, . . . being gone down with the Stream of Time, or in distant Places," Richardson wrote. Where the dressmaker's art embraced transience—playing to the doomed desire to keep up with

the latest fashion—the limner flirted with transcendence. "In Picture we never dye, never decay, or grow older," Richardson wrote in 1715. To "sit for one's Picture is to have an Abstract of one's Life written, and published, and our selves thus consign'd over to Honour, or Infamy." In an era newly obsessed with the Enlightenment notion of a stable, coherent, unique, irreplaceable self, the portraitist was close handmaiden to the biographer, ancestor of the therapist, cousin to the necromancer and the alchemist, transmuting base materials into soul. Its length, its intimacy, and the weight of expectations it generated meant that the practice of portraiture could not help but be shot through with tension.[81]

By the time he bought the house on Cambridge Street, Copley had substantially perfected the elements of his craft. He painted fabrics that shimmered, almost rustled; eyes that seemed to have mind, even spirit behind them. Perhaps the clearest way to glimpse the rapid evolution of his skill is to move from hand to hand to hand, from *Mrs. Joseph Mann* (1753), with the jointed wooden fingers of a drawing figure; to *Joshua Winslow* (1755), whose left hand hides in his pocket while his right— lined palms, tapered fingertips—gestures almost elegantly enough to pass for human; to the *Anatomical Drawings* (1756), which dissect, inventory, flay the hands in search of verisimilitude. The most uniquely human of features, hands were (and are) notoriously difficult to paint; artists avoided the task when they could, and sometimes charged extra for it when they couldn't. The young Copley made himself a connoisseur of the human hand. The portrait he painted of Thomas Ainsley in 1757 is now lost, the ravages of time trumping the medium's promise of transcendence. But Ainslie reported that when his fifteen-month-old son caught sight of the canvas at his grandmother's house in Glasgow, whence Ainslie had shipped both the likeness and the boy, so far from wartime Quebec, the lad had "sprung to it, roared, and schriched, and attempted gripping the hand, but when he could not catch hold of it, nor get [the picture] to speak to him, he stamp'd and scolded." Toddlers being the most honest of critics, Ainslie felt sure Copley would delight in this "proof of the Painters Skill."[82]

There is no doubting Copley's hands, or the skill of his hand at the easel. But we know remarkably little about what it was like to sit to Copley, whose studio had not yet, and in fact never would, become a place of fashionable resort or anecdotal report. Perhaps he covered the walls with deep green cloth, as Smibert had done. Copley would have moved the remnants of Peter Pelham's library to Cambridge Street, along with whatever additions he had purchased after his stepfather died. Clients might leaf through prints, selecting poses and costumes that married their biography to their aspirations. For those who, wary of fickle fashion, wished to be painted in invented dress, the painter would have had on hand lengths of fabric to drape and pin on a layman large enough that he could see the play of light on the folds.[83]

How did such negotiations play out? Copley was younger than most of his adult sitters, and poorer than all of them. If his hand was fluent, his tongue was not. The voice of his letters is deliberate, earnest, self-serious. It seems inevitable that his youthful stammer would have thickened in anxious moments, and courting custom among the powerful cannot have put the young man at his ease. He was small of stature. A later picture puts him in the front row of a company of artists, where he stands nearly a head shorter than the painter to his right, and barely taller than many who are seated. His mien, his gaze, his posture is pugnacious: a bantam caught midstrut. Copley was not notably handsome, as West was; a traveling companion would later describe Copley as "thin, pale, a little pock-marked," likely the legacy of a childhood bout with smallpox. His nose, the traveler said, was "wide at the Nostrils and pinch'd to a Point as if by Accident," bringing to mind "Doctor Slops adopting the Forceps" in Sterne's enormously popular *Tristram Shandy*: a profile Copley's self-portraits confirm.[84] In all of these ways, Copley failed at the signal virtue of smoothness: the even, unruffled surface of the gentleman.

Copley's diligence warred with the easy grace that a portraitist needed both to have and to sell. A spiky, anxious man, raised poor in a spiky, anxious place, he neither possessed nor bestowed ease. He was "very tedious in practice," recalled Henry Sargent, whose mother Copley had painted.

"She told me that she sat to him fifteen or sixteen times! Six hours at a time!! And that once she had been sitting to him for many hours, when he left the room for a few minutes, but requested she would not move from her seat during his absence. She had the curiosity, however, to peep at the picture, and, to her astonishment, she found it all rubbed out." Another sitter, Mrs. Thomas Mifflin, remembered posing some twenty times merely for the hands in her portrait. "This tediousness of operation deterred many from sitting to Copley," Rembrandt Peale later claimed.[85] Even his setup was painstaking, halting. When a fellow painter later commented on "the remarkable neatness of His Painting room," Copley explained that he could not paint "unless everything was in order abt. Him. He sd. He cd. not bear to see rags & other things scattered about." Even his palette had to be just so: he "used to match with his palette knife a tint for every part of the face, whether in light, shadow, or reflection," another artist recalled. One patron later took Copley to arbitration for his dilatory manner. The sitter said he "did not know what was the common practise," but "Mr. Copley seldom began to paint before 11 or 12 oClock, appearing to be a very long time in setting His Pallet."[86] Copley could not be rushed. He would be correct, diligent. Never loose, never free.

Perhaps this meticulous hesitancy helped Copley to see so well and so deeply so early in his life. Perhaps sitters, bored and frustrated beyond the point of tolerance, impatient to get on with the business at hand, betrayed their own smooth surfaces, revealing an interiority often hidden in the eighteenth-century world of masquerades and mirrors. By the tender age of twenty, Copley's gaze was acute, penetrating. Year by year his pictures began to speak, not only of the appearance of his patrons but of his under-standing of their characters, their desires—qualities perhaps more present to the artist than to the sitter, qualities, on occasion, that they may not have applauded in themselves. This was the profound gift of the watcher from the Long Wharf: in an era before photography, when the clearest sense of one's own image came from pitted mercury mirrors, if not from puddles, Copley's portraits captured something of Boston's inner life along with its civic face.

That face was proud, prosperous, and increasingly British. The year 1759, which began just weeks after Copley purchased his Cambridge Street house, would be called an annus mirabilis—a year of miracles—as the war that had started so disastrously surged toward improbable, total victory in North America. The French forts at Niagara and Ticonderoga—sites of early British losses—fell in July. Crown Point surrendered in August. And then came the big prize: Quebec, set upon by red-coated British regulars and buckskinned American rangers and kilted Highland infantrymen and Mohawk scouts, capitulated on 18 September. General James Wolfe, the commander of this mixed British force, perished near the moment of conquest, martyr to Britain's glory.

When news of this latest British victory reached Boston, time briefly stopped. The good tidings were "no where received with greater joy, no part of the king's dominions being more interested in it," Thomas Hutchinson said. "*Quebec is taken*, was the joyful Note, / *Quebec is taken* thrills thro' every Throat," rhymed one writer in the *Boston Gazette*. The selectmen declared 16 October a "Day of general Rejoicing in this Town, on Account of the great and important Success of His Majesty's Arms." Church bells started at dawn and pealed late into the night. King Street filled with a phalanx of troops blasting "Rejoicing Fires" from their muskets. Cannon sounded from the fortress at Castle William, and the men-of-war anchored in the harbor picked up the salute, with Britain's colors fluttering from tall masts of New England pine. When night fell, the Common glowed with "large bonfires formed in a pyramidal manner" just to the west of Copley's house. The display of fireworks was "extraordinary," the *Gazette* reported, easily "the greatest Quantity of Sky-Rockets ever seen on any Occasion." Just as the conquest at Quebec was incomparable, so "the Rejoicings were the greatest ever known, an universal Joy appearing in Persons of all Ranks." As the governor, his excellency Francis Bernard, proclaimed, the taking of Quebec reminded the people of Massachusetts of "the blessings they derive from their *subjection* to Great Britain, without which they could not now have been a free people."[87]

John Singleton Copley, painter and property owner, had every reason to join in the celebration of the victory. Rhymed the *Gazette*'s poet,

Oh happy Shade! what Trophies can we raise
How pay an adequate Return of Praise,
What has America to give, since She
Her Being owes to Amherst and to Thee?

Just as Boston now looked forward to many years of renewed peace under "GEORGE'S happy Reign," so too an artist might anticipate new custom and new canvases, to commemorate the newly crowned heroes of the day.[88] What had America to give? What better trophy than a painting.

THE IMPERIAL EYE

*J*HE OLD KING was dead. George II, who sat saddle more gracefully than he spoke English, the last British monarch to ride into battle at the head of his army. George II, who had, on his second try, engineered the near-total expulsion of France from the North American continent. And then, having ruled for more than three decades, having survived his biblical three score and ten plus a few years more, including, at the last, Britain's annus mirabilis, the good-enough king, the second King George, the only monarch most of his subjects could remember, breathed his last on 25 October 1760.

Not until the inaptly named *Racehorse* dropped anchor at the Long Wharf in late December did the people of Boston learn "the melancholy news."[1] On the first day of the new year, as the town's church bells pealed in mourning, the governor, his council, and the members of both houses of the assembly gathered at the Old Brick Church, on King Street, to hear a sermon "upon the sorrowful occasion." From the windows of the meetinghouse, they could see the gilded statues of the English lion and the Scottish unicorn atop the stately brick Town House across the way. At precisely ten o'clock, the mounted guns at Castle William blasted seventy-seven volleys, one for each year of the king's long life. "Hail! thou honour'd Shade!" exclaimed an anonymous panegyric in the *Boston News-Letter*. "Hail to thy useful Glories! PATRIOT KING!"[2]

His people, arrayed around the globe from Bengal to Boston, in prov-

inces stretching as "far as the western from the eastern sun," as the students of Harvard College put it in a volume of commemorative poetry, must mourn.[3] But there was a new British king for Boston's British subjects to celebrate even as they grieved his grandfather. The governor decreed that at noon on 6 January—the Christian Epiphany—the people of the province should set aside their business to proclaim his majesty "with full Voice and Consent of Tongue and Heart," pledging their "Faith and constant Obedience," and "Beseeching GOD (by whom Kings do Reign)" that this third Hanoverian George, just twenty-two years old at the time of his accession, might live as long and rule as benignly as his grandfather. The empire's horizons had widened, and peace loomed. New Englanders had every reason to hope that George III's reign would inaugurate what the Harvard poets called "a new Era for North-America."[4]

Copley can hardly have escaped news of the impending coronation of the new king, his exact contemporary, born just a month before the painter. The elaborate preparations dragged on for months. Repeated delays meant that people in North America could anticipate the joyous moment in something like real time. Copley could have seen in his mind's eye the staging of the king's procession, all eighty-six delegations, from the maidens "strewing sweet herbs" before the royal feet to the yeomen of the guard bringing up the rear. The red, the red, everywhere red: the newspapers described a corps of trumpeters sporting "rich Liveries of crimson Velvet." Drums kitted out with "Banners of Crimson Damask." Judges "in their scarlet robes." The king and queen rising from a "magnificent crimson bed," purpose-built for its single night of service to the realm. The yards of "superfine scarlet cloth, studded with gilt nails," upon which the king would make his stately walk toward the ancient throne at Westminster Abbey, accompanied by the strains of Handel's "Zadok the Priest." The glorious event at last took place in late September 1761. By February 1762, "new-fashion CORONATION RIBBONS," just arrived from London, could be purchased on Boston's King Street. The cloth seller Anna Adams offered discounts to customers who paid cash, which was again in short supply.[5]

It is hard to imagine how the pomp and pageantry of the coronation played in a town that was again suffering. By the time George II died, the war in mainland North America was winding down. Red-coated regulars departed New England for other fronts, taking their purses and patronage with them. It was not easy to wean the economy from the wages of war, especially as Britain began to tally its debts, dialing back specie payments to the colonies, and tightening the enforcement of the trade laws Boston's merchants had grown rich by flouting.[6]

While the faraway mechanisms of imperial statecraft pinched Boston in those years, more local perils tightened the vise. On 20 March 1760, a devastating fire—"the most terrible Fire that has happened in this Town, or perhaps in any other Part of North-America," the *Boston Post-Boy* deemed it—consumed much of the city's center, including the neighborhood surrounding Copley's former home on Lindall's Row. Months later, when the church bells tolled the loss of the old king and rang the glories of the new, exposed cellars still gaped like missing teeth in the profile of the city. On wet days, Boston smelled of charred wood.[7]

Good Calvinists saw in that apocalyptic night a punishment and a portent: the "Rebuke of God's Hand" that had smote them with a vehemence evoking Sodom and Gomorrah. "Boston! How art thou distrest? How art thou fallen of late?" ran one letter to the *Post-Boy*. "Thy beauty is consumed, thy streets are laid waste!" What "was once an *English* town, the most populous and flourishing on the whole continent of *North-America*," now "looks like a frightfull skeleton . . . worn and melted down by an inward heat and burning."[8]

Copley's god was gentler, an Anglican god who smiled on the great and good. But there was no denying the impact of the fire in the here and now. Nearly four hundred homes—about one in ten structures in the city—went up in flames. Many of those who were poor before the fire were left desperate, homeless at the end of a bitter New England winter. Several of Copley's early patrons sustained significant losses. Joshua Winslow filed a claim for £96; Andrew Oliver lost goods valued at more than £300; and William Brattle, whose coach house burned to

the ground, hoped to recover the cost of his grand chariot and two tons of hay. All three men apparently managed to save their Copley portraits, though scores of pictures were consumed: mezzotints, sets of prints, family portraits in gilded frames.[9]

The great fire, one eyewitness wrote, was a coup de grâce visited upon a people already "exhausted . . . by the great Proportion this Town has borne of the extraordinary Expences of the War."[10] Estimates of the total cost of the disaster varied, from a high of £300,000 (as much as $60 million in today's money) to a low of £50,000.[11] No matter the precise figure, the price of rebuilding Boston would be enormous. The town meeting appointed two agents to present the claims of 439 sufferers to the House of Commons.[12] Their plea fell upon deaf ears, which is unsurprising: faced with staggering debts from an ongoing global war, Parliament thought New Englanders were only beginning to shoulder their rightful share of the burden of victories that benefited them greatly. In Westminster the question was not how to alleviate the suffering of the provinces, but rather what the provinces might do to mitigate the suffering of the national treasury.

There are no surviving Copley portraits bearing dates of 1760 or 1761, the only such break in his output in the two decades of the artist's North American painting career.[13] The fire claimed the attention and the resources of many who might otherwise have purchased art. And there were, at war's end, fewer battles to commemorate, fewer promotions to seek, less favor to curry or bestow. More than a decade would pass before new wars called for fresh expanses of vermillion paint.

The conflagration spared "New-Boston"; Copley paid off his mortgage in Cambridge Street in April 1760, just weeks after his old rented quarters on Lindall's Row burned.[14] But those could not have felt like lucky years, easy years, to an ambitious young artist with an aging mother and a young brother who would soon need to settle on a trade of his own. As a flood of medals and coins and ceramics and prints made the aquiline profile, full lips, and cleft chin of the newly crowned king familiar to his beleaguered subjects in Boston, Copley can scarce have imagined paint-

ing his sovereign's likeness. Kings and princes did not tour such remote provinces. The poets might call Neptune "Britain's friend." An aspiring painter might depict the seas as a happy medium for that trident-toting god. But hard by the ruins of the late, great fire, the ocean loomed wide, and London seemed very far away.[15]

In the waning days of March 1760, shortly before news of the great Boston fire reached Philadelphia, Benjamin West stashed his sea stores aboard the *Betty Sally*, bound for Italy. High seas made for a swift if queasy passage; the sailors gained the British fortress at Gibraltar in less than a month. But they needed to wait for a convoy to protect them from the French privateers still trawling the Mediterranean, so it took three weeks more to reach Leghorn (Livorno), a free port on Tuscany's Ligurian coast. There the ship was quarantined. Finally, on 2 July, with bribes duly paid, the exhausted American seafarers saw firsthand the baroque splendor of Italy.[16] West quickly pushed on to Rome. Almost six decades later, near the end of his long life, he would still remember his first glimpse of the "sublime dome of St. Peter's" in the distance. He paused to contemplate "the contrast between the circumstances of that view and the scenery of America," his America: a world of woods and wigwams. His thoughts "naturally adverted to the progress of civilization": the "procession of the arts and sciences from the East to the West," and the eventual "glory which they would attain in their passage over America."[17]

West, who proved more original in his painting than in his prose, used a timeworn trope to map the arc of his life and art. But in fact, the progress of civilization narrative so familiar in West's place and time ill suited his particular journey. Until he stepped aboard the *Betty Sally*, the traffic of art in the Anglo-Atlantic world had run entirely as expected, from "old world" cores to "new world" peripheries. West reversed that centuries-long course, the first American-born painter to do so. His Atlantic crossing would prove to be a one-way trip.

West's exodus, much like his meandering journey from Newtown

to Lancaster to Philadelphia, was a Seven Years' War story. The bloody fighting eroded support for pacifist Quakers and brought West's Philadelphia patrons—the Proprietary faction led by William Allen, Edward Shippen, and William Smith—enormous political power. The economics of wartime swelled their already considerable fortunes. Like other well-capitalized mid-Atlantic merchants, Allen made a killing in illicit trade with the French West Indies, which the British blockade had severed from their supply lines.[18] In the winter of 1760, when Allen learned that French sugars were fetching giddy prices on the Continent, he and the Shippens packed the hold of the *Betty Sally* with hundreds of hogsheads full. It was a risky scheme; such a cargo might attract unwanted attention from British customs officers and French privateers alike. But though Allen and his partners worried about the placemen and the pirates, it was the prospect of a truce that really haunted them.[19] The investors instructed the two sons they entrusted with the cargo to sell the sugars "immediately . . . for fear of a Peace." They should invest the profits in wine and spirits and dry goods, including 500 dozen cheap straw hats, likely destined for enslaved workers in the cane fields of the Caribbean.[20] And they were to bring with them a young painter raised in a tavern in rural Pennsylvania. While Josey Shippen and Johnny Allen toured antiquities, West would "improve himself in the Science of painting," drawing on Allen's purse as he did so. For as the great merchant told his London bankers, Benjamin West was shaping up to be "a very extraordinary person in the Painting Way, and it is a pity such a Genius should be cramped for want of a little Cash."[21]

The combination of Allen's cash and West's perseverance kept the painter afloat in Italy for three years. He was often ill, but managed to tour Florence, Bologna, Parma, and Venice, and to spend considerable time perfecting his craft in Rome, which he later called "the mistress of the world." There he presented his letters of introduction to well-connected connoisseurs and antiquaries, including Cardinal Albani, dean of the city's cultural cognoscenti. In West's recollection of their meeting, Albani greeted the young painter as a curiosity: "fancying that the American must

be an Indian," the blind cardinal had asked, "Is he black or white?" (When he related this story, John Galt, West's amanuensis-cum-biographer, took care to assure the reader that, in fact, "West's was even of more than the usual degree of English fairness.")[22]

Yet despite his "English fairness," West skillfully traded on his provincialism, fashioning himself as a backwoods genius. A clutch of learned men crowded around the artist at the Vatican, eager to witness his encounter with the Apollo Belvedere, widely considered one of the most perfect exemplars of classical statuary. "My God, how like it is to a young Mohawk warrior!" West was said to exclaim. When the assembled gentlemen recoiled, shocked to hear their beloved Apollo "compared to a savage," West explained "what sort of people the Mohawk Indians were. . . . 'I have seen them often,' added he, 'standing in that very attitude, and pursuing, with an intense eye, the arrow which they had just discharged from the bow.'"[23]

I have seen them: West's claim to a kind of empirical eye that transcended miles and millennia cemented his reputation as an unspoiled natural man, straight from the pages of Rousseau. Among the first commissions he received in Italy was an assignment to provide an image of an Indian warrior, correct in dress and ornament, for a series of paintings representing the edges of Britain's empire. Though fantastical and idealized, *A Savage Warrior Taking Leave of His Family* gives the impression of meticulous ethnographic detail. West poses the eponymous leave-taking warrior in the attitude of Hercules, choosing between the claims of the hearth and the call of country. The canvas "staggered the connoisseurs in Italy," the poet Joel Barlow later wrote, not least because they were struck by the work of "the American pencil on an American subject."[24] West had not been in Rome two months when connoisseurs took to calling him "the Raphael of America."[25]

During his years in Italy, West encountered not only the timeless relics of antiquity—the Apollo, the Venus de' Medici—but also some of the leading artists of the day, many of them born outside the Italian states. The German Raphael Mengs, the Scot Gavin Hamilton, the

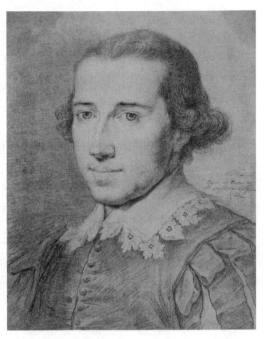

Benjamin West, SELF-PORTRAIT, *1758–59* *Angelica Kauffman,* BENJAMIN WEST, *ca. 1763*

Austro-Swiss Angelica Kauffman, the Englishman Nathaniel Dance, and the Tuscan-born Pompeo Batoni drew on the accomplishments of Renaissance masters to forge the new style of history painting that came to be known as neoclassicism. West learned by copying their work, along with pictures by Reni, Raphael, Titian, Van Dyck, and Domenichino. He shipped his efforts back to his patrons in Philadelphia, who continued to advance him cash, to be repaid in canvas.[26]

West's Italian sojourn transformed his art. It also required him to craft a new, cosmopolitan persona. Such transmutations come more easily early in life, which is one reason that the grand tour was so often the purview of youth. For aspiring gentry from Europe, Britain, and increasingly from the American provinces, Italy was the world's best finishing school. Born the same year as Copley and George III, West was not yet twenty-two when he crossed the Atlantic, a fine age at which to cover a backwoods boyhood with a glossy veneer of gentility.[27] Comparing West's ca. 1758–59 self-portrait, a pocket-sized miniature he painted for

a sweetheart shortly before he left Philadelphia, to the sketch Angelica Kauffman made of him in Rome four or five years later makes his transformation plainly visible. In Rome, the round-faced boy in the sober dress of his Quaker forebears lost his rusticity along with his baby fat. Depicted in the court costume of an earlier era fashionably resurrected as a kind of Van Dyck masquerade, West joined the artistic lineage that was coming to be known as the English school.[28]

In 1763, after news of the Treaty of Paris reached Pennsylvania, West's father wrote to advise Benjamin that, "as peace had been concluded between France and England," the painter should "go home for a short time before coming to America." By "home," the elder West meant England, and especially London, which his son had never so much as glimpsed. This was a common locution among American provincials of the day. As Galt wrote, "the mother country was . . . still regarded as the home of her American offspring," regardless of whether they had ever set foot on Britain's home islands.[29] Flush with the spoils of victory, travelers born in British America went "home" in unprecedented numbers in the 1760s, sailing on packet boats, a new service that crossed the Atlantic with greater frequency through safer waters, upon pilgrimages for commerce and culture.[30] As West unpacked his kit in London, he told Joseph Shippen, "Thank God, I am at last arrived safe at the mother country, which we Americans are all so desirous to see, and which I could not but desire as much, or more, than Italy itself."[31]

The London that greeted Benjamin West was a writhing, reeking stew of humanity, a "great and monstrous Thing," as Daniel Defoe had said.[32] With nearly three quarters of a million inhabitants, London was fully thirty times the size of Philadelphia. The metropolis was a great, gaping maw that devoured newcomers. It grew explosively during the second half of the eighteenth century, reaching a million souls shortly after 1800. But every year, more people died in London than were born there. The metropolis was a charnel house, a cesspool. Smoke blanketed the city. The wastes of hundreds of thousands of animals used for food and transport piled high in streets that functioned as open sewers. Through the

stinking heaps rumbled all manner of conveyances, powered by horses, oxen, and low-waged men: thousands of carts and wagons, smart two-wheeled gigs and lacquered chariots, all axel deep in filth: a traffic dense enough to run down any person not borne aloft in a sedan chair.

If the tangled, filthy streets of London forged its capillary network, the Thames was the aorta of the metropolis. One traveler estimated that some fifteen thousand boats plied the river, vessels ranging from tiny one-man transports to hulking three-masted frigates. Below London Bridge, he said, you could barely see the water for the boats, "vessels from every country . . . anchored in rows, forming streets with open passages between."[33]

The tide of global commerce that surged up the Thames meant that much as London seethed and stank, it also glittered. The produce of the great round globe surged through the city. The Royal Exchange, on Threadneedle Street, became a world in microcosm, its arches housing traders whose routes stretched from Venice to Moscow, Jamaica to Jakarta, the North Sea to the Cape of Good Hope. The merchant who grew rich on this polyglot trade became a true "Citizen of the World," as Joseph Addison famously put it.[34]

The London that West discovered in 1763 was a city of extremes, from the gilded splendor of its palaces to the desperate poverty of its fetid alleys. There were thousands of gin shops, hundreds of coffeehouses, scores of social clubs, reams of newsprint. Boisterous crowds gathered at theaters, concert halls, opera houses, pleasure gardens, and public executions. In the bustling neighborhood around St. Paul's churchyard, the painter would have found more bookshops than in the whole of North America, and more paupers than in a dozen Philadelphia almshouses. The city's scale and its density, its opulence and its manifold horrors: all would have been astonishing to West, even in the wake of Rome, which was a fraction of London's size. Perhaps he picked up a copy of *London and Its Environs Described*, a popular six-volume guide promising "travelling Virtuosi, whether natives or foreigners," a comprehensive listing of the city's "numberless curiosities," arranged alphabetically, from the grandeur

Canaletto, THE RIVER THAMES WITH ST. PAUL'S CATHEDRAL ON LORD MAYOR'S DAY, *1747–48*

of the Abbey at Westminster to the grit of Zoar Street in Southwark.[35] Eighteenth-century London was exhausting and enchanting by turns. Its champions proclaimed it the very center of the civilized world. "Why, Sir, you find no man, at all intellectual, who is willing to leave London," said Samuel Johnson to his Boswell. "No, Sir, when a man is tired of London, he is tired of life; for there is in London all that life can afford."[36]

The visual arts assumed new importance among the many and various pleasures of the imagination that life in postwar London afforded. Wealthy Britons had long privately patronized the fine arts, but much of their collecting and sponsorship had focused on the same French, Dutch, German, and Italian masters whose works had been the focus of West's own grand tour. In London, groups of artists formed clubs, meeting in private homes and in coffeehouses, to advance both the skills and the interests of an emerging English school. For decades, such efforts remained decidedly informal, as did the city's exhibition culture, which centered on the collections of the nobility and upper gentry, to which admission could be gained only by favor. In the 1740s, London patrons of the arts might tour the new Foundling Hospital, which displayed contemporary British works as goads to charity, or frequent the pleasure gar-

dens at Ranelagh and Vauxhall, where paintings served as backdrop for entertainments ranging from the polite to the scandalous. But there were no art museums to speak of, nor any major public collections.

A decade later, London burst forth as an artistic capital. As the Seven Years' War unfolded, resurgent imperial pride both fueled and was fueled by a more concerted and official cultural program. Private clubs became chartered societies, like the Society for the Encouragement of the Arts, Manufactures, and Commerce, first organized in a coffeehouse near Covent Garden in 1754. Its members met regularly, enlisted aristocratic patrons, elected officers, collected dues, and awarded prizes for achievement in realms ranging from agricultural innovation (the planting of madder, which produced red dye vital to the British army); to artistic excellence (the finest painting "taken from our own History, the Figures as large as Life," or the best drawing by a girl under sixteen).[37]

In late 1759, as London celebrated the triumph of the king's forces in Quebec, a group of artists working under the society's auspices hatched a plan to stage the first public exhibition of contemporary British art. The show opened in late April, at the peak of the London social season, as Benjamin West sailed from Pennsylvania. The works on view—130 pieces by sixty-eight contributors—were a hodgepodge: history paintings hung cheek by jowl with needlework; refined sculptures in marble stood beside gaudy models in wax. The public response exceeded the organizers' fondest expectations. Over 6,500 catalogs were sold at the door, and many entered who hadn't shelled out a shilling for the catalog—"great Numbers" of people "whose Stations and education made them no proper judges" of art, "and who were made idle and tumultuous by the opportunity of a shew," the society's leaders lamented.[38]

As London pressed its claims as both a cultural capital and an imperial metropolis, annual public art exhibitions became a highlight of the spring season. Contending groups of artists vied to discipline the raucousness of the first exhibition by charging admission and narrowing the definition of the arts worthy of display. Still the crowds surged in. In 1761, the crush of visitors was sufficient to knock over the liveried por-

ter hired to keep order at a competing exhibition staged by a breakaway group calling itself the Society of Artists of Great Britain. Two years later, the large, fashionable crowds that gathered for the annual showcase would become a prime target for pickpockets, who lifted seven watches in mere minutes by working the line outside the door.[39]

As its name suggested, the Society of Artists of Great Britain linked painting and patriotism in new ways. Its first exhibition catalog featured a frontispiece by the aging Hogarth—Britain's best-loved and most ardently patriotic artist—in which a benevolent George III watches over Britannia, who waters the tender shoots of painting, sculpture, and architecture.[40] Where George II reveled in his boorishness, his refined English-born grandson had become convinced that art nourished empire, and vice versa. The painter Joshua Reynolds called him "a PRINCE . . . who promotes the Arts, as the head of a great, a learned, a polite, and a commercial nation," flattery with more than a grain of truth behind it.[41]

The ground was well tilled for Benjamin West, then, when he arrived safe at the mother country in late 1763, trailing the recommendations of some of the most renowned connoisseurs in Italy. Their backing was "good Luck," one critic said.[42] And in London, West's good luck multiplied; his most prominent American patrons, including William Smith and William Allen, were waiting for their protégé, having sailed to the metropolis as soon as the war ended. Before year-end, West painted most of their circle, several of them in suits of red with blue facings and gold braid: civilian fashions playing on military dress.

West's reputation spread quickly. In January 1764, William Allen marveled that West had "got into Vogue" more suddenly than even Reynolds had done. "If he keeps his health he will make money very fast," Allen predicted, and "is not likely to return among us."[43] When the spring exhibition opened in April, West was already robed in considerable glory. He exhibited three pictures: two scenes from Italian Renaissance literature that he had painted in Rome, and a full-length, full-dress military portrait of General Robert Monckton, Wolfe's second-in-command at Quebec: an English officer and an American hero.[44]

The *Public Advertiser* ran competing translations of French verses lauding "*Monsieur* WEST, *Peintre celebre . . . connú en* Italie *sous le Nom du* Raphaël Americain."[45] After visiting the exhibition, one critic worried that West's "sanguine Friends" had praised him too lavishly, "and by their exaggerated Accounts of the Powers of his Pencil, rather diminished than added to his Reputation." Until and unless he improved, the writer quipped, "surely the glorious Title of the *American Raphael* can never be, without Irony, bestowed on him."[46]

"American" was, from the first, a key descriptor—one might say a term of art—for West, who wrapped himself in Britain's flag and in the rusticity of the provinces. This was not an inconsistent position. In the Britain of the early 1760s, "American" was a multivalent term: an adjective used to denote the curious and the outlandish, and a noun that referred more often to indigenous North Americans than to the settlers of British and European descent who had invaded their continent. Londoners had long known America as the destination of felons punished with transportation instead of hanging: a place beyond the pale. During the Seven Years' War, new maps of the colonies gave Britons a mind's eye picture of their faraway provinces, as places they could envision, inventory, and perhaps even visit.[47]

America also came to them. American sugar sweetened their tea and American rum dulled their senses: products of Jamaica and elsewhere in the West Indies, islands that were, from the metropolitan perspective, the very heart of Britain's America. People in the metropolis strolled in botanical gardens that featured American maples and hemlocks among their exotic imports. At the newly opened British Museum, they could marvel at American curiosities ranging from indigenous artifacts to fossils. Londoners smoked American tobacco, which they bought at shops whose signs and trade cards often featured caricatures of American Indians tricked out in feathers and beads. (Hogarth satirized such images in his 1762 print series, *The Times*, where a shop sign labeled "Alive from America" shows a smiling Indian girdled with bottles of rum and holding bags of cash, symbols of the prosperity that would return with peace.)[48]

Londoners knew indigenous Americans firsthand as well. Native dip-
lomats toured the English metropolis on several occasions during the
eighteenth century; a delegation of three Cherokee headmen had arrived
the year before West. Huge crowds turned out to view these exotic visi-
tors whenever they appeared in public: an American *tableau vivant*. Bal-
ladeers joked, "Are [Manners] so rare in the *British* Dominions / That we
thus shou'd run crazy for Canada Indians?" The presence of increasing
numbers of planters and merchants from the southern colonies and the
West Indies meant that London's black population was also growing in
the years surrounding West's arrival. These dark-skinned slaves and free
people, too, were "Americans": remote, exotic, *other*.[49]

In the provinces, "American" was only just becoming a collective noun
when West barnstormed London.[50] When newspapers in Britain or in its
American dominions used the word "Americans" in 1763, it was most

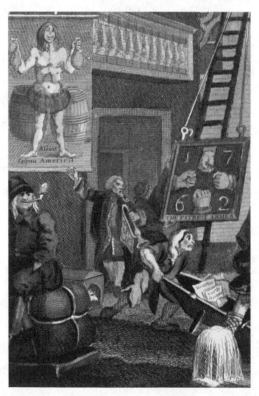

William Hogarth, THE TIMES, *1812 (1762), Plate I, detail*

often in connection with the Royal Americans, a British army regiment that fought with distinction in the western (or "American") theater of the Seven Years' War. Only at the end of that year did "Americans" begin to denote a group of political subjects with common economic interests and possibilities—not yet common grievances.[51]

What, then, did it mean to be called the American Raphael? West took it as a compliment: a straight-faced comparison to the painter who was widely acknowledged to be the greatest modern master. When West's first child was born, in the spring of 1766, he named the boy Raphael.[52] But surely the accolade had an edge. West's self-conscious exoticism made his achievements appear all the more astonishing: here was the Raphael not of Urbino but of the American woods, the marchlands: the far ragged edge of the empire, which the imperial eye could make out only faintly. Just twenty-five years old, a fine figure of a man, a sudden celebrity: the new Londoner out of Pennsylvania via Rome was a paradox—a prodigy and a curiosity, a rustic and a gentleman, a provincial and a citizen of the world. West was an enchantment, a novelty, an imperial fantasy borne Home by the currents of empire. His critic, in other words, was onto something: the glorious title of the American Raphael could scarcely be used without irony. It had something of the ring of the Hottentot Venus or the Zulu Shakespeare.

William Allen was also right: West's canny self-presentation, fortunate timing, and overwhelming reception meant that the American Raphael would never return to America. As his illustrious career spooled out in London, West became known for the particular generosity he extended to other aspiring provincial painters who soon sailed east in his wake. Beginning with Mathew Pratt, a Philadelphian who escorted his kinswoman, West's fiancée, to London in 1764, a trickle of eager pupils washed up on the stoop of West's "very large elegant house" in Leicester Square, bearing fulsome letters of introduction and, in most cases, ambitions ill matched to their talents. Remade through his travels as a gentleman who embodied the easy complaisance that numbered among the era's highest virtues, West greeted them with open arms, making

space in his studio and at his table. Pratt said West acted as "his Father, friend and brother." West knew, by practice and by instinct, when to show deference, when to extend fraternity, when to exert mastery. The innkeeper's son had left Springfield for Philadelphia in time to have his rough country edges planed away, and then had left Philadelphia still young enough, skillful enough, and open enough to learn a courtier's manners, and learn them fluently.[53]

There was some sense, even early in West's London career, that the students gathered round his easel might one day form the germ of a regional variant of the English school. In 1766, Matthew Pratt showed at the annual spring exhibition a conversation piece entitled *The American School*. Wearing a plain green suit and a black hat that he has not doffed, in good Quaker style, West offers instruction to a quartet of disciples, who range in age and skill, from newly breeched boys copying by rote to young men drawing from life, to Pratt himself, painting in oil. *Transito studii*: the aspiring artists map an evolution, a rising glory.[54]

In 1768, having spent two and a half years at West's elbow, and another eighteen months perfecting his trade in Bristol, Matthew Pratt returned to Philadelphia. There he painted portraits of the great and the good, not quite enough of them to cover the costs of a growing family. In the depression that followed the Revolution, as his son later recalled, "the Fine arts, were very poorly encouraged."[55] Pratt turned to painting shop signs. His designs were artful: stripped down history paintings featuring subjects like Neptune ruling the waves, used to peddle coffee and tea. With its vaunting ambitions to the highest reaches of art, the "American school" could not possibly exist in Britain's America, nor even, years later, in the young United States. In many ways, in the 1760s, London *was* the American school: the place where travelers from disparate British provinces imagined and marketed themselves as a people.

~

While West robed himself in the romance of the provinces, Copley confronted the realities of postwar Boston. The winter of 1764 was bleak,

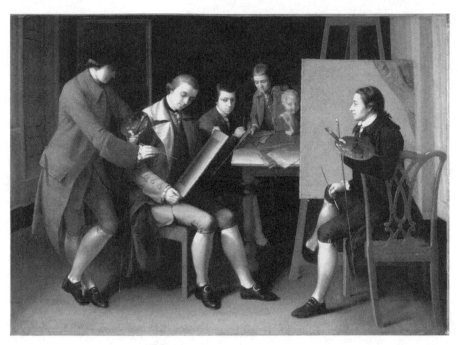

Matthew Pratt, THE AMERICAN SCHOOL, *1765*

even by New England standards. Snowdrifts piled up in the alleys. The papers carried news that the Lords Commissioners of His Majesty's Treasury, desperate for revenues, would henceforth strictly enforce the duties stipulated by the Molasses Act decades before. The "Merchants Say, there is an end of the trade of this Province," Governor Francis Bernard wrote, "that it is time for evry prudent man to get out of debt with Great Britain as fast as he can, & betake himself to Husbandry & be content with such coarse manufactures as this Country will produce."[56]

An outbreak of smallpox soon added injury to insult. The *Boston Gazette* noted the first death on 2 January. Before the month was out, banners denoting the presence of sufferers flew from thirteen buildings in town.[57] Copley wrote to his stepbrother Charles to warn him that "the small Pox had spread its contagion so far as to render it utterly unsafe" to visit "this distresst Town, till its surcumstances are less mallancolly than they are at present."[58] By March, the epidemic was widespread enough that the selectmen felt obliged to give *"Publick Notice, That we*

have no Hope to stop the Progress of the Small-Pox," and would withdraw
the guards posted to keep people from leaving "infected Houses." Shop-
keepers relocated to the countryside. Trade slowed to a crawl. A pam-
phlet protesting the tighter enforcement of the sugar duties went into its
second printing.[59]

And, as it did every winter, fire stalked the town that was both built
of and heated by wood. The same evening that Copley advised Charles
Pelham against coming to Boston, Harvard College burned. This, too,
was, at least indirectly, the fault of the pox: the General Court of Mas-
sachusetts had relocated to Cambridge in order to spare the province's
elected officials. A fire was kept burning overnight in the college library
for the court's greater comfort come morning. While the politicians slept,
a beam beneath the hearth burst into flame. The blaze quickly devoured
the library, claiming every one of the five thousand volumes that wasn't
offsite with a reader. Fueled by the most precious of paper, the confla-
gration consumed the college's oldest building and badly damaged its
newest. The newspapers inventoried the casualties in excruciating detail:
priceless books, manuscripts, antiquities, scientific instruments, and a
"variety of curiosities natural and artificial."[60] Here was "the work of ages,
in a few hours turn'd to ashes," wrote the daughter of Edward Holyoke,
the college's president, whom Copley had painted a couple years earlier,
perched stiffly in his monumental presidential chair. Elizabethan if not
medieval, Holyoke's knobby throne was quite literally the seat of Amer-
ican learning.[61] The portrait and the chair survived the fire, but Harvard
Hall, the perch from which Copley's *Holyoke* surveys his domain, burned
to its foundation, "levell'd to the Dust."[62]

The snow melted and the embers cooled, but the bad news kept com-
ing. An uprising of native peoples in the interior of the continent was
spreading nearly as fast as the smallpox. Four regiments of British regu-
lars, and two more from Ireland, would sail for America in May to keep
the hard-fought peace. Parliament was debating a raft of new bills to offset
the cost of the war and its aftermath. The first of them, reported in Boston
in May, leveled new duties on sugar, molasses, rum, and fortified wines.

There was ominous indication that other such laws would follow; buried deep in the Sugar Act was a statement that it might, in future, be "proper to charge certain Stamp Duties in the said Colonies and Plantations."[63] The Boston town meeting instructed the town's representatives to the General Court to resist the new taxes, which would weigh heavy upon "a Town which lives by its Trade," and could very well die by it, too.[64]

In early June, Bostonians celebrated the king's birthday—his twenty-sixth—with cannon and fireworks and other "usual Demonstrations of Loyalty and Joy."[65] A month later, Governor Bernard warned the Board of Trade that the taxes "must arouse the turbulent to an high pitch, & give a new Spirit to the popular demagogues."[66] Before July was out, James Otis, one of the town's most "turbulent" politicians, published a pamphlet entitled *The Rights of the British Colonies Asserted and Proved*, in which he argued that sovereignty rested on the consent of the governed, and that chattel slavery, no less than metaphorical slavery to tyranny, violated natural law. "The Colonists are by the law of nature free born," Otis insisted, "as indeed all men are, white or black." There was no justification for the new taxes, much less for the slave regimes they propped up, in Jamaica and indeed in Boston. "It is a clear truth," he warned, "that those who every day barter away other mens liberty, will soon care little for their own."[67]

As the summer wore on, Bostonians made plans to boycott imported English cloth and stockpile wool to make their own. Some agreed to give up eating lamb, so that more sheep would survive to be shorn. A group of artisans committed to "wear nothing but Leather for their Working Habits," and only that made from skins dressed and fashioned locally. "English Cheese is now hawk'd about the Streets of this Town" at rock-bottom prices, noted the *Gazette* in steamy August, "so averse are the People from purchasing any Manufacture" from Britain.[68] By the time the Sugar Act took effect, on 29 September, a full-blown assault on luxury goods was under way. A writer calling himself PhiloPublicus— friend of the people—praised a recent "Agreement to suppress Extravagance and promote Frugality" and bemoaned merchants' affection for

"shining Side Boards of Plate" and "costly Piles of China," and their wives' "Fondness for Dress and Fashions, for Trinkets and Diversions."[69] He might have been inventorying a Copley portrait.

By all accounts, including his own, Copley's business was flourishing in the difficult year of 1764. Like George III, the painter turned twenty-six that summer. Now the most sought-after portraitist from Hartford to Halifax, Copley increasingly signed and dated his work, which allows for at least a rough estimate of his artistic production. In 1763, he took the likenesses of no fewer than sixteen sitters, nearly as many as in the previous several years combined. In 1764—year of the pox and the fire and the ominous news from London and the colonies' consequent disavowal of luxury—at least thirteen patrons sat to him, and possibly twice that many.[70] His productions had grown more elaborate and sophisticated in

Copley, NATHANIEL SPARHAWK, *1764*

every way. Jules Prown, the reigning authority on the artist's style, has noted a new "visual opulence" in Copley's work beginning in 1762, the year Joseph Blackburn left Boston and Copley became the town's unrivaled eminence. By the mid-1760s, he was painting an increasing number of larger, busier canvases whose carefully observed details highlighted the painter's growing mastery of faces, fashions, and furniture: the ingredients, as the art historian Paul Staiti has written, of sitters' character and class.[71]

In these years, Copley experimented with new scales, from a life-sized full-length portrait over ninety inches tall, to an intimate oval miniature, stippled in watercolor on ivory, cased in a gold locket barely an inch high. His grand-manner portrait of the merchant Nathaniel Sparhawk uses a pose reminiscent of the official state portrait of George III. Sparhawk had made his fortune the old-fashioned way: by marrying well, to the only daughter of Sir William Pepperrell, hero of the first conquest of Louisbourg and part of the extended circle of Samuel Waldo. (Among other sources, Copley's portrait quotes Smibert's image celebrating Pepperrell's triumph.) Sparhawk and his family lived as grandly as the marchlands allowed, in a Georgian mansion deep in the Maine woods, wearing taffeta and sipping tea. They bought Atlantic commodities ranging from oysters, which they ate by the bushel, to young female slaves. (Sparhawk once bid to purchase "6 Negros Girls," along with rough cloth for their working dress and a "Number of Rugs" for them to sleep on.)[72] Like others of his status, Sparhawk regularly overextended himself; in 1758, he went bust, owing, in part, to heavy taxes on his lands as Massachusetts struggled to finance the great war. The following year, his father-in-law rescued him from this embarrassment by dying. By the time Sparhawk sat, or rather stood, to Copley, he was very much back on top. Copley set him in an imaginary landscape of fluted stone columns and classical statuary, a surround that disguises the roughness, not to say brutality, of Sparhawk's actual environs. Fat and happy: *Sparhawk* is that rare portrait subject who smirks. And infrared photography shows that Copley, who was called upon to act as tailor as well as limner, altered his sitter's

painted suit, moving the buttons out, to make him appear fatter, and thus more masterly.[73]

In November of 1764, the year he painted Sparhawk, Copley's friend Thomas Ainslie, who had advanced over the course of the war to become the chief customs officer for the port of Quebec, suggested that the painter make "a Jaunt" to Canada the following summer. Such a painting tour, he said, would "rather add to [Copley's] Credite, and fortune, than deminish it." Ainslie offered the use of a room in his house and promised, "Not only my family, but all those of Credite in the town would be glad to employ You."[74] Copley demurred: he would "receive a singular pleasure in excepting [*sic*], if my Business was anyways slack, but it is so far otherwise that I have a large Room full of Pictures unfinishd, which would ingage me these twelve months, if I did not begin any others. . . . I assure You I have been as fully imployd these several Years past as I could expect or wish to be," he continued. For the time being, Copley said, it was "impossable for me to leave the place I am in."[75]

And yet there were reasons—ample reasons—to begin to think about doing just that. Word of the progress of Art in the metropolis made its way to Boston, in letters and gossip, in scattered references in the newspapers, and in longer essays in periodicals like the *Gentleman's Magazine*. The May 1764 issue, available in Boston by July, featured two pages on the spring exhibitions, including particular praise of "Mr. West," whose pictures were deemed "very good and very pleasing."[76] The connoisseur Horace Walpole, son of the longtime prime minister of Britain, had lately published his *Anecdotes of Painting in England*, a four-volume set that greatly extended earlier writings about the rising English school. (So many particulars and still not enough: "Walpole amidst all his exactness" had failed to note "what time Vandyck came to England," Harry Pelham lamented, in response to a query from his half brother, Copley.)[77] The painter could have purchased these and other volumes at the new London Book Store, recently opened on King Street where it intersected Cornhill, in the shadow of the English lion that reared atop the Town House. The proprietor promised "a very great Collection of Books in almost every Art,

Science, Language, and Faculty," along with a fresh supply of *The Lon-don Magazine* and other periodicals just off the packet boats.[78] Customers could take their prints down the street to the British Coffee House, there to read them in the company of other polite gentlemen. "Just arrived from London." "Imported in the last Ships from London." "The very best of London." "London Made." The "newest Fashion wore in London." Nearly four thousand advertisements hawking London goods, images, and opinions were published in Boston in the five years after 1760.[79]

Boston's troubles more than matched London's allure. The winter of 1765 was the coldest the town had endured in more than a decade. By the end of January, the harbor had frozen solid. The pinch of the Sugar Act—the *"Black Act,"* as the merchant John Rowe called it—had reduced the Indies trade to a fraction of its normal size.[80] Bankruptcies toppled grand fortunes. The first to collapse was Nathaniel Wheelwright, an iron-monger and thus an arms dealer, who had parlayed "the great Business he was in for the Government at Home during the Wars" into such a mountain of treasure that his personal notes of credit were used as paper money throughout Massachusetts. On 15 January, Wheelwright stopped payment on an estimated £170,000 worth of notes, an event that James Otis compared to the bursting of the "South Sea Bubble . . . in England some years ago." People holding Wheelwright's now worthless paper tried to secure their debts, "but it was too late to shut the Stable door," Otis said. On 19 January, John Scollay, a longtime Boston selectman, was "run upon" by creditors and forced to shutter his business. Joseph Scott, a wholesaler who sold a variety of "Braziers Ware," went bust the next day.[81] Copley had painted both men, and their wives, just a year or two before. Perhaps he found himself among their legions of creditors as their failures rippled through Boston.[82] A "Stop to all Credit was expected," Governor Bernard said, "& a general bankruptcy" feared.[83]

⁓

As the credit crunch spread, the threat of the Stamp Act drew near. New Englanders learned in May that the law so long debated and feared was

a fait accompli. "The STAMP ACT!!!!!! is to take Place in these Colonies on the First Day of *November* next," the *Evening Post* reported. Said the *Boston Post-Boy* in early June, "Our Trade is in a most deplorable Situation, not one fifth Part of the Vessels now employed in the West-India Trade, as was before the late Regulations. Our Cash almost gone . . . Bankruptcies multiplied, our Fears increased, and the Friends of Liberty under the greatest Dispondency." And all this before the Stamp Act took effect. "What these Things will end in, Time only can discover!" the writer concluded.[84]

As spring turned to summer, Bostonians pored over the details of the new legislation. The Stamp Act required that a seemingly endless range of printed materials, from playing cards and newspapers to writs and wills, appear on paper bearing a stamp issued by Parliament, in which American provincials had only "virtual" representation. The cost of the stamp ranged from a halfpenny for a pamphlet to ten pounds for a law license. (Mezzotints and other engravings were not enumerated in the lengthy schedule, likely because the number produced in the colonies remained too small for taxing them to make a difference.)[85] The paper would be shipped from London and distributed by local officials tapped by the crown. Boston newspapers published the names of the designated stamp officers for every port from Bridgetown to Halifax: somewhere between breaking news and a hit list. Opposition to the act was nearly unanimous, across all twenty-six British provinces, with their widely divergent economies and interests. Caribbean sugar planters, Pennsylvania wheat farmers, Massachusetts merchants, and Nova Scotia sailors alike considered the act an assault upon their ancient liberties as Britons, who, in the provinces as in London, understood taxes as gifts freely given by loyal subjects via their elected representatives in the House of Commons, where the power of the monarchy's purse resided.

Even more than the Sugar Act, which actually *lowered* import duties while tightening their enforcement, the Stamp Act was experienced as an "insupportable Grievance," as one writer in the *Gazette* put it in July.[86] "The People are extremely out of Humour with the Stamp=Act," Gov-

ernor Bernard told the Board of Trade. The hotter politicians, whom he labeled "the Opposers of Government," were using the unrest to advance the power of "their faction." Bernard expected that moderates—"friends of government," so called—would win the day. "Murmurs" of discontinent "would in time dye away," and good order return to Boston.[87]

⁓

Painters longed for summer. December, as the English artist James Northcote wrote, is "a most sad part of the year," when "the days are so short that I can do but little, and the weather very cold." Paint dried slowly, and a fortune in candles could barely penetrate the gloom. In the sitter books of painters who kept good records—Copley, alas, not among them—you can see the shaping force of the calendar. In his genteel studio in Leicester Square, Joshua Reynolds couldn't paint much past one o'clock in January; he booked appointments till two or three in March; he worked into the evening in June.[88] By then, in Boston as in London, the days were long and warm. Light flooded the house on Cambridge Street. Sitters could pose in comfort, bored and twitching but at least not shivering, as Copley went about his painstaking work. Pigments set quickly and varnish dried completely. If only the daylight of June could be saved, to spend in December. But it could not, any more than berries or melons. Best to keep at it, head down in the work, with the diligence that had become his watchword.

Sometime in the summer of 1765, as Boston merchants bewailed their fate and the town's armchair politicians took to the press and then, in due course, to the streets, Copley began a portrait of his half brother, then fourteen years old. Harry must have been a willing model; it was the second time Copley experimented on the boy, whom he had made the subject of a candlelit scene about five years earlier. That little picture, a loose oil sketch barely seventeen inches tall, feels intimate, personal. (Copley kept it near to hand; it was still in his possession in late 1765, when he lent it to a visitor, the aspiring Philadelphia painter Charles Willson Peale.)[89] Copley's second collaboration with Harry pro-

duced something very different: no mere likeness of his young kinsman but a public statement—a "performance," in the parlance of the day. He meant to send it to London for inclusion in the exhibition of the Society of Artists. It was a daring gambit, "presenting a Picture to the inspection of the first artists in the World." The "great timerity" of doing so made Copley anxious.[90] "I confess I am under some apprehension of its not being so much esteem'd as I could wish," he told the captain who agreed to ferry the canvas from the customs collector in London to the connoisseurs who would decide whether it was fit to hang. But he asked for a faithful report of its reception nonetheless. "I can truly say if I know my own heart"—always probing, always searching, himself as his sitters—"I am less anxious to enjoy than deserve applause."[91]

Praise, or censure, lay months ahead and an ocean away. Winter crossings were notoriously long and rough, a lesson brought home to Copley

Copley, HENRY PELHAM, *ca. 1760*

in early 1765, when his friend Peter Traille wrote from Halifax to say that some pastel portraits Copley sent him had been lost, along with the vessel, which broke open on the coastal shoals off Nova Scotia. Traille was mortified to report that Copley's works had "become the prey of the barbarous Inhabitants. . . . I cannot conceal the innexpressible pain this loss gives me," he said, not least because he was so eager "to acquire some knowledge in the Art of colouring of which I have very disstant Ideas of yet." This business of distant ideas—of projecting his own, on canvas, some three thousand miles eastward, and then straining to hear any conversation the picture occasioned in London, as it rippled back to Boston—lay at the heart of Copley's gamble.[92]

And so, in the summer of 1765, Copley worked backward and forward, Janus-faced. To hang at Spring Gardens in April, the picture had to be received by February, when the exhibition committee made its choices. It should be crated and shipped during the fall. The seas were calmer then, and Copley had identified an escort for his cargo. Roger Hale, a London-born collector of customs, had lately run afoul of his superior. By spring 1765, it was clear that Hale's days in Boston were numbered, which proved to be Copley's good fortune. When Hale sailed for London, he promised to "take the care" of Copley's picture "and put it among his own baggage."[93] There was no safer way for a package to travel home than with an officer of his majesty's customs service.

When the *Boscawen* deposited Hale and his baggage on the banks of the Thames, another friend of Copley's would be there to meet the canvas. The painter's frequent correspondent R. G. Bruce captained the *John and Sukey*, a ship fatefully named, it would turn out. The *John and Sukey* plied a trading circuit from London to Boston to Antigua and back. Bruce was at home in the metropolis in the summer of 1765, ready to receive Copley's precious shipment and to help it thread its way through the capital, to the Leicester Square home of Benjamin West.[94]

The picture Copley prepared to submit to West, via Bruce, via Hale was at once transcendent and specific. While dwelling on the minute particulars of his brother's face—the swirl and dip of his hairline, the way

his fine chestnut hair eddies around his folded ear—Copley also elevates Harry's likeness, showing him in full profile, as if he is a warrior on a Greek frieze, or a king on a golden coin. The painter plays with surfaces, conjuring illusions of velvet and satin, gold and glass, still water and polished wood. He lavishes attention on the fluted white edge of the gray fur ruff that marks Harry Pelham's (imaginary) pet not just as the kind of tamed squirrel shown, by convention, in many boys' portraits of the day, but more particularly as a flying squirrel: a North American emblem that might speak directly to the American Raphael.

As *Boy with a Flying Squirrel* dried in Copley's house on Cambridge Street, months of murmuring turned to riot. At daybreak on 14 August, a

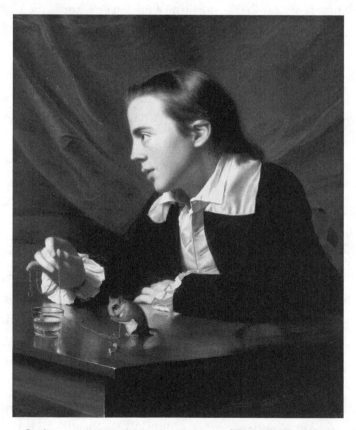

Copley, A BOY WITH A FLYING SQUIRREL *(Henry Pelham), 1765*
[Plate 4]

crowd began to assemble at the head of Essex Street, a block from the water's edge. The attraction was a pair of effigies hanging from an ancient elm. One took the form of a boot, with a vile green sole, out of which "a young Imp of the D——l" peeped: a pun on the names of the Earl of Bute and George Grenville, architects of the king's revenue policies. The second effigy took the shape of Andrew Oliver, the long-serving secretary of the province who had lately accepted the post of stamp master. On his lapel ran the inscription "HE THAT TAKES THIS DOWN IS AN ENEMY TO HIS COUNTRY."[95]

All through the morning, onlookers massed, dozens becoming thousands. The governor convened his council to discuss the growing disturbance. Bernard and Lieutenant Governor Thomas Hutchinson thought it was "a serious Affair," which demanded an official response, but most of the councillors dismissed the spectacle as "boyish sport," a "trifling Business, which, if let alone, would subside of itself."[96]

By nightfall, the gathering had swollen to what Hutchinson called "an amazing mob." Fortified by hours of chanting and drinking, the crowd paraded the effigies to the Town House, where the governor and council continued their huddle. The procession, led by "forty or fifty tradesmen, decently dressed," then made its way dockside, to Oliver's eponymous wharf. In minutes, they demolished the new brick building that, rumor held, would house the stamp office.[97] From Oliver's Wharf, they swarmed, bricks in hand, to nearby Oliver Street, as if determined to erase the stamp collector's name from the map of the city. While Oliver and his family sought refuge in a neighbor's home, the mob forced their way into his house, raided the cellars, and "help'd themselves to the Liquor which they found there." The raiding party splintered his fine mahogany furniture and shattered his mirrors, one of which was "said to be the largest in North-America," the *Gazette* reported. Copley's intimate portraits of Oliver and his family, miniature likenesses painted on copper, most of them less than two inches high, would not have been displayed in the public spaces of so grand a house, and so were spared the attentions of a mob intent on a symbolic decapitation. Instead, the crowd turned on the effigy, pulling its straw head from its body and burning the remains.

The next day, several leaders of the action gently suggested that Oliver resign his commission. The following morning, Oliver conceded, leaving Boston without a stamp master.

Thomas Hutchinson had been the mob's most visible and vocal opponent; "it was rumord about my turn would be next," he wrote. He barred his doors, shuttered his windows, and decamped to his country seat in Milton. And right on cue, the night after Oliver pledged to return his commission, hundreds of men surrounded Hutchinson's house, a three-story Georgian mansion that loomed above its cramped surround in the old North End. After about an hour of chanting, the crowd dispersed, leaving behind a few broken windows.[98]

Hutchinson suspected the peace was temporary, and events proved him right. Ten days later, a "peculiar Hoo[t] and Whistle" summoned people to a bonfire in King Street.[99] A large crowd arrived at dusk, carrying makeshift weapons. The first house to suffer their rage belonged to William Story, one of the officers of the Admiralty Court. From Story's, the mob turned north onto Hanover Street, where they converged on the home of Benjamin Hallowell, named Boston's comptroller of customs just the year before. Copley painted him, most likely at the time he received the valuable office. Seated at a velvet-draped table in a polished gray suit, Hallowell appears paunchy and prosperous. His quill is poised above his ledger, ready to reckon duties paid, and owed.

People in the crowd attacked what they saw as symbols of Hallowell's ill-gotten wealth.[100] They smashed china and mirrors, stripped wainscot from the walls, and shredded books. They stole Hallowell's fancy clothes, perhaps the very suit he wore in the painting. And they fell upon the portrait, stabbing and slashing the painted figure, especially the face: Copley's gift for catching likeness made accessory to a kind of proxy murder.[101]

Armed with clubs, axes, and barrel staves, heated with liquor they had liberated from Hallowell's cellars, the crowd continued up Middle Street to Hutchinson's place. By the time the mob had spent its rage hours later, the "House was a meer Skeleton," the *News-Letter* said.[102] As dawn broke, the looters fled, dropping some of their purloined treasures. Governor

Bernard described "Streets . . . scattered with money, plate Gold rings &c." Paper was everywhere: Hutchinson's library, the work of decades, reams of manuscripts, armloads of provincial documents: all burnt, torn, soaked, scattered, destroyed. Feathers ripped from the family's bedding eddied in the gutters like a freakish late-summer snow.[103]

The inventory of Hutchinson's losses covers pages and spans the globe: Chinese porcelains, Turkish carpets, Indian ivory, Brazilian mahogany, Canary and Madeira wines, French beads, Dutch tiles, and cabinetry lacquered in the style of Japan. Clothing of velvet, corduroy, silk, calico, rateen, linen, and wool, including two sets of scarlet judicial robes. The tiny shifts that clothed his children and the humble garments that covered his tenants, servants, and at least one slave. A quartet of family portraits spanning generations, a dozen framed prints and paintings. (Copley's *William Welsteed*—the mezzotint memorializing Hutchinson's

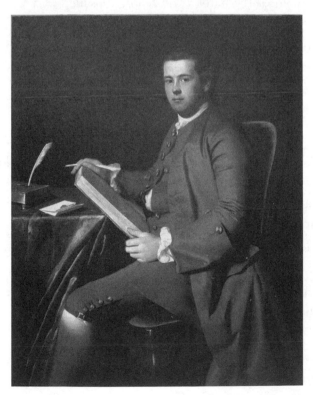

Copley, BENJAMIN HALLOWELL, *ca. 1764*

late brother-in-law—may well have been among the casualties.) "People came in from many parts of the country, to view the ruins," Hutchinson wrote.[104] Copley lived barely half a mile from the ravaged mansion.

Two weeks after the tumult, the picture Copley meant to make his calling card was loaded aboard the *Boscawen*. The arrival of the stamps, "which has made so much noise and confusion among us Americans," was much on the painter's mind. Like so many of his countrymen, he hated the Stamp Act. Yet by temperament and by calling, he also detested noise and confusion. And the confusion was spreading. In his letter accompanying the painting, Copley noted the destruction of two houses in Rhode Island that had followed the attacks on Oliver, Story, Hallowell, and Hutchinson. In Newport, he said, good men had been "obliged to save their lives by flying on board the Kings Ship that Lay in the Harbour." In Boston, only "a strong Military watch . . . keeps the Town in quietness," he wrote.[105] On its way out of the harbor, the *Boscawen* sailed past Castle William, where Hutchinson cowered in the wake of the riots. This, this was British liberty? In his mind's eye, Copley traveled every mile of the journey of *Boy with a Flying Squirrel* from the Long Wharf to the exhibition room in Spring Gardens. He could already picture himself on the boat.

In the spring, after the Stamp Act protests had achieved their ends, and Parliament repealed the misguided tax, after the exhibition opened in London, but long before he received any verdict on his performance, Copley received a letter from his friend Peter Chardon Jr., a neighbor on Cambridge Street who had sat to him, perhaps in 1763, when Chardon was admitted to practice as a barrister at the province's Superior Court.

Chardon's letter, intimate and playful, is directed to Copley "at his Seat near St. James Square, London Place, in Boston," a fictitious address, an inside joke between two friends who must have shared their cosmopolitan longing, leavened with a healthy degree of self-mockery. He wrote from Barbados, where he had sailed the previous November, soon after the Stamp Act took effect. Among the reasons for his tour was a commission to collect on Thomas Hutchinson's accounts, as the lieutenant governor called in his debts, everywhere, to try to salve the

wounds the mob had inflicted. Chardon sent fond regards to Copley's stepbrothers, his "ingenious little Brother Harry," and his "very worthy mama," the widow Pelham, who he wished "could enjoy only one twentieth part of the Health that I partake of." But mostly, Chardon missed his friend, "in whose Company I have enjoy'd so many pleasing hours." He hoped Copley might follow him south, to "the Island of Barbados, alias Garden of Eden," where Chardon had decided, to his surprise, to stay on. He laid out the advantages: "the blessedest Weather and the most enchanting scenes human imagination can paint" weighed against Boston winters. "People hospitable and generous to a Fault, and the most polite, polish'd and gentile of any I ever saw before." (That their elegant manners were built upon the misery of sugar slavery eluded him.) These were the sorts of people who wanted portraits. A painter with Copley's skill would quickly grow rich there. Within ten years, HIM said, Copley would be riding through the island's lush green countryside in a "Chariot and four."

Chardon knew that what he counseled was far from easy: "It is with Difficulty my dear friend that a man can get away from the Country where he receiv'd his birth and Education," he acknowledged, "but when he has once broke the spell, and goes out into the World he sees things that he never could see in his Father's Chimney Corner."[106]

Copley did not answer Chardon for months, an unusually long lag time for him. Perhaps the letter had given him pause—so many vivid scenes to imagine, to fret over, ultimately to reject. He said he enjoyed imagining his friend so comfortably ensconced, "in a fair way of making Your fortune . . . and as our friend Shakespear says, that which seasons all unfisickd helth." (Here is Copley, nearing age thirty, who—as if he had attended Harvard along with Chardon—delights to read and longs to quote "our friend Shakespear," but cannot spell the bard's name, and muffs the attribution in any case: the line to which he alludes comes from the Puritan poet James Howell.) If this was "the happy effect of leaving ones native Country," Copley wrote, "is it not strange any one should ever submit to the shackels which deprive him of such great Blessing[s].

especily when a little resolution would break em off"? Copley would continue to submit to his shackles. "You know my Bondage (if you seriously consider) is of a much more binding nature than the tie of Country," he said, alluding to his nation of two: his fragile mother and Harry, still as tender in years as he appeared in *Boy with a Squirrel*.[107]

Copley promised he would slip his yoke in due course. "Believe me, Dear Peter," he wrote, "when I can get disingaged from this frosen region, I shall take my flight to Europe, where tho I shall not find the warmth You injoy in Barbados, I shall still feel a much enlivening one. I shall there be heated with the sight of the enchanting Works of a Raphael, a Rubens, Corregio and a Veronese."[108]

He would meet those sainted names from storybooks, whose genius he knew from black-and-white prints, in full color, face to painted face. He would sail. When he heard more from London. When he had put away more money. When his "shackles" were loosed. When he could get "disingaged." Just not yet.

⸺ Chapter Four ⸺

A SON OF BRITISH LIBERTY

*H*OW HARD IT WOULD have been, the waiting, the silence, through winter and spring and summer and into autumn again. Knowing the exhibition had gone up, and come down, so far away. Knowing that his work, his best work, had been seen by thousands, who had paid for the privilege, and by the very few who mattered—by Joshua Reynolds, by Benjamin West, by the *king*, for heaven's sake—and still hearing nothing. All the while, catering to the particular vanities of particular sitters in Boston, as the town recovered from the tumult of the previous year. Perfecting the vocabulary that telegraphed the ripeness of brides and the rigor of matrons, the probity of merchants and the piety of ministers. Fussing over buttons and bows, wigs and moles. Attending to the occasional child, who fidgeted with the occasional pet. Scanning the horizon for the ship that would bring news from the world of Art.

By the time he wrote to Peter Chardon in September 1766, almost exactly a year after he put the picture on the boat, Copley had heard the first faint echoes from London. The early signals were good. His picture "was much approved, and such handsom things said of it that my Modesty would not permit me to repeat one of them but to You, who I have a better oppinion off, than to think it would be made any use of to my disadvantage," he told his friend. (Self-promotion, like unvarnished ambition, was impolite by the standards of the age.) The news trickled into Boston at second or third hand, eyewitness reports confided in letters copied and forwarded to Copley by friends. He could barely contain his

excitement. The "incouragement . . . adds new Vigeour to the pencil," he told Chardon. "I have som foundation to build upon, some more sure prospect of attaining what has cost me so many hours of severe study." Not a promise but at least a prospect, a distant view: an omen that his diligence and severity and even his monastic loneliness might yet pay off.[1]

Written in London in early August, the accounts that mattered arrived in Boston in October. "Dont imagine I have forgot or neglected your Interest by my long Silence," Captain Bruce said. He had waited on an evaluation from West, long promised and long delayed by the painter's "extreme Application to his Art." But West had at last come through; his letter was enclosed. To West's "more conclusive" verdict Bruce added his own less expert view, gleaned from "the general Opinions which were pronounced on your Picture when it was exhibited. It was universally allowed to be the best Picture of its kind that appeared on that occasion." Bruce conveyed "the sentiments of Mr. Reynolds," whose response he knew would "weigh more . . . than those of other Criticks." He put his recollection of Reynolds's words in quotation marks, as if to give it the veracity of court testimony, or the immediacy of dialogue in a novel:

> He says of it, "that in any Collection of Painting it will pass for an excellent Picture, but considering the Dissadvantages" I told him "you had laboured under, that it was a very wonderfull Performance." "That it exceeded any Portrait that Mr. West ever drew." "That he did not know one Painter at home, who had all the Advantages that Europe could give them, that could equal it."

Here are roses and thorns: Copley's work is very wonderful—for outsider art, produced under those nameless disadvantages that Bruce, who knew Boston, had conjured. And there was more in this vein. Reynolds said—still in Bruce's quotation marks—

> "that if you were capable of producing such a Piece by the mere Efforts of your Genius, with the advantages of the Example and Instruction which

you could have in Europe, You would be a valuable Acquisition to the Art, and one of the first Painters in the World, provided you could receive these Aids before it was too late in Life, and before your Manner and Taste were corrupted or fixed by working in your little way in Boston."

Bruce added a metropolitan urgency to Chardon's siren song from the tropics. Copley needed to slip the yoke of Boston and to do it soon, before he was stuck, "fixed" in his "little way." He had already missed a chance to sail as a young man, still impressionable, like wet plaster awaiting pigment to become fresco, as West had done. How long until the mortar set, and it was harder to change the picture?

"Dont imagine I flatter You," Captain Bruce wrote, after laying out Reynolds's complex response. "I only repeat Mr. Reynolds's words, which are confirmed by the publick Voice. He, indeed, is a mere Enthusiast when he speaks of You." (This was indeed flattery, softening the blow to come.) "At the same time he has found Faults." For those, paraphrase would suffice: "He observed a little Hardness in the Drawing, Coldness in the Shades, An over minuteness, all which example would correct. 'But still,' he added"—back to praise, back to quotations—"*it is a wonderful Picture* to be sent by a Young Man who was never out of New England, and had only some bad Copies to study.'" West would have more to add, Bruce promised. "Mr. Reynolds would have also wrote to You himself," he said, "but his time is too valuable."[2]

Some hardness, then, in the painting, and in the reported reaction. But on balance, this was heady stuff, especially when coupled with Bruce's revelation that the canvas remained even then at Reynolds's house in the West End, nestled among the grand manner portraits and a peerless collection of old masters.

An elegant, affable gentleman some fifteen years older than Copley, Reynolds collected people as well as paintings. He belonged to at least seven dining and drinking societies: a club for every night of the week. Among his intimates he counted singers and scientists, countesses and courtesans, and most everything in between. Literary celebrities includ-

ing Laurence Sterne, Samuel Johnson, Fanny and Charles Burney, Oliver Goldsmith, and Hester Thrale; scholars such as the naturalist Joseph Banks, the historian Elizabeth Montagu, and the philosopher turned politician Edmund Burke; David Garrick, the leading light of the London stage: the cream of the polite world—and a smattering of the fashionably louche—passed through Reynolds's octagonal studio, the heart of his mansion at 47 Leicester Square. He dressed his servants in silver-laced livery and rode through London's filthy streets in a chariot with gilded wheels. Reynolds pinned over a hundred sitters a year, four or five times the number who sat to Copley. He charged much more as well: £70 for a half-length, against Copley's £11. While Copley's neighbors were hanging Lord Bute and George Grenville in effigy, Reynolds was serving them sherry and taking their likenesses. When Grenville's ministry fell, with the Stamp Act, Reynolds painted his successor, Lord Rockingham.[3] And somewhere in that house, the soft brown eyes of Copley's *Boy with a Flying Squirrel* watched over the ministers and the military heroes, the duchesses and the dilettanti. Bruce assumed that Copley would follow the painting to London, perhaps as early as the spring exhibition. The captain declared himself proud to have done his part "to make your Merit so far known to the World, and hope it has laid the Foundation of your being the great Man Mr. Reynolds prognosticates."[4]

Copley must have pored over Bruce's letter many times in the months and years ahead. But it is hard to picture him reading it all the way through before tearing open the enclosed note from West, which was addressed after the fashion of the Spring Gardens exhibition catalog, where the Boston painter's name, garbled by time and tide, had appeared as Mr. William Copely.[5] Where Bruce reported gossip, West offered something deeper: a sustained critique of a sort entirely unavailable in the colonies, an arts academy by post. "The great Honour the Picture has gaind you heer . . . I dare say must have been made known to You Long before this Time," West wrote. Instead of repeating the chorus of accolades, he would digest the comments "made by those of the Profession," from his own seat, "in the Midst of the Painting world."

West told Copley how the work had become known, or *mis*known, to Reynolds, at whose home it arrived without "the Perticulers" describing whence it came. Reynolds had initially guessed the canvas was the work of Joseph Wright, a painter from Derbyshire who had likewise "just made his appearance in the art in a sirprising Degree of Merritt." The mistake was a telling one: the canvas read as the work of a "young man," just breaking in from the provinces. The surprise cannot have lessened when Captain Bruce arrived with the explanation that this was "the Proformanc of a Young American."

With little in the way of prefatory puff, West delved into "the Criticizems" voiced at the exhibition. The picture was widely thought too "liney": having "too much neetness"—too sharp a seam—where one color met another. He warned Copley against "endevouring at great Correctness in ones out line," a kind of overpreparation that tended to "Produce a Poverty in the look of ones work." The hardness Reynolds had noted West diagnosed as an artifact of diligence—of "great Desition," as he put it. It was as if the viewer could still see the laboriousness of Copley's practice: could see his charcoal tracing an outline on the primed canvas, hesitant and careful, always careful. The resulting effect was "apt to be to[o] fine and edgey," West said. Truly "great Painter[s] . . . strictly a voyded" such apparent effortfulness. They effaced their outlines and blended their colors until the transitions appeared "with the greatest Bewty and freedom." His prescription echoed Bruce's: "nothing is wanting to Perfect you now but a Sight of what has been done by the great Masters."[6]

Copley answered West's letter immediately, determined not to let "this first oppertunity slip. . . . It seems almost needless to say how great my desire is to enter into a corraspondence with You," he wrote, "as it is very obvious that the pleasure and advantages would be very great on my side." He appears almost breathlessly eager to embrace West's offer of confraternity, as "an artist ingaged in the same studys with myself," and whom he "esteem[ed] as my Country man, from whom America receives the Same Luster that Italy does from her Titiano and Divine Raphael."[7]

To imagine a British American from a distinct province several

hundred miles away as a "countryman" was itself a new way of seeing, a dawning horizon of fellow feeling prompted by the still recent Seven Years' War and by the provinces' shared response to an ever more costly peace. Shortly after Copley dispatched *Boy with a Flying Squirrel* to London, small groups of provincials all along the North American seaboard began calling themselves Sons of Liberty, a name evoking the freedoms prized by subjects around the empire, freedoms they understood to be uniquely British. The North American provinces, they believed, embodied British liberty in its purest form, uncorrupted by court politics and place seeking. Beginning in early 1766, Sons in several port cities began to work in concert, or at least in parallel, knitting local coteries into something resembling chapters of a larger federation. In later years, Copley would have a loose association with the Boston group, which grew out of the town's first, more orderly Stamp Act protests.

When Boston's Sons gathered on the first anniversary of what the *Gazette* called "the glorious 14th of August 1765," at the elm that had come to be known as "the sacred Tree of Liberty," their toasts were fiercely loyal: *"King GEORGE the Third, may his Reign be long and prosperous"! "May the Union between Great-Britain and the Colonies never be dissolved"!* But they also drank to a new spirit of intercolonial cooperation: *"May the British Colonies ever be united in the Principles of civil Liberty"! "May our Brethren of Great-Britain; ever be averse to lay Restraints upon the constitutional Liberties of American Fellow-Subjects"!*[8] The trouble with Parliament, and the resulting rise of this newly imagined "America," helped to catalyze Copley's and West's sense of each other as countrymen. London—the "American school"—played a part in their bond as well; their sense of shared identity routed through the metropolis.

On the ground, Pennsylvania and Massachusetts remained distant. "I was allmost tempted the last year to take a tour to Philadelphia, and that chiefly to see some of Your Pictures, which I am informd are there," Copley told West.[9] Almost tempted, but not quite tempted enough. As if the journey involved as great an effort as sailing Home, which in some ways it did; the seas were highways and the roads not much more than footpaths.

Even years later, when an American continental congress began meeting in 1774, more of its delegates had been to London than to Philadelphia, which by then had eclipsed first Boston and then New York to become the largest town in British America.[10]

The America of Copley and West's burgeoning correspondence was a relatively recent invention, and also a straw man, not unlike the effigies that hung from the Liberty Tree. "In this Country as You rightly observe there is no examples of Art, except what is to [be] met with in a few prints indiferently exicuted, from which it is not possable to learn much," Copley wrote. The lack of examples left him "at a great loss to gess the stile that You, Mr. Renolds, and the other Artists pracktice." Copley's America had no "taste of painting." Indeed, "was it not for preserving the resembla[n]ce of perticular persons, painting would not be known in the plac[e]. The people generally regard it no more than any other usefull trade, as they sometimes term it, like that of a Carpenter tailor or shew maker, not as one of the most noble Arts in the World. Which is not a little Mortifiing to me," he said.[11]

Though West, the American Raphael, wrapped himself in rusticism when it suited him, he understood Copley's chagrin. "I am from America, and know the little Opertunities is to be had their in they way of Painting," he said. Only in Europe would Copley "have an oppertunity of Contemplateing the great Productions of art, and feel[ing] from them what words Cannot Express. For this is a Scorce [source] the want of which (I am senseble of) Cannot be had in Ameri[c]a." Their shared *America* was a backwater, where painters were mere cobblers: a country so visually impoverished that Copley didn't know what he couldn't see.[12] "While the Arts are so disregarded," Copley answered, "I can hope for nothing, eith[e]r to incourage or assist me in my studies but what I receive from a thousand Leagues Distance."[13] He began, in 1766, to live for that long-distance feedback.

In order to advance Copley's reputation in the capital, and to put the connoisseurs' responses to *Boy with a Flying Squirrel* into practice, West advised him to submit a picture for the 1767 exhibition. He suggested a

half-length featuring two figures, "a Boy and Girle, or any other subject you may fancy."[14]

This was all very well and good for West to recommend at the beginning of August, when the exhibition remained some eight months in the future, and from Leicester Square, where models abounded, and where the distance between the painting room and the Spring Gardens gallery, in Charing Cross, was a scant mile. But by the time West's invitation reached Boston it was mid-October. West's "countryman" would rise to the challenge, of course. But Copley's Art had to respond to the dictates of trade: to weather and boats and bills to pay. As he explained to West, "I fear it will not be in my power to comply with Your design, the time being two short for the exicution of two figures, not having it in my power to spend all my time on it, and the Days short and weither cold, and I must ship it by the middle of Feby. at farthest, otherwise it will come too late."[15]

Through the last days of 1766 and into the first of the new year, Copley raced to finish his second exhibition performance, striving with every brushstroke to improve upon his success the year before. Though he initially promised "another small Picture for the exhibition," he ended up working at an expanded scale, as West had counseled: a half-length rather than the more intimate bust size used for *Boy with a Flying Squirrel*.[16] The London eye imposed different constraints than the Boston eye. Perhaps Captain Bruce had described the demands of the exhibition hall, where pictures hung from floor to ceiling, so close to each other that their frames nearly touched. In such a crowd, a larger painting stood a better chance.

Copley decided to follow his *Boy* with a young girl. Procuring a model on short notice for uncertain ends was difficult, nearly doomed. A sitting took a long time, at the end of which the parent of any young subject painted in such a manner and for such purposes would have seen the likeness of their precious child crated for London, there to be peered at, even leered at, by connoisseurs, then quite possibly to be sold, even reproduced. (The next year, Copley sent West a pastel of a young lady who he thought might be recognized by some exhibition-goers, who "may be desireous

to have a coppy of it." This he begged West to forbid, "as I am under the strongest obligations both to her Parents and herself having given my word and honour that no Coppy shall be taken of it.")[17] After all the sizing up, it would have been far from certain that such a picture would return to Boston. No wonder "subjects [were] not so easily procured in this place," as Copley said.[18]

The likeliest candidates to tolerate such an enterprise were family members, and it was in this role that young Harry Pelham had served so gamely the year before. But there was no young girl in the Copley-Pelham family in 1766.[19] So the painter appears to have turned to a friend, John Powell, a Boston merchant with frequent business in London. Copley had painted Powell's mother, Anna, in 1764, and some time shortly thereafter had also taken pastel portraits of Powell and his wife, Jane.[20] Powell sometimes bought supplies on Copley's account; he was also one of the cluster of sea captains and merchants who had worked to introduce the work of the Boston painter to "some of your Bror Artists" in the metropolis in 1765. The following fall, Powell carried West's letters across the Atlantic to Copley. And when one of those letters called for Copley to paint another exhibition picture, Powell likely lent his six-year-old daughter, Susanna, to the cause.[21]

The picture that the Society of Artists cataloged as *Portrait of a young lady, with a bird and a dog* is as full of life as it sounds. Its central figure appears in folded full-length, kneeling on a bolster of navy silk. Despite the differences in scale and pose, the girl is in many respects in dialogue with the previous year's *Boy with a Flying Squirrel*. In place of the striking full profile Copley used for Harry Pelham, he here chooses a partial profile, casting half the girl's face in shadow. In place of a squirrel on a chain, he offers a parrot perched upon a blue satin ribbon, which is tied to an armchair upholstered in mustard-colored silk. The girl with the bird, like the boy with the squirrel, does not return the gaze of the viewer. But where Harry Pelham's sidelong stare evokes contemplation, Copley's girl appears inattentive. He thinks; she smirks. While her gaze wanders, her dog is riveted by the bird.

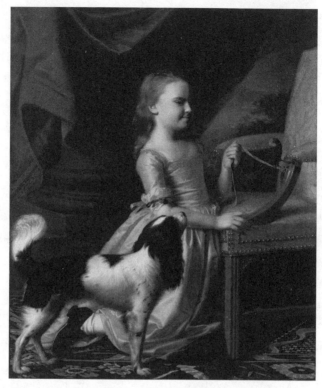

Copley, YOUNG LADY WITH A BIRD AND DOG, *1767*

Both parrots and lapdogs were familiar status symbols, and paint-ers often used trained birds to signify the polite accomplishments of those rarae aves, educated women. But parrots also sang of the tropics: of India, and of the Spanish and Portuguese new world, especially Brazil. The breed of dog, then as now, was known as a King Charles spaniel, favorites of Charles II, Restoration decadent and royalist extraordinaire. The dog's design upon the tropical bird might be read as an allegory of empires.[22]

Behind the dog and the bird and the girl and the chair, the frame grows still more crowded, as if Copley kept adding elements to overawe the critics. We see the base of a column of the massive Doric order, typ-ically used to convey forthrightness in masculine spaces like banks and government buildings. Draped in fringed vermillion, the column seems to have wandered into the nursery from a state portrait. An intricate tur-

key work carpet brings the red of the curtain, the yellow of the chair, and the blue of the kneeling cushion into dialogue, making them fight all the harder against the pulsing pink of the girl's dress.

Copley also experiments with a variety of focal lengths, perhaps in an attempt to avoid the "liney" quality that West and Reynolds had taken as an embodiment of Boston's "little way." The surfaces meant to appear at the front of the picture plane—the dog's ruff, the sole of the girl's shoe, the gleaming mahogany of the armchair and the brass studs of its uphol-stery: these he showcases with his customary tight brushwork, in almost photorealistic detail. But as the depth of field increases, harder lines give way to softer, more mottled surfaces.

Sometime in February 1767, Copley crated his *Young Lady* and secured her a berth on a ship cursed with making the winter crossing, this time directing the precious cargo to West. (Whether Captain Bruce would be in London to receive it was "altogether uncertain," Copley explained, "and I have no friend else that I am certain would give them-selves the trouble of sending it to the exibition.") The "Picture arrived just in time," West later reported. He hied it to Charing Cross for the 22 April opening.[23]

Copley's second transatlantic performance marked another bold bid for metropolitan favor. But while Copley languished in Boston, awaiting reviews, other aspiring provincial artists proved bolder still. West's ate-lier filled with ambitious Americans, none so gifted or so accomplished as Copley, but all more venturesome than he was. Shortly before Cop-ley's *Young Lady* reached West's studio, Philadelphia's Charles Willson Peale—three years younger than Copley and light-years behind him in skill and reputation, got there in the flesh. In March, Peale reported that he was hard at work at his "Studies with Mr. West who gives me Encouragement to persue my Plan of Paintg. and Promises me all the Instruction he is capable of giving." He met Reynolds and other artistic luminaries, purchased art supplies, and began to learn the techniques of composition and coloring not from prints and books and long-delayed letters, but at the master's elbow. Peale had nothing to hang in the spring

exhibition. But when the cognoscenti gathered at Spring Gardens, he was there, in new silk stockings.[24]

⁓

Copley scarcely exaggerated when said that he could ill afford to devote all his time to a second exhibition piece. His craft might be regarded as no more elevated than that of a leather-aproned shoemaker, but business, nonetheless, was booming.

Boston had begun to emerge from its postwar doldrums. In 1765, the Charlestown merchant Joseph Barrell, who sold a combination of English and West Indies goods at his shop on King Street, was bankrupt, determined to flee "this Dying town" to become a country shopkeeper.[25] By 1766 or 1767, he had recovered his fortunes sufficiently to make his way to Copley's studio, where he commissioned portraits of himself and his wife, Anna Pierce.[26] Copley rendered the pair in pastel, still novel in

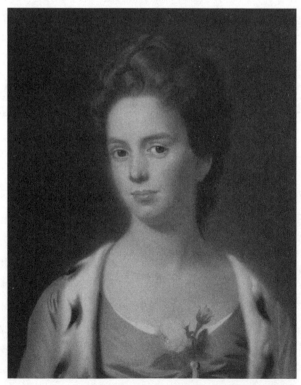

Copley, MRS. JOSEPH BARRELL *(Hannah Fitch), ca. 1771*

the colonies, though, as he had recently learned, considered a lesser art form in London. (Reynolds "condemns your working either in Crayons or Water Colours," Captain Bruce told him. "Oil Painting has the superiority over all other Painting," West insisted. Copley had urged West to "be more explicit on the article of Crayons, and why You dis[ap]prove the use of them, for I think my best portraits done in that way.")[27]

In Boston, it scarcely mattered that West and Reynolds frowned on crayons. The Barrells wanted family portraits, not exhibition pieces. When Joseph Barrell remarried several years later, he would commission Copley to portray his second wife, the former Hannah Fitch, in the same medium. Her likeness, peachy and lush, ranks among Copley's loveliest. Softly blended by the nature of their making, pastels could scarce appear "hard" or "liney."

Copley depicted Joseph Barrell without a wig, his natural hair, like his gaze, embodying the square-dealing directness requisite to the suc-

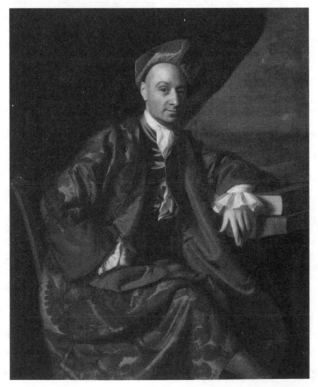

Copley, NICHOLAS BOYLSTON, *ca. 1769*

cessful man of commerce. He wears a blue silk robe known as a banyan. Figured with a floral pattern that echoes Chinese porcelain, Barrell's banyan speaks of cosmopolitan connections and global ambitions. (Much later, when America's commerce looked still farther east, Barrell would become one of the continent's first China traders.) Numerous other merchants chose to be portrayed in similar attire, including Nicholas Boylston, whom Copley first painted in 1767. The merchant's shaved head, peeking from beneath a silk cap, denotes the same carefully cultivated informality as his robe.

That men like Barrell and Boylston were back on top, and seeking out Copley, was a political as well as an economic story. In the realm of imperial affairs, too, the turnaround had come quickly. In March 1766, Governor Bernard supposed that he couldn't hold out much longer against the Stamp Act's opponents. "I did not apprehend that mine was so much of a military post, as to require my maintaining it 'till I was knocked on the head," he told his paymasters in London. But soon a swirl of gossip held that the Stamp Act had been repealed. "Thinking Men know not which will bring most danger, a Repeal or a Confirmation," Bernard wrote. The "Latter they say will make the People mad with desperation; the former insolent with Success."[28]

Insolent with success it would be. In late April came certain news that Parliament had repealed the Stamp Act. Boston city fathers proclaimed a day of general rejoicing. In addition to the usual bells and cannon blasts, the governor issued a general pardon to all debtors held in the jail on Queen Street. The king's colors flew from ships in the harbor and from "many of the Houses in Town." And there were portraits, painted heroes, everywhere. Paul Revere, a silversmith from the North End of town who often supplied frames for Copley's miniatures, designed a wooden obelisk that was built upon the Common, capped with likenesses of King George and Queen Charlotte, along with the faces of "fourteen of the worthy Patriots who have distinguished themselves by their Love of Liberty." Houses near the Liberty Tree were festooned with gauzy banners painted with "Figures as large as the Life, the Colours all in a glow with

the Lights behind them." The transparencies depicted the British pro-
tagonists of the repeal campaign, including the "immortal PITT," and of
course also those greatest protectors of British Liberty, "our most gra-
cious King and Queen." Copley may have painted some of these; there
were not so many artists in the town to carry off the display without his
hand. Perhaps indeed these stage scrims gave him his first taste of royal
portraiture.

The celebrations of repeal were as peaceable as the previous summer's
protests had been violent. "To the Honor of the Sons of Liberty we can
with Pleasure inform the World, that every thing was conducted with
the utmost Decency and good Order," the *News-Letter* declared. "All was
Loyalty to the King, Blessings on the Parliament of Great Britain, Hon-
our and Gratitude to the Present Ministry, and Love and Affection to the
Mother-Country."[29] Some thought the hoopla masked a dark undercur-
rent. Peter Oliver, brother of Boston's defrocked stamp collector and, like
Andrew Oliver, a Copley sitter, worried that "the general Joy . . . was not
the Joy of Gratitude, but the Exultation of Triumph": the gloating of an
"America" that had "felt her own Superiority," and might well be moved
to feel it again.[30]

The conflagration at Harvard proved to be another, more perverse
blessing for Copley. Immediately after the fire, the General Court
decided that Old Harvard Hall, a rambling gabled affair with a distinctly
Elizabethan look, must be rebuilt at the expense of the province.[31] Its
replacement, completed in June 1766, soon after the celebration of the
Stamp Act's repeal, was an altogether grander pile, airy and symmetrical,
befitting the aesthetics of a different century. In a letter to the Board of
Trade, Governor Bernard called it "a Magnificent Building," neglecting
to mention that he had designed it himself.[32] The main floor of the rebuilt
hall featured a grand gallery space measuring 36 × 45 feet, a single room
larger than most houses of the day. Its east face was left windowless spe-
cifically for the purpose of displaying art.

Copley would fill that blank wall with three of the most important
commissions of his career. The first was a likeness of Thomas Hollis,

great patron of the now lost library, whose portrait had burned with the old hall. The painter worked from a copy sent to Cambridge by Hollis's great-nephew, aided by an engraving Peter Pelham had made back in 1751, depicting a person almost nobody alive in New England had ever met. To see the fatal awkwardness of Copley's *Hollis* is to realize how much of the feeling of life in his work emerged from the delights and discomforts of the studio session.[33] *Hollis* was to be paired with another full-length, of Thomas Hancock, who had left the college money to endow a professorship in Hebrew. Perhaps because Copley had known that man, Hancock's likeness seems to have come more easily. But the translation from the miniature Copley had painted of him in the 1750s to the gigantic canvas scaled for public display proved fraught. Infrared photography shows that Copley second-guessed every element of the picture but the face, its most successful passage.[34] The prime spot over the mantel, between the two benefactors, was reserved for another large-scale Copley, a three-quarter-length of Governor Francis Bernard, which has long been lost. Bernard would have been only too happy to sit for as long as the picture took. Perhaps his portrait was an artistic triumph, which would only have served to point out Copley's failure with its neighbors.

By early 1767, *Hollis*, *Hancock*, and *Bernard* were installed in purpose-built cabinetry, in a high-ceilinged room as magnificent as any in Britain's colonies. The two full-lengths hung in matching ornately carved frames, each capped with its subject's coat of arms.[35] The new Harvard Hall offered a museum-style display of American achievement in the fine arts: a Copley gallery.

Given the visibility of the college commissions, it is telling that the painter executed at least two of them so poorly. There were many reasons for his stumbles. Better times meant more work; Copley's docket was crowded. He had no one to help him. In London, masters of the stature he had attained could focus on faces and hands, employing jobbers called drapery painters to do the clothing and backgrounds—to hold the hems of their sitters' garments, so to speak. Not in Boston, as Copley explained

to West: "Having no assistance I am obliged to do all parts of my Pictures with my own hand."[36] In addition to dividing his attention over many projects, Copley found himself pulled in competing directions: between calling and trade, London and Boston.

The political rifts of 1765 had not entirely healed, but their jagged edges had softened. The Braintree lawyer John Adams, a proud Son of Liberty, noted in his diary "that this Province is at present, in a State of Peace, order and Tranquility: that the People are as quiet and submissive to Government, as any People under the sun—as little inclined to Tumults, Riots, Seditions, as they were ever known to be." The Stamp Act's repeal, he said, "has hushed into silence almost every popular Clamour, and composed every Wave of Popular Disorder into a smooth and peaceful Calm."[37]

Amidst that smooth and peaceful calm, Copley rendered the likenesses of patriots like John Hancock, who commissioned a portrait of himself when his uncle Thomas's death made him rich, and the preacher Jonathan Mayhew, whose August 1765 sermon on liberty had been seen as a spur to the worst of the rioting. He painted supporters of Parliament's authority, among them Newport's would-be stamp man Martin Howard, who had suffered at least as badly as Hutchinson, and who then had fled, in fear of his life. Howard licked his wounds in London until he received another imperial post: a judgeship in North Carolina. Copley portrayed him in the red robes of his new office, most likely when he passed through Boston to take a bride.[38]

On occasion, Sons of Liberty and friends of government socialized together, much as they appeared to do, on canvas, along the walls of Copley's painting room. In December 1766, leaders of the Stamp Act protests gathered at the British Coffee House on King Street with some of those whose houses and livelihoods they had attacked the year before. According to the custom of such occasions, they ate much and drank more. They toasted the king, queen, and Parliament, Britain's army and its navy, the chancellor of the exchequer and the lords of trade. To the "United &

Inseparable Interest of Great Britain & her Colonies," all raised their glasses, the words growing slurred as bumper after bumper drained in the service of peace, union, and prosperity.[39]

⟿

The fragile parliamentary majority supporting repeal of the Stamp Act had been procured by the passage of another bill, a rider of sorts, officially titled "An Act for the Better Securing the Dependency of His Majesty's Dominions in America," and more familiarly known as the Declaratory Act. Its text appeared in the Boston newspapers in May 1766, in two compact paragraphs. The nub of the law was this: first, that the American provinces "have been, are, and of Right ought to be, subordinate unto, and dependent upon the Imperial Crown and Parliament of Great Britain"; second, that the King-in-Parliament had "full Power and Authority to make Laws and Statutes of sufficient Force and Validity to bind the Colonies and People of America, Subjects of the Crown of Great Britain, in all Cases whatsoever"; and finally, that any colonial resolutions to the contrary were perforce "utterly null and void to all Intents and Purposes whatsoever."[40]

Amidst the joyous noise surrounding the Stamp Act's repeal, this brief, rousing affirmation of Parliament's authority landed like a feather. About the first clause almost none disagreed. "That the Mother Country has a *power* of imposing what burdens she thinks proper, on any part of her dominions, is a position so evident, that it cannot possibly admit of a debate," wrote the Boston clergyman Samuel Cooper, a strong supporter of the colonial opposition whose congregation included John Hancock, Samuel Adams, and other liberty men.[41] Some leaders of the Stamp Act resistance pondered the meaning of that tantalizing phrase at the end of the second clause, "in all cases whatsoever." "I am solicitous to know whether they will lay a Tax, in Consequence of that Resolution, or what Kind of Law they will make," John Adams jotted in his diary.[42] Taxation, of course, was the rub, the hard case among "all cases whatsoever" that tested many colonists' ideas about the limits of parliamentary power. "By

the fundamental laws of the British constitution, it is absolutely declared, that no Englishman is to be taxed without his own consent," Cooper wrote, expressing what the great majority of Britons on both sides of the Atlantic understood as common sense. Because the colonists had no elected representatives in Parliament they had not—could not—bestow that consent, except through the acts of their own legislatures. This, Cooper argued, was the principle that had doomed the Stamp Act. He worried that "the Mother Country" had failed to learn that lesson. Cooper's pamphlet, published in late 1766, was called *The Crisis*, and he insisted that the crisis had not yet passed.[43] But with the stamp duties removed, few were as curious as Adams or as furious as Cooper about what might come next.

Working under the direction of yet another new ministry, and spurred on by the chancellor of the exchequer, Charles Townshend, Parliament soon answered Adams's question, and justified Cooper's fears. Passed in June 1767, the trio of revenue laws that came to be known as the Townshend Acts lacked the deftness and concision of the enabling Declaratory Act. Colonists would begin, come November, to pay duties on a series of goods, including glass, tea, paper, boards, and "painters colours": the powdered pigments on which portraitists and housewrights alike relied. Since the duties were to be collected at the point of importation, these were considered "external" taxes, and thus thought less likely to arouse provincial ire than the "internal" stamp duties, so vigorously opposed and hastily withdrawn. But the list of articles covered by the new acts was long. Parliament enumerated sixty-four varieties of paper alone. The collection of these revenues would be overseen by a new Board of Customs Commissioners, royal placemen to be headquartered in Boston, the angriest head of the colonial hydra. The commissioners would be paid from the revenues they collected under the new act, an arrangement that gave them every incentive to venality, while insulating them against any action by provincial legislatures to withhold their salaries, the age-old check of representative authority against executive tyranny.[44]

News of the Townshend Acts dribbled into Boston. On 10 August, the *Evening Post* reprinted an article from New York, which in turn

copied a squib from an Edinburgh newspaper, noting "a plan said to be under consideration for Taxing America." A British sea captain added details when he anchored at Casco Bay: "That the Board of Commissioners of the Customs was actually established," that new duties upon "Glass, Lead, Colours, Paper, &c. were not yet fix'd," and that "nothing would be attempted by way of Internal Taxation of the Colonies."[45] These initial reports were greeted with sufficient equanimity that the second annual celebration of the Stamp Act protests four days later was sparsely attended. Though the organizers took "great pains . . . to procure a respectable Company," Governor Bernard reported, "the Meeting was Very thin & insignificant; so much so, that I am told it will be an easy Matter to obtain a complete list of ev'ry person there," in case the Board of Trade might like him to name names, as he was plainly bursting to do.[46] In addition to drinking the health of the royal family, the clutch of men assembled under the Liberty Tree pledged that "the Man who will not defend the Cause of his Country, in Case of Danger" should "be held in universal Contempt by every Son of Virtue and Liberty." The final toast was the hottest: "May that Day which sees America submit to Slavery, be the last of her Existence."[47] These were fighting words. But not many were there to hear them.

While Parliament debated Townshend's proposals in Westminster, Benjamin West and Captain Bruce wrote their reports of Copley's performance at the annual spring show of the Society of Artists. "I have been assiduous to collect the Connoiseur's Opinions of your last Exhibition," Bruce wrote in mid-June, once again enclosing a detailed critique from West. Copley would have received their accounts in August, from the very same packet boats that carried news of the new taxes.[48]

Copley must have known that the news was bad when he read Bruce's warning: "I must give you one Caution, which is, that if any of the Critical Reviews, Examinations, etc., of the Exhibition (which have been published here) should fall into your Hands, pay no manner of Regard to what they say, as they are most execrable Performances and universally condemned."[49] This ominous disclaimer would have sent Copley scur-

rying to the London Book Shop on King Street, where the pamphlet entitled *A Critical Examination of the Pictures . . . Exhibited at the Great Room, in Spring-Gardens, Charing-Cross, Intended for the Use of Those Who Would Understand What They See* might well have been among the titles recently imported from England. Turning breathlessly to find mention of his picture on the seventh page, Copley would have seen a devastating four-word evaluation: "This picture is horrible."[50]

The verdict Bruce rendered on Copley's *Young Lady with a Bird and Dog* was more nuanced. But however valiantly the captain strived to soften the blow, there was no denying that the picture's reception had been mixed at best. "The general opinion was that the Drawing and Execution exceeded the last, and some went so far as to say it was the best Portrait in the Room in point of Execution," Bruce wrote, "but you have been universally condemned in the choice of your Subject." The picture's homely sitter was deemed "so disagreable a Character, as to have made the Picture disliked by every one but the best Judges who could discern the Excellence of the Painting." Why had Copley chosen her? Bruce blamed the model's father. "I'm astonished that you should have suffered Mr. Powel's vanity to lead you into such an error," he wrote. "The Nobility in gen'l have condemned" the painting "for this excellent Reason, that 'it is an ugly Thing,'" Bruce said, with brutal frankness. "Let me therefore intreat You to ransack the whole Town and Country for a pleasing Subject for your next Exhibition."[51]

Bruce could not conceal the fact that the cognoscenti had impugned the striving painter as well as his unfortunate subject. Reynolds "approved of the Painting," the captain reported, but "dislikes your Shades; he says they want Life and Transparency. He says 'your Drawing is wonderfully correct, but that a something is wanting in your Colouring.'"[52] West elaborated: the composition suffered from "Each Part of the Picture being Equell in Strenght of Coulering and finishing, Each Making to[o] much a Picture of its silf, without that Due Subordanation to the Principle Parts, viz they head and hands." Details vied with substance: "the dog and Carpet to[o] Conspichious for Excesry things," the girl's "Modern dress" out

of sync with her classicized surround. Finish, composition, shadow: all these were faults, but West, like Bruce, homed in on palette. He declared the painting's "Coulering very Briliant, tho this Brilantcy is Somewhat missapplyed, as for instance the Gown too bright for the flesh."[53]

Once again the provincial eye had run up against its limits. Given enough talent and effort, outline might be perfected to a very high degree by copying from woodcuts and mezzotints; West, like Reynolds, marveled that Copley's "Picture is in Possession of Drawing to a Correctness that is very Surpriseing."[54] But palette could not be translated from prints, nor did formulas for mixing colors and layering tints announce themselves from the observation of nature. Indeed, Bruce said, it was difficult even to summarize Reynolds's critique on that score. He had begged Sir Joshua "to explain it[,] that I might communicate it to You, but he told me 'that it was impossible to convey what he meant by Words, but that he was sure (by what you have already produced) he could make you instantly feel it by Example, if you was here.'"

The proposed remedy remained the same. "If You have been able to attain this unassisted at Boston, What might you not atchieve in Europe?" Bruce asked. Best not to wait too long. "I am afraid you will delay coming . . . till the Force of your Genius is weakened, and it may be too late for much Improvement."[55] West had been in Italy and London for six years already, half his painting life, while Copley soldiered on in Boston, past his majority, past the age where men typically married, now on the cusp of thirty. And if the response to *Young Lady with a Bird and Dog* was any indication, he was backsliding. "I observe the Critisisms made on my last picture were not the same as those made on the first," he wrote in a sad, petulant fragment of a response to West or Bruce that survives only in draft. By "striving to avoid one error," he had "fallen into another." And now that his London interlocutors had called for him to make a third attempt, it seemed entirely likely that he would stumble onto yet another rock-riddled path.[56]

Copley was a fretful sort, and there was, of a sudden, quite a lot for him to worry about. To understand his agitation in the waning months

of 1767 and throughout the following year is to wrestle with challenges of figure and background, challenges much like those he had tried—and failed—to overcome when he painted *Young Lady with a Bird and Dog.*

There was, first, the difficulty of putting into practice the artistic instruction in his yearly round of correspondence from London. Perfecting Art via letters, the lessons attenuated over months and miles, seemed increasingly impossible. His entrant for the 1768 spring exhibition, a three-quarter-length of the merchant Daniel Rogers, was an ordinary portrait, and a hurried one at that, abandoning a leg to the shadows and hiding a hand as well. Copley wrapped the canvas in regrets. "I think common justice to myself requires some Apologys, that in case it should not answer your expectations it may not be intirely at the expence of my Reputation," he told West. Copley had wanted, naturally, to "rise above the common level of his practice" in what he sent to the Society of Artists, which had voted him a member in September 1766, and notified him of this happy fact in a letter that did not reach Boston until October 1767. (This was the gap—of time, tide, and culture—separating the West End from the Long Wharf.)[57] "Yet such has been my ill Luck," Copley complained, "that this as well as the last Years I have not have the advantages I generally have for my other portraits." Mr. Rogers had been so busy preparing for his own trip to London that he had not "spared time to have sat as I found occation for him."

Copley had hectored the sitter—he found himself "obliged sometimes to beg sometimes to scold"—but even so he "met with so much dificulty" that he barely finished the face before Rogers sailed. He told West to blame Rogers "for all the Defects" he found in the picture. West had a hand in its failure, too; Copley said he had suffered, once again, from "not receiveing the Critisisms of the Artists and publick earlyer." As the months stretched on without a letter, he had decided it was better to "submit to that inconveniance" of painting without instruction "than to the evil of doing it in the depth of Winter."[58] But in the end, he waited too long to avoid the weather yet not long enough to benefit from West's and Reynolds's counsel.

Their advice was always the same: West and Captain Bruce and the great Joshua Reynolds had each made the case for Copley to sail—had made it twice, and would do so again after the exhibitions. Their argument was logical enough: he could not improve further—could not map the outer limits of his talent—without example. He worried, indeed, that he could not, in his current context, serve the mission of the Society of Artists of Great Britain well enough to merit his election. Since he was "sensable the Hounour of the Society depends on the promotion of the Arts," Copley told its secretary, he was forced to "reflect with concern on my present situation, which utterly deprives me of every oppertunity (but what Nature has furnish'd me with) of . . . aiding in this laudible work." He lived in "a Country where their is neither precept, example, nor Models," he explained.[59]

This much was clear: Copley had to sail if he were to see. But after he sailed and saw, what then? "What shall I do at the end of that time (for prudence bids us to Consider the future as well as the present)"? Here is how Copley parsed the dilemma for Captain Bruce: "I must eighther return to America, and Bury all my improvements among people intirely destitute of all just Ideas of the Arts, and without any addition of Reputation to what I have already gaind," as the most sought-after painter in New England; or "sett down in London in a way perhaps less advantagious than what I am in at present," as one among many in a marketplace already crowded with genius, gaining skill but risking the income he had worked so hard to build, from modest beginnings, to a comfortable "three hund'd Guineas a Year." Copley reminded Bruce that he had inherited nothing: "I have not any fortune, and an easy income is a nesasary thing to promote the art. . . . Painters cannot Live on Art only, tho I could hardly Live without it." To gain reputation in London but outstrip the tastes of his Boston market would leave Copley without a country. "I cannot think of purchasing fame at so dear a rate," he wrote.[60]

Captain Bruce had urged him to "raise the price of your pictures . . . immediately."[61] But when Copley did so, at least one patron balked. "As to the price you wrote me it exceeds considerably what was customary

with you when I was in Boston some two years since, and at present is
more than was expected by some Gentlemen here, especially for a copy,"
wrote George Livius, a New Hampshire merchant who contracted with
Copley to replicate a couple family pictures painted a generation earlier,
in Germany. And so a newly elected fellow of the Society of Arts of Great
Britain found himself haggling over the fee for a bit of hackwork. "I need
not observe to you the very few opportunities you have of copying from so
good a picture as one of them is," Livius scolded. As if he were ordering
a suit, or a pair of shoes.[62]

In November 1767, three commissioners appointed to the new Board of
Customs arrived at the Long Wharf, ready to tally the revenues when
the acts took effect late that month. The Indies merchant John Rowe, a
passionate supporter of the opposition in 1765 whose ardor for the rebel
cause would cool in the coming years, called the new "Duties on Glass,
Painter's Colour's &c. An Imposition on America in my Opinion as
Dangerous as the Stamp Act."[63] Governor Bernard agreed. "Never were
people more divided in Opinions Hopes and Fears than those of Boston
now are," he reported to London. "Men of a timid Complexion give up
the Town, and expect greater Disturbances than have been hitherto; and
at the same Time wish for Troops to protect them, and are afraid of their
coming here."[64]

By character and by calling, Copley was just such a man of timid com-
plexion: less a creature of the *Boston Gazette*'s clamorous headlines than
of the steadier rhythms of its back pages, which were crowded with the
everyday business of making a living. Yet the Townshend taxes impinged
upon him, far more directly than the threatened stamps would have done.
The new tarrifs leveled duties on many of the imported materials upon
which art depended, from the fine laid paper used for pastel portraits,
to the powdered red and white lead ubiquitous in oil paintings, and to
the high-quality crown glass that sealed a finished picture. Perhaps this
specific impact is what drew Copley into the boycott movement that rose

in resistance to the taxes. In mid-November, he joined 664 of his fellow townsfolk in a pledge to forswear purchasing a wide variety of English finery, from hats to shoe soles.[65]

The signatories—whose number is greater by half than the number of votes typically cast in Boston's municipal elections of the period—spanned a broad array of Bostonians, from merchants to common laborers. Nearly 10 percent of them were women, several of whom signed with an X. (Peter Oliver found it "highly diverting" that so many "Porters & Washing Women" had promised to forgo "*Silks, Velvets, Clocks, Watches, Coaches & Chariots*.")[66] Some reconsidered their pledge on the spot: three names are carefully crossed out, indicating not only the fickleness of the signers but also the perceived seriousness of the step. Many of the usual patriot suspects—those Bernard called "The Faction"—appear in the lengthy columns of names: Paul Revere was one of the first to sign, and James Otis inked his name firmly on page three. But there are puzzling absences and equally surprising inclusions. John Hancock and Samuel Adams refrained from subscribing to the cause, while Jonathan Clarke, scion of a leading Boston family, close kin to the Hutchinsons and the Olivers, signed on.

Importers of a wide array of Atlantic commodities, from Jamaica sugar to Carolina indigo to Halifax mackerel to the finest East India teas, the Clarkes sold their wares from a shop on lower King Street. They were the sorts who might be counted as *friends of government*, in Bernard's black-and-white schema, which poorly fit Boston's many shades of gray.[67] Copley had portrayed several members of Jonathan Clarke's extended family, including his sister Mary, one of a sextet of accomplished young ladies. Mary Clarke died, tragically young, in 1764, doubtless making the miniature Copley had painted of her all the more precious to her kin, who had lived until 1766 near the painter's house on Cambridge Street. By then, Copley may have already begun to pay court to the next of the Clarke girls, twenty-one-year-old Sukey.[68]

It seems safe to say that Copley sifted and weighed his pledge with care, and likely with some particular sense of what the commitment would mean for a painter whose work required some of the items pro-

scribed on the boycott's long list, and represented many others in brilliant detail. Velvet, silk, gauze, and lace; jewels of diamond and paste; gold and silver buttons, metallic thread and braid: all of these the subscribers forswore, and all of these feature prominently in Copley portraits. Paintings like Copley's 1768 portrait of the Boston merchant John Amory, who poses in a fine silk suit with nearly two dozen gold buttons rendered in such detail that you can count the squares in their basket-weave pattern; or the likeness he painted the same year, of George Watson of Plymouth, depicted with a suite of similar buttons and yards of gold braid upon a plush velvet suit, can almost be read as collections of proscribed objects.

Both men wear brown. This somberness may have represented an artistic effect, or a commentary on the mood of the town, or even a practical response to the taxes on other pigments. As colonists flaunted their local manufactures—tea steeped from herbs or barley, homespun cloth

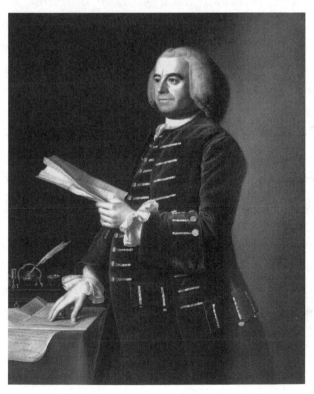

Copley, COLONEL GEORGE WATSON, *1768*

woven from local wool or linen—there was some attention to paints. Parliament's "tax upon painter's colours has set a whole continent to explore their hills and mountains" in search of iron-rich earth, from which Americans made "red and yellow oc[h]re, superior in quality to what was imported from England," one newspaper reported. "Oil is extracted from our flax-seed, not only for our own consumption, but for exports; white lead, so necessary for the painters, which it was imagined could not be obtained, has been made in Boston, equal in goodness to the British."[69] At a moment when both the content and the materials of painting were inevitably politicized, perhaps some Copley patrons wanted to fly the colors of resistance to the Atlantic trade or, conversely, to demonstrate the high cost of its interruption.

Regardless of the palette, 1768 turned out to be a year of few portraits and much tumult. As customs officers clamped down on smuggling, Boston merchants broadened the terms of their boycott, coordinating their efforts with Sons of Liberty in other cities. In February, the provincial legislature dispatched a circular letter to the assemblies of other Anglo-American provinces, seeking a collective response to the Townshend Acts. As the snows melted, ritual edged toward riot on the narrow streets of Boston. In March, a "Genteel Dinner & Entertainment" commemorating the Stamp Act's repeal was followed by the gathering of a "considerable Mob of young fellows & negroes": a crowd made up of the lower sort, some eight hundred strong, according to John Rowe. They massed at the Liberty Tree and surged toward the North End, where the customs commissioners lived. No violence took place, but there was "great Noise & Hallooing." When dawn broke, effigies bearing the officials' initials were discovered hanging from the Liberty Tree, a pointed echo of August 1765.[70] The commissioners called for backup. In May, the frigate *Romney*, a man-of-war with fifty mounted cannon, sailed into Boston Harbor.

Gunboat taxation began in earnest in June, when the commissioners directed the *Romney*'s men to impound the cargo of John Hancock's sloop *Liberty*. The crowds protesting that seizure—the capture of *Liberty* by military tyranny!—comprised not hundreds but thousands. Customs

officials were mobbed and beaten. The governor negotiated an uneasy truce with the town meeting. But by the end of the month Bernard, the People, and their representatives were again at loggerheads, this time over February's circular letter. The governor demanded that the statement be retracted. On 30 June, the members of the provincial assembly voted by an overwhelming majority of 92 to 17 not to rescind it. Bernard dissolved the legislature.[71]

Barely a month after the defiant vote, eighteen lawyers and merchants, including James Otis, John Hancock, and Samuel Adams, gathered at the insurance office of Nathaniel Barber, a Son of Liberty so passionate that he had named his son "Wilkes," after the English radical Whig John Wilkes, a great supporter of the American cause.[72] Barber and his confreres drank their toasts from a vessel newly fashioned by the silversmith Paul Revere: a footed silver bowl emblazoned with the iconography of British liberty, including a Phrygian cap perched upon a liberty pole, and images of the Magna Carta and the 1689 English Bill of Rights. The vessel weighed forty-five ounces—an Andean king's fortune in silver—and held forty-five gills (a gill is a half cup, about the size of a healthy gulp of rum punch): nods to Wilkes's *North Briton* No. 45, the pamphlet that had touched off riots in London back in 1763, when Parliament censored it for libeling the king. Revere engraved "No. 45" and "Wilkes & Liberty" on the bowl's broad surface.[73]

Commissioned by a group of fifteen patrons, the bowl was a major order for the silversmith in an otherwise straitened year, the leanest in a lean decade. The income he recorded in his ledgers in 1768 amounted to only forty pounds, a fraction of what he had made before the war ended.[74] It was, to say the least, an odd moment for Revere to commission a portrait, a luxury that few craftspeople and shopkeepers could afford, or would seek. (Jules Prown estimated that only 12 percent of Copley's American sitters, or fifteen men, plied artisanal trades like Revere's—a number in which Prown includes Copley himself.) And yet Revere sat to Copley that year, and quite possibly that tumultuous summer. *Paul Revere* is one of only five Copley portraits that can be firmly dated to 1768.[75]

Oceans of ink have been lavished on the painting, which has become, in the two and a half centuries since Copley painted it, so iconic that it seems to stand in not only for the artist and the patron but for America itself. Revere appears plainspoken, his gaze direct to the point of challenge. He is plainclothed, too: depicted in his shirtsleeves, his collar open, without wig or ruffles or braid, in a loosely cut woolen waistcoat of bottle green. Just two buttons—possibly of Revere's own manufacture—are visible, to *John Amory*'s twenty-three. Seated behind a worktable, with engravers' tools before him, Revere is at once maker and thinker. Highly finished and elaborately staged, the portrait is a paradox, dazzling in its seeming modesty.[76]

Though *Revere* uses the brown tones that dominate *George Watson*,

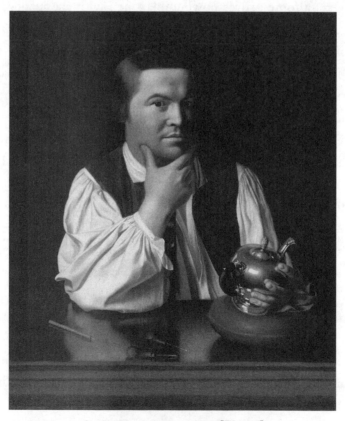

Copley, PAUL REVERE, *1768* [Plate 5]

the silversmith's likeness is otherwise anomalous, even singular: Copley's only portrait of an artisan amidst the trappings of craft work. Among the picture's many mysteries are why (and indeed whether) Revere commissioned it and how he (or some other patron) paid for it. Copley charged about twice as much to paint a bust-length portrait as Revere made by forging a teapot. And orders for complex objects like teapots were rare indeed; Revere recorded payment for just nine teapots between 1762 and 1773, only one of those in 1768. Copley occasionally purchased goods from Revere, especially cases for miniatures. It is possible that the painter and the silversmith bartered wares.[77]

Generations of scholars have treated the picture as a political statement: Revere's linen becomes homespun; he contemplates the vexed commodity the teapot will hold as well as the challenges of its design. In this version, *Paul Revere* arises from the collaboration of two American liberty men. But this is more wrong than right. To be sure, both Revere and Copley had signed the October 1767 nonimportation agreement, and it seems likely that they were among those who assembled to celebrate the third anniversary of the Stamp Act protests the following August. It was a scene of "extraordinary Festivity," the newspapers said. There were cannon and French horns and a new *"American* Song of Liberty." There were forty-five toasts, including paeans to Wilkes and to Pitt, to the province's "glorious NINETY-TWO," and to "The Sons of Liberty throughout the World." But glasses were also raised to the monarch and his ministry. "Prosperity and Perpetuity to the *British Empire*, on Constitutional Principles!" the assembly chanted. The flag fluttering from the Liberty Tree was the Union Jack. In other words, Revere and Copley and the "very large Company of the principal Gentlemen and respectable Inhabitants of the Town" who processed in their carriages from the Liberty Tree to the Greyhound Tavern in Roxbury remained, even then, sons of *British* liberty.[78] Neither man could afford to alienate the kinds of patrons who purchased gold buttons, or who sat for portraits wearing them.[79]

Even before the ministry learned of faraway Boston's impassioned response to the seizure of the *Liberty*, Whitehall had determined that the

town must at last be brought to heel. The "Colonies appear to be in a State of Infatuation dangerous not only to themselves but to the whole Empire," wrote Lord Hillsborough, the American secretary. He instructed Major General Thomas Gage, commander in chief of the king's forces in the American provinces, to "forthwith Order, one Regiment, or such Force as you shall think necessary," to redeploy from Halifax to Boston.[80] Fed a steady diet of news from Massachusetts in his headquarters in New York, Gage knew too well "the Outrageous Behavior, the licentious and daring Menaces, and Seditious Spirit of the People of all Degrees in Boston." The *Liberty* incident convinced him that Britain's policy of "Moderation and Forbearance" had failed, and the time for sterner methods had arrived. "But if Measures are taken to subdue them, it is to be hoped they will be taken Effectualy, and nothing done by halves. Quash this Spirit at a Blow," Gage urged.[81] When the general's pleas reached London, along with news of the *Liberty* affray, Hillsborough dispatched two additional regiments from Ireland. The transport ships sailed from Cork, thus retracing the journey of Copley's parents, three decades and two wars earlier.[82]

Having long fought to preserve and enlarge Britain's empire, Gage was ready to impose martial law if necessary. Days before the troopships landed, he told Hillsborough that "the People of Boston" had "now delivered their Sentiments in a Manner not to be Misunderstood, and in the Stile of a ruling and Sovereign Nation, who acknowledges no Dependence." It was a dangerous innovation, and the general meant "to use all the Powers lodged in my Hands, to make Head against it.[83]

⁓

For weeks, all eyes were trained on the horizon, scanning for sails.[84]

On 29 September, the convoy from Halifax anchored at Castle William. An anonymous pressman writing what he called *A Journal of the Times* reported, "We now behold Boston surrounded at a time of profound peace, with about 14 ships of war, with springs on their cables, and their broadsides to the town!"

On 1 October, as maple trees across New England began to trade

their green for scarlet, the troops marched in formation from the Long Wharf to the Common, "with muskets charged, bayonets fixed, colours flying, drums beating and fifes, &c. playing."[85] In total, the Halifax battalions comprised some twelve hundred soldiers, with a thousand more on the way from Ireland: a force amounting to nearly 15 percent of the town's population. Additional transport ships carried their wives and children, a distaff phalanx numbering in the hundreds.[86] The incursion was palpable, and visible, in every corner of the city. In tinted versions of Paul Revere's famed engraving of the landing, produced more than a year later, after tensions between the soldiers and the townsfolk had reached a desperate peak, the harbor and the wharf bleed vermillion: red banners, red-tipped cannon, and the ubiquitous red coats, the color now played for shock, so different from the way it had looked just a decade before, when sons of Boston rushed to wrap themselves in the scarlet mantle of empire. During the French and Indian War, red-robed images of British power had helped to make the futures of Copley and many of his patrons. In 1768, red became the color of occupation.

Boston's response to the landing was measured and tactical, denying Gage the armed uprising he predicted. By day, a tense civility reigned. After darkness, stealthy bands of vigilantes staged targeted attacks.[87]

Many held the governor responsible. Bernard knew, when the troops landed without even the council's consent, that he alone must "be made answerable to the Fury of the People."[88] And on 5 October, after night fell, somebody, or bodies, struck at his likeness in Harvard Hall. Though the room was broadly accessible to members of the college and their guests, it was not an open or plebeian space; the vandals—or perhaps they should be called assailants, for they attacked, very deliberately, the simulacrum of a man—would have needed a reason to enter. Maybe they were students, many of whom had recently sworn off tea in patriotic protest. Maybe John Hancock or Samuel Cooper, Harvard overseers, turned a blind eye, or even lent a hand. The assailants needed tools, too: a stool or ladder, a razor or a knife. They carried a note, likely written in advance. The *Journal of the Times* described the performance this way:

Paul Revere, A VIEW OF THE TOWN OF BOSTON, *1770*

From Cambridge we learn, that last evening, the picture of —— ——, hanging in the college-hall, had a piece cut out of the breast exactly describing a heart, and a note,—that it was a most charitable attempt to deprive him of that part, which a retrospect upon his administration must have rendered exquisitely painful.

This was a ritual, a piece of scripted political theater rather than a spasmodic expression of frustration. It strikes me as the work of educated men, men of satire and sympathy who, by cutting a heart-shaped hole in the governor's likeness, rendered Bernard visibly what they had always known him to be: heartless.[89]

The records of Harvard College are almost entirely silent on the subject of the attack. The overseers expressed none of the sorrow they had lavished on the fire, and none of the opprobrium they heaped upon students caught swearing or whoring or breaking the Sabbath. On 25 November, nearly two months after the painting was slashed, the presi-

dent and fellows voted that the picture be "put into an handsome Frame, the Expence to be defrayed out of the College Treasury." Once Bernard's portrait was reframed, it and the others in Copley's triptych were to be moved upstairs to the Philosophy Room, where they could be kept under lock and key.[90]

Before the picture could be reframed, it had to be repaired. Harvard contracted with Copley to do the work. By early March, Bernard's likeness had been returned to the college, the *Journal of the Times* reported, noting, "Our American limner, Mr. Copley, by the surprising art of his pencil, has actually restored as *good a heart* as had been taken from it; tho' upon a near and accurate inspection, it will be found to be no other than *a false one*." Bernard's continuing heartlessness was clear; come summer he would be packed off to London. But where did Copley's heart lie? Would a truly "American limner" have done the work so well, if indeed he did it at all?[91]

A week after the attack on Bernard's portrait, General Thomas Gage arrived in Boston, having decided that his presence was required in order to resolve the contentious matter of the soldiers' quarters. As the ranking British officer on the continent, Gage was one of the highest imperial officials ever to visit the town. He "& his Retennu," consisting of two colonels, two majors, and three captains, arrived in full regimental splendor, pulling up to the Common "just before sunset . . . in his Chariot & 4, his Aid de camps on Horseback." Their arrival made "a gallant Show," as one diarist noted.[92]

Gage quickly set to work winning over the best men of the town. He stood as sponsor for a child at the baptismal font of Trinity Church. (The baby was christened with the name of Grenville, an unlikely playmate for Nathaniel Barber's young Wilkes.) The general and his officers held elaborate entertainments with some of Boston's leading merchants.[93] While the entourage was in town, Copley held a "Levee" that some of Gage's men attended. An occasion of studied informality—levee, from the French *lever*, was meant to suggest rising from bed to greet one's guests at home—such a gathering made a courtly setting in which to

attract custom. At least one member of the general's party, Captain John Small, commissioned a pastel portrait.[94]

Bit by bit, the sheer politesse of Gage and his officers seems to have eased the tensions enough to settle the soldiers into their winter quarters and Boston into its occupation. The customs commissioners returned to the city. The Irish regiments landed without incident. "Every thing now has the Appearance of Peace and Quiet," Gage reported on 3 November.

Before he left Boston, Gage sat to Copley. The result of their collaboration is a canvas that could not be more different from *Revere*: a military portrait that follows the example of some of Reynolds's most famous works, which circulated in engraved form, as well as John Smibert's images of the heroes of Louisbourg. Gage stands, with an officer's ramrod bearing, in the buff waistcoat and blue-faced scarlet jacket of a general's undress. He holds the wooden baton that signifies field command, and points to an enormous red-coated fighting force drilling in the distance. He is bathed in light; his ranks are orderly; blue sky dominates the horizon: signs that, as Gage told Hillsborough, "the Presence of the Troops has already produced some good Effect."[95]

⁓

The general's future looked bright, as did the painter's. Copley turned thirty the summer before the occupation began, which meant that he had been painting for money roughly half his life. He had grown skilled, eminent, and comfortable; he had portrayed judges and governors and commanders, matriarchs and blushing brides.

For all that, *General Thomas Gage* was one of the most important portraits of Copley's career, incomparably more useful to him than the bust of Paul Revere, which has grown so much more famous over time. Gage offered a kind of official patronage, a greatly enlarged version of what a much younger Copley had chased when he painted lesser officers during the French and Indian War. *General Thomas Gage* would have been perfect fare for the spring 1769 exhibition sponsored by the new Royal Acad-

Copley, GENERAL THOMAS GAGE, *ca. 1768* [Plate 6]

emy of the Arts, organized by Benjamin West and several others, and chartered with the direct imprimatur of the king.

Gage's portrait did eventually make its way across the Atlantic, under the general's auspices, not the painter's. First Gage took it to his head-quarters in New York, where it garnered widespread acclaim. Sometime late in 1769, Gage shipped it to London. By the spring of 1770, it was hanging in one of the main rooms of the Gage mansion on Arlington Street. Captain Small assured Copley that in London, too, the picture had been received with "universal applause and Looked on by real good Judges as a Masterly performance." One "Test of its merit": Gage had installed it between two family pictures "done by the Celebrated Reyn-olds, at present Reckon'd the *Painter Laureat* of England."[96] Copley hardly needed Small to identify Reynolds for him. As he painted Gage,

he must more than ever have pictured himself at Home, where men as powerful as the general did not arrive at one's painting room on the heels of an occupying army.

The rub, as Copley told anyone who would listen, was family. "What ever my ambition may be to excell in our noble Art," he told West, "I cannot think of doing it at the expence not only of my own happyness, but that of a tender Mother and Young Brother whose dependence is intirely upon me." To "remove an infirm Mother" must add considerably "to the difficulty and expenciveness" of even a short study trip to Europe, Copley knew.[97]

But what if he sailed and then stayed, as West had done? Copley floated the possibility in a waste book of letter fragments, beneath a sketch of what appears to be a fanciful Pelham family tree. It would not do "to go there to improve myself, and than return to America," he wrote, "but if I could make it worth my [while] to stay there I would remove with Mothr & Brothr, [to] who I am bound by all the ties of Duty and Effe[c] tion not to Desert as Long as I live."[98]

With its combination of longing, love, and bondage, Copley's pledge sounds, almost, like a wedding vow.

Chapter Five

THE MARRIAGE PLOT

READER, HE married her.

On the evening of 16 November 1769, a year that ended even better than it began, John Singleton Copley pledged his life, liberty, and happiness to Susanna Farnum Clarke, known to kin and friends as Sukey. The ceremony took place in the Brattle Square Meetinghouse, which her family had joined only lately, after Sukey's father severed ties with his longtime minister Jonathan Mayhew, whom Clarke accused of inciting the riots of 1765 with a hot sermon on liberty.[1] But liberty talk followed the Clarkes to Brattle Square, where their fellow congregants included Samuel Adams and James Otis, and their pastor was the Reverend Samuel Cooper, author of *The Crisis*, which fulminated against the Declaratory Act. The message was presumably much gentler when Cooper, whose aquiline nose and pensive mien Copley painted twice, blessed the couple, for which he collected his customary fee of one golden guinea.[2] Beyond that we know nothing of the celebration. If the wedding was like other marriages between well-to-do Bostonians, a party at the Clarke mansion on School Street would have followed the exchange of vows. The diarist John Rowe described one such occasion, in which a "great concourse of People" attended the church ceremony and then continued their revelry at the home of the bride's father. "Wee all Drank Tea, spent the evening there, had a Dance, wee were merry & spent the whole day very clever & agreeable."[3]

Copley had ample reason to be merry, for Sukey Clarke was in every

way a prize. The eighth of twelve children born to Richard Clarke and Elizabeth Winslow Clarke, she was a pretty gentlewoman, twenty-four years old to her husband's thirty-one. Her father—like her brothers, a graduate of Harvard—was one of Boston's wealthiest merchants; her mother, kin to the Hutchinsons and the Olivers, boasted a lineage reaching back to the *Mayflower* (such things were beginning to matter) and extending laterally along many strands of the web of Boston's commercial elite.[4] Sukey Clarke wrote with a fine clear ladies' hand, and spelled with far more confidence and consistency than did her new husband. She must have had some formal education, then, likely at one of the dame schools that sprang up around town in her youth, places where girls from good families read belles lettres, practiced their penmanship, and learned some French, geography, and history along with ornamental needlework.

It remains unclear how Sukey and Copley first crossed paths. Their social worlds did not intersect, nor did they worship together. Both of Sukey's older sisters had married men who followed their father's line of business: a trade Richard Clarke elevated to a calling. Clarke was conscious of station, too. In a letter to his son Isaac, a young man just a year behind Sukey, Clarke touted the mercantile virtues of fidelity, submission, and industry, and warned his journeyman son against fraternizing with the "many loose, idle young people in this Town," who might threaten his "innocency" with the "contagion of their bad example." Surely Clarke watched over Sukey with equal acuity, preparing her for a match that would extend his contacts and influence, a match like those her sisters Hannah Clarke Bromfield and Mary Clarke Barrett had contracted. The cost of marrying his older daughters well would scarce have dented the coffers of a man like Clarke. There is no reason to suspect that he was any less ambitious for Sukey's prospects, or she any less eligible than her sisters. Indeed, that Clarke married his daughters in strict birth order suggests a father's careful tending of the value of his daughters.[5]

Perhaps the couple met at the dancing school that Copley's stepbrother, Charles Pelham, ran sporadically, most recently in the spring of 1762, when Sukey was seventeen, a ripe age to learn the latest steps from

London. Copley might have taken instruction, or partnered Charles's young lady pupils in an effort to help his kinsman turn a profit.[6] When Mary Clarke sat to Copley in the early 1760s, her younger sister Sukey may well have attended as a chaperone, portraiture being a charged and intimate situation for a proper young lady and a male painter of penetrating gaze to endure à deux. Sitting to one's portrait could be a social occasion; in 1767, three wealthy Marblehead patrons repaired "to Copley" one spring afternoon to have their pictures done, as a friend of the party noted in his diary.[7] Such an experience would have been memorable. By all accounts, Copley cut a dashing, even foppish figure. The Connecticut-born painter John Trumbull, who arrived in Boston in 1772, en route to matriculate at Harvard, was struck by Copley's "dress and appearance—an elegant looking man, dressed in a fine maroon cloth, with gilt buttons—this was dazzling to my unpracticed eye!"[8]

However the eligible Sukey first met the "dazzling" Copley, the two had formed a connection by late 1768, when Copley hosted the levee that welcomed General Gage's adjutants to occupied Boston. Upon reading the news of Copley's marriage in the press, Captain John Small wrote from New York to say that he remembered Copley speaking that day of Miss Clarke "with such warmth of Encomium as Convinc'd me of your serious and well plac'd attachment." Small deemed their marriage an "*agreable* Event," highly beneficial to his friend, though he worried it would deafen the painter to the pleas of New York's "Beau Monde," who "earnestly and eagerly wish'd" he would make a tour of their city.[9]

By the time Copley and Sukey Clarke wed, the marriage plot, wherein a female protagonist's fate resolves at the altar, had become a commonplace of both life and letters. The marriage plot forms the skeleton of every major Anglophone fiction of the long eighteenth century, from *Pamela* and *Clarissa* in the 1740s through *Sense and Sensibility* and *Pride and Prejudice* in the 1810s. The year of the Copleys' wedding, London theatergoers were treated to plays spanning a tonal gamut from *The Clandestine Marriage, a Comedy* to *The Forced Marriage, a Tragedy*.[10] Printed fare on marriage was rather more sober in the colonies, running to wedding

sermons and conduct literature, including a perennially popular pamphlet entitled *The Advantages and Disadvantages of the Marriage-State, as Enter'd into with Religious or Irreligious Persons*, which went through eight editions in the decade Copley took his vows.[11] From reading such works, and from their pastors, and doubtless from their mothers, eighteenth-century women learned that the choice of a mate would chart the course of their lives. Marriage provided the signal occasion for female portraits, too, because marriage was *the* female plot point: the "defining life event," as the art historian Margaretta Lovell has written.[12] For a woman of parts—a woman who was substantial but not scandalous—marriage was the moment one's name might appear in the press, as that of Copley's bride did, in three Boston papers, and one in Salem besides, and never again, till death did them part.[13]

But the marriage plot was Copley's plot, too—indeed, was every man's plot. Marriage ramified in men's lives, in public as in private, for richer and for poorer. To be sure, married men almost always retained more control over their persons and their destiny than did married women, who by law had little power over their property and by custom had still less power over their bodies. Yet for men as well as for women, the personal—the domestic—was economic and political. Early modern English households were, famously, little commonwealths: models for the ladder of hierarchy that set parents over children, husbands over wives, rulers over subjects, and God over all. Households were also, from the bottom to the top of the social order, little corporations; preindustrial families produced as well as reproduced. The burdens of everyday life—of cooking and washing, getting and spending, caring for the young and the old and the sick—were enormous. It was hard to get by without a partner in the enterprise. Mary Copley Pelham was a distinct and telling exception; most widows and virtually all widowers remarried quickly, often within months. Trained in the classics, Copley's father-in-law, like any Harvard graduate, would have known that the word "economy," often spelled "œconomy," stemmed from the Greek root *oikos*, meaning household. It was difficult to function as an œconomical adult without the support of a mate.[14]

Beside every woman who married down was a man who married up, a time-tested household strategy in Copley's day. Richard Copley had married up when he wed Mary Singleton, daughter of the squire of Quinville Abbey. His only son did just as well for himself in the marriage market, if not better. John Singleton Copley was by every evidence a uxorious man whose marriage hewed to the companionate ideal just coming into vogue in the eighteenth century. No courtship letters between him and Sukey survive, but it seems a very fair bet that he married for love as well as money, a false opposition, then as now. Certainly he loved Sukey afterwards. "My dear wife," he began a letter posted in 1774, when the couple had been married five years. "Could I address you, by any name more tender than that office, I should delight in using it when I write to you: but my Dear Sukey, how tender soever the name may be it is insufficient to convey the attachment I have to you."[15] There is no reason to doubt his sincerity.

But even in an increasingly youth-driven marriage market, where young people chose their mates and valued companionship, the union of two families of measurable means involved a property settlement: a transfer of wealth from the bride's father to her husband. And so, like the brushes and crayons Copley ordered from Europe, his marriage into the house of Clarke was instrumental: a tool in his pursuit of happiness. His wedding rated as news less because of his own surpassing talent than because he took as his bride "Miss *Sukey Clarke*, Daughter of *Richard Clarke*, Esquire," whose firm puffed its stock of "Choice Loaf-Sugar" on the same page of the *Massachusetts Gazette* that reported the nuptials.[16]

Copley had many reasons to be especially conscious of the male marriage plot. He delayed taking a wife a full six years longer than most of his male peers, who typically wed around the age of twenty-five. (Sukey's age when she reached the altar was exactly the demographic average for young women.)[17] Moreover, Copley was conscious of the wait: of the "resolution" required "to live a batchelor to the age of twenty eight," as he had told Peter Chardon three years before he eventually took his vows. "However I dont dispair, but I shall be Married," he continued, offering as

evidence that "Mericle[s] have not ceas'd" the news that his stepbrother Charles Pelham had just taken a bride at the ripe age of forty-four.[18]

"When I wrote to you last I menshoned some obstruction in my way to making such a tour, and you have doubtless heard before this time I have increased the dificulty . . . I have entered into engagements that have retarded my travilling": this is how Copley broke the good news of his marriage to West, a year after the fact. He took pains to assure his long-distance mentor that he would nonetheless "make all give way to the predominant passion of cultivating our Art."[19]

Young Sukey Clarke was beautiful, at least in Copley's eyes, for we see her only through his hand. In the pastel portrait he rendered at the time of their union, she is pale, fine-featured and swan necked, with calm blue eyes and a long, straight nose. Only a sprig of flowers in her chestnut hair adorns her chaste, vernal loveliness. In his paired self-portrait, Copley plays the peacock to Sukey's muted hen. He sports the figured silk banyan of a merchant or learned man in studied undress over a crimson waistcoat clotted with gold lace. His collar is slightly askew but his bobbed wig is carefully frizzled and powdered, and a long queue of natural hair trails down his back, neatly tied. His color is high, suggesting passion. But the focus of the portrait is the artist's stare. Copley shows his gray eyes penetrating, calculating; his gaze is as probing as Sukey's is placid. Marriage marks the first time we can see Copley, and he wants to be seen seeing.[20]

"I see by the papers you have chang'd your condition, and have taken to yourself a wife," wrote William Johnston, who had lately removed to Barbados, when he learned the news. "I have [not had] the pleasure of knowing your Lady by sight: but from the Charracter of that family in general, you must be the happy Man."[21] Copley had reason to be happy indeed. The Clarkes were prosperous and prominent. Their politics were practical, flexible, respectable: the politics of wealth. In 1764, Clarke had joined a "Committee of Merchts & others" who sued to prevent the collection of additional duties on loaf sugar.[22] The August 1765 attacks on Andrew Oliver and Thomas Hutchinson—kin to the Clarkes by

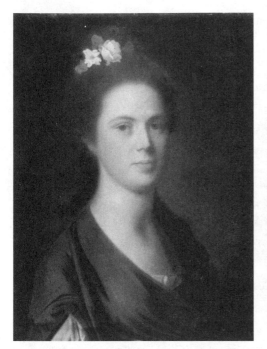
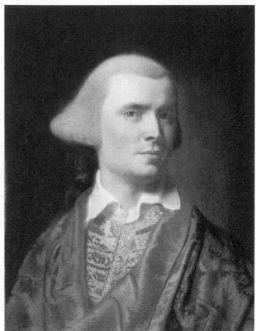

Copley, MRS. JOHN SINGLETON COPLEY
(Susanna Clarke), 1769 [Plate 7]

Copley, SELF-PORTRAIT, *1769*
[Plate 8]

marriage—breached the outer limits of Richard Clarke's willingness to protest Parliament, as his break with the Reverend Mayhew attested. But if Sukey's father was no Son of Liberty, neither was he reflexively loyal to government. Like most of his neighbors, Richard Clarke embraced no party but his pocketbook. He was a friend of liberty, a friend of order, and, above all, a friend of the house of Clarke.

And so, when enforcement of the Sugar Act tightened, Clarke sold off the little refinery he had built and began selling tea, some of it imported by the very same sea captain who had ferried *Boy with a Flying Squirrel* to London. Among his many customers he counted John Adams, who purchased a small barrel of fine bohea from Clarke & Son in January 1768.[23] Later that year, when the resistance movement fastened on tea, Clarke restocked his shelves once again. By November, Richard Clarke was said to be "intierly done with Tea"; one son-in-law heard that he had "design'd even burning your canisters."[24] When his daughter Sukey solemnized her

improbable match with a painter—a painter!—the tides of commerce had turned and Richard Clarke was selling sugar again. With ample capital and fluid principles, Clarke's fortune grew.

By marrying Miss Sukey Clarke, daughter of Richard Clarke, Esquire, Copley augmented his coffers and elevated his circles of patronage, as he knew he would. Their union also had consequences unintended and unforeseen, as marriages did, and do.

The year of Copley's marriage dawned calm and cold. The harbor froze solid; people walked across the ice from Castle William to the Long Wharf and traveled from Boston to Cambridge by sleigh.[25] Tempers cooled as well; tensions that had boiled in October merely simmered by January. The newspapers insisted that the threat level remained acute. But "the Writers for the Gazettes will always endeavor to raise a Clamour," as General Gage reported to Lord Hillsborough. "Colonel Pomeroy who has commanded at Boston during the Winter has acquainted me in general that every thing has been very quiet and Peaceable there."[26]

As the months dragged on, both the soldiers and their unwitting hosts settled into the syncopated rhythms of occupation. The townsfolk resented the troops, and vice versa. The soldiers drank and swore and gambled and whored. They stole jobs, undercutting local laborers in order to supplement their meager pay. They marched on the Sabbath; preachers found themselves drowned out by military bands. John Adams described a daily musical battle: "The Spirit Stirring Drum, and the Earpiercing fife" of the companies drilling every morning, followed by "the sweet Songs, Violins and flutes of the serenading Sons of Liberty . . . in the Evening." At night, fueled by rum, some of the redcoats robbed men and catcalled women. The *Journal of the Times* beat a steady tattoo of "outrages" large and small, including reported threats of abduction and one attempted rape.[27] But an uneasy peace was peace nonetheless. The madder and vermillion of the brigades receded into the background.

As summer came to New England, daughters of liberty massed with

their spinning wheels on the greens of town after town, passing long, warm days making yarn to be woven into homespun. General Gage issued orders to halve the forces occupying Boston.[28] The Irish regiments decamped to Halifax. On 1 August, the despised Governor Bernard, his portrait repaired but his reputation for heartlessness intact, sailed for London on the *Rippon*, another man-of-war evacuated from the harbor. Lieutenant Governor Thomas Hutchinson would rule in his stead. The town celebrated the departure of Bernard, whom the *Gazette* called "a Scourge to this Province, a Curse to North-America, and a Plague to the whole Empire," with the usual bells and bonfires.[29] Amidst this atmosphere of lifting gloom, Copley dedicated himself to Sukey and his future to Boston.

In the waning days of 1768, Copley had received a letter from Benjamin West, commenting on the pieces he had sent for the spring exhibition, so many months before. West apologized, as he always did, for his "long Silence," which "must have made you think by this [time] that I had forgot you." Of *Daniel Rogers* and the pastel Copley shipped with it, West said nothing. (That Mr. Rogers carried West's letter to Boston could not have prompted much candor on that score.) He instead repeated his exhortation that Copley sail for Europe, there to experience what "Cannot be Communicated by words and is onely to be felt by those which Nature has Blessd with Powers." Once again West counseled Copley to "viset while young and befor you determin to Settle": to take on a family, to fix in Boston.[30]

But it was already too late. Around the time West's letter reached him, Copley found himself "accidentaly one Evening" in the home of his neighbor Peter Chardon, father of his late lamented friend of the same name. The elder Chardon told Copley that he needed to sell off some of the land he administered as executor of a complicated estate: the legacy of Nathaniel Cunningham, an enormously wealthy merchant who had died in 1756.[31] Cunningham had lived in Cambridge amidst considerable splendor. Like many of the richest New England traders, he also owned slaves; the inventory taken at his death includes five bondspeople. Three

of them—a "Negro Man nam'd Pennywell," a "Negro Woman nam'd Violet," and a "Negro Girl," perhaps their daughter—were treated by the assessors as human capital, with a combined value estimated at about £50. But Cunningham had also claimed ownership of an "old Negro Man & Woman not appriz'd"—that is, not considered exchangeable for cash. This elderly couple, identified in another document as a "Husband & Wife, Named, Harry & Nancy," could no longer work, and by the calculus of slavery, this made them worse than unsalable; they must be "look[ed] upon as a charge to ye Estate"—as liabilities.[32] In time, the cost of their care fell to the town of Cambridge, which may mean that Cunningham's heirs had turned them out to fend for themselves.

A decade after Cunningham's death, Harry and Nancy lived on, and Peter Chardon received the General Court's permission to sell £100 worth of Cunningham's extensive real estate holdings "for defreying the Charges of said Negros."[33] Two more years passed before Chardon offered Copley a chance to purchase some of Cunningham's land: some unbuilt lots on a spit called Barton's Point, and an enormous tract of eight and a half acres, stretching from the northern edge of the Common to the tidal flats along the Charles River, one of the largest continuous lots in the city. (Much of the neighborhood that today is called Beacon Hill was built on those acres.) The land came cheap, a bargain reflecting the fact that its title had been embroiled in litigation for decades, long before Cunningham purchased it. Copley later recalled that Chardon gave him a deed "without Warranty," because of the likelihood that a lawsuit would follow, as indeed it did, before the snow melted.[34] For the two parcels Copley tendered a total of £160, barely half the cost of his house on Cambridge Street. Decades later, he recalled that he had paid "in Gold, and that the sd. Peter Chardon who was a very exact Man brought Scales with him for the purpose of weighing the Money."[35]

There are many ways of valuing what Copley handed Chardon that day. The 152 gold guineas (plus a few shillings and pence) that equated to £160 would have made a tidy pile on Chardon's scales, weighing nearly three pounds: a fat jingling pouchful.[36] Copley would have measured

the payment in hours and brushstrokes. As he had told Benjamin West, "three hundred Guineas a Year, which is my present income, is a pretty living in America."[37] By that estimation, Copley paid Chardon more than six months at the easel—six months of the painter's peculiar alchemy, turning ordinary, earthbound materials quite literally into gold. To have saved that much treasure, Copley must have generally asked payment for his work in cash, and then husbanded his coin carefully.

To spend that reserve was to barter away much of what he had managed to "Lay up," savings he expected to "carrie me thru and support me handsomly for a Couple of Years with a family"—just Harry and his mother, at that point—when they finally made their way to London.[38] To spend it in Boston, on Boston, was to postpone that fine day, which may be one reason that Copley did not respond to West's September 1768 letter for nearly two years, and did not send additional pictures to suffer the withering judgments of the London cognoscenti. "I am afraid you think I have been negligent in suffering two years to pass without exhibiting somthing, or writeing to you to let you know how the Art goes on this side of the Atlantick," Copley wrote at the end of 1770, by which point he had not only a wife but a baby girl, named Elizabeth, after his wife's mother. For the lengthy gap Copley offered all manner of excuses, both artistic and personal. It remained "extreemly dificult to procure Subjects fit and pleasing to entertain the Publick with," he said. West must know "in this country the hands of an Artist is tied up, not having it in his power to prosicute any work of fancy for want of meterials." In any case, Copley said, his "time is so intirely engrosed in painting portraits as to make it very dificult for me to exibit constantly." But "the most meterial Reason of all others," he explained, "was the prospect I had of visiting Europe before this time."[39]

Instead, Copley had set aside thoughts of London, and even New York, to till his fields in Boston. In March 1769, Boston freeholders chose him as one of the twelve men to serve as Clerk of the Market, an ancient and largely honorific local office whose holders, like those elected to serve as Informers of Deer, Surveyors of Boards, and Sealers of Leather, were

charged with policing community standards. The Clerk of the Market's particular purview was the weight of bread offered for sale in local bake-shops. Copley seems to have been swept into office—the only one he ever held—on something of a Clarke family ticket, along with his future brother-in-law Jonathan Clarke and Elisha Hutchinson, son of the lieutenant governor and a maternal kinsman of Sukey.[40]

Such moments of extended family unity are telling, for both status and, to some degree, principles separated Copley from his in-laws. At the time of his marriage, Copley inclined, however slightly, toward the American cause. When the fourth anniversary of the Stamp Act resistance came around in August, Copley was among the 369 Sons of Liberty who gathered at the Liberty Tree, processed to a tavern in Dorchester, and, after drinking the customary forty-five toasts to the usual suspects, paraded blearily back to town, with John Hancock's elegant coach in the lead. After him followed many of the leading men of Boston, scores of them Copley sitters: a portrait gallery in motion.[41]

Though the celebration encompassed a wide swath of Boston's better sort—men of varying degrees of ardor for colonial resistance—there was nary a Hutchinson or a Clarke in sight. Indeed, on the very day that the Sons of Liberty held this largest and giddiest of their anniversary meetings, several patriot newspapers took the extraordinary step of printing the names of those who continued to import British goods in defiance of the boycott movement. Clarke and the Hutchinson brothers, Thomas Jr. and Elisha, accounted for three of the eight names published as "IMPORTERS contrary to the Agreement of the Merchants," whose shops patriots were instructed thenceforth to shun.[42]

Just days after the publication of Clarke's name among the despised importers, newspapers announced that Richard Clarke & Son had "fully acceded to said Agreement, and are therefore now to be considered Non Importers."[43] Clarke's belated conversion to the nonimportation lasted only as long as it had to, a matter of pragmatism, not politics. The boycott was a notably leaky vessel, as John Mein, owner of the London Book Store, amply demonstrated when he began in the summer of 1769 to print

in his *Boston Chronicle* shipping manifests passed to him by the customs commissioners. Clarke's name figured regularly among those to whom banned goods were addressed. But so too did many of the boycott's organizers. A week after Copley's wedding, Richard Clarke was importing pepper, and the Hutchinsons were importing tea. At the customhouse at the same time were chests of banned goods addressed to John Hancock. And in the hull of the *Boscawen*, the same ship that had carried *Boy with a Flying Squirrel* to London, came a case of imported wares labeled "John Copley."[44]

Jack and Sukey went to housekeeping. The bride would have expected to "enjoy the Confidence, the Friendship, and affection" of her new "*Lord and Master*," as her sister Sarah later wrote, evoking the "great Athority" of Saint Paul, and his oft-quoted injunction that wives must "obay their Husbands, &c &c." It was "much less difficult to teach the Apostle's Matrimonial doctrines, than entirely to Practice them," she joked.[45]

In the first months of their marriage it is almost certain that they lived with Mrs. Pelham, nearing age sixty, and Harry, now a young man of twenty, on Cambridge Street. The house on the large lot that Copley had bought from the Cunningham estate was an ancient, rickety pile, built in the previous century. With his purchase, Copley also inherited a tenant, a leather dresser named Ephraim Fenno, who had rented the place for about two decades. So the new old house was neither suitable for nor available to the newlyweds. But come summer, Copley bought two large lots adjacent to the Bannister Pastures from Sylvester Gardiner, an enormously wealthy physician and speculator in Maine lands. (Gardiner had sat to Copley.) The land Copley added in July 1770 was far more expensive than the purchase he had made before his marriage: he shelled out £650, once again in cash, much of which was likely Sukey's marriage portion. Two houses stood on the newly acquired lots. And it seems very likely that sometime before the year 1770 was out, the painter and his pregnant bride moved into one of them, in the neighborhood

above the Common, where Copley's holdings would soon total nearly twenty acres.[46]

The couple's new environs were rural enough to support a large crop of potatoes.[47] But what the Copleys soon took to calling Mount Pleasant was less a working farm than a gentleman's pastoral fantasy.[48] John Hancock owned the Georgian mansion immediately to the east, which sat just below the signal tower that gave Beacon Hill its name. Hancock's house was surrounded by ornamental gardens, and he had edged his estate with an allée of linden trees, creating a shaded mall for promenading. In a watercolor view painted by Christian Remick for Hancock in October 1768, the lands that would soon become Copley's look less regimented and more picturesque, suitable for a painter. The Common was no romantic heath, however. From their front windows, the newlyweds would have seen cows grazing and troops marching as well as ladies out for a stroll with their beaux. They would also have looked out over the working city, the enslaved city. Remick's view of the Common shows Boston's black laborers: a stooped old man with a straw hat and cane, a woman selling produce from her wheelbarrow, and at least one liveried servant—a young boy, judging by his size—attending a pair of elegantly dressed women as they stroll with a small dog.[49]

Many of those wealthy and vain enough to sit to Copley were also wealthy and vain enough to include bondsmen and bondswomen in their households and among their property. Among the 2,275 ratable "polls" surveyed by tax assessors in Boston in 1771, some 248, or about 11 percent, were found to possess "Indian, negro, or molatto servants for life" of between fourteen and forty-five years old—that is, to own a slave of roughly working age. Slaveholding was asymmetrical across the population, an index of wealth to a large degree. Many of Copley's neighbors on Cambridge Street owned slaves; the assessors counted eight bondspeople in the houses nearest the one Copley had shared with his mother and Harry. Peter Chardon was assessed for the value of one slave, as was Samuel Winthrop, who lived several doors down. Copley's new Beacon Hill neighbor, John Hancock, owned two. Large enslaved workforces

were rare in the city; the assessors recorded only eight Boston households with three or more slaves. But the presence of one or two bondspeople in the home of a wealthy family was unremarkable.[50]

Slavery had always been part of Copley's world. His marriage to Sukey Clarke brought the institution under his roof. Sukey grew up with slaves in the family. Her maternal grandfather, Edward Winslow, owned a woman named Tammy and a man named Julian; her uncle William owned a man called Boston.[51] Sukey's sister Hannah and her husband, Henry Bromfield, owned Othello, an African-born slave, later servant, who, in the words of one nineteenth-century town historian, followed Bromfield "like a shadow."[52] As a merchant with business in the Caribbean and the Carolinas, Sukey's father made his fortune trading with large-scale slaveholders. From his shop on King Street, he sold slave-produced commodities, including sugar and indigo. Like other New England merchants whose ships sailed the Carolina and West Indies circuits, Clarke occasionally sold a few slaves on the side; days after Copley sent *Boy with a Flying Squirrel* to London, Clarke and two partners advertised for sale an "active, strong and sensible Negro Boy, about fourteen Years old," who was "somewhat us'd to Farming, and seems inclin'd, and is well qualified for that Employment."[53]

Copley's potato patch notwithstanding, there was little farming to be done in Boston. Like those enslaved in other port towns around the Atlantic littoral, Boston's bondsmen and bondswomen were employed in a wide variety of urban labors. Some plied menial trades, working as carters, dockworkers, water haulers, street cleaners, and rope makers. Others were skilled artisans. Enslaved men built ships and barrels; they distilled liquor and brewed beer; they shod horses, operated printing presses, and delivered newspapers. Enslaved Bostonians also labored as servants in elite families. Women and girls, especially, were often touted as being fit for household work, or skilled at cookery. Men and boys waited at table and drove carriages.[54]

But bondspeople did much more than heavy lifting for Boston's wealthy, who might otherwise have purchased extra hands far more

cheaply, by the day or the season. In addition to their everyday labors, urban slaves performed the ineffable work of imperial fantasy. In Boston as in London, people held in bondage burnished the status of their masters. Sometimes their owners dressed them in elaborate livery sewn from imported cloth, costumes meant to set off the servant's black skin and to highlight, as if by the artist's familiar technique of contrast, the owner's whiteness—her Englishness. Copley certainly knew the pictorial function of liveried bondspeople, who had appeared in noble portraiture since the beginnings of England's empire.[55]

Men like Richard Clarke—Indies merchants or planters—often devolved slaves upon their daughters when they married. By law and by custom, married women, whose legal personhood was "covered" by their husbands, did not own land. When fathers settled property upon their marrying daughters, they therefore favored "movables," goods that would follow a young woman into her new household, goods she might keep with her when she was displaced into widowhood. The gift of a slave was a multifold pledge toward the future of a daughter. The young woman who brought a slave to housekeeping when she became a wife would be spared some of the most arduous of female labors. The work of her slaves, and their value, also ensured that she would retain some measure of the status with which she had been raised, regardless of the economic fate of her husband. The gift of a slave was, in this sense, a hedge against the vicissitudes of the marriage market that ramified well beyond the altar. For under the hideous logic of slavery, the gift of a human being appreciated as no other portable property did, which is doubtless why enslaved women and children were often specially selected as wedding presents, thereby tearing asunder black families to strengthen the unions of white ones. Textiles faded and tore. Porcelain broke. But slaves begat slaves. If linens and china spoke of a daughter's posterity, a bondswoman or a child slave promised *futurity*. There was, in an age long before feminism, a distinctive vision of female independence acknowledged by the gift of a slave of one's own.[56]

Only a handful of inventories document the movables New England

women were given to set up housekeeping, and Sukey Clarke's is not among them. But a careful reading of Copley's letters makes clear that Sukey brought slaves with her to Cambridge Street and then to Mount Pleasant. One of them was a girl named Lucy. In 1771, while Copley and Sukey were away from Boston, Harry placed Lucy out for wages with one of the town's richest families: William Pepperrell Sparhawk, son of the great Maine proprietor whom Copley had depicted in a swaggering full-length; and his wife, Elizabeth Royall, whom Copley had painted when she was a girl of fifteen. Elizabeth Royall had grown up surrounded by bondspeople; her father, the Antigua merchant Isaac Royall, ran an improbably large plantation just outside Boston, where dozens of enslaved men and women tilled hundreds of acres.[57] She was full of praise for Lucy's work. The couple had "determined to keep Lucy, as they like her exceedingly and think she is the best Servant they have met with," Harry told Copley. Sukey must have agreed to convert part of her marriage portion to cash, for Harry and the Pepperrells sealed the bargain with £40 sterling. "Luce herself is very much pleased with her place," Harry reported. But Lucy's opinion, in the end, mattered little. "I am glad you have sold Lucy," Copley replied. "I wish you could sell the House." (At that point, he owned four dwellings.)[58]

Some years later, when Boston belonged to a different country, the Brattle Square Church solemnized the marriage of "Cato of Mr. Copeley" to "Lucy of Mr. Goldthwait." Perhaps this was the same Lucy, a youth in 1771 grown to womanhood, sold a second time (to a second Copley sitter) when Pepperrell fled to London, and married to a bondsman she had met during her brief service for Mr. and Mrs. Copley. Or perhaps not; Lucy was a common enough woman's name, though not especially frequent among enslaved women. In any case, the marriage of "Cato of Mr. Copeley" documents a second enslaved person in the household, who, if he married at something like the average age, would have been in his teens when Copley and Sukey wed.[59]

The fullest documentation of Copley's slaveholding concerns a child named Snap.[60] Letters between Copley and his brother mention the boy

regularly, and with some affection. "You have never said anything of Snap," Copley chided Harry. "I hope he is well and a good Boy. If he continues to do well he will merit my Care and tenderness for him and I shall reward him Accordingly on my return." Harry reported that Snap "has been well, except one fit, which he had, since you was away, but it was so much less violent, than any of his former ones, that we are in great hopes that they will entirely leave him." Otherwise the boy had "behaved himself very well and is a cleaver Fellow. Since I began to write this Letter, he came up . . . and beged that I would give his Duty to his Master and Mistress, and tell them that he was very glad to hear they were well. Antony is well," too, Harry continued. Antony was Copley's dog, a "most faithfull affectionate and humble Dog," Harry said, more formally known as "Antonio Marco": Marc Antony, named with the same biting classicism that stuck so many Boston slaves with cruelly ironic names like Cato and Caesar.[61]

Copley did not need bondsmen to till his fields or tend his cattle. His slave owning was something like his potato farming: genteel, pictur-esque. It would have felt all too real, nonetheless, to Snap and Lucy and Cato, human wedding gifts. That somber reality did not prevent Copley or Harry from describing Snap's good behavior in language that makes him sound like something between a child and a pet. Harry seemed to feel the same brand of affectionate condescension toward Phillis Wheat-ley, a young bondswoman of about his own age. Struck by her brilliance and her piety, Wheatley's owners had provided her with an education unusual for a girl and unheard for a slave. By the mid-1760s, she had begun to publish poems, at first anonymously and then under her own name. Wheatley's elegy upon the death of the evangelist George Whitefield—a friend of American liberty, though not of black freedom—was hawked in printshops from Boston to Philadelphia in 1770. Harry sent a copy to his stepbrother Charles, pronouncing it "a new Specimen of the Abilitys of our Boston Poetess Phillis, which has undergone no Corrections what ever." His delight in her "abilities" mingled with the frisson of curiosity—much as it did when cognoscenti in Italy and London first encountered the American Raphael.[62]

Boston had enslaved painters as well as a famous enslaved poet. One of them, Scipio Moorhead, likely created the portrait that served as the frontispiece of Wheatley's collected *Poems on Various Subjects*, first published in 1773.⁶³ Another, Prince Demah Barnes, perfected his trade in part by copying Copley's canvases. Prince's owners, Henry and Christian Barnes, knew of his aptitude for painting when they purchased him in 1769. The following March, Mrs. Barnes told a friend that Prince—whom she called "my Limner"—was "fix'd in one corner of the room improving himself in the art of Painting" while his mistress wrote. "He is a most surprising instance of the force of natural Genius," she said, "for without the least instruction or improvement he has taken several Faces which are thought to be very well done." Among them was "a Coppy of my Picture" by Copley—or "Copling," as Mrs. Barnes spelled it—which she thought captured "more of my resemblance" than the original. "He is now taking his own face which I will certain send you as it must be valued as a curiosity." Mrs. Barnes was eager to see Prince improve his genius. She asked her correspondent, Elizabeth Murray Smith, a feme sole trader and fellow Copley sitter, to help her acquire a proper set of crayons and the right kind of paper for pastel portraiture. "If you should meet in your Travils with anyone who is a Proficient in the art I wish you would make some inquerys in these perticulars for People in general think Mr. Copling will not be willing to give him any instruction," she wrote, "and you know there is nobody else in Boston that does anything at the Business."⁶⁴

Mrs. Barnes did not elaborate upon the reason for Copley's widely assumed reluctance to teach the aspiring black painter. Time was money; perhaps Copley thought he could not afford to be generous. Or perhaps his presumed diffidence suggests Copley's attitudes on the newfangled fiction of race: a belief in black inferiority nourished by the anxiety of a once poor boy about rank and station, which were far less stable categories than they seemed. Since quite early in his youth, Copley had hungered after mastery: of his craft, of his household, of his destiny and legacy. In

many respects the goal tantalized and eluded him. But he secured it, in the fashion of his times, as a newly minted slaveholder.

Prince progressed, by hook and by crook, finding an able mentor in London, where he accompanied Mr. Barnes on business in 1771. Upon his return, Mrs. Barnes wrote, Prince painted better than ever. He "has taken five Pictures from the life," she reported, and "three of them are as good likenesses as ever Mr. Copling took. I am in no doubt but he could coppy a Picture as well as any Body in the Country." The Barneses were eager "to recommend our Limner to the Publick," for his wages, like his person, were their property. They advertised his services in the newspapers in 1773: "At Mr. McLean's, Watch-Maker, near the Town House, is a Negro man whose extraordinary Genius has been assisted by one of the best Masters in London: he takes Faces at the lowest Rates." Five years later, Prince died a free man, having liberated himself when Mr. and Mrs. Barnes fled to England.[65]

Scipio Moorhead was less fortunate. In 1775, after his owner died, he was sold with the rest of the estate, at an auction near the Liberty Tree.[66]

~

Copley became a slaveholder at a moment when the metaphor of enslavement was increasingly marshaled in ideological combat against the tyranny of taxation. The same Boston newspapers that waxed rhapsodic about liberty regularly featured advertisements offering black men, women, boys, and girls for sale. This irony was not lost on people of the day. In a pamphlet entitled *Taxation No Tyranny*, Samuel Johnson famously asked, "If slavery be thus fatally contagious, how is it that we hear the loudest yelps for liberty among the drivers of negroes?"[67]

Those yelps for liberty grew sharply louder in the months after Copley's marriage. On New Year's Day of 1770, the *Boston Gazette* rolled out a new masthead, designed by Paul Revere, in which Britannia, clutching a liberty pole topped with a Phrygian cap, released the dove of peace over the steeples of Boston—an image at once pointed and hopeful. But hope proved forlorn. The tactics that had prompted the speedy repeal of the

Stamp Act failed to bring about the end of the Townshend duties. And so the organizers of the importation ban stepped up their campaign against the merchants who continued to bring English goods to American shores, and the officials who would collect the lawful taxes upon them.

To those who remained defiant apostles of the market, the boycott represented the action of self-interested men determined to protect one kind of liberty by squelching another. Theophillus Lillie, a dry goods seller proscribed on the front page of the *Boston Gazette* every Thursday, declared that he would rather trust the crown than the mob. "I own I had rather be a slave under one Master; for if I know who he is, I may; perhaps, be able to please him, than a slave to an hundred or more, who I don't know, where to find, nor what they will expect from me."[68]

In late January, "the whole body" of merchants visited Lillie and three other importers, including Daniel Rogers, whose picture Copley had sent to London in 1767. Several weeks later, Lillie arrived at his shop to find standing before it a large wooden head carved in his image, and a board on which likenesses of other merchants who continued to flout the importation ban had been crudely painted. A crowd numbering in the hundreds, "chiefly Boys," one diarist said, massed on Middle Street, admiring the artists' handiwork. When one of Lillie's neighbors, a some-time informer to the customs commissioners named Ebenezer Richardson, tried to take the effigy down, the mob chased him into his house and began smashing the windows. His family surrounded, Richardson fired wildly into the crowd, wounding one boy and killing a second, a young servant named Christopher Seider. On 26 February, huge crowds assembled at the Liberty Tree to give Seider, who might otherwise have lain in a pauper's grave, a burial fit for a fallen hero. "My Eyes never beheld such a funeral," John Adams noted in his diary. "This Shews, there are many more Lives to spend if wanted in the Service of their Country. It Shews, too that the Faction is not yet expiring—that the Ardor of the People is not to be quelled by the Slaughter of one Child and the Wounding of another."[69] A letter to the *Boston Evening Post* called Seider the "first martyr to the noble cause."[70]

Five more soon followed. A week later, on the night of 5 March, an angry crowd surrounded a group of soldiers in front of the Town House. Some hurled snow and ice, others insults. "Come on you Rascals, you Bloody Backs, you Lobster Scoundrels, Fire if you dare, G—d Damn you, Fire and be damned; we know you dare not," one rioter yelled. Both military and rebel leaders tried to quell the growing unrest. But as the tense minutes ticked on, one of the soldiers fired. Several others in the little clutch of embattled grenadiers discharged their weapons in turn, perhaps eight volleys in all. When the gunsmoke cleared, three members of the crowd lay dead; a fourth succumbed to his wounds before daylight, and one more would die the following week.[71]

Whatever one's view of the troops and the taxes, surely none could countenance murder. Thousands of freeholders flocked to Faneuil Hall the morning after shooting. The Reverend Samuel Cooper, who had presided over Copley's wedding just four months earlier, opened the meeting with a prayer. Then people with information about the melee on King Street stepped forward with their accounts. Copley appears to have been the first to testify, describing what happened when some of the troops ran through Cambridge Street after the affray. He and Harry and Sukey had "heard a Soldier to say . . . *that the Devil might give quarters he should give them none.*" Several other men offered similar stories, and it quickly became clear that more clerks would be needed to record all the depositions. Before the gathering dissolved, a declaration was issued: "it is the unanimous Opinion of this Meeting, that the Inhabitants and Soldiery can no longer dwell together in safety." A group of resistance leaders was dispatched to urge acting governor Hutchinson to remove the troops or risk an all-out uprising. Eager to ensure the safety of the king's regiments as well as the town, Hutchinson began evacuating the men to Castle William.[72]

In the weeks to come, the chaotic killings on King Street became fixed in word and image as "The Bloody Massacre." (General Gage, by contrast, described a "Misunderstanding"; the acerbic Peter Oliver remembered a "Riot.")[73] Copley's brother, Harry Pelham, quickly got

to work on what he would bill as "an Original Print . . . taken from the Spot." A zealous reader of patriot tracts and self-proclaimed "Friend of the Liberty of America," Harry would have known that the cause had occasioned a number of popular pamphlets but not yet an iconic image. A successful engraving stood a good chance of winning hearts—and of opening purses, too, on both sides of the Atlantic, for friends of liberty also abounded in London.[74]

Entitled "The Fruits of Arbitrary Power, or the Bloody Massacre," Pelham's view is framed like a theatrical set by the shops lining King Street. At the center of the scene, the redbrick Town House looms, statues of the English lion and the Scottish unicorn visible atop its hipped roof. In the foreground, soldiers stand in formation, legs pointed with the grace of a corps de ballet, bayonets at shoulder height. They have fired, on their captain's orders, into a clutch of unarmed men: gentlemen in hats and knee breeches, not laborers in trousers and leather aprons. Smoke billows. Two victims lie in the street, while a third bleeds out in the arms of his compatriots: an imperial pietà.

Harry rushed his design into production, working up the drawing and cutting the plate, likely with his late father's tools, contracting with a printer to buy hundreds of sheets of paper (ironically, imported) and pull 575 prints, an expense of more than five pounds, which he expected to recoup many times over. (The print was to sell for eight pence, and so would cover its costs after 150 copies.)[75] But when he opened the newspaper on 26 March, he discovered that Paul Revere, who had the skill necessary to engrave such a scene but not to sketch it, had beat him to market. And when Harry saw Revere's print, it became clear that Revere had not just scooped him but in fact had pirated his drawing.

How Revere saw Harry's plate remains unclear. It is not impossible that Harry had shown his handiwork to the senior engraver himself. They knew each other; Harry had borrowed prints from Revere, and Mary Pelham had lent or rented him some pieces of her late husband's printing press. Regardless of the channel, the visual evidence of Revere's copying was unmistakable. Harry wrote to him in a rage. "When I heard that

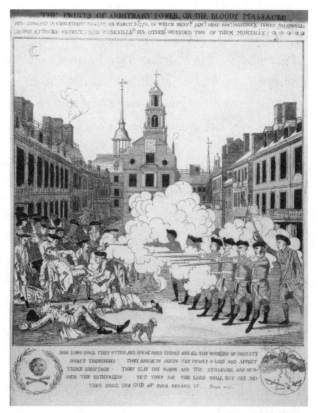

Henry Pelham, THE FRUITS OF ARBITRARY POWER; OR,
THE BLOODY MASSACRE, *1770*

you was cutting a plate of the late Murder, I thought it impossible, as I knew you was not capable of doing it unless you copied it from mine." Harry had trusted Revere, trusted his "regard to the dictates of Honour and Justice But I find I was mistaken, and after being at the great Trouble and Expence of making a design paying for paper, printing &c, find myself in the most ungenerous Manner deprived, not only of any proposed Advantage, but even of the expence I have been at, as truly as if you had plundered me on the highway. If you are insensible of the Dishonour you have brought on yourself by this Act," he continued, "the World will not be so."[76]

The indifferent world let Harry Pelham down, as it would do many times in the coming years. Revere issued his print in close partnership

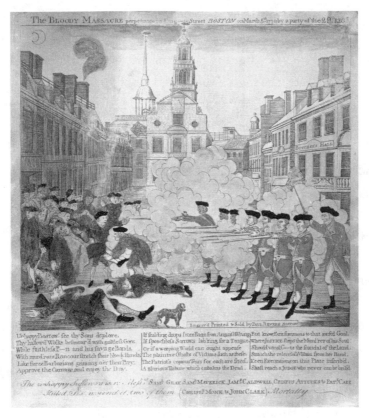

Paul Revere, THE BLOODY MASSACRE PERPETRATED ON
KING-STREET, *1770*

with Edes & Gil, the printers of the *Boston Gazette*, who promoted his version aggressively. In April, they used Revere's print to headline a broadside. Later in the spring, when they published a book of the official testimonies, called *A Short Narrative of the Horrid Massacre in Boston*, Revere's engraving served as the frontispiece. Hundreds of impressions were made, enough to wear out the copper plate. By year-end, Paul Revere's engraving, plainly derived from Henry Pelham's uncredited drawing, had become, and would long remain, an emblem of the American cause, familiar throughout the English-speaking world.[77] The politics of art, no less than the art of politics, was blood sport.

Two months after the "massacre," Boston remained tense. Harry Pelham felt "certain that if there is not a change of Measures, and that very

soon, the British Dominions will be plunged into one of the most dread-full of all temporal Evills, into all the Horrors of a civil War." These were hot words, seldom voiced in the public prints, words less prophetic than merely intemperate: the high moral dudgeon of youth.[78]

It is possible, though by no means certain, that Copley painted his now iconic portrait of Samuel Adams around the time of the affray on King Street. It has long been argued that the portrait depicts Adams in the midst of a heated confrontation with Lieutenant Governor Hutchinson the day after the bloody events of 5 March, when a delegation of town leaders demanded the withdrawal of the troops from Boston. But this is legend that has congealed, over more than a century, until it passes for fact.[79]

Copley's Adams points with his left index finger to the provincial charter of Massachusetts, which unfurls on the table before him, its great seal prominent in the foreground. The charter was the bedrock of Boston's conception of British liberty, mobilized in virtually every defense of colonial rights from the 1690s through 1776. In his taut right hand, he holds his uncompromising "Instructions of the Town of Boston to Its Representatives," landmarks of American political theory he drafted in 1764 and 1765, writings upon whose strength Adams was elevated, in 1766, to the General Court. Iconography cannot date the canvas to any particular point in the unfolding colonial struggle. If Copley's *Samuel Adams* is, as some scholars have alleged, a history painting in the guise of a portrait, it depicts a stream of time: a movement, not a moment.[80]

Style more than substance dates the portrait to some time after Copley's marriage, when the artist favored the somber palette and dramatic lighting effects present in *Samuel Adams*. Since the painting hung for many years in John Hancock's house, it seems likely that Hancock (who could well afford such a luxury) paid for the likeness of Adams (who could not). In any case, Copley was executing the vision of his patron(s), more than his own. A descendant of the sitter said that "Copley was a great admirer of Samuel Adams, and undertook *con amore* the task of transferring his features to canvas."[81] Everything about this claim is doubtful. Copley did

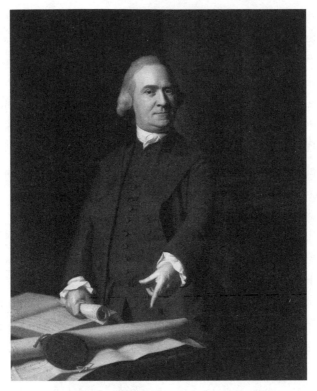

Copley, SAMUEL ADAMS, *ca. 1772*

not paint for love. Nor did he embrace full-throatedly the American cause, especially as voiced by the likes of Adams, who was nearly as fiery and unmodulated as the mad James Otis.

Not long after the massacre, Copley began again to think of Home, even as he continued to buy up land and put down roots on Beacon Hill. Right around the time Harry Pelham summoned the specter of civil war, Copley received a letter from his childhood acquaintance John Greenwood, who had left Boston for warmer climes and fatter purses in Suriname, and then had decamped Suriname for Amsterdam and finally for London, where he had made his living in art since 1763.[82] "It has given me infinite pleasure from time to time, to see your masterly performances exhibited here," Greenwood said, requesting that Copley make Greenwood's mother, remarried as Mrs. Humphrey Devereux, the subject of his next public performance. "I am very desirous of seeing the good

Lady's Face as she now appears, with old age creeping upon her," he said. (She was turning sixty.) Greenwood wanted her depicted "in as natural a posture as possible," with fitting "gravity" in the "choice of Dress."

In addition to this detailed commission, Greenwood offered tales of his own travels: "visiting most of the Courts of Europe, and admiring the thousand fine paintings that one finds distributed among them." There was talk of the rise of painting in England, which, he said, "bids fair to become the seat of the Arts and Artists." And of course there were paeans to West, whose fame grew ever more outsized while Copley continued in his little way, in his little town, painting portraits. "West goes on painting like a Raphael and realy out does every thing one could have expected," Greenwood said. "His Compositions are Noble, his design correct, and his Colouring harmonious and pleasing, and a certain Sweetness in his Cha-recters, that must please every one that beholds them." Every fault West had found in Copley's work—the hardness of lines and of tints, the ignoble subject of *Young Lady with a Bird and Dog*—was reversed in Greenwood's effusive evaluation of the backwoods boy turned metropolitan sensation. "You certainly have seen the prints after him," Greenwood continued, but those "give you but a faint Idea of his Performances." As if Copley did not know, all too well, what was lost when one made do with prints.

Greenwood closed his letter, as all of Copley's English correspondents seemed to do, with a plea for the Boston painter to visit. The exhibition culture was thriving, with several shows of old and new masters every year. In London, in season, Copley "wou[l]d hear of nothing . . . but the Virtu," Greenwood promised, "just as children in Boston for a fortnight before the 'Lection, prate of nothing else."[83] How tantalizing it would have been, in the summer of 1770, to imagine a city full of people making, seeing, buying, and talking art with the intensity Bostonians brought to politics.

Copley began his likeness of Greenwood's mother as soon as he was able. The result of their collaboration is an extraordinarily acute portrait, even by Copley's penetrating standards. The magic of the picture lies in the unflinching attitude toward age that the sitter and the artist appear to share. Certainly Copley had spent a lot of time studying his mother,

who was about the same age. The palette is autumnal. Mrs. Devereux's
skin is lined, her eyes pouched and careworn. She projects gravity and
modesty, though her hands, strong hands, radiate competence. There is
no feint toward piety or industry: no Bible, no needlework. Her gaze
appears reflective, like the polished mahogany table upon which she rests
her elbow, a surface not unlike the one Copley had used in his bravura
exhibition portrait of Henry Pelham five years earlier.[84]

"I am now painting a portrait of Mr. Greenwood's Mother for him,
which he designs to place in the exhibition Room," Copley told West
in November 1770, about two months before the picture was ready to
ship. Eager to return to the world of exhibitions under the most favorable
guise possible, he wondered whether he might elevate Mrs. Devereux to
the realm of allegory by pairing her image with a portrait of a child, "to
contrast that Picture of a subject in the Evening of Life with one in the

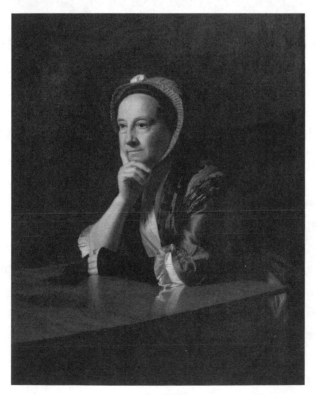

Copley, MRS. HUMPHREY DEVEREUX, *1771*

Bloom of youth."[85] Candidates for a picture of youth remained scarce, but he mentioned to West one possibility—a likeness he had painted of Nathaniel Barber's four-year-old son, which earlier that fall had been sent to London, to the man after whom the boy was named: that apostle of liberty John Wilkes. (Wilkes Barber had younger siblings named Oliver Cromwell and Catherine Macaulay: a nursery full of little republicans.)[86] Upon receipt of Copley's canvas, Wilkes had expressed his delight in the picture of his "dear namesake," extolling "the merrit of the Work" as evidence that New England had come to rival the home islands "in every essential good": in virtue, in ardor, in liberty, and now in "the most elegant art of Painting."[87]

Copley would have been edified by the praise of so renowned a man, a champion of British liberty and a particular hero of the American cause.[88] But his terror of politics vied with his hunger for fame. "I beg you will do what you shall think best," he told West, for "the party spirit is so high, that what ever compliments the Leaders of either party is lookd on as a tassit disapprobation of those of the other." It would not do to earn accolades from radical Whigs while alienating their Tory opponents. "Tho I ought to be considered in this work as an Artist imploy'd in the way of my profession, yet I am not sure I should be," Copley went on. "I am desireous of avoideing every imputation of party spir[it], Political contests being neighther pleasing to an artist or advantageous to the Art itself." He preferred not to exhibit it "if there is the Least room to supose it would give offence to any persons of eighther party."[89]

All winter long, Copley must have fretted about the promise and the perils of exposure the spring exhibition represented. West did not reply until June, after the show was done; Copley wouldn't have received it until August. His letter was clipped, breezy. "Your Picture of Mrs. Greenwood was exhibited and did great honour. The other Picture you mentioned I have not seen but I hear them much spoke of." So much for Copley's inner turmoil about the art of politics. "The arts Continue to receive great in Corragement," West offered. "London at preassent seems to be the onely

place in Europe where a man is rewarded for his productions in the Art of painting."[90]

Copley's *Mrs. Devereux* may indeed have done him great honor, as West said, but the picture attracted no printed notice whatsoever, a silence nearly as stinging as the one-sentence denunciation of his last public performance some three years before. Indeed, by 1771, the Society of Artists of Great Britain's spring exhibition had itself become something of a sideshow: its audience split with the competing exhibition staged by a rump group calling itself the Free Society of Artists, and eclipsed utterly by the third annual exhibition of the Royal Academy, a group with such close ties to its sponsor, the king, that its president, Joshua Reynolds, had lately been knighted. Rumors held that West, like Reynolds a founder of the new academy and part of its inner circle, would be likewise honored. Those rumors proved premature.[91] Nonetheless, an entirely disproportionate share of the great encouragement of the arts West described had gone to him that spring.

One of the pictures West showed at the Royal Academy's exhibition had utterly engrossed both the crowds and the critics. Among the first history paintings to feature contemporary rather than classical costume, West's *The Death of General Wolfe* depicted the heroic battle on the Plains of Abraham that had cemented Britain's stunning victory in the Seven Years' War. West later recalled that when King George heard the painting was in the works, he deemed it "very ridiculous to exhibit heroes in coats, breeches, and cock'd hats." Modern dress might be suitable for political prints—for ephemera—such as Pelham's and Revere's dueling images of Boston's so-called massacre. But history painting was for the ages. Reynolds, ever the apostle of the transcendent over the documentary, told West that "the classic costume of antiquity" would prove "much more becoming the inherent greatness of [the] subject than the modern garb of war." West held his ground, talking back to the great Sir Joshua as he had to the king himself. "The subject I have to represent is the conquest of a great province of America by the British Troops," he said. "It

is a topic that history will proudly record, and the same truth that guides the pen of the historian should govern the pencil of the artist."[92]

West did not mention how pregnant the topic would have been in 1770 and 1771, when the fate of America was talked of nearly as much in London as in Boston. Where Copley startled at the whisper of politics, West found within the rocky road of imperial conflict the smooth and easy path of opportunity. His epic canvas celebrates the empire of 1763: the realm now so hotly contested. British army and naval officers achieve the ultimate victory alongside Scottish Highlanders and leather-stockinged provincials. A Mohawk warrior, posed as a classical statue but with almost fetishistic attention to his costume and ornament, extends the bonds of imperial unity felt so strongly, and celebrated so universally, even in Boston, just a decade before.

West recalled the skeptical Reynolds sitting rapt before the large canvas "with deep and minute attention for about half an hour" before declaring, "Mr. West has conquered. He has treated his subject as it ought to be treated. I retract my objections I foresee that this picture will not only become one of the most popular, but occasion a revolution in the art." The account is self-serving, but it is not entirely fanciful. Well known even before it left West's studio, *The Death of General Wolfe* became a sensation. William Pitt sat in front of the canvas long enough to study it minutely.[93] David Garrick, frequent subject of Reynolds's brush and the leading light of the London stage, acted out part of West's tableaux in the exhibition room in tribute. The king, who sometimes knew when he was wrong, ordered a copy for the Royal Collections, slightly larger than the original, for an astonishing £400—more than Copley made in a good year. And shortly thereafter, George III brought the American Raphael into the Hanoverian court, offering him a sinecure as History Painter to the King, with an annual stipend of £1,000.[94]

Talk of West's towering achievement in *Wolfe* preceded the painting's exhibition, and may well have reached Copley's ears by January 1771, when he finally sent John Greenwood his mother's portrait. "It gives me great pleasure to find the Arts travill[i]ng Westward so fast," he wrote,

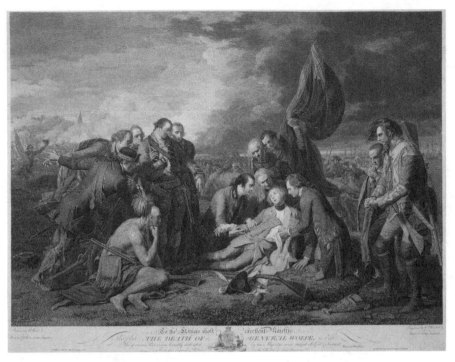

William Woollett after Benjamin West, THE DEATH OF GENERAL
WOLFE, *1776 (1771)*

responding to Greenwood's comments about the English art world. The
news gave him "hopes they will one Day reach this Country[,] how-
ever destitute at present it appears of every affection for them." He told
Greenwood, "I sincerely rejoice in Mr. West's successfull progress toward
the summit of that Mighty Mountain where the Everlasting Lauriels
grow to adoarn the brows of those Elustrious Artists that are so favourd
of Heaven as to be able to unravel the intricate mazes of its rough and
perilous Asent."[95]

Copley's flowery encomium is naïve and slavish, a poignant provincial
imitation of the rhetorical flourishes of the treatises on art that made their
way to Boston.[96] He said he was thrilled to hear of West's attainment,
and perhaps he meant it. He also seems acutely aware of the intricacy of
the mazes West had mastered, and the perils of the climb he had made,
a journey at once so necessary and so treacherous.

"A STUDENT unacquainted with the attempts of former adventurers, is always apt to over-rate his own abilities," Joshua Reynolds warned the members of the Royal Academy. The artistic provincial tended "to mistake . . . every coast new to him, for a new-found country. If by chance he passes beyond his usual limits, he congratulates his own arrival at those regions which they who have steered a better course have long left behind them."[97] This was Copley's British American dilemma: to leave or to be left behind, secure in his limitations, blind to his faults, powerless even to apprehend how far ahead others had raced.

⌐ Chapter Six ⌐

THE TYRANNY OF LIBERTY

FTER WAVING OFF so many invitations to travel—West's and Bruce's and Greenwood's repeated pleas to visit Europe; entreaties to make painting tours of Quebec, Halifax, and Barbados, all of which belonged to what Copley and his countrymen understood as greater New England—Copley and Sukey lit out for an extended stay in New York City. The invitation was longstanding, and had emerged from the circle of military patrons who sat to him during General Gage's trip to Boston. Shortly after the Boston massacre, Gage's adjutant, Captain John Small, wrote to remind Copley how ardently fashionable New Yorkers wished for *"Even* a Short Visit from you: Indeed I dare say they might undertake to bespeak you for several Years Employmt at this place alone."[1] By the spring of 1771, Copley was working with Captain Stephen Kemble, Gage's brother-in-law, who, like Small, had attended the general in Boston, to fill out a subscription of eager sitters in New York. The fees Copley quoted—forty guineas for a full-length portrait, twenty guineas for a half-length, and ten guineas for a kit-kat or bust-sized picture, with a supplement for painting children, "because of the addition of hands" that was inevitable in a portrait of a subject too small to fill the frame without them—were considerably higher than those he could charge in Boston.[2]

Copley had every reason to believe that the people of New York would bear the increased tariff. By 1771, the city on the Hudson outshone the metropolis of New England in every realm but godliness. New York was

richer, denser, and more dynamic, with a population of nearly 22,000 when Copleys' coach rolled into town, an increase of nearly 65 percent since the beginning of the Seven Years' War. (Boston had grown barely 5 percent in that time.) Crowded into a few dozen gridded blocks near the southern tip of the island called Manahatta by its aboriginal inhabitants, New Yorkers were more urbane and more polyglot than Bostonians. Low-country accents, Dutch surnames, and styles of housing imported from the Netherlands offered a constant reminder of the city's beginnings as New Amsterdam. New York was tall: four stories high to Boston's two or three. It was built chiefly of brick and stone, while Boston was substantially made of wood. The city was opulent and extravagant—even, from the perspective of Boston, licentious. New Yorkers relished horse races and gambling. They flouted the Sabbath and frequented the playhouse. New Yorkers drank more and prayed less. No wonder Copley's mother cautioned him not to "Lett the Gayeties and Pleasures of New York" threaten his health.[3]

The streets of New York also ran redder than Boston's; the army's vermillion was everywhere. Since the great British victory in the last war, large numbers of military men had been stationed at Fort George, the star-shaped citadel at the base of Broadway, below the Bowling Green. Whereas Boston's Castle William was an island redoubt, removed from the city, Fort George was in many ways the heart of fashionable New York. The soldiers and sailors quartered in Manhattan occasioned less contention than the regiments sent to Boston in 1768, for New York's companies were generally viewed as part of a continent-wide peacekeeping force, rather than as occupiers sent to suppress an uprising of the townsfolk. As in Boston, his majesty's troops jockeyed for jobs with local laboring men. But in New York, soldiers' demands for housing also created work, especially in the construction trades. General Gage, the commander of the forces stationed in the city and of all the regular troops on the continent, was generally beloved by elite New Yorkers. He lived, in grand style, on Broad Street, two blocks from the fort, with his wife, the former Margaret Kemble, a celebrated beauty and renowned hostess.

She was the first to subscribe for a portrait by Copley, headlining a list studded with the names of officers, political leaders, great landowners, and their glittering wives.[4]

Copley planned to leave Boston in late May and to return in September, devoting the longest, lightest days of the year to New York sitters. He thought he could execute "12 or 15 half Lengths"—roughly one per week—or a proportionate number of smaller or larger canvases, a rate of production and a set of calculations that sound almost industrial. Before Copley and Sukey headed south, Captain Kemble had lined up a dozen sitters and promised "as many more . . . as your time will permit you to take."[5] With that much income assured, and with Sukey's dowry clearly plentiful, Copley contracted with a housewright named John Joy to complete an extensive remodeling of his houses above the Common, which would involve building a barn with space for horses and cows, digging new foundations for two of the extant houses, moving the easternmost (or "upper") house, and transforming the central property into what the legal documents describe as a "great house," with all the appropriate trimmings. The project employed a battalion of craftsmen: diggers and carters, bricklayers and stonemasons, carpenters and turners and cabinetmakers, braziers and ironmongers, plasterers, paperhangers, and painters. With his customary precision, Copley estimated that the labor and materials would cost £519, with £100 to be paid up front and installments as the work progressed.[6] He received permission from the selectmen to extend the tree-lined promenade from Hancock's boundary line to the water's edge.[7] And then he and Sukey packed up their trunks and set out in a carriage, leaving behind (after Copley's many protestations of his "bondage" to family) their infant daughter, their siblings and parents, and at least two of their young slaves, Snap and Lucy. It is likely that Cato attended them on the journey.

The Copleys reached New York on 13 June, after a trip that the painter pronounced "delightfull beyond all expectation. Our Horses held out wonderfully well and brought us with great spirit forty Miles the last Day of our Journey"—that one day's travel alone a farther piece than Copley

had wandered in his thirty-three years. He told Harry that the adventure had "contributed a great deal to my looks," perhaps raising his color. "I cannot say Sukey has improved so much in looks as myself," he continued, "tho she is very well." Their lodgings in New York were "very comodious," though stabling the horses proved "so expencive" that he planned to send one of them back. He had seen just enough of the city to report that it "has more Grand Buildings than Boston, the streets much Cleaner and some much broader." New York had monumental public sculptures where Boston had only effigies; Copley had "seen the Statues of the King and Mr. Pitt, and I think them boath good." On balance, though, he prounced New York "not Boston in my opinion yet." In any case, there was little time for sightseeing. Copley concentrated his energies on readying his rooms for sitters; Mrs. Gage was to attend him shortly. He asked Harry to send his pastels, his "Drawings" (possibly the anatomical sketch book of 1756), and his layman, the mannequin he used for modeling drapery. Once the work started, he "would not be able to do long without them." He also called for "some Gold Buttonholes" that Harry would find in Copley's desk drawers; there was a lot of military braid among the residents of Gage's enclave, and his portraits would need to replicate it.[8]

Separation is a bane to kin but a boon to historians. While the Copleys remained in New York, for several months longer than they planned, letters sped to and from Boston in a matter of days, giving their exchanges a very different rhythm from the three-month round-trip that marked correspondence between Boston and London.

There are glimpses, thanks to these months of absence, of everyday life. From Boston, in late July: Harry has seen Betsy, a bouncing girl of eight months, "excellently tended" by a wet nurse in the countryside; she "has got two teeth and cuts them very easy." Three months later, Copley's "fine Girl . . . is almost able to walk alone." While Betsy grows in great spurts, Mrs. Pelham, their "honor'd Mamma," is always much the same: "in very tolerable Health for her," or "as well as can be expected for her." Their larder comes into view: the potatoes planted above the Common the previous spring yield eighty bushels, "and most excellent ones they

are," Harry reports after the harvest. He asks Copley to send him "a Barrell of Newton Pippins and a Barrell of the fine New York Water Mellons."[9]

From New York comes vague mention of the "great sivility" extended to the Copleys, and an account in "minute detail" of their daily routine: rising at six, breakfast at eight, and at "our respective Labours till 3, when we dine," and "at six ride out." Of their work: "Sukey . . . is imployed in working on muslin, and myself in the Labours of the pencil." Copley describes a feast of pineapple, cheap at seven pence apiece. (Harry says they can get them for tuppence in Boston, "and excellent Fruit too.")[10] He asks Harry to fetch from Sukey's trunk of linens "the suit of Black" that Mrs. Pelham had given her; her sister-in-law had died, and "as we are much in company . . . her other Cloaths are mostly improper for her to wear, as she must put on some little mourn'g."[11]

There are hints of tension between the brothers: Copley is often inattentive, Harry perpetually disappointed.

"Write often and send no blank Paper," Harry urges in June. "I must before I conclude remonstrate against your not writeing," he adds two weeks later.[12]

"You must not expect I should sett up so late to night as to fill up this whole paper, for We propose rising so early tomorrow Morng. as to take a ride before Breakfast," Copley answers.[13]

In response, Harry mocks his fashionable brother: "You tell me, You must not expect I should sett up so late to night as to fill up this Paper. That is very clever indeed! not write for better than three Weeks, and than tell me I must not expect etc., etc. Yes, dear Sir, I will expect severall Things: that you won't sett up late, that you will write often, that you will send no blank Paper (I repeat it for all you sneer about a Letter's being couvered)."[14]

Harry chides Copley for neglecting to ask after his daughter: "I am very much affronted that you made no Inquiries after my dear little Neice. I suppose you have forgot her, therefore I don't address the Paragraph to you but to my Sister," as he called Sukey.[15]

Copley chides Harry for chiding: "you have a good talent at scolding which you have well improved, and wraught up in that Letter."[16]

Harry turns tables: "I think my self very happy in possessing a talent, which, is so very neacessary and usefull," and which had, after all, finally produced a reply.[17]

There seems to be a deeper worry beneath Harry's barbed brotherly joking: a fear that it might be hard to keep Copley home once he had seen New York, on this "Summer abroad," as Harry called it. In September, the newly cosmopolitan Copley began to sign his letters "Adieu."[18]

There is, of course, talk of art, usually its business end. A week after he arrived in New York, Copley reported that "painting much engages the attention of people in this City and takes up all my time." Their rooms were large and airy—"about 9 feet high and 20 feet long and near as broad, with a good room ajoining it, the ligh[t] near north." He quickly got to work lining the walls: three canvases begun by June 20, eleven in progress by mid-July. Copley asked the owner of one of his Boston portraits—likely one of Gage's officers, painted back in 1768—to bring the picture to his chambers, so that New York sitters could see the quality of his product. Since he was "visited by vas[t] numbers of People of the first Rank, who have seen Europe and are admirers of the Art," he told Harry, "I was glad to have a Picture so well finish'd. Most of them say it is the best Picture they ever saw." His production was relentless. "I beleive you will think we take a good share of pleasure," he wrote, somewhat defensively, "but I find I can do full as much Business as in Boston, having no interruptions and very Long forenoons, and punctually attended."[19] "The Pencill goes on very briskely and I have no time," he jotted in late July. "I hardly get time to eat my Victuals," he wrote a month later. "I find it a great work to finish so many pictures, as I must do every part of them myself," he said in September, the days growing shorter. And everything must be so "well finishd": "the Gentry of this place distinguish very well, so I must slight nothing."[20]

"I must work like a Beaver," Copley said. He reckoned his time in gold: "I have began Painting to the amount of 3 hundred pounds Sterg.

Shall take four more and than Stop." He reckoned his days in pictures: "thirty Busts in 20 Weeks." In November, he began to turn away commissions. When he completed all the work he had accepted, the tally would come to "no less than 37 Busts," he told Harry in December, as he prepared to head back to Boston.[21]

About these three dozen likenesses Copley offered few specifics, though on balance he thought he had "done some of my best portraits here." Among them were ladies in silk, merchants in velvet, and at least one little boy with a squirrel. He painted Gage's officers in full scarlet splendor. He got to know one of them, Captain John Montresor, well enough to ask him to ferry letters to Boston. Born in Gibraltar, Montresor was a child of the army who rose through his service in the American theater of the Seven Years' War. A member of the Royal Corps of Engineers, he served as a surveyor and draftsman, and had drawn a likeness of the late lamented General Wolfe that was recognized as especially fine. When Gage dispatched Montresor to Boston to oversee the renovation of the fortress at Castle William, Copley introduced him to Harry as "a Gentlemen we have received great Civility from," and hoped the captain might comment on the finer points of construction on Mount Pleasant.[22]

Perhaps, when Montresor sat to Copley, he answered stories of Boston's tumults with tales of the upheaval New York had witnessed during the Stamp Act protests. The merchant-gamblers in the coffeehouses near Wall Street had covered their backgammon boards and even their dice in little black crepe shrouds. This to Montresor was the height of hypocrisy, for the Sons of Liberty wanted both their American pieties and their British luxuries. As soon as the Stamp Act was repealed, he noted, they shed "their Home spun clothes, and supposed only to remain with Homespun hearts." He peppered his journal with nicknames for the rebels, mocking the Sons as "the Libertines" or "Spawns of Liberty and Inquisition." Both the captain and the painter detested the specter of mob rule. Copley depicted his friend pockmarked and careworn, with storm clouds gathering behind him: a battle-weary veteran with no relief in sight.[23]

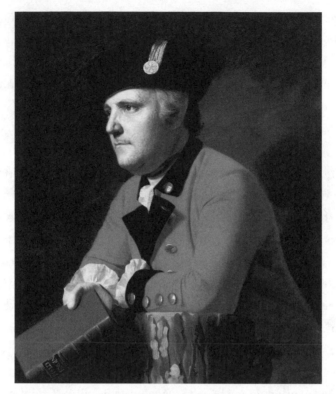

Copley, COLONEL JOHN MONTRESOR, *1771*

Montresor shares its subject's contemplative aspect with the New York portrait of which Copley professed himself proudest: his bravura picture of Margaret Kemble Gage, the general's wife, painted at half-length, in fanciful Turkish costume. The sitter reclines in seeming reverie: a clothed odalisque, an American sultana. Copley thought it "beyand Compare the best Lady's portrait I ever Drew," he told Harry, without a trace of false modesty. Matthew Pratt, painter of *The American School*, who had returned to the provinces after his stint in London, saw the picture in New York and told Copley that it would "be flesh and Blood these 200 years to come, that every Part and line in it is Butifull." Pratt suspected that Copley must get his "Ideas from Heaven," a compliment especially pleasing to an artist who was repeatedly faulted for excessive fealty to what was in front of him. Mrs. Gage agreed to part with the picture for a season; in November, Copley told Harry he had shipped it to London

for the spring exhibition. The following year, the Gages would join it in England, where it would remain, "flesh and blood," for nearly as long as Pratt foretold.[24]

While Copley beavered away at the easel in New York, Harry kept the books, totaling up his brother's earnings, logging the art supplies ordered from London, sending him glass and frames sufficient to complete the tour. But he longed to talk of Art as well as sums. He submitted his own fledgling efforts—"I have been exerciseing the Pencill. . . . I have been trying to etch a little thing, an Impression I Inclose"—and received no response. He hankered after scraps of description of what Copley had seen. "You say you have seen two of Mr. West's Portraits," Harry wrote. "Let me have some Account of them."[25]

Only once during his six months away did Copley satisfy his brother's yearning for discussion of the practice of painting. After spending a

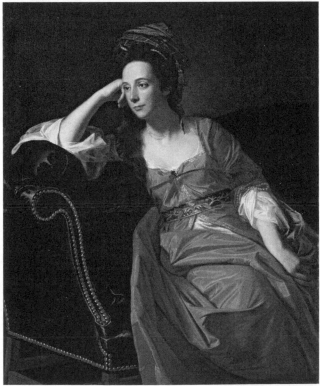

Copley, MRS. THOMAS GAGE *(Margaret Kemble), 1771* [Plate 9]

fortnight in Philadelphia, where a letter from General Gage introduced him to Chief Justice William Allen, Copley reported in some detail about Allen's collection, which included copies after the old masters that he pronounced "beyand any Picture I have seen." In those works, the instructions Copley had read in West's letters became flesh: "there is no minuteness in the finishing; everything is bold and easey," he wrote, parroting the critiques leveled against him. "I must observe had I Performed that Picture I should have been happrehensive the figures in the Background were too Strong." (Copley does not mention, and perhaps did not know, that these copies had been painted for Allen in Italy by his protégé Benjamin West.) On their ride back to New York, Copley and Sukey stopped in New Jersey to see a group of Van Dyck portraits. He asked Harry to research the date Van Dyck had arrived in England, which set him rummaging—fruitlessly, it turned out—through Copley's collection of books on art.[26]

While Harry hung on his brother's scanty, secondhand reports of what he had seen and done, Copley was preoccupied with another topic entirely: the renovation of the houses above the Common, and the progress of the lawsuits brought by the ancient claimants of the cloudy title Chardon had granted him. The demands of his painting tour notwithstanding, no detail of the construction escaped Copley's attention. As his time in New York progressed, his architectural horizons enlarged, and his vision of the grandeur of Mount Pleasant inflated in turn. "If it is not two late I should like to Direct how to make the Sashes somthing different from what is usual with you"—with *you* in Boston, not with *us* in New York—he wrote to Harry after barely a month away. "A pattern of Chinese for the Top of the house I will send you, as I think they excell in that way here." He devised a plan to "add a peazer when I return, which is much practiced here, and is very beautiful and convenient."[27]

"I dont comprehend what you mean by a Peazer," Harry answered; "explain that in your next."[28]

Though Copley's letters about everything else were dilatory, he responded immediately, exhaustively to Harry's questions about the

house. "You say you dont know what I mean by a Peaza," he wrote, only five days after Harry posted his letter in Boston. "I will tell you than. it is exactly such a thing as the cover over the pump in your Yard, suppose no enclosure for Poultry their, and 3 or 4 posts aded to support the front of the Roof." His exegesis on the "peazer"—a phonetic spelling of piazza— included drawings and specs down to the width of the scantlings. Copley simply must have one: "these Peazas are so cool in Sumer and in Winter break off the storms so much that I think I should not be able to like an house without," he wrote.[29]

With every letter from New York came more additions to the original plans. Copley sounds headlong, heedless, even manic. After decades of strenuous economy, he grew shockingly extravagant. There must be more windows, everywhere: Three in the kitchen, "Otherwise it will be Dark." Two more in his painting room, "to keep it cool and pleasant when it will be convenient to open them." His windows should have "new fassioned Blinds such as you see in Mr. Clarke's Keeping Room." He fretted over the closets and the wainscoting, the fanlights over the front door and the curve of the ballustrade, the relative advantages of locust trees and lindens for his planned allée. He declared himself "long Ancious" over the "roomlyness" of the hallways, especially "the hight of that which leads to my great Room. I hope you will take care of it, as you may ruin the House by a mistake in that."[30] Harry gave over his summer to serving Copley and his runaway project, drawing and redrawing plans, once even narrating a walk-through by letter. ("To make the thing as plain as possable, let us take a Walk up stairs.")[31]

Copley never supposed that any of the changes he ordered would substantially increase his costs. "I think it cannot be much," he said of the piazza. He was stunned to discover his mistake: the parsimonious Yankee rudely wakened from a dream of New York opulence. He told Harry to cut corners, especially in the upper house, which he intended for his mother. Behind the woodstove, painted plaster would suffice instead of granite jambstones, he said, "and your Mamma will never make fire in the Best room; so plaster will do as well their too you must please

our Mamma, but you know my plan is frugallity."[32] But his frugality came too late when it came at all. Costs mounted and delays multiplied. By September, it became clear that neither house could be made habitable before the winter.[33]

Copley and Sukey and perhaps Cato left New York on Christmas Day, planning to travel slowly, Copley said, in order "to take so much care of ourselves." Harry likely recognized this for the code it was; Sukey was four months pregnant. They arrived back in Boston on 3 January, riding into the teeth of another brutal winter. ("The Ink Freezes as I write," John Rowe noted in his diary.) In March, as the snows melted, Copley's lawyers vanquished the Bannister heirs and he took title to the grand new houses that made up the estate of Mount Pleasant.[34]

There he found waiting a stack of contractors' bills. As one legal battle ended, the next began: John Joy filed suit to recover costs of nearly double what he and Copley had agreed upon. Piazzas did not come cheap.[35]

When Copley left Boston for New York, the war whoop of politics had dulled to a whisper. The soldiers were gone from the Common. All but one of the hated Townshend duties—the taxes that fueled the outrage that provoked the occupation that begat the "massacre"—had been rolled back. After news of the repeal reached the colonies, the nonimportation movement, which needed two parts coercion for every part passion, began to crumble.[36] It had largely collapsed by late October 1770, when the last of the soldiers charged with the murders on King Street went to trial. Passion was the enemy of justice, insisted Samuel Quincy, the colony's solicitor general, who had been tapped to prosecute Captain Preston, the officer in charge at the time of the massacre. "The prints exhibited in our houses have added wings to fancy; and in the fervour of our zeal, reason is in hazard of being lost," he warned the jury. In the end, cool reason triumphed over the heat of Pelham's and Revere's images. Most of the soldiers were acquitted; the two found guilty of manslaughter got off with branded thumbs.[37]

After the trials, the customs men returned from their months in "Exile at the Castle," as Commissioner Henry Hulton's sister Ann put it. The "Sons of Violence" had retreated, she wrote in December, "& the past Scenes of confusion & disorder, appears as a dream." In January 1771, Bostonians who had previously found themselves at loggerheads came together to celebrate the queen's birthday with a "Grand Assembly" that included acting governor Hutchinson, the customs commissioners, the captains of the army and the navy, and "all the Best People in town—A General Coalition so that Harmony Peace & Friendship will once more be Established in Boston."[38] For some radicals, harmony and friendship remained too much to ask. But peace prevailed. "I cannot flatter you that Faction is extirpated out of North America, or that Acts of Parliament will not be opposed, but We are free from Tumults and Mobs," General Gage told his superiors that July. It is telling, in this regard, that almost no mention of the imperial struggle invades the Copley-Pelham correspondence during the painter's seven months in New York.[39]

The end of the nonimportation agreements boosted the fortunes of many merchants and traders, Copley included. None benefited more than his father-in-law, Richard Clarke, who had joined the boycott late and grudgingly, and left it early and happily. When the Copleys' carriage departed for New York, bins of fine hyson, souchong, and bohea tea again lined the shelves at Clarke & Son on King Street.[40]

First introduced in New England around 1690, tea had become a regular presence in polite households by the time Copley was born. Indeed, tea and politeness went hand in hand. To serve it properly required money, know-how, and leisure. Taking tea was cosmopolitan; tea leaves came from the East Indies via London and Amsterdam. The brew was sweetened with sugar grown in the Caribbean, steeped in pots of silver mined in the Andean highlands, served in ceramics from Europe or porcelain from China, upon tables of mahogany cut in Brazil. Where coffee was masculine and public—the coffeehouse, famously, was known as a penny university—tea was feminine and domestic. Coffee was disputatious; tea, luxurious, almost decadent. "The ladies here visit, drink

tea, and indulge every little piece of gentility, to the height of the mode; and neglect the affairs of their families with as good a grace as the finest ladies in London," wrote one traveler to Boston in 1740.[41] As the century wore on, the everyday luxury of tea overspread British America; by the 1760s, the colonies were importing, by hook and largely by crook, nearly a million pounds of tea per year. One mid-Atlantic merchant reported that "the Practice of Tea Drinking, is so prevalent that the Tribes of the Mohocks and Cononjohare Indians . . . drink it frequently twice a Day, as do many of the Delawares."[42] The enormous popularity of tea was one reason that Parliament levied a duty on it; even though most tea consumed in the provinces was smuggled, a small levy on legal imports stood to raise significant revenue.[43]

Upon the passage of the Townshend Acts in 1767, the symbolic valence of tea reversed. Where taking tea had affirmed settlers' Britishness at the ragged edges of a vast, dispersed empire, forswearing the beverage suddenly came to incarnate a new provincial identity at loggerheads with that empire. Especially after the arrival of the troops in Boston late the following year, tea became the central focus of nonconsumption. The *Boston Gazette* urged "ye fair ones"—tea-sipping ladies—to "deny yourselves this foolish Custom." Days after the troopships landed, the students of Harvard College elected, "with a Spirit becoming Americans . . . to use no more of that penicious Herb TEA." Some fifteen hundred families in Boston and several neighboring towns likewise took the pledge.[44] One of Richard Clarke's suppliers mocked "the Vigilance of our worthy Patriots, who are as assiduous in detecting & removing any trifling package [of tea], as if all the Evils of Pandora's Box were inclos'd, or the Fate of Empires depending."[45]

When Lord North repealed the duties his predecessor had imposed upon the American provinces, the levy on tea was the only one left standing, both as a symbol of Parliament's right to tax the colonies, and a source of badly needed monies for the straitened British treasury. Some patriots continued to see the evils of Pandora's box in every teapot. But Americans wanted their tea. Imports quickly rebounded to pre-boycott

levels. In 1771, Clarke & Son imported over seven tons of tea: more than 5 percent of all the tea shipped to all of New England that year, and about enough to provide every man, woman, and child in Boston with a strong cup every day.[46] If Mount Pleasant was the estate that Sukey's portion of Clarke's fortune built, then Copley's grand house rested upon tea leaves.

For a time after the Copleys' return to Boston, that foundation held firm. Spring came to Mount Pleasant. The locusts and laurels and fruit trees so carefully chosen burst into bloom, a shower of fragrant pinks and whites.[47] In May, Sukey gave birth to the couple's second child, a boy named after his father. John Singleton Copley Jr. likely had a wet nurse, either at home or in a salubrious country town like Roxbury, as his sister, Betsy, had.[48] It is quite possible that their nursemaid was enslaved. That summer a patron from Newport wrote to Copley to commend the painter's portrait of his wife, which he called "the most natural and just painting I have seen of yours." He urged Copley to try his hand at something more ambitious: a genre picture, centered on "a Child in the Cradle, sick," tended by a fretful mother. He could use his "wife and child" as models, and add contrasts of color and texture by including a "nurse old and black of complexion," a "Physician long visaged, covered under a hideous wig," and an "eligantly dressed" young woman looking on, "all, in a bed Chamber with such furniture as to show" the family's "genteel rank."[49] The narrative was pure invention, but any of its elements might have been plucked from Copley's Mount Pleasant.

Reunited after their sojourn in New York, the Copleys and Pelhams exchanged few letters. The fleeting glimpses that survive of life on Mount Pleasant hint at a whirl of sociability centered on Sukey and her sisters. A chattering letter from the youngest of them, twenty-year-old Lucy, describes visits with neighbors, blushing exchanges of intimacy with some of the "smittin" Boston cadets who drilled on the Common under Colonel John Hancock, and a secret missive relating hidden crushes ("don't carry this letter in your pocket").[50] Politics stayed in the background. We "are quite tire'd a hearing the Bell ring" to announce one mass meeting

or another, Lucy told her brother, away in Newfoundland. She worried he might think it "a little out of my Province" to have commented, even indirectly, on imperial affairs. "I think you told me . . . that enquiries of this Nature were not becomeing to young Ladies," she wrote.[51] The ladies were expected to retire when the talk turned to tariffs and protests. Cato and Snap would have attended Mrs. Copley and her guests at a tea table supplied with brews from Clarke & Son, their bright livery a signal of the Copleys' unfettered ease.

While Sukey and her sisters took tea with the wives and daughters of the great and the good in the parlor, Copley busied himself upstairs at the easel, each spouse's work in the œconomical household bound up with the success of the other. The usual parade of merchants and ministers, brides and Brahmins trooped to Copley's airy new painting room, with its shuttered windows facing the pastureland that sloped down to the Charles River. Tributes flowed in, from the colonies and once again from London, where three of Copley's paintings hung in the Society of Artists' spring exhibition, including the portrait of Margaret Kemble Gage that the painter himself deemed a masterpiece. Benjamin West wrote to say that the picture had "received every praise from the lovers of arts." Mrs. Gage's friends thought the portrait didn't much resemble the sitter, but no matter; in London, verisimilitude was but one element of artistic success. Even those who quibbled with "the likeness" had "Honour'd [the portrait] as a pice of art," West explained.[52]

In Boston, though, likeness remained the alpha and omega of the portraitist's skill. William Carson, a Rhode Island patron, wrote to say that his wife's painting had arrived in Newport in "good health and beauty," as if he were describing the woman herself. He loved to stare at it. "I discover new beautys every day, and what was considered as blemishes now, raises the most exalted Ideas of the perfection of the Painter 'and painting to the life.'" Carson thought that Copley had, of yet, scant idea of his own gifts. "You are unknown to the world and yourself," he said. "Rise but in your own opinion, and you will attempt something worthy of yourself, and then every judge will bestow on you that applause which you justly

merit." Copley's exchanges with West, with Peter Chardon, and especially with Harry reveal that he was neither so modest nor so unworldly as Carson supposed; the painter's studied deference toward his patron must have proved all too convincing. Nonetheless, Carson clearly sensed Copley's hunger for more. "A painter of faces gains no reputation among the multitude, but from the Characteristick strokes in the outlines," Carson said. "To gain reputation, you should paint something new."[53]

The trip to New York seems to have liberated Copley from his perpetual agonizing indecision. In the summer of 1772, while the grass grew high in his meadows, or early that fall, before the potato crop came in, Copley began in earnest to plan a trip to Europe. He would journey first to Italy, routing through Leghorn on a commercial vessel, much as West had done a dozen years earlier. (Copley's cargo would be New England salt cod, rather than the smuggled Caribbean sugars that accompanied West east.) He would settle in Rome, where art abounded and living came cheap. Sukey's brother Jonathan, who had recently arrived in London and taken a flat amidst the printers and the bankers in St. Paul's churchyard, estimated that Copley and his wife could live in Rome "genteely for about one hundred pounds per Ann." This was but a fraction of the cost of life in the English capital, where money evaporated all too quickly and, Jonathan quipped, "you Sons of Liberty will find some times without your consent." Boston patriots, he knew, demanded an unusual level of power over their purse strings.

Jonathan also passed along West's advice that Copley leave Sukey in Boston for the eighteen months or two years that a proper grand tour would take; "the attention so good a wife will require from so good a Husband" would necessarily "retard" the painter's "pursuit of the grand object" during "the most important period of your life." He thought this was bunk; "perhaps Mr. West does not know what little trouble your wife will be," he said. His own concern was of a different order: he worried that Copley and Sukey would not return to America. "All the objection we can have to our friends traveling is that after they have been some time abroad and much improved themselves, and been used to the society of Men of

Literature and attached to the polite arts, upon their return they find our young Country don't furnish a great number of the same relish and therefore are obliged to seek them in older Countrys where it is reasonable to suppose they more abound." By the resulting drain of talent, "our Country is check'd in its improvement." Jonathan expected "better things" of Copley "than a disposition which is rather selfish." The painter should tour Italy and then resume his life in Boston, their "native Country," much as he himself planned to do once the press of commerce relented.

Jonathan Clarke's letter, sent via South Carolina in December 1772, didn't reach Boston until the following March.[54] By the time Copley received it, his plans to sail were firm. Sukey's sister, writing from Philadelphia, asked "wether Brother Coply holds his intention of going Abroad in the Spring" and learned that he was set to depart some time after July.[55] Elected for the second time to town office, Copley informed the selectmen "that he was about leaving the Province for some time" and excused himself from service.[56] In June, he borrowed £600 against his landholdings: exactly the amount that Jonathan said would fund a year in Italy and a year in London.[57] All was in readiness.

But July came, and Copley did not sail. Sukey was once again with child. By midsummer, she would have felt the fetus "quicken," the moment at which people of the era acknowledged pregnancy.[58] If he planned to sail with her—and the size of his budget suggests that he may have—they would need to wait until the baby was born, as they had waited on Betsy's arrival before heading to New York. And so, when Boston politics revived in full splendor, Copley was there. By then, the manifold blessings of his happy union with Sukey Clarke had been palpable to him for several years. Yet it was only in the fall of 1773 that he would discover the fateful twists of his marriage plot.

～

Shortly after Copley mortgaged his property for cash, the Boston papers mentioned a new tea bill making its way through Parliament. Its proper title, "An act to allow a drawback of the duties of customs on the expor-

tation of tea to any of his Majesty's colonies or plantations in America; to increase the deposit on bohea tea to be sold at the India Company's sales; and to impower the commissioners of the treasury to grant licences to the East India Company to export tea duty-free," was far longer than the initial reports. Americans would come to know the new law as the Tea Act. It was an enormously complicated piece of legislation, designed less to punish the rebellious colonials than to right the ship of the East India Company, which foundered on the shoals of bankruptcy. Far from adding to the colonists' tax burdens, the Tea Act actually *lowered* the tariffs on teas imported from England. With the duties roughly halved, the act's supporters hoped, the East India Company's product might successfully compete with the smuggled Dutch tea that flooded provincial markets. Vending directly to American merchants, who would vie for the privilege of serving as its "consignees," the company could sell off its huge surplus inventory. The Townshend duty on tea—the last tattered remnant of those despised taxes—was to remain in force; it would not do to give the rebels another victory until they better demonstrated their fealty.[59]

American interests in Parliament considered that decision unfortunate rather than fatal, and provincials seemed at first to agree. "When the intelligence first came to Boston, it caused no alarm," Thomas Hutchinson wrote. "The three-penny duty had been paid the last two years without any stir, and some of the great friends to liberty had been importers of tea. The body of the people were pleased with the prospect of drinking tea at less expense than ever."[60] In the summer of 1773, merchants and politicians alike focused on the profits to be made by the opening of thirsty American markets, windfalls imagined in millions of pounds of tea and sterling.

A frenzied jockeying for licenses began almost immediately. Throughout June and July, as Copley readied for his trip and then set his plans aside, the factors who traded with American tea merchants made their way to India House, the company's splendid headquarters on Leadenhall Street, in the thrumming financial quarter of London's ancient City. In this parade of hopefuls, Clarke & Son had a partic-

ular advantage: Jonathan Clarke was in London, "on the spot," as he put it in a letter to the company. He reminded the directors that his father's firm, the second-largest tea-trading concern in Massachusetts, had "always fulfilled our engagements with punctuality and honor," and remained ever attentive to "the interest of the East India Company." In early August, Jonathan received the good word that his arguments had prevailed. The company would soon dispatch six hundred chests of tea to Boston. Clarke & Son would serve as agents charged with selling a hundred of those, some forty thousand pounds by weight—one shipment containing nearly three times what the firm had imported in the entire boom year of 1771.[61]

Summer turned to fall, and as Sukey approached the date of her confinement, neither the Tea Act nor those who sought to profit from it aroused much notice in Boston. John Bromfield, the brother of Sukey's sister's husband, said some London merchants saw the scheme as yet another ministerial overreach, and were counting on the Sons of Liberty to "once more exert themselves" in opposition. Henry Bromfield dismissed his brother's fretting and grumbled that their firm, too, should have applied for a license.[62]

Come October, merchants in New York and Philadelphia began a concerted campaign of resistance to the act and the tea ships en route to America. They argued that the new law represented a thinly veiled effort to ram the last lingering Townshend duty home, while granting monopoly privilege to the East India Company. For once, Boston was late to the rebellion. On 17 October, Copley and Sukey made their way to Trinity Church to baptize their third child, a daughter they christened Mary, the name of Sukey's sister who had died in her twenties, and Copley's mother's name as well.[63]

The day after Mary Copley's baptism, the *Boston Gazette* began to inveigh against the Tea Act and its minions. The paper's printers, Edes & Gil, called out the East India Company's Boston agents, dripping poison on the familiar names of Richard Clarke and "the young Messers Hutchsinsons," sons of the increasingly despised governor. The animus

provoked by the new scheme, they said, would be sufficient to "render men much more respected than they are, as obnoxious as were the Commissioners of stampt-paper in 1765." Returning the cargoes to England, as New York and Philadelphia had already pledged to do, would send a strong signal to Lord North; the Tea Act and even the stubborn Townshend duty on "this pernicious Drug" would quickly fall. And so, the *Gazette* implored, the tea must be sent packing—and the consignees with it, for "it would be highly improper to return those great Cargoes of Tea that are expected, without sending the important Gentlemen whose existence depends on it along."[64]

This was not the first time Richard Clarke had wandered into what he called the "paper skirmishes" that had come to dominate the Boston prints. Ten days later, he took to the town's more conservative newspapers to defend himself. Signing himself "Z," he argued that objections to the Tea Act were "either founded on Ignorance of the facts . . . or are intended to delude the People." He then methodically demolished the sophistry of the protesters, offering a calm, deliberative lesson in mercantilist economics:

> Have not large quantities of Teas for some years past been continually imported into this Province from England . . . all which have paid the American Duty? How in the Name of common Sense does [the new arrangement] differ unless it be in favor of America . . . ? What consistency is there in making a Clamor about this small Branch of the Revenue, whilst we silently pass over the articles of Sugar, Molasses and Wine, from which more than three-quarter parts of the American Revenue has and always will arise, and when the Acts of Parliament imposing Duties on these articles stand on the same footing as that respecting Tea, and the Money collected from them are applied to the same Purposes?

Moreover, there was something to be gained by joining forces with the East India Company, which was, after all "a Company of Merchants incorporated under a Charter," who had "exerted themselves in favor of

Charter Privileges," much like the province of Massachusetts itself. The company's "Influence may be of great use to us in our present Controversy with Great Britain with respect to our Charter Rights": rights that Z, at least implicitly, supported. He declared himself "utterly at a loss to comprehend" the resistance.[65]

Clarke had math, law, self-interest, and common sense on his side. But reason was nothing in the face of zeal. In the wee hours of 2 November, he woke to "a violent knocking" on his front door. The servant who answered was handed a directive instructing Clarke and his fellow consignees to appear at the Liberty Tree at noon on 3 November to give up their commissions to sell the tea. The echoes of 1765 were unmistakable. "Fail not upon your peril," the note concluded, as if it were a legal summons. When Clarke left the house after daybreak, he saw handbills posted all over town—"at almost every Corner," John Rowe said—calling the freemen of Boston and neighboring villages to assemble to witness the consignees' resignation. The notice, like the missive delivered to Clarke's door, was signed "O.C. Secretary," a nod to Oliver Cromwell, avenging angel of the last English Civil War.[66]

The appointed day, a Wednesday, arrived with the customary pageantry. At eleven that morning, Clarke told his London factor, "All the bells of the meeting-houses for public worship were set a-ringing and continued ringing till twelve; the town crier went thro' the town summoning the people to assemble at the Liberty Tree." Considering the scale of the organizers' efforts, the size of the crowd was modest: about five hundred people, "chiefly . . . of the lowest rank," Clarke said. Or so he was told, for the tea merchants did not appear, nor had they "ever entertained the least thoughts of answering the summons." Instead, the consignees gathered at Clarke's warehouse on King Street, their numbers bolstered by stalwart friends: "gentlemen of the first rank," committed "to oppose the designs of the mob, if they should come to offer us any insult or injury."[67]

The mob came, led by a delegation that included Samuel Adams, Dr. Joseph Warren, and several other gentlemen who likewise had sat to Copley. The appointed spokesmen presented Clarke, the Hutchinsons,

and the other agents with an oath declaring that they would send back the tea in the very ships that brought it, and demanded that they sign or be declared "enemies of the people." The teamen refused, answering what they called an "extravagant demand . . . with a proper contempt." (*Contempt* would emerge as a key issue in the struggle; the newspapers remarked on the consignees' "haughty manner" and peremptory dismissals.) When the rebel leaders reported the results of their negotiations to the group waiting outside Clarke's warehouse, the crowd began to turn away. But then some thought better of retreating, and rushed the store in full fury. One of Clarke's supporters, a judge, made a plea for the rule of law, "declaring repeatedly, and with a loud voice, that he was a magistrate and commanded the people, by virtue of his office, and in his Majesty's name to desist from all riotous proceedings, and to disperse." But overnight, it seemed, the season of law and right order had ended. Members of the crowd pulled the doors of Clarke's store off their hinges. Others "rushed into the warehouse" and tried to break open the counting room, where the cash and documents were kept. Clarke and his allies held them off by brandishing iron window bars. Eventually the mob dispersed, and the consignees went home, shaken but unharmed, and more than ever convinced of the rightness of their arguments.[68]

Friday was 5 November, Pope's Day: the annual bacchanal during which Boston's working people commemorated the thwarting of a Jesuit plot against Parliament in 1605 by burning effigies of the pope and the devil. The selectmen called a special town meeting, "duly qualified and legally warned," in hopes that some more official solution to the current imbroglio might be reached before the tea ships landed. Faneuil Hall was packed when the meeting opened at ten, with John Hancock wielding the gavel. By midday, the assembled freemen had passed a series of resolutions labeling the tea taxes a despotic "tribute," and formally calling on the consignees to do what the crowd had demanded earlier in the week. "It is the duty of every American to oppose this attempt," the resolutions declared. Anybody who would "in any wise aid or abet in unloading receiving or vending the Tea" must be considered "an Enemy to Amer-

ica." A delegation was dispatched to wait on Clarke and his fellow agents with the signed votes in hand. Once again the consignees refused to submit. "It is impossible for us to comply with the Request of the Town," they responded. They did not yet know how much tea would be sent upon what terms, or "what Obligations either of a moral or pecuniary Nature we may be under to fulfill the trust that may be devolv'd on us."[69]

Such steadfastness was the heart of the merchant's calling. To men like Clarke, pecuniary obligations were moral obligations. Years before, when he placed his son Isaac as an apprentice in the firm of another Indies merchant, he counseled the young striver on the essential "principles of fidelity, diligence & submission": "I hope that you will cheerfully do whatever your Masters direct you to do, even the lowest offices," he urged. The merchant's word was his bond, his creed, his *currency*. Loyalty, constancy, transparency: these were the building blocks of reputation, which in turn was the foundation of credit in an early modern economy.[70]

Confronted with the demands of the town meeting to renege on their promises, the tea merchants did what they were trained to do: they pitted the fidelity and trustworthiness that were the hallmarks of their guild against the duty of every American. It was hardly a fair fight. The consignees' letters were unanimously voted "*Daringly Affrontive* to the Town." One patriot leader, Dr. Thomas Young—among those who had headed the delegation to Clarke's store earlier in the week—was far less temperate. The "People would be justified by ev'ry Consideration if they should tear Such Wretches to Pieces," he said.[71]

It is hard to imagine that Copley disagreed with his father-in-law's arguments for probity and moderation. These were a portraitist's values as well as a merchant's; Copley had made a career building up, layer by layer, the simulacra of honorable merchants on canvas. He, too, was a dutiful man, a respecter of obligations. And his politics—to the extent that his worldview admitted politics at all—were family politics, as the coming weeks and months would clearly reveal.

Copley did not write about the events of 5 November, but Harry Pelham did, with characteristic vehemence. In a letter he wrote that night

to his stepbrother Charles, he contrasted what he imagined was the pastoral idyll of Newton with the "Noise and disturbance of a turbulent and factious town." As darkness fell on Boston, the "various and discordant Noises" of the day gave way to the "sounding of Horns . . . the ratlings of Carriages, the noises of Pope Drums and the infernal yell of those who are fighting for the possessions of the Devil." The din of Pope's Day was but an analogy for the tumult of politics. "I have been several days attentively observing the movements of our Son's of Liberty, which was wonce . . . [an] honorable distinction."[72]

Just weeks, maybe even days before, Harry himself had found the Sons "honorable." His affinity for their cause had not so much waned as vanished, snuffed out. So it was for the rest of the Copley-Pelham-Clarke clan. In lives, as in history, change happens slowly, imperceptibly, and then all at once. November 1773 was the moment that the American cause—a cause espoused for nearly a decade, with greater and lesser degrees of fervor, by Harry, Copley, and the Clarkes alike—soured and then curdled; the moment the Sons of Liberty became the handmaidens of tyranny; and, in consequence, the moment pragmatists became loyalists. "Your Friends here wish every possible success may attend your noble struggle, against a Sett of cursed Venal, worthless Raskalls," wrote a correspondent from Worcester to Sukey's brother Isaac on 7 November. "I hope you will persevere in so good a Cause, and by so doing convince these lawless Raskalls, that you even dare to withstand these Devils, that call themselves *Sons of Liberty*—But from such Liberty! good God! deliver us."[73]

On 17 November, Jonathan Clarke arrived at the Long Wharf, just ahead of the cargo he had counted himself so lucky to secure. That night the extended family gathered at the Clarke mansion on School Street to celebrate his homecoming, "in the perfect Enjoyment of that Harmony of Soul and Sentiment, which subsists in a well united and affectionate Family," said a letter to the *Boston Post-Boy*, likely written by Richard Clarke. Copley and Sukey were surely there, at the hearthside, when the din of a crowd intruded on the scene: "a violent Knocking at the Door,

and at the same Instant a tremendous Sound of Horns, Whistles, and other Noises of a Multitude." The tumult "caused, in those of the tender Sex a Distress, that is more readily conceived than described," the writer said. And no wonder: the house was surrounded by hundreds of men glowing with drink, armed with bricks and sticks and stones, and fully convinced that they held the law in their hands. Sukey was just out of childbed, and her youngest sister was barely of age. They had every reason to be "thrown into a violent Panic on the Occasion," as the *News-Letter* reported they had been.

After securing the women upstairs, the Clarke men and their brothers-in-law shuttered the windows and barred the doors. But in time the crowd broke into the first floor, trashed some of the furniture, "and slightly hurt one or two of the Besieged." Somebody fired a warning shot from a second-story window. The ensuing battle raged for nearly two hours. Then the mob, having spent its rage, proposed a parlay, or "Treaty," as the newspaper put it: they would disperse in exchange for a promise that the consignees would face their accusers the following day. The Clarkes and their allies would have none of it. They questioned "the Propriety of conferring with such People on any Terms—People who were so riotously assembled, and had just committed such a violent Outrage against the Peace of the Community."[74]

In the Clarkes' version, probity and steadfastness carried the day; met with manly firmness, the crowd turned tail and slunk home. The *Gazette*, by contrast, ridiculed the notion that "a small number of invincible heroes had spread terror among a mere host of poltroons." Instead, the writer signing himself "X.Y."—a punning response to Richard Clarke's "Z"— emphasized "the obstinacy and haughtiness" of the teamen, who had, once again, "treated the people with an air of contempt," pressing their "private advantage at the expence of the general ruin." It was this hauteur, this selfishness that the crowd meant to correct, massing peaceably, with a few hearty "huzzahs" to demonstrate "their uneasiness," so that Clarke might, "for his own sake," rethink his position on the tea. The people were "much quieted," X.Y. said, until the blustering Clarke men provoked

them with threats and guns. All the while, Richard Clarke had cowered in the house, too frightened to face the interlocutors he so disdained.[75]

But not even the most radical printer could deny the physical evidence: Clarke's house was wrecked. The elegant mansion whose "new fassioned" details Copley copied in his own remodeling had been systematically stripped of its pretensions, even its habitability.[76] Richard Clarke went to stay with his sister's family in Salem. The unmarried Lucy headed to the Copleys' house. Jonathan and Isaac secured themselves at Castle William, where the other consignees soon joined them, after being hounded out of Boston and the surrounding towns. The *Massachusetts Spy* ran a pagelong letter that seemed even to countenance their deaths. "There are many instances, wherein men lose the protection of the law in their property, . . . even of their lives," the author, who signed himself "Massachusettensis," argued. "When we are reduced to this sad dilemma that we must destroy the lives of a few of our fellow men and their property or have the community destroyed by them we are not allowed to hesitate a moment," he insisted. "The rule here is that which is chosen by all wise men, and vindicated by the law of nature, viz., *of two evils chuse the least*, and rid society of such dangerous inmates."[77]

The day after the riot at Clarke's house, the selectmen again called the consignees to account. Once again they met with a stone wall: another letter pleading a lack of written instructions from the East India Company, and a gentlemanly fealty to promises given. Instead, the consignees took their case before the governor and his council, whom they styled "guardians and protectors of the people." They asked that the executive body safeguard both the tea and the teamen until the situation clarified. The council—eminent men, most of whom had Copley portraits hanging in their parlors—chewed on the matter during several meetings over the next ten days before declaring themselves powerless to intervene. They did point out, however, that once the tea was landed, the duty upon it—the Townshend tax that so enraged the populace—would need to be paid.[78]

On 28 November, the day before the council handed down its tepid ruling, the *Dartmouth*, carrying 114 chests of the consigned tea, had

reached the harbor. Its arrival had been logged at the customhouse, which simple act, in quill and ink, set in motion a countdown: by law, its cargo would have to be cleared within twenty days—by midnight on 16 December—lest the port of Boston commit itself to wholesale defiance of king and Parliament. Mass convocations were called, among the largest the town had ever seen. "Friends, Brethren, Countrymen!" read a handbill warning, "That worst of Plagues The Detestable Tea" has arrived, and "the Hour of Destruction or manly Opposition to the Machinations of Tyranny Stares you in the Face."[79]

On the morning of 29 November, a thousand people gathered in Faneuil Hall. By afternoon, their number had tripled. To accommodate the still-swelling crowd, the convocation was moved to the Old South Meetinghouse, there to consider the day's urgent question: "Whether the Tea which had arrived . . . should go back in the same Bottom without being unloaded."[80] This was not the official town meeting of Boston freemen, but a larger body calling themselves "*the People*": an assembly more broadly inclusive and, Thomas Hutchinson recalled, possessed of a "more determined spirit . . . than in any of the former assemblies." The meeting "was composed of the lowest as well, and probably in as great proportion, as of the superior ranks and orders, and all had an equal voice," he said. Their proceedings followed the "'form' of a town meeting," with motions and minutes and gavels, Hutchinson wrote. But it was an orderly Palladian façade, masking anarchy.[81]

Samuel Adams and John Hancock held the floor for much of the day. When one of the ship's owners protested that losing his cargo would prove a terrible hardship, Adams responded that cargo was lost all the time to storms; the current crisis amounted to "a *Political* Storm" of great force. The People "had now the Power in their Hands," and meant to use it, he said. John Hancock warned that the governor—"that *Tool of Power* and *Enemy of his Country*"—would be only too happy to make any crowd action a pretext to bring back the troops.[82]

As the eldest of the teamen, Richard Clarke had served as their senior statesman. Now with Clarke and his sons barricaded in the castle, his

son-in-law became the de facto family patriarch and, in that capacity, the spokesman for a position that had become untenable to the town. Copley addressed the assembly, which can only have terrified him, a self-taught scholar of the individual countenance confronted with a massive, seething crowd. His stutter likely worsened under stress. He disdained "the party spirit," enemy to art and artist alike, as he had said to West. But family was everything—was love and money, past and future. And so he answered, however haltingly, the demands of the People. The tea agents had just the night before at last received their written orders from London, Copley explained, and must meet before they could "make any further Proposals." He bought them time. The meeting adjourned until the following morning. During the interval, Copley was asked to confer with his father-in-law and his colleagues and see what progress might be made.[83]

Late November was no easy time to navigate the harbor. Copley could have chosen a longer water passage, more than two nautical miles from the Long Wharf, or a land-and-sea route, riding out of the city via its narrow neck, and then racing the tide along the flats of Roxbury, out to the eastern tip of Dorchester Neck to hire a small boat across a short channel to the castle. Once inside the ramparts, he advised his kinsmen that in order "to prevent immediate outrage," they must "send something in writing to the Select men." They gave him a statement to take back to town. But when he read it, and saw that the consignees had flatly refused the People's request, "Copley . . . fearing the most dreadful consequences, thought best not to deliver our letter," as one of the agents wrote. He repeated the journey to ask for something softer; he cannot have returned to Boston much before daybreak with the second version in hand. The revised letter was addressed to John Scollay, a selectman, and thus a duly elected official of the town. The consignees recognized his authority, a pointed slap at the legitimacy of the assembly that had called them to account. As a fellow merchant, Scollay knew what it was to keep promises, and what it felt like to fail when they broke.[84]

At nine the next morning, Scollay presented the consignees' revised

statement to the People. The teamen declared that, much as they wished "to give satisfaction to the Town," sending back the cargo was impossible, "utterly out of our power." They were willing, however, "to store the teas" until they might apprise the East India Company of the situation, and "receive their further orders."[85] In the best of times, that circuit would take three months; winter crossings could lengthen the interval considerably. To accede to the consignees' wishes would mean waiting till spring. Tempers would have cooled by then, Clarke and the others must have thought. The moment would be lost, the rebels would have known.

While the body debated this latest proposal, the sheriff entered the meeting with a proclamation from the governor, who had declared the assembly to be a riot and ordered its dispersal. "Confused Noise and a general Hissing" greeted the governor's edict, followed by a motion about whether to follow it—a vote, in effect, on whether Hutchinson still governed. The motion "passed in the Negative." Samuel Adams took the floor and, speaking "in the most vehement Tone and in the most abusive, virulent and vilifying Manner arraigned the Conduct of his Excellency": the People in judgment of their rulers, as one onlooker cast the scene. Adams ranted, "He? He? is he that Shadow of a Man, scarce able to support his withered Carcase or his hoary Head! is he a *Representation of Majesty?*" Hancock made as if to tear up the proclamation, garnering "Shouts of Applause, Clapping, etc." Dr. Thomas Young compared the gathering to the sainted assembly of nobles who had gathered at Runnymede to craft the Magna Carta.[86]

How must all of this have struck Copley's eyes and ears? Samuel Adams, Copley's masterly portrait sprung to malignant life, the finger stabbing, the barrel chest heaving, this time only to slander the artist's kinsman, and to threaten, at least implicitly, his father-in-law, the only patriarch the painter had known since boyhood. Perhaps it was this scene that played in Copley's mind's eye a few years later, when he told Peter Oliver that "if he wished to draw the Picture of the Devil, that he would get *Sam Adams* to sit for him."[87]

Copley rose to ask for an affirmation of the most basic principle of lib-

erty: "in case he could prevail with the Messrs. Clarkes to come into this meeting, . . . Whether they should be treated with Civility while in the Meeting, though they might be of different Sentiments with this Body; and their Persons be safe until their Return to the Place from whence they should come." Was Boston still a place where one might disagree with the People and keep one's head? Surely this was the very definition of the *civility* Copley so prized. His motion passed without dissent. Copley begged two hours to convey the news to his family, and began again the journey by land and water that he had made two times the night before.[88]

Copley's errand outlasted the adjournment, and the assembly resumed its proceedings. The People debated how best to warn the town in case anybody should attempt to land the cargoes. Adams proclaimed that the tolling of bells would most effectively call out the citizenry, and "said that for his Part he had for some time kept and should keep his Arms in Order and by his Bedside as every good Citizen ought." Boston would be not just forewarned, then, but also forearmed. (One merchant reported the next day that pistols were not to be found at any of the shops in town, "being all bought up.") The assembly turned its self-conferred enforcement powers upon the owners of the tea ships; if the merchants could not be moved to return their consignments, then the owners must redirect their captains. John Rowe, who held a share in the *Eleanor*, which was approaching with another cargo of tea, regretted "that any Vessel of his should be concerned in bringing any of that detestable and obnoxious Commodity," and asked "Whether a little Salt Water would not . . . make as good Tea as Fresh." Rowe had lately been considered soft on liberty; his apparent conversion was greeted with "Shouting Clapping etc." He was added to the committee that would carry news of Boston's resolves to the other colonies—"much against my will," he noted in his diary, "but I dare not say a word." One man in attendance whispered "that now they had brought a good Tory over to their Side—that Mr. Rowe had now become a good Man and they should soon make the Rest of the Tories turn to their Side" as well. So much for the blending of overly harsh lines: this was a world of *sides*, now—of "good men" and evil. A world in which what Jonathan Clarke

had called "the moderate part of the town" had yielded to the "most zeal-ous." A world where political cartoons trumped portraits.[89]

Copley returned well past his allotted hour. He "had been obliged to go to the Castle," he explained, and hoped that "the body . . . would consider the difficulty of a passage by water at this season as his apology." But heroic as it was—his third circuit within twenty-four hours—his mission had failed. He had met with the consignees, "and though he had convinced them that they might attend this meeting with safety, and had used his utmost endeavours, to prevail upon them to give satisfaction to the body," they refused to return with him. The Clarkes and their con-freres knew that "nothing short of reshipping the Tea (which they deemed impossible) would be satisfactory," and so "thought it not prudent . . . to appear at the Meeting," which "might create some new Disgust." They renewed their proposal to store the cargo until the company responded. In the long meanwhile, they pledged to make no attempt to sell the tea.

Asked "whether the return made by M. Copley from the consign-ees, be in the least degree satisfactory to this body," the People offered a unanimous "nay." The cargo must not be landed, and any importer of tea must be treated "an enemy to his country." John Hancock concluded the assembly with ringing words from the pulpit: "My Fellow Countrymen, we have now put our Hands to the Plough and Wo[e] be to him that shrinks or looks back."[90]

Copley trafficked in the rearward glance; his trade and his character alike inclined him to look back. He had done his best. "I made use of every argument my thoughts could suggest to draw the people from their unfavourable oppinion of you," he wrote to his brothers-in-law. Some "very warm things" had been said, but Copley thought that his interven-tions might have "cooled the Resentment"; the meeting had concluded without any profound display of personal animus toward his family. If Clarkes could "avoid seeing the Govournor"—and could thereby escape being blackened by the brush that must tar Hutchinson, come what may—their lives might still be put to right. "I have no doubt in my own mind you must stay where you are till the Vessel sails that is now in, at

least," he wrote, "but I beleive not Longer; Then I think you will be able to return with Honour to Town."[91]

Fifteen days later, thousands of Bostonians rushed the waterfront to watch scores of patriots in crude Mohawk drag dump hundreds of crates of tea into the frigid shallows of the harbor. However penetrating his vision of human character, the painter could not see the future.

"This is the most magnificent Movement of all," wrote John Adams in his diary on 17 December. "There is a Dignity, a Majesty, a Sublimity in this last Effort of the Patriots, that I greatly admire. . . . This Destruction of the Tea is so bold, so daring, so firm, intrepid and inflexible, and it must have so important Consequences, and so lasting, that I cant but consider it as an Epocha in History."

This seemingly oracular passage of Adams's private writing is often quoted. Less frequently do we dwell on the sentences that followed: "This however is but an Attack upon Property. Another similar Exertion of popular Power, may produce the destruction of Lives. Many Persons wish, that as many dead Carcasses were floating in the Harbour, as there are Chests of Tea." But it would not take quite so many, he mused; "a much less Number of Lives however would remove the Causes of all our Calamities." Among that small number Adams listed the governor, the consignees, and the customs men, "Persons so hardened and abandoned" that they had dared to continue implacable in the face of the People's distress. Their carcasses would suffice. They should drink the bitter draught they had tried in vain to force down the throats of the People.[92]

⁓

Winter choked Boston Harbor. Thomas Hutchinson Jr., who shared Castle William with the soldiers and the Clarkes, reported that they were "as comfortable as we can be in a very cold place, driven from our family's & business, with the months of Jany & Feby just at hand." Cold comfort for the "poor banished Consignees," protected by the king's arms but "imprisoned" by the People.[93] Handbills went up threatening the teamen—"those odious Miscreants and detestable Tools to Ministry and

Governor . . . those Traitors to their Country, Butchers"—with violence should they attempt to return to Boston. Whenever one of them was spotted off island, the *Gazette* trumpeted the sighting and hinted at the exile's vulnerability.[94] "There was never any Thing in Turkey nor in any Part of the World, so arbitrary and cruel as keeping old Mr. Clark[e], at the Castle all this winter, an old Man, from his family," one friend of government was heard to say.[95]

With his native country turned against him, Jonathan Clarke could not help joining the exodus of talent from the provinces that he had decried only a year before. In late January, he directed a manservant named Michael to collect his sea stores, including a good supply of souchong tea. He sailed for England as soon as the ice allowed.[96] A week or so later, Richard Clarke wrote to ask whether Copley, now the de facto family head, thought the consignees might clear their names by petitioning the General Court. Copley advised against writing such a memorial, which would offer yet another occasion for facts to be "controverted, your conduct misrepresented, and what ever you either have or shall say misconstrued by the prevailing party in the House." He suggested that the consignees try the press instead. "I own I think the prospect of success very small, but I dont dispair neither," he wrote. "I shall not neglect any thing that will have a tendancy to remove every obstacle to your return and that will do justice to your Carracters as far as may be in my power." He signed his letter, "Your Most Dutifull Son."[97]

After the harbor became a teapot, what place was left for the slow, contemplative practice of portraiture? Not since his very first years at the easel had Copley attended as few sitters as he did in 1773 and 1774. In March, upon the annual commemoration of the so-called massacre, a shocking transparency was exhibited on the balcony of Mrs. Clapham's tavern on King Street, overlooking the site of the affray four years earlier. It depicted Captain "Preston, and his infamous butchers" alongside "a figure of America, pointing to her slaughtered sons." Another part of the panel showed Hutchinson and Oliver recoiling as they gazed upon figures from the past who foretold their futures: two nobles beheaded centuries

before, shown "with their Heads off, and the Blood fresh streaming after the Ax." Crudely rendered on gauze or paraffin-soaked paper, backlit with candles to create the illusion of movement, such scenes were meant to provoke horror, and action.[98] So too were the engravings Paul Revere rendered that spring of Hancock and Samuel Adams, using Copley's portraits as models. Revere's prints, which circulated in the *Royal American Magazine*, frame the likenesses with political symbols. In *Mr. Samuel Adams*, Britannia spears a redcoat, and Liberty steps on a volume labeled *Laws to Enslave America*. The allusions were not subtle, and the drawing was crude, but the point was made, in black and white. Such was the art that convulsed Boston in 1774.[99]

In late April, the harbor calmer and the air warmer in the mercurial New England spring, Sukey Copley and her sister Lucy Clarke ventured

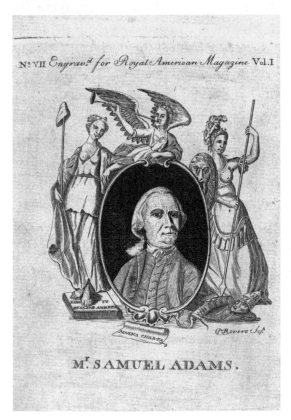

Paul Revere after Copley, MR. SAMUEL ADAMS, *1774*

to Castle William to visit their brother Isaac, who was still confined there. Copley reported that they had spent "a most agreable day" on the island before returning to Mount Pleasant and heading to bed "at the usual hour." At midnight, Copley and Sukey were awakened by knocking on their front door. Copley went to the window and discovered "a number of persons" below. He asked what they wanted. They told him they were hunting the Plymouth merchant George Watson, a friend of government whose chief crime consisted of the fact that his daughter was married to Thomas Hutchinson Jr. Copley answered that Watson had been there earlier but had left, headed home, he presumed, "as he went in his chaise." The men asked Copley how he "came to entertain such a Rogue and Villin." He answered that Watson had been in town visiting John Hancock and stopped at Mount Pleasant afterwards. Dropping Hancock's name seemed to work; the crowd headed "a little way up the Street."[100]

But then the hive mind changed, and the liberty men came back to Copley's and resumed "the Indian Yell." He went to the window and again insisted, "Mr. Watson was not in the house . . . and beg'd they would not disturb my family." But "they said they could take no mans word," Copley told his brother-in-law, for "they beleived he was here and if he was they would know it, and my blood would be on my own head if I had deceived them; or if I entertained [Watson] or any such Villain" again. If Copley defied them, he was told, he "must expect the resentment of Joice." (The pseudonymous Joyce Jr., named for a member of the Parliament that had sentenced Charles I to the ax, was a patriot enforcer of rough justice; he led an informal tar-and-feathering committee.) There was "a great deal more of such like language" exchanged before the group dispersed. "What a spirit!" Copley said. What "if Mr. Watson had stayed (as I pressed him to) to spend the night. I must either have given up a friend to the insult of a Mob or had my house pulled down and perhaps my family murthered."[101]

Two weeks later, a ship named *Harmony* arrived from London, bearing news of Parliament's response to the dumping of the tea. The Boston Port Bill, the first of a series of laws that would be known in America as the Coercive or Intolerable Acts, directed that, as of 1 June,

the harbor would be blockaded until the East India Company received full restitution for its plundered property. Commerce would come to a standstill; the rebels could eat their rage. It was "the Severest Act ever . . . Penned against the Town of Boston," John Rowe said, "a Great Evill."[102] An English cartoon Paul Revere pirated that month figured America as an Indian woman, stripped to the waist, restrained by England's chief justice, the Earl of Mansfield, while the leering Earl of Sandwich lifts her skirts and Lord North shoves the spout of a teapot into her mouth. The Boston Port Bill is visible in his pocket. The ravished maiden gags on "the bitter draught": Richard Clarke's tea.[103]

On 13 May, General Gage marched up King Street with a company of grenadiers to take office as the military governor of a province under martial law. In the following days, as Thomas Hutchinson and his family readied

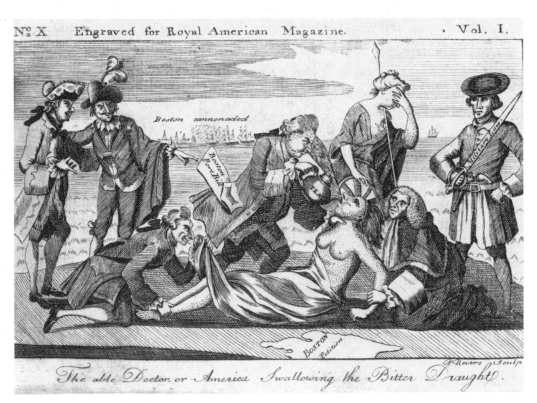

Paul Revere, THE ABLE DOCTOR; OR, AMERICA SWALLOWING
THE BITTER DRAUGHT, *1774*

to sail into exile in London, a statement was "handed about and Signed in a private manner," praising the deposed governor's "wise, zealous, and faithful administration," decrying the "lawless proceedings" that had culminated in the destruction of the tea, and affirming the crown's demand that restitution be paid. "May you enjoy a pleasant passage to England," the address concluded, "and under all the mortifications that you have patiently endured, may you possess the inward and consolatory testimonies, of having discharged your trust with fidelity and honor, and receive those distinguishing marks of his majesty's royal approbation and favor, as may enable you to pass the remainder of your life in quietness and ease." The statement garnered only 123 signatures before it was delivered to Hutchinson on 21 May.[104]

Hutchinson's addressers were no Tory party, the customs commissioner Henry Hulton insisted. Some had "signed from personal respect to the Governor; many, thinking he would endeavour to get the Port opened again, and would be glad to represent their conduct in a favourable light" when he got to London.[105] But if the signatories did not see themselves as a faction, they were quickly made into one. Within days, a broadside went up around Boston offering a "true LIST" of their names, along with "their several Occupations, Shops, Stores or Places of Abode," so that "every Friend to his Country may know who is Assisting to carry the execrable Purposes of the British Administration into Execution." Standing with the despised former governor was a wanton provocation, a civil death sentence.

They do not appear to be an especially imposing lot, these new-minted enemies of American liberty. Among the expected scattering of merchants, humbler traders predominate, a city directory's worth of shopkeepers. A baker, a miller, and a peddler signed. So did a bookbinder, a toy seller, and one portrait painter, who might have hoped for the help of Hutchinson, his wife's kinsman, when he got to London.[106]

Chapter Seven

LUXURY IN SEEING

EN DAYS AFTER the Port Bill took effect, the *Thomas* set sail for London. The papers reported that Mr. John Singleton Copley numbered among the passengers, in a line of tiny type barely visible amidst other, graver news. Harvard had canceled commencement, owing to the "present dark Aspect of our public Affairs." Two regiments of his majesty's troops would soon reach the Long Wharf. Even those like the writer in the *Evening Post* who decried "the outrage of rash and inconsiderate men" against the East India Company feared "the approaching calamity, which will soon overwhelm the town."[1] With the port closed to trade, with warships crowding the harbor, with soldiers once again encamped on the Common, the business of getting and spending and just making do would be very difficult indeed. "Poor Unhappy Boston. God knows only thy wretched Fate," wrote John Rowe in his diary. The town's very name became a rallying cry for insurgents all along the North American seaboard, who packed coastal ships with relief supplies for the blockaded New England port.[2]

The hostility Copley faced as a signer of the Hutchinson address must have been considerable, and ugly. And with the port closure looming, there would have been competition for every berth on every ship out. After many years of pining and planning for Europe, Copley embarked with such haste that he did not complete his round of farewells. "I hope my Hon'd Mother did not take it hard: that I did not see her, or Brother or Sister Bromfield before I left em," he told Sukey. "I hope you have

taken care to let them know how it happened that I did not."[3] He did not even say goodbye to his mother.

The conversations that surrounded Copley's endlessly postponed, finally frantic departure can only be imagined. The times were perilous and his family vulnerable in particular ways: his mother fragile and Harry hotheaded, his in-laws hounded from their homes. He had left Sukey surrounded by "dear little Babes"—Betsy (nearly four), Jack (newly two), Polly still an infant—and pregnant again, though the Copleys may not have known it. (She was about six weeks along when he sailed.)[4] To depart at such a moment borders on unforgivable, and many must have told him so. Surely Mary Pelham, for one, did "take it hard"; she took everything hard. Her son's impetuousness flew in the face of a lifetime of plodding deliberation. It was desperately, unquestionably selfish, this seizing of the best worst time to leave. Yet it was also perversely generous: a preservation of the painter's hard-won patrimony and, through it, of the family's options.

Copley set sail from an impossible present toward an uncertain future, at the last moment when his journey might be deemed a sojourn rather than a flight. He fretted over those left behind. Their time apart must figure as a "blank in life for I can call it no other," he told Sukey, promising to keep his wanderings "as short as it is possable." He was "very ancious" about the family's health and even their safety, given the volatile "state the Town is in." He reminded Sukey, "You cannot shew your love to me in a stronger manner than by takeing the utmost care of your own health." And then he offered up his "prayers for [their] happiness health and safety . . . to the throne of Divine mercy," entrusting their fate to "Gods goodness" and the kindness of kin and friends.[5]

With each nautical mile, the cacophony of politics grew fainter. Favorable winds lofted the sails of the *Thomas*. It glided past the wharves, past the town's stilled trading fleet, past the king's warships, past the troop transports that anchored the morning Copley sailed.[6] The ship tacked around Castle William, then a few smaller islands dotting Massachusetts Bay just beyond the harbor, the steeples of Boston receding in the

distance. And then only open water, with the vague, wobbling promise of London—of Home—somewhere beyond the seas.

⁓

The crossing took a scant month, quicker than Copley had dared hope. "Capt. Robson has been his whole life passing the seas and never knew any thing like it," he told Sukey. Clear skies and steady winds favored them throughout, but for "about six hours calm." Copley spent two days of the voyage heaving, wretched. But mostly he felt strong and well. Even so, "after 29 Days at Sea the land is a most greatfull Sight," he said.[7] He sent word of his safe arrival immediately, penning one letter to leave with Captain Robson and tucking a second version into the mailbag of another westbound vessel, in case the first went awry, as mail too often did across such distances, in such times. Letters were lifelines. Writing to his family, he told Sukey, would be "one of the first & greatest pleasures I shall find while absent from you."[8]

But other pleasures came thick and fast after the *Thomas* docked at Deal. Before he recovered his land legs, Copley boarded a coach to London, some seventy miles to the west. The countryside was ordinary enough—fields and fences much like those of that newer England across the water—but still Copley pronounced it a "most enchanting Country, of which no part of North America . . . can give you the least Idea of."[9] It was all so perfect: the post chaise "as Genteel as any Charriots that are in Boston," the road straight and smooth, the land thoroughly improved, with "not a spore of Grass" out of place, the tea in roadside way stations finer than what graced the best tables on Beacon Hill. Not two days in England, and Copley declared that those who "said we were Saints & Angels in America compared to those that inhabit this Country" had been "greatly mistaken." To the contrary: "really we Americans seem not halfway remove'd from a state of nature when brought into comparison with those of this Country."[10]

And then, at journey's end, rose London, the provincial pilgrim's celestial city. His whole life long, Copley had glimpsed it half darkly,

through letters and pictures and travelers' tales. To be there, to *see* there, was a waking dream. After four days on the ground, he told Harry, "this is really an astonishing City; many parts of which, I mean, the buildings, are so exactly what I had conceived that I am surprized at it."[11] If the streets and squares matched what had so long shimmered in his mind's eye, the "Manly politeness" of the people surpassed his expectations.[12] There is "so much Civility in this place," he reported, "more than equil to all I have ever received in Boston in my whole life."[13]

A clutch of kin welcomed him: he met Sukey's brother Jonathan the evening he arrived, at the New England Coffee House on Threadneedle Street, hard by the Bank of England and the Royal Exchange. (Letters to and from Copley would be routed through Clarke at that coffeehouse for the remainder of his European sojourn.) Thomas Hutchinson stopped by the next day. With each exile's crossing from New England, the circle of Copley's London acquaintance grew.[14]

"Brother John" put him up for a few nights, but the painter quickly found a flat of his own, two rooms "very Genteel, for which I pay a Guinea a week," he told Harry. (With no money coming in, Copley had to husband his pounds and pence.) "I am sorry Brother Clarke and I are so distant from each other, but he is in the City and I at the Coart End of the Town," he explained. As he had during his London sojourn in 1772–73, Clarke lived among traders and stockjobbers in the tangled streets near St. Paul's. Copley unpacked his trunks in the fashionable environs of Leicester Fields, near the playhouses and the parks, where the bon ton rubbed shoulders with the artists who celebrated them on canvas.[15]

As soon as Copley had bought some clothes "to be Decent in," he called on Benjamin West, so long his acquaintance by post. West abounded in "those amiable quallitys that makes his friendship boath desireable as an artist and as a Gentleman," Copley reported. No longer the backwoods prodigy known as the American Raphael, West had become a courtier: History Painter to the King, with rooms in Windsor Castle. He was, in the fullest eighteenth-century sense, complaisant: graceful, generous, eager to share his considerable bounty, especially with

visitors from North America. West lived on Castle Street, "a few doors" from Copley's flat, and issued Copley a standing invitation to dinner. He introduced the new arrival to Sir Joshua Reynolds and squired him to the Royal Academy, where Copley discovered that "the Students had a naked model from which they were Drawing." West showed this latest American acolyte his *Death of General Wolfe*, the modern-dress history painting that had dazzled the critics at the academy's spring exhibition three years earlier. The storied picture was "sufficient of itself to Immortalize the Author of it," Copley assured Harry. (An engraving was in the works, so Harry might soon see at least its outlines.) Such performances amazed him, yet there was also something reassuring about witnessing "the Practice of Painting" at first hand. Mastering the process of composing historical scenes might be "attained easyer than I thought," Copley wrote. Sketches were "made from the life, . . . often from groups": not so far from face painting after all. Seeing the method unfold had lifted "a great dificulty . . . that lay on my mind."[16]

The summer months marked the slow season in fashionable London. Nobles and their hangers-on decamped to country estates. But though "this End of the Town is said to bee quite Dull," Copley found it "brisk anogh."[17] July and August sped by in a whirlwind of kin and friends and Art: one long enchantment. He toured the queen's picture collection and stepped aboard the yacht that had brought her from Mecklenburg years before, as a princess without a word of English. (Copley saw even her bed, hung with crimson damask: birthplace of a nation.) He visited the famed Greenwich Hospital and the Adelphi, the enormous speculative complex recently built along the Thames embankment. He strolled St. James Park, where (he blushingly told Sukey), "the Ladys sometimes make such a show that it is almost anough to warm a Statue & imbue it with life." He joined the assembly at the Vauxhall pleasure gardens.[18] And everywhere Copley went, he greased the wheels of his career, delivering the letters of introduction that he had gathered up the autumn before he sailed, courting future commissions, making valuable friends. Harry could have "no Idea how time is filled up in this great City," Copley wrote, in a rush,

in August. "I am fallen into a much larger Circle of acquaintance than I could have expected." Family remained at the core of that larger circle. "Immagine how much it adds to my pleasure having Brother Clarke here," he said. Jonathan was "so used to the place that I am already allmost inneciated into all the manners and Customs of the City." Copley dined with Hutchinson, Clarke, and a clutch of others, "all Bostonians, and we had Choice Salt Fish for Dinner." The family politics that had cost him so dearly in Boston paid dividends in London.[19]

The newly cosmopolitan Copley meant to give his brother a correspondence course in Art, much as he himself had undertaken via West's tutelage. But the marvels "come so thick," he said.[20] "I see so much that it is impossible to know where to begin." Copley counseled the kind of diligence that had kept him single well into his twenties: "Study incessantly, and practice continually." He reminded Harry to subordinate the parts of each picture to the harmony of the whole. Since Harry could not meet Joshua Reynolds, he should hunt down a copy of his annual addresses to the academicians. (The "Book Deallers will send for them for you.") Above all, Harry should strive. Remember, Copley wrote, "you must be conspecuous in the Croud if you would be happy and great."[21]

The crowd was large. The *London Morning Chronicle* counted "upwards of one hundred and twenty painters in and about this metropolis, each eminent in his respective mode." Yet when the writer reckoned "how few, how very few, have business enough to enable them to live easily and comfortably (not to say genteelly)," he professed himself "filled with anguish for the distresses and miserable existence of the majority and their families."[22] Copley meant to join those happy few. But he would not set up his easel, not yet. "I might have begun several Pictures if it would have consisted with my plan," he told Harry, "but I must see Italy first."[23]

West found him a companion for the journey. A failed mercer lately turned painter, George Carter was a good deal more educated and far less accomplished than Copley. He lived on Argyle Street, a new road built over the remains of the old pest house, well north of the fashionable parts of Westminster. In the exhibition of the Society of Artists

that concluded just before Copley arrived, Carter had entered seven small pictures, little genre scenes with titles like *Two Children Begging* and *A Nose-Gay Girl*, along with a suite of images inspired by Laurence Sterne's picaresque travel narrative, *A Sentimental Journey through France and Italy*. Carter was contemplating a sentimental journey of his own. He and Copley shared a craft, a purpose, and the peculiar urgency of middle age.[24] Most grand tourists were younger: callow Etonians with tutors in tow, aspiring lawyers in search of refinement. Copley and Carter would need to be more purposeful, economical, while their families pined and their coffers drained. Copley was delighted that Carter knew both "the french and Italian language." His escort's smoother tongue could open the wide world to them. On the morning of 26 August, the two painters boarded a post chaise headed south, toward the coast. Copley told Sukey, "I shall have nothing to do but to see."[25]

The voyage from Boston to London was swifter and easier than the journey from London to Rome. Delays began at once. Heavy weather pinned Copley and Carter in Brighthelmstone (now Brighton) for days. When they finally ventured the crossing, it took their packet boat twelve hours to fight its way across a Channel so storm tossed that Carter nearly fell overboard. In Normandy, they picked up a three-horse chaise—"a Vile Cabriolet," Carter called it. "I saw not the least Appearance of the Air of Conquerors; poor Devils how must they have degenerated to be the lineal Descendants of William," he wrote in his journal.[26] Keen to spy the effects of Catholic despotism, reared on engravings like Hogarth's *O the Roast Beef of England*, Carter often contrasted the starving, slavish French with the ingenious, robust British, so famously devoted to their liberties. Copley, an altogether more sincere sort, was eager to be amazed. "I beleive there is somthing in the Air of France that accilerates or quickens the Circulation," he declared, upon reaching Paris. "I already feel half a Frenchman in this respect." He praised the landscape, the food, the people, and the lodgings: a modest but clean pension on the rue Jacob

where, Carter grudgingly admitted, there were "but very few Fleas, a rare Instance."[27]

The pair of painters spent their few days in Paris studying the master-works in the Palais Royale, where the Duke of Orléans kept his collections, and at the Luxembourg Galleries, which were open to the public. Copley was surprised to discover that pictures by such luminaries as Poussin, Titian, Rubens, and Correggio ranged in quality, "some very fine, some indifferant, some bad." Carter agreed. "If I see no better in Italy, I must own, I shall be very much disappointed."[28]

In his advice to Harry, an aspiring painter "who has not seen any Works of Art," Copley confessed that he felt "utterly unacquainted" with so much of what he now encountered. The prints available in Boston conveyed the bare "design" of the Rubens canvases at the Luxembourg, Copley explained, "but you have not the colouring, it is very brilliant, rich and tender."[29]

How to pin color to the written page? Copley tried out the possibilities within Harry's reach: The "head at Mrs. Hancocks"—a Van Dyck, Copley thought—was "a little too Raw." Maybe "the Pan and Sirinks at Mr. Chardon's comes neigher the mark than any I can think of; only if I remember right the tints in that are more Grey and broken than Rubens's and darker." Another copy at Chardon's might work, if Harry imagined adding a bit of yellow to it. Copley grew frustrated with his powers of description and with the limitations of Boston: "I know not what to refer you to by which you will form to yourself the Idea I wish to convey," he said. Perhaps Harry could combine the structure indicated by the prints with Copley's description of colors and techniques and attempt his own copy. "Mr. Carter thinks this Account I have given you is so just that it is equel to your seeing the Pictures." But Copley knew—knew better than ever he had—that a thousand words were *not* worth a picture. There "is a kind of luxury in seeing as in eating and drinking," he sighed.[30]

Despite Copley's frequent promises to Sukey that he was husbanding every minute for his—and the family's—betterment, not all was work. He saw his first opera, an art form inconceivable in Boston, where even psalm

singing courted controversy. "I was much entertained; tho a strainger to the Language, the Musick Charmed me," he said of Gluck's *Orfeo ed Euridice*.[31] They ate sumptuous meals: "Soupp . . . in Silver Turenes," followed by "Bully" (consommé), and then "two Courses of everything that is in season, and of the best kind; than a Desert." The tables were elegant, and immaculate, Copley marveled, for "they never bring any thing a second time to table (not even the Linen) without Wash'g." Copley shared these vicarious pleasures with his mother when he at last sat down to write to her in September. He assured her that his health continued excellent, and that he had "really grown fatter than you ever saw me."[32] He did not mention that he had bought himself a sword, made to order in a shop on the place Saint-Michel. (While Copley waited for the craftsman to mount the blade, Carter flirted with the smith's comely wife.) It was a nobleman's accessory, or a soldier's. Copley was neither. But he wore it everywhere, "the dear Companion of his every Moment," Carter said. While they slept, Copley swaddled the blade in "various Night Caps . . . that it might not get tarnished."[33] His sword at his side, the man from Boston resumed the habit he had begun in New York, of signing his letters *adieu*.[34]

Copley and Carter left the French capital in an enormous coach called *une diligence*, which held eight passengers and was pulled by as many horses. The carriage "seems to have been built at the Beginning of the World, and designed . . . to last 'til the End," Carter joked. Copley said it felt like riding in "a moving house." Days on the move began at dawn and lasted till nightfall. The travelers slept in roadside inns that sometimes reminded Carter of "Spencers Cave of Dispair." Still Copley continued wide-eyed, discovering "such a fund of pleasure . . . in all the sceens through which I pass, that it is an ample recompence for all the time, and expence, that attends such a Tour." He told Sukey that the "dangers and dificulties" of the trip turned out to be far smaller than those who "sit at home, and paint out frightfull Storys to themselves in their Imaginations" might suppose.[35]

In Lyons the travelers shifted their trunks to a horse-drawn barge.

Copley declared the boat "as comfortable as . . . any Room." Carter couldn't bear the stink of "so many People in wet Cloaths, cram[m]ed together, their Breaths somewhat like Sanchos Description of Dulcineas," all rotten cheese and garlic.[36] Carter romped through a barbed picaresque worthy of Cervantes, while Copley chronicled his earnest *Pilgrim's Progress*. Their differing sensibilities began to chafe, at least on Carter. "Mr. Carter [is] well versed in traveling, has the languages . . . is a very polite and sensable man, who has seen much of the World," Copley told his mother. It was "an happy event[,] the having a companion," he assured Sukey, "by this everything goes on easy."[37]

The very next day Carter noted: "my Companion . . . is a perfect dead Wait."[38]

As the weeks stretched to months, Carter's litany of complaints grew longer and louder. Copley was needy, "not knowing a Syllable of the Language," yet had "so much to say in his own . . . that it rather Fags the Spirits." He could be combative and even perverse, always taking "Things at the wrong End." He defended the untenable, arguing that "a Huckaback Towel was softer than a Barcelona Silk Handkerchief," or that fealty to law was nobler than unforced honor. Yet he brooked disagreement poorly. Carter's diagnosis: Copley had been too "long the Hero of each little Tale," allowed to believe "there is Nothing that he is not Master of."[39] Boston was a small pond.

Copley was a clod, Carter said: "uncouth and unlettered," a stumbling, stammering bumpkin of the sort who had animated travelers' tales since the days of Chaucer. He was out of fashion, tripping over a floor-length brown greatcoat edged with fading worsted binding—"the Cut of it seemed to indicate Anno 1760"—made all the more ridiculous by the gleaming new sword belted at its waist. Yet if Copley was vulgar, he was also delicate, discomfited by a hard word, an empty stomach, a rough road, or a cold bed. One morning, Carter recalled, Copley threw up his hands "in a Kind of Agony . . . uttering, Dear, Dear, only think . . ." Carter feared apoplexy, but the crisis proved smaller: the man who powdered Copley's wig had forgotten "to wipe the Dust off his shoes."[40] The

American was selfish, quickly snatching up the best bed or the choicest morsels for himself. But if ever Carter corrected him, Copley "sulked for three days." Brittle, whimsical, and covetous by turns, Carter's Copley was nothing so much as feminine. "I cannot help sometimes doubting his Gender and take him for a Woman with Child, for he longs and wishes for every Thing he sees, and always fancies every Thing is better than that which he possesses," Carter mused. In Avignon, Carter thanked god the two were "not wedded to each other." By Marseilles, he was contemplating divorce.[41]

Carter wearied, especially, of Copley's paeans to the colonies. Every leaf, every vista, was measured against America—and found wanting: the mirror image of Copley's letters home. American wood burned hotter than English coal. American milk tasted sweeter than French; surely the French cows "had eat dandelion." (This after Copley had slurped eleven cups of milky tea greedily enough.)[42] From Toulon, near the end of September, Carter wrote,

> My Companion is solacing himself that if they go on in America for an 100
> Years to come as they have for 150 years past, they shall have an indepen-
> dent Government . . . Art will then be more encouraged there, great Artists
> would arise and that was the great object that induced him to take this Tour
> to Roame. I just hinted that it was probabl[e] he might not live to see that
> Period; and therefore his coming to Rome, if that was the End intended to
> be answered, would he not be some what mistaken in the Outset?[43]

As it happened, independence came far sooner than Copley predicted.

Carter's caricature might exaggerate, but Copley did want sophistication, and he knew it. On more than one occasion he expressed "some degree of mortification in not having the Language." Having learned his manners from borrowed books, he strained to project the easy grace that lay at the heart of eighteenth-century concepts of politeness. The ladder of

hierarchy was steeper across the ocean, and more rigid. "There is a subordination of People in this Country unknown in America," he told Sukey. (Visitors from Britain to the colonies noticed the opposite: "there is, no distinctions, scarsly in the So[ciety]," lamented an Englishwoman who thought Boston boys were reared on "Independancy & Liberty" that made them "proficients in Vice.")[44] A once poor boy from a plainspoken place, Copley performed both dominance and obeisance poorly. By turns ingratiating and imperious, he kissed up and kicked down. He was probably vain and certainly ambitious: qualities that meshed uneasily with his deep, pervading caution. Carter dissected all these foibles brilliantly, making Copley a shambling Shandy.[45]

Yet Carter failed to reckon with the aching loneliness beneath Copley's too brave face. Throughout the long separation from his family, Copley whipsawed between joy and longing. "Be assured my Dear Wife my absence from you some times shakes that fortitude, which it is absolutely necess[ar]y I should possess," he told Sukey before he left London.[46] The tour was wondrous, "like a Dream." But it was also a "time of Banishment" that could not end quickly enough. Copley measured out his progress in works seen and techniques mastered, and in miles from the moment he would rejoin his family. "We shall I trust soon be at the utmost distance from those I so tenderly love," he wrote from Lyons. After that, "every remove will bring us nearer together."[47]

What Carter heard as his companion's irksome boasting about the wonders of his tiny corner of the new world concealed Copley's profound ambivalence. Before he left England, he told Sukey that he longed for their reunion, "either here or in America." Whichever side of the ocean "providence orders," he knew she would "submit to with chearfullness." As the tour progressed, Copley began more openly to stump for London. He knew it would be "an unpleasing thing to leave our Dear connections." But a quick "three or four years" in the metropolis might earn him "as much as will make the rest of my Life easey," and allow him to "leave something to my family, if I should be called away." Just those few years. And then, he promised, "I will go back & enjoy that Domestic happiness

I think our little Farm so capable of affoarding . . . I am sure you will like England very well," he said. It "is a mere Paradise[,] but so I think Boston Common is if the Town was what it once was."[48]

But could anyone imagine a return to the status quo ante? "I am impation to know how things go in Boston," he wrote in mid-September.[49] Letters were long in coming—at least a month to Jonathan Clarke at the New England Coffee House in London, weeks more tucked in some merchant's kit en route to Copley's next way station on the Continent. After their week in Paris, Copley and Carter seldom stopped anyplace long enough to meet up with their mail.

By barge and coach and single-masted *felucca*, the squabbling pair raced from southern France to northern Italy. September gave way to October without so much as a whisper from Mount Pleasant. "O my Dear Sukey it is now a long time since I have been so happy as to hear from any Dear family, it is more than three months." He felt "ready to fly to the place where I expect to meet with some of your letters that will inform me how you are what state you are in and our Dear friends."[50]

Copley bragged to Carter of America's wonders and its bright future. But he could scarcely conjure them up, even in his mind's eye. "I think if I could be suddenly transported to Boston," he wrote, "I should think it only a collection of wren boxes."[51]

~

By the time their bark sailed into the Gulf of Genoa, Copley had become expert at what he called the "business of Feasting my eyes." He and Carter toured the palaces, delivered their introductions, and took in a play. They shopped: the town was "fitted with all kinds of rich Merchantdise," and Copley bought himself "lace ruffles & silk stockings," along with enough black velvet and crimson satin to have an elegant winter suit made. "I believe you will think I am become a Beau to dress in so rich a suit of Cloaths," he told Sukey, "but you will remember you used to think I was too careless about my Dress & I wish to reform from all my errors." He declared the little coastal city the prettiest place he had yet seen. Its layered

past—Christian altars built atop ruined Turkish mosques—fascinated him. This was no spare Protestant aesthetic. The "Italian magnificence begins to break forth," Copley said, finding it hard to imagine that "Rome will make Jenoa look small." As he neared his ultimate destination, he grew "more and more impatient": impatient to hear from Sukey, "impatient to reach Rome," "impatient to get to work & to try if my hand & my head cannot do something like what others have done and by which they have astonished the world Immortalised themselves & will be admired as long as this Earth shall continue."[52]

On 14 October, Carter and Copley arrived in Florence, where Michelangelo, Leonardo, and Raphael had birthed the Tuscan Renaissance. Engravings and dim copies studied long ago and a world away sprang to vivid life. In the Tribuna of the Uffizi palace, the octagonal sanctum sanctorum where the Medici family displayed their greatest treasures, Copley came face-to-face with the statue of Venus he had drawn so carefully as an eighteen-year-old. The prints, even the plaster cast that John Smibert kept in his painting rooms, gave only the faintest sense of the original. Sculpted "near two Thousand years" before, Copley told Sukey, it remained "as perfect in all its parts, as Clean and fair in its Colour as if it had been finished but a Day . . . one stands astonished to see how Marble could be imbued with so much the appearance of real life."[53] Across the river Arno at the palace of the grand duke of Tuscany, he saw several Raphael Madonnas that "delighted me very much." A print or copy of one of them hung over their mantel in Boston.[54] "I wish I could convey to you a just Idea of Raphael's Painting, but I am at a loss how to do it," Copley said to Harry. He could study Smibert's copy of the famed *Madonna della Seggiola*, but it was a pale imitation: the original "has nothing of the olive tint you see in the Copy, the read is not so bricky in the faces . . . the whole Picture has the Softness and general hew of Crayons [pastels], with a Perlly tint throughout."[55] The pearly tint, the living marble, the ultramarine of the Madonna's robes and the Tuscan sky at dusk: it was so very hard to reduce any of them to pen and ink and press them into the folds of a letter.

Some time during their five packed days in Florence, Copley received

a pair of visitors in the rooms he shared with Carter—two "very warm American Gentlemen," Carter called them.[56] The callers were almost certainly the wealthy southern planters Ralph Izard and Arthur Lee, likely directed to Copley by Benjamin West, who had painted Izard a decade before. Izard, from South Carolina, had lived in high style in London for years. At once a proud subject of the British king and a passionate advocate for the American cause, he and his wife, Alice, the daughter of prominent New York loyalists, left for the Continent shortly before Copley did, hoping to "get a little relief" from the din of politics "by flying to a country where they are seldom, or never, the subject of conversation."[57]

Izard was too optimistic on that score. From the next room, Carter eavesdropped on Copley and his guests as they began "disputing upon American Affairs." Explaining that he had transcribed the dialogue with no other purpose than to present it to Copley later, as a "Hint . . . meant for his Improvement," Carter scribbled down Copley's lines "*verbatim et literatim* . . . as faithfully as tho my Life depended upon it." (Izard's and Lee's "warm speeches" Carter passed over, for propriety's sake.)

In Carter's comedy of manners, Copley stammers and bumbles, defending every side of the argument and, ultimately, taking no side at all:

"If, If—eh—if they will give up, will give up America—they they must. But, there is many Things may be urged—eh—may be urged in their Favour.—I. I am well assured the Dispute, the, the Dispute—will never—will never be settled—For—the People, *is* enraged to such a Pitch,—to such a Pitch—I—I—I was—ah—ah was *arst* . . ."

Copley having forgotten where he started, much less his destination, his interlocutors try to redirect him. But he continues rambling, undeterred:

"But if the Crown—if the Crown will encourage, for tis in the Power of the Crown—tis in the Power of the Crown—now if the—"

The Americans break in again, but Copley has another card to play, his kinship by marriage to the deposed and despised Governor Hutchinson:

"I have no doubt myself but America will be in Opposition 'till some contingencies take Place for, for the greatest—the greatest Part of

America—and Governour H—Governour H—himself told me though I must say however good Man is Governour H—I dont agree with him in Politick—then the Distilleries, but I am not so much a Master of that—"

His remarks about Governor Hutchinson having failed to clarify the point, Copley got to the heart of the dilemma: would there be war?

"But what ah eh what do you think of a War, do you suppose—do you suppose I, I, I could wish the Americans I could wish the Americans had never conducted, had ah ah never conducted themselves, for I told them at the Time, they would by this Step put, by this Step they had taken put themselves back 50 Years from Independence why there is—there is John Handcock . . ."

Copley continued to talk over his friends, offering a disquisition on the dumping of the tea, a subject upon which he had been forced to become all too expert:

"Now for Example here is a Body of People got together, and how comes it that they are got together?—Because they—because the Body is unanimous and there is few Persons, but after this—after this they had not Strength enough, and what have the Americans to do with the Loss of the [East India] Company[?] a Number of People was there, no Body knows who no Body know[s] who, therefore if the Company if the Company suffered the Loss of a Million who did it, who throwed—eh eh who throwed the Tea into the Sea why the Mob, who are the Mob, why nobody knows &c. &c."

The discussion "continued in this Style, an Hour and Half longer," before Carter decided that he had jotted enough to capture Copley's "Itch for Oratory," and left their apartments in search of "more rational Amusement."[58] He was not much interested in the American crisis. But Copley, like his guests, found the subject consuming. And beneath the puffing and stammering and doubling back that mark Carter's rendition of the exchange, a political position *does* emerge. Like many imperial reformers on both sides of the Atlantic, Copley believed that independence must one day find British America. The rapid growth of the colonies' popula-

tion and the dynamism of their markets made any other outcome impossible. But independence should come naturally, inexorably, in the fullness of time.[59] Decades hence, even a century: the Americans should work, and breed, and wait.

The Americans, they, Copley said, not *the Americans, we. They* should not have dumped the tea. *They* would never back down. Only the king might yet save face, spare the rod, pull them all back from the brink. In this convoluted, hesitant neutrality, Copley joined the majority of his countrymen.

~

The last days Copley and Carter spent together were the most strained of their entire journey. They slept in stinking inns, among "Cutthroats," Carter said, upon pallets of straw infested with "Lice, Fleas, Flies and Knatts or any other Creature that chuse to come in upon us in the Night." They approached Rome by inches, all but on their knees. Carter dreamed of his "Releasement" from the companion Benjamin West had foisted on him. The two men had been "locked into the Chaise" together for ten weeks.[60]

On 23 October, all their long and rutted roads led them, at last, to Rome, storied Rome, the "famousest place in the world," as one English traveler called it.[61] Where the young Benjamin West had been over-awed by his first glimpse of the dome of St. Peter's, Copley felt a sense of belonging.[62] He told Sukey that he felt "more at home" after a day in the "Grand City" than he had "since I left England; & doubt not I shall spend my time very happily"—as happily, he quickly added, "as the seperation from my dear friends will permit."[63]

Copley thought he and Carter might room together through the winter and then return to England in the same coach. Carter was less sanguine: "I told him we had taken the Apartments for a Month and we should see if in future we thought more alike." The future revealed itself all too quickly: Copley wrong-footed it as soon as he crossed the threshold. While Carter was settling their accounts with the porters and the

coachmen, Copley blithely "took Possession of the best Rooms." Carter balked, insisting they "draw Lots" for the larger sleeping chamber. Copley "seemed a little Blank, but agreed to it"; he pulled the short straw and grudgingly rearranged his things, sword and all.[64]

The next day, Copley broke this uneasy truce with what Carter deemed a fatal breach of etiquette. He asked Carter to "spare him the Servant" for the morning, and then headed off with their man, traipsing "Half over Rome," to deliver the letters of introduction he had gathered before leaving Boston.[65] To James Byers, the dean of British antiquaries, Copley carried a testimonial declaring him to be "the best Painter that has ever performed in America, without excepting our American Raphael, as I have often heard Mr. West called." The Abbé Grant, a Scottish priest and scholar who was known to have the pope's ear (British travelers nicknamed him *l'Introduttore*—the introducer), was presented with Dr. John Morgan's tribute to Copley's "Genius," which the Philadelphia physician proclaimed "even superior . . . to some of those whose works he is now gone to study."[66] Grant, Byers, and the other recipients of such introductions were powerful men, men with access to princes and palaces, men who might smooth Copley's way into the busy world of Roman connoisseurs. And he did not mean to share their largesse with George Carter.

Carter learned the nature of his flatmate's errands when Copley failed to turn up for dinner. "I don't scruple to own it hurt me much," he wrote. Over the next several days, the two men bickered off and on, over "little Things." When Carter finally raised the issue of the letters, Copley "flew into a violent Passion and left the Room." It may have been just then that he wrote to Sukey, "I cannot get fixed in my Lodgings[.] those I have at present are very good but I think them much too Dear, so am looking out for others."[67]

Having failed fully to air his complaint, Carter soon spelled out his concerns in writing, so that Copley "might read it at his Leisure" and repent fully. Because he "dreaded the Duplicity of this Bostonian," Carter copied the letter into his journal for posterity. It is a veritable brief at law, covering six pages, through which scrolls a long list of accumulated

grievances: Carter's declaration of independence. "At Paris did I not . . . At Avignon did I not . . . At Marseilles . . . At Antibes . . . At Genoa . . . at Leghorn": had Carter not, always and everywhere, shared his table and his letters and his friends and his worldly know-how with Copley? Could Copley "really think these Things would have been the immediate result of your Genius and Address?"

Carter had shared, but Copley had not shared alike, far from it:

> Your Letters were to Rome, did you not deliver them privately without ever giving me the least Offer to take me with you? And when you met with two American Gentlemen at Florence and they were an Hour in the Room where I was necessarily obliged to be did you ever once say, this (Gentleman) is Mr. Carter; yet Sir I boast that that Name is at this Instant by all that know it, at least as reputable as any one on Earth and wholly incapable of the little Tricks which you this Morning insinuated it would be equal to.

Copley sat with Carter's complaint for a day, and then replied that "he had not Leisure for Disputes," an answer entirely of a piece with his response to the imperial crisis. His erstwhile companion "determined there to close the Account with him forever." After fifteen hundred miles and seventy days together, Carter thought it "more than probable we may never meet again." He was not sorry.[68]

—

Copley had little time to replay the battle of the introductions and its messy conclusion. Reports from Boston soon crashed upon him in waves. A letter Sukey had sent in July was waiting when he got to Rome, and probably one of Harry's as well; a more recent and troubling missive followed a week later. There was some good news: Sukey and the children were healthy, thank heaven, hardly to be taken for granted with smallpox stalking Boston and a pregnancy in progress. (His fears for her well-being increased as the time of her confinement neared.) And her letters gave

the lie to disturbing rumors that the king's warships had begun shelling Boston in early September.[69]

But the letters also "contained some very disagreeable things," Copley said.[70] Political turmoil continued to escalate. "I was in hopes to have been able by this time to inform you that this Town was restored to its former flourishing State," Harry had written. "But alas! delusive hope still spreads its fascinateing Charm over the minds of a once happy but now too fatally deluded and distressed People." The other colonies had pitched in to assist poor Boston, postponing the moment the town would be forced to come to its senses, pay restitution to the East India Company, and end the blockade. Meanwhile, the influx of infantry and artillery had transformed the very palette of the city. "The Common wears an Entire new face," Harry said, rendering politics in painters' terms. "Instead of the peacefull Verdure with which it was cloathd when you left it, it now glows with the warlike Red." The pastoral environs of Mount Pleasant had turned martial: "The fireing of Cannon, the Rattling of Drums, the music of the fife, now interrupt the pleasing silence which once rendered it so peculiarly deligh[t]full." Still, Harry found the orderly drilling of the king's troops "incomparably to be preferred to the infernal Wistle and shout of a lawless and outragious rabble."[71]

Copley felt relieved to learn that his "ever Dear Mother is so well[.] I was fearfull Politicks would have been too much for her." But the turbulence of the times had taken a toll on Harry. He suffered from "nervous complaints," including what he described as "an almost continued Dizziness, Headack, Loss of Appetite, Trembling of the Nerves, and Lowness of Spiritts. . . . From the fatal publick Movements of the last Winter I date my present Disquietude," he said. (A posttraumatic depression, we would call it today.) The doctors prescribed a tincture of steel steeped in wine, along with "frequent Riding," and a "long journey," away from jangling Boston.[72] Reports of Harry's condition terrified Copley. "I wish you had been more perticular in your Account of his health," he told Sukey, "my fears are great for him, least he should be in

anyways Dangerous"—suicidal?—"which I am led to suspect from the Doctors advice."[73]

Copley also worried about his beloved house. The property could "be greatly injured by the Soldiers having the Hill." Between the redcoats and a perfidious tenant who refused to pay his rent, he found himself wishing he had "sold my whole place" before he sailed. "I should than have been worth something," he said. "I dont know that I am worth a shilling in the world." If Sukey could get a fair price for the estate on which he had lavished so much time and money, she should "sell it without Delay." The buildings needed painting, but Copley wasn't sure it was worth doing even that; in the current climate, people might cart off the very pigments. Harry should collect any debts he could, since "if they are not collected now they never will be." For "things will grow worse and not better," Copley prophesied. He grew "very fearfull Boston will soon become a place of Bloodshed and confusion."[74]

England must be the only answer, Copley urged, with increasing vehemence. "I find you will not regret the leaving Boston," he told Sukey at the end of October. "I am sorry it is become so unpleasant a place & think it will determine me to stay in England, where I have no doubt I shall meet with as much to do & on better terms."[75] In November: "I think there is but little dependance to be put on what I have in Boston; considering my surcumstances." His trade, a luxury; his kin, still hounded by the Mob: he would "suffer more than most People in the Dispute."[76] In December: "I tremble for you all, as in a state of Blood Shead and general confusion no one is safe, and I greatly fear the Dispute will end in the most fatal and Dredfull consequences."[77]

Finally, a week before Christmas, came Sukey's answer, now lost, but its gist clear from Copley's response. "Your letter makes me very happy my Dear Sukey," he wrote. "I find you have answered a question I asked in my last letter"—and the one before that, and the one before that—"viz, weither you would wish me to go to Boston or you to come to England, you seem desirous to go to England." He felt enormous relief. In terms of raw natural beauty, he conceded, "America has the preferance." But in

the realm of culture, of "sentiments . . . England has the advantage (by many degrees)." Leave the Americans to make something of the many "blessings they injoy if they are not happy it is their own faults."[78]

It was settled, at last, this vexing question of Home.

~

Copley relaxed into Rome: for Anglophone Protestants, an outlandish place, alive with the pageantry of Catholic ritual. About 150,000 people lived within the city walls, a mere fraction of the human panoply concentrated in London. Three or four hundred churches, many of them recently tricked out in baroque splendor, served the spiritual needs of the city: one for every four or five hundred souls. Nearly "every twenty yards" one stumbled on "some marks of religious superstition," Copley told Sukey.[79] On holy days of obligation—an average of ten times each month, Sundays included—commerce came to a standstill, clouds of incense blanketed the city, and the light of candles turned night to day. Palaces clustered at the crook of the Tiber, and there were so many ornamental fountains that travelers complained about the din of burbling water at night. But in the poorer parts of the town, people squatted in streets given over to foraging pigs. Relics of the ancient past could be found everywhere, ripe for the plucking. Bands of antiquaries looted, all but unchecked by the authorities. Cattle grazed on the Forum. Vines covered obelisks and columns. Ivy and blackthorn wreathed even the Coliseum.[80]

Yet for all its otherworldliness, eighteenth-century Rome was an easy place to be British. By the time Copley got there, generations of travelers had built, piece by piece, an elaborate infrastructure for grand and less grand tourists. Connoisseurs offered courses in the study of antiquities. Merchants sold artifacts, reproductions, and other curios to visitors who wished to take Rome back home to England and Scotland, even to America. Painters and sculptors specialized in the tourist trade, offering grand manner portraits and faux antique busts as lasting testimony to a traveler's wealth, taste, and classical *virtù*. British traders and travelers gathered at the English Coffee House, near the Spanish steps. One of the

best-appointed brothels nearby was called The City of London. In Avignon, Copley had encountered "a little English Colony." Rome boasted a veritable English nation, encompassing a handful of Americans among the other provincials.[81]

Soon after he broke with Carter, Copley struck up a friendship with Gavin Hamilton, a Scottish painter and antiquary who lived above his showrooms off the Via del Corso, the ancient racing route of Roman charioteers. Hamilton, whose "friendly manner" and "opennesse of temper" Copley praised—surely a welcome relief from Carter—found new lodgings for the American just across the street from his own.[82] "I have three Rooms as pleasant as any in Rome," Copley wrote in December. "I find my own Tea & shugar bread But[t]er & have my Diner brot every Day to my Rooms." The price was modest and the company congenial: an enclave of artists, scholars, and other sojourners, many of them Copley's fellow Britons. Some ninety Anglophone travelers passed through Rome in 1775, and at least a score of them were painters. So thick was "the agreeable association of English" centered on the coffeehouse "that I Need not be alone but from Choice," he told Sukey.[83]

What passed for winter—so "mild, seldom any frost," Copley marveled— came to the Campania, and Rome's magnificence gradually turned routine. After breakfast at home, he strolled down the Corso to the French Academy, or hiked to the new museum on the Capitoline Hill to study ancient statuary. He toured churches and palaces, confronting in the painted flesh works he had seen only on the printed page: Annibale Carracci's magnificent trompe l'oeil *Loves of the Gods*, which covered the ceiling of the grand hall in the Farnese Palace; Guido Reni's glorious baroque fresco, *L'Aurora*, one of the most reproduced works of the day, above the loggia of the Palazzo Pallavicini; Raphael's fabled *Transfiguration* at the Church of San Pietro in Trastevere. He kept company with Gavin Hamilton and reconnected with Ralph Izard, who soon became a "very Valuable Friend."[84] Everywhere Copley went, he drew. "I would have you keep in your Pocket a book and a Porto Crayon, as I now do, and where ever you see a butifull form Sketch it in your Book," he counseled Harry. Copley sketched in

pocket-sized books, on loose sheets, and in the margins of his letters home.[85]

While Copley steeped himself in the panoply of Rome, America waxed and waned. When a letter arrived from Boston or London newspapers reached the English Coffee House, the colonies loomed all too large. Copley fretted over his Clarke kin, so long "exposed to the Rage of the People," and now berthed at Mount Pleasant for the winter. He doubted that Pitt's ministry would simply abandon years of efforts to "humble the Provinces." He feared what would befall his countrymen. "When I reflect what a happy people the Americans have been & how unhappy they are at this time I am much greaved." Then he quickly swatted away the thought: "but I have dwell'd longer on this subject than I intended so shall leave it for this time, for I will avoid engaging in politicks as I would wish to preserve an undisturbed mind and tranquility that is inconsistent with political disputes."[86]

St. Peter's was so vast, he told Sukey, that their own large home would fit within it "like a box of a foot square in our sitting Parlour." After "seeing the stupendous things that I have been attending to for several Months[,] to be transported to Boston I should think the people lived in Huts." It seemed that "every thing is on a little Scale in America."[87]

Everything, except politics.

~

The grand tour nourished Copley's preoccupation with scale. For the journey was, in large part, an exercise in measuring one's life against eons. Copley found himself "in Rooms & in Churches where Raphael, Michael Angelo, Poussin, & c. have spent much time & trod the pavement on which I stood." He wandered through "Ancient Palaces where the Emperors of Immortal fame have Resided . . . some famous for their good, some for the bad Actions." To ponder their fates and their fame was to reckon with his own.[88]

Copley had planned a spring excursion deeper into the past, from Rome to Naples and the celebrated antiquities just beyond. But in Jan-

uary he crossed paths with three other travelers bound for Naples and followed "a sudden resolution" to join them. One of his companions was Gulian Verplanck, a Dutch merchant whom Copley had painted in New York, and whom Sukey had met there as well. ("I had no more thoughts of seeing him than an inhabitant of the Moon," Copley told her.) Another member of their party was an Englishman living in Spain who had done some business with Richard Clarke. The citizens of this shockingly small world rumbled south through an earthly Eden, past orange groves "laden with fine fruit so pleasing to the Eye that it would tempt a Second Eve to sin," Copley said. His rhapsody would have been cold comfort to Sukey, who had just delivered her baby in Boston, where redcoats marched on the snow-covered Common, news Copley would not learn for months.[89] "I wish I could be with you my Love to administer comfort to you in that Critical moment," he wrote. "Adieu my Angel Adieu." His letter reached Sukey months after the hour of her travail had passed.[90]

Naples itself was no Eden. The city teemed; with some 400,000 residents, it held nearly three times the population of Rome. The seat of an independent kingdom buffeted by imperial warfare, it was a place of extremes, breeding up destitute peasants and dissolute nobles in seemingly equal number.[91] "The City of Naples is very large, very Dirty, & very pleasantly situated," Copley told Sukey. The streets "Stink often to that Degree as to make me quite sick; and the People are as Dirty as the Streets; every step you take you will see People picking the Lice from one another. I have even seen a well Dressed Shop Keeper leaning over his shop windows with a Man Picking the Lice from his head."[92]

If such grotesqueries proliferated in crowded streets and alleys, politeness abounded in the city's palaces, theaters, and concert halls. Copley carried letters addressed to Sir William Hamilton, Britain's envoy to the Bourbon kingdom and a celebrated connoisseur, said to be "picture mad."[93] When Copley arrived at Hamilton's villa to present his credentials, a servant ushered him into a parlor where an assembly had gathered to hear a concert. Before Copley could make himself known to Sir William, Ralph Izard, who had turned up in Naples around the same

time Copley did, "imediately stept forward & introduced me." Taking Copley's letter in hand, Hamilton announced: "Mr. Copley wants no letter of introduction[.] his name is sufficient to introduce him any where." Copley was so tickled that he reported the exchange verbatim. "I have been surprized to find myself so known in places so distant," he told Sukey. He felt "happy in being less a stranger to the world than I had thought myself."[94]

From Naples, Copley journeyed deeper into the interior, and into the past. In his youth, antiquaries had begun excavating the cities of Herculaneum and Pompeii, buried by the cataclysmic eruption of Vesuvius in 79 CE. The humble details of everyday life frozen in those ruins astonished all who flocked to them, Copley included. He wandered stone streets still bearing "the Marks of the Carriages . . . deeply worn," long before the city was destroyed. He described for Sukey the "house of a prince of some consiquince," its ancient walls "plaister'd as smooth as Glass and painted in an ornamental way with so much eligance as would suprize you." Its "neatness of finishing" reminded him of Joseph Greene's house in Boston. These had been "a people of great Society," he said: people much like themselves, consigned, in an instant, to the ash heap of history.[95]

Copley was forever reckoning his distance—from the present moment, from Boston's struggles, from the bosom of his little family. Paestum, the sixth-century BCE ruins of one of the plantations of Magna Graecia (or Greater Greece) some sixty miles down the Tyrrhenian coast from Naples, marked the southernmost point of his wanderings. He went there with Ralph and Alice Izard, who offered to carry him back to Rome in their carriage. They were among just a handful of British travelers to visit the site in those years, and may well have been the first American provincials to see it.[96] So "little has this place been known," Copley told his mother, "that it is not menshoned by any Auther."[97]

Copley and the Izards spent but three hours wandering through the massive Doric columns that loomed over Paestum's wildflowers and olive trees. But the tumultuous present would not release them for long. Shortly before leaving Naples, Copley had gotten a letter from Harry,

who lamented Boston's course during the final months of 1774. "Discord and Distrust, Cruelty and Anarchy" still reigned over an "unhappy Land," Harry wrote. He blamed "the envenomed tongue of party Malice" and the "Gall dipt pen of Faction": the voice of the People who would be sovereign.[98] Izard, by contrast, praised the People and damned the king, his ministers, and their American minions. He singled out for special opprobrium those merchants and "gentlemen, who were so officious in offering themselves as securities for the tea": men like Richard Clarke. The talk in the Izards' carriage would have been heated, then—perhaps a variation on their conversations in Florence the preceding fall.[99]

Copley arrived back in Rome in February, feeling at once cheerless and fortunate. "I have made a great sacrafice in depriveing myself of the Infinite pleasure of your company & that of our Dear Children," he told Sukey. (*Whose sacrifice?* she could be forgiven for wondering.) "But when I consider the unhappy state of Boston I think it one those occurences that Providence has blessed me in, for what should I do in that unhappy place but share largely in it[s] misery"?[100]

When it grew too cold to hold a lead in the drafty palaces where Copley sketched, he set up his easel in his rooms. (It had not been his "intention to do anything of the kind here, were not the weither too Cold to sit in those places to Study where there is no fire," he assured Sukey, perhaps anticipating her concern that he was dawdling in splendor while she languished.)[101] He got to work on two paintings, the only canvases he finished during his Roman sojourn. Should Harry think he had "done but little," Copley insisted, he might "reflect that it takes a great deal of time to see the Works of Art in this place."[102]

The first was a double portrait of Ralph and Alice Izard, his valuable friends now turned patrons. When Copley wrote to Harry in the middle of March, he estimated that two weeks more work would finish the ambitious canvas, which shows the Izards in a bright, Italianate palette dramatically unlike the more muted tones Copley had used for the mari-

tal pairs he painted in Boston. Facing each other across a marble-topped table carved and gilded to a baroque frenzy, the Izards are surrounded with emblems of their tour, a scene so crowded with antiquities that it reads like an auction catalog. Some scholars have interpreted particular objects in the painting—a sculptural group and a vase that allude to ancient episodes of fratricide and parricide—as allegories of the political struggle raging in far-off America.[103] Certainly the din of politics was hard to quiet. But the picture was also, for Copley, a calling card, showcasing the grandeur his portraits would achieve in London. When Gavin Hamilton saw it, still unfinished, in Copley's rooms, he said, "You are a perfect Master of Composition," a verdict Copley eagerly reported to Harry. Even "Mr. West," Hamilton had averred, "could not paint such portraits." In London, as in Boston, the Scottish painter reminded the American, "portraits are always in demand."[104]

With the fate of his Boston property hanging in the balance, Copley worried even more than usual about his finances. Portraits were bread and butter; for all his high-minded talk about the hierarchy of the genres, even Reynolds needed the income that came from taking likenesses. But Copley had not crossed an ocean to paint faces. Before his detour to Naples, he had begun his first foray into the higher reaches of Art. The "Subject is the ascension of Christ," he told Sukey. "I have made a Drawing that has had the approbation of all who have seen it & I am encouraged to paint it." He estimated that the project would "cost me about three months."[105] Sukey's feelings when she learned this news we can only guess.

Copley's *Ascension* engages in a layered dialogue with the religious and artistic past. The attitudes of the figures reflect Copley's biblical study; he described to Harry his repeated reading of the first chapter of Acts as an aid to understanding "how the Appostles would be affected at that Instant." In addition to Bible verses, Copley found it essential "to Warm his Immagination by looking at some Works of Art." *The Ascension*'s palette, heavy on ochre, red, and yellow greens, owes a debt to Poussin. But especially central to *The Ascension*'s cosmology were the works of Raphael, "the greatest of The Modern Painters," as he reminded Harry.[106]

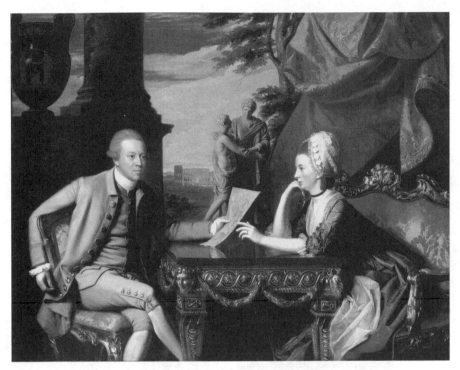

Copley, MR. AND MRS. RALPH IZARD *(Alice Delancey), 1775*

The Ascension offers both homage and challenge to Raphael's *Transfig-uration*, which, Copley said, had "always been allowed to be the greatest picture in the world." The enormous painting had been "placed at the head of the corpse" when Raphael died, in 1520, at the age of thirty-seven: almost exactly Copley's age when he saw it. For "near three hundred years," he told Sukey, the picture had endured, "an Immortal Monument to him who Lay Dead by it & was soon to be mixed with the Dust of the Earth."[107] *Vita brevis, ars longa*: to take on the same subject was to recog-nize the fragility of life, and of fame, all the while bidding for immortality.

With great care, Copley explained to Harry the way he had analyzed Raphael's composition and blocked out his own. He "determined the Action of each figure" and then sketched it, using a three-foot-high man-nequin draped in a wet tablecloth to model the costumes, and his own face and hands, reflected in a mirror, to rough out the heads and gestures. When he was ready to move from paper to cloth, he transferred this out-

Copley, THE ASCENSION, *1775* [Plate 10]

line to a bust-sized canvas and "procured a Model to sit for some heads, from the same Model I think I painted 5 heads varying the Colour of the hair, etc." (Were he one day to "paint it large"—altar-sized—he would "chuse a differant model for each.") Through the painstaking weeks of creation, Copley "studied the works of Raphaiel, etc., and by that kept the fire of the Imagination alive and made it my object to produce a work that might stand by any others."[108]

Copley detailed the making of *The Ascension* in a letter that runs to twelve closely written pages. Several tiny sketches illustrate the finer points. "I hope you will be profited," he told Harry. "I should have been very happy to have had such a plain account of the process when I was in America." But in the end, only one thing mattered: "is it good for anything, and what is its merit?" Though he anguished about the impropriety of saying so, Copley thought that *The Ascension* was good, maybe even

transcendent. Hamilton had been "lavish in its praises, and says he never saw a finer Composition in his life, and that he knows no one who can equil it." The great Venetian engraver Giovanni Piranesi professed to love it, too. And Copley thought he had earned their compliments. "I believe it will support its merit in any Cumpany whatever," he declared.[109]

This was where it led, then, this business of feasting one's eyes: your easel beside Raphael's. The ascension of Jesus—a far more dynamic figure in Copley's version than in Raphael's—marked Copley's ascension too.

⁓

Soon after he finished *The Ascension* at reduced scale—the canvas is smaller than *Paul Revere*—Copley wrote to John Greenwood, seeking letters of introduction to smooth his way through Venice and the Low Countries. He bought plaster casts of the most prized ancient statues, including the Laocoön, the legendary sculpture depicting the sacrifice of innocents—a father and his two sons—in the Trojan War. It was "the best peace of Art now in the world," he told Sukey. By owning such copies, he would "possess all that I would recommend to an Artist to Study for it is not the number of things that an Artist Studys but thoroughly understanding those he studys and the principals of Art that is in them that will make him great." At the end of May, just before summer's heat gripped Rome, Copley packed his sketches and his paintings and his easel, his sword and his velvet suit. And he began to take stock of what he had learned in the course of this dizzying, extravagant "blank in life."[110]

"A man who has not been in Italy, is always conscious of an inferiority, from his not having seen what it is expected a man should see," Samuel Johnson told his Boswell.[111] How much greater that prickling sense of inadequacy for one who came from the provinces. And not from enlightened Edinburgh, like Gavin Hamilton, but from those rougher, remoter British territories across the great ocean.

Now Copley had been and seen. His world of prints and copies—a black-and-white world, a world of muddy olives and bricky reds—had burst into full, glorious color. He had feasted his eyes on the canon of

works widely acknowledged as the very pinnacle of human achievement and, like a good Enlightenment empiricist, had added his voice to that consensus. But he also learned that the greats had feet of clay. Even "in Rome itself," the number "of the very excellent is not great," Copley told Harry. "You are to remember that the works of the great Masters are but Pictures, and when a man can go but a very little beyond his cotemporarys he becomes a great Man."[112]

Copley would venture that "little beyond." For he had learned, too, that his own artistic practice was not quite as lowly as Reynolds and West had led him to believe. The "little way" he had painted in Boston wasn't so very different from what the Immortals had done. Even the great Raphael, in the *Transfiguration*, had "painted warts on some of the faces," which showed he was "painting from the life," not merely from the higher realms of invention.[113]

"I hope I shall be enabled to make such a use of my Tour as will better my fortune," Copley had written to Sukey shortly after he got to Rome.[114] By the time he left, he had grown a bit bigger, and the great world had come to seem both smaller and friendlier than he had imagined. After all, he told his mother, moving through Italy was "only passing from one Town to another, as from Boston to Roxbury."[115]

Poor Boston. In March, in the last letter he sent Harry before leaving Rome, Copley asked, "Could anything be more fortunate than the time of my leaveing Boston?"[116]

Yet the letters he would have received in April and May from that longtime, no-longer home held out some hope. He learned that on 13 January Sukey had been safe delivered of a son. Harry proclaimed the baby more beautiful than "the finest Child ever animated by the Pencill of Giudo," perhaps gently chiding his brother with the suggestion that when all was seen and done, life trumped Art. The family had named him Clarke, after Sukey's beleaguered father. "I really thin[k] we are in a better [state] than we were some time ago," Harry wrote. "Certain I am this town is incomparably more peaceab[le] than it was when you left it, and I flatter myself that the time is approaching when Reason will

aga[i]n recover her empire over the turbalant Passons of an enthusiastic and misguided People, and that jarring and hatred, jealosies, distrust and mutual revili[n]gs, will give place to the long Cataloge of exiled Virtues; that Peace with her swe[e]t Voice will again hail this Happy Land, once more the seat of Plenty Justice Security and Fre[e]dom."[117]

As far as Copley knew in the beautiful Italian spring of 1775, the long-promised bloodshed had not come. "I hope the best but I fear the worst," he told Harry. But one way or another, he felt "certain," America would "finially Imerge from he[r] present Callamity and become a Mighty Empire." It was "a pleasing reflection" that when it happened, however it came to pass, Copley would proudly "stand amongst the first of the Artists that shall have led that Country to the Knowledge and cultivation of the fine Arts," which would "one Day shine" there, "with a luster not inferior to what they have done in Greece or Rome."[118]

THE AMERICAN WAR

OPLEY LEFT ROME at the beginning of June 1775, the long days growing cooler as his carriage rattled north into the Apennines. After a year's absence, he could scarcely picture the family he had left behind, now grown to include Clarke, the infant he had never met. He recalled his daughter Mary, a babe in arms when he sailed. "I suppose Polly is grown a fine Girl and runs along," he told Sukey, imagining the "fine noise" of "those Dear Creatures when they are at play. O my Dear I cannot express the Love I have for them & for you nor my desires to be with you." He hoped they would enjoy "many happy years together in this life & to see those Dear Children grow up to be blessing to us when we may be Old & decending to the Grave."[1]

But first there was work to do. He would tarry in Parma—which seemed "a little obscure place after being so long in Rome and other Great Citys"—just long enough to take a copy of Correggio's famed *Madonna of Saint Jerome*, painted in the sixteenth century, shortly before Raphael's *Transfiguration*. (An "English Nobleman" was waiting on Copley's copy.)[2] There were several other British painters bent on the same conquest. William Parry was painting a version when Copley got there; Joseph Wright, whose work had been confused with Copley's own in the 1760s, arrived a short time after; Ozias Humphry, whom Copley had met on the tour, would shortly follow. And the keeper who controlled access to the picture in Parma's Royal Academy told Copley that he had recently received a letter from "a Mr Carter, George Carter," who "was coming

Correggio, MADONNA OF SAINT JEROME, *ca. 1527–28*

very soon to Copy the Picture." The attendant asked Copley whether he knew Carter. "I told him I did," Copley said. He set to his easel with customary diligence, turning up when the keeper unlocked the doors at eight and painting till noon, then returning by three and working until the light failed.[3]

By the time Copley reached Parma, his sense of wonder had faded. He was desperate for news from America. "While I was in Rome I saw the English Papers twice a Week, but in this place I have not the least oppertunity," he told his mother. "I now grow very impatient to receive a letter from you," he wrote to Sukey, knowing full well that she would not hear his plea for months. Nor was Harry writing fully or often enough. "I wish he would consider that the smallest surcumstances are rendered interesting from the distance I am at," Copley said.[4] He sent Harry meticulous descriptions of what he was seeing, and received only silence in return.

The brothers' roles had reversed themselves since New York. Now it was Copley who stayed up writing, chiding, late into the night.[5]

The rapprochement that Harry sensed in February 1775 notwithstanding, life had been hard in New England since Copley left. Warships filled the otherwise empty harbor. The business of art was "entirely Stopped," Harry said. The collection of fees proved impossible; "People are very backwa[r]d in paying, there being now no law to Oblig[e] them to it."[6]

Everywhere the People organized, as if their will, and their will alone, were law. Committees of Safety and Observation administered rough justice, policing everything from the import bans to the observation of fast days. The Committees of Correspondence that had long coordinated protest actions with other provinces gave way to a grand continental congress in Philadelphia. When Harry Pelham traveled there in the late fall, on a journey to fulfill the doctor's prescription to relieve his nerves, he found one of the family's best friends, whom Copley had painted, "so ingaged with the Congress of which he was a Member" that he could not take time to introduce the young artist around.[7] At least in Philadelphia there were people who still wanted portraits; Boston seemed to house only soldiers. Troops from eleven regiments were billeted throughout the town, and the populace had armed itself in turn. "The people were preparing their fire Arms, and melting all the lead they could get into bullets, and there was not a musket to be sold in Boston, but was bought up," wrote Henry Hulton, one of the ill-fated customs commissioners.[8]

Everywhere those branded Tories were menaced, as the now routine practice of tarring and feathering took its place alongside other forms of political terror. "One person was put in a coffin, and was near buried alive," Hulton wrote. A friend of former governor Hutchinson mounted his saddle to find that the patriots had driven nails into it, spurring his horse to throw him, "whereby his Collarbone was broke." Nobody was immune: Tory children were throttled, Tory wives menaced, Tory horses poisoned. Hulton tried to track the insults, but soon decided that it would be "endless to relate all the various modes of persecution, and

torture, practiced on those who were deemed by the People unfriendly to American liberty."[9]

Harry had tasted the People's justice firsthand, and he found it bitter indeed. On his way to Philadelphia, he and his companions—Sukey's sister Sarah and her husband, as well as a family friend who had been appointed a judge under the new military government—encountered a mob in Springfield, which branded the travelers "a damn'd pack of Torys." The crowd fired at the windows of the inn where they were staying, and said the guests could not depart until they confessed their crimes. Harry boasted to Copley that the little Boston company had sneaked out before daybreak, "leaving those Sons of —— to find recantations where they could."[10]

None of Sukey Copley's letters from Boston survive, which makes it difficult to get a sense of life on Mount Pleasant. The burdens of managing the estate would have fallen to her, as they did to the many women transformed into "deputy husbands" when their spouses were away for prolonged periods.[11] She tended to the children and managed the servants and slaves, some of whom took the day's heated talk of liberty seriously enough to slip their bondage. Two of Sukey's maids left her service, though a manservant named Redman continued faithful, and Snap, Harry said, remained "a very good Boy."[12] She also tended the household accounts. With Harry's help, Sukey wrangled with the Copleys' recalcitrant tenant, Edward Green, a patriot merchant who was scheming to reduce the rent for the upper house. In addition to failing to honor his lease, Green had sublet the Copleys' barn; John Hancock was parking his chaise there, and Ephraim Fenno, the leatherworker who rented the oldest dwelling on the estate, was using it to quarter chickens. Eventually, at Copley's urging, Sukey enlisted the help of a lawyer, to no avail: Green would neither pay up nor move out. It is possible that politics entered into Copley's dispute with Green and Hancock, who also owed the painter money. Harry reported that every time he tried to seek "an audience" with Hancock, the colonel either seemed to have "a Violent Headack," was "laying down," or offered some other "such trifling excuse." Were

Hancock "a less Man, or I a greater, or the times more favorable," Harry said, he would tell the great merchant that he considered him "a very trifling Fellow." But "the temper of the times forbids my doing other than taggle after his plagey heels whenever he is pleased to appoint it."[13]

Sukey's lodgers helped her make ends meet; the Copleys received nearly three pounds per week toward the cost of boarding her father, brother, and younger sister Lucy. Clarke bought their wood for the winter and purchased whatever genteel sundries he could scare up, including some sugar and even a bit of tea, the detested tea, the cargo for which he continued to pay with his very liberty. But the baggage that came with the Clarkes—still personae non gratae—would have been more cumbersome than the bedsteads and linens and silver and wines they carted up the hill from the wreckage of their house on School Street.[14] The jeers and taunts of the People must have followed wherever they went, if indeed they ventured out much at all. "Our Fr[i]ends here live very quietly, and ther[e] is but little danger I think of their not continuing so to do, let the dispute be as it will," Harry told his brother in early April. Mary Pelham struggled along in her fragile, fretful state. "She would have wrote you a few lines, but as I thought it would worry her I diswaded her from it," Harry explained.[15] The sheer mass of imperial might on display in Boston safeguarded the little bands of internal refugees.

Amidst the peeling splendor of Copley's house on the hill, with the troops drilling just below the parlor windows, the relics and remnants of the intermarried Clarke, Copley, Pelham, Oliver, and Hutchinson families continued to gather. Their talk must have been more bitter than their tea. As they understood the political climate, the "Sons of Anarchy" squared off against the "God of Order." In the Copleys' great room, where letters from absent loved ones could be shared by a hearth well stocked with firewood, order prevailed. But outside, much of the time, anarchy seemed to be winning.[16]

And then came 19 April. "A day to be remembered by all Americans of the present Generation, and which ought, and doubtless will, be handed down to Ages yet unborn, in which the Troops of Britain,

unprovoked, shed the blood of sundry of the loyal American Subjects of the British King, in the Field of Lexington," declared one patriot.[17] "That fatal day," Harry called it, scene of an "obstinate and Bloody Battle," in which "the Bravest and best Disciplined troops that ever Europe Bred" were "attack'd by an Enemy they could not see, for they skulk'd behind trees." Sukey had nearly landed in the middle of the chaos; she was set to ride with Harry to Newton, to warn Charles Pelham and his family of the impending "disturbance" and carry them back to Boston. But Harry went alone, in Copley's chaise, riding home just ahead of the minute-men who pursued the retreating British troops. "Alass! My dear Brother where shall I find Words sufficiently expressive of the Distractions and Distresses of this once flouish'g and Happy People," Harry wrote. "My hand trembles while I inform you that [the] Sword of Civil War is now unsheathd."[18]

The rebels, nearly ten thousand of them, cut the city off from the countryside that fed it. Gage and his men scrambled to fortify Boston against attack. Patriot sympathizers gave up their arms, gathered what property they could carry, and abandoned the occupied town; by the end of May, some ten thousand Bostonians had fled. Loyalists straggled in from the countryside, trusting Gage's promise to shelter them.[19] Copley's family remained in the garrisoned city, safer there than they would have been anyplace else in the colony. Having dreaded just such a "political Storm," they had laid in enough food to last six months. Since the battle, Harry said, they had "been obliged to live intirely upon salt provisions and what stores we have in the house." This "distressing scene" was what Harry had so long imagined, the specter that had been "the cause of that illness" which set him wandering the previous fall. And what now? "I cant but think myself very unfortunate thus to have lost so much of the best part of Life," he said. All his "bright prospects anialated, the little Property I had acquired rendered useless, myself doomed either to stay at home and starve, or leave my Country [and] my Fri[e]nds, . . . to seek that Bread among strangers which I am thus crually deprived of at Home."[20]

Copley had spent 19 April in Rome, racing to finish *The Ascension*,

with no inkling of his family's distress. More than two months passed before the news began to trickle into Parma, via Rome, via London. "I pray God preserve and keep you from all from the Miserys of War," Copley wrote to his mother on 25 June, after hearing from John Greenwood that "Civil War . . . has began already with the spiling of the blood of an hundred and fifty or two hundred persons." Copley seems not to have known whose blood, or where it had been lost, for the rest of his letter comprises a breezy narrative of art and travel. A week later he knew more: "I have seen a letter from Rome by which find menshon is made of a Skirmish having been at Lexington, and that numbers were killed on boath sides. I am exceeding uneasy not knowing to what you may be exposed in a Country that is now become the seat of War."[21] A report from London soon added details. "My Life[,] the accounts from America make me exceedingly ancious," he told Sukey on 2 July, after learning that "the Americans have an Army of fifteen thousand Men incamped within a Mile of Boston." Copley thought any attempt to "starve ye Town" was doomed, but knew the family must still be "dreadfully distressed. May God preserve you my Life from such an evil," he wrote.[22]

From the moment he heard the news from Lexington, Copley described the unfolding conflict—which the American rebels would soon call a revolution, and later understand as a war of national liberation, a "founding"—as a civil war. "The flame of Civil War is now broke out in America," he wrote to Harry, "and I have not the least doubt it will rage with a Violence equil to what it has ever done in any other Country at any time."[23] The rebels would win: of this Copley felt certain, a belief for which there was little precedent in modern history, and which only a tiny minority of his countrymen on either side of the British Atlantic shared. But he had witnessed at close range the grim resolve of the Americans, that furious faraway people across the ocean, in "that country." "I know it may seem strange to some Man of Great understanding [that] I should hold such an opinion," he told Sukey, "but it seems a very evident thing to me that they will have the power of resistance till grown strong to conquer & Victory & Independence will go hand in hand." He had long

suspected "that this would be the end of the attempt to tax the Colonys"; he reminded her "how Warmly I expostulated with some of those violent Sons of Liberty"—with Samuel Adams, maybe, or Revere. With "how little Judgment did I than seem to speak, in the wise Judgment of those People," he recalled, filled with the schadenfreude of having been proved so regrettably right. "I aught to have many friends and thanks for the pains I took to prevent so violent and rash a peice of conduct" as the dumping of the tea, he said to Harry. But his efforts had earned him only enemies.[24]

And now it had come to pass, the "Day of tribulation," as Copley called it. Britain would "persevere in Vigorous measures" until the Americans made restitution for "the outrage offered . . . in the destruction of the Tea." The Americans, too, would persist. "I think that the people have gone too far to retract and that they will adopt the proverb, which says, when the Sword of Rebellion is Drawn the Sheath should be thrown away," he told Harry. A long war, "a Struggle of many years," must ensue. Speaking the vernacular of the Old Testament larded with *Macbeth*, Copley predicted—accurately, as it happened—that "the Ground will be drunken with the Blood of its Inhabitants before peace will again resume her Dominion in that Country."[25]

At the end of it all, Copley forecast, "the Americans will be a free independant people." But the strife would not end with independence. To the contrary: the country would be "torn in pieces," twice: "first by the quarrel with Great Briton till it is a distinct Government, and than with Civil discord till time has settled it into some permanant form of Government." Whether that form would be "free or Dispotick," Copley told his mother, "is beyond the reach of human wisdom to deside."[26]

Copley feared for Sukey and the children, who he hoped would soon remove to England, and for his mother, who he suspected would refuse to do so, good sense notwithstanding. But of all his besieged and benighted kin, he worried most about twenty-six-year-old Harry, a rash young man of fighting age on a continent that was discovering an insatiable hunger for soldiers. "I dont know what you may be called to in so critical a con-

junctor," Copley warned him in late July. "It may be (for my fears suggest many terrable things) that you are called to Arm yourself. But if you should be, it is my injun[c]tion that You do not comply I trust an injun[c]tion from me will have its Weit intirely," he said, acting as faraway father. "For God Sake, dont think this a Triffling thing," Copley urged. "You Must follow my directions and be neuter at all events."[27]

Mindful that patriots were opening letters, Copley was vague about his reasoning.[28] In addition to his obvious concern for his brother's life, he was likely motivated by anxiety over the fate of his houses and land. He may well have heard that the provincial congress that functioned as the shadow government of Massachusetts had begun in 1775 to authorize the seizure of loyalist property. That May, it voted to suspend the titles of those who had quit the countryside for Boston; later in the year, the estates of loyalist refugees would be sequestered. Confiscation and banishment seemed soon to follow.[29] And there was more than land at stake in a civil war. To take up arms might make one a citizen of a new polity, or a traitor to the king, depending on who was holding the gun when the firing stopped.

In late July, Copley received word from Sukey that she was safe in London. She had sailed at the end of May, with three of their children and two or three maids. The cost of their passage was exorbitant: seventy pounds for the group and their baggage.[30] After a speedy crossing, they had installed themselves in the home of Thomas Bromfield, the brother of her sister Hannah's husband. Bromfield and his family lived in Islington, just past the fashionable watering hole of Sadler's Wells. But if Sukey and the children were somewhat rusticated, they were hardly isolated. "The Americans Muster very thick in England," she said.[31]

Great politeness was quickly extended to Mrs. Copley and the children. Benjamin West sent his "Servilitys"—his servants—to deliver his compliments, and Sukey soon visited him in his new house and gallery on Newman Street, in the grand neighborhood rising just north of Oxford Street. "I was much entertained with his works, which are very great and must have cost him much Study and labor," she wrote, knowing first-

hand the demands of excellence in the painting way.[32] Thomas Hutchinson summoned her to dinner at St. James Square, the most fashionable address in Westminster. Around the table crowded others who had sailed with Sukey on the *Minerva*, including John and Katherine Amory, and Joseph Greene and his wife, Mary: a gallery of Copleys.[33]

Copley's relief was enormous. Indeed, he declared himself "doubly happy" that Sukey had landed before he knew she had sailed; he had been "saived the angsiety I should have indured had I known that you & those Dearest Children were on ye Seas." He was distressed to hear that Harry and his mother had lingered in Boston. ("Dear mother surely ought not to have stay'd behind," he said, wishing he had "wrote more pressing to her to come.") And Sukey had told him she carried three of the children out of "that Misarable place," but she had been "remiss," Copley said, in not saying "where the other was nor which you left behind, nor for what reason." He guessed that Clarke had been deemed too young for the trip, and this made him anxious. Nor were his other children yet home free; he knew they faced the mortal trial of smallpox inoculation after the peril of the journey. "I trust God has preserved them in life," he wrote. He pictured "with the greatest Imaginary pleasure" the moment he would "clasp them in my longing Arms." They were only nine hundred miles apart now: about two weeks by letter. Copley urged Sukey to route her correspondence directly to Parma, which took "but twelve Days . . . whereas it takes 17 Days [from London] to Rome than 17 from Rome here makes 25 Days."[34] Perhaps she chuckled over his math.

Copley redoubled his efforts to finish the *Madonna of Saint Jerome*. He left Parma at the end of August, after which he tarried some two months in Venice, perhaps deciding that it would be harder for him to find the time and the money to get back to the Continent than to endure a bit longer without his family.[35] His mood was almost giddy. "I am not dejected in the least," he told Harry, "and was not my impatience to get to England greater than I can express, and my anxiety for you and my other friends in America very distressing to me . . . I could say my spirits were never better than at this time." He knew that, in Boston, he had

"lost perhaps my all": every coin laid up, every inch of ground husbanded, from the age of thirteen, when he became the head of his little household of three. But "although I may by this unhappy struggle be reduced to a state of poverty," he had every reason to hope that he would "meet with that incouragement in England which will enable me to provide for my family, and in a decent manner bring these Dear Children up which God has blessed me with."[36]

The time apart had been terrible, "like the Seperation of Soul & Body," Copley said. "I cannot express the violence I did to nature" by cleaving the family as he had, leaving Sukey where he had, when he had.[37] Despite that awful cost, Copley had learned a great deal about Art, as well as the central lesson of history: "How short a way do we penetrate into the secrets of Futurity!" He asked Harry, who was still stuck in besieged Boston, where tempers and provisions alike ran short, "did you think when I left Boston such a sceene would have taken Place? that I was leaving so much distress? and that my choice was so undoubtedly the most eligiable? and what ere long I should have been obliged to have adopted?"[38] Was he not, in fact, "pecularly bless'd in having it in my power to leave the distresses of that unhappy Country" when he had, and also why he had: without foresight but also without rancor?[39]

Sukey, in London, often found herself reflecting on "some Sermons Mr. Parker preached not long before I left Boston, from these words: The Lord Raineth."[40] While she meditated on the flight from Egypt, Copley continued to imagine himself a pilgrim, on an earnest progress toward deliverance. The distinction would come to matter greatly. What others may have seen as selfishness, he experienced as a form not just of luck but of grace: the tender mercy of "that beneficent being," who had so long showered him with "mercy," and had at last intervened "in a very perticular maner for the course of my affairs." And now the plan had been revealed, he told Harry:

> I am just now on the point of finishing my Tour, which I should have found it very dificult to have taken if I had stayd in America longer than

I did, and if I had left it sooner, it would have been doing more violence boath to myself and Dear Wife to have fix'd in England. but now there is no choice left.[41]

No choice left: that was Copley's peculiar blessing. Let the Americans revel in choosing their destiny and fighting to make it so. That purposeful act was central to the stories they told about themselves and their rebel nation. It remains central to the American story still: a core tenet of our national faith, a secular religion that makes founding fathers of the fallible men who chose the winning side. But for Copley, life, liberty, and happiness depended on the freedom *not* to choose. His side—of the ocean, in the war—had chosen him.

~

"I trust, when we meet again, we will not be separated till our Creator take us to himself," Copley had written Sukey before leaving Parma.[42] And so it happened, much to the couple's delight and the historian's chagrin. No letters between Copley and his wife dated after the end of his tour survive. The bright light of London, with its competing exhibitions and its well-developed culture of criticism, makes the public Copley far more visible than was the case when he lived in the enforced obscurity of the provinces. But the family man submerges. Were it not for the American War, which scattered members of the Copley, Clarke, and Pelham families around the English Atlantic, the artist's domestic life would disappear completely after December 1775.

It was then, after eighteen months and thousands of miles, that he found Sukey, Betsy, Jacky, and Polly at the Bromfields'. Richard Clarke and his son Isaac joined them before the year ran out, having braved the winter passage to put Boston forever behind them.[43] Shortly thereafter, the Copley family took up elegant quarters at 12 Leicester Square, two doors down from the house in which William Hogarth had lived, and within sight of Sir Joshua Reynolds's mansion across the plaza, in the middle of which stood an enormous statue of George I

on horseback: first of the Hanoverians, German progenitor of Britain's imperial glory.[44]

Almost immediately, early in 1776, he began what Curwen described as "a family piece containing himself, Mr. Clarke, his wife and 4 Children." (The fourth was a hopeful chimera; baby Clarke was still in Massachusetts.) When Curwen saw the canvas, on April 1, it was far enough along that he noted "a very striking likeness." The painting that has come to be known as *The Copley Family* was the painter's most ambitious work to date, larger even than the mammoth full-lengths he had painted to hang in Harvard Hall, and as intricate in composition as a history painting. It was in many ways a European work, showcasing Copley's new freedom with his brush, and embracing the sinuous dynamism that characterized the rococo style. With seven figures spanning three generations, ranging in age from one to sixty-five, the picture teems with an irrepressible vitality. Painted during one of the most frigid winters of London's mini–ice

Copley, THE COPLEY FAMILY, *1776–77* [Plate 11]

age, it radiates the warmth of Italy. The hillside in the background echoes the ancient mountains that recede behind Copley's *Ascension* and Correggio's *Madonna of Saint Jerome*, though here the painter has added water: they are on a far shore.

The Copley Family owes more than its pastoral backdrop to the Correggio with which the painter had spent so much time in Parma. With her hair piled high and twined with silk, and a loose cerulean mantle of vague classical drape, Sukey is the Madonna of Leicester Square. Even her foot, in a dainty pump of embroidered peau de soie and perched on a damask hassock, echoes Correggio's Mary, who rests her holy toes on an outcropping of rock. Where the infant Jesus and an angel crowd the lap of Correggio's virgin, Sukey holds two children vying for her attention: a giggling Jacky, still in skirts at age four, nuzzles her nose while two-year-old Polly squeezes her mother's arm. The sense of touch is palpable, delicious; the toddler chub of Jacky's chest and arm appears to yield to the gentle pressure of his mother's long, elegant fingers. A chain of hands— Jacky to Sukey to Polly to Betsy—binds the distaff side of the family. In the middle of that chain, Sukey's filigreed wedding ring sparkles.

Whereas Sukey and the two children gamboling on her lap are bathed in light, Copley and Richard Clarke are shadowed; an opening behind them seems to show sunset, and gathering gloom. Copley, the artist, stands behind them, dressed in bottle-green velvet, presiding over the scene in the fashion of Saint Jerome. He holds a set of plans and leans on a plinth, symbols of his dominion, and of his classical learning, so hard and lately won. This is a man who has been to Italy, who has seen, and is seeing still. The seated Richard Clarke, white-wigged patriarch, is stone-faced in dull black cloth, impassive despite the toddler who wriggles in his lap and shakes a rattle in his face. Perhaps the elder Clarke, who sits west and faces east, wishes he had stayed behind in Boston with his namesake. In any case, the torch has been passed, from Clarke to his daughter and from her to her children. Betsy Copley, at age six, the eldest of the rising generation, claims center stage. She is a serious girl, her expression grave beyond her years. She stands almost frontal to the pic-

ture plane, and engages the viewer directly, unblinkingly. In her father's and grandfather's shadow but in her mother's orbit, she unites the two sides of the frame.

Scholars have long compared *The Copley Family* to Benjamin West's *The Artist's Family*, painted in 1772. West's painting was small, not much larger than a folio sheet of paper, possibly intended for engraving; a print was issued in 1779. Copley may have seen the original in West's home. The two men kept company when Copley finally got to London; in fact, West was taking tea at the Copleys' when Samuel Curwen happened upon *The Copley Family* on the easel.[45]

The Copley Family was at once a celebration of private life and a bravura public performance. Six feet tall and nearly eight feet long, it was meant to hold the wall. Copley had last exhibited in 1772, when *Mrs. Thomas Gage* and two other half-lengths hung under the auspices of the Society of Artists, which recorded his name in its catalog as "Mr. Copeley, F.S.A., At Boston, North America."[46] Around the time Copley arrived in London, the society enlisted John Greenwood to entreat him to remain on their roster.[47] But the fortunes of what one critic called a "drooping Society" of "wandering Artists" had fallen in recent years, as the Royal Academy rose in power.[48] Copley quickly switched his allegiance. In the spring of 1776, while he continued work on *The Copley Family,* Copley submitted for the academy's annual exhibition a painting listed as "A conversation"—presumably the double portrait of the Izards, which he had finished after the couple left Rome and carried through his travels. In the academy's catalog, he is listed as "John Singleton Copley, Leicester Fields," flagging his new London address and also highlighting, for the first time in print, his middle name, the name of his mother's fine Anglo-Irish family.[49] At precisely the moment that half of Britain's American colonies were preparing to rechristen themselves as a new nation, Copley's debut at the Royal Academy represented his declaration of independence from all he had left behind.

The world beyond the frame was far darker than Copley's roseate family picture discloses. Every vessel that landed from America brought

fresh cause for alarm. Despite Copley's repeated entreaties—and Sukey's, and Harry's—his mother refused to hazard the trip. Copley was annoyed at her reluctance; "I now would ask our Dear Mother," he wrote, "weither a month's Voyage is by any means an evil to be compaired to the evils" surrounding her in Boston.[50] There was little fresh food, even for the old and the sick. The countryside had been transformed by the fighting: "fences pulled down, houses removed, Woods grubbed up, Fields cut into trenches and molded into Ramparts. . . . An hundred places you might be brought to and you not know where you are," Harry told his brother. The troops pulled down the railing around Mount Pleasant, claiming it for fuel.[51] The estate had escaped damage while Sukey and the Clarkes were there, but once they departed, British officers claimed the Beacon Hill houses. When the American general, Washington, drove the British out, a second army, the Continentals, had quartered "a Considerable Number of Soldiers" in Copley's estate.[52] Harry and his mother continued on Cambridge Street, with Snap.

The damage to Boston was far from the worst of what Harry related. In March, Sukey received the news she had been dreading: the death of baby Clarke. "A fine boy in good Health," Harry had called him shortly after Sukey departed.[53] But she knew better. "I am very anxious for my poor Babe," she had written in September, "but am happy it is under the care of those who will do the best for it. I desire to be resind [resigned] to the all wise will of the great disposeer of all things, neither to dispise his chastenings, nor to faint when I am rebuke'd of him."[54] Clarke had perished in January, a few days after his first birthday, from "a consumption with which he has been declining for some months," Harry wrote. He urged Sukey and Copley to look past the baby's death to "the bright scenes which lie beyond the grave."[55] And perhaps they managed to do so, facing the loss of a child in its first, most vulnerable year, so very far away, with the equanimity of believers in divine will.

By the time she got word of Clarke's death, Sukey was pregnant, for the fifth time in seven years. In October 1776, the Copley family welcomed a daughter named Susanna, after her mother. All of the Copleys'

children had been born British, but Susanna was the first of the brood native to England's home islands. That fall or winter, Copley painted *The Nativity*. It is a small picture, about the size of *The Ascension*, but rendered from a much closer vantage point. The viewer is welcomed into the manger, near enough to feel the scratch of the hay. Copley crowds eight people into the little scene. Six of them are generic figures, emblems, in the manner of Raphael's famed cartoons. But the Madonna, robed in dazzling white, and the infant Jesus are rendered precisely, even minutely. They are people, not types; their humanity is the foundational mystery of the Christian tradition. The baby looks to be about a month old. He sucks his fist while he sleeps. The Virgin who gazes at him with rapt attention has the unmistakable profile of Sukey Copley.[56]

Copley, THE NATIVITY, *ca. 1776*

Shortly after baby Susanna was born, the members of the Royal Academy made Copley an associate, a probationary rank granted to up to twenty artists. In time, a few of them would become full academicians, whose number was limited by charter to forty.[57] Of the nearly two dozen aspirants for associate status in 1776, Copley was one of only two elected, which allowed him to add the initials "A.R.A." to his name when he displayed *The Nativity* and *The Copley Family* at the academy's exhibition in 1777.

That year's show was awash in family pictures, a type whose popularity got a boost from the astonishing fecundity of George III and Queen Charlotte. The queen was pregnant with her twelfth child when she toured the exhibition, as the sovereigns did each year, with great fanfare, just before the public opening. The scale and vitality of the king's brood mattered greatly to the nation; the royal children ensured the stability of the Hanoverian line, and served as a metaphor for the happiness of the mother country and its colonial dependencies. *The Copley Family* hung in the same packed salon with Benjamin West's group portrait of the six youngest children of George III, which promoted a similarly boisterous and romantic version of childhood. The scale of both pictures would have placed them above the line, as the wainscot dividing larger from smaller pictures was called.[58]

None of the newspapers mentioned Copley's *Nativity*, though it was regarded well enough to be issued in mezzotint two years later, a costly undertaking that presumed some market for the print.[59] *The Copley Family*, though, attracted notice, as its massive scale intended. "Mr. Copley, from the size of his family piece, is likely to be as much the subject of observation in the rooms as any artist who has exhibited," noted a reviewer in the *Morning Chronicle*. Parts of the painting had "great merit," the critic continued; the figures of Sukey and her father, and the portrait of the infant the artist had never seen, and who had since perished, were singled out for praise. But the harmony of the whole was found wanting,

THE EXHIBITION OF THE ROYAL ACADEMY OF PAINTING,
IN THE YEAR 1771, *1772*

"destroyed from a want of proper proportion of light and shade." And the
painter himself was poorly integrated into the scene. "The figure of the
gentleman, leaning behind with some plans in his hand, seems also to be
oddly placed, and not properly one of the family."[60]

Yet, for better or worse, Copley was properly one of the family: Rich-
ard Clarke's family. And with Clarke and his kin came an inescapable set
of commitments, as the family politics that Copley had joined upon his
marriage became a matter of international debate. The American War
was everywhere the topic of passionate conversation in London, spawn-
ing hundreds of books, prints, and pamphlets along with thousands of
newspaper articles, a stream that began with the destruction of the tea
and widened with the rebels' July 1776 declaration that they meant to
stand as a nation among nations.[61] Crowds flocked to the printshops along

the Strand, eager to purchase the likeness of George Washington and the leaders of the newly organized American army. As the conflict spread and casualties mounted, growing ranks of Londoners sported mourning wear to honor their fallen family members.[62]

Richard Clarke brought the American War into Copley's house in Leicester Square, where the aging patriarch lived from the moment of his arrival in London until his death two decades later. Clarke's circle of acquaintance consisted largely of other wealthy New Englanders displaced by the fighting: a whole coterie of Massachusetts officials and merchants whom events had made Tories. Copley and Sukey dined and drank with the Hutchinsons, the Greenes, and the Amorys, with Samuel Curwen and Samuel Quincy, and presumably with other New England refugees, who didn't keep diaries. Copley saw the pamphlets they read: a steady diet of polemics on the burning question of the day.[63]

Early in 1776, about a score of them organized as a "New England Club," to meet weekly, on Thursdays, for dinner. Copley, along with Richard and Jonathan Clarke, and their fellow tea consignee Elisha Hutchinson, attended the inaugural gathering at the Adelphi Tavern.[64] Talk of American affairs dominated the club's weekly meetings, from the fall of Boston in March, to the rise of rumors, come October, that the French would hazard the rebellion of their own American colonies to join the war against their ancient English enemies. No wonder Samuel Curwen reported that a "nervous head ach[e]" and a "restless, sleepless night" was "a Constant attendant on my weekly Club."[65]

Among the sizable and growing body of Americans forced by the fighting to call London home, Clarke and the other tea agents claimed a perverse pride of place. When they first petitioned Whitehall for relief, early in 1777—with Clarke acting, always, as elder statesman and spokesman—the consignees explained that their "great sufferings" had commenced "near a year before any other persons were molested for their attachment to Government," which fealty had rendered them "so obnoxious to the Rebel Party in America" that they could not possibly return until the rebellion was put down.[66] Clarke's losses had overspread three gen-

erations: "Mr Copley who married my Daughter is a portrait painter, and was in Italy when the rebellion broke out in America, which put my daughter under the necessity of removing with her Children to this Kingdom," he told the Treasury Office in October 1777. "Mr Copley has a considerable property in Houses and Lands in Boston, but has not had it in his power to avail himself any thing from it since the commencement of the rebellion; and he is not yet so well established in his business here, as to be able to support his Family in the most frugal manner; which obliges me to do all I can towards their subsistence."[67]

Owing to their quasi-official character as agents of the East India Company, the consignees had each been granted an annuity of £100 from his majesty's treasury. In response to pleas like Clarke's, the crown increased the subsidy to £150, and awarded the teamen an "advance" of £200 apiece.[68] But the amount was nowhere near the scale of their losses, and far from enough to live decently in London. The cash Copley had borrowed against his lands before he sailed was depleted. He had little in the way of income, having sold few works in Italy or yet in England. The noble patron who commissioned the copy of Correggio's *Madonna* appears not to have claimed the picture. (Copley's son still owned it when he died.) *The Ascension*, *The Copley Family*, and *The Nativity* were all painted without patrons; all three likewise remained in the family.[69] Nor did Ralph Izard deliver the agreed-upon fee for his elaborate double portrait. Though Izard embraced the rebellion, the American War trapped him on the eastern side of the Atlantic as much as it did the tea consignees. He petitioned the American secretary for permission to return to South Carolina, in order "to preserve even the wreck of my Estate" from the fighting. But his plea was denied, and Izard passed the war years in Paris, possessed of neither Copley's canvas nor the money to pay for it.[70]

Almost all of Copley's portrait commissions in those early London years came from other Americans who were nearly as strapped for cash as he was. He painted Gilbert DeBlois, a Boston merchant who had lived near him on Cambridge Street and who, like Copley, had at first

supported the American cause. But in time, DeBlois slid into loyalty; when the British evacuated Boston, he fled with them.[71] He painted the exiled governor Sir Francis Bernard, and the family of the colonies' other baron, Sir William Pepperrell, conjuring up the likeness of his late wife, who had died of a fever in besieged Boston. (Sukey Copley served as a stand-in.)[72]

Early in his London years, while Copley painted the exiles' likenesses and resurrected their dead on canvas, he also painted portraits of Benjamin West and himself.[73] Neither would have been a source of income. The portrait of West was almost certainly a gift to the subject, and that of Copley a kind of calling card. Though the two pictures differ in obvious respects—West, in a finished portrait, is presented at half-length, while Copley depicts himself in a smaller roundel, with the freedom of an oil sketch—they speak to each other. Both men are rendered in partial profile, facing left. Both wear red jackets and white cravats. They sport identical short-rolled wigs with identical hairlines; both figures show their natural hair tied behind in trailing queues. Both men emerge from dark backgrounds, with the light of immanent genius radiating from their capacious foreheads.

Copley, BENJAMIN WEST, *ca. 1776–80*
[Plate 12]

Copley, SELF-PORTRAIT, *ca. 1780–84*
[Plate 13]

By the time Copley painted him, London newspapers regularly cast Benjamin West as an English artist. "To B. West, Esq., Historical Painter to his Majesty," one critic, who styled himself Divine Patriotism, addressed an open letter in the *Morning Chronicle*. He heralded West as a leaders among the field of brilliants whose work demonstrated that "the genius of painting, under the royal favour, has reared his standard in Britain," and who thus richly deserved "every national encouragement."[74] Copley, too, wanted to be a British painter. But despite his Leicester Square address, and his Anglo-Irish middle name, America remained his context and his contest.

After Harry Pelham joined the Copley household in London, leaving his mother to her fate, he advertised a subscription to support the engraving of a large-scale map of Boston and its environs, "an actual survey," he said, "taken at a Time when his Loyalty had rendered him totally idle." The map, which Generals Gage and William Howe had endorsed, showed the numerous "Military Works" constructed around Boston, a place expected to be "the Seat of War for some Time to come." People who wanted to purchase a copy were invited to sign up at a number of places around London, Copley's house among them. When the large-scale map was ready, those who shelled out eight shillings might see the painter's name engraved onto the landscape of battle: COPLEY'S HILL, just below the powder magazine.[75]

Harry had come to see the imperial conflict as a kind of hysteria, its flames fanned by self-interested men who put their own "unbounded Ambition" and a "lust of Power and Dominion" before the welfare of a "once happy but now too fatally deluded and distressed People."[76] He and Clarke and the other Boston émigrés could not shake the pain of their forced removal. Copley insisted on a different story: he was pulled by art, not pushed by politics. In a petition seeking to retain her son's Boston lands while other absent loyalists were declared "inimical" and had their property seized by the new state of Massachusetts, Mary Pelham told the General Court that Copley had been "for Some years meditating a Voyage to Europe to

Henry Pelham, A PLAN OF BOSTON IN NEW ENGLAND
WITH ITS ENVIRONS, 1777, *detail*

perfect himself in the Business of his Profession, Portraiture, and in May 1774, some short Time before the Port Bill" took effect, he had sailed, leaving "so long before the Rupture as that he could not foresee that it would take Place." This was both true and false. As Copley's mother surely knew, he had departed not in May but in June, some short time *after* the Port Bill took effect. But her story nonetheless mirrored the one Copley told his whole life long, to anyone who would listen: that he found himself "accidentally in England," there to "make further Improvement by Practice." That he had left Massachusetts "purely upon his private Business," without rancor for America, "having never directly or indirectly taken Part with the Enemies" of the patriots' cause. Most of all, that his journey marked not a fall but a rise.[77]

~~~

Britain's American War took a shocking turn in the fall of 1777. After a rocky start, the year had been going well enough, with a string of modest victories culminating in the capture of Philadelphia from the rebels in September. But just weeks after that city fell, General John Burgoyne suffered a stunning defeat at Saratoga, New York, surrendering a fighting force of nearly six thousand redcoats to the rebels. Rumors of the disaster trickled into London in the last days of November. Thomas Hutchinson could not quite believe what he read in the papers until he learned the details thirdhand from Brook Watson, a British-born merchant who had spent years in the colonies, and then had risen to become one of London's largest Canada merchants. "Into the city—universal dejection," Hutchinson wrote in his diary. "Everybody in a gloom: most of us expect to lay our bones here."[78]

The mortification of Burgoyne wounded national pride as grievously as any defeat in a generation. But the real peril introduced by the debacle at Saratoga lay less in North America than in Paris. "Spent the evening at Judge Sewalls[.] Mr Copley & lady, Messrs Clarke, Pelham, Scott & Quincey were also there," wrote Edward Oxnard, one of the younger members of the New England Club, on 15 January. "Strong talks prevalent about a French war."[79] For once the rumors were right; February brought confirmation that Louis XVI's government had entered into treaties of commerce and alliance with the American rebels. The chatter in the City coffeehouses kicked into high gear again; word was that Spain would throw in with France, aiming to reclaim territories lost in the Seven Years' War. Any who doubted that the Bourbon kingdoms would soon unite behind the American cause should recall, one writer warned, that Spain "has a long time wished and waited for an opportunity" to retake Gibraltar and Minorca, and to avenge another bitter wound, "the loss of the Havanna," which had fallen to Britain for a brief, shining moment at the apogee of empire, in 1762. Rumors held that the Spanish naval force at Havana was strengthening daily. Were Spain to

declare war, one Jamaica merchant wrote, "I should not have the least hope of this important colony being secure." The loss of Boston was a black eye; the loss of Kingston would spell catastrophe.[80]

The year 1778 was a moment very different from 1763, when Benjamin West had reached the English metropolis. The American Raphael discovered a victorious, confident nation, and made Britain's conquest his own. Fifteen years later, the empire's reversals in the American War presented a distinct challenge to a would-be English artist from Boston—a city now held by a rebel army—who was desperate to make good the tale that London marked for him a grand entrance and not an exile. "I don't think a Man a perfect Artist who on occasion cannot Paint History," Copley had written to Harry from Parma in 1775.[81] West's success with *The Death of General Wolfe* had showed the potential impact of modern-dress history painting. But in late 1777 and early 1778, as Copley readied his submissions for the spring exhibition of the Royal Academy, scenes of unambiguous triumph were in woefully short supply. How to portray patriotism, even heroism, amidst what was rapidly becoming a losing war? This was the crisis of representation that Copley confronted that winter for the first time.

Its solution came in the form of a collaboration with Brook Watson, Hutchinson's informant about the loss at Saratoga. It is not clear when Copley and Watson first met, though they had been in each other's orbits for years. Born in England, Watson was just two years Copley's senior; as a ten-year-old orphan, he had been apprenticed to a relative with a store on Belcher's Wharf, very near where Copley's family then lived. The two boys could easily have met on Boston's waterfront.[82]

In 1749, when Watson was thirteen, his guardian sent him to the Spanish Caribbean. With a population nearly three times the size of Boston's, roughly a quarter of it enslaved, Havana was known as the pearl of the Antilles. It was a garrison town, filled with sailors and soldiers charged with protecting the Spanish treasure fleet. When Watson got there, King George's War had just ended, and the bustling seaport had resumed its central role in the illicit trade of British American

merchants selling hides and tobacco and sugar and slaves and much else besides.[83] It seems likely that Watson, who had sailed "in a merchant ship," was there as part of a smuggling trip when the attack that changed his life—and which Copley later depicted—took place. In an article about the incident printed in London's *General Evening Post* in April 1778, while Copley's painting hung at the Royal Academy, Watson recalled "amusing himself one day by swimming about" as the ship on which he had journeyed "lay at anchor." A shark attacked, striking twice before a group of sailors in a rowboat could reach him. Thanks to their heroism, combined with "the skill of the surgeon, and the aid of a good habit of body," the hapless swimmer survived, one-legged, "literally saved from the jaws of death."[84]

Watson's luck held. He followed the seas from the West Indies to Nova Scotia, where he allied himself to powerful men: Lieutenant Colonel Robert Monkton, who would stand with Wolfe that fateful day on the heights of Quebec; and the Boston-born Joshua Winslow, who held the lucrative post of commissary for the British troops. After the Seven Years' War, Watson parlayed his military connections into a fortune in fish and firs. In the 1770s, he returned to England and set himself up with a counting house in the City and a country estate in Essex.[85] When the Tea Act opened the door to direct shipments from the East India Company to North American consignees, Brook Watson recommended several of his friends in Boston, including a cousin of Sukey Clarke's.[86] And when the beleaguered Boston consignees detailed their suffering at the hands of the mob, they routed their letters to the company through Watson. Between the Hutchinsons, the Clarkes, and the Winslows, Watson had multiple conduits to Copley. He may even have seen the portrait Copley had taken of Joshua Winslow in 1755, resplendent in the red coat and silver lace of an officer in the king's army.[87]

Like that portrait, the painting on which Copley and Watson collaborated was a picture of empire, albeit on a vastly different scale. At once a seascape, a city view, and a history painting with a cast of ten men and two sharks, it was a more complex work than anything Copley had

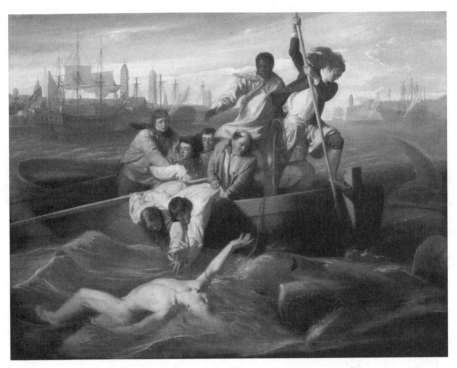

*Copley,* WATSON AND THE SHARK, *1778* [Plate 14]

painted before. It is unclear who posed for the picture. Five of the ten human figures, including the harpooner and four of the seated oarsmen, are caricatures rather than likenesses, their expressions based on physiognomic masks meant to incarnate the emotions such a scene would have aroused.[88] (In this sense they resemble the awestruck witnesses who populate *The Ascension* and *The Nativity*.) The forty-two-year-old Watson could not possibly have played the nude young hero, his blond hair billowing in the waves. The imperiled youth is as figured part man, part statue; art historians have found antecedents for his pose in sources ranging from the Laocoön to the Borghese Warrior, both of which Copley had seen in Rome.[89] But others in the group are highly particular. The trio of rescuers at the gunwale—the boatswain, with his bald pate and fringe of chestnut hair going to gray, a young sailor with the shiny black locks and pale skin of an Irish tar, and another lad, his sandy eyebrows salt flecked—read as men, not mannequins.

Most striking of all is the standing figure who holds the rope and who, together with the jacketed harpooner, forms the apex of the composition. He, too, is individual rather than typological. And like very few central figures acting heroically in eighteenth-century paintings he is black: a sailor who embodies the African diaspora, the engine driving the Atlantic trade. Several of the critics who reviewed the sensational picture thought Copley had erred in making the African figure a site of sentiment and sympathy. "It would not be unnatural to place a woman in the attitude of the *black*," wrote a reviewer in the *General Advertiser*, "but he, instead of being terrified, ought, in our opinion, to be busy."[90] The sailor's combination of stillness and stoicism bothered other critics as well. An article in the *St. James Chronicle* called him an "idle Black," paralyzed by "the connate Fear of his Country for that ravenous Fish," as if a dread of sharks were some primitive superstition.[91]

Now as then, the figure provokes—as the artist meant him to, for he chose carefully. Several preparatory drawings for the picture survive, making clear that Copley originally envisioned the man as a European. The character of that central figure, then, was something about which Copley had gone back and forth—perhaps in discussion with Watson—during the early stages of the picture's design. In the course of his work on *The Pepperrell Family* the same year, the painter had made the opposite choice, eliminating a black figure planned for the right side of the portrait. An early sketch shows a serving boy in turban and livery, a nod toward the conventions of English noble portraiture as well as toward the slaveholding heritage of the Pepperrells and the Royalls. But in later drawings and in the final painting, Copley went another way, balancing the composition with two dogs at the opposite edge.[92] It does not seem an exaggeration to suggest that the painter and his patrons were wrestling, that year, with the political and pictorial possibilities of figuring men of African descent.

Nothing is known of Copley's model, of whom he also made, at presumably the same time, a vivid oil sketch. As many who have written about the picture note, it is a strikingly intimate portrait; here is a man, not a minstrel.[93] He is portrayed at close range, his gaze direct, with his

*Copley,* HEAD OF A NEGRO, *ca. 1777–78*

mouth partly open, as if in conversation. In both the sketch and, to a lesser degree, in *Watson*, the man's teeth are visible: a striking departure in Copley's practice. Only once before had he painted a smile; in *The Copley Family*, the artist's four-year-old son and namesake shows a row of gleaming baby teeth. He would do so only twice more, both times in pictures of his children.[94]

The sketch stayed in Copley's family, only to be auctioned upon the death of the artist's son, in 1864. In the catalog, it is described this way:

HEAD OF A FAVOURITE NEGRO. Very fine. Introduced in the picture of "The Boy Saved from the Shark."[95]

Who was the man, and whose "favourite" was he? Had he come to London in the household of one of Copley's intimates—Thomas

Hutchinson, perhaps, or Ralph Izard?[96] The Carolina planter almost certainly brought slaves to accompany him and his wife on their grand tour of the Continent.

It is less likely that the "favourite negro" was part of Copley's retinue in Leicester Square. Sukey Copley sailed with servants, but her father's accounts describe them as maids. (Copley's granddaughter, the author of a hagiographic memoir written shortly after *Head of a Favourite Negro* sold, took pains to establish that Mrs. Copley's young maid was white, "with the American beauty of feature and complexion which exposed her to much remark and attention in London.")[97] Copley's male servants appear to have stayed behind in Boston. In the spring of 1777, "Cato, of Mr. Copely," married Lucy, "of Mr. Goldthwait," at the Brattle Square Church, where Copley and Sukey had wed eight years before.[98] Snap remained in the household of Mary Pelham, scraping by on Cambridge Street after the siege. "Snap behaves some thing better than he has don for some time past," she told her faraway son in 1780. "I hope he will be more gratefull."[99]

It is hard to say whether Snap would have been better off in Boston or in London. In both places, the logic of slavery was increasingly unstable. In 1772, England's chief justice, William Murray, first Earl of Mansfield, had ruled in *Somerset v. Stewart* that no "positive law" allowed for a slave from the American territories who escaped bondage in the home islands to be forcibly returned to slavery overseas. In an opinion followed with great interest on both sides of the Atlantic, Mansfield dwelt as much on the vulnerability of British liberty as on the rights of African slaves. At stake, wrote the abolitionist Granville Sharp, was whether the core of Britain was to be made "as base, wicked and Tyrannical as our colonies."[100] *Somerset* did not abolish slavery. But the ruling weakened the institution in Britain—fatally so, many believed. For American slave owners, the decision thus marked one more reason to cast Mansfield as an inveterate enemy of colonial rights. (It is he who shackles America while Lord North forces tea down her

throat in the famous 1774 cartoon.)[101] A small but growing number of activists against the slave trade likewise treated the *Somerset* case as a milestone: a sign that Britain might yet earn its vaunted association with liberty.

It is no coincidence that the years around the *Somerset* decision witnessed an efflorescence of black life in London. The city's population of people of African descent swelled with the eastward journeys of colonials in the flush of victory following the Seven Years' War, and then grew once again with the flight of thousands of loyalists after 1775. Estimates of the number of black Londoners vary, but during the American War it likely exceeded ten thousand.[102]

Their presence at once precipitated and was reflected by a shift in the figuration of black people, especially black men, in British art and

*Francesco Bartolozzi after Thomas Gainsborough,*
IGNATIUS SANCHO, *1781*

*Joshua Reynolds,* A YOUNG BLACK, *1770*

letters. Once relegated to roles as exotic staffage—"part of the colorful decor setting off princely magnificence," as one scholar has written— some black Londoners became the subjects of meticulous likenesses.[103] In 1768, the fashionable portraitist Thomas Gainsborough painted a bust of Ignatius Sancho, an African-born former slave then employed as a valet to the Duke of Montagu. Around the same time, Joshua Reynolds completed an oil sketch of an anonymous black man, likely his servant.[104] While these works, like their antecedents, made a fetish of black skin and what figured in the popular imagination as exotic "African" features, they also projected dignity, personhood, even a natural aristocracy. Gainsborough's Sancho, painted in Bath in 1768, was engraved before 1782, when a collection of the freedman's letters was published with great fanfare. Reynolds's students painted numerous copies of his study, which Copley could have seen in the master's Leicester Square studio. Certainly he saw the prints of black figures that circulated, many of them caricaturing the fashionable appearance of men like Julius Soubise, a well-known black dandy who featured in several engravings in 1772 and 1773. Copley knew there was a vogue for such images.[105]

No black celebrity occasioned more notice than Boston's Phillis Wheatley, who visited London in the summer of 1773, about a year after the *Somerset* decision and just before the publication of her book of poems. She visited Lord Dartmouth, the American secretary, to whom she had written a paean the previous year. Benjamin Franklin—himself a slave owner—paid her court; Granville Sharp accompanied her on a visit to the Tower of London. She also met with Brook Watson, who may have had some trading connection to John Wheatley, who had bought Phillis when she landed, chained, as a young girl on the Boston docks, and owned her still. Watson gave her "a Folio Edition of Milton's Paradise Lost, printed on a Silver Type, so call'd from its elegance," Wheatley said. His coat of arms was affixed to the flyleaf. It featured three martlets, small black birds usually depicted without legs: severed things.[106]

Copley's daughter Mary later recalled that *Paradise Lost* was her

father's favorite book.[107] Did *Watson and the Shark* depict a bygone American Eden? And what of the "bondage" of the American people? That, of course, was the question on everyone's lips in the spring of 1778, when *Watson* transfixed the crowds at the Royal Academy. The painting's narrative of a lost leg in a lost harbor makes it tempting to read it as an image of the violent dismemberment of Britain's empire, as some scholars have done.[108] But in the end, *Watson* is less an allegory of loss than a parable of redemption: of victory snatched quite literally from the jaws of defeat. That February, as the long-expected Franco-American alliance became a reality, Lord North had hatched a plan to treat with the American rebels, offering terms that stopped just shy of independence.[109] Less than a fortnight after the peace commissioners departed London for Philadelphia, a moment of extreme oscillation in the waves of empire, the academy exhibition opened.

*Watson* caught the national mood. The magic of the picture, as some critics noted, lay precisely in its presentation of an instant of unresolved peril: pitched as if at the crest of an impossibly high wave, before plunging into the looming trough of the next. The shark had already struck twice, noted the *General Evening Post* in an article about the painting's factual grounding. The predator was approaching for the third blow, "the very instant" when Watson would have been devoured. "This is the moment the ingenious artist has selected from the distressing scene," the author—likely Watson or Copley—explained: the painter as dramaturge, as puppeteer, as conjurer of a magic lantern show. Copley had chosen well, noted the *General Advertiser*'s critic. "He has improved upon the horror of the shark, by leaving it unfinished, and we think he studied narrowly the human mind in this circumstance. *No certain and known danger can so powerfully arouse us, as when uncertain and unlimited.*"[110] With *Watson*, in other words, Copley had pioneered the visual mechanics of suspense, not a signal feature of history painting, which tended toward the marmoreal, portraying heroes who had died trying, battles long since won or lost. No lover of art or student of history who stood in line before West's *Death of Gen-*

*eral Wolfe*, for example, had any doubt whether Britain had triumphed at Quebec, much less whether Wolfe had survived his glory. In *Watson*, life hung in the balance.

One critic praised the painting's powerful sense of place and moment, a sensory tour de force that conveyed "the Dampness of the hazy hot Climate," in that "glorious Time, and the Place where our Tars so nobly exerted themselves." Watson's "glorious time" in 1749 prefigured the British triumph at Havana in 1762; perhaps history would repeat itself. Perhaps the king's forces would hold America, and even retake the pearl of the Antilles. Perhaps the empire would not only endure but thrive, as Watson had so improbably done. "The proposals to America are much too favourable to be rejected by them," predicted one writer in the *General Evening Post* in a letter that appeared just above Watson's narrative of the facts upon which the painting was "founded." If the peace commissioners prevailed, "stocks will rise . . . . The very idea of America not being against us will make a war with France appear as a trifling affair, particularly when English, Scotch, and Irish, laying aside all bickerings, become one family, one people, and with inseparable interests."[111] A family much like the united tribes that peopled the boat that rescued Watson. Copley had painted an image of a war in which Britain might still prevail—and of the battle it was arguably winning: the contest for liberty, against the hypocrisy of American slave owners proclaiming themselves the guardians of human freedom.

The collision of Watson's moment, ca. 1749, and London's moment, ca. 1778, ignited Copley's English career. "It is curious to remark how men sometimes by a kind of casual happiness exceed themselves," noted the author of "The Painter's Mirror," a column that dished the exhibitions every April. Copley had hung three pictures. One of them, a woman's portrait, was innocuous, meriting "neither praise nor censure." *The Pepperrell Family*, the reviewer said, was "a mere daubing." But *Watson*, with its cumbersome title—*A boy attacked by a Shark, and rescued by some Seamen in a Boat; founded on a fact which happened in the harbor of the Havannah*—

was the hit of the season.[112] "Mr. Copley is a native of America," said the critic who wrote for the *St. James Chronicle*. He had "sent some excellent Portraits to the former Exhibitions, before he had been improved by any academical Education in Europe." But improved he was. With *Watson*, Copley had revealed himself as one of "our Countrymen": an English artist and "a Genius, who bids fair to rival the great Masters of the ancient Italian Schools."[113]

⌒ *Chapter Nine* ⌒

# WAGING PEACE

*I*N *WATSON'S* WAKE, John Singleton Copley was everywhere in the public eye of London, emerging all at once from "silent insignificance to the beam of general notice," as one critic put it some years later.[1] Months after the exhibition, subscriptions opened for a mezzotint after Copley's "celebrated Picture," from a plate worked by Valentine Green, "Mezzotinto Engraver to his Majesty, and to the Elector of Bavaria, and the Palatinate of the Rhine." At a guinea for subscribers, twenty-five shillings for those who waited till it was published, the price was more than twice as high as the next most expensive print Green advertised for sale.[2] Early in 1779, Copley was elected to full membership in the Royal Academy, receiving more votes than any other candidate proposed, and three times as many as when his name had been put forward, unsuccessfully, the year before.[3] That April, Green exhibited his print of "Mr. Copely's [*sic*] picture which was so much admired in a former exhibition" at the Royal Academy, insisting that it "very faithfully preserved all the beauties of the original." In July, the mezzotint was delivered to subscribers and offered for general sale.[4] Hundreds must have purchased it, for Green's plate wore out within six months.[5] By the end of 1779, a print based upon Copley's most famous work was hanging in many of the most elegant drawing rooms in London. On the floor of the House of Commons, a member of Parliament struggling to set a scene with words said he "wished for the pencil of a West or a Copley to do it full justice." *Watson* made the man into a metaphor.[6]

Fame brought clucks of envy as well as murmurs of appreciation.[7] Copley figured largely in a satire published during the 1779 exhibition season by the pseudonymous author Roger Shanhagan—in reality a troika comprising an architect and two painters—who assigned each of the Royal Academy's luminaries a signal failing. Angelica Kauffman was too sweet, Gainsborough too gaudy, Reynolds too derivative, and West too unctuous. Shanhagan made Copley's overfaithfulness the painter's signature fault. Describing a canvas called *Portraits of a Family*—a mash-up of *The Copley Family* and the Pepperrells—the authors heaped pretended praise upon the liney literalness of which Copley had been accused since the exhibition of *Boy with a Flying Squirrel*:

> He discovers a profound knowledge of the different mechanical professions, such as the Cabinet-maker, the Mason, Upholsterer, Silver-smith, and Shoe-maker: He is also acquainted with the business of Toy-makers and Milliners, for who but them could have invented and decorated that ornamental play-thing, with which the child upon the floor seems to divert itself? Who but a Mason could so nicely discriminate the various sorts of marble which diversify this Picture[?] Pinchbeck and brass, green-baize and Manchester-cotton, burgundy and table-beer, have each their proper character.

Shanhagan suggested his fictive Copley canvas might more properly be called "A Gentleman's Family and Furniture."[8]

Fame was a cudgel, but it could also be a lever: a tool to pry open the fine homes of the gentry and the nobility. Yet self-promotion was fraught with peril. Just as political candidates of the period were eager to win but loath to stump for themselves, so too were artists and writers expected to be wary of chasing commercial success—or at least of doing so openly. Fame—like fortune, like love—appeared most deserved when least bidden. In London as in the colonies, the more eminent the artist, the less apt was he to hawk his wares. Genius did not hang shop signs.[9]

Fickle fame having at last found him, Copley meant to use it. He did

so, in part, in the expected genteel manner: quietly, through a network of fashionable patrons. Copley continued to ply his now customary trade in portraits of American exiles.[10] But his triumph at the exhibition of 1778 also yielded commissions of a sort that had not come to him before, from high-ranking British military officers eager to convey the same kind of heroism-snatched-from-defeat that Copley had carried off so brilliantly in *Watson*.

In 1779—a year that began, Thomas Hutchinson wrote, "with a dark prospect for this poor kingdom" and then got worse; a year that witnessed the shaming of Generals John Burgoyne and William Howe in Parliament and the long-expected entry of Spain into the war, a year in which some began to declare publicly that the conflict was unwinnable—Copley managed to fashion a bright and shining naval hero.[11] Clark Gayton, commander in chief of his majesty's forces in Jamaica, had returned to London covered in glory while *Watson* hung at exhibition. The admiral's trophies— his forces had seized no fewer than 235 rebel ships in the Caribbean— were noted in the public prints.[12]

Copley's portrait was occasioned by a less martial prize: the admiral's second marriage, in February 1779, to Elizabeth Legge, a much younger woman as well connected as she was voluptuous. Copley painted the new Mrs. Gayton at three-quarter length, her powdered hair and jewel-trimmed gown a study in shimmering grays. His brushwork is loose, calling attention to the artist's hand as well as the beauty of the sitter. Such cosmopolitan patrons had learned, from seeing the acclaimed works of Reynolds and especially of Gainsborough, that the display of a painter's signature touch was more fashionable than the illusion of realism. Admiral Gayton's companion portrait is as rigorously vertical as his wife's is languorous. *Gayton*, like *Watson*, is figured in the strategically vital waters of the Caribbean. But though the seas behind him look perilous, he appears commanding in his dress blues. His firmness in the right projects hope that such men will hold the line, the challenges of an annus horribilis notwithstanding.

Another valuable commission came from Hugh Montgomerie, scion

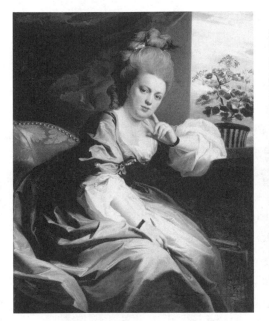

*Copley,* MRS. CLARK GAYTON
(*Elizabeth Legge*), *1779*

*Copley,* ADMIRAL CLARK GAYTON, *1779*

of a noble Scottish family recently elected to Parliament from his native Ayrshire. Copley portrayed the middle-aged man as if at the height of his martial prowess, when he fought for Britain's glory in the Seven Years' War two decades earlier.[13] *Montgomerie* bestrides the canvas in the kilt and sporran of his Highland regiment, with a tableau of native warriors battling at knee level, as if in the distance. Copley's indigenous warriors are less specific than those of Benjamin West, who collected native artifacts to give such pictures as *The Death of General Wolfe* (1771) and *Penn's Treaty with the Indians* (1772) an ethnographic frisson. But much like the buildings ringing Havana Harbor in *Watson*, the presence of native fighters marks *Montgomerie* as both an American scene and an imperial triumph, a combination that had become ever more oxymoronic as the war progressed.[14]

Copley exhibited Montgomerie's likeness at the Royal Academy's annual rite of spring, where it was billed as *Portrait of a Highland Officer.* The 1780 exhibition was the first held in the Royal Academy's grand new quarters. The refashioned Somerset House was part cultural empo-

rium, part workaday government building. It backed onto the Strand, an elegant avenue with wall-to-wall printshops and other venues alluring to the bon ton, and fronted the Thames, that artery of maritime commerce. In addition to the academy, which claimed space for its library, collections, classrooms, and lectures as well as the annual exhibition, the building housed numerous more prosaic elements of Britain's growing imperial bureaucracy, offices whose *raisons d'état* ranged from naval provisioning to tax collection. Copley's *Montgomerie* hung in the skylit Great Room, whose entrance was emblazoned with an inscription in Attic Greek: "Let none but Men of Taste presume to enter."[15]

At the moment of the academy's founding, Britain's military prowess was seen as capable of lifting its emerging arts. In a dozen short years, the terms had nearly reversed: triumphs of Art must redeem failures of arms. Several paintings, like Copley's, glanced backward to more confident days. West depicted two long-ago triumphs: *The Battle of the Boyne*, a victory over the Catholic Jacobites in 1690; and *The Destruction of the French Fleet at La Hogue,* a sea battle fought in 1692. King William's War, the Seven Years' War: therein lay glory. The present moment required a wider lens, focused on the South Seas, for example: one sculptor exhibited his design for a monument to Captain James Cook, who had recently died in the Sandwich Islands (present-day Hawai'i), martyred—like James Wolfe before him—while enlarging the globe for Britain.[16]

An imposing public building unveiled in the middle of a costly war, the academy's extravagant new home was not without critics. Some grumbled about the cost of admission.[17] Others worried about the delicate sensibilities of the ladies—princesses, even—who must promenade past the copies of classical statues that made the space a veritable "temple of Priapus." But most praised the exhibition and its magnificent showroom, which combined to create "a very grand *Spectacle*, . . . not to be equalled in any Part of Europe."[18] Crowds thronged Somerset House. The academy counted over 61,000 visitors, more than twice as many as the year before. The busiest days saw some 2,600 art lovers make their way up the wide spiral staircase that led to the Great Room.[19]

By the time of the 1780 exhibition, two years after *Watson*, Copley's eminence was secure enough that nearly every reviewer mentioned his works. "*Mr. Copley's* genius for historical painting is now fully established, and confirms the opinion of the world on the exhibition of his *Boy and Shark*," said one critic, heaping special praise on a large biblical composition called *Samuel and Eli*, which hung in the Lecture Room, on permanent display beside Reynolds's portraits of the king and queen in their coronation robes. The remainder of Copley's contributions that year drew brief, appreciative notice. The "reason why [Copley] has not favoured the Public with more this year," said the author of a pamphlet promising *A Candid Review of the Exhibition*, was "his great application to 'the Death of *Chatham*,'" a magnum opus not yet completed.[20] Already the public knew quite a lot about Copley's *Chatham*. The painter had used his new-found fame to tout it in the press, repeatedly.

⁓

The Earl of Chatham was William Pitt the Elder, the Great Commoner having at last accepted a peerage. He had collapsed on the floor of the House of Lords in April 1778, several weeks before Copley's *Watson* went on view. Long known as a friend of the American cause, Chatham was nonetheless an enemy of independence, and of the "unnatural ruinous war" being waged to achieve it. As the crisis widened, Chatham argued for something quite like the status quo ante: a loose imperial fabric within which the Americans would be neither hamstrung by the sinews of empire nor free of them. At the moment he was stricken, Chatham was inveighing against a resolution to withdraw the troops and let the United States take their places—for they were always, in those days, plural—among the family of nations. If "American independence was allowed by Parliament, then England's sun was set," he thundered. "The same spirit might soon pervade both the Indies; it might catch Ireland, and at length reduce the empire to the small island of Britain." He died trying to prevent such an outcome.[21]

Chatham's death was a loss to the nation, one widely seen as a har-

binger of the fate of the rebel colonies. Those who had despised him in life sought to outdo each other in mourning. Hundreds of panegyrics appeared in print. Parliament voted unanimously to fund a lavish state funeral. City merchants wanted Chatham interred in St. Paul's; the ministry would have him buried in Westminster Abbey. One commentator suggested splitting the difference by placing his remains under glass in Leicester House, Sir Ashton Lever's new museum of natural curiosities, located partway between the abbey and the cathedral.[22]

Proposals and counterproposals for a suitable monument filled the press. (A satirist writing in the *Morning Post* quipped that an honest inscription for any such memorial must praise the "Great and Excellent Statesman / Whom the King did Not consult or employ," the "Convincing and most Eloquent Orator" to whom Parliament failed to listen.)[23] In an attempt to spur "an Emulation among the Artists"—a kind of productive envy—a contest was suggested, with substantial premiums for the winning designs. The *London Chronicle* estimated that when all the expenses were counted, some £30,000 would have been spent on the funeral and the monument, with many thousands more devoted to pensions for Chatham's heirs.[24]

In December 1778, after months of wrangling over how best to commemorate the fallen Cassandra and his unheeded prophecies, London's aldermen decided that "Painting was . . . the best Method to perpetuate his Memory." A critic in the *Morning Chronicle* described the accepted design: a canvas centered upon "Lord Chatham fainting in the House, upon his attempting to reply to the Duke of Richmond, . . . while the Peers are crouding to his Lordship's assistance. As they are all drest in their parliamentary robes, the picture makes a very brilliant appearance."[25] The submission was likely Copley's, though Benjamin West may have offered a version of his own. The connoisseur Horace Walpole later pronounced West's "small sketch . . . much better expressed & disposed," recalling that West had set the project aside so as "not to interfere with his friend Copley."[26]

Copley, unlike West, had no sinecure to underwrite his genius. Before

beginning *The Death of Chatham*, he had to imagine a way to repay the time, effort, and materials involved in the undertaking, which would consume him for most of two years. He had learned to his chagrin, with the pans that greeted his youthful submission of the *Young Lady with a Bird and Dog*, and then again to his delight, with the applause for *Watson*, "how far and forcibly Choice of Subject leads the Artist onward in the Pursuit of Fame."[27] Chatham's death promised at once a fit theme and a fat purse.

Early the following year, Copley got to work taking the portraits that he would fit together in an intricate jigsaw puzzle to compose an epic canvas over ten feet long and seven feet high—more than half again the size of *Watson*. Every likeness taken in the service of that grand design would bring the painter into close proximity with a peer of the realm, creating a large network of potential patrons. It is not clear whether the lords came to Copley or he traveled to them. His kit was portable: he worked in graphite and chalk, on blue laid paper, concentrating on the faces and wigs that would distinguish one red-robed eminence from another in a scene stuffed with nobles. Some of the study heads note the height of a given figure and add a scale demarcating the position of eyes, nose, mouth, and chin, keys to later placement. The sketches are quick and warm but startlingly real, likely the work of a single sitting. One of the men whose likeness he took this way pronounced the result "most striking."[28] Three of those Copley gathered around the dying Chatham later sat for full-dress portraits, in poses that closely mirror their roles in the epic crowd picture.[29] By October 1779, Copley had executed many of the individual likenesses; the *General Evening Post* reported that "no less than fifty portraits of noblemen" would feature in the finished picture.[30]

But as Copley collected heads, the City's plans for a painted memorial came under attack in the press. The "damps of this climate" too often proved "fatal to our paintings," argued a critic calling himself "A Citizen." Sculpture "would have been a far more noble, as well as lasting testimony" of the public's esteem for Chatham.[31] Another correspondent

*Copley, Study for Lord North, 1779–80*

accused the aldermen of cheapness. Why had they tried to "put his Lord-ship off with a picture" while a lesser hero had lately been honored with marble statue in Guildhall?[32]

Copley had worked for a year on the project when the court gathered to reconsider its decision. He resubmitted his design, now in a more elaborate "sketch in colours," featuring "fifty-six different figures, all executed in a masterly manner," perhaps half of them sufficiently detailed as to have been taken from life.[33] But this time Copley lost out to the sculptor John Bacon, a longtime member of the Royal Academy whose proposed monument featured a toga-draped Chatham on a pedestal atop "the figure of Commerce, who receives into his protection the four quarters of the world, who are pouring plenty into the lap of Britannia." Bacon's allegorical design promised to endure the winds of war and the storms of

politics, much like marble itself. It also flattered the City, which was personified in the busy design. After what the papers said was "a good deal of debate," the aldermen awarded Bacon £3,000 to realize his vision.[34] Copley would need to find another way to compensate himself for the time already invested and the work yet to come.

Some weeks after the City pulled its sponsorship, Copley took his case directly to the public. In the spring of 1780, while the second impression of the *Watson* print was engraving and *Montgomerie* and the others readied for the Somerset House exhibition, Copley bought space from several newspapers for a long column outlining his "Proposals for Publishing, by Subscription, an Engraved PRINT, from the Original Picture, now Painting by JOHN SINGLETON COPLEY, R.A. Elect, Representing the Death of the late EARL of CHATHAM." It was uncommon for an artist of Copley's stature—stature so long hunted and so recently earned—to court fame so directly. To pre-sell a print of a painting not yet completed was all the more wanton, especially given that the mezzotint was not promised to subscribers until August 1782. In a time of financial chaos, Copley sought in effect an advance payment to support his work, monies he would hold, interest-free, for the more than two years he estimated it would take to finish the painting and bring to fruition the engraving.

Copley couched his "Proposals" in a hawker's vernacular, heavy on superlatives. The painting, which he described in detail, would require "the most arduous work of the kind hitherto undertaken in any country." The finished canvas was to entail sixty figures: "noble personages" of "high dignity and distinguished abilities." He listed thirty-seven of them—dukes, marquises, earls, bishops, and viscounts—whose portraits he had already "taken from the life," making an asset of the specificity that his critics deemed a liability. Lest readers think that his proposals amount to "self-commendation," Copley insisted that the virtues of the work would come from these men, and "the lustre of the character" of Chatham, as well as "the singularity of the incident," which had registered so deeply "on the minds of Englishmen."

The print would be both large and costly; its price of three guineas

would "amount to nearly three times the sum ever given for one plate."
But when the effort involved was considered, "Mr. Copley flatters him-
self, that his terms will not be thought unreasonable." *Chatham* would be
an investment: by "uniting the value of living characters to the dignity
of an historical fact," the composition was sure to rise "in estimation in
every succeeding age," and thus remain "valuable to posterity." Striving
to unite a sense of urgency and exclusivity with this broad appeal to
the newspaper-reading public, Copley noted that subscriptions would
be accepted at his studio, at the shop of J. K. Sherwin, the engraver; and
at the print gallery of Alderman John Boydell, "and no where else." He
concluded by offering open studio hours, on Saturdays, to "such of the
Nobility and Gentry who may be desirous of seeing the Picture, and to
prevent their being disappointed while he is finishing it."[35] It is not clear
now many people beat a path to Leicester Square to watch Copley paint.
He hinted that they came in droves. Those escorted into his "picture
room" would have seen, in addition to the epic *Chatham*, a full-sized copy
he had painted of *Watson*, and the Copley family portrait: testaments to
survival, as well as to the artist's prodigious talent.[36]

Copley first published his proposals for the Chatham subscription
at the end of March. Less than three months later, swaths of London
lay in ruins, casualties of the most devastating riots the metropolis had
witnessed in more than a century, since the last civil war. Over six days
in June 1780, tens of thousands of protesters rampaged through the city,
in opposition to the Catholic Relief Act, a 1778 law that had removed
some of the civil barriers imposed upon Roman Catholics. (The law was
enacted, in large part, to make it easier for Catholics to enlist in the king-
dom's army, to fight on the many fronts of the war that now stretched
from the American interior to the Philippines.) The crowds, wearing
blue cockades and calling themselves the Protestant Association, heeded
the call of Lord George Gordon, a young Scottish peer. What began as a
march on Parliament quickly became an avenging army. Lord Mansfield
was attacked in his carriage, the long white wig Copley painted with
such careful brushstrokes yanked from his head. Several of the other

peers portrayed in the orderly *Chatham* tableau were subjected to similar rough music.

On the fourth day of rioting, Gordon's forces surged into Leicester Fields, just behind the Copleys' house. The mob broke open the mansion of Sir George Savile, sponsor of the Relief Act. The bonfire built from Savile's fine furnishings lit up the square. The next night, six fires burned in the neighborhood. Wreathed in smoke and soot, the rioters looked "like so many *Infernals*," a woman who lived near the Copleys wrote. Before the violence spent itself, Gordon's forces had put Mansfield's Bloomsbury mansion to the torch, stormed the prison at Newgate, and threatened the Bank of England and the royal palaces. Come August, gallows rose from the rubble, as rioters were executed all around the city, near the sites of their crimes. Copley, who had seen the work of too many mobs, must have felt the terror of 1773 afresh. His children never forgot it. "Again and again they would describe the horrors of the Gordon riots, beheld from their nursery windows," his daughter's daughter wrote a century later.[37]

In November, as Londoners worked to rebuild their wounded city, Copley published an update of his progress on *Chatham*. Almost "all of the noble Personages have already honoured him by setting for their Portraits," he reported. Though "his labours on this subject are drawing towards a speedy conclusion," the subscription list remained open; the artist "rests on the hope, that a work so replete with interesting matter, will not fail of receiving . . . encouragement and support from the Public."[38]

It was no easy moment to rest on hope of public support. The news from America went from bad to worse. The Bourbon navies held the Caribbean in a pincer grip. Ireland verged on revolt, and the Spanish siege of Gibraltar continued unabated into its second year. Chatham's vision receded day by day. By the end of 1780, his attempt to steer a middle course between a punitive Parliament and an independent United States seemed almost quaint.[39]

In March 1781, Copley placed notices in the papers to inform the public he had cultivated so assiduously over the previous year that he must bar his door to them. His "time for finishing the picture . . . is so

short," he explained, "it will not be in his power to submit that work to . . . inspection as usual." He found himself "compelled earnestly to request" that readers "suspend their curiosity, till the picture is finished." No strategy was better calculated to inflame curiosity. He forecast that the unveiling would take place "in about six weeks."[40] All the while Copley's head-hunting continued; in early April, Samuel Curwen walked to Leicester Square to visit Richard Clarke, "but seeing a nobleman's carriage at door, presumed he was sitting," and turned away.[41]

In April, Copley announced that he would exhibit his new masterpiece on its own, "at Mr. Christie's Great Room, in Pall-mall, late the Exhibition Room of the Royal Academy." Admission would cost a shilling; a catalog listing the figures in the picture, "with proper references," would be "delivered gratis" to ticketholders. The proposals for purchasing the print were appended to the catalog, and on the last page, any who wanted to subscribe could find a receipt form wanting only a signature. The picture was to debut on 30 April, the very day the academy's annual exhibition was slated to open several blocks away.[42]

Reaction came swiftly. Sir William Chambers, one of the founders of the academy and the architect of Somerset House, wrote Copley to remonstrate against his plan. "No one wishes Mr. Copley greater success, or is more sensible of his merit," Chambers insisted. But at the same time, he worried about the obvious challenge to the annual exhibition, especially given Copley's design to use the room in Pall Mall, which was owned by the king, and thus might give the terribly misleading impression that the academy's sovereign patron had in some way endorsed this competing show. Chambers thought "no place so proper as the Royal Exhibition to promote either the sale of prints, or the raffle for the picture, which he understands are Mr. Copley's motives." (A jab there already.) And if, for whatever reason, Copley "objected to" the conventional venue, why, then, Chambers said acidly, there was "no place so proper as Mr. Copley's own house, where the idea of a raree-show will not be quite so striking as in any other place," and where the artist's "own presence will not fail to be of service to his views."[43]

In the wide world of London spectacles, which spanned a gamut from coronations to public hangings, the entertainments branded "raree-shows" were among the lowliest. *The Spectator* classed raree-shows with dancing monkeys and other such "Curiosities." The raree-show trafficked in cheap illusions. Describing a faux waterfall conjured by candles in one of the pavilions at the Vauxhall pleasure gardens, a London travel guide said that the "moving picture, attended with the noise of the water, has a very pleasing and surprizing effect both on the eye and ear," yet when the curtain fell and the mirage dissolved, the viewer felt duped by "too much the air of a raree show.[44] Raree-showmen might be found in London's seedier lanes and alleys, "strolling up and down with portable Boxes of Puppet-shows at their Backs," noted the *New University Dictionary* of 1776. They were "Pedlars," hucksters, flimflam men.[45] "There you shall

THE POLITICAL RAREE-SHOW, *1779, detail*

see," says the busker in a 1779 engraving titled *The Political Raree-Show*, enticing a credulous boy with the promise of a quick peep through his magic window. If Copley would act the barker, Chambers implied, he should do it in his own home.

Chambers's opposition proved powerful. Barely a fortnight after Copley had advertised his original plan, he informed the readers of several London papers that he found himself "under the disagreeable necessity of relinquishing his agreement for Mr. Christie's Great Room." The exhibition would start a day later than planned, at the Great Room in Spring Gardens. (This was the same commercial space once leased by the Society of Artists, the hall where the display of *Boy with a Flying Squirrel* in 1766 had marked Copley's London debut.) Defying the conventions of politeness, Copley left no doubt about what had caused the sudden switch: it was "the result of Sir William Chambers apprehensions that it would be prejudicial to the Exhibition of the Royal Academy; and Mr. Christie's having been, in consequence thereof prohibited letting his room for that purpose." About whether those fears had been justified, and whether "so powerful an interference" was needed to safeguard "the Royal Academy, from being injured by the Exhibition of a single picture is left to the public to decide," Copley said. To grant his canvas such powers exceeded his "most sanguine hopes of an approbation of his labours."[46] (As it happened, the academy's receipts did fall by nearly a third that year, and the crowds at Somerset House shrank, too, by as many as ten thousand visitors.)[47]

By airing his disagreement with Chambers in the newspapers, Copley stuck a very public thumb in the academy's eye. Though he was not the only academician to desert the annual exhibition, he was the most eminent, and the most brazen. The defection occasioned a good deal of chatter. *The Ear-Wig*, a satire posing as the gossip of a shrewish old woman, faulted the conformity of the academy, but also accused the painter of biting the hand that fed him: "Copley was made an Academician; and, as soon as he had reaped such advantageous honours, he no longer chose to contribute to their show; but deserted his standard." The "ambition" of such a painter was "directed toward becoming the author of a revolution,

and the chief of a numerous party."[48] In the context of the American War, the charge of forsaking one's flag to foment revolution would have stung all the more.

Despite—or because of—such concerns, *Chatham* proved a sensation. Hung without sponsorship or supplementary attractions, the lonely picture in its gaping room should have been uniquely vulnerable. But Copley had taken his case directly to the public, and public opinion proved a mighty force. Lengthy reviews followed the opening, most of them gushing. A writer in the *Morning Chronicle*, "a constant attendant on the Debates of the House of Peers" who had been there when Chatham collapsed, found Copley's version "beyond all expectation," especially when one considered "the obvious difficulties that lay in the way of its execution, and the still greater improbability of one painter's being able . . . to give even a tolerable resemblance of fifty-five different personages in one picture." Most of the individual portraits were "not only striking likenesses, but strongly marked with character": that is, both particular and transcendent. Lord Mansfield's portrait was said, sardonically, to outdo the original. But on the whole, the reviewer thought, "the picture cannot fail to be esteemed by every candid spectator, as admirable in itself, and as a most valuable medium of transmitting to posterity one of the most remarkable historical occurrences of the present era."[49]

There were critics, to be sure. "On first entering the room I could not help being immediately fascinated by the predominance of drapery in the picture; the whole seemed to me drapery in motion . . . a war of dress," said a writer calling himself ENSIS.[50] Others faulted the picture for excessive license. "Mr. Copley ought to have known, that their Lordships are *never* robed when in *debate*," argued A By-Stander.[51] But even ENSIS knew that his critique, however withering, would "not take from the canvas one gape of applause, or one number from the subscription book." The groundswell for *Chatham* had rendered it judgment-proof.[52]

The public—the "vulgar eye," as one poet put it—was indeed undeterred by the critics.[53] By 8 June, according to the *London Courant*, "nearly

*Copley*, THE DEATH OF THE EARL OF CHATHAM, *1779–81* [Plate 15]

*twenty thousand persons"* had paid a shilling to see the picture.[54] Another writer suggested that the "immense and continued Success of Copley's Picture" revealed the city's enormous appetite for a similar exhibition of such a canvas as Raphael's *Transfiguration*, "or any other Individual Picture of great decided Fame."[55] The show was due to close in late June, but in its final days Copley announced it would be held over by popular demand; a group of City merchants had rented a second venue, above the Royal Exchange, where the painting hung on public display through July and August, torpid months when the elite sought refuge at their country estates.[56] But as his critics recognized, Copley had not painted for them alone. The display of *The Death of Chatham* was an amusement for the middling thousands who bought prints as much as for the scores of nobles and gentry who commissioned large-scale works of art. Copley's single-picture exhibition was pathbreaking—indeed, revolutionary.

Even three decades later, Copley's decision to court a wider public provided fodder for satire. In 1810, the *Morning Herald* published what

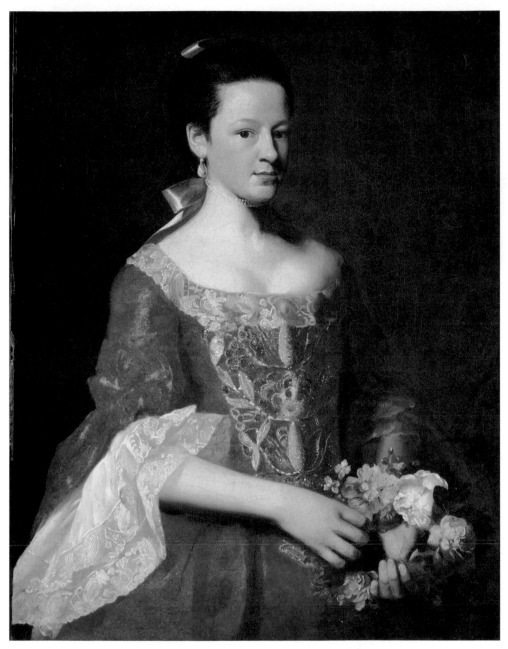

PLATE I: *Copley,* DOROTHY MURRAY, *ca. 1759–61 (oil on canvas).*
*Fogg Art Museum, Harvard Art Museums. 92.1 x 71.4 cm.*

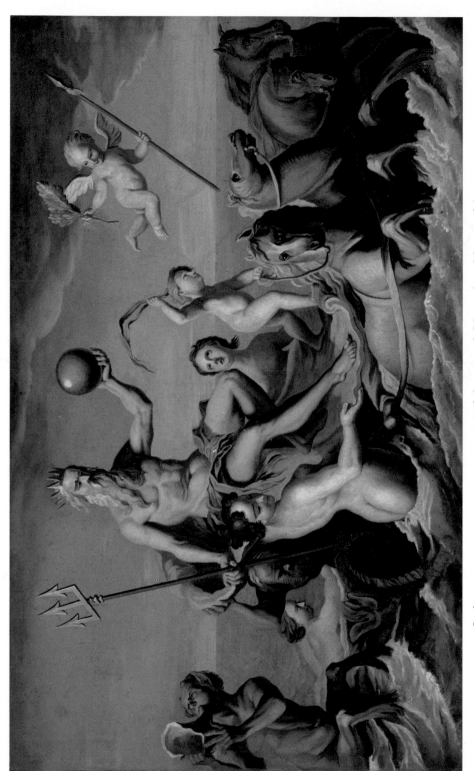

PLATE 2: *Copley, THE RETURN OF NEPTUNE, ca. 1754 (oil on canvas), Metropolitan Museum of Art. 69.9 x 113 cm.*

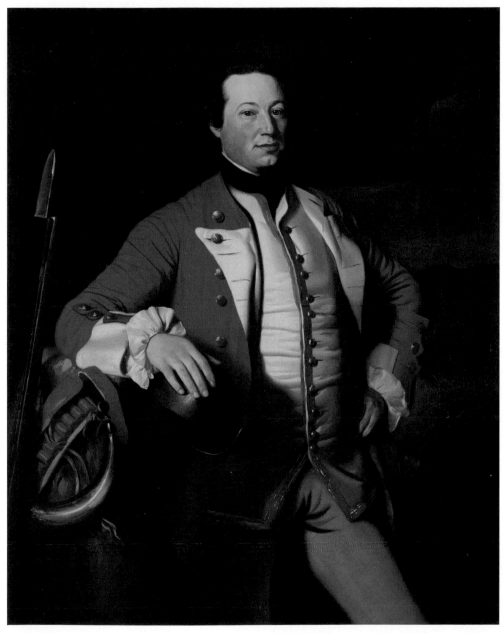

PLATE 3: *Copley,* MAJOR GEORGE SCOTT, *ca. 1755–58 (oil on canvas).*
*Private Collection. 127 x 101.6 cm.*

*Plate 4: Copley,* A BOY WITH A FLYING SQUIRREL *(Henry Pelham), 1765 (oil on canvas).
Museum of Fine Arts, Boston. 77.2 x 63.8 cm.*

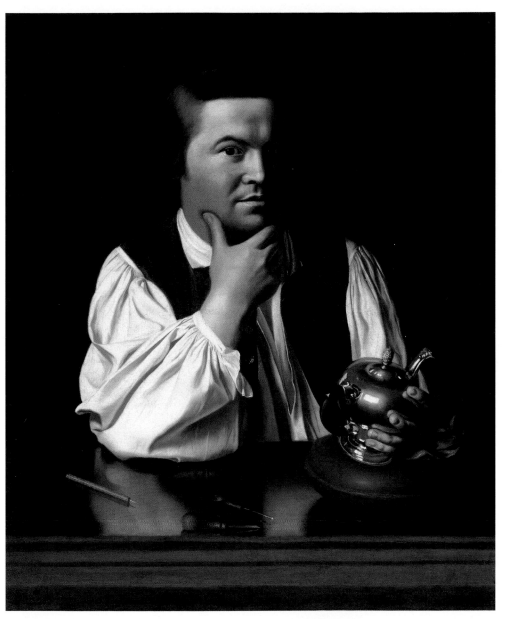

PLATE 5: *Copley,* PAUL REVERE, *1768 (oil on canvas).*
*Museum of Fine Arts, Boston. 89.22 x 72.39 cm.*

GENERAL the HON.ᵇˡᵉ THOˢ GAGE
OBᵗ 1788

PLATE 6: *Copley,* GENERAL THOMAS GAGE, *ca. 1768 (oil on canvas mounted on masonite).*
*Yale Center for British Art, Paul Mellon Collection. 127 x 101 cm.*

PLATE 8: *Copley, SELF-PORTRAIT, 1769 (pastel on paper). Winterthur Museum. 1127 58.72 x 44.5 cm.*

PLATE 7: *Copley, MRS. JOHN SINGLETON COPLEY (Susanna Clarke, 1769 (pastel on paper). Winterthur Museum. 1128. 58.72 x 43.81 cm.*

PLATE 9: *Copley,* MRS. THOMAS GAGE *(Margaret Kemble), 1771 (oil on canvas).*
*The Putnam Foundation, Timken Museum of Art, San Diego. 127 x 101.6 cm.*

PLATE 10: *Copley,* THE ASCENSION, *1775 (oil on canvas).*
*Museum of Fine Arts, Boston. 81.2 x 73 cm.*

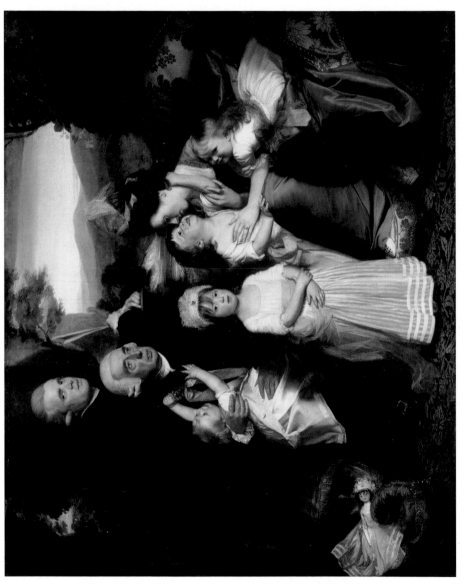

PLATE II: *Copley*, THE COPLEY FAMILY, *1776–77 (oil on canvas).*
*National Gallery of Art, Washington, DC. 184.1 x 229.2 cm.*

PLATE 12: *Copley*, BENJAMIN WEST, *ca.1776–80 (oil on canvas).
Fogg Art Museum, Harvard Art Museums. 76.3 x 63.5 cm.*

PLATE 13: *Copley*, SELF-PORTRAIT, *ca. 1780–84 (oil on canvas).
National Portrait Gallery, Smithsonian Institution. 45.4 cm.*

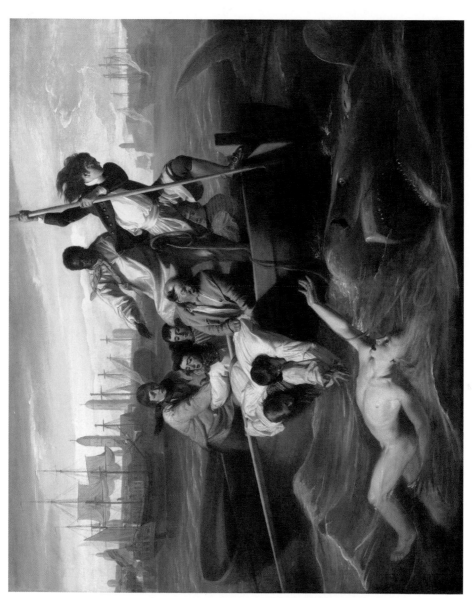

PLATE 14: *Copley,* WATSON AND THE SHARK, *1778 (oil on canvas).
National Gallery of Art, Washington, DC. 182.1 x 229.7 cm.*

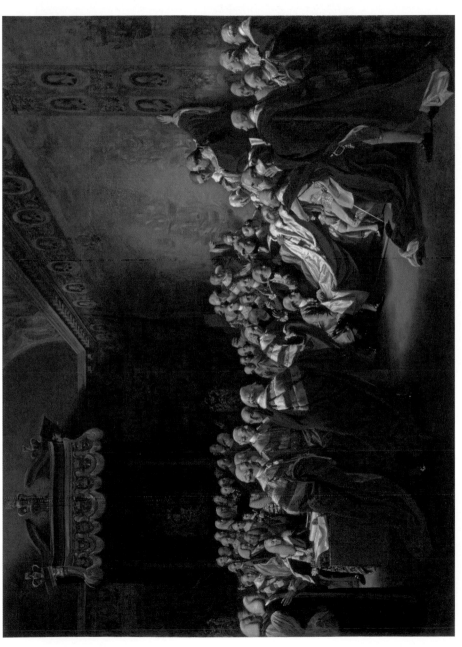

PLATE 15: *Copley,* THE DEATH OF THE EARL OF CHATHAM IN THE HOUSE OF LORDS, *1779–81 (oil on canvas).*
*Tate Gallery, London. 228.6 x 307.3 cm.*

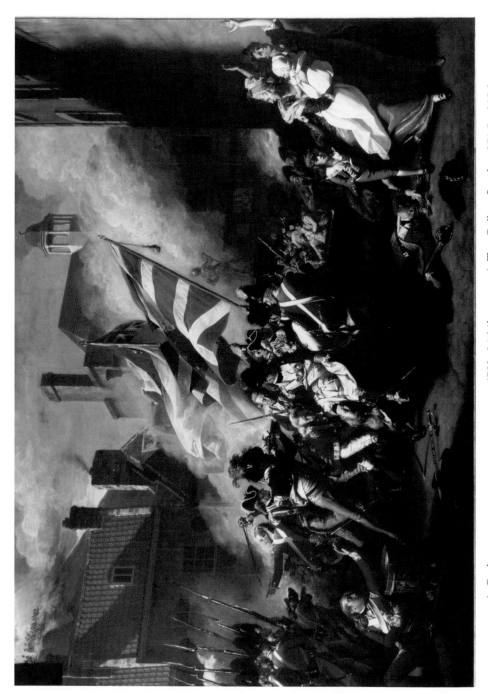

PLATE 16: *Copley,* THE DEATH OF MAJOR PEIRSON, *1782–84 (oil on canvas). Tate Gallery, London. 251.5 x 365.8 cm.*

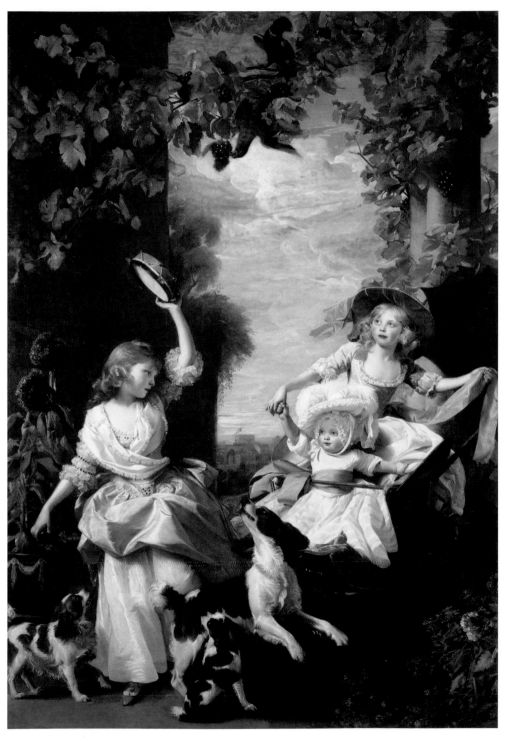

PLATE 17: *Copley,* THE THREE YOUNGEST DAUGHTERS OF GEORGE III, *1785 (oil on canvas).*
*Royal Collection Trust. 265.4 x 185.7 cm.*

PLATE 18: *Copley,* ELIZABETH COPLEY GREENE, *1800–02 (oil on canvas).*
*Spencer Museum of Art, The University of Kansas. 77.2 x 64 cm.*

purported to be a "favourite descriptive travelling duet" between West and Copley, sung to the tune of "Yankee Doodle." Two verses mocked the display of *Chatham*:

> From Massachusetts rebel state,
> When loyalty was crying,
> I ran on shipboard here to paint
> Lord CHATHAM, who was dying.
> Then I hung up the House of Peers!
> (Though some were quite unwilling)
> And gave the groupe to public view,
> And shew'd them for—a shilling![57]

What did Copley show them for a shilling, the hundreds who filed past the painting each day, from eight in the morning until night fell, sometime past nine in the evening? An engraving published in the fall of 1781 gives some sense of the setting. Set into a recess demarcated by cloth panels, and elevated upon a heart-high platform, *Chatham* is not so much hanged as staged: a play within a play. An elaborate swag caps a frame ornamented with carvings of an English lion and a Scottish unicorn. A more intimate experience than could ever have been achieved in the crowded Great Room of the Royal Academy, Copley's stagecraft offered a visit to the empire's sanctum sanctorum, at a moment of the highest national importance: as much séance as spectacle. The composition itself enhances the viewer's sense of witness, of presence in a room that recedes deeply from the tragedy at the front of the picture plane. Light seems to dance around the canvas, shining brightest on the dying Chatham and his intimates, but also picking out particular faces in darker recesses of the crowded scene.[58] ENSIS joked that it looked as if "a sudden play of springs and wires" was controlling the action: "had I been uninformed of painting, I should have expected the whole to move, to shake, and perhaps been clamorous for the display of the machinery behind." This, he said, was the basest "subterfuge."[59]

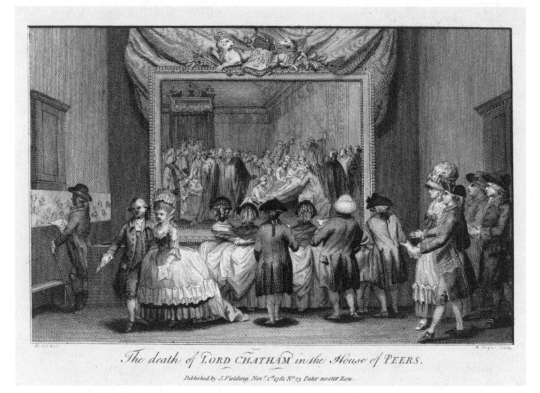

The death of LORD CHATHAM in the House of PEERS.

Published by J. Fielding, Nov.r 1.st 1781 No 23 Pater noster Row.

*Angus Williams after Copley,* THE DEATH OF LORD CHATHAM
IN THE HOUSE OF PEERS, *1781*

But unlike the boisterous crowds who frequented raree-shows, the
patrons who visited Copley's show were subdued, even awed. "The general
Effect of the Painting is astonishing," said a writer in the *St. James Chroni-
cle*, "for the Room, whatever Number of People it contains, is silent, or the
Company whisper, as if at the Bed of a sick Person."[60] The engraving of
the exhibition seems to bear this out: where visitors to the academy were
often depicted staring at one another, Copley's patrons—well dressed but
not foppish—have the temerity to focus on the art. They file across the
room in an orderly manner; they stand at the apron of *Chatham*'s stage;
they gaze reverently. Several patrons pore over their programs. One man
studies a sketch of the various heads that Copley has mounted alongside
the painting, as if matching the names in his brochure to the outlines on
the wall. To seek out Copley's *Chatham* was to ponder what had been lost

when Chatham collapsed, beneath the tapestry depicting Britain's victory over the Spanish Armada, the long-ago triumph that had given birth to a vast blue-water empire. To contemplate his death was to also see the peerage—those wigged men assembled in their chamber of hereditary privilege, resplendent in velvet and braid and furs—as but a collection of heads, men as mortal as any others, upon whose slender shoulders the fate of a nation rested.

By November 1781, Copley's *Death of Chatham* was back in the painter's home on Leicester Square, and Chatham's vision of a network of colonies loosely held by the reins of an empire that governed best by governing least had been finally and forever buried. Late that month, Londoners learned that the combined forces of the rebel commander George Washington approaching by land and the French admiral François-Joseph-Paul de Grasse closing in by sea had forced the surrender of Charles Cornwallis and his army at Yorktown, Virginia. From Jamaica to Gibraltar to Mysore, Britain's American War ground on. But though the king still refused to recognize it, thirteen rebel colonies and their Bourbon allies had prevailed in their small theater of the great global conflict.

"Many of the Shades of the Portraits, both of Persons & Times, I confess are very dark: that is not my Fault. My Business was to draw true Portraits."[61] So wrote Peter Oliver, Sukey's kinsman and the Copleys' friend and neighbor, both in Boston and in London, when he sat down to complete the "Narrative of the *American Rebellion*" he had drafted over the course of that terrible year. The man who had painted Oliver's portrait so long ago, an ocean and a world away, would not have disagreed. But Copley, unlike Oliver, had found fame in the war and its unwanted outcome, by a formula that seemed to transform losing into winning.

⁓

"Your fame my dear son is sounded by all who are lovers of the art you bid fair to excell in," Mary Pelham wrote to Copley in February 1782, while the war on the seas still raged, and letters still often miscarried. "May God prosper and succeed you in all your undertakings, and enrole your

name among the first in that science."[62] But success was not prosperity. In the aftermath of his triumph with *Chatham*, Copley continued to wrestle with the challenge he had first pondered in prewar Boston: how to convert fame to fortune.

His pioneering one-picture exhibition had failed to solve the equation. If more than twenty thousand people had indeed paid homage to *Chatham* by early June, Copley would have grossed £1,000 from the door in the first six weeks. The picture itself was rumored to be worth much more; a reviewer in the *Gazetteer* guessed it would fetch £8,000. But such estimates proved wildly inflated. The Marquis of Buckingham had expressed interest in the picture while it was being painted, going so far as to request several modifications to the design. But after Copley quoted him a price of two thousand guineas, Buckingham's interest evaporated; when Copley next turned up at his door, Buckingham sent a servant to say he was "engaged."[63] In June 1781, before the canvas moved from Spring Garden to the room above the Royal Exchange, two London papers reported that Chatham's nephew had purchased the painting for a thousand guineas. But this, too, proved false; the next day, the *Morning Chronicle* noted that "the article was without foundation, the picture not being sold." And so it would remain, for more than two decades.[64]

The *Public Advertiser* speculated that the sale of prints would add a thousand guineas to Copley's overall take, but that aspect of the venture, too, proved fraught.[65] In late August, as the long exhibition drew to a close, Copley announced that, "painful as that measure has been to him," he must change engravers for the *Chatham* mezzotint. John Sherwin, whose involvement with the project Copley had announced nearly two years before, and whose name was recorded in the catalog of every patron who attended the exhibition, was to be replaced by Francesco Bartolozzi, one of the leading engravers of the day. Copley did not say why he had made the switch, though he did make clear that Bartolozzi was charging him over twice as much for the job, and would take much longer to execute the commission as well: the print for which some subscribers had paid as early as 1779 would not be ready until 1785. (As it happened, the

engraving would not be published until 1791, a decade after Copley first exhibited the painting and thirteen years after the event it depicted: long enough for Chatham's death to be supplanted by other losses.)[66] Depending on how much Copley paid to lease the exhibition spaces, on how many people had prepaid their subscriptions, and on how much of his fee Bartolozzi demanded up front, it is possible that Copley *lost* money on the display of *Chatham*—even before we account for the two years of labor he invested in its execution, and the portrait commissions he turned away in the process.

Copley was hardly the only one. In the fast-falling twilight of the American War, making a living from art in London became ever more difficult. Money was scarce, bankable heroes, scarcer. But artists there were plenty. "The town is overrun with painters, as much as with disbanded soldiers, sailors and ministers," wrote Horace Walpole in May 1783, joking that "half of all four classes must be hanged for robbing on the highway, before the rest can get bread, or anybody else eat theirs in quiet."[67]

In the new United States, supply and demand intersected very differently. By the end of the war, the Continental dollar—never much more than a speech act backed by trust—had become worthless. But painters were scarcer still, and newly minted national heroes abounded. George Washington was the greatest prize, arguably the most famous face in the world. Artists on both sides of the Atlantic jockeyed for the chance to pin him. Many of the members of the "American school" who had rushed to London in the mid-1760s began, in the wake of Yorktown, to tout the virtues of a new national art. Charles Willson Peale laid plans for an American museum in the capital, Philadelphia. He and John Trumbull, both of whom had studied with West, had served stints in Washington's army, and they built their reputations upon his likeness. "You will naturally conclude that the arts must languish in a country imbbroiled with Civil Wars," Peale told his erstwhile mentor, Benjamin West, in April 1783, writing at "the earli[e]st opportunity after the news of a peace." But since leaving the army, Peale had "not wanted employment" at the easel. He promised to send a "Whole Length of Genl: Washington," which he

hoped might sell in London. "Weather the picture would meet with a sale hear I cannot tell," West replied, "but I am shure there are hundreds hear who would be curious to see the true likeness of that Phinomeny among men."[68]

Though West's salary came from the king, and portraits of the royal family dominated his studio, he, too, flirted with a series of paintings on American themes. In June 1783, he asked Peale to send him precise sketches of American army dress "from the Oficers down to the common Souldeir," along with descriptions of "thier Armys or camps from which I may form an axact Idea, to enable me to form a few pictures of the great events of the American contest." West planned to engrave the group, which he would call "the American Revolution."[69]

"What then is the American, this new man?" asked J. Hector St. John de Crèvecoeur in his *Letters from an American Farmer*, read avidly in London after King George at last grudgingly conceded the independence of the United States. Crèvecoeur, a French-born yeoman who had spent much of the war serving the British in occupied New York, emphasized the novelty of the American and his newborn world. "He is an American, who leaving behind him all his ancient prejudices and manners, receives new ones from the new mode of life he has embraced, the new government he obeys, and the new rank he holds." Americans elected their country and invented their flag; they dreamed themselves up.[70]

Crèvecoeur's "new man" was a refugee from a decaying Europe, a westering sojourner: a trope that would long endure. But what, then, in this insistently new world, was the British American, this *old* man, who had sailed east, through a world he understood, only to find that world remade, its borders redrawn, both inside and out? In the 1780s, Copley and the many others like him, people who had long abided more or less comfortably under the capacious umbrella of empire, as American provincials and British subjects both, were called upon to recalibrate their senses of self and citizenship: To recognize new borders. To choose, as Copley had so strenuously avoided doing at the beginning of the imperial crisis, and ever since.

In the immediate aftermath of the *Chatham* sensation and the York-town debacle, Copley, like West, tried his hand at recognizably American subjects. He painted Henry Laurens, a wealthy South Carolina planter who had served as president of the Second Continental Congress. Late in 1780, Laurens was captured en route to a diplomatic mission in Amsterdam and held in the Tower of London: a human bargaining chip. Soon after his release in December 1781, Laurens sat to Copley. As with *Chatham*, a mezzotint was planned from the outset; Valentine Green, who had done the print after *Watson*—still selling well—was to do the work. Subscribers were invited to purchase the engraving after Copley's *Laurens* as part of a pair, with Green's *General Washington*, based on Trumbull's original.[71] The companion print of Laurens was nearly as close as Copley ever got to Washington. (A decade later, when Copley sent him a copy of the mezzotint after *Chatham*, the president responded with a letter of endorsement, declaring that the image, "highly valuable in itself, is rendered more estimable in my eye, when I remember that America gave birth to the celebrated artist who produced it." A draft copy survives among Washington's papers, but Copley does not appear to have kept the letter.)[72]

He settled instead for John Adams. In the waning months of 1783, Adams and his son passed through London after signing the Peace of Paris, which formally ended the conflict between Great Britain and the United States. The American diplomat sat to Copley in the painter's new house on George Street, in leafy Hanover Square in Mayfair. (Copley's family had "changed houses to great advantage" that summer, Elisha Hutchinson wrote, "the rent being nearly the same; but the house is elegant and well finished, and well calculated for his living.")[73] There Adams would have seen the aging Richard Clarke, whom just a decade earlier he had called a person "so hardened and abandoned" that he deserved the vengeance meted out by the people.[74]

The People had since become sovereign in word as well as in deed. Copley's *Adams* is a state portrait, in which the onetime rebel is cast as the official representative of a great nation. Drawn up to his full bantam

*Copley,* JOHN ADAMS, *1783*

height, Adams sports a velvet court suit with a sword at his waist. He
grips a scroll, perhaps the treaty itself. Before him stands a carpeted table
covered with maps; peeking out from below it is a large globe, "signify-
ing *the World is before him*," wrote a critic who later saw the painting in
Copley's studio. Adams points to the ocean that separates the United
States from their erstwhile parent—although as the reviewer noted, "as
he stands, he is on the *right* side of the Atlantic!"[75]

But which was the right side—of the ocean, of the late war—now that
the once seamless British Atlantic was firmly and finally divided? And on
which shore did Copley belong? To many English onlookers, the painter's
Americanness seemed obvious, even unshakable. "It is a circumstance
rather remarkable that the two Painters, the greatest in the 'Ad Captan-
dum' way, viz., West and Copley, are natives of America. West was born
at Philadelphia; Copley comes from Boston," wrote a correspondent in

the *Whitehall Evening Post*. It was a slightly backhanded compliment: *ad captandum* was shorthand for *ad captandum vulgus*: appealing to the People, or crowd pleasing. Rhetoric that was *ad captandum*, one writing manual of the period instructed, was tawdry, effect-driven prose, meant only "to raise a *Dust*, and insinuate *Scandal* into the Hearts of the People."[76] There was something *American* in the way Copley and West pinned their men and staged their scenes, the writer implied—something passionate and brash and more than a little vulgar. John Adams would make the same claim in a different register when he suggested, in a letter written on the glorious Fourth of July in 1786—the new nation's tenth birthday— that Copley, West, and other painters born in the colonies belonged in Thomas Jefferson's "Catalogue of American Genius."[77]

Copley may have been delighted to incarnate American Genius. But his America—his "native Country"—was a collection of colonies, not a nation.[78] Born a British subject, he was prouder still to have made himself a leading light of British art. That he had been born in the provincial city of Boston mattered no more than that Gavin Hamilton came from Edinburgh, or Joseph Wright from Derby. In 1783, when John Boydell engaged Gilbert Stuart (born in the British province of Rhode Island) to paint bust-sized portraits of fifteen of the "most eminent English artists" on the contemporary scene, Copley and West were featured alongside Reynolds and Humphry and others born in the home islands.[79]

Boydell, who was a run-of-the-mill engraver but a peerless printseller, began in the late 1760s to publish a series of expensive folios entitled *A Collection of Prints, Engraved from the Most Capital Paintings in England*. The *Collection*, which swelled to seven volumes, made his name. But it was the mezzotint he published of West's *Death of General Wolfe*, from a plate by William Woollett, that made Boydell's fortune. With the pile he earned from *Wolfe*, Boydell expanded his printshop at the corner of Cheapside and Ironmonger's Lane, in the most elegant retail precinct in London. The shop attracted large crowds who gathered on the sidewalks— themselves an innovation catering to commerce—to browse its windows, hung edge to edge with prints. People flooded to Boydell's to "enjoy the

pleasure of seeing something fresh," as one German traveler mused.[80] The shop was one of the several places where patrons could add their names to the subscription list for Copley's *Chatham* print.[81]

Copley and Boydell shared a commitment to the rising English school of art, and to the representation of contemporary events. "Being fully persuaded that modern subjects are the properest for the exercize of the pencil and far more Interesting to the present Age than those taken from Ancient History I have as much as possible employed myself in Events that have happened in my own time," Copley wrote.[82] At the same time Copley worked on his portrait of the American Henry Laurens, he began what the *Public Advertiser* touted as "a modern History for Mr. Boydell, in a great Style."[83] From his collaboration with Boydell would come the painting that stands at the pinnacle of Copley's career, a winning scene from a losing war that improbably contained the painter's life in microcosm.

~

It is not clear whether Copley or Boydell first proposed the subject of the painting, which the newspapers revealed in November 1782: "the death of Major Pearson."[84] Pearson (more often spelled Pierson or Peirson), was then, for a brief moment, a minor household god in London. Francis Peirson, a Yorkshire lad, had joined the army in 1772, when he was just fifteen years old. After war broke out with America, he quickly attained the rank of major. In the summer of 1780, Peirson and his regiment shipped out to Jersey to join a garrison charged with defending the Channel Islands against attack. He had been there about six months when a rump group of French legionnaires landed under cover of darkness. Colonel Moyse Corbet, the island's lieutenant governor, was seized in his bed and sent orders telling the soldiers to stand down. Defying Corbet's instructions, Peirson led his men to the market square of St. Helier to engage. There he perished, almost immediately, "in the moment of victory, after the French had given way," one paper reported. The entire skirmish lasted fifteen minutes.[85]

Even after the battle in which the "gallant" young major lost his life, Jersey loomed small enough in the London imaginary that the press felt obliged to tout its significance. The *Evening Post* ran a column headlined the "Importance of the Isles of Guernsey and Jersey," which insisted that the "vast importance of the islands, does not . . . depend alone on the benefit we reap from having them in our hands; but yet more from the mischief which would arise from them, if the enemy was to get possession of them."[86] Despite such bombast, Jersey was clearly no Quebec, and Major Peirson no General Wolfe. A minor major's death in a miniature theater at the edge of a great war would not, on its face, seem the stuff of Art.

*The Death of Major Peirson* is both larger and smaller than *The Death of Chatham.* The monumental canvas, nearly twelve feet long and more than eight feet high, dwarfs *Chatham* much as *Chatham* exceeds *Watson.*[87] But the scene Copley stages in *Peirson* is less crowded, more like *Watson* than *Chatham*: an intimate epic. The key to the picture, which visitors received

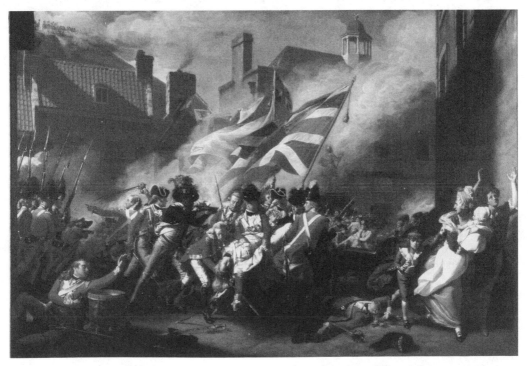

*Copley,* THE DEATH OF MAJOR PEIRSON, *1782–84* [Plate 16]

gratis with their tickets to see it, identifies eleven central figures, against *Chatham*'s cast of fifty-five. With fewer actors, presented in extremis, at the apron of a larger stage, *Peirson* offers an enveloping, immersive experience. Whereas *Chatham* freezes the nation's worthies in diorama, *Peirson* plunges the viewer into the chaos of battle. The image is alive with simulacra of sensory details, from the sulfurous smoke of musket fire to the glint of sunlight on bayonets to the drip of Peirson's lifeblood in daubs of vermillion impasto. "I lookt upon it untill I was faint," Abigail Adams wrote after seeing the painting in July 1784, "you can scarcly believe but you hear the groans of the sergant who is wounded and holding the hankerchief to his side, whilst the Blood Streams over his hand."[88]

As in his previous large-scale performances, Copley chased both soaring grandeur and earthbound fidelity in the making of *Peirson*. It is not clear how he gathered the information he needed to render the setting, St. Helier, in such detail. Unlike Havana Harbor, the contours of which could be gleaned from prints and seascapes, Jersey was not much depicted in the rich visual culture of the day—another index of the island's insignificance. Scholars speculate that Copley either traveled to Jersey himself or dispatched Henry Pelham there to record scenic details.[89] But it seems equally likely that the artist gathered material for the picture when some of the men who had defended the island came to London for the court-martial of their lieutenant governor, held at the Horse Guards over five days in May 1781. At Corbet's trial, the invasion was rehearsed in minute detail. Even if Copley did not himself attend the trial, a transcript of proceedings, running to thirty-four closely printed pages, was available for two shillings at the counters of booksellers across London.[90]

Two of the men represented in the painting's central group gave testimony at Corbet's trial: Adjutant Harrison, who cradles the fallen major in Copley's picture, and Clement Hemery, a captain in the local militia, who stands at the feet of the dying man, wearing the distinctive blue uniform of his artillery company. Harrison and Hemery are presented with great particularity; Copley may have painted them from life. More of those involved in Copley's tableau may well have attended the trial,

though Peirson and possibly others were based on models, extant like-
nesses, or statuary.[91] Indeed, Copley made his arduous head-hunting
much less central to the story of *Peirson* than it had been to that of *Cha-
tham*. And for good reason: the men arrayed around Chatham's lifeless
form were the faces of a nation, while the officers whose portraits anchor
*Peirson* were unknown soldiers.

Nearly a score of preparatory studies for *Peirson* survive. They concen-
trate on compositional matters—the arrangement of figures, the details
of uniforms.[92] It was important, visually and narratively, that the protag-
onists be convincing as real people rather than types. But there could be
no meaningful critique of the painter's skill in capturing these likenesses,
for these men were everymen, the standard-bearers of an empire. It mat-
tered less that Peirson was figured accurately than that he was one among
many, far too many, of Britain's gallant sons sacrificed upon the altar of
a losing war.

This was the message not only of Copley's picture but also of a set
of published verses that reflected on the gallant major's death:

> Alas! that wreath of conquest bought so dear,
> O let me strew it over Pierson's bier!
> In vain did Britain's anxious bosom raise
> Fond hopes of glory from his future days.—

The poet inveighs against the Roman god of war, "stone-hearted Mars,"
from whom "this evil flows":

> To thee my favor'd isle this havock owes;
> Still reeks thy red-drawn weapon, fed with gore,
> Tho' drunk with slaughter, yet athirst for more.

Copley's picture was an image for what the poet called a "dispeopled
Albion," scarred by a war that had produced too many fallen heroes and
not enough rising glory. The reader of "Verses Written at Jersey, January

6, 1781," like the reader of any British newspaper on any given day in the early 1780s, could be forgiven for wondering what had become of "Freedom, great partner of her British reign."[93]

Whither British liberty? The question lay at the heart of Copley's life, and it figures at the center of *Peirson*. In a scene overstuffed with martial elegance, the man Copley's key labels as "3. Major Peirson's black Servant" stands out. Against a palette of skin ranging from the mottled pink of Captain Hemery to the ghostly pallor of the martyred Peirson, the servant's complexion is a deep, radiant walnut, a good deal darker than that of the standing sailor in *Watson*. His hair is trimmed close and sharp. In a field of scarlet, he is costumed in navy, and sports a distinctive round hat, plumed with ostrich feathers of blue, white, and brown: a hat that would seem more at home in the Vatican's Swiss Guard than on the outer edges of Britain's American War. Some who have written about the painting assert that this is the costume of the Royal Ethiopian Regiment, a company of former slaves who rallied to the call of Virginia's royal governor, who promised freedom to those who defended their British homeland. But Copley's figure wears livery rather than a uniform.[94] His triple-breasted waistcoat, silver epaulettes, and plumed hat are designed not to conform to a regiment but to bolster the status of the officer he served, who was not in fact Peirson, but Captain James Christie.

Christie was an ambitious young officer rising through the ranks as the American War widened and lengthened. His tour of duty began in South Carolina, where he took into his service a black youth named Abraham Allec, about fifteen years old. As Britain's campaign against the rebels inched south into Georgia, Christie added another black man to his retinue: Isaac Burton, about age twenty. Those were no colonies for free men of color; Allec and Burton were almost certainly slaves who had fled to the British lines in search of British liberty. They found a version of it in Christie's service: they wore his livery, and they were bound to him, but he did not own them. They followed him to the Isle of Jersey, two among the thousands of black Britons set in motion, willingly or forcibly,

or some combination of the two, by the American War. Allec and Burton continued in Christie's service through the battle, and afterwards, when he returned to Britain to find a wife. Two years later, when Christie took up a new and better captaincy, in the more vital theater of Jamaica, he left them behind in London, in a rented flat in Golden Square, just blocks from the Copleys. They were to attend his young Scottish bride, acting as house servants and coachmen; Allec, who was younger and could write, was directed "to learn hair-dressing."[95]

One of Christie's servants was mentioned in some accounts of the Battle of Jersey. A Glasgow newspaper published extracts of a letter naming a local tradesman "who distinguished himself greatly" in the battle, adding that "so likewise did a negro servant of Capt. Christie's, of the 95th regiment."[96] Adjutant Harrison, who testified at Corbet's trial, penned a lengthy account of the action, in which he assured Peirson's father that his son's death had been "instantly revenged by a Jersey Militiaman and a black servant of Capt. Christy's of the 95th Regt—both of whom instantly rushed forward and shot the Frenchman." In Copley's sketches for *Peirson*, he labels the figure that slays the man who killed the hero—a figure that remains, at that point in the composition, both raceless and faceless—as "Capt. Christie's Black Servt," suggesting that he had heard some version of Harrison's account.[97]

The servant's face, like the faces of Harrison and Hemery, belonged to somebody; it is a likeness, not a mask. It is almost certainly the image of Allec or Burton. (Burton, who was twenty-four when *Peirson* was exhibited, seems to me the more likely.) But if there is a documentary quality to Copley's portrayal of the black figure, the painter also changes the story, just as he smoothed out other elements in the battle. In Copley's version, the servant becomes *Peirson*'s retainer; Captain Christie is not depicted at all. The key explains, "The Major's death was instantly retaliated by his black servant on the man that shot the Major."[98] The substitution straightens a kink in the narrative; the viewer is not asked to wonder why Christie is absent, or why his servant is acting on another man's behalf.

*Copley,* THE DEATH OF MAJOR PEIRSON, *detail*

Copley's plotting also has the effect—surely intentional—of soften-
ing the shocking image of a black man firing a gun. Burton avenges his
master, and not quite on his own initiative: Captain McNeil points out
the villain. His raised arm and extended index figure direct the action:
*there!* Despite that visual bracketing, both the picture and the narrative
that accompanied it demand not only that we linger over the servant's
face and his stunning costume but that we mark his deed, which created
a second gallant hero in a war notably short of them.

Some scholars who have written about the figure have interpreted
him as an emblem of fidelity: "the duty-bound servant."[99] But Burton
seems notably *un*bound. As a nonsoldier, he falls outside the chain of
command in Copley's scene, as in the battle. He does not stand mute, like
the watcher in Copley's *Watson,* or the young liveried attendant who holds
the helmet of the Earl of Stanhope in Reynolds's heroic painting, which

was exhibited while Copley was working on *Peirson*. Much less does he kneel in chains, pleading *Am I not a Man and a Brother?* in the manner of Josiah Wedgwood's famed medallion for the Committee for the Abolition of Slavery. Peirson's servant does not mug, bend, or beseech. He acts: violently, "instantly," as battle demands. But also acts reasonably, precisely. He is armed and trained; he carries his own rifle and his own casings and powder; he loads and sights, aims and fires, passionate and dispassionate at once. He lands his shot. His target dies.

In all of these ways, Burton's depiction in *Peirson* marks a striking departure from the figuration of black bodies in European painting. Not until the overthrow of slavery in Saint Domingue a decade later would artists begin with some frequency to depict armed black men, sometimes as heroes, more often as villains, as if fulfilling the prophecy of Samuel Johnson, who found the American rebels hypocritical in the extreme, and who was heard to offer a toast, in the early stages of the American War, "to the next insurrection of the negroes in the West Indies."[100] Loyal Caribbean planters certainly worried about the rebellion of bondsmen mustered in defense of the empire. But on the whole, British forces were more sanguine about the vexed question of arming slaves, to whom they regularly offered freedom in exchange for service. The patriots typically opposed such tactics. "Your Negro Battallion will never do," John Adams responded to a proposal to create a small force of black troops in 1776. "S. Carolina would run out of their Wits at the least Hint of such a Measure."[101] Copley's Burton—slave turned servant turned soldier of sympathy—embodies British liberty, pitted against false freedoms of the Americans and their French allies, with their lofty talk of the equality of all men amidst the base reality of their tobacco and cane fields.

It is impossible to say whether Copley meant, with this revolutionary image, to ally himself with the rising tide of antislavery sentiment in England. It would be convenient to think so; one of the basic tropes of United States history is that however flawed at its outset, the nation called into being by the Declaration of Independence inclined inevitably and inexorably toward the equality invoked in that document's soaring first

line. But Copley's moral arc refuses to bend quite so neatly toward justice. There is no evidence that he joined any of the groups then organizing in support of abolition. Moreover, there is every possibility that he was still a slaveholder in Massachusetts; no record documents that Mary Pelham freed Snap. And in ways Copley could not yet know, slaving wealth would become just as important to his wherewithal near the end of his life as it had been upon his marriage. Still, the progression from *Watson* in 1778 to *Peirson* in 1784 gestures, however partially, in the direction of black freedom. Certainly no critic could say of *Peirson*, as some had of that earlier performance, that "the *black*" was overly terrified and insufficiently active.[102]

While he was working on *Peirson*, Copley painted and exhibited a spectacular three-quarter-length portrait of William Murray, Lord Mansfield, enemy of America and of slavery alike. The image derived from Mansfield's pose in *The Death of Chatham*, where he had appeared seated, far enough from the action to scandalize critics. In the full-dress portrait, the chief justice appears imposing, robed in the fur-trimmed scarlet of the peerage, grasping a legal scroll much as *John Adams* grips the documents of the new American nation. *Mansfield* is fierce, commanding. The critics called it a "most inimitable representation, . . . speaking as if it were the actual presence of the original."[103] Since the chief justice's decision in *Somerset* a decade earlier, he had been strongly identified with antislavey, and the racial arrangements of his household had grown notorious. Mansfield and his wife had raised Dido Belle, the illegitimate daughter of their great-nephew and an enslaved woman, almost as a daughter. Thomas Hutchinson met her when he dined at the chief justice's estate in 1779. "A Black came in after dinner and sat with the ladies, and after coffee, walked with the company in the gardens, one of the young ladies having her arm within the other," he noted with some astonishment. Mansfield, he said, "has been reproached for shewing a fondness for her—I dare say not criminal."[104] Such associations would have hovered over any representation of the controversial chief justice.

Taken together, *Watson*, *Mansfield*, and *Peirson* could be seen as a triptych loosely themed around the issue of slavery, which had become one of the great questions of the day. But if reviewers brought such associations to the exhibition of *The Death of Major Peirson*, they did not record them. The first critic was the most important; before the public was invited to see the picture, Copley had it carted to Buckingham House so that the royal family might view it privately. An article in the *Morning Herald*, quite possibly placed by Copley or Boydell, noted that the king had cut short his morning ride out of his "desire to see this distinguished performance," and spent "near three hours" poring over it, "with the minutest attention" to its "various excellencies in point of *design, character, composition*, and *coloring*."[105] From Buckingham House, *Peirson* made its way to the Haymarket, where it was installed in a rented room, alongside *Chatham* and *Watson*.[106] And though the *Morning Post* insinuated that Copley had withheld *Peirson* from the Royal Academy's exhibition "*for personal considerations*," this second raree-show—as it was once again called, at least in private—attracted both less controversy and less notice than the first. After a bit more than two months, the "celebrated picture" moved to its permanent home, on the upper floor of Boydell's gallery in Cheapside, where it hung "at the head of the room," in a frame capped with the likenesses of Copley, the engraver James Heath, and Boydell himself; alongside other dramatic scenes from British history, "modern paintings" by England's best. Stuart's portraits of the "most eminent English Artists" ringed the wall above them.[107]

Nary a word was printed against the majesty of *Peirson*, "esteemed by the Conoisseurs [as] the *Chef d'Oeuvre* of the artist." The *General Evening Post* compared it to Shakespeare.[108] Others praised Copley's choice of subject, noting somewhat defensively that the "important event" depicted was "inferior in point of *honor* to no transaction of the late war," and had taken place on an "*island* of great consequence to England, a part of the heritage of our Kings of the Norman line." Reviewers extolled Copley's composition, his use of light and shadow, and his skill as a colorist. "The scarlet drapery of a body of British soldiers would have produced a *fierceness*,"

*Copley, Study for* THE DEATH OF PEIRSON *(Young Boy and Fleeing Mother and Child), ca. 1782–84*

had it not been enlivened by "the blue drapery of the *black servant* and the uniform of the *Jersey Officer,*" the *Whitehall Evening Post*'s critic noted.[109]

The sensational black figure otherwise received nearly as little attention from critics as the small group of civilians at the right of the picture plane: a young boy, a woman holding a baby, and a nursemaid, all shown "flying with terror and distress from this scene of blood," as Copley wrote in his printed key to the picture.[110] Only one reviewer mentioned, in passing, these "*female inhabitants* of the town."[111] Yet Copley spent a great deal of time upon the little quartet. Four sketches document their evolution in chalk and graphite and ink. The infant is rendered first chubby and nude, then in swaddling clothes. Three times Copely figures the mother with one breast bared, a Madonna, before shifting the position of the baby to cover her frantic dishabille. The young boy—the only figure in the entire composition to stare, full face, at the viewer, is sketched in a sweet pencil

portrait, close-lipped, without the terrified yawp that seems to contort his face in the finished picture.

These are members of Copley's family: his older son and namesake, his wife, his youngest child, named Jonathan, after Sukey's brother, who died shortly before the baby was born in the winter of 1783. *The Death of Major Peirson* is a picture about loss amidst victory, about slavery and liberty. But it is also a family picture, featuring a woman and a growing boy who had fled the terror of the American War years before.

The war is over now. And still they endure, on this far shore, as their kin and friends disperse around the Atlantic basin, some to Canada, some to America, some to other parts of Britain. They have been in London for a decade, in joy and in sorrow, their private lives hidden by the glare of Copley's very public fame.

*⁓ Chapter Ten ⁓*

# DAUGHTERS AND SONS

"**A**ERIAL FLIGHTS ARE now the raining passion of this place," Sukey Copley wrote in November 1784. She told a kinswoman in Massachusetts not to be "surprised if you be visited by any of your Old Friends in these new invented Vehicales for traveling in the Air."[1] Earlier that fall, as many as 150,000 Londoners turned out to witness a young Neapolitan named Vincenzo Lunardi climb into a carriage beneath the great globe of his "aerostatique machine"—with two bottles of Madeira, an Italian greyhound, a cat, and a brace of pigeons in tow—and rise into the air, the faces of the little menagerie growing small as the wind currents swept them up past the roofs, crammed with sky watchers, and then over the steeples, and on into the atmosphere, until the balloon "appeared, the size of a tennis-ball." By the time, Lunardi touched down in Hertfordshire, the pigeons had flown, the cat had died, and twelve glasses of wine had been drunk for warmth. The aeronaut emerged festooned with icicles; the little dog was so cold, the *Evening Post* reported, that he "put it into his bosom." He estimated the craft had soared three vertical miles.[2]

Sukey scarcely inflated the capital's "raining passion," a veritable "ballonomania," Horace Walpole called it.[3] Imitators quickly followed Lunardi's flight. John Jeffries, a doctor from Boston who was a bosom friend of the Copleys, gave the painter a ticket to watch him ascend later that fall, and introduced him to Jean-Pierre Blanchard, with whom he would soon cross the English Channel *en ballon*. In the coming years,

VINCENT LUNARDI'S AERIAL ASCENT FROM THE ARTILLERY GROUND, *1784*

Jeffries would hand out tiny clippings of a ribbon that he had carried to France "by the route of the air": holy relics of a new science.[4] The *Morning Post* reported that countless doubters "seemed now inclined to believe the possibility of attaining many things less immediately within the reach of man."[5] Airships invited this kind of cosmic contemplation, at once inward looking and panoramic. Certainly they provoked such thoughts in Sukey, who watched more than one aerialist ascend "with as much intrepidity as any experienced Mariner." She found herself "agitated" by the experience. To "see human Beings there suspended between Heaven and Earth appeard too presu[mptuous] a situation for Mortals," she said.[6]

The Copleys had been in London for nearly a decade when Lunardi's balloon rose over Moorfields. The family, too, was suspended: between England and America, present and past, success and striving. "If I should

endavor to give you some account of myself," Sukey wrote, in the same letter in which she described England's reigning passion for ballooning, "I should be puzzled in which important period of the [last] eight years to fix."[7] The war was over, in the thirteen rebel colonies that the Treaty of Paris officially acknowledged to be the United States of America, and from the Caribbean to the North Sea to the Bay of Bengal, and everywhere else around the great globe that the cancer of their rebellion had spread. The terms of the peace gave the loyalists less than they had hoped but more than they had feared. By contrast, the hotter sort of patriots deemed the treaty too soft on the traitors, whom they blamed for causing the eight-year-long civil war in which tens of thousands died and from which nearly one hundred thousand fled—numbers equivalent to nearly ten million people from today's United States.[8] In March 1784, when the peace treaty was celebrated in Boston, a triptych illuminated over State Street featured George Washington on one panel and loyalists swinging from nooses on another. Samuel Adams argued that the "Mutual Hatred and Revenge" between "the people" and the exiles made the return of the displaced impossible.[9]

But it takes vigilance to keep the flame of hatred burning, and the people of the new United States soon found themselves too busy rebuilding their war-ravaged world to stoke the coals. Some of the New Englanders who had formed the core of the Copleys' London circle retraced the journeys they had made in 1775 and 1776, rejoining old communities in a new country. In July 1784, while *Peirson* still hung in the Haymarket, Samuel Curwen walked to Hanover Square "to take leave and pay my last compliments" to the Copleys and Richard Clarke before heading back to Salem.[10] Americans sailed east, as the packet boats resumed their steady traffic across the Atlantic. "Had we been told only a few years past that we should converse with such a number of our American Friends on this side of the water the improbability would have appear'd too great for credit," wrote Sukey's sister Sarah Startin, who had spent much of the war in England, severed from her New England kin. In the wake of the peace, she found herself "disappointed if an American Vessel arrives without a *Friend*."[11]

Seen as if from the vantage point of an aerostatic machine, the year 1784 found the Copley-Clarke-Pelham clan scattered across the new political geographies of the postwar Atlantic. Mrs. Startin sailed west, to join her husband in New York. Sukey's brothers had spent the latter part of the war serving the British army at Quebec; Isaac had since made his way to Montreal. Harry Pelham, who joined the Copleys in London 1776, had since left and loved and lost. Before departing Boston, he had taken up a correspondence with his mother's kin in county Clare, who forged new connections for him in Ireland. Around 1780, he married Caroline Butler, the daughter of a landed family from Castle Crine, a crenellated stone pile just south of his mother's birthplace. Four years later, his wife was dead, most likely during childbirth. Harry divided his time between London and Ireland, where he did some drawing, and worked as the manager of a nobleman's estates.[12]

In Boston, Mary Pelham endured, longer than anybody—especially she herself—thought she would. Once or twice a year, usually during the coldest, darkest months, she sent off a letter to London. "My heart yearns more and more towards you all, my Dear little Grand Children included," she wrote in 1779, when the wound of their departure remained raw, and their separation, "in this decline at life . . . at times hard to bear."[13] While she awaited their return, she managed Copley's Boston lands, staving off the courts and haggling with renters. "Don't be uneasy for me My Dear Son," she said. God watched over her, though never quite well enough. Her health grew ever poorer.[14] By 1782, she found herself "scarce able to walk across the room." She longed to tell her sons "all I've suffered since you left me," and nursed "the pleasing hope that you would Close my dyeing eyes."[15]

In the meantime, letters would have to do, a fragile paper chain stretched across a vast ocean. Twice she was devastated when a dispatch from Copley vanished from the post office on King Street. "You cannot think how distracted I have been on account of this loss," she wrote in 1782, "as 'tis 2 years since I have heard from you by letter, and 3 since I have had a line from Harry."[16] When a second parcel went missing, she took to

the newspapers to recover it. "As the Letter is from her Son, all who have the feelings of a Parent, 'tis hoped will be interested for her," she pleaded, sure that this bundle, like the previous, had been "secreted by some unkind person."[17] She may well have been right; since she knew that the purloined letters had made it to Boston, it is hard not to suspect some malignity in their disappearance, even all those years after Copley's hasty departure.

America, England, Ireland, Canada: these were the far-flung corners of the Copleys' world as a balloon might have overflown it. To peer in the mind's eye across the ocean, to unspool the war and ponder what might have been was irresistible to those who had left. But the world of revolution was a go-ahead world, facing forward as unflinchingly and insistently as the figure on the prow of a ship. The backward glance, the Janus face, the painter's gaze, divided always between posterity and futurity: these were casualties of the age. "I am in no better condition than Lot was in going out of Sodom, when looking back he saw his houses and effects destroyed by fire," wrote Samuel Curwen in 1785. Just a year after he had said his goodbyes to the Copleys, Curwen so regretted his return to Massachusetts that he sailed again for London.[18]

When "I look back upon" the war years, Sukey wrote, "I shudder [lest] I should not have been thankful for the Blessings I have injoy'd." The greatest of these was "a fond Family in whome my future hopes of happiness are built." But she well knew that the "slender ties on Earthly Bliss" were more delicate than the moorings of an airship. Sukey fretted over "the insificiancy of even this superstructure."[19] A fond family was everything. But families, like countries, were fragile, their gossamer bonds buffeted by the strongest winds.

～⁾

At two centuries' remove, it is far easier to glimpse the great world—as London was often called—than the family that Copley placed at the center of his aspirations. We see as if suspended from the basket of Lunardi's balloon as it soared over London. But on occasion, the archive affords glimpses of the hearthside: flickering scenes of a household magic lantern show.

In 1784, when Lunardi soared, Sukey Copley resumed her transatlantic correspondence. After giving birth five times within six years, she had delivered her sixth child two years before. A gap of nearly half a decade separates the toddling boy from his youngest sister. He is to be the last of the Copleys. Sukey is done with childbearing, likely at her own initiative, and quite possibly with the contrivance of her husband. She is nearing her fortieth birthday and will endure for over half a century yet, lucid to the last, a fact that would astonish her.

Her husband is a little older, forty-six. The physical demands of a career in painting have started to make themselves felt in his eyes and hands and shoulders and knees, even perhaps in his mind. White lead, the most extensively used pigment, gradually poisoned those exposed to it. Color grinders suffered worst and soonest; they were "sure in a few Years to become paralytic by the Mercurial fumes of the Lead; and seldom live a dozen Years in the Business," one trade manual warned. But artists, too—even academicians—were affected by the toxicity of lead and other pigments, and by the "Smell of the Oyls," which over time were known to "affect their Nerves and Lungs." Copley has been working with those materials for three decades.[20] The toxins accumulate, compounding in some invisible way his discontented temperament. The American War may be over, but Copley cannot stop fighting it. It has been his context and his subject for far too long.

At the center of their lives are the five children who crowd the new house on George Street. Three of them—Betsy, now fourteen; Jacky, twelve; and Polly, eleven—were Boston-born, though only the oldest two can dimly remember that faraway town or the ocean crossing. The youngest Copleys, eight-year-old Susanna, born the year of America's bumptious Declaration, and Jonathan, just two years old, are native Londoners.

This summer, the Copleys experience what is arguably the summit of any British subject's life: an extended period in the presence of the royal family. The king, who was so dazzled by *The Death of Major Peirson*, has at last given Copley the opportunity he so long sought. When he first got to London, in 1774, he told Sukey that he would not delay his embarkation

to the Continent to take portraits of "any one Subject the King had; but if he should do me the honour to sit to me himself," it would be well worth the wait. Copley has been waiting ever since.[21] Finally, this year, comes news that he will be allowed to paint some unspecified assortment of the young royals, and perhaps the queen. It is not the arrangement that West has, but it is an important opportunity: a chance to secure a royal commission in future or, at the very least, to showcase his talents in a way that will make him a sought-after portraitist among the aristocracy.[22]

In July, Copley and Sukey decamp to Windsor. Though the Hanoverian court is barely a patch on Versailles, Windsor is the apogee of the London social world. Copley finds a veritable stable of painters there beside him. West is there, along with John Trumbull, lately returned from Boston for another period of study.[23] Young John Hoppner leaps at the call to paint the royal children. The king had tapped him very early as a "Lad of Genius," only to turn on him when he married the daughter of Patience Wright, the Philadelphian famed as a sculptor in wax and also, reputedly, a spy for the rebels. Hoppner arrives at Windsor the same week the Copleys do, trailing high hopes of winning back royal favor.[24] On July 13, the *Morning Post* reports that Copley has "been employed for a short time past on some of the Royal children." (There were so many—fifteen born and all but one of those still living.) Two days later, another newspaper quips, "*The paragraph respecting* Mr. Copley painting the Royal Family, *must be paid for, as it is to all intents and purposes an advertisement.*"[25] Even still, despite his recent fame, he stands accused of puffing himself up. Critics dismiss the "accidental Vogue of Copley" as a product of luck, arising from a fortunate "Selection of Subject" rather than "any ascendant Skill in the Manner of treating it."[26]

Windsor, the royal borough a day's ride west of London, is "a most delightful part of this Cuntry," Sukey tells a kinswoman, "and being a Royal residence has every assistance from Art to highten the Beautys of Nature." Chief among its delights is the ancient rambling castle, begun at the time of the Norman Conquest. As History Painter to the King,

West has rooms in the castle. No such accommodation has been made for Hoppner or the Copleys, who rent space at an inn. Sukey's niece Abigail Rogers (née Bromfield) is with them, at the end of a long European honeymoon. They hope the country air will restore her health, which has been poor. On sunny days, the ladies ride in the royal parks. Copley paints Mrs. Rogers, with a blush of health upon her pale cheek, beneath a swirl of powdered gray hair capped by an ostrich-plumed hat of the sort lately made fashionable by Georgiana, the Duchess of Devonshire, a noble beauty who has the temerity to dabble in politics. Georgiana has been celebrated by Reynolds and Gainsborough, and Copley renders his niece much in that vein, with an Italianate sky and free, painterly brushwork: American royalty.[27]

*Copley*, ABIGAIL BROMFIELD ROGERS
*(Mrs. Daniel D. Rogers), 1784*

The Copleys and other American-born place seekers gather around West. The Americans dine together, sometimes on their native foods; Samuel Shoemaker, a loyalist who decamped from Philadelphia when the city fell to the rebels, relishes "some boild Indian Corn & Squashes which I have not seen at any other Table in this Country, the Corn was raised in Ben. Wests Garden and I thought it as sweet as is common in America." But the visitors also enjoy boating on the king's lakes and tramping through his forests. And they, no less than their English neighbors, are eager for a glimpse of the sovereign—father of an empire—*en famille*.[28]

West wrangles Shoemaker an audience when the royal entourage stops at the painting room to see his latest masterpiece, an enormous canvas depicting the last supper. In a journal he keeps for his wife, Shoemaker describes the scurrying of pages to meet the royal coaches, the procession of the king and his equerry and the princesses and their "sub governess," the minuet of bows and curtsies, the complaisance of the king and the sensibility of the queen, whose "delicate feelings" cause her to "shed some Tears" for Shoemaker's children, who had died. If "some of my violent countrymen could have such an opportunity as I have," he writes, "they would be convinced that George the third has not one grain of Tyran[n]y in his Composition, and that he is not, he cannot be that bloody minded man they have so repeatedly and so illiberally called him. It is impossible; a man of his fine feelings, so good a husband, so kind a Father cannot be a Tyrant."

Shoemaker found himself "fluttered and embarrassed" when confronted with the royal presence. He rose to the occasion in grand style, though, conversing with the king in German.[29] It is hard to picture Copley producing such courtly manners, if indeed he has the chance to see the king at such close range. Sukey is vague: "here we behold Majesty and Royalty happy in retireing to injoy Domesestic pleasures and Rural amusements," she tells her niece. Though she is writing to a citizen of the new American republic, she cannot refrain from falling into rhapsody about the royals, in the way that so many Americans had done before her,

and have done ever since. The "Kings is a most remarkable handsom and fine Family," she reports, "so much beauty of the mind is added to the externals that we can't but admire."[30]

Copley means to burnish the royal reputation, and his own, by painting a gay little corner of that fine family. Meticulous, as always, to a fault, he considers several possibilities before settling on a grouping of the king's three youngest daughters, portrayed with their pets. A thirdhand story still circulating in the 1830s holds that "the children, the dogs, and the parrots became equally wearied" by Copley's effortfulness. The princesses' retainers reported the young royals' frustration to the queen, the tale goes, and the queen took their concerns to the king, who asked West what was to be done. "Mr. West satisfied his majesty that Copley must be allowed to proceed in his own way, and that any attempt to hurry him might be injurious to the picture, which would be a very fine one."[31]

If the thrice-told tale is true, the picture belies the laboriousness of its creation, radiating joy and spontaneity. Commoner and provincial though he is, the painter may well feel an affinity for these sitters who can scarce sit still: he has children nearly the same ages. Mary, the eldest of the young royals, was born just a few months before his daughter Susanna, and Sophia, the next of the royal tots, just a year later. Copley's son Jonathan is a few months older than Amelia, the littlest princess.[32] Dressed in their finery, the wee ladies gambol like the spaniels at their heels. Mary shakes a tambourine, which seems to amuse the seated Amelia, whose pudgy fist grips Sophia's more graceful hand. But for the glimpse of the castle's round tower in the background, these could be any three Georgian daughters, including the painter's own.

The critics damn this buoyant informality when the picture goes on show in 1785. By then, the fractiousness of the Royal Academy has become a popular subject of gossip in the papers, and reviews of the annual exhibitions have taken on the aura of blood sport.[33] "The wise men all go toward the *East*, and turn their backs upon the WEST," quips the *Morning Herald*, punning on West's surname and the sudden outflow of London artists to India, where a bumper crop of British placemen are

*Copley,* THE THREE YOUNGEST DAUGHTERS OF
GEORGE III, *1785* [Plate 17]

hungry for portraits, much as the soldiers serving an earlier King George in an earlier set of provinces had been during the Seven Years' War. Of course, one could defect from Somerset House without shipping off to Cuddalore; Hoppner is expected soon to join "the many artists who have succeeded from the Royal Academy," staging a show on his own, much as Copley did several times in recent years.[34]

Tales are told out of school. The *Morning Post* reprints an exchange of letters in which Hoppner says "that the presence of Mr. Copley was always dreaded . . . in the Academy, and that particularly when Mr. West rose to give his opinion, Copley immediately followed in opposition to it." (West "always bore it with great calmness and patience.")[35] Either Hoppner exaggerates, or the friction between Copley and West does not

leak beyond the academy. The families still dine together, sometimes at Copley's, sometimes at West's.[36]

The tension between Copley and Hoppner is real, however, perhaps a product of their shared summer in Windsor. Unfortunately for Copley, Hoppner has a platform for his grievances. He has lately turned critic, and airs his grudge against Copley in a brief, stinging, anonymous review of *The Three Youngest Daughters* in the *Morning Post*.[37] It reads in its entirety,

> So Mr. Copley, is this the fruit of your long studies and labours? Is it for this you have contemplated the Iris and the Prism? Is it because you have heard fine feathers make fine birds, that you have concluded fine cloaths will make Princesses? What delightful disorder! Why, you have plucked up harmony by the roots and painted confusion in its stead! Princesses, parrots, dogs, grapes, flowers, leaves, are each striving for pre-eminence, and opposing, with hostile force, all attempts of our wearied eyes to find repose![38]

It matters not that Hoppner's competing efforts—pictures as stiff and spare as Copley's canvas is boisterous—are also condemned.[39] His critique of Copley sticks. A consensus builds: *Three Youngest Daughters* is irredeemable. Its critical failure calcifies a popular understanding of Copley's familiar faults; its "overcharged style of tinting" and "levity of pencilling" will be ridiculed even a decade hence, as a sort of "pert tawdriness" better suited to a traveling fair "than a Royal Palace."[40] It is the style of work that will be dismissed, a few decades hence, as chocolate box art.

Never mind that *The Three Daughters* is a stunningly gorgeous painting, at once sumptuous and sprightly. Never mind that the king and queen like it well enough to hang it in a ballroom at Windsor. (The Windsors like it still: *The Three Daughters* flanks the entrance of the throne room in Buckingham Palace, while many of the Wests are tucked away, in narrow dark hallways, or over television sets in guest rooms.) But the royal imprimatur remains too vague to make good Copley's labors. *The Three Daughters* marks the painter's Icarus moment, his zenith too quickly bending toward earth.

Though they might blush at the comparison, Copley's children have good cause to empathize with the princesses, squirming in their silks. All of them, since they were tiny, have posed for their likenesses, and so have seen themselves more often and more fully than most children of their time. Copley painted Susanna into *The Nativity* as a newborn; his friend Benjamin West sketched her, fat-cheeked and stubby-fingered, soon after she learned to sit. Betsy and Jacky form the nucleus of Copley's bravura family portrait, exhibited before they could read and write. The Copley children are repeatedly revealed to themselves, to the art-loving public, and even, by degrees, to us. Like the three princesses, they are often shown at play, at once an artistic convention and a feature of Georgian childhood, at least among such fine folk as the Copleys aspire to be. The boys, Jacky and Jonathan, have also posed in more strenuous roles, as ref-

*Benjamin West,* MISS SUSANNA COPLEY, *ca. 1777*

*Copley*, VENUS AND CUPID, *ca. 1779*

ugees from the Battle of Jersey, their faces contorted in fear. A few years before that, Jacky played Cupid to his mother's Venus, in a marvelous oil sketch, all caught motion, her hand tousling his chestnut curls. That picture, and a delicious portrait of little Susanna pouting beneath the shadow of her bonnet sometime in the early 1780s, will remain in Jacky's possession until his death.[41]

The easel is not a mirror, much less a therapist's couch. When the Copley family is revealed on canvas, we see selves carefully performed. Much remains offstage, including the labor of the household: the work of the servants, black and white, who keep those billowing linens clean and starched, and Copley's wig powdered, and Sukey's hair dressed, and the larder full, and the children fed and scrubbed. Mary Copley, youngest of the surviving Boston-born children, would later mention a fever that had laid "two of our servants" low, implying the presence of more pairs

of invisible hands, hard at work.[42] Nor do we see, in those brightly lit pic-
tures, the shadows that darken the household when it is not on exhibit:
pangs of worry and loss that stalk every family, in every place and time,
but which fall with special force on those caught up in the counterflows
of revolution.

Money remains a constant anxiety. Unlike many of the American
refugees, Copley is able to ply his trade in London. But he struggles,
much as other ambitious artists do, against the demands of a crowded,
fickle market for goods that take months if not years to produce, all the
while living in a city that eats cash, and in a style that befits his stat-
ure and, crucially, that of his would-be patrons. He paints the second
half of his life story upon a canvas wiped clean of everything that he
accumulated before 1774. The Suffolk County deeds state that he owns
a vast swath of land stretching from the Beacon Hill to the Charles
River. But that property is now utterly illiquid—frozen, inalienable, if
not quite gone.

To the strain of finances add the pain of family members. Mary Pel-
ham's agony makes its way only intermittently across the Atlantic, but
the suffering of Sukey's father is a constant presence, the basso ostinato
beneath the family melody. Richard Clarke is now well past his biblically
apportioned three score and ten years, with a decade to go. He feels him-
self cursed like holy Job, and he isn't shy about saying so. "Mr. Clarke by
invitation drank tea with me," Samuel Curwen noted in his journal in
1781, year of Yorktown. For more than two hours, Clarke treated his host
to "a long recital of his sufferings in New England. His condition here is
truly pitiable," Curwen said.[43]

And still, despite the strains and lingering sadness, the sweetness of
the Copley household seems undeniable. Copley posted scores of bless-
ings and thousands of kisses in his dispatches from the grand tour, when
he ached for the sight and sound and touch of his children. Surely some
of that affection still suffuses the parlor on George Street; off the easel as
well as on it, the Copley children are petted and coddled and plied with
"pretty things," in an elegant house filled with art and affection.[44]

Yet in October, the household experienced the bitter visitation every family dreaded: a bout of what people of the day know as putrid sore throat, and which we call strep. The disease was perilous, especially for the young and the old. Susanna succumbed first, on 24 October. Jonathan died on 9 November, just long enough after his sister that the family may have dared to hope he would escape. Elizabeth West, the painter's wife, recorded the dates of their passing in her household account book; perhaps she helped nurse the family through those terrible days. The Copleys buried the little ones in the village of Croydon, lying south of the Thames and not yet eaten by the sprawl of London, in the ancient church of St. John the Baptist, where the Boston-born loyalist East Apthorp served as pastor, and where the bones of Thomas Hutchinson also rested.[45]

The survivors were laid low. Sukey and Copley "look as if [bowed] down under affliction," wrote John Adams's daughter, who dined at George Street two months after the children's deaths. "No one can wonder at their dejection," however much "they seem to exert themselvs to appear chearfull."[46] The family struggled to recover a posture of "humble submission" to God's "Allperfect Will," and to recall "the gracious ends of His Paternal discipline," as Richard Clarke said when his son Jonathan—Sukey's brother and the baby's namesake—died the year before. The burden of divine discipline felt heavy indeed. "I fear this repeatd affliction will make a deep impression on her mind," Sukey's sister writes.[47]

Decades hence, when her daughter buries a child of her own—the Copleys' first grandchild, dead before his tenth birthday—Sukey will feel afresh "the Impotence of human Nature in these struggles." She "wept too much uppon that occation," she will recall.[48]

Now there are three.

No child born in London is left in the house on George Street.

⌒⟋

The "progression of time is so rapid," noted John Jr., explaining to his mother why he so seldom wrote home. By 1791, the Copley family no

longer much resembled the portrait hanging above the fireplace in the dining room.[49] The surviving Copley children had grown into young ladies and gentleman, accomplished in the ways that befitted their ages and sexes and station. All three outshone their parents, and especially their father, in the breadth and depth of their learning. All had learned the rudiments of drawing. Betsy evinced a striking talent for crafting artificial flowers, "with so much nature and truth as to deceive every person who has seen them," Harry reported. He tutored his niece "in Perspective and Geography for both which she has a great fondness," as well as in "the rudiments of Astronomy," useful knowledge for a young lady in a nation of balloon voyagers and stargazers. Years later, when Betsy is separated from her by an ocean, Sukey will wish that her daughter had "made a greater proficiency in the Arts," so that she might send pictures along with her letters.[50]

All three children went away to primary school. The young ladies' formal education stopped there.[51] Afterwards, both daughters returned to George Street. Polly, now called Mary, was fifteen. The polite world knew her older sister, Betsy, as Miss Copley. They gathered with their little circle of friends in the parlor they called "the Red Room," over cards and "sandwiches in a wedgwood Tray, with as much chat, as these meetings will afford."[52] Sukey and the girls worked at sewing or *bon point* embroidery. "Do come and sit down, you are a long time about that sleeve," wrote a friend to Betsy, imagining the family of an evening. "Miss Mary! But your inventive genius produces something now—what is it? . . . here is the Scissors."[53] The children of the Massachusetts exiles remained the Copley sisters' bosom friends. Miss Ann Jeffries, daughter of the Boston-born balloonist, stayed with the Copleys periodically.[54] Mary and Betsy traded letters with the younger generation of Hutchinsons and Olivers. Already Betsy was a saver of correspondence, which would remain important to the family story for generations.[55] Having reached the marriageable age of twenty-one, she and her family were always on the lookout for appropriate suitors. In October, she went with her parents to Bath, to make her debut at the balls and the assembly

rooms, much in the manner of the characters Jane Austen will place in that fashionable resort several years later.[56]

Jacky, now J. S. Copley Jr., was living a life that his parents, and even his grandfather Richard Clarke, Harvard College class of 1729, can scarce have imagined. From grammar school at Clapham, he moved on to study Latin and Greek under the tutelage of a clergyman in Chiswick. There he had demonstrated such mastery that he was sent up to Cambridge, where he showed the genius of a scholar and the temperament of a wit. His letters home pick at tiny errors in Copley's religious pictures. "A merciless critic!" he called himself. He wrote seldom to his mother and almost never to his father, whom he mocked gently as "the Knight of the Brush."[57] He lived at Trinity College in genteel style, in rooms that (he told Sukey) contain "eight chairs and two tables commodiously. Not so extremely small you perceive." He set the scene for her: "Here, according as my inclination prompts, I either turn over the pages of science, or wander through the flowery and less rugged paths of Poetry and polite literature." He haunted the coffeehouses, poring over the heated pamphlets exchanged between Thomas Paine and Edmund Burke about the situation in France, which grew more alarming by the day. And he strove, tirelessly. Like his father, John Jr. was ambitious, a climber of mighty mountains. "Though it be impossible to arrive at the summit of the Hill," he wrote, "let us endeavor to approach as near to it as we are able. Labour and perseverance overcome many great obstacles." Fashion must not be neglected, however; John Jr. asked his mother to send along his silver knee buckles and his fencing foils.[58]

Writing from Paris in 1774, Copley had told his mother that one of the chief purposes of his "excursition" to Europe was to "ennable me to provide for my Dear Children in such a way as to bring them into the great World with reputation."[59] He labored to make good that pledge, though the entrance of Betsy into society and the debut of John Jr. on the professional stage were, in their different ways, expensive. John Jr. was pensioner at Cambridge, without stipend. Betsy needed to be outfitted to make her rounds during the London season, after which any reasonable

husband would expect a reasonable settlement.[60] The critical failure of *The Three Youngest Daughters of George III* in 1785 becalmed the sails that had lofted with Copley's triumphs in *Watson*, *Chatham*, and *Peirson*. Those single-picture exhibitions brought celebrity, but great gusts of reputation translated, in the end, to little in the way of solid foundation. Sukey's aging father continued to front most of the family's costs.

Copley's quest, and the market's, for novelty as well as excellence, remained relentless. His imagination exhausted, he seems to have trained his ambition on scale: the next biggest thing. In March 1783—before *Peirson* was done, when there were five young children still romping through the house in George Street—Copley had won a commission from the City to paint one of the most glorious victories of the late inglorious war: Britain's defeat of the floating Spanish batteries that had besieged Gibraltar for nearly three years. The subject was a popular one; a reviewer of the Royal Academy's exhibition that spring declared his "patience . . . literally worn out with looking at floating batteries and Gibraltar," of which four versions hung on the walls of Somerset House. More would shortly follow, including one by Copley's unhappy grand tour traveling companion, George Carter.[61] Even John Trumbull, busily making his name with American subjects like the signing of the Declaration of Independence, decided to paint "a passage or two of British History," starting with the liberation of Gibraltar, in order to "Give the Devil his due."[62]

It was a sign of Copley's fame, circa 1783, that he beat out West to win the commission for the City's official monument. Copley triumphed in part by underbidding his competition. He would capture all the drama of the siege, the defense, and the eventual relief of the fortress in a single picture, whereas West forecast a series. Copley set his price at a thousand guineas, which seemed ample compensation for the two years the Common Council estimated the work would entail. Copley hoped to pull it off in eighteen months.[63]

The painting took him eight long years. John and his sisters grew up, quite literally, in the shadow of the enormous picture, which doubled in both size and complexity from the plan the council approved. Stand-

ing nearly eighteen feet high and stretching twenty-five feet in length, the painting could fit *Watson*, *Chatham*, and *Peirson* together within its frame, twice over.[64] *Gibraltar* was so large, in fact, that the canvas could not be stretched entire within the confines of Copley's painting room. A young visitor who saw the picture in process said "it was managed by means of a roller, so that any portion of it, at any time, might be easily seen or executed." Copley worked it in sections, "raised upon a platform."[65] Even partially rolled, the outsized picture may have spilled between the large skylit room where the painter displayed his finished works and the smaller studio tucked behind it where, Copley's granddaughter later said, his "real life was passed."[66] News of his progress on the towering canvas peppered the newspapers year upon year. In the fall of 1786, the *London Chronicle* reported that the painter was "literally laying siege to Gibraltar, as he has models, not only of the fortress, but of gun-boats, ship-tackle, men, and every instrument of destruction, arranged before him."[67]

And so the better part of a decade passed with the painter consumed like some mad admiral at his water table. "I shall ask nothing concerning the great picture," wrote John Jr. from school in 1789.[68] One critic joked that Copley and the Irish artist James Barry, who had lately completed a series of murals on the rise and progress of British art, had placed a wager about which of them could more quickly paint "a certain number of ACRES."[69]

*The Defeat of the Floating Batteries at Gibraltar* shifted shape as new constituencies stepped forward to demand their places in the epic tableau. In 1787, Copley and Sukey and Betsy traveled to Germany, to take likenesses of four Hanoverian officers whose efforts Lord Heathfield, the governor of Gibraltar, deemed crucial to the English victory.[70] The journey took them through Flanders and the Netherlands, a "pleasurable and professional excursion," one newspaper said.[71] Many years later Betsy Copley will entertain her daughter with tales of "that golden time" on the Continent, when collectors opened their galleries and nobles their palaces to the Copleys, who carried letters of introduction from George III himself. Among the many German gentry who welcomed the travelers

was Frau Charlotte Buff-Kestner, who had once spurned the advances of the poet Wolfgang von Goethe, thus setting in motion the plot of *The Sorrows of Young Werther*, touchstone of the dawning Romantic aesthetic. "My mother never forgot her meeting Charlotte," Sukey's daughter wrote, though she reported that the heroine had "outlived romance, except in fiction."[72]

*Gibraltar* was Copley's main bet during the long years of its planning and painting, crowding out portrait commissions along the way. The question, through it all, was what would see the family through until the gargantuan picture was complete. The long-promised engraving of *Chatham* remained in demand; by the mid-1780s, a secondary market had arisen for the eventual proofs, which sold like commodity futures, for up to twenty-five guineas.[73] In 1787, Copley and the engraver Bartolozzi promised that the mezzotint was "without fail under penalties to be published in April 1788."[74] But that year came and went, and the next, and the next. One frustrated subscriber took to the press early in 1791, joking that the print "has been in labour ever since 1781," and "cannot possibly be deemed . . . a premature birth." Another wag suggested that future subscriptions for Copley's prints should be issued "on the plan of *Tontine*," a form of lottery in which the prize went to the last surviving investor.[75] But if the subscribers resented being so long out of pocket, the painter found himself in much the same boat: Copley had committed £2,000 to Bartolozzi for the mezzotint after *Chatham*, and £2,700 to William Sharp to engrave the not yet painted *Gibraltar*. The down payments of subscribers, numerous though they were, barely offset those costs.[76] The "difficulties of a Painter began when his picture was finished, if an engraving from it should be his object," Copley told Joseph Farington, a landscape painter and fellow member of the academy.[77]

Caught between his largest-ever commission and its completion, Copley scrambled. He set aside other projects, some for years, others for good.[78] In 1788, he tried once again to sell *The Death of Chatham*, consigning it to a crowded exhibition in the academy's former rooms in Pall Mall, whose novel catalog included the names of the bankers who would

handle deposits, along with the precise dimensions of each painting, so that collectors might know where in their great houses a given picture might fit.[79] One critic who reviewed the sale recalled "the national and historical importance" of Copley's "wonderful performance" in *Chatham*, and expressed surprise that "it should still remain in the hands of Mr. Copley, though valued at Twenty-five Hundred Guineas."[80] But there were no takers, and the painting returned to the George Street rooms still embattled by *Gibraltar*.

Copley's mother died a year later, after "a very long and almost uninterrupted cou[r]se of misery," as her stepson Charles Pelham put it.[81] Mercy Scollay, the spinster daughter of the powerful patriot politician John Scollay, attended Mrs. Pelham through the final stages of her long decline, sending reports to London that caused Copley "many painfull sensations. . . . what is the sum of Human Life?" he asked in response to Miss Scollay's account of his mother's worsening condition. "Detach it from a World to come and truly it is vanity and nothing in it that is real but the pains, which are many, and great and proportion'd to the time we live." Copley's mother recompensed Miss Scollay with a bequest of £12, to which Copley added £30 of his own, perhaps in recognition of how very difficult the old woman's care had been.[82] The bulk of her property Mary Pelham ordered divided between her two sons. But there wasn't much; her estate was estimated to be worth only £123, including a pile of Continental dollars, to which the inventory committee assigned no value at all. (It appears that Snap was, by this point, either dead or free; there is no provision for him in the will, nor was a valuation for his person entered in the inventory of Mrs. Pelham's possessions.) Copley's acres remained, of course. Mrs. Pelham asked her executor to assume "the charge and oversight of all and every [of] the Houses and Lands in the Town of Boston" owned by her son, collecting the rents "to reserve for his use awaiting his Orders." But as she had written many times before she died, the tenants simply weren't paying.[83]

As Copley prepared to unveil the high-stakes gamble that was

*Gibraltar*, the family's accounts remained a constant worry. Betsy's friend
Margaret Oliver conjured up in one letter an image of Mrs. Copley,
"always busy . . . looking over papers in that little draw[er]."[84] John Jr.,
writing from Cambridge, asked his mother to update him about the
state of "those various and complex concerns which at present engage
and agitate the minds and Bosoms of our Circle in G[eorge] St."[85] The
subject of those papers, the heart of those various and complex concerns
was surely the perennial nagging matter of money.

The debut of the gigantic canvas was fraught with gigantic hur-
dles. No exhibition space could house it; a pavilion must be erected.
"The building will cost Mr. Copley upwards of 300£," one newspaper
reported: much of what the City had advanced him against the picture.
In April, a team of housewrights began to frame an enormous tent,
some eighty-four feet long, at the edge of Green Park, just behind
St. James Palace. No sooner had they staked the perimeter than a
nobleman declared the building interfered with his view. The workers
adjusted the footprint, only to be told that "now it impedes the prospect
of another house, the proprietor of which makes heavy complaints."
A petition was got up among the neighbors, who included, among
the other eminences who tended to roost in the king's backyard, the
Marquis of Salisbury, Lord Chamberlain of the Royal Household. The
nobles entreated the king "to order Copley's booth to be removed from
before their windows." (They called Copley's pavilion a "booth," as if a
band of tinkers had set up a carnival.) King George, who had weath-
ered a monstrously unpopular war, more than one attempt on his life,
his first bout of rumored madness, and the political crisis that followed
it, took Copley's side. "Push it up nearer to my *wife's* house—she won't
complain," he told the petitioners. The tent was nudged west, toward
Buckingham House.[86]

The king toured Copley's picture before it opened to the public, with
Queen Charlotte and all six princesses in tow.[87] "Many are the artists
who have to boast of Royal notice, but none more than Mr. Copley,"

said the *World* shortly after the visit. This would seem, on its face, a joke at Copley's expense. Yet what follows suggests, rather, a new height of sycophancy, a squib placed by the painter himself:

> The generous patronage of his Majesty must certainly serve as a stimulative to that gentleman's future exertions—in fact, it must be the most pleasing event of his life: for he cannot but feel with the most lively gratitude the kind and endearing condescension of . . . a Monarch whom we reverence, and who has to add to his title of "Father of his people" the protector of genius and encourager of the arts. An artist sanctioned by such a Sovereign, cannot fail of receiving the support of a generous public.[88]

Copley must have felt great relief that the painting was done, and that the enormous shadow it had so long cast might begin to lift. Whether or not it proved "stimulative," the king's applause punctured that gloom like a ray of June's purest sunshine. At precisely the moment many Americans had begun to erect their shrines, in painting and marble, to George Washington, so-called Father of His Country, whom ordinary (white, male) American citizens had elected, with great fanfare, to their new nation's highest office, Copley basked in the light of the "Father of his people": a ruler born, not made, given, not chosen, like fathers everywhere.[89]

Not everybody was so enchanted with royal fathers. Not in Paris, especially: less than two weeks after *Gibraltar* opened to the public, Louis XVI, his despised Austrian queen, and their unfortunate son fled the Tuileries disguised as commoners. They were escorted back to the capital by an army the king no longer commanded. In July, when Margaret Oliver asked Betsy Copley to tell her how many people paid to see *Gibraltar* on "the last fine day," she also wondered, as every English newspaper did, "what is become of the King of the French"?[90]

London, too, was suffused with a spirit of reform that touched everything from love and literature to slavery and taxation. Supporters of the

French experiment—and there were many—greeted the news from Paris with wonder. The poet William Wordsworth would later recall the temper of the times:

> Bliss was it in that dawn to be alive,
> But to be young was very heaven!—Oh! times,
> In which the meagre, stale, forbidding ways
> Of custom, law, and statute, took at once
> The attraction of a country in romance![91]

The rage against monarchy was less fevered in London than in Paris. But not everyone recalled the late wars of empire with quite the same fondness as Copley's epic canvas.

The critics did not find much in it worthy of praise, beyond *Gibraltar*'s gargantuan size. They faulted Copley's palette, his composition, his use of perspective, even his likenesses. The men were wooden, the ships leaden, the horses as adamantine as the great rock itself. The sea "looks like threads of worsted," said the *St. James Chronicle*. Once again the crowds ignored the critics: Copley's tent was a mass experience, a spectacle not unlike the panorama, a newly patented form of painting displayed in the round. Copley later recalled that more than sixty thousand people had filed through the pavilion on Green Park.[92]

Just after noon on 17 August, a gentleman from the neighborhood, a man of about Copley's age, hurried to the park railings a few feet from the entrance to the great painting. He was "dressed in black," warm for the hot summer day. When the king's carriage passed—as it did every day at about that time, en route back to the palace—the man pulled a paper from his pocket and propped it on the fence. From his coat he drew a gun, a "small pocket pistol, with a barrel of six inches long." He put it to his chest. He was still holding the gun when he fell, theatrically, with the king's party before him and *Gibraltar* behind. In the days after James Sutherland's shocking public self-murder, the newspapers filled with details about the man and the travails that drove him to his

rash act. He had been a placeman in the late wars, not far from the scenes depicted on Copley's canvas: an admiralty judge on the island of Minorca, which had fallen to the Americans' Spanish allies. Sutherland lost that position in a dispute with the island's governor, a quarrel over loyalty that he took to Parliament and then, by petition, to the king and finally, in death, to the court of public opinion. "Allegiance and protection are constitutionally reciprocal," he wrote in his suicide note, which was reprinted many times over.[93]

An ordinary man made victim to a callous and unfeeling state in an age of perpetual war, the martyr of *Gibraltar* became something of a folk hero. Despite the unholy manner of his death, he received "genteel and decent" burial at St. Martin's in the Field. His long pamphlet about his case, advertised before his staged suicide, was printed immediately after the interment. Newspapers and magazines quoted its "remarkable" and ominous last lines: "The machine seems to be worn out by anxiety, vexation, and disappointment. The tree must fall!"[94]

Weeks, months, years: all have new names for a new epoch. In France, 1795 is the Year III. Louis XVI and Marie-Antoinette were likewise retitled, as M. and Mme Capet, and then executed by guillotine, their no-longer-royal blood sluicing between the cobblestones of the place de la Revolution. On the 13th Pluviôse in the Year I (1 February 1792 in London), just days after Louis lost his head, the Assemblée Nationale declared war on Britain. The armies of the French republic rolled through Brussels and Amsterdam. A young officer, a Corsican named Napoleon Bonaparte, put down a rebellion in Paris and received a general's rank in return. The conscription of half a million Frenchmen helped to distract the nation's poor from famine and riots and patriotic gore: the wages of life under the Terror.

In London, too, a blighted harvest caused widespread hunger, which in turn occasioned widespread unrest. In late October, more than 100,000 people—crowds on a scale not seen since Lunardi's balloon

flight—assembled to block a royal procession to the House of Lords. Some chanted *No famine!* and *No war!* Others risked cries of *No king!* and *No George!* They pelted the royal coach with stones, marbles, and oyster shells; the king, lately recovered from another bout of seeming madness, thought he had been shot. After his equerry spirited him to safety, the crowd fell upon the carriage. Shards of glass from its broken windows were hawked about like relics of an impending revolution.[95]

Britain's latest conflict with France was Copley's fourth major war; together these geopolitical conflicts would span more than half the painter's lifetime. The first of them—King George's War to British Americans, the War of Austrian Succession to their king—began when he was barely six years old, and may have claimed his father's life. The second one, the global war for empire between France and Britain, brought more opportunity than heartache to a then young painter, who rose to prominence catering to the vanities of military men. The third, the American War, was the cruel nursery of Copley's most sublime achievements. *Watson, Chatham*, and *Peirson*, tales of Britain's American War as it unfolded at the wings of the stage, all painted during the long twilight of that wrenching struggle, ranked among a great empire's greatest works of art, even if they did not pay the bills. Copley tried to wrest art from this latest war, too, turning out a handful of military portraits, some of them offshoots of the giant *Gibraltar*, others dating back to the heads he had hunted for *Chatham*.[96] But no *rage militaire* quickened English pulses in this latest French war, at least not yet. In 1795, the satirists were better positioned to make a living from the beginnings of a war nobody wanted.[97]

In the house on Hanover Square, a great deal had changed in a scant four years. Sukey's irascible father died in February, at the great age of eighty-four. Sukey told her nephew Samuel Cabot, who sent condolences from Boston, that she took comfort in picturing her father in heaven.[98] Clarke's good works continued on earth; shortly before his death, he changed his will to benefit the Copleys, forgiving his son-in-law's substantial debts. Such an "unequal Distribution of his Property" surprised

and even "mortified" Sukey's sisters and brothers-in-law. Some wondered whether the old man's "Mind had lost its Firmness." To the contrary, Clarke had remained fully in control of his faculties to the end, one of his grandchildren, based in London, reported. He had freely chosen to do "a great Deal for Mr. Copley's Family, which was expensive, & increasingly so . . . . Delicacy prevents me altho' an Executor from saying anything to Mr. Copley upon the affairs of the Estate," the young man wrote.[99]

Sukey, now fifty, and Copley, at fifty-eight, had reached what they considered the autumn of their days. Their parents were gone, their children grown. In her letter to Cabot, Sukey calls herself and her husband "us old Folks," while imagining that their friends and family across the Atlantic were still young, frozen in time—that her brother-in-law, for instance, "looks as he did twenty years ago," when she left him, amidst a world in flames.[100] The intervening two decades had been kind and cruel by dizzying turns. In the 1770s and the early 1780s, Copley profoundly enlarged his compass, bursting the frame of the "little way" he had once worked in Boston, as Reynolds had put it when he first saw *Boy with a Flying Squirrel*. But Copley's triumphs were succeeded by disappointments both intimate and public, of which *Gibraltar* was in every way the most spectacular: a costly, bloated wreck.

Copley's relations with his fellow academicians, already soured by the solo exhibitions that competed with their own, had curdled. Worse yet, he seems for the most part not to have recognized his increasing isolation. In the winter of 1792, mere days after the academy's founding president, Sir Joshua Reynolds, died of liver disease—the price of a clubbable life—Copley put himself forward as a contender for the academy's presidency, a bid the newspapers deemed absurd. "Mr. COPLEY has laid *siege* to the President's Chair of the Royal Academy," the *Argus of the Constitution* quipped. "Copley, it is said, entertains some hopes of success," the *Morning Herald* reported, "but it is thought without the smallest foundation." West received all but one of the thirty ballots cast. The outlier endorsed Richard Cosway. Copley received no votes at all, not even his own.[101]

Unbowed by the drubbing, if not entirely deaf to it, Copley continued to tilt angrily at one tiny windmill after another, sometimes with a handful of allies, more often on his own. In 1794, he went to war with the critic Robert Bromley, whose *History of the Fine Arts* praised West's *Death of Wolfe* above all modern history paintings. When Copley sought to banish the book from the Royal Academy's library, Bromley published a series of letters against the painter in the *Morning Herald*. He lampooned Copley's vainglory, pitting West's indomitable *Wolfe*—"the Wolf"—against the humble flying squirrel that a much younger Copley had long before "sent hither . . . as the harbinger of his fame." The whole of Copley's argument against him, Bromley proclaimed, originated by "the jerking of a *squirrel*." The sly barb made Copley suspect that West was behind Bromley's campaign against him, for only West could have relayed the fervency of Copley's hopes for the picture he sent from Boston to London in 1765.[102]

The figure of West—his mentor and his doppelgänger, his oh-so-much-better half in every way but the painting way—loomed increasingly large among Copley's multiplying phantoms. Their relationship had grown ever more tense since those halcyon days in Windsor. West, as per his wont, conducted even his rivalries smoothly, leaving no fingerprints. He promoted John Trumbull's rival version of *Gibraltar*, for example, rather than overtly damning Copley. Copley, every inch the poor student of manners whom George Carter had lampooned two decades before, could not manage to veil his combativeness. Henry Singleton captured the volatile connection between the two men in a painting of the academicians. West presides with the serene authority of a confident general, while Copley, placing himself, as always, at the forefront, assumes a duelist's stance, with his left index finger extended, as if to score a point.[103]

Beneath the hostilities simmered the lingering question of money, for which Copley struggled, more than ever, and for which struggle he continued to be lampooned. Bromley inveighed against Copley's commercial spirit, all puff and no substance. Copley so lauded his own epic paintings that to praise them further "would have been adding butter to bacon," he joked. The American was ravenous, insatiable, hawking his engrav-

*Cantelowe W. Bestland after Henry Singleton,*
ROYAL ACADEMICIANS, *1802 (1795), detail. West is seated
in hat, Copley front right, in dark suit.*

ings, flogging his shows, always hustling.[104] Bromley was neither the first
nor the last to allege that Copley was "immoderately fond of money."
The critic who called himself Anthony Pasquin explained that while the
"warm beams of genius" typically "thaw the icy altars of avarice," Cop-
ley's greed froze his talents. This, he implied, was a peculiarly American
failing. Years later, Pasquin imagined Copley and West singing together
to the tune of "Yankee Doodle":

> Let DAVID paint for hungry fame;
> And WILKIE subjects funny;
> Let TURNER sit and study storms,
> But we will paint for money![105]

Thank goodness for Sukey and the children, at once his burden, his muses, and his purpose. He had painted Betsy, Mary, and John again in 1793, using them as models for a scene from Spenser's *Faerie Queen* in which the Red Cross Knight, gentle and steadfast, encountered two comely virgins, "sober, chast, and wise," named Fidelia (Faith) and Speranza (Hope). John Jr. plays the knight in gleaming armor. Betsy poses in virginal white muslin and Mary in rich blue satin, their powdered hair flowing behind them. The picture's free, gestural style and its literary subject matter marked a departure for Copley, who hung it at the Royal Academy's exhibition that doleful spring.[106] Responses to the performance—his first at the academy in half a dozen years—were not kind. This "is by no means equal to what we have hitherto conceived Mr. Copley capable of," said the reviewer in the *London Packet*. Complained a writer in the Tory paper *True Briton*: "The figures are so very light and airy, that if the wind of Heaven were to visit them a little too roughly, it would blow them all away."[107]

The children had not scattered quite so easily as Copley's brushwork suggested. The young ladies remained at home, unmarried. This was hardly noteworthy for Mary, just coming on twenty. But the fate of Betsy, who had reached the age of twenty-five, must have been concerning. She had had at least one suitor, who carried her miniature portrait with him to India: an intimate gesture that smacks of a promise. He did not return for her. (Decades later, he will die there, in the heart of Britain's second empire, with her likeness among his effects, a faint label reading "Miss Copley" pasted to its back, on a slip of paper grown yellow with age.)[108] Her friends—some of them married and mothers already—peppered their letters with news of wedding parties. "I do not know what has got into people[,] they seem all wedding mad," Mary Copley will write several years hence, when she, too, teeters on the precipice of spinsterhood, which will indeed be her fate.[109]

The sisters were accomplished enough, and devoted to the family business. They were regulars, along with their mother, in their father's painting room, especially during the exhibition season, when they helped

*Copley,* THE RED CROSS KNIGHT, *1793*

with the frenzy of getting pictures ready for show. They plied their brushes "rebeautifying the prints," and they probably sometimes modeled. (The academy's female models did not like to work with Copley, who took twice as long and paid half as much as other painters.)[110] They made for good company. John Quincy Adams, the dashing young son of the American vice president, dined with the family in the fall of 1794 and pronounced Betsy "handsome, if not beautiful, and . . . very pleasing in her manners. There is something so fascinating in the women I meet with in this Country," he continued, "that it is well for me, I am obliged immediately to leave it."[111] It was high time, even past time, for Betsy to begin her own chapter of the family's marriage plot, that braided tale of love and money. But if she fascinated other eligible men, they did not apply to her father for her hand, perhaps because her portion was so meager.

Different pressures attended John Jr. at twenty-three. His grandfather's largesse had funded "a very liberal Education" for the boy, as one of the other grandchildren, elbowed out of Clarke's will, groused.[112] John Jr. made the most of his opportunity at Cambridge, the stutterer's son winning plaudits for oratory. He and his father seem to have lined up on opposite sides of the escalating national debate about revolution, radicalism, and reform. For nearly a decade, Copley had devoted some of his energies to a large painting centered on the struggle for power between Charles I and the House of Commons in January 1642, a pivot in the English Civil War, which reached its climax seven years later with the king's beheading. Copley envisioned the picture as a companion piece to *Chatham*, based on painstaking research. The relics Copley examined include "a piece of the sky blue ribbon which suspended the searge on the neck of the unfortunate Charles . . . on the Scaffold."[113]

The republicanism of the project was unmistakable. When it debuted in May 1795, alongside yet another showing of the still unsold *Chatham*, there must have been some whispering, in that season of king killing. In a satire published the following year, a mock-Copley proudly alters the design of Michaelangelo's *Last Judgment*. "I have placed WILL TELL and TOM PAINE by the Redeemer," he says, "and suspended MUN BURKE between Heaven and Hell."[114]

John Jr., the Red Cross Knight, was a cooler sort, preferring the purgatory of constitutional monarchy with Burke over fantasies of a republican heaven with Paine. He was also, even at such a young age, a consummate political actor, as polite as he was driven: a scholar and an English gentleman. His baccalaureate examinations took first place at Trinity, second university-wide, yielding a prize of £25. "Perhaps you'll be discontented that I am not first," he told the father whose ambition, frustrated and then projected, must often have seemed relentless. Trained in mathematics and moral philosophy like a latter-day Newton, young Copley fancied architecture but excelled at argument. Offered a berth at Lincoln's Inn, to pursue advanced study in law, he deferred the position to take up a postgraduate fellowship at Trinity College, with a stipend of £100 per

annum. His official title was Traveling Bachelor; he would serve as an ambassador for Cambridge, reporting on his journeys to faraway places, in Latin.[115] Copley had a plan for his son's travels: shortly after the riots that threatened the English king, he packed off John Jr. to the United States, an America that both was and was not the land of his birth, on a kind of reverse grand tour.

The trip had been some time in the making. Besieged in his profession, in a nation at war, Copley turned his gaze west. Several years before, he had written to his brother-in-law Henry Bromfield, enclosing prints of *Chatham* and bills of exchange. From the latter, he directed that £420 be paid against a debt he owed to William Phillips, and asked Bromfield to "let me know what remains due." Phillips held a lien against Copley's Beacon Hill property, a mortgage Copley had taken out when he sailed for Europe.[116] He needed cash still, and had begun to think about the vast property separated from him by decades, an ocean, and a new nation.

A year later, shortly after the French beheaded their king and the winds of war began to buffet London in earnest, Copley wrote to the Boston merchant Samuel Cabot, his nephew by marriage, enclosing a plan of the property, and asking that Cabot find some way to repair the fences destroyed during the late siege. The letter makes clear how vivid the house on the hill remained in Copley's mind's eye, even twenty years after he last walked the grounds. He described the stables perched "a small space back from the [property] line," maybe only "two feet"; he recalled the beach at the base of the meadow behind the house. He instructed that the fence along that strand—to be done in "some Cheep manner," in order to mark his "Legal possession"—allow for the "foot passengers" who often walked at the edge of the river toward West Boston.[117] He called for a proper survey of the property, and pondered what it "ought to sell for." He supposed that his part of town, a remote retreat when he left, was now ripe for development—for improvement, in the parlance of the day. About this Copley was prescient. Boston had begun to rebound from the depredations of the war. The inhabitants returned and multiplied. Mansion houses and banks sprang up like mushrooms.

The seat of state government was slated to move from the old brick Town House at the corner of King (now State) and Queen (now Court) Streets, up to Beacon Street, on the former pastures of John Hancock, abutting Copley. "If I had any prospect of returning to Boston, I would not part with a foot of that ground," he told Cabot.[118]

When Copley next wrote to Cabot, in March 1794, he reported that he had recently entertained "some applications for the purchase of the place"; Captain James Scott, who commanded one of Hancock's ships, offered him £2,500: far too little. It is unclear whether Copley knew that Scott was the agent of a syndicate of investors who were planning to build an entire new neighborhood. They would soon organize as a corporation called the Mount Vernon Proprietors, chartered for the express purpose of developing the site. One of them was Charles Bulfinch, the young architect already remaking the face of Boston in the new Federal style, soon to erect the golden-domed State House that would come to define Boston's profile, much as St. Paul's defined London's. Bulfinch and his confreres were new men for a new Boston. Many of their parents had sat to Copley, but they would pay for likenesses by Gilbert Stuart, who had found his way to New York, and was closing in on his ultimate quarry, George Washington.[119] Already Stuart was making a reputation as "certainly the best portrait painter who has ever been in America." The young nation had a short memory.[120]

Both Copley's title to the land and his standing in American law were cloudy. He worried about pending litigation involving his late father-in-law's estate, in which Clarke could be ruled "an Alien." Might the Copleys be similarly designated? He restated to Cabot what his mother had told the Massachusetts courts years before, while the last war raged: that he had "left The America in pursuit of improvement in my profession that was not attainable in America a year before the War commenced and was not influenced by political Opinions as I can abundantly prove."[121] The investors seeking to buy the land knew the shakiness of Copley's position. In June 1795, immediately after Cabot signed on as Copley's agent in the negotiations, they reached an agree-

ment to buy the painter's property for 3,000 guineas, or £3,150, a modest premium on the offer that Captain Scott had tendered the year before, which Copley had summarily rejected. Acting as Copley's attorney, Cabot inked the deal on 17 June.[122]

By August, Copley had learned of the sale, and balked; he refused the payment Captain Scott brought to complete the transaction. Turning away a sum so badly needed reveals some measure of Copley's pique. Scott was astonished. He warned that if Copley failed "to comply with the Agreement made by Mr. Cabot in your behalf," the investors must turn to the English courts to enforce the contract.[123] Copley wrote Cabot in a lather, instructing him "to make no communications what ever . . . to Scott his principals or any one else." He hoped the would-be investors will not be "so Mad as to commence a suit that will probably not have a termination in this generation." And if, against odds, they won their case in English courts, what then? "Do they think Americans would ever suffer a Court in England to decree away Estates in America?" Copley thundered. No, "they never will."[124]

Copley had identified another buyer, William Hull, a jurist and politician who had served in the Continental forces and then risen through the ranks of the military and government of Massachusetts. The two had discussed the property when Hull visited London. Copley asked his nephew to wait on Hull, who could explain "in what manner he is now connected with me." It will later be revealed that Hull advanced Copley £1,000, in down payment for a property that was no longer Copley's to convey.[125]

At the same time that he struggled to extract a price he considered fair, Copley had also begun to think of returning to the city of his birth. Some reports held that the lengthy postwar depression had ended, and this new America was doing very well indeed. John Trumbull had lately returned to London in an entirely new capacity, as a secretary to the American ambassador John Jay, on a mission to reduce the tensions between the United States and Britain that had escalated since the outbreak of the French War. Early in the conflict, Trumbull had wondered, "In such a state of things, what hope remained for the arts? None—my great enter-

prise was blighted." But by the summer of 1794, he had grown sanguine. "The Arts are likely to be well encouraged in America," Trumbull told Joseph Farington. "Stuart is now at New York and well employed. His prices are not so great as He had in England, but his expenses are proportionately more reasonable."[126]

Shortly after Copley put his son on the boat to Boston, Farington noted, "It is understood that Copley would go to America but . . . Mrs. Copley will not." Betsy's bosom friend Margaret Oliver wrote in a panic when she learned of John Jr.'s trip, afraid that it was "only preparatory to your all leaving England. . . . I hope however, that you are not going to settle at Kentucky, to build yourselves Log Houses and plant Trees for your great great Grand-Children to burn."[127]

John Jr. sailed from Ramsgate on the *Zephyr*, with a dog named Vixen in tow and an English translation of Comte de Volney's *The Ruins; or, A Survey of the Revolutions of Empires* tucked in his valise. "I am a great sailor already," he told his mother, the Kentish coast still in sight. He expected an easy crossing and felt confident that peace was at hand. He was nearly as wrong about the journey as about the French war. The *Zephyr* limped into Boston eight weeks later, in weather "so cold that you would expect your fingers to drop off," he reported. The dog was "half starved—half starved! three quarters, at least," by the time the pair reached the Long Wharf.[128]

Young Copley had scarce recovered his land legs before he began to explore the chances of invalidating the sale Cabot had agreed to. "If you can make yourself a subject of the United States you are clear," he told his father. "I am not yet sufficiently informed of what may be the result If you are decreed an Alien."[129] But within a few weeks, he determined that the sale must stand. "After much negociation and after various consultations," he endorsed Cabot's deal, with some small modifications. The deeds were drawn up and the property transferred, every inch of it. In April, the Mount Vernon Proprietors mapped out a grid of new streets

on Copley's land. By August, they were advertising house lots for sale, "which afford the best situations in town." The "thing is done," young Copley told his sisters. "My father, I fear, is disappointed. All I can say now is, that if it had been my own, my conduct would have been precisely the same."[130]

The land was gone, but the dream of America didn't die so easily. When he read the latest war news from London, John Jr. told his family, "I sincerely wish you were all safely landed in America." His business concluded, he meant to go on pilgrimage. "I have thought ever since I set foot in this country that it was possible you might think of returning hither," he told his father. That Copley would find his "profession more profitable than in England I have no doubt." Moreover, "the state of society and of government wd be more congenial to your inclinations and nothing but the difficulty of moving seems to stand in the opposite scale." (It was, of course, easier to slight the difficulty of moving at age twenty-four than at age fifty-eight.) John Jr. proposed that he hang on to some of the money that the Boston sale had netted, in case he should see another property he liked. "If I had a tract of good land perhaps five thousand acres which may be purchased for no very considerable sum," he said, "I wd in four or five years if it shd please God to bless me with health and strength not only render it a very valuable and productive estate but also a delightful retreat to you and my dear Mother whenever you shd choose to enjoy it."[131]

Young Copley traveled for a year, nearly twice as long as he had anticipated. From the outset, he said his mother and sisters would be "agreeably disappointed at a view of Boston," and his subsequent reports retain that tone of agreeable disappointment, vacillating between a bemused confidence in the superiority of London and wonder at the scope and strangeness of America. "Shall I whisper a word in your ear?" he asked Betsy and Mary. "The *better* people are all aristocrats. My father is too rank a Jacobin to live among them," he reported from Boston, where the Federalists—Anglophiles all—set the sumptuous tone of political culture. The strenuous republican style had fallen out of favor, much like Samuel Adams, who was "superannuated, unpopular, and fast decaying in every respect."[132]

But Philadelphia, the young nation's temporary capital, had a different flavor entirely: proudly plain and plebeian, in the style of the new Democratic-Republican opposition led by Virginia's Thomas Jefferson. After only four days there, John Jr. reported that the city's low manners had turned him into *"a fierce Aristocrat! This is the country to cure your Jacobins,"* he said. "Send them over and they will return quite converted." (In later years, he often proclaimed that his time in America had left him "effectually cured of Democratick principles.") He worried that the Democratic-Republicans would derail the American Congress's pending trade treaty with Britain. "A war with England," and a "great schism" within the barely United States—a second "civil war," he called it—was sure to occur if the opposition carried the day.[133] All along the seaboard, people seemed to talk of nothing but elections and commerce. "It is seldom that literature or philosophical enquiries are made subjects of discussion, and it would be difficult to find here a literary person, such as would be so considered in Europe," he told his supervisor back in Cambridge. *"Those who apply themselves to mercantile pursuit are generally the richest and most esteemed throughout the whole of America.* The luxury of these persons however, and their houses and domestic conveniences—in short (if you except slavery) whatever is adapted to make life enjoyable, approaches very nearly the English mode of life."[134]

As John Jr. journeyed south, the traveling aristocrat never mentioned slavery again. He gained an audience with George Washington, whom he found *"courteous, hospitable, and facetious."* Mount Vernon, he said, possessed a kind of republican simplicity, with "no appearance of luxury—*the simple, honest character of Washington is alone conspicuous."* He described in minute ethnographic detail a delegation of Catawba diplomats who shared his audience with the American president, but Washington's myriad bondspeople attracted no more notice than the hundreds more whom he saw building the new federal city. *"Labor omnia vincit,"* young Copley wrote. In his accounts of the national capital rising from the mud, the all-conquering, backbreaking work seems to do itself. The river is "ren-

dered navigable," the capitol building's "foundations . . . laid," the stone for the president's house "dug out of the quarries": all by so many invisible black hands.[135]

Not until four months later did John Jr.'s anxious mother learn that after leaving the south, her prodigal son had ventured west, crossing Virginia and "the whole of Kentuckey" before heading north to Detroit, and on across Lake Erie to Niagara Falls. When at last he reached Albany, he explained that he had trekked "thro a wilderness," living "partly among Indians partly among whites." The reason for the excursion, he said, was to decide conclusively "the expediency of returning to America." The "principal Cities" had failed to offer "sufficient inducements to persuade me . . . to a change of situation." And so into the heart of the continent, to see what might await "a young man of prudence and of education" in the way of "wealth and honour," in "a country which is at present so much a subject of conversation, and which is extolled as the garden of the world."[136]

After all the months and miles, he voted with his feet, sailing from New York in such haste that he ignored an American cousin's entreaties to stop in Boston, to see to some final details concerning the deed to his father's property, and to collect Vixen, his "very favorite Dog," whom he had parked there during his travels. He told his kinsman that lingering in America was a "waste of time" he could ill afford. "Before I left the university I was elected as fellow of Trin: Coll:" he explained. "The emoluments attending this situation amount to a small independence."[137] In the end, he preferred that "small independence" to the lofty pronouncements on the subject offered by the United States.

John Jr. sympathized with the Americans, truly, he did. The "haughty inhabitants of Europe" regarded them "with too supercilious an eye," he told his New York aunt, Sarah Startin, after he had regained London. But the "situation of Europe" seemed to be resolving, and he no longer imagined tearing his family away from the fireside on George Street, where they were once again cozy in "our domestic circle."[138]

Mrs. Startin did not give up so easily. "How happy should I be my

dear Neace could I say to you, and your beloved Parants, return to your Native Country," which offered "all the means of Happiness your reasonable minds can desire," she told Betsy. She hoped "some American Gentleman" would approach her, and "try his persuasive powers on this head." Maybe the aging Miss Copley would find herself an American husband, or, rather, one would find her. Novels, which were, after all, a form of history, abounded with such tales, some of which ended very well indeed.[139]

# BETSY COPLEY'S SMILE

RARE IS THE PERSON who grows easy and generous with passing decades, rarer still the artist whose last works transcend biography. The mythos of late style was just emerging at the end of Copley's life, which means he may have felt some compunction to measure himself against it, thus finding a fresh avenue for disappointment.[1] Copley's old age was marked by prolonged personal agony, and his late work evinces nothing so much as exhaustion. A faded star in an aging empire, he lived out his final decades still fighting the war he had tried to escape when he left British America in 1774, all the while watching the new United States, with its fetish for youthful innovation and its unshakable faith in its own rising glory, shimmer at the edge of his vision. His fetters multiplied and tightened. His pictures stayed big, while his insight diminished. Writing in 1796, the year of John Jr.'s American tour, the satirist who published as Anthony Pasquin called Copley "an observing inveterate drudge, who is true to trifles, from a conviction that he can never be great."[2] For all Copley's professed confidence in his own greatness, it may well be that Pasquin understood the painter's innermost dread.

Certainly a deep, abiding sense of defeat had descended on Copley by the late 1790s. Quick to anger and slow to forgive, he never got over the sale of his Boston property. He made a good deal of money from the deal he was stuck with, receiving about five times what he had paid for the land, though considerably less than he might have if his title and

his national allegiance had been clearer. The Mount Vernon Proprietors knew just how much they stood to profit from those acres, and just how difficult it was for Copley to negotiate from miles and months away, without key documents at his disposal. But if they forced a tough bargain upon their mark, they did not cozen him, as Copley began to allege to anyone who would listen in the spring of 1796, when he learned from his son that the deed, quite literally, was done.[3]

Even then, Copley refused to concede the fight. That summer, when Samuel Cabot came to London to settle the claims of American merchants whose ships had been seized by the British in the late "quasi war," the battle of Beacon Hill grew heated. Copley confronted Cabot in the London Coffee House, where he read aloud a letter from Boston: hard evidence, he said, that the property had sold below market value, chicanery in which his agent had colluded. Cabot was aghast. Having "passed a life of 26 years as a Merchant . . . of unsullied integrity & honor, to be charged with the perpetration of a crime of the basest kind I confess fills me with emotions I am totally unable to express," he wrote his uncle Copley after a sleepless night fretting over his wounded honor. Cabot demanded to see the offending letter and to learn the name of its author; he intimated that Copley might have written it himself. He warned that he would pursue the matter until he recovered his reputation—"my principal property," he called it.[4] And so he did, spreading news of the "foul aspersions" Copley had heaped upon him on both sides of the Atlantic. By year-end, more than a score of outraged Bostonians had signed a letter accusing Copley of wielding "the *tongue* of *slander* and the *assassin's poignard*" against the upright Cabot. The signatories included politicians, bank directors, preachers, and leading merchants, among them men who had sat to Copley in Boston before the war, or in London since.[5]

To battle Cabot was to burn bridges, then, both abroad in the United States, and much nearer to home in London. Cabot's correspondents said that Copley should be treated "with very little respect"; "silent contempt" might suffice unless the allegations became more public, in which case

legal action would be justified. Both Copley and Cabot felt themselves wronged. Neither would apologize.[6]

The most painful and telling response to the whole sorry ordeal came from Sukey's sister Sarah Startin, who professed herself "both astonished & shagrin'd" by her brother-in-law's conduct. But she did not seem to have been entirely surprised. If "Sister C is deceived in the business it would not be in my Power to Convince her of the truth," she told her nephew Cabot. Sukey would take her husband's side; indeed, her sister implied, she had ignored reason before where Copley was concerned. Perhaps the family had talked about her blindness to his faults for years.[7]

When John Jr. got back to London and confronted his father with the hard facts of the case, Copley and Sukey formally relinquished any further claim to the land.[8] "I have been deeply Injured, and that Injury is irreparable," he told Cabot.[9] The sale of the farm he had once christened Mount Pleasant altered the core of Copley's narrative, transforming his pilgrimage into exile.

~⌣

In July 1798—Thermidor of the Year VI—crowds thronged the streets of Paris to watch Napoleon's greatest trophies, including the Belvedere Apollo, the Laocoön, Correggio's *Saint Jerome*, and the greatest of all prizes, Raphael's *Transfiguration*—paraded in chariots to the Louvre, former palace of vanquished kings. It was as if Copley's grand tour had been packed up and relocated wholesale, for the glory of the French people.[10]

As old heads of state rolled and new ones rose, portraitists and sculptors, no less than soldiers and politicians, did the work of forging new nations. And new nations questing for glory made artists' reputations in return. Much as George Washington transformed the careers of Charles Willson Peale, John Trumbull, and now Gilbert Stuart in the newly United States, Napoleon boosted the fortunes of Jean-Louis David, who cannily shifted his allegiance from the fallen Robespierre to the rising emperor. Britain, too, wanted heroes from this new war. But while Copley had managed to wring both art and honor from the Seven Years'

War and, in his sidelong way, from America's Revolution, this greatest of imperial conflicts eluded his brush.

It was not for lack of trying. Before the end of 1798, Copley embarked upon two large-scale history paintings depicting recent British naval victories over the French and their allies: the Battle of Camperdown, off the coast of Holland, in October 1797; and Admiral Horatio Nelson's triumph in the Battle of the Nile in August 1798. Copley set to the research with his customary assiduousness. He was painting, as was so often the case with histories, on spec; he offered both works to Alderman John Boydell, who he hoped might purchase them for the City of London. But the struggle over *Gibraltar* had sufficiently soured the corporation that it turned down the chance to work with Copley again.[11] Patronless, he persevered.

For a variety of reasons, Copley advanced farther, faster on the picture of the Dutch engagement. The battle in the North Sea took place earlier, some ten months before the victory near the mouth of the Nile. And Copley had already completed a vigorous full-dress portrait of Admiral Duncan, which he had exhibited at the academy's annual rite of spring in 1798. A "bold, strong, faithful likeness," one reviewer had called it: the kindest verdict on any of the four pictures Copley submitted that year.[12] A full-length of Viscount Sidmouth, the speaker of the House of Commons, was savaged by the critic for the *Whitehall Evening Post*, who mused, "How the left hand is employed we cannot possibl[y] conjecture, unless in holding up the breeches." The same writer deemed Copley's *Saul Reproved by Samuel* a "story so badly told, that Saul has the appearance of being intoxicated."[13] The appraisals were harsh but not wrong; Copley's mastery of narrative and even anatomy had indeed begun to falter, though not so quickly as his claim upon public attention.

Copley unveiled the 10' × 12' *Admiral Duncan* in May 1799, barely eighteen months after the battle. He had planned to show it in Green Park, but once again met with opposition and was forced to move it several blocks east. "Copley, disappointed in his hopes . . . ," began an item

in which the *Morning Chronicle* reported where the painter had "this year pitched his tent." "Disappointed" had become something of a familiar descriptor for him.[14] The exhibition of *Duncan* did little to reignite the long-ago vogue in Copley. The king and queen viewed the painting, and the few reviews were polite, but the crowds did not flock to Albermarle Street. After two weeks, the painter revised his advertisements, noting that *Chatham* and *Charles I* could also be seen alongside his newest masterwork. This may have only served to remind viewers that those epic canvases, the first of which had caused a sensation some two decades earlier, remained unsold.[15]

In rushing to complete *Admiral Duncan* and setting Nelson to the side, Copley had bet on the wrong horse. Duncan was a victor of impeccable naval credentials. In his brochure for the exhibition, Copley said that "so glorious and splendid event" as Duncan's great victory "can never be neglected or forgotten." But in fact, the man and his moment had already vanished by the time Copley's painting faced "the ordeal of public exhibition," as the *British Magazine* called it. "Popular and national as the subject of this picture was, its spirit had evaporated and sunk into torpid neglect before the exhibition . . . was opened to the town."[16] When Copley exhibited *Duncan*, Horatio Nelson's name was the one on everyone's lips, the stuff of ballads. Nelson was a new style of hero for a new century: gallant, dashing, and publicity mad. It was Nelson whose exploits animated three-dimensional spectacles ranging from the sensationally popular panorama near Copley's old home in Leicester Square to the mimic battles staged with twee model ships in flooded amphitheaters.[17]

And the vogue was only beginning. The admiral's greatest gift to the nation, and to British art, came six years later, in October 1805, with his death at the Battle of Trafalgar, off the southern coast of Spain. For months, the newspapers followed the slow progress of the admiral's remains toward their final resting place in London's great cathedral. Mary Copley and her brother counted themselves "fortunate . . . to have tickets for the interior of St. Paul's," where they waited twelve hours for

a glimpse of Nelson's flag-draped coffin. Copley and Sukey watched the procession from Somerset House.[18]

The scene of Nelson's death was the image of the moment, if not the century, and Copley was fated to miss the admiral a second time.[19] Even before the funeral, Benjamin West announced in the *Morning Post* that he and the engraver James Heath were rushing to make the terrible, glorious tableau of the admiral's martyrdom the subject of a painting and allied print, in every way a fitting companion to *The Death of General Wolfe*.[20] Two months later, a Soho printseller called on Copley to commission a painting of the death of Nelson upon which he might base a print, offering a desperately needed £1,200 for the image.[21] That summer, as West unveiled his *Nelson*, Copley took a fall and sprained his arm. The injury took longer than expected to heal, and kept him from "getting on with the picture of Ld Nelson," Sukey said.[22] Unable to counterfeit a new hero, Copley raffled off an old one, selling *Chatham* by lottery. Twenty ticket buyers invested 100 guineas per chance: a steal for the man who "drew the fortunate Lot," and said he would not part with the picture for less than £5,000, though an impolite ending for the painting that had catalyzed Copley's celebrity, and embodied his American War.[23]

Politeness was the last thing anybody expected from the aging painter. That same June, Joseph Farington noted in his diary, Copley "endeavoured to prevail upon the King to sit to Him for a Portrait." After "having tried many ways to obtain it," Copley stationed himself in a room in St. James Palace, where George III was expected soon to appear. When the king swept in with his entourage, Copley quickly asked "to speak to His Majesty in private."

"Whatever you have to say you may speak here," the king replied.

Copley then asked—"humbly requested," as Farington described the interview—that the king sit for a portrait.

"*Sit to you for a Portrait, What do you want to make a Show of me*"? the aging monarch barked, and huffed off "indignantly."

He would not be made the subject of one of Copley's tented specta-

cles. Indeed, George III resolved, "He never wd. sit again, & if any person shd. ask him twice He would turn Him out of the House."[24]

Copley did not ask again.

⟶

On 3 July 1800—her father's sixty-second birthday—at the height of summer in the first year of the new century, in St. George's Church, just down the street from the elegant London town house in which she had spent most of her life, Elizabeth Clarke Copley became the third Mrs. Gardiner Greene. The bride was just shy of thirty. Her groom was a forty-seven-year-old two-time widower.[25]

The Boston-born Greene had left Massachusetts in 1774, when Copley sailed for Italy, and for some of the same reasons; his people, too, signed the address praising Thomas Hutchinson. Like Betsy's father, Greene had committed himself early to "the grand secret of success, the habit of application." Whereas Copley had looked east, Greene trained his ambitions southward, upon the Dutch trading entrepôt of Demerara, huddled at the edge of what people called the wild coast of South America: one of the most profitable and least stable parts of the Atlantic trading basin.[26] Demerara had since become a British colony, and Gardiner Greene had grown to be a very wealthy man. The slave labor camps he called Evergreen and Greenfield spanned hundreds of acres. Nearby plantations had names like Tranquility Hall, or Free and Easy—names that, like Greenfield, disguised the essential nature of their enterprise.[27]

Greene's was a volatile, violent world. It was well known throughout the English-speaking world that the slavery in the Caribbean was hell on earth. Places like Demerara—frontiers without towns and nearly without laws—were the deepest pits of that hell, where planters acted with wanton impunity, where slaves were racked and burned and gibbeted and beheaded with a casualness that was shocking even to the sensibilities of a nation that had long mounted the heads of traitors on London Bridge.[28] "I think you ought to cho[o]se some pleasant place to the southward in America for your durable residence," Greene's kinsman and business

partner, William Parkinson, advised him in the summer of 1795, as an uprising of the enslaved on the nearby island of Grenada descended into all-out war. Parkinson doubted that Demerara would ever "become an Eligible situation for Ladies."[29] Greene, then in Boston, ignored his partner's counsel. He and his second wife returned to Demerara, that nursery of gold and pain, shortly thereafter. There she perished, leaving behind three children, the youngest of them barely two years old.

"It is a truth universally acknowledged, that a single man in possession of a good fortune must be in want of a wife," runs the famous first line of *Pride and Prejudice*, of which Jane Austen had lately completed a draft. How much more did that universal truth apply when the suddenly single man found himself with three little ones to care for! And so, in the spring of 1799, Greene sailed to London in search of a replacement bride.[30] Mary Copley supposed that it was no "great compliment" to the "American belles" that gentlemen "come to England for wives."[31]

The Copleys and the Greenes had known each other for decades by the time the Demerara scion arrived at George Street. Copley had painted Greene as a boy, standing beside one of his aunts. He had taken likenesses of Greene's father, his sister, his aunts and uncles and cousins, a group of commissions that began before Gardiner put on breeches and continued until both families left Boston.[32] Gardiner's brother David, his aunt Mary, her husband, Joseph, his cousin Katherine, and her husband, John Amory, had all sailed to London on the *Minerva*, the same small ship that carried Sukey Copley and her children and servants. They remained in other's worlds, especially during their early years in that forbidding metropolis that British Americans had long and over-optimistically called Home.[33]

The newly eligible Gardiner Greene turned up at a moment when Copley badly needed money and his daughters almost as badly needed husbands. The visitor quickly became a familiar presence, and a voluble one; Sukey later recalled his "maxim . . . that it is better to talk among *friends*, even nonsense, than to be silent." He must have passed many an evening among the family circle "assembled at the fire in the Red Room,"

debating politics with young John, and alternately flattering and instructing the ladies. Mary found him to be "much of a critic," in all the best ways, and took to heart "his prudent admonition, 'never procrastinate.'"[34] He hosted a splendid dance, "the pleasantest I ever was at," Mary said.[35] With each minuet and bon mot, he cataloged the Copley sisters' virtues and weighed their faults. At some point, he inquired of their father. The two men signed a contract in which Greene settled $3,000 per year upon his prospective bride: a queen's ransom.[36]

Even still, Betsy's cannot have been an easy choice. A new woman for a new age, she appears to have taken to heart the message of Mary Wollstonecraft in the scandalous and sensational *Vindication of the Rights of Woman*. She had always professed herself "fond . . . of freedom," her brother said; she would not "submit without a struggle to the slavish and galling yoke of Matrimony."[37] And in some ways, Greene's yoke weighed especially heavy. The family later marveled at the "courage" of the young woman who would soon become the third wife of Copley's patron Sir Edwin Knatchbull: the bride in her early twenties, the groom "about five and forty," with ten children spanning the gamut from toddlerhood to nearly her own age. Greene was a mite older than Sir Edwin. And though he had, thank goodness, many fewer offspring underfoot, he could hardly promise a country house in Kent. But a bride on the verge of her fourth decade could not be too finicky. Greene was, at the very least, a man of parts—a "gentleman of leisure," as Mary Copley said.[38]

There is no evidence that Betsy followed Wollstonecraft to the edges of her argument, which linked the "slavery of marriage" to the "hellish yoke of slavery," under which "black heroes" labored from birth to death.[39] Greene's leisure was visible, his business out of sight. The third Mrs. Greene would never set foot in Demerara. Still, Greene kept at it, reaping the profits of Evergreen and Greenfield, and sometimes investing in new plantations, as his kinsman John Hubbard would invite him to do in 1804: "wont you join me in the Mainstay & Reliance, & put in your Negroes from the Evergreen & sell those Lands for what they will fetch"? Hubbard asked, promising that "with such an addition of

Negroes I could produce a Revenue of £20,000 sterling per annum," a fortune to divide between them. He sent along a careful inventory of the 126 enslaved hands who would earn them such handsome profits. They ranged in age and price, from a little girl called Sarah, valued at £50, to men worth at over £1,000 each. Two of those whose strength and skill placed them among the plantation's most valuable assets were named Hope and Choice.[40]

In the decades since the Copleys left Massachusetts, the former colony had become a fierce guardian of its reputation as the cradle of American liberty, and a professed enemy to chattel slavery as well as to monarchy. By the time of Betsy's marriage, it was commonly held that Massachusetts had abolished slavery "by publick opinion." But despite several highly visible and successful freedom suits in state courts after the American War, Massachusetts had not ended slavery by statute.[41] And Greene's slaving took place offshore, his gold washed clean by the time it got to Boston, where he was known as a man of "public services" and "private virtues": a "finished Christian gentleman," with manners "of the old school." Recognized for his piety and his charity in equal measures, Greene was said to possess the "Demerara character of an honest man."[42]

The underlayers of Greene's "Demerara character" would not have been invisible to the Copleys. It is almost certain that two slaves accompanied him to London. Sheba, whose name, frequent among Caribbean bondswomen, derived from the Akan word *Quasheba*, meaning Friday, appears to have served as the nursemaid to his two older children on the journey.[43] Still closer to Greene was Harry, "his man" since 1784, before he first married. Called a "mulatto" in the records, Harry was likely Greene's son biologically as well as metaphorically, as Greene's later generosity to him would suggest.[44]

The marriage was a mixed bargain, then. But it was the one Betsy was offered, and to all outward appearances, it turned out well. "I am Blest in her, and in her union with you," Sukey told her son-in-law.[45] Mary was glad her sister had caught "a good American husband," and doubted that

she herself would "be so successful" in the marriage market, even if she ventured to the United States to fetch a groom.[46]

A month after Betsy and Greene exchanged their vows, they sailed for the town where she had known both wealth and war in her first years of life. Her mother called it "our Native shore."[47] But the Copleys would scarcely have recognized Betsy's Boston, much less the contours of her America, whose shirt-sleeved multitudes made Thomas Jefferson their president shortly after her arrival. The opposition party that had so appalled John Jr. on his progress through the United States triumphed in Jefferson's election. The new president deemed it a second American Revolution. Betsy's United States would be an "empire for liberty," as Jefferson called the westward-facing nation.[48] Thanks to his deal with Napoleon, the boundaries of Betsy Copley's once and future country would soon reach the Mississippi River. How tiny England was by comparison!

Betsy's long absence from London, which lasted decades, until her father and her mother and her husband all had died, rent the family heart. "Mr. Greene . . . can have no idea of the number of enemies he has made himself by carrying you to America," Mary told her sister, joking that "if he should return here by himself I do not know what would be the consequence."[49] But the rupture of the Copleys' "little circle" also dredged a deep channel of correspondence. Brother and sister and mother sent letters by every traveling friend. It became something of a family joke that Copley himself never picked up a pen. "I don't know when you will see a letter in his hand writing," Sukey admitted two years after Betsy left. He "is all ways so engaged," she said, "and in the Evenings you know that it hurts his eyes to write." His penetrating vision was failing. Still, Mary told her sister, the old man had "grown at least ten years younger" since Betsy left, becoming "such a beau that he quite outdoes John," who was known for his vanity, much as Copley had been in his youth.[50]

The enormous portrait of Sir Edwin Knatchbull's family dragged on, months turning to years, with numerous casting changes, including the

addition of the new young wife. There were battles with engravers, whose work continued faulty and slow. There were also scattered commissions, "remarkably" good health, and, late in 1801, the stunning news that France and England had agreed to peace terms.[51] The Copleys celebrated by lighting a season's worth of candles—some forty-five lights in the drawing room alone.[52] The mood on George Street grew still brighter in the summer of 1802, when news arrived that Betsy had been safe delivered of a son. "I have been told from *undoubted authority* that my little nephew is the greatest *beauty* that ever was seen," Mary wrote. "It will be such a pity not to have it preserved on canvas that it is worth while for you and Mr. Greene to bring it over for my father to paint."[53]

But England and France soon resumed their perpetual war. "The change of scene is at present dark upon us," Sukey told her daughter the following spring. Rumors abounded that the detested Bonaparte—"disturber of the repose of the World"—would invade England. The Copleys worried that young John, now rising steadily in his chosen profession of law, would be called to soldier. Sukey wondered whether it might "be best for us to go and see how our Dear Friends are in America." There were "very strong allurements" to such a journey, as well as "many difficulties at our time of life." Still, faced with "the prospect of another long and distressing war; perhaps your father may think it the best measure, as those who are in the Arts first feel the distresses that war occations." She passed along Copley's request that his son-in-law discover the value of his one remaining "Peace of Ground" in Boston: the unimproved lots to the west of the town that Peter Chardon had tossed into the bargain they struck back in 1769.[54]

"Peace of Ground" was a wonderful slip. The Copleys began that fall to speak of America as a place that might offer them "asylum" from their land of exodus turned exile. The talk around the Royal Academy held that Copley "was so little attached to anything in this Country that He would have quitted it had not his wife opposed it." She dreaded the crossing and the bone-chilling New England winters.[55] Copley had cast the family's eastward migration as Sukey's decision back in the 1770s, and it remained, a lifetime later, her decision still. Meanwhile, he buried him-

self "in his quiet retreat painting as usual, and wishing not to be disturbed by the din of war."[56]

Napoleon's march was not the only clamor invading the sanctuary of Copley's painting room. Long-simmering factionalism in the Royal Academy burst into flames that spring. The "terrible bustle," as Mary Copley termed it, centered on the respective powers of the academy's eight-member council and its general assembly.[57] Copley, who had finally earned a seat on the council in 1802, drafted resolutions asserting the smaller body's supremacy. The assembly then used its majority to suspend the rump group who signed Copley's manifesto. Word of their censure spread; a pamphlet defending the suspended members—a practiced lawyer's brief anonymously authored by John Jr.—said the "humiliating sentence" had traveled from the London papers to "all the foreign journals" from Paris to Petersburg. News of the vote had even "crossed the Atlantic—to America, the 'terra altrix' of the President" (and of Copley as well).[58]

The manifest content of the dispute was procedural, but its deeper substrate was personal indeed. Copley had asked for an extension of the deadline for submissions to the spring exhibition, hoping to persuade Sir Edwin Knatchbull to allow the family picture that had consumed the painter's last three years to be shown. West, as president, opposed the extension. Copley then turned against West's contribution, pointing out that it had been exhibited in 1776; a second showing would violate academy rules. Copley received the extension he sought, and West's submission was denied. The aging and ailing George III reinstated the suspended members, and largely upheld Copley's understanding of the academy charter, which was, after all, an assertion of monarchical privilege in the face of a base majoritarian impulse. Even so, the king said, "the Academy was filled with *Anarchists*." He declared himself exhausted by the lot of them.[59]

These Pyrrhic victories cost Copley dearly. The floor fights among the academicians dredged up longstanding grievances. Joseph Farington, a close enough friend to have dined many times at Copley's table,

denounced him at length, mocking his "zealous labours," his "jealous tenacity of the power vested in him as a member of the Council," and the cramped scholasticism Copley substituted for honest reasoning. "When hard pressed upon questions of consistency and sometimes of integrity," Farington said, "John is one who can make His way through a very narrow passage. Darkness is to him visible. If his pursuer sees only by the light of reason and justice He is sure to be left behind." The man whom Farington lampooned as "honest John" was a changeling who "varies his shape to suit the necessity of the moment." This, he said, was "the correct, tenacious, law-supporting, privilege-maintaining John Singleton Copley." Farington's measure of the man, scrawled in a tiny handmade booklet held together by steel pins, appears to have been delivered in open assembly at the academy. In his private diary, Farington was harsher still: Copley, he said, "had done more injury to the Arts, & to the Character of Artists, than any man of his time." It is an angry epitaph, yet it chimes, to a considerable degree, with the image of Copley that George Carter had sketched three decades earlier.[60]

The most painful cut of all must have been the final fraying of Copley's tattered relationship with Benjamin West, who had done everything to bring him from Boston to London, and much to smooth his way in the capital since. West's famous politeness stretched thin and tore, worn bare by Copley's rough edges. Elizabeth West, who had hosted the Copleys on Newman Street and at Windsor, and had consoled with them over the loss of their babes in 1785, greeted the new year of 1804 by writing a verse imagining the death and resurrection of her husband's erstwhile friend. She gave the poem to Joseph Farington, who pasted it into his diary:

> The Clock Struck Twelve!—the hour is past,
> And Copley now, has breathed his last,
> Thou Genius, who presides o'er Art,
> Create anew, his envious heart.
> Drive Hatred, Malice from within,
> Blot from his Face, that ghastly grin."[61]

A rictus, filled with anger and envy. The thinnest of skins, grown papery with age: this was Copley's late style.

~~~~~~)

In 1811, as a fresh war between Britain and its former colonies loomed, a young American painter named Samuel F. B. Morse—Finley, to his friends—abandoned his job as a bookstore clerk and sailed for England, where he meant to improve in his chosen field of art. Among his first stops was the studio of Benjamin West. West proved generous to a fault, as he always had been with young American acolytes, a whole new crop of whom had lately flocked to Newman Street. "Mr. West is in his seventy-sixth year (I think)," Morse told his parents, "but, to see him, you would suppose him only about five-and-forty. He is very active; a flight of steps at the British Gallery he ran up as nimbly as I could." The praise lavished on some of West's recent paintings had "given him new life," Morse reported.[62]

How different the scene Morse found on George Street. "I visited Mr. Copley a few days since," he wrote. "He is very old and infirm. I think his age is upward of seventy, nearly the age of Mr. West." Copley was, in fact, three months West's senior, but the years had treated him differently: "His powers of mind have almost entirely left him," Morse said. His "late paintings are miserable; it is really a lamentable thing that a man should outlive his faculties." Where West became the emblem of death-defying fecundity, Copley was cast as the ghost of glories past. "I saw in his room some exquisite pieces which he painted twenty or thirty years ago," Morse wrote, "but his paintings of the last four or five years are very bad. He was very pleasant, however, and agreeable in his manners."[63]

Except for the unaccustomed compliment on Copley's manners, Morse's assessment jibed with the consensus on the aged American masters. West was ascendant and expansive; Copley was fading, half a shade already. Several years before, he had suffered "an ill turn," Sukey said, describing what sounds like a small stroke: "Numbness in his Hand and which likewise affected his Leg, and Foot." The affliction proved tran-

sient; after taking "the Bark"—probably quinine—he "very near recover'd his usual tone of health."[64]

But festering grievances compounded the daily multiplying indignities of age. Copley's inquiry into the unsold portions of his Boston lands renewed rather than eased the family's sense of constraint. Mary noted that "every person who comes from Boston tells him of the immense value of the Estate." Each time a ship landed, visitors' sympathies reopened the wound.[65] Carefully cataloging each new loss, chastened and furious by turns, Copley dwelt ever more in the backward glance, a disease that infected many of the losers in the revolutionary upheavals. His daughter sent him turkey and salt fish and cranberries: the foods of American reverie. Sukey continued to dread that they would be forced to retrace their Atlantic crossing. "Your dear father often regrets that he did not take that step many years past," she confessed in 1807, "but these retrospects are vain."[66]

Copley's vain retrospects wore deep ruts in his conversations with those who would listen. In 1810, the "Business from which he has suffer'd so greate a loss and mortification" again resurfaced: the heirs of the long-ago owners who had disputed Copley's title in the 1770s now challenged the Mount Vernon Proprietors' claim. Copley was asked for an affidavit, adding insult to the injury still so keenly felt. Sukey felt "certain that these gentlemen have no right to come to him for any thing in that Business." But the dispute continued to metastasize. She described its "revival" that year, and a "recurrence" the next: a cancer blighting their old age.[67] In the fall of 1811, Copley called on Benjamin West "several times," rehearsing the fate of "His American estate at Boston": what he had paid, what he had gotten, what he thought he had lost. "Copley repines," West said. He "ruminates." Beset with "reflections founded upon disappointment," he "passes these His latter days unhappily." Farington noticed "a great alteration in Copley's personal appearance." The onetime dandy now had a "dejected" air, even "a look of imbecility, and a sort of absent, bewildered manner": the shuffling, grumbling way of a man who abided in the past.[68]

Sukey told Betsy that Copley was "still able to pursue his Art but says sometimes that he is too Old to paint."[69] He completed little and showed

less. But in the annual exhibition of 1810, he displayed an outsized portrait of the Prince of Wales on horseback, at which he had labored, on and off, over six years, bidding for rather than responding to the future king's patronage. The prince had appeared "much interested in the picture," about which he had said many "handsom things," Sukey wrote. She thought it "a very just and fine likeness," though she knew that the Copleys were "partial ones," their judgment clouded by pride. She applauded her husband's endurance above all. It is "impossible . . . to convey to you in words the perseverance of your Father at his time of Life," she told Betsy. "I think it wonderful and amidst all the vexations he has had to contend with."[70]

Beyond the family circle, there were no prizes for perseverance. The reviews of *H.R.H. the Prince of Wales at a Review* were scant and stinging. Copley had made "the Prince look like a Bobdignag general at a

Copley, H.R.H. THE PRINCE OF WALES AT A REVIEW, *1809*

Lilliputian review," one critic quipped. The soldiers seemed to be "cut out of pasteboard or tin," while the prince himself was "an apparition of the old exploded taste of Hyacinth Rigaud," the court painter to Louis XIV, whose stiff, gilded aesthetic had long since fallen out of fashion, the detritus of an ancien régime in portraiture as much as in politics.[71] A wooden man on a cardboard horse, Copley's prince possesses neither the antique stateliness of canvases depicting his equestrian great-grand-father George II, nor the romantic windswept grandeur of Jean-Louis David's *Napoleon Crossing the Alps*. The future king appears fey and untrustworthy—much as he was in life but not, surely, as he wanted to be represented, especially not on the eve of the regency that would sub-stitute his judgment for that of his fast-fading father, George III, who was almost exactly Copley's age.

Copley's *Portrait of H.R.H. the Prince of Wales at a Review* is as awk-ward as anything he had painted since he burst on the scene in Boston in the 1750s, offering cheap likenesses of rising redcoats during the Seven Years' War. Among the last of his military pictures, *Prince of Wales* does not transcend but rather recurs: late style as second childhood.

~

H.R.H. the Prince of Wales at a Review was Copley's last big gamble, and it went the way of too many others. The prince did not want the picture, nor was a print after a canvas so coolly received likely to sell. Copley had "not yet been able to get it through at which we have been much disap-pointed," Sukey reported in September 1811. The mezzotint of *Gibraltar* finally materialized; the family thought the perfidious engraver William Sharp had at last done good work. But its sale, too, fell "so short of what has been expected." After twenty years, the long list of subscribers was nearly useless, the would-be buyers "so dispersed," Sukey said, that it was impossible to track them down. Many had died; others had forgotten the grand tented exhibition of 1791; still others could scarce remember the battle, or even the (last) American War, obsessed as they were now with Trafalgar and the machinations of Napoleon. Copley was "still paint-

ing," Sukey told Betsy. But even she, the tireless booster, sensed the futility of the enterprise: "these works . . . ought to procure him more ease," she said, but "there are no money[s] for [their] purchase." It made her "melancholy" to "see his rooms so full of pictures that are so highly spoken of." Diminished in every way but the size of his canvases, Copley pondered quitting the house on George Street for something cheaper, where the family might eke out a living, even if there was no room to paint.[72]

But there is another way to imagine Copley's last years that is more fully consistent with his own sense of the totality of his enterprise. One of his chief purposes in his profession was more artisanal than artistic: to achieve a family competence sufficient to propel his children above their station, just as he had dragged himself above his own, canvas by canvas, from the rough-and-tumble world of the Long Wharf to the rough-and-tumble world of the London art scene. Helping John Jr. and Betsy and even the spinster Mary climb their respective mountains was the Copley family's transcendent late work.

Betsy's entry into the "great World" began and in some ways ended with her marriage, as was the case for most elite women of her day. Gardiner Greene's slave-made fortune purchased his family a large estate near Copley's Mount Pleasant: a house that had once belonged to the Jamaica merchant William Vassall, among the largest of prewar Boston's slaveholders. To Vassall's grounds on the promontory called Cotton Hill, Greene added several acres that he purchased from the Mount Vernon Proprietors, the men by whom his father-in-law felt himself so badly cheated. Upon that pastoral expanse, the Greenes built formal gardens and terraced orchards. His plantings included "many ornamental trees brought from foreign lands," some of them doubtless from Demerara. A pair of cows and a mastiff—generation after generation of dogs named Pedro—gave the place the air of a scene rendered by the great English animal painter George Stubbs.[73] The mansion's interior, one of Betsy's daughters later wrote, was something of a throwback, "graced by all that was elegant & aristocratic, in times when the term *aristocratic* was not

one of contempt." The "very core & essence" of the house was the draw-
ing room, whose walls were crowded with "pictures by Copley of stately
dames & gentlemen in full powdered wigs." She found it a "strange coin-
cidence" that the artist's daughter "should have been transplanted from
her English home to find her fathers works in her new Land."[74]

Betsy Clarke Copley Greene presided over a large family. To her
husband's three children, the third Mrs. Greene added seven more, the
last of them born when she was forty-seven. She named her third child
Susannah, after her mother; the fifth, born in 1810, was christened John
Singleton Copley Greene. The family called him Copley.[75] Is "he to be
the great painter in some future day?" Sukey wondered. "Thus the mind
wanders into futurity for those that are coming on the stage of Life," by
those who felt themselves passing from it.[76]

The Greenes' lavish household was crowded with servants as well as
children; the United States census of 1810 counted fifteen souls living
under their roof, three of them "colored" persons, nominally free. Harry,
at least, was still enslaved, though Greene said he had "long considered
him and treated him as a Freeman."[77] Betsy's daughter remembered him
with the full racist armature of the era in which she wrote, just after
the American Civil War, calling him a "pampered, fat, consequential
negro who reigned supreme" in the kitchen and pantries, lording it over
"his sub-dogs, monkeys, parrots," all of them "as necessarily belonging
to the establishment of that day as the master."[78] The press couched the
relationship somewhat more softly. "He has always been kind, and I have
endeavored to serve him faithfully—he has been a good husband, a good
father, a good friend, and a kind master, and I love him, and shall always
love him," Harry Greene was reported to say when his owner died, in
1832.[79] Greene's will manumitted his beloved human property, granting
Harry the right to live rent-free in "the ten foot building I now own in
Ridgeway's Lane," along with an annual stipend of $60 for the remain-
der of his days: a lavish bequest for a mere servant, though not much of
one for a son, from an estate valued at over a million dollars.[80] By the
time of Greene's death, Boston abolitionists—among the intellectual

leaders of the movement nationwide—had begun to publish a news-paper called the *Liberator* from their offices in Merchant's Hall, right down the street. The paper called Greene "the most opulent man in New England." Greene's "only bequest of a general charitable nature," the papers reported, was a legacy of $3,000, to be "applied in such a manner as will be most likely to subserve the cause of civilization of our fellow-beings, the negroes, and of their conversion to the Christian religions."[81]

Betsy's good fortune, with its familiar and paradoxical American admixture of slavery and freedom, was also part of Copley's late work. And though it pained him to do it, Copley ensured that the wealth she married would redound to his son as well. The only letters he wrote to his daughter's family after Betsy left England sought funds to underwrite the career of John Jr., who found his ascent through the ranks of his chosen profession threatened by the end of his fellowship from Cambridge. Copley first pled the case in 1803, explaining that John Jr. had applied himself to his studies with "the utmost industry," and had been "prepared to be called to the barr more than a year." But the cost of riding the circuit and setting up chambers was steep. "I thought I had provided" for those expenses, Copley said, but "the renewal of the War has given so unexpected a check to the progress of the Arts that I have it not in my power at this time to . . . secure him from embarrassment till he may reasonably expect to get into business." Copley did what must have been repugnant to a man who had worked so hard, from such a tender age, and against such long odds to establish his own competence, and to parlay that competence into a kind of enduring excellence: he begged a loan of £1,000. "I certainly should not have troubled you on this subject but it is not possible at this time to raise money on my property without *a very great Sacrifice*," he added, urging Greene to send "as early an answer to this letter as possible."[82]

Greene agreed, of course. And so Copley forfeited to his son-in-law more of what he had earlier ceded to his father-in-law: the only species of American independence that had ever mattered to him. He remained, to

the end of his days, a debtor to his children, obliged and abashed. "I am really hurt at finding myself compelled to trouble you," he wrote in the summer of 1809, seeking another infusion of £500, "but when I consider of how much importance it is and how much I may suffer without this assistance I feel that I shall be excused and that I aught not to be silent upon this subject to a friend so much interested in the circumstances of my family."[83] In coming years, Copley renewed his entreaties, his once elegant penmanship growing large and ragged, evidence of failing eyes and trembling hand. In the last of his letters to Greene, written in the summer of 1812, Sukey acted as his scribe.[84]

An agony of dependence and decay, then, this element of Copley's late style. Yet unlike the disastrous last paintings, the gambit worked; Copley's son achieved the stature for which his father prostrated himself. "I am now to launch my bark into a wider sea," John Jr. wrote, thanking Greene for his largesse.[85] Copley lived to see his son become something of a folk hero for his success in defending the weavers whom the press dubbed Luddites, men who broke their looms rather than succumb to the dawning industrial future. John Jr. was tenacious, assiduous, mind-numbingly casuistical when he had to be: "His Father's *double refined*," Benjamin West said: "a Chip of the Old Block."[86]

~

One of Copley's last great pictures was a portrait of Betsy begun shortly before her marriage. He had completed only the head when he dashed off to Kent to wait on Sir Edwin Knatchbull. Even while it lingered unfinished, the family doted on the likeness, showing it to admiring kin and friends.[87]

Copley returned to the portrait in the winter of 1803, during what turned out to be the final months of the short peace with France. Sukey wanted her daughter to know that "this was the first thing that was take[n] in hand by your Dear Father" after the Knatchbull commission was done. Enough time had passed since Betsy sailed that it would have been hard to conjure up her face. "The trio assembled in the painting

room," Sukey said, each playing an accustomed part. "Dear Mary" served as model, "the substitute in the Robe," standing in for her sister. Sukey acted the role of the admirer, "pleased with each stroke of the pencil which increased the likeness to the dear original." And Copley, of course, played the alchemist, teasing the precious semblance of life from a few ounces of powder and oil.

Copley's likeness of his daughter on the threshold of marriage reveals a handsome woman, with a long face and a square jaw and eyes of a brown so deep they run almost to black. There is no trace of the coquette about the figure, whose bosom has already grown matronly. Yet both her steady, unflinching gaze and her costume, of white muslin with a coral sash, plainly recall the child of six who stares from the center of the family portrait, completed more than a quarter century before. Betsy has just a hint of a smile, one of the handful of Copley portraits to reveal

Copley, ELIZABETH COPLEY GREENE, *1800–02* [Plate 18]

teeth. She looks poised to resume the stream of familiar fireside chat her family missed so much. In her absence, the picture would have to do. Sukey told her daughter that she was glad the couple had "left so much of your selves" in their likenesses.[88] Modest in scale, informally posed, finished with the brio of an oil sketch, *Elizabeth Clarke Copley Greene* is of her family, and for her family. It would have hung in the red room, where they gathered of an evening, to talk of present woes and absent friends.

There in the summer of 1815, shortly after the Battle at Waterloo, which sealed Napoleon's fate and gave Britain its latest and greatest military hero, Mary wrote to Betsy to say that "a melancholy scene" had "embitter[ed] the happiness of our little circle": their father had suffered a "paralytick seisure." The doctors thought he would recover from the massive stroke slowly—would leave his bed, even walk again, "with a stick." The crisis past, John Jr. headed to Paris with friends.[89]

Two weeks later, when Copley's condition had improved enough that the family dared imagine "he might so far recover as to enjoy life in comfort to himself," another stroke "reduced him so extremely" that Mary did not know whether to wish he survived it. She and Sukey were wrung out by his care, and worried that he might endure "a great while" in a hopeless state. They took comfort from the fact that "his mind is not affected . . . and that he is perfectly composed." He was "perfectly resigned and willing to die," secure in his faith and confident of heaven, Mary said.

As it happened, the end came quickly, a good death, in the fashion of its day. In the early hours of 9 September, he slipped away, having remained "perfect sensible" to almost the last. Mary assured her faraway sister that their father "had all the comfort which religion and human aid could afford him." She and Sukey were at his bedside. Together they must have closed his eyes.[90]

Copley died almost inconceivably far from the rooms on Boston's Long Wharf where he had spent his first years, surrounded by art that mapped almost the whole of his journey, from *Boy with a Flying Squirrel* to the failed portrait of the future George IV. His own surpassing talent meant that he could watch his family age before him in his last moments,

from the family portrait of 1776, to the incarnations of his son as Cupid and his daughter as the baby Jesus, to the grand-manner full-lengths of his surviving children in the first blush of a robust adulthood in *Red Cross Knight*, to the farewell picture of Betsy, whose marriage had both divided them and kept them whole. The pictures, which had failed to take him everywhere he wanted to go, formed a complex legacy. But it was none-theless a wholly astonishing one.

There were no printed encomia to Copley's passing, and no elabo-rate public funeral: none of the hoopla that would attend the apotheosis of Benjamin West four years later. Indeed, Copley's family could scarce afford to bury him. They interred him in the church in Croydon, where the remains of his little son and daughter had lain long since, in a tomb tucked into one of the side aisles, with only "a plain slab in the floor of the church" bearing "a modest inscription" to mark his passing.[91]

Copley left behind a tangle of accounts "in a very unpleasant and involved condition," and too many canvases and prints unsold, lining the walls of his painting room like sentries: his bid for immortality, insufficient, at the end, to cover his debts. Sukey tallied up the ledger and decided to take in a boarder. Their "various embarrassments" had "ocationed great dis-quiet," she said. Her husband had worked so hard, desperately trying "to avert the end" that was now upon them. Yet his "every exersion did but end in disappointment, and a variety of events have shewn that he was not to receive pecuniary gratification from the Art in which he so much delighted." His disappointment was a family tragedy, as much a story of the age of revolutions as Gardiner Greene's wealth.

Amidst the general gloom, Sukey took some modest "comfort that from his pursuit in the Art he derived great pleasure."[92]

The trace of that pleasure lingers, like the flicker of Betsy's smile, even still.

— Epilogue —

HEN COPLEY REACHED Rome, his larger life in a wider world beckoning, he yearned "to try if my hand & my head cannot do something like what others have done and by which they have astonished the world Immortalised themselves & will be admired as long as this Earth shall continue."[1] Nearly two and a half centuries have elapsed since. To stare at Copley's work, to be transported by it, even now, is to realize that he got his wish. But immortality, as it happens, is a tricky business. To transcend is also to be wrenched out of time, out of hand, and out of mind. In the intervening centuries, the painter has been both found and lost.

Having outlived his vogue, his vision, his insight, and, at the end, the preternatural facility of his hands, Copley died an impoverished subject of the king, beneath a mountain of debts in a painting room stacked with pictures. There followed an auction. In 1820—a year that saw the passing of both Benjamin West and his royal patron, George III—the Copley family contracted with Sotheby's to liquidate the artist's collection of prints. Over 1,100 works on paper were offered for sale. The proceeds amounted to less than £400. Even then, in an hour of great need, the family held on to the oils.[2]

While the Copley family struggled under the burdens left to them in London, the artist's halting rebirth as an American genius was in progress an ocean away. Copley's so-called repatriation, to a country he had never seen, would be the work of decades. It had begun while Copley

was still alive, in letters and stray mentions in the American press. It accelerated somewhat after 1815, when the United States defeated Great Britain on the battlefield for the second time in living memory, and a nascent American culture industry kicked into higher gear, with a spate of new magazines and museums devoted to celebrating—and indeed to inventing—the raw young country's artistic heritage. John Trumbull, with his romantic paintings of Revolutionary War battles, typically sat highest in the painters' pantheon; Benjamin West's enduring connection with the artist and museum founder Charles Willson Peale kept his work in the American eye as well. Gilbert Stuart had in his favor George Washington, of whom he had painted more than one hundred likenesses, three of them from life. Versions of Stuart's *Athenaeum* portrait, engraved and pirated and painted on glass, hung in parlors as far away as Canton: the face of a bumptious new nation.

Copley was known in the early United States chiefly for likenesses he had painted before the Revolution, almost all of which still hung in private homes, among the sitters' descendants, precisely as they had been commissioned to do. But for a few portraits that recrossed the ocean with returning loyalists, the labors of Copley's expansive second act remained in Britain, the country of his birth, nearly invisible to the provincial eye. In an echo of Copley's own early life, spent straining to see, the pictures he was able to paint once he escaped his American "bondage"—the epics, the allegories, the Bible scenes—were seen across the Atlantic as engravings, as if through a glass darkly. And so, when Americans talked about Copley at all, they tended to say that his best work had been done before he left, which was doubly ironic, since little of the "American" work, and less of the "English," was on public view in the United States. Copley's journey became an Icarus story, one of many in the boom-and-bust world of the early American republic. Speaking with the biting folksiness that his sitters loved, Gilbert Stuart was heard to say, in 1810, "that Copley had first a manner of his own; & a very good manner." But when he tried "to adopt a more perfect one," he had "totally failed," much like "a cow dancing a hornpipe!"[3]

⁓

A generation later, William Dunlap, who had studied with West in London at the peak of Copley's fame, varnished this familiar tale of overreaching with a gloss of disloyalty. Copley had been "a prudent, assiduous, persevering man . . . a good painter before he left his country," Dunlap wrote in his mammoth *History of the Rise and Progress of the Arts of Design in the United States.* But the arc pointed downward from there. Unimpressed even with the greatest of Copley's London works, Dunlap dredged up passages of George Carter's damning sixty-year-old travel journal, excerpts of which had found their way into an anthology on the lives of eminent British painters.[4] Allan Cunningham, the author of that compendium, had affirmed Copley's Anglo-American origins. (Some then placed his birth in Ireland.) But it meant little, Cunningham conceded, that Copley "was all along *claimed* as American by the general rumour of the United States, . . . since, in a country constantly receiving, and willingly adopting, new citizens from all quarters, considerable looseness as to such a point might be considered as natural."[5]

Whereas Cunningham had discovered in Copley an adopted American citizen, Dunlap fashioned a man who forsook his native country to paint the "enemies in opposition to our independence." In this connection, he faulted especially Brook Watson, who had not only rejected the Revolution but later argued against abolition, "in support of the trade in human flesh To immortalize such a man was the pencil of Copley employed." Dunlap's Copley was no mere second-class history painter, but a traitor in the service of slavers.[6]

Even those American critics who treated Copley more kindly than Dunlap did made him the painter of the world *before*: a world of "brocade, buckles, velvet, powder, and other characteristics of an aristocratic and obsolete toilet," things "associated with the old-fashioned dignity and formal self-possession of the eminent and the prosperous subjects of Britain," as the Boston critic Henry Tuckerman put it in 1867. The "possession of one of these ancestral portraits is an American's best title

of nobility," Tuckerman said.[7] But nobility was out of fashion. Obsessed with its own self-creation—with the *after*, the now, the next—the United States was proud to have left that world behind, and "such relics" as Copley portraits with it.

⁓

By the middle of the nineteenth century, everywhere but Boston, the name John Singleton Copley conjured up the son more readily than the father. The painter's namesake had tacked from law to politics, in which sphere he soared so high and so fast that in 1827, barely a dozen years after his father's death, he was elevated to the position of Lord High Chancellor of Great Britain. With the office came a baronetcy of the new creation. John Singleton Copley Jr. rechristened himself Lord Lyndhurst. He devised a coat of arms featuring a brace of phoenixes, risen from the ashes much like the baron himself. Below the crest unfurls a banner emblazoned *Ultra Pergere*: Going Beyond. The motto recalls the long-ago words of Copley when he first saw the works of the great masters in Italy: "when a man can go but a very little beyond his cotemporarys he becomes a great Man."[8]

His coat of arms to the contrary, Lyndhurst, né Copley, never got entirely beyond. Though he had indeed become a great man, he remained a controversial politician, more malleable than his party. His long face offered easy fodder for the satirists, who were quick to mock the improbable baron's humble origins. A print issued in 1829 depicted him as a racehorse called Woolsack (his perch as Speaker of the House of Lords), sired by "Jack-Painter, out of Nothing."[9]

Lyndhurst kept the house on George Street, where he cared for his widowed mother until her death in 1836, and looked after his aging sister Mary, the spinster who would outlive them all. Periodically, after their mother died, the surviving London Copleys met their American sister, Betsy, in Paris. All three of Copley's children lived and wrote into their nineties, in the 1860s, when the America that had descended into civil war during their youth came apart once again. "How strange that

you and I should live to witness two revolutions in the same country," Lyndhurst told Betsy in 1862, calling the war between the northern and southern United States a revolution, just as his father had called the American Revolution a civil war.[10] A year later, Abraham Lincoln signed the Emancipation Proclamation, which began to dismantle the institution that had helped launch Copley into the world of wealth in the 1770s, and had undergirded the marriage of his daughter and the rise of his son a generation later. Like most Britons, whose queen and country remained formally neutral in America's Civil War, Lyndhurst tacitly supported the Confederacy, where slaves grew so much of the cotton processed in the mills of northern England.[11]

Lyndhurst never forgot the bright-burning, sometimes consuming flame of his father. He passed the bulk of his nine decades surrounded by Copley's art, his house a veritable museum. He died in that house, in October 1863. Several months later, Christie's put the contents of 25 George Street to the gavel. Thirty-eight Copley canvases were on offer, ranging in scale from the intimate to the colossal.

The question of national patrimony hovered over the sale. "The room was crowded with the curious to know what Government would do for the National Gallery," reads a note scrawled in the margin of a surviving copy of the catalog. People cheered when the hammer fell on lot 90, *The Death of Major Peirson*, which went to the British people, for £1,600. Betsy's daughter, or those acting for her, bought fifteen works, including *George IV as Prince of Wales*, which fetched all of £5. For *Boy with a Flying Squirrel*, the purchase marked the beginning of a return trip, back to its ancient birthplace in its no longer new country. All the others, even *The Copley Family*, left England for the first time with the painter's American grandchildren.[12]

Betsy Copley Greene died in Boston two years later, at the great age of ninety-six. The *Nation* ran a story entitled "Curiosities of Longevity," which said her passing had severed "one of the last links that connect the present times with those before the Revolution." An oration on her long life noted the astonishing "track of time" she had endured, "a period

which includes perhaps more vital changes, moral, mental, physical, political and domestic, than any of its predecessors."[13]

Just as her brother safeguarded the paintings, Betsy Copley Greene had tended the family papers. At her death, the letters passed to her daughter Martha Babcock Greene Amory. When Martha died, descendants carved up the archive. Letters written by Copley went to the Library of Congress, as the official property of the United States. The cache of correspondence exchanged among the female kin during those many years when Copley would not set down his brush to pick up a pen were donated to the Massachusetts Historical Society. Scores of them, spanning decades. Martha Amory included versions of some of those letters in her biography of her grandfather, *The Domestic and Artistic Life of John Singleton Copley*. But she edited them freely, diluting both the politics and the pain. The archive Betsy Copley tended and preserved is far richer—more brightly colored—than the story her daughter planed and published. Both the preservation and the distortion were women's work: the work of the household as a locus of history, representation, and, in the end, repression.

~

By the time Martha Amory died, the end of the American Civil War and the centennial of those newly reunited states had combined to create a vogue for early Americana: a "colonial revival" in art, architecture, literature, and design. Private portraits became public art. When Harvard honored the sacrifice of its Civil War dead by building a vast gothic Memorial Hall, the college overseers filled it with Copley portraits, a baker's dozen, including *Samuel Adams* and *John Adams*. Another half century would pass before President Warren G. Harding coined the phrase "founding fathers" to celebrate their cohort of onetime rebels. But already they were iconic, gods in an emerging American pantheon.[14] On 3 July 1876, the eve of the Declaration's centennial and, as it happened, Copley's 138th birthday, Boston city fathers cut the ribbon on the grand new Museum of Fine Arts, a palace of painting. In 1883, a year after *The*

Domestic and Artistic Life of John Singleton Copley was published, the open space in front of the museum was christened Copley Square.[15]

As the descendants of Copley's sitters came to believe that their ancestors' likenesses belonged in the story of American Art, Copley's portraits found their way to museums, first in Boston, New York, and Philadelphia. Once the East Coast capitals of the former British America had glutted themselves on Copleys, the pictures began traveling west, following the imperial project of the United States, and incarnating, wherever the paintings came to rest, the spirit of an America the artist had never known. *Young Lady with a Bird and Dog* landed in Toledo. *Colonel George Watson*, whose sitter had been hunted by the liberty men at Copley's house in 1774, went to New Orleans. The likeness of Copley's daughter fetched up in Lawrence, Kansas.

In 1984, the Timken Museum of Art in San Diego's Balboa Park, one of the smallest and westernmost museums in the continental United States, leapt at the chance to acquire *Mrs. Thomas Gage* (Margaret Kemble) from descendants of the sitter. The canvas had spent its entire life in Great Britain, moving from British New York, where Copley painted it in 1771, to London the following year, and finally to the Gage family's country estate, Firle Place, in Sussex. The oldest parts of Firle Place were built around the time Columbus sailed, and in the way of such ancestral piles, the cost of upkeep had grown crippling. When the sixth Viscount Gage died, the family decided to part with some of their patrimony to better preserve the rest. The Timken deaccessioned a painting by Frederic Remington, an authentic if kitschy piece of western Americana called *Halt—Dismount!*, to pay for the Copley portrait.[16]

For a while that spring, the parties to the sale fretted that government regulations in the United Kingdom would prevent the removal of *Mrs. Gage* to the United States. A letter to the director of the Timken reporting on "what we can now call l'affaire Copley" observes that "British export rules . . . are rather peculiar," not least for detaching their definition of cultural patrimony from "the nationality of the artist."[17] In the end, no British institution stepped forward to buy the painting, and the Timken

got its Copley. The canvas for which the artist had originally been paid twenty guineas fetched the Gages over a million pounds, enough to patch quite a few holes in the roof at Firle.

Newspapers tracked the journey of the great painting to the tiny museum an ocean and a continent away. The Timken's director, Grant Holcomb, told reporters that "Copley was the first great painter of America's colonial period," and *Mrs. Gage* "one of the great works of American art." "Portrait of a Lady Returns," ran the headline announcing the sale in the *New York Times*.[18]

When he painted Margaret Kemble Gage, Copley told his brother, Harry, that the canvas was "beyand Compare the best Lady's portrait I ever Drew."[19] Probably true to that point, though my vote, in the end, goes to *Abigail Bromfield Rogers*, painted a dozen years later, after Copley had seen the skies of Tuscany and the palette of Rubens and the brushwork of Gainsborough. Still, *Mrs. Gage* takes your breath away, all the more so for her startling location in a vestpocket gallery, in a jewelbox museum, in a park flooded with the dazzling sunshine of southern California.

Mrs. Gage is the Timken's great national treasure, starring in the role *Paul Revere* plays at Boston's Museum of Fine Arts. Copley's sumptuous likeness of a redcoat general's wife, the daughter of loyalist parents, and, like the painter, a longtime Londoner and lifetime Briton, recently served as the centerpiece of an exhibition mounted by three museums in that sparkling city on the Pacific. The show was entitled "Behold, America! Art of the United States."[20]

� Acknowledgments ⟶

A BOOK IS LESS a portrait than a teeming history painting, bearing the signature of one person but resting on the labor of an entire studio. I herewith offer a printed key to the personages who have helped in many ways with the crafting of this canvas.

Several institutions generously underwrote the expense of a protracted, image-laden, international project. My thanks to the Paul Mellon Centre for Studies in British Art, London, for research support and image subvention grants; and to publication funds from Harvard University's History Department and Division of Social Sciences. A fellowship from the Radcliffe Institute for Advanced Study provided a laboratory for this project in its formative stages, in the company of a dazzling group of life writers: John Demos, Suzanne Lebsock, William S. McFeely, and Megan Marshall. The generosity of the Andrew W. Mellon Foundation has been peerless, twice: a "New Directions" Fellowship allowed me to study art history for a year in London at the Courtauld Institute, where David Solkin and Martin Myrone gave me new ways of seeing. Several years later, Mellon funded a yearlong interdisciplinary Sawyer Seminar at Brandeis, "Rethinking the Age of Revolutions: Rights, Representation, and the Global Imaginary." I learned an enormous amount from our seminar guests, from my Brandeis colleagues, and especially from my fellow principal investigator and longtime co-conspirator, Susan S. Lanser. The first draft of the book was produced at the Susan and Donald Newhouse Center for the Humanities at Wellesley College, where I served as the Mary L. Cornille Vis-

iting Professor, and enjoyed the company of a lively and distinguished group of young humanists.

No work of history would be possible without the often hidden labors of librarians and archivists. I am greatly indebted to the staffs of the British Library, the Glamorgan Record Office in Cardiff, Wales, the National Archives of the United Kingdom in Kew, the Library of Congress, the Boston Public Library, Harvard's Houghton Library, the Historical Society of Pennsylvania, the Massachusetts Archives, the Massachusetts Historical Society, the Manuscripts and Archives Collections of Yale University, the archives of Historic New England, and the New England Historic and Genealogical Society. This would also be a very different book without the generosity and trust of Charlotte Moore and her brothers.

One of the delights of my research has been working with some of the curators and conservators who bring Copley's work to life. Susan Earle at the Spencer Museum of Art in Lawrence, Kansas; Jim Petersen at the Timken Museum of Art in San Diego; Theresa Fairbanks Harris at the Yale Art Gallery; Betsy Kornhauser, Amelia Peck, and the great Copley scholar Carrie Barratt at the Metropolitan Museum of Art; Ellen Miles at the National Gallery of Art, and Brandon Fortune and David Ward at the National Portrait Gallery in Washington, DC; Val Nelson at Jersey Heritage in St. Helier, Isle of Jersey; Martin Myrone at Tate Britain; and Desmond Shawe-Taylor, Surveyor of the Queen's Pictures, have shown extraordinary patience, acumen, and hospitality—complaisance, in Copley's terms. I owe a yet larger debt to Erica Hirshler of the Museum of Fine Arts, Boston; and to my colleagues at the Harvard Art Museums, especially Teri Hensick, Kate Smith, and Ethan Lasser; whose galleries, study spaces, and store rooms I have haunted.

I have shared parts of this work with audiences at Berkeley, Brandeis, Brown, Harvard, the University of Kansas, Oxford University, Queen Mary's University, London, and UCLA. Their feedback has illuminated many otherwise shadowy corners of my canvas. I have also benefited from lively discussions at the Huntington Library, the Massachusetts Histor-

ical Society, the McNeil Center for Early American Studies, the New-
berry Library, and the Paul Mellon Centre for the Study of British Art.

Many fellow travelers in history and art history have lent me their
ears and shared their wisdom on thorny questions over email, coffee,
wine, and, on occasion, tears. Thank you, thank you, Bob Allison, John
Bell, David Bjelajac, Chris Brown, Dick Brown, Trevor Burnard, Chris
Bryant, Stephen Conway, Annette Gordon-Reed, Mark Hallett, Ben
Irvin, Colin Jones, Sarah Knott, Jill Lepore, Margaretta Lovell, Mar-
tha McNamara, Margot Minardi, Sarah Pearsall, Mark Peterson, Jen-
nifer Roberts, Amanda Vickery, Wendy Warren, and Gloria Whiting.
Mark Peterson, Leslie Reinhardt, Serena Zabin, and Rebecca Zurier
generously shared unpublished work that will soon transform the way
we understand the revolutionary world. I have also benefited from the
scholarship of many of my students, including the members of the
plucky Brandeis Copley lab in 2013–14, Gloria Whiting, who recently
completed her dissertation at Harvard, and especially John Hannigan,
who remains the most brilliant researcher I have ever known, an archi-
val savant. Lindsay Silver Cohen and Pembroke Herbert have provided
meticulous production support, Lindsay with words and Pembroke
with pictures.

Jules Prown, who surely knows more about Copley's work than any-
one alive, has been an amazingly gracious, humane, and wise interlocutor
over the last several years, even though we disagree on the crucial ques-
tion of whether it would be better to meet Copley or Benjamin West in
some otherworldly byway. I stand by hell with Copley, but may we each
get our wish, and not for many years to come.

Elise Broach, Trevor Burnard, John Demos, Sue Lanser, Cathy Mat-
son, Robert St. George, and David Waldstreicher have each read and
substantially improved parts of this manuscript. Ed Gray, Jill Lepore,
and Jennifer Roberts generously tackled the whole thing, when it was
the size of the *Siege and Relief of Gibraltar*. I have benefited enormously
from their individual and collective wisdom, not to mention their axes
and their scalpels. Tina Bennett at WME has been a tireless advocate for

this book, and Alane Salierno Mason at Norton an astonishingly perspicacious editor, again and again and again.

This is a book about a world in revolution and a book about family. It is also, in some inchoate sense, the author's family portrait. Dennis Scannell shared me with another man—a very difficult and demanding one—for the better part of a decade, seldom complaining. Calvin and Malcolm Scannell grew up alongside Copley, and traveled the stations of his cross with me, sometimes literally, in Britain and in Italy, sojourns I will treasure always. Irrepressible boys when I began this journey, they are now splendid young men who tower over the bantam painter from centuries past.

Copley was dedicated to fashioning his world for the family he created, but he was also powerfully shaped by the one that made him, as are we all. And so this book is dedicated, with love, to my mother, who has an artist's questing spirit, and to the memory of my father, weary pilgrim and too-brief sojourner.

Illustrations and Credits

P-1 & Plate 1 John Singleton Copley, *Dorothy Murray*, ca. 1759–61. Oil on canvas, 92.1 × 71.4 cm. Fogg Art Museum, Harvard Art Museums, Gift of Mrs. David Simmons. Bridgeman Images.

1-1 Peter Pelham, *Cotton Mather*, 1728. Engraving after portrait by Pelham, 34.5 × 25 cm. American Antiquarian Society. Bridgeman Images.

1-2 John Singleton Copley, *Charles Pelham*, 1753–54. Oil on canvas, 91.5 × 71 cm. Private Collection. Bridgeman Images.

1-3 John Singleton Copley, *Mrs. Joseph Mann* (Bethia Torrey), 1753. Oil on canvas, 91.44 × 71.75 cm. Museum of Fine Arts, Boston, Gift of Frederick H. Metcalf and Holbrook E. Metcalf. Bridgeman Images.

1-4 John Singleton Copley, *Joseph Mann*, 1754. Oil on canvas, 91.4 × 71.8 cm. Museum of Fine Arts, Boston, Gift of Frederick H. Metcalf and Holbrook E. Metcalf. Bridgeman Images.

1-5 & Plate 2 John Singleton Copley, *The Return of Neptune*, ca. 1754. Oil on canvas, 69.9 × 113 cm. The Metropolitan Museum of Art, Gift of Mrs. Orme Wilson, in memory of her parents, Mr. and Mrs. J. Nelson Borland, 1959 (59.198). Image © The Metropolitan Museum of Art. Art Resource, New York.

2-1 John Singleton Copley, Book of Anatomical Studies, 1752–1815. Right measured study of *Medici Venus* from the side (1756). Red and black chalk. Inv. 1864,0514.143. © The Trustees of the British Museum. Art Resource, New York.

2-2 John Singleton Copley, Book of Anatomical Studies, 1752–1815. Right back, full length, numbered "X" (1756). Red and black chalk. Inv. 1864,0514.142. © The Trustees of the British Museum. Art Resource, New York.

2-3 John Singleton Copley, *Joshua Winslow*, 1755. Oil on canvas, 129.2 × 102.6 cm. Santa Barbara Museum of Art, Gift of Mrs. Sterling Morton for the Preston Morton Collection.

2-4 & Plate 3 John Singleton Copley, *Major George Scott*, ca. 1755–58. Oil on canvas, 127 × 101.6 cm. Private Collection.

3-1 Benjamin West, *Self-Portrait*, 1758–59. Watercolor on ivory, 6.4 × 4.6 cm. Yale University Art Gallery.

3-2 Angelica Kauffman, *Benjamin West*, ca. 1763. Black chalk on greenish-gray paper, 41.9 × 31.8 cm. © National Portrait Gallery, London.

3-3 Canaletto, *The River Thames with St. Paul's Cathedral on Lord Mayor's Day*, ca. 1747–48. Oil on canvas, 118.5 × 237.5 cm. Lobkowicz Palace, Prague Castle, Czech Republic. Bridgeman Images.

3-4 William Hogarth, *The Times*, Plate I, illustration from *Hogarth Restored: The Whole Works of the Celebrated William Hogarth, Re-engraved by Thomas Cook*, 1812 (1762). Private Collection, The Stapleton Collection. Bridgeman Images.

3-5 Matthew Pratt, *The American School*, 1765. Oil on canvas, 91.4 × 127.6 cm. Gift of Samuel P. Avery, 1897 (97.29.3). Image © The Metropolitan Museum of Art. Image source: Art Resource, New York.

3-6 John Singleton Copley, *Nathaniel Sparhawk*, 1764. Oil on canvas, 231.14 × 149.86 cm. Museum of Fine Arts, Boston, Charles H. Bayley Picture and Painting Fund. Bridgeman Images.

3-7 John Singleton Copley, *Henry Pelham*, ca. 1760. Oil on canvas, 42.5 × 34.9 cm. Private collection. Photograph © 2016 Museum of Fine Arts, Boston.

3-8 & Plate 4 John Singleton Copley, *A Boy with a Flying Squirrel*, 1765. Oil on canvas, 77.2 × 63.8 cm. Museum of Fine Arts, Boston, Gift of the artist's great-granddaughter. Bridgeman Images.

3-9 John Singleton Copley, *Portrait of Benjamin Hallowell*, ca. 1764. Oil on canvas, 127 × 101.6 cm. Colby College Museum of Art, Gift of the Vaughan Family of Maine, Funding of Painting's Conservation by Louisa Vaughan Conrad, 1978.006.

4-1 John Singleton Copley, *Young Lady with a Bird and Dog*, 1767. Oil on canvas, 122 × 101 cm. Toledo Museum of Art, Purchased with funds from the Florence Scott Libbey Bequest, 1950.306. Photo credit: Photography, Incorporated (Toledo).

4-2 John Singleton Copley, *Mrs. Joseph Barrell* (Hannah Fitch), ca. 1771. Pastel on paper mounted on canvas, 60.64 × 45.72 cm. Museum of Fine Arts, Boston, Gift of Benjamin Joy. Bridgeman Images.

4-3 John Singleton Copley, *Nicholas Boylston*, ca. 1769. Oil on canvas, 127.3 × 101.6 cm. Museum of Fine Arts, Boston. Bridgeman Images.

4-4 John Singleton Copley, *Portrait of Colonel George Watson, 1718–1800*, 1768.

Oil on canvas, 127 × 101.6 cm. New Orleans Museum of Art, Museum purchase and gift, by exchange, of Isaac Cline, Herman E. Cooper, F. Julius Dreyfous, Durand-Ruel & Sons, and Lora Tortue, 77.37.

4-5 & Plate 5 John Singleton Copley, *Paul Revere*, 1768. Oil on canvas, 89.22 × 72.39 cm. Museum of Fine Arts, Boston. Gift of Joseph W. Revere, William B. Revere, and Edward H. R. Revere 30.781. Photograph © 2016, Museum of Fine Arts, Boston.

4-6 Paul Revere, *A View of the Town of Boston with Several Ships of War in the Harbor*, 1770. Engraving, 16.8 × 26.5 cm. I. N. Phelps Stokes Collection, Miriam and Ira D. Wallach Division of Art, Prints, and Photographs, The New York Public Library. Art Resource, New York.

4-7 & Plate 6 John Singleton Copley, *Portrait of General Thomas Gage*, ca. 1768. Oil on canvas mounted on masonite, 127 × 101 cm. Yale Center for British Art, Paul Mellon Collection. Bridgeman Images.

5-1 & Plate 7 John Singleton Copley, *Mrs. John Singleton Copley* (Susanna Clarke), 1769. Pastel on paper, 58.72 × 43.81 cm. Courtesy of Winterthur Museum, Gift of Henry Francis du Pont, 1957.1128.

5-2, Plate 8 & frontispiece John Singleton Copley, *Self-Portrait*, 1769. Pastel on paper, 58.72 × 44.5 cm. Courtesy of Winterthur Museum, Gift of Henry Francis du Pont, 1957.1127.

5-3 After Henry Pelham. *The Fruits of Arbitrary Power; or, The Bloody Massacre*, 1770. Hand-colored engraving, 23.4 × 22.2 cm. American Antiquarian Society. Bridgeman Images.

5-4 Paul Revere, *The Bloody Massacre Perpetrated on King-Street*, 1770. Colored engraving, 20 × 22.8 cm. © Massachusetts Historical Society, Boston. Bridgeman Images.

5-5 John Singleton Copley, *Samuel Adams*, ca. 1772. Oil on canvas, 125.7 × 100.3 cm. Museum of Fine Arts, Boston. Bridgeman Images.

5-6 John Singleton Copley, *Mrs. Humphrey Devereux*, 1771. Oil on canvas, 102 × 81 cm. Museum of New Zealand Te Papa Tongarewa, Wellington, New Zealand. Gift of the Greenwood family, 1965. Bridgeman Images.

5-7 After Benjamin West, *The Death of General Wolfe*, 1771, engraved 1776 by William Woollett. Copperplate engraving, 46.4 × 59.1 cm. Museum of Fine Arts, Houston, The Bayou Bend Collection, Gift of Dr. and Mrs. Edward F. Heyne III. Bridgeman Images.

6-1 John Singleton Copley, *Colonel John Montresor*, 1771. Oil on canvas, 76.2 × 63.5 cm. Detroit Institute of Arts. Bridgeman Images.

6-2 & Plate 9 John Singleton Copley, *Mrs. Thomas Gage* (Margaret Kemble),

1771. Oil on canvas, 127 × 101.6 cm. The Putnam Foundation, Timken Museum of Art, San Diego. Bridgeman Images.

6-3 Paul Revere, *Mr. Samuel Adams*, 1774. Engraving, 18.2 × 12.2 cm. American Antiquarian Society. Bridgeman Images.

6-4 Paul Revere, *The Able Doctor; or, America Swallowing the Bitter Draught*, 1774. Engraving. Private Collection. Bridgeman Images.

7-1 John Singleton Copley, *Mr. and Mrs. Ralph Izard* (Alice Delancey), 1775. Oil on canvas, 174.62 × 223.52 cm. Museum of Fine Arts, Boston, Edward Ingersoll Brown Fund. Bridgeman Images.

7-2 & Plate 10 John Singleton Copley, *The Ascension*, 1775. Oil on canvas, 81.2 × 73 cm. Museum of Fine Arts, Boston, Bequest of Susan Greene Dexter. Bridgeman Images.

8-1 Correggio, *Madonna of Saint Jerome* (The Day), 1527–28. Oil on panel, 205 × 141 cm. Galleria Nazionale, Parma, Italy, Mondadori Portfolio, Electa, Marco Ravenna. Bridgeman Images.

8-2 & Plate 11 John Singleton Copley, *The Copley Family*, 1776–77. Oil on canvas, 184.1 × 229.2 cm. National Gallery of Art, Washington, DC. Bridgeman Images.

8-3 John Singleton Copley, *The Nativity*, ca. 1776. Oil on canvas, 62.2 × 76.2 cm. Museum of Fine Arts, Boston, Ernest Wadsworth Longfellow Fund. Bridgeman Images.

8-4 After Michel Vincent Brandoin, *The Exhibition of the Royal Academy of Painting, in the Year 1771*, 1772. Mezzotint with etching, 46.9 × 55.9 cm. © The Trustees of the British Museum. Art Resource, New York.

8-5 & Plate 12 John Singleton Copley, *Benjamin West*, ca. 1776–80. Oil on canvas, 76.3 × 63.5 cm. Fogg Art Museum, Harvard Art Museums. Bridgeman Images.

8-6 & Plate 13 John Singleton Copley, *Self-Portrait*, 1780–84. Oil on canvas, 45.4 cm. National Portrait Gallery, Smithsonian Institution. Art Resource, New York.

8-7 Henry Pelham, *A Plan of Boston in New England with Its Environs, 1777*. Detail, full sheet 98.0 × 69.0 cm. Map reproduction courtesy of the Norman B. Leventhal Map Center at the Boston Public Library.

8-8 & Plate 14 John Singleton Copley, *Watson and the Shark*, 1778. Oil on canvas, 182.1 × 229.7 cm. National Gallery of Art, Washington, DC, Ferdinand Lammot Berlin Fund No. 1963.6.1. Bridgeman Images.

8-9 John Singleton Copley, *Head of a Negro*, ca. 1777–78. Oil on canvas, 53.3 × 41.3 cm. Detroit Institute of Arts. Bridgeman Images.

8-10 After Thomas Gainsborough, *Ignatius Sancho*. Engraving by Francesco

Bartolozzi, published 1781 (b/w photo), 12.8 × 9.7 cm. Private Collection © Michael Graham-Stewart. Bridgeman Images.

8-11 Joshua Reynolds, *A Young Black*, 1770. Oil on canvas, 78.7 × 63.8 cm. Menil Collection, Houston, Texas.

9-1 John Singleton Copley, *Mrs. Clark Gayton*, 1779. Oil on canvas, 127 × 101.6 cm. Detroit Institute of Arts, Gift of Mr. D. J. Healy. Bridgeman Images.

9-2 John Singleton Copley, *Admiral Clark Gayton, 1712–1784/5*, 1779. Oil on Canvas, 127 × 101.8 cm. National Maritime Museum, Greenwich, London, Caird Collection.

9-3 John Singleton Copley, Study for Lord North, 1779–80. Chalk on paper, 55.6 × 41 cm. © Boston Athenaeum. Bridgeman Images.

9-4 *The Political Raree-Show; or, A Picture of Parties and Politics during and at the Close of the Last Session of Parliament*, June 1779. Engraving, 23.7 × 35.2 cm. © The Trustees of the British Museum. Art Resource, New York.

9-5 & Plate 15 John Singleton Copley, *The Collapse of the Earl of Chatham in the House of Lords, 7 July 1778*, 1779–81. Oil on canvas, 228.6 × 307.3 cm. Tate Gallery, London, Great Britain, Presented by the Earl of Liverpool, 1830. Art Resource, New York. [Also known as *The Death of the Earl of Chatham*.]

9-6 After John Singleton Copley, *The Death of Lord Chatham in the House of Peers*. Etching and engraving by Angus Williams, 1781, 12 × 17.7 cm. © The Trustees of the British Museum. Art Resource, New York.

9-7 John Singleton Copley, *John Adams*, 1783. Oil on canvas, 238.1 × 147 cm. Fogg Art Museum, Harvard Art Museums. Bridgeman Images.

9-8 & Plate 16 John Singleton Copley, *The Death of Major Peirson, January 6, 1781*, 1782–84. Oil on canvas. 251.5 × 365.8 cm. Tate Gallery, London. Art Resource, New York.

9-9 Detail, *The Death of Major Peirson*, as above.

9-10 John Singleton Copley, Study for *The Death of Major Peirson* (Young Boy and Fleeing Mother and Child), ca. 1782–84. Black and white chalk on paper with pencil, 35.2 × 56.5 cm. Museum of Fine Arts, Boston. Bridgeman Images.

10-1 *Vincent Lunardi's Aerial Ascent from the Artillery Ground Moorfields*, 1784. Hand-colored etching, 37.6 × 51 cm. © The Trustees of the British Museum. Art Resource, New York.

10-2 John Singleton Copley, *Abigail Bromfield Rogers*, ca. 1784. Oil on canvas, 127 × 101.6 cm. Fogg Art Museum, Harvard Art Museums, Gift of Paul C. Cabot. Bridgeman Images.

10-3 & Plate 17 John Singleton Copley, *The Three Youngest Daughters of George III*, 1785. Oil on canvas, 265.4 × 185.7 cm. Royal Collection Trust © Her Majesty Queen Elizabeth II, 2015. Bridgeman Images.

10-4 Benjamin West, *Miss Susanna Copley*, ca. 1777. Drawing, dimensions unknown. Courtesy of the Frick Art Reference Library.

10-5 John Singleton Copley, *Venus and Cupid*, ca. 1779. Oil on canvas, 63.5 × 51.1 cm. Museum of Fine Arts, Boston, Bequest of Susan Greene Dexter. Bridgeman Images.

10-6 Cantelowe W. Bestland after Henry Singleton, *The Royal Academicians Assembled in Their Council Chamber, to Adjudge the Medals to the Successful Students in Painting, Sculpture, Architecture and Drawing*, 1802 (1795). Stipple engraving, 46.9 × 55.9 cm. © The Trustees of the British Museum. Art Resource, New York.

10-7 John Singleton Copley, *The Red Cross Knight*, 1793. Oil on canvas, 213.5 × 273 cm. National Gallery of Art, Washington, DC. Bridgeman Images.

11-1 John Singleton Copley, *Portrait of H.R.H. the Prince of Wales at a Review, Attended by Lord Heathfield, General Turner, Col. Bloomfield and Baron Eben*, 1809. Oil on canvas, 372.1 × 318.5 cm. Museum of Fine Arts, Boston, Bequest of Susan Greene Dexter. Bridgeman Images.

11-2 & Plate 18 John Singleton Copley, *Elizabeth Copley Greene*, 1800–02. Oil on canvas, 77.2 × 64 cm. Spencer Museum of Art, University of Kansas, Gift of Mr. and Mrs. R. Crosby Kemper Jr., 1982.0338.

THE LARGE EXTANT corpus of letters from John Singleton Copley and members of his family is as unusual among artists as it is among people of the status of his birth. Nearly five hundred family letters survive, in collections whose shape and location help to reveal the arc of the artist's life. A group of pre-1775 letters, drafts, and copies collected by the Copley family in Boston, including many by Copley and Henry Pelham, was seized by British customs when Pelham arrived in London in 1776, and has remained in the files of the Colonial Office, now in the National Archives of the United Kingdom. Most of those letters were annotated and published in 1914 under the aegis of the Massachusetts Historical Society as *Letters & Papers of John Singleton Copley and Henry Pelham, 1739–1776*. I have checked that volume against the originals in London and cited the published versions except for those few cases where the manuscript departs meaningfully from the editors' generally excellent transcription.

Most of the letters of Copley's wife's kin—the entangled Clarke, Bromfield, Rogers, and Startin families—can be found in the Bromfield Family Papers at Yale University. That large collection, not extensively used before, contains a wealth of information about the crucial turning point of the Boston Tea Party, and about the life of the Copley family into the 1780s and 1790s.

The bulk of letters written by and to the Copley family in Europe and London are held by the Library of Congress in Washington, DC, and the Massachusetts Historical Society in Boston. Many of them

were excerpted in the biography published by Martha Babcock Amory, Copley's granddaughter, in 1882. But the letters Amory included in *The Domestic and Artistic Life of John Singleton Copley* are very freely adapted, and sometimes deliberately and silently redacted. I have used the originals whenever I have been able to locate them, the first scholar to do so. Several key letters are missing, likely disappeared into the private cabinets of autograph collectors.

If Copley's life has hidden in plain sight, his art is well known, the subject of decades of nuanced analysis by art historians and museum professionals. Any student of Copley's oeuvre remains indebted, first, to Jules Prown's magisterial two-volume catalogue raisonné, *John Singleton Copley* (1966). Fifty years after its publication, Prown's work remains astonishing for its depth, its comprehensiveness, and its pioneering use of quantitative methods to trace the artist's patronage networks. Some Copleys have been discovered since, and new findings have challenged a few details of the study's arguments, but Prown's work remains indispensable.

Two major exhibitions of Copley's paintings, one of his "American" work and the other of his "English" canvases, were mounted in the mid-1990s, and generated insightful and detailed catalogs. For those researching Copley, Carrie Rebora and her coauthors' *John Singleton Copley in America* (1995) and Emily Neff and her coauthors' *John Singleton Copley in England* (1995) remain the crucial places to start.

Abbreviations Used in the Notes

COPLEY FAMILY MEMBERS

| | |
|---|---|
| ECG | Elizabeth Clarke Copley Greene (Betsy) |
| GG | Gardiner Greene |
| HP | Henry Pelham (Harry) |
| JSC | John Singleton Copley |
| JSC Jr. | John Singleton Copley Jr. |
| MC | Mary Copley |
| MCP | Mary Singleton Copley Pelham |
| SCC | Susanna Clarke Copley |

REPOSITORIES

| | |
|---|---|
| BL | British Library, London |
| LoC | Library of Congress, Washington, DC |
| MassArchs | Massachusetts State Archives, Columbia Point, Boston |
| MHS | Massachusetts Historical Society, Boston |
| NEHGS | New England Historic and Genealogical Society |
| RAA | Royal Academy of Arts Archives, Burlington House, London |
| TNA-UK | The National Archives of the United Kingdom, Kew |

NEWSPAPERS

Boston

| | |
|---|---|
| BEP | Boston Evening Post |
| BG | Boston Gazette |
| BNL | Boston News-Letter or Boston Weekly News-Letter |
| BPB | Boston Post-Boy |

London

| | |
|---|---|
| GEP | General Evening Post |
| LC | London Chronicle |
| LEP | London Evening Post |

| MC | *Morning Chronicle* |
|---|---|
| MH | *Morning Herald* |
| MP | *Morning Post* |
| PA | *Public Advertiser* |
| SJC | *St. James Chronicle* |
| WEP | *Whitehall Evening Post* |

FREQUENTLY CITED WORKS AND COLLECTIONS

| | |
|---|---|
| *American Adversaries* | Emily Ballew Neff and Kaylin H. Weber, eds., *American Adversaries: West and Copley in a Transatlantic World* (New Haven: Yale University Press, 2013) |
| *ANB* | *American National Biography* |
| Amory | Martha Babcock Amory, *The Domestic and Artistic Life of John Singleton Copley* (Boston: Houghton Mifflin, 1882) |
| BFP | Bromfield Family Papers, Manuscripts and Archives, Yale University |
| *BSM* | *Boston Selectmen's Minutes*, various years in 12 vols. (Boston: Municipal Printing Office / Record Commissioners, City of Boston, 1877–1906) |
| *BTR* | *Boston Town Records*, various years in 11 vols. (Boston: Boston Municipal Printing Office / Record Commissioners, City of Boston, 1884–1909) |
| Carter Diary | George Carter Diary, 2 vols., unpaginated manuscript in private hands |
| CFP-LoC | Copley Family Papers, Library of Congress |
| CFP-MHS | Copley Family Papers, Massachusetts Historical Society |
| *CPL* | Guernsey Jones et al., eds., *Letters & Papers of John Singleton Copley and Henry Pelham, 1739–1776* (Boston: Massachusetts Historical Society, 1914) |
| *FD* | Kenneth Garlick and Angus D. Macintyre, eds., *The Diary of Joseph Farington*, 15 vols. (New Haven: Yale University Press, 1978) |
| HGOBP | Business Papers of Harrison Grey Otis, Historic New England, Boston |
| *HMB* | Thomas Hutchinson, *The History of the Colony and Province of Massachusetts-Bay*, ed. Lawrence Shaw Mayo, 3 vols. (Cambridge: Harvard University Press, 1936) |

| | |
|---|---|
| *Hutchinson Diary* | Peter Orlando Hutchinson, ed. and comp., *The Diary and Letters of His Excellency Thomas Hutchinson, Esq.*, 2 vols. (1884; repr., New York: AMS Press, 1973) |
| *JSC in America* | Carrie Rebora and Paul Staiti, eds., *John Singleton Copley in America* (New York: Metropolitan Museum of Art / H. N. Abrams, 1995) |
| *JSC in England* | Emily Ballew Neff, ed., *John Singleton Copley in England* (Houston: Museum of Fine Arts / London: Merrell Holberton, 1995) |
| LLP-GRO | John Singleton Copley, Lord Lyndhurst Papers, Glamorgan Record Office, Cardiff, Wales |
| Lovell | Margaretta M. Lovell, *Art in a Season of Revolution: Painters, Artisans, and Patrons in Early America* (Philadelphia: University of Pennsylvania Press, 2005) |
| *NEHGR* | *New England Historical and Genealogical Register* |
| *ODNB* | *Oxford Dictionary of National Biography* |
| P-*JSC* | Jules Prown, *John Singleton Copley*, 2 vols. (Cambridge: Harvard University Press, 1966) |
| *PMHB* | *Pennsylvania Magazine of History and Biography* |
| *Rowe* | Anne Rowe Cunningham, ed., *Letters and Diary of John Rowe* (Boston: W. B. Clarke, 1903) |
| *Sibley's* | John Langdon Sibley and Clifford Kenyon Shipton, *Biographical Sketches of Graduates of Harvard University, in Cambridge, Massachusetts / Sibley's Harvard Graduates* (Cambridge: Charles William Sever, University Bookstore, 1873–) |
| *WMQ* | *The William and Mary Quarterly* |

\smile *Notes* \smile

PREFACE

1 Photograph, ca. 1951, *Paul Revere* object file, Museum of Fine Arts, Boston.
2 *MC*, 26 April 1777.
3 Eviatar Zerubavel, *Hidden in Plain Sight: The Social Structure of Irrelevance* (New York: Oxford UP, 2015). In his life and in his work, Copley in many ways refused, or rather failed to internalize, his society's concepts of margins and center.
4 On Dorothy Murray, known as Dolly, b. 1745, see Patricia Clearly, *Elizabeth Murray: A Woman's Pursuit of Independence in Eighteenth-Century America* (Amherst: U of Massachusetts P, 2000), 35, 76–77, 95–96.

CHAPTER ONE: THE PROVINCIAL EYE

1 John Bonner, *New Plan of the Great Town of Boston in New England in America* (Boston, 1743); see also Jared Sparks, ed., "Bennett's History of New England; Boston in 1740," *Proceedings of the Massachusetts Historical Society* 5 (Jan. 1861): 108–26. For the Copleys' rooms, see the inventory and administration of the estate of Richard Copley, May 1748, Suffolk County Probates, 8979, MassArchs, repr. in P-*JSC*, 8.
2 Copley as Jack: William Johnston to JSC, 14 Sept. 1764, CO 5/38, ff. 52–53, TNA-UK.
3 *BG*, 3 July 1738.
4 Bonner, *New Plan of the Great Town of Boston.*
5 Sparks, "Bennett's History of New England," 109, 111.
6 *BG*, 3 July 1738.
7 The only record of Mrs. Copley's business surfaced when she advertised that it would continue after her second marriage: *BEP*, 25 July 1748.
8 John J. McCusker, "Colonial Statistics," Table Eg 60-64, in *Historical Statistics of the United States Online*, http://hsus.cambridge.org.resources.library.brandeis.edu/HSUSWeb/toc/tableToc.do?id=Eg60-64, accessed 27 May 2014.
9 Sparks, "Bennett's History of New England," 115–16.

10 *BG*, 3 July 1738.

11 Bernard Burke, *A Genealogical and Heraldic History of the Landed Gentry of Ireland* (London: Harrison & Sons, 1899), 412; and Amory, 2–3.

12 John Singleton, Esq., to JSC Jr., ca. 1825, repr. in Amory, 3.

13 Amory, 4. See also Ambrose Leet, *A Directory to the Market Towns, Villages, Gentlemen's Seats, and Other Noted Places in Ireland* (Dublin: Printed by Brett Smith, 1819), 35, where John Copley of Ballyclough is listed with the title "Esq.," indicating that he was at least a modest property owner.

14 "Ireland Births and Baptisms, 1620–1881" database in the LDS website, https://familysearch.org/pal:/MM9.1.1/FR98-2X7. Sarah Copley must have died soon after, for she leaves no other record.

15 Aaron S. Fogelman, "Migrations to the Thirteen British North American Colonies, 1700–1775," *Journal of Interdisciplinary History* 22:4 (April 1992): 691–709, esp. 698, 704–7.

16 Clifford Kenyon Shipton, "Immigration to New England, 1680–1740," *Journal of Political Economy* 44:2 (April 1936): 225–39, esp. 227–30; Cornelia Dayton and Sharon Salinger, *Robert Love's Warnings: Searching for Strangers in Colonial Boston* (Philadelphia: U of Pennsylvania P, 2014), 23. Many of the 1710s migrants were skilled artisans.

17 *BSM, 1736–42*, 15:3–4, 7, 9–10, 12, 54, 70–72, 79–81, 148, 181; *BSM, 1716–36*, 13:311, 312–13.

18 *BTR, 1729–1742*, 12:207.

19 Gary B. Nash, *The Urban Crucible: Social Change, Political Consciousness, and the Origins of the American Revolution* (Cambridge: Harvard UP, 1979), 104, 112–19, 402. On the warning out of strangers, see Ruth Wallis Herndon, *Unwelcome Americans: Living on the Margin in Early New England* (Philadelphia: U of Pennsylvania P, 2001); and Dayton and Salinger, *Robert Love's Warnings*.

20 A county-by-county census of Ireland ca. 1732–33, appeared in numerous period sources: the *BPB*, 10 Sept. 1739, reprinted them from the London *Gentleman's Magazine*.

21 *BEP*, 19 Sept. 1737; *New-England Weekly Journal*, 8 Nov. 1737. See also *New-England Weekly Journal*, 23 Aug. 1737; *BEP*, 19 Sept. 1737, 22 May 1738; among many others.

22 *BNL*, 30 Sept. 1736. The Boston papers also featured reports of crimes committed by Irishmen in nearby cities: rape in New York (*BEP*, 25 Oct. 1736), robbery in Newport (*BNL*, 23 Sept. 1736).

23 *New-England Weekly Journal*, 26 Sept. 1738.

24 *BSM, 1736–42*, 15:316–17, 320, 328.

25 William Taylor Jr., *The Story of the Irish in Boston: Together with Biographical Sketches of Representative Men and Noted Women* (Boston: J. B. Cullen, 1889), 31 ff.

26 Joseph Williamson, "General Samuel Waldo," *Collections of the Maine Historical Society*, 1, 9 (1887): 75–93. Waldo's advertisements ran in the newspapers and as broadsides; see, e.g., *Samuel Waldo of Boston, merchant, intending with all possible expedition to settle two towns of forty families each, on a tract of land . . . lying on the western side of a navigable river known by the name of St. Georges River* (Boston, 1735). He advertised in the *BG* on the day Copley was born; *BG*, 3 July 1738. For the conditions attached to Waldo's grants see, e.g., Samuel Waldo to James Gilmore, 20 June 1738, York County Deeds, bk. 20, l.208r, York County Courthouse, Alfred, ME. Later deeds set a rent of "one Pep[p]er Corn" in perpetuity; see, e.g., Walton to James Nelson, 1738, York County Deeds, bk. 23, l.157v. Waldo seemed to relish such feudal trappings and styled himself "Hereditary Lord of Broad Bay"; Jasper Jacob Stahl, *History of Old Broad Bay and Waldoboro* (Portland, ME: Bond Wheelwright, 1956), 45, 60–78.

27 Massachusetts Archives Collection (SC1 ser. 45X), vol. 113, ff. 692–93, MassArchs.

28 Richard Copley vs. James Hamilton, July 1741, Suffolk County Court of Common Pleas Record Book, Suffolk Files, vol. 345, no. 53765; MassArchs. The debt had been contracted in May 1739, the latest possible date of the Copleys' arrival in the colonies.

29 Sebastian Zouberbuhler to Samuel Waldo, 25 May 1744, Samuel Waldo Papers, MHS.

30 Family tradition that Richard Copley "died in the West Indies about the time of the birth of the artist" (Amory, 2) is belied by the 1741 debt action. The elder Copley was alive in 1742, and dead by the time his widow probated his estate in May 1748, probably long before. The Waldo grants are thinly documented before the 1760s; the records of the lower township—the future Cushing, ME—are especially spotty. Of the forty-five names listed on the petition in which Copley's name is invoked, barely a third are mentioned in other contemporary documents. No vital records or town records survive before 1789. Military records of the thousands of New England men who served on the northern frontier in King George's War are incomplete; muster rolls of the 1745 Louisbourg expedition burned in Boston's Town House in 1747.

31 Inventory and administration of the estate of Richard Copley, May 1748, Suffolk County Probates, 8979, MassArchs. The bed, blankets, and hangings are valued at £42 10s., in an estate totaling £97 13s., 6d.

32 George Cheyne, *The English Malady: or, A Treatise of Nervous Diseases of All Kinds*, 4th ed. (London, 1734), 104–5; see also *A Collection of Select Aphorisms and Maxims; with Several Historical Observations, Curious Remarks, and Characters of Persons and Things; Taken Out of the Best Authors* (Dublin, 1722); and Henry Bracken, *The Midwife's Companion; or, A Treatise of Midwifery:*

Wherein the Whole Art Is Explained (London, 1737). Medical opinion today holds that onset typically falls between age two and age seven; see Benson Bobrick, *Knotted Tongues: Stuttering in History and the Quest for a Cure* (New York: Simon & Schuster, 1995), 17–21, 30, 170–71; Marcel Wingate, *Stuttering: A Short History of a Curious Disorder* (Westport, CT: Bergin & Garvey, 1997), 35–37. The evidence of Copley's stutter comes from later in his life; see chap. 7, below. My physical description extrapolates from Copley's self-portraits and other paintings.

33 Nash, *Urban Crucible*, 165–67, 168–72.

34 *BNL*, 12 Dec. 1745.

35 John Demos, *A Little Commonwealth: Family Life in Plymouth Colony* (New York: Oxford UP, 1970).

36 Amory, 1, 9–10. Compare to John Galt, *The Life and Studies of Benjamin West, Esq., President of the Royal Academy of London, Prior to His Arrival in England* (London: T. Cadell and W. Davies, 1816), 9–19.

37 Pelham's first children, Peter (b. 1721) and Charles (b. 1722), were baptized in London; his third, William, was born in Boston in 1729. Penelope (b. 1735) and Thomas (b. 1737) were born to Pelham and his second wife in Newport, RI. Pelham surfaces in Boston in Feb. 1728, when he offered his engraving of Mather for sale; *BNL*, 29 Feb. 1728. See also Georgia B. Barnhill, "Pelham, Peter," *ANB Online*, Feb. 2000, accessed 2 July 2014; Andrew Oliver, "Peter Pelham (ca. 1697–1751): Sometime Printmaker of Boston," in *Boston Prints and Printmakers, 1670–1775* (Boston: Colonial Society of Massachusetts / UP of Virginia, 1973), 133–69; and Meredeth B. Colket, "The Pelhams of England and New England: VII. Peter Pelham of Boston, Massachusetts," *American Genealogist* 20, no. 2 (Oct. 1943): 65–76.

38 *BNL*, 15 Feb. 1728.

39 *BNL*, 29 Feb. 1728. Mather's funeral took place 19 Feb.

40 Oliver, "Peter Pelham (ca. 1697–1751)," 170–73.

41 Sparks, "Bennett's History of New England," 125.

42 *BG*, 20 Nov., 4, 25 Dec. 1732, 1, 8 Jan. 1733. See also Barbara Lambert, "Social Music, Musicians, and Their Musical Instruments, in and around Colonial Boston"; and Cynthia Adams Hoover, "Epilogue to Secular Music in Early Massachusetts"; both in Barbara Lambert, ed., *Music in Colonial Massachusetts* (Boston: Colonial Society of Massachusetts / UP of Virginia, 1985), 409–514, 715–867.

43 *BSM, 1736–42*, 13:91; *BG*, 22 May 1738.

44 *BEP*, 30 Sept. 1745. See also *BEP*, 7 Dec. 1741, 27 Sept. 1742, 16 Jan. 1744, 20 Oct. 1746.

45 *BEP*, 6 June 1743.

46 *Charitable Irish Society, Founded 1737: Its Constitution and By-Laws . . .* (Bos-

ton, 1917), 21–22; and Taylor, *The Story of the Irish in Boston*, esp. 31–40. For Charles Pelham as secretary to the society, see *BEP*, 6 April 1741, 15 March 1742. Henry Pelham joined in 1774.

47 *BEP*, 8 Feb. 1742.

48 Helena Pelham to Peter Pelham Jr., 1 Sept. 1741, *CPL*, 9; see also Helena Pelham to Peter Pelham Jr., 19 Feb. 1742, *CPL*, 12–14.

49 *Boston Marriages 1700–1751*, vol. 28, Reports of the Record Commissioners of the City of Boston (Boston: Rockwell & Churchill, 1898) p. 288; Suffolk County Probates, 8979, MassArchs.

50 Andrew Oliver and James Bishop Peabody, eds., *The Records of Trinity Church, Boston, 1728–1830* (Boston: Colonial Society of Massachusetts, 1980), 719; Oliver, "Peter Pelham," 159–65.

51 Peter Pelham Sr. to Peter Pelham Jr., 30 Nov. 1749, *CPL*, 18.

52 *BEP*, 25 July 1748, 19 Sept. 1748. Thomas Pelham died of consumption in 1770, at the age of thirty-three, at which point two of his young children were bound to their uncle, Charles Pelham; Charles Pelham to HP, 3 Dec. 1770; Charles Pelham to HP, 28 March 1771; *CPL*, 99–100, 107–10. The elder Thomas Pelham's family had been poor before his death; Harry Pelham refers to their "poverty and Misery," in HP to Charles Pelham, 29 March 1771, *CPL*, 110.

53 For tavern keepers on and near Leverett's Lane, see *BSM*, *1736–42*, 15:202; *BSM*, *1742/43–53*, 17:79, 143.

54 Suffolk County Probates, 10085, MassArchs.

55 *Boston Births from A.D. 1700 to A.D. 1800*, vol. 24, Reports of the Record Commissioners of the City of Boston (Boston: Rockwell & Churchill, 1894), 267; *Records of Trinity Church*, 534.

56 *BNL*, 30 Dec. 1731.

57 For the press, see HP to Paul Revere, 29 March 1770, *CPL*, 83.

58 Richard Saunders, *John Smibert: Colonial America's First Portrait Painter* (New Haven: Yale UP, 1995).

59 *P-JSC*, 10.

60 AAS catalog of American engravings; Saunders, *John Smibert*, 92; Ellen G. Miles, "Portraits of the Heroes of Louisbourg, 1745–1751," *American Art Journal* 15:1 (Winter 1983): 48–66.

61 *BPB*, 22 Sept. 1746.

62 Richard H. Saunders and Ellen G. Miles, *American Colonial Portraits, 1700–1776* (Washington, DC: National Portrait Gallery, 1987), esp. 43–44. On the vexed relationship between art and markets, see Louise Lippincott, *Selling Art in Georgian London: The Rise of Arthur Pond* (New Haven: Yale UP, 1983), esp. 34, 48–52; and David H. Solkin, *Painting for Money: The Visual Arts and the Public Sphere in Eighteenth-Century England* (New Haven: Yale UP, 1993).

63 Berkeley [now George Bishop Cloyne] to Smibert, 31 May 1735, in Saunders, *John Smibert*, 256.

64 Smibert to Sir Archibald Grant, 20 May 1734, in Saunders, *John Smibert*, 255.

65 *New-England Weekly Journal*, 14, 28 Oct. 1734, 5 May 1735; see also *BNL*, 17, 24 Oct. 1734; *Weekly Rehearsal*, 21, 28 Oct. 1734; and Smibert's letters to his London supplier, Arthur Pond, repr. in Saunders, *John Smibert*, 257–60, quotation at 257.

66 Carl Bridenbaugh, ed., *Gentleman's Progress: The Itinerarium of Dr. Alexander Hamilton, 1744* (Chapel Hill: U of North Carolina P, 1948), 114.

67 Saunders, *John Smibert*, esp. 88, 123–24, 208–12, 221–23.

68 During his travels in Italy, Copley often referred Henry Pelham to what he could see "at Smibert's"; see *CPL*, 245, 304, 338, 340.

69 Smibert to Arthur Pond, 6 April 1749, repr. in Saunders, *John Smibert*, 259. No portraits painted by Smibert are listed in his account book after 1746; see Evans et al., eds., *The Notebook of John Smibert* (Boston: MHS, 1969), 99.

70 Feke was painting prolifically in Boston in 1748; see Ralph Peter Mooz, "The Art of Robert Feke" (PhD diss., Univ. of Pennsylvania, 1970), 107–60; *P-JSC*, 11–13; and Zara Anishanslin, *Portrait of a Woman in Silk: Hidden Histories of the British Atlantic World* (New Haven: Yale UP, 2016).

71 *Gentleman's Progress*, 102. Hamilton encountered Feke in Newport.

72 Mooz, "Art of Robert Feke," esp. 123–25.

73 Isaac John Greenwood, *The Greenwood Family of Norwich, England in America*, ed. H. Minot Pitman and Mary M. Greenwood (Concord, NH: privately printed, 1934), 57–58; Alan Burroughs, *John Greenwood in America, 1745–1752* (Andover, MA: Addison Gallery of American Art, Phillips Academy, 1943).

74 *P-JSC*, 13. My sense of Greenwood's character comes from the way he depicted himself in the *Greenwood-Lee Family* (ca. 1747, MFA 1983.34).

75 *P-JSC*, 9; and Oliver, "Peter Pelham," 170–73.

76 R. Campbell, *The London Tradesman: Being a Compendious View of All the Trades, Professions, Arts, . . . Now Practised in . . . London and Westminster* (London, 1747), 94. For colors see C. Taylor, *A Compendium of Colors, and Other Materials Used in the Arts Dependant on Design, with Remarks on Their Nature and Uses* ([London?], 1797).

77 Helena Maria Pelham was baptized on 26 May 1751; Pelham was buried on 14 Dec. 1751; *Records of Trinity Church*, 538, 773.

78 Suffolk County Probates, 10085, MassArchs. The will of Peter Pelham Sr. is reprinted in *CPL*, 20–22. The bequest to Peter Pelham was devised to his sister, Helena, if Peter predeceased his father.

79 Peter Pelham III, the organist, had moved to Virginia, and William Pelham, the youngest of the children from the first marriage, was said to be "of a poor constitution," never married, had no children, and died in 1761, at the age of thirty-two. See Helena Pelham to Charles Pelham, 15 Feb. 1762, *CPL*, 24; and William Henry Whitmore, *Notes concerning Peter Pelham, the Earliest Artist Resident in New England, and His Successors Prior to the Revolution* (Cambridge: J. Wilson, 1867), 14–16.

80 *BPB*, 28 Oct. 1754; *Records of Trinity Church*, 774.

81 Saunders, *John Smibert*, 122; and *BNL*, 4 April 1751. For Feke's departure from New England, see Mooz, "Art of Robert Feke," 161–85.

82 Samuel Richardson, *The Apprentice's Vade Mecum; or, Young Man's Pocket-Companion* (Dublin, 1734), 26–27.

83 Nash, *Urban Crucible*, 184–85.

84 *Industry & Frugality Proposed as the Surest Means to Make Us a Rich and Flourishing People* (Boston, 1753), 7.

85 Ibid., 13.

86 *JSC in America*, 162–66; *P-JSC*, 20. The identity of the second brother is disputed, but is most likely William, who remained in Boston.

87 *P-JSC*, 15–16; *JSC in America*, 162–63.

88 Frederic C. Torrey, *The Torrey Families and Their Children in America* (Lakehurst, NJ, 1924), 77. On Copley's mezzotint source, see *P-JSC*, 19–20; Theodore E. Stebbins Jr., "An American Despite Himself," in *JSC in America*, 80. Mann as constable: *BTR, 1742–57*, 14:229.

89 Barbara N. Parker, "Documentary Portraits by Copley," *Bulletin of the Museum of Fine Arts*, 42:248 (June 1944): 33–34. Parker sees the shift in style as evidence of Blackburn's influence, which seems dubious.

90 *P-JSC*, 17–18; *JSC in America*, 168–70; Albert Teneyck Gardner, "A Copley Primitive," *Bulletin of the Metropolitan Museum of Art* 20 (April 1963): 257–63.

91 Donald Burrows, *Handel*, 2d ed. (New York: Oxford UP, 2012), esp. 122–24, 158–59, 203–5, 218–21, 348–49, 492.

92 *BEP*, 3 April 1749; *BPB*, 3 July 1749. See also Gardner, "A Copley Primitive."

93 Burrows, *Handel*, 396–401; Cynthia Adams Hoover, "Epilogue to Secular Music in Early Massachusetts," in *Music in Colonial Massachusetts*, 788, 814–815.

94 *BEP*, 1 May 1749 (reprinting London news from Jan.).

95 "On seeing the Late Fireworks," reprinted in *BEP*, 21 Aug. 1749; *BPB*, 17 July 1749.

96 George Allen, *Some Occasional Thoughts on Genius, with an Apology for So Long Deferring the Publishing of Observations in the Art of Painting* (London, 1747), 14, 16, 17.

97 Ibid., 8–11, quotation at 9.

98 JSC to Benjamin West, 12 Nov. 1766, *CPL*, 51.

CHAPTER TWO: A DAZZLING OF SCARLET

1 JSC to Ozias Humphry, 2 July 1775, Charles Henry Hart Autograph Collection, Smithsonian Institution; Archives of American Art Online, http://www.aaa.si.edu/collections/viewer/john-singleton-copley-letter-to-unidentified-recipient-florence-italy-6897. On the sandarac-spirit varnish recipe, see Lance Mayer and Gay Myers, *American Painters on Technique: The Colonial Period to 1860* (Los Angeles: J. Paul Getty Museum, 2011), 28–30, 39 n13.

2 Charles-Alphonse Du Fresnoy, *The Art of Painting*, trans. John Dryden, 2d ed. (London, 1716), 69, 71.

3 HP to John Singleton, 16 May 1775, *CPL*, 319. On ambition in Enlightenment thought, see J. M. Opal, *Beyond the Farm: National Ambitions in Rural New England* (Philadelphia: U of Pennsylvania P, 2011), esp. 1–16.

4 JSC to Benjamin West, 17 Jan. 1768, *CPL*, 68–69.

5 JSC to Thomas Ainslie, 25 Feb. 1765, *CPL*, 33 ("diligence," "design . . . both"); JSC to Peter [Chardon], 12 Sept. 1766, *CPL*, 48 ("severe study").

6 Mary Russell to Chambers Russell, n.d. [1757], repr. in Lawrence Park, "Joseph Blackburn—Portrait Painter," *Proceedings of the American Antiquarian Society*, n.s., 32 (Oct. 1922): 273. See also Richard H. Saunders, "Blackburn, Joseph," *ANB Online*, Feb. 2000, http://www.anb.org/articles/17/17-00075.html, accessed 11 Aug. 2014; and Ellen G. Miles, "Blackburn, Joseph (fl. 1752–77)," *ODNB Online*, 2004, http://www.oxforddnb.com/view/article/65538, accessed 11 Aug. 2014. For Blackburn's stylistic influence on Copley see P-*JSC*, 22–24.

7 Jenny Uglow, *Hogarth: A Life and a World* (London: Faber and Faber, 1997), 65–69, 275–76.

8 Matthew Hargraves, *Candidates for Fame: The Society of Artists in Great Britain, 1760–1791* (New Haven: Yale UP, 2005), esp. 1–18.

9 Richard H. Saunders, *John Smibert: Colonial America's First Portrait Painter* (New Haven: Yale UP, 1995), 123–25.

10 James Northcote to Samuel Northcote, 19 Dec. 1771, James Northcote Correspondence, NOR/6, RAA. See also Deanna Petherbridge and Ludmilla Jordanova, *The Quick and the Dead: Artists and Anatomy* (Berkeley: U of Cali-

fornia P, 1997); Ann Bermingham, *Learning to Draw: Studies in the Cultural History of a Polite and Useful Art* (New Haven: Yale UP, 2000), esp. 40; and Catherine Whistler, "Life Drawing in Venice from Titian to Tiepolo," *Master Drawings* 42:4 (Winter 2004): 370–96.

11 Angela Rosenthal, *Angelica Kauffman: Art and Sensibility* (New Haven: Yale UP, 2006), esp. 189–223.

12 William Dunlap, *History of the Rise and Progress of the Arts of Design in the United States*, ed. Alexander Wycoff (1834; rptd., New York: Benjamin Blom, 1965), 1:198.

13 Du Fresnoy, *The Art of Painting*, 54, 55.

14 Jules Prown, "An *Anatomy Book* by John Singleton Copley," in Prown, *Art as Evidence: Writings on Art and Material Culture* (New Haven: Yale UP, 2001), 12–25; see also *JSC in America*, 172–74.

15 Printed Harvard catalogs, esp. 1723; digitally searchable Mather Family Library, http://www.librarything.com/profile/MatherFamilyLibrary, accessed 8 Aug. 2014. Harvard still does not own these three works. I traced Genga's appearance in scholarly libraries and book catalogs of the eighteenth century via Eighteenth-Century Collections Online.

16 Prown, "*Anatomy Book*," 13, 24.

17 *Book of Anatomical Studies*, plate III, British Museum, 1864,0514.136-143; Prown, "*Anatomy Book*," 15–18.

18 JSC to HP, 16 June 1771, *CPL*, 117. The Lyndhurst sale catalog shows that the folio of drawings remained with him till his death, and that his son kept it thereafter; see *JSC in America*, 174 n1; and *Catalogue of the Very Valuable Collection of Pictures of the Rt. Hon. Lord Lyndhurst, Deceased: Including Most of the Important Works of His Lordship's Father, That Distinguished Historical Painter, John Singleton Copley, R.A.* (London: Christie, Manson and Woods, 1864), lot 676.

19 *CPL*, 51–52, 170–71; *P-JSC*, 16. Francesco Algarotti's *An Essay on Painting* was published in Italian in 1763, had its first London edition in 1764, and arrived at the shop of the Boston bookseller John Mein in 1766. Horace Walpole's *Anecdotes of Painting in England* (London, 1762) surfaced in the Harvard College library catalog in 1773; Daniel Webb's *Inquiry into the Beauty of Painting* (London, 1760) wasn't mentioned in a book auction catalog in Boston until 1772. See Janice G. Schimmelman, *Books on Art in Early America* (New Castle, DE: Oak Knoll Press, 2007), 10, 187, 209, 227, 257–58; *Catalogus librorum Bibliothecae Collegij Harvardini quod est Cantabrigiae in Nova Anglia* (Boston, 1773), 26.

20 JSC to HP, 29 Sept. 1771, HP to JSC, 22 Oct. 1771, *CPL*, 164, 171. Copies of de Piles, and possibly Du Fresnoy as well, remained in Copley's library until his death; see lot 116 of the Lyndhurst library sale, repr. in *P-JSC*, 397.

21 Du Fresnoy, *The Art of Painting*, 13 (invention), 25 (nature and genius), 45 (grapes).

22 Roger de Piles, *The Art of Painting, with the Lives and Characters of above 300 of the Most Eminent Painters . . . To Which Is Added, an Essay towards an English School*, 3d ed. (London, 1750), 1, 9. On the new ideal of artistic genius in the Italian Renaissance, see Patricia A. Emison, *Creating the "Divine" Artist: From Dante to Michelangelo* (Leiden: Brill, 2004); and Darrin M. McMahon, *Divine Fury: A History of Genius* (New York: Basic Books, 2013), esp. chap. 3.

23 Du Fresnoy, *The Art of Painting*, 63.

24 Ibid., 65–67. De Piles, by contrast, counseled that "genius must be corrected by rules, reflection, and industry"; de Piles, *The Art of Painting*, 10, 25.

25 William Johnston to JSC, 14 Sept. 1764, CO 5/38, ff. 52–53, TNA-UK.

26 Du Fresnoy, *The Art of Painting*, 396–97; de Piles, *The Art of Painting*, 354 ff.

27 J. G. A. Pocock, *Barbarism and Religion*, vol. 3, *The First Decline and Fall* (New York: Cambridge UP, 2005), 127–78. See also Karlheinz Stierle, "Translatio Studii and Renaissance: From Vertical to Horizontal Translation," in *The Translatability of Cultures: Figurations of the Space Between*, ed. Sanford Budick and Wolfgang Iser (Stanford, CA: Stanford UP, 1996), 55–67.

28 "Verses by the Author, on the Prospect of Planting Arts and Learning in America," in George Berkeley, *A Miscellany, Containing Several Tracts on Various Subjects* (London, 1752), 186–87. See also Rexmond C. Cochrane, "Bishop Berkeley and the Progress of Arts and Learning: Notes on a Literary Convention," *Huntington Library Quarterly* 17:3 (May 1954): 229–49; and Charles L. Sanford, "An American Pilgrim's Progress," *American Quarterly* 6:4 (Dec. 1, 1954): 297–310.

29 *BNL*, 3 Sept. 1730; John Smibert, *The Notebook of John Smibert*, ed. Andrew Oliver (Boston: MHS, 1969), 102–3. On the 1730 hoax and the later use of the spurious verse by patriot writers, see John D. Seelye, *Memory's Nation: The Place of Plymouth Rock* (Chapel Hill: U of North Carolina P, 1998), 35–39.

30 JSC to Jean-Etienne Liotard, 30 Sept. 1762, *CPL*, 26.

31 Fred Anderson, *The Crucible of War: The Seven Years' War and the Fate of Empire in British North America, 1754–1766* (New York: Knopf, 2000), esp. 22–41; Mark Peterson, *The City-State of Boston* (New Haven: Yale UP, forthcoming), chap. 5; and John A. Schutz, *William Shirley, King's Governor of Massachusetts* (Chapel Hill: U of North Carolina P, 1961), 152–67.

32 Gary B. Nash, *The Urban Crucible: Social Change, Political Consciousness, and the Origins of the American Revolution* (Cambridge: Harvard UP, 1979), 242–43; Fred Anderson, *A People's Army: Massachusetts Soldiers and Society in the Seven Years' War* (Chapel Hill: U of North Carolina P, 1984), 3 n1.

33 Anderson, *People's Army*, 99–107; Nash, *Urban Crucible*, 245.

34 *BTR, 1742–57,* 12:302; *HMB* 3:29–30. For the population of the almshouse, see Eric Guest Nellis and Anne Decker Cecere, *The Eighteenth-Century Records of the Boston Overseers of the Poor* (Boston: Colonial Society of Massachusetts / U of Virginia P, 2007), esp. 113–19. On the northern campaigns, see Anderson, *Crucible of War,* 77–87; George Rawlyk, *Nova Scotia's Massachusetts: A Study of Massachusetts-Nova Scotia Relations, 1730–1784* (Montreal: McGill-Queen's UP, 1973), chap. 11.

35 William Smith quoted in Nash, *Urban Crucible,* 236. See also Stephen Brumwell, *Redcoats: The British Soldier and War in the Americas, 1755–1763* (Cambridge, UK: Cambridge UP, 2002); and Thomas M. Truxes, *Defying Empire: Trading with the Enemy in Colonial New York* (New Haven: Yale UP, 2008). On the role of Thomas Hancock in the Acadian expulsion, see John Mack Faragher, *A Great and Noble Scheme: The Tragic Story of the Expulsion of the French Acadians from Their American Homeland* (New York: Norton, 2005).

36 Isaac Morrill, *The Soldier Exhorted to Courage* (Boston, 1755), 13, 15; see also Rawlyk, *Nova Scotia's Massachusetts,* 207–9.

37 Bernard Bailyn, *The Ideological Origins of the American Revolution* (Cambridge: Harvard UP, 1967), 61–63, 112–19; John Phillip Reid, *In Defiance of the Law: The Standing-Army Controversy, the Two Constitutions, and the Coming of the American Revolution* (Chapel Hill: U of North Carolina P, 1981).

38 For versions of this argument, see Douglas Edward Leach, *Roots of Conflict: British Armed Forces and Colonial Americans, 1677–1763* (Chapel Hill: U of North Carolina P, 1986), esp. 76–133; and Anderson, *People's Army,* esp. 111–41; contra Brumwell, *Redcoats,* 2–4.

39 John Maylem, *The Conquest of Louisbourg: A Poem* (Boston, 1758), 11–12; see also Brumwell, *Redcoats,* esp. 26–30, 49–53.

40 Samuel Johnson, *Idler Number 5,* reprinted in *BEP,* 2 Oct. 1758.

41 "Extract from the *Monitor,*" *BEP,* 17 April 1758; Daniel Jones advertisement, *BEP,* 18 Feb. 1760; John Gore advertisement, *BG,* 9 March 1761. In later letters, Copley orders "finest Vermillion" from London, the only pigment other than white lead that the surviving records show he regularly imported; see *CPL,* 115, 141. On artist's materials in British America, see also Mayer and Myers, *American Painters on Technique,* 1–4.

42 See chap. 1, above; and Ellen G. Miles, "Portraits of the Heroes of Louisbourg, 1745–1751," *American Art Journal* 15:1 (Winter 1983): 48–66.

43 *BTR, 1742–57,* 12:260–61.

44 *BEP,* 18 Sept. 1758.

45 J. Clarence Webster, ed., *The Journal of Jeffery Amherst: Recording the Military Career of General Amherst in America from 1758 to 1763* (Chicago: U of Chicago P, 1931), 85–86. The connection to Thomas Hancock is documented in Park, "Joseph Blackburn—Portrait Painter," 274, 278–79.

46 The picture, long mistakenly attributed to John Greenwood, is signed and dated; see Bayley, *Life and Works of JSC*, 258; P-*JSC*, 21–22. Prown notes the painting's formal affinities with two canvases by Feke: *Isaac Winslow* (1748) and *Tench Francis* (1746). For Winslow's biography, see John Clarence Webster, ed., "The Journal of Joshua Winslow, Recording His Participation in the Events of the Year 1750, Memorable in the History of Nova Scotia," *Publications of the New Brunswick Museum*, no. 2 (1936): 7–12.

47 "William Brattle," *Sibley's*, 7:10–23; William Brattle, *Sundry Rules and Directions for Drawing Up a Regiment* . . . (Boston, 1733).

48 C. P. Stacey, "Scott, George," *Dictionary of Canadian Biography*, http://www .biographi.ca/en/bio/scott_george_3E.html, accessed 8 Sept. 2014; Faragher, *Great and Noble Scheme*, 275, 292–93.

49 Robert J. Dunkle and Ann S. Lainhart, *The Records of the King's Chapel in Boston*, CD-ROM, NEHGS, 2001, 58. The portrait could also have been painted in Dec. 1759, when Scott married Abigail Erving; *Boston Marriages from 1752 to 1809*, vol. 30, Records Relating to the Early History of Boston (Boston: Municipal Printing Office, 1903), 326.

50 Bayley, *Life and Works of John Singleton Copley*, 221; Brumwell, *Redcoats*, 145–50.

51 Lovell, 60–70, discusses the shell in the portrait of *Mrs. Jonathan Belcher*, but not the fountain. See also S. Buggey, "Belcher, Jonathan," in *Dictionary of Canadian Biography*, http://www.biographi.ca/en/bio/ belcher_jonathan_4E.html, accessed Sept. 8, 2014.

52 Thomas Ainslie to JSC, 8 Oct. 1757, *CPL*, 23.

53 Waldo himself was painted by Robert Feke in 1748. For Waldo's wartime service, see Joseph Williamson, "General Samuel Waldo," *Collections of the Maine Historical Society*, ser. 1, 9 (1887): 75–93.

54 New Hampshire and Nova Scotia sitters counted for a small percentage of Copley's American output (just over 5 percent) but a disproportionate number of early commissions; P-*JSC*, 120–21. Prown calls this patronage network "surprisingly far-flung geographically," P-*JSC*, 27. When we take the war into account, it is not surprising at all.

55 Quoted in Douglas Fordham, *British Art and the Seven Years' War: Allegiance and Autonomy* (Philadelphia: U of Pennsylvania P, 2010), 2; see also M. John Cardwell, *Arts and Arms: Literature, Politics and Patriotism during the Seven Years War* (Manchester: Manchester UP, 2004); and Holger Hoock, *Empires of the Imagination: Politics, War, and the Arts in the British World, 1750–1850* (London: Profile Books, 2010).

56 Ellen G. Miles et al., *American Paintings of the Eighteenth Century* (New York: Oxford UP for the National Gallery of Art, 1995), 351–62; Nash, *Urban Crucible*, 234–42.

57 John Galt, *The Life and Studies of Benjamin West, Esq., President of the Royal Academy of London, Prior to His Arrival in England* (London: T. Cadell and W. Davies, 1816), 9–11, 17–18. On Galt's biography and West's work of self-invention, see Susan Rather, "Benjamin West, John Galt, and the Biography of 1816," *Art Bulletin* 86:2 (June 1, 2004): 324–45; and Ann Uhry Abrams, *The Valiant Hero: Benjamin West and Grand-Style History Painting* (Washington, DC: Smithsonian Institution P, 1985), chap. 2.

58 West to Thomas Eagles, 10 Oct. 1810, repr. in David H. Dickason, "Benjamin West on William Williams: A Previously Unpublished Letter," *Winterthur Portfolio* 6 (1970): 130, 131; Galt, *Life and Studies*, 1:21–22 (box of supplies). For Gravelot's illustrations, see *Histoire de Tom Jones, ou l'Enfant Trouvé* (London, 1750).

59 Dickason, "West on Williams," 131; Galt, *Life and Studies*, 1:27–29.

60 Allen to William Beckford, 27 Nov. 1755, in William Allen, *Extracts from Chief Justice William Allen's Letter Book* ([Pottsville, PA: Standard Pub. Co.], 1897), 31; Jerome H. Wood, *Conestoga Crossroads: Lancaster, Pennsylvania, 1730–1790* (Harrisburg: Pennsylvania Historical and Museum Commission, 1979), 74–75.

61 Charles I. Landis, "Benjamin West and His Visit to Lancaster," *Historical Papers and Addresses of the Lancaster County Historical Society* 29:5 (May 1925): 57–61; see also Scott Paul Gordon, "Martial Art: Benjamin West's 'The Death of Socrates,' Colonial Politics, and the Puzzles of Patronage," *WMQ*, 3d ser., 65:1 (Jan. 2008): 71–72, 73–76; and Wood, *Conestoga Crossroads*, 142, 133.

62 Smith also contemplated enrolling Indians at the college; William Smith, *A General Idea of the College of Mirania with a Sketch of the Method of Teaching Science and Religion, in the Several Classes* (New York, 1753), 14; see also Horace Wemyss Smith, *Life and Correspondence of the Rev. William Smith, D. D. . . . with Copious Extracts from His Writings* (Philadelphia: Ferguson Bros., 1880), 1:129–51.

63 "Preface to the Poetical Essays" and "Upon Seeing the Portrait of Miss **—** by Mr. West," *American Magazine and Monthly Chronicle*, Feb. 1758, p. 238.

64 "Verses inscribed to Mr. Wollaston," *American Magazine and Monthly Chronicle*, Sept. 1758, pp. 607–8. On the influences of West's early painting masters, including Williams and Wollaston, see Ann Uhry Abrams, "A New Light on Benjamin West's Pennsylvania Instruction," *Winterthur Portfolio* 17:4 (Dec. 1982): 243–57.

65 "Preface to the Poetical Essays," *American Magazine and Monthly Chronicle*, Feb. 1758, p. 237.

66 *BG*, 12 June 1758; see also *BNL*, 29 Dec. 1757; *BEP*, 3 April 1758. See also Lyon H. Richardson, *A History of Early American Magazines, 1741–1789*

(1931; repr., New York: Octagon Books, 1966), 99–123; and Rodney Mader, "Politics and Pedagogy in the *American Magazine, 1757–58*," *American Periodicals* 16:1 (2006): 3–22.

67 Copley painted a miniature of the British officer John St. Clair, who was stationed in Philadelphia and stopped briefly in Boston. St. Clair may have overlapped with West's pro-war circles, so West could possibly have heard of the Boston painter; *JSC in America*, 181.

68 See advertisements in *BEP*, 24 Sept. 1750, 27 Jan. 1752, 21 April 1755 (quoted), 2 Oct. 1758, 11 Feb. 1760, and 15 Dec. 1760.

69 Suffolk County Deeds, book 92, ff. 136r–138r, MassArchs.

70 Including the strip of land purchased from the Jackson estate, Copley's lot had bases of 49 feet (on Cambridge Street) and 54 feet, and sides of 164 feet and 187 feet long. The estimated area is approximately .22 acres.

71 *BEP*, 4 Sept. 1758.

72 Samuel Fayerweather to JSC, 7 July 1963, *CPL*, 27–28.

73 *BPB*, 8 April 1751; *BG*, 9 April 1751 (Smibert); *BG*, 13 May 1765 (Badger).

74 *BPB*, 18 Nov. 1765. For the etymology of *limner*, see *OED*.

75 Mason advertised in *BPB*, 26 April 1762; Bryant in *BEP*, 27 Sept. 1762.

76 Reprinted in *BG*, 7 May 1764. The painter was Joshua Reynolds.

77 Jonathan Richardson, *An Essay on the Theory of Painting* (London, 1715), 24–25. On Georgian gentry and bespoke tradesfolk, see Amanda Vickery, *Behind Closed Doors: At Home in Georgian England* (New Haven: Yale UP, 2009).

78 William Hazlitt, "On Sitting for One's Picture," in *The Plain Speaker: Opinions on Books, Men, and Things* (London: H. Colburn, 1826), 262, 264.

79 Richardson, *Essay on the Theory of Painting*, 24, 10.

80 R. Campbell, *The London Tradesman, Being a Compendious View of All the Trades, Professions, Arts, . . . Now Practiced in . . . London and Westminster* (London, 1747), 94.

81 Richardson, *Essay on the Theory of Painting*, 9, 10, 16. The quasi-sexual intimacy of the sitting is one reason that portraiture was considered a fraught occupation for female artists. See Angela Rosenthal, "She's Got the Look! Eighteenth-Century Female Portrait Painters and the Psychology of a Potentially 'Dangerous Employment,'" in Joanna Woodall, ed., *Portraiture: Facing the Subject* (Manchester, UK: Manchester UP, 1997), 147–66.

82 Thomas Ainslie to JSC, 12 Nov. 1764, *CPL*, 30.

83 Staiti, "Character and Class"; Carrie Rebora Barratt, *John Singleton Copley and Margaret Kemble Gage: Turkish Fashion in 18th-Century America* (San Diego, CA: Putnam Foundation, 1998), esp. 10–12; and Leslie Kaye Reinhardt, "Fabricated Images: Invented Dress in British and Colonial Portraits"

(PhD diss., Princeton Univ., 2003). Copley's use of a layman is documented in *CPL*, 117, 126, 132, 146, 246, 297, 298.

84 Carter Diary, 12 Oct. 1774. For Copley's stature, see Henry Singleton, *The Royal Academicians*, 1795. Copley was nearly sixty when Singleton painted the group portrait, and could have shrunk modestly, though others in the scene were similarly aged.

85 Henry Sargent's letters are quoted in Dunlap, *Rise and Progress*, 1:144. Margaretta Lovell works out that the Sargent portrait would have taken Copley some ninety hours, compared with Joshua Reynold's estimate of five to eight hours per sitter; Lovell, 56–58. Rembrant Peale recalled the ordeal of Mrs. Thomas Mifflin's much-labored-over hands; "Reminiscences. Exhibitions and Academies," *Crayon* 1:19 (May 9, 1855): 290.

86 *FD*, 10:3712 (17 Aug. 1810); Charles Robert Leslie quoted in Dunlap, *Rise and Progress*, 144; Sir Edwin Knatchbull quoted in *FD*, 6:2259 (3 March 1804).

87 *HMB*, 3:60–61; *BG*, 22 Oct. 1759. The celebration took place on Oct. 16.

88 *BG*, 22 Oct. 1759.

CHAPTER THREE: THE IMPERIAL EYE

1 *BEP*, 29 Dec. 1760.

2 *BG*, 5 Jan. 1761 ("sorrowful"); "On the Death of His Late Majesty, and the Accession of King George III," *BNL*, 1 Jan. 1761. See also Brendan McConville, *The King's Three Faces: The Rise & Fall of Royal America, 1688–1776* (Chapel Hill: U of North Carolina P, 2006), 108–9, 213–15.

3 *Pietas et Gratulatio Collegii Cantabrigiensis apud Novanglos* (Boston, 1761), 23.

4 *BG*, 5 Jan. 1761; *Pietas et Gratulatio*, xiii; see also Jeremy Black, *George III: America's Last King* (New Haven: Yale UP, 2006), 43–70.

5 *BEP*, 16 Nov. 1761 (procession); *BPB*, 26 Oct. 1761 (bed); *BPB*, 8 Feb. 1762 (ribbons for sale). See also Black, *George III*, 47–49; and Holger Hoock, *Empires of the Imagination: Politics, War and the Arts in the British World, 1750–1850* (London: Profile Books, 2010), 23–36.

6 The last campaign in which large numbers of New England men were involved took place in 1760. Fred Anderson notes, "By 1760 or 1761 at the very latest, the Bay Colony's whole political and economic system had come to depend on the imperial war-making machinery," in *A People's Army: Massachusetts Soldiers and Society in the Seven Years' War* (Chapel Hill: U of North Carolina P, 1984), 21; see also Gary B. Nash, *The Urban Crucible: Social Change, Political Consciousness, and the Origins of the American Revolution* (Cambridge: Harvard UP, 1979), 246–53.

7 *BPB*, 24 March 1760.

8 *BPB*, 28 April 1760; [Andrew Johonnot], *A Poem on the Rebuke of God's Hand*

in the Awful Desolation Made by Fire in the Town of Boston, on the 20th Day of
March, 1760 (Boston, 1760).

9 *A Volume of Records Relating to the Early History of Boston: Containing Mis-
cellaneous Papers*, vol. 29 (Boston: Municipal Printing Office, 1900), 17,
91 (Brattle), 95 (Oliver), 99 (Winslow). For other claims enumerating art
losses, see *Boston Miscellaneous Papers*, 29:6, 13, 14, 51, 59, 67, 76, 78, 86.
At least two claimants specified "family pictures" in the range of value
that we know Copley charged: one pair worth £9 and another worth £15.
This is especially interesting in light of Margaretta Lovell's discovery
that family portraits were rarely enumerated in probate inventories; see
Lovell, 21–22, 137–39. Of course, probate inventories, which were tied
to tax valuations, had cause to understate the worth of objects, whereas
petitions that served as proxies for insurance claims had reason to inflate
them.

10 *BPB*, 24 March 1760.

11 *HMB*, 3:58; *Boston Miscellaneous Papers*, 29:100. For conversion of values to
modern currency see http://www.measuringworth.com/.

12 "To the Honorable the Commons of Great Britain in Parliament Assem-
bled," ca. May 1760, in *Boston Miscellaneous Papers*, 29:iv–vi.

13 *P-JSC*, 33, 128–29. Prown assigns eleven undated portraits to ca. 1758–61.

14 The discharge of the mortgage is indicated on the deed: Copley to William
Brown, 12 Dec. 1758, Suffolk Deeds, vol. 92, fol. 138r, MassArchs. The
terms of the mortgage specified that the balance of £120 was due to Browne
on 12 Dec. 1759.

15 For Neptune quieting the seas on Britain's behalf, see *Pietas et Gratulatio*, 30,
80–81. The cartouche of William Price's *New Plan of ye Great Town of Boston
in New England* (1743) and the updated 1769 edition of the same map both
feature the pair.

16 The *Betty Sally* cleared Philadelphia on 27 March 1760; news of the great
fire did not reach that city until 3 April; *Pennsylvania Gazette*, 27 March, 3
April 1760. For the voyage see Joseph Shippen Letterbook, Shippen Family
Papers, 1701–1856, Box 1, Collection 595, Historical Society of Pennsylva-
nia (hereafter HSP); Joseph Shippen Travel Journal, 1760–61, vol. 1 (unpag-
inated), collection Am.1373, HSP.

17 Joseph Shippen to Edward Shippen Jr., 13 July 1760; Joseph Shippen to
Edward Shippen Sr., 13 July 1760, Joseph Shippen Letterbook; John Galt,
*The Life and Studies of Benjamin West, Esq., President of the Royal Academy of
London, Prior to His Arrival in England* (London: T. Cadell and W. Davies,
1816), 92–94.

18 Stephen Brobeck, "Revolutionary Change in Colonial Philadelphia: The
Brief Life of the Proprietary Gentry," *WMQ*, 3d ser., 33:3 (July 1976):

410–34; and Norman Cohen, "William Allen: Chief Justice of Pennsylvania, 1704–1780" (PhD diss., Univ. of California, Berkeley, 1966). On mid-Atlantic merchants and the French West Indies, see William S. Sachs, "The Business Outlook in the Northern Colonies, 1750–1775" (PhD diss., Columbia Univ., 1957), 85–92; Marc Matthew Egnal, "The Pennsylvania Economy, 1748–1762: An Analysis of Short-Run Fluctuations in the Context of Long-Run Changes in the Atlantic Trading Community" (PhD diss., Univ. of Wisconsin, 1974), 185, 195–202; and Thomas M. Truxes, *Defying Empire: Trading with the Enemy in Colonial New York* (New Haven: Yale UP, 2008), chaps. 4 and 5.

19 Joseph Shippen Letterbook, HSP. Arthur Jensen calls this "one of the largest-scale smuggling ventures" of the period; *The Maritime Commerce of Colonial Philadelphia* (Madison: State Historical Society of Wisconsin, 1963), 133.

20 William Coxe to Joseph Shippen and John Allen 3 March 1760, Joseph Shippen Letterbook, HSP.

21 Allen to David Barclay, 16 April 1760; Allen to David Barclay, 10 Aug. 1761, in William Allen, *Extracts from Chief Justice William Allen's Letter Book* ([Pottsville, PA: Standard Pub. Co.], 1897), 11, 47.

22 Nicholas B. Wainwright, ed., "Notes and Documents: Conversations with Benjamin West," *PMHB* 102:1 (Jan. 1978): 111 ("mistress of the world"); Galt, *Life and Studies*, 1:103 (Albani meeting).

23 Galt, *Life and Studies*, 1:104–7, quotations at 105, 106; see also Julia A Sienkewicz, "Beyond the Mohawk Warrior: Reinterpreting Benjamin West's Evocations of American Indians," *19: Interdisciplinary Studies in the Long Nineteenth Century*, no. 9 (Nov. 2009), http://19.bbk.ac.uk/index.php/19/article/view/515/667.

24 Joel Barlow, *The Columbiad: A Poem* (Philadelphia: C. and A. Conrad, 1807), 430; see also Helmut von Erffa and Allen Staley, *The Paintings of Benjamin West* (New Haven: Yale UP, 1986), 420–21.

25 The first appearance of "the Raphael of America" comes in Joseph Shippen to Edward Shippen Jr., 9 Sept. 1760, Shippen Family Papers, 1744–1878, American Philosophical Society. Robert C. Alberts mistakenly dates the nickname to 1763, which may be the first time it appeared in print; *Benjamin West: A Biography* (Boston: Houghton Mifflin, 1978), 54.

26 For West's years in Italy, see, in addition to Galt, von Erffa and Staley, *Paintings of Benjamin West*, 14–23 and catalog nos. 504–7, 509–11, 516–20; Alberts, *Benjamin West*, 29–56; Christopher Lloyd, "Benjamin West and Italy," in *American Adversaries*, 150–59; and E. P. Richardson, "West's Voyage to Italy, 1760, and William Allen," *PMHB* 102:1 (Jan. 1978): 3–26.

27 John Brewer, "Whose Grand Tour?" in *The English Prize: The Capture of the Westmorland, an Episode of the Grand Tour*, ed. María Dolores Sánchez-Jáuregui and Scott Wilcox (New Haven: Yale UP, 2012), 45–62; Andrew Wilton and Ilaria Bignamini, eds., *Grand Tour: The Lure of Italy in the Eighteenth Century* (London: Tate Gallery, 1996); and Jeremy Black, *The British and the Grand Tour* (London: Croom Helm, 1985).

28 Von Erffa and Staley, *Paintings of Benjamin West*, 17.

29 Galt, *Life and Studies*, 1:143. Benedict Anderson has labeled this phenomenon of affection for a never-visited "home" "long-distance nationalism"; Anderson, "Exodus," *Critical Inquiry* 20:2 (Winter, 1994): 314–27; see also Michael Warner, "What's Colonial about Colonial America?," in *Possible Pasts: Becoming Colonial in Early America*, ed. Robert Blair St. George (Ithaca: Cornell UP, 2000), esp. 63–67.

30 Julie M. Flavell and Gordon Hay, "Using Capture-Recapture Methods to Reconstruct the American Population in London," *Journal of Interdisciplinary History* 32:1 (July 2001): 37–53; Julie Flavell, "Decadents Abroad: Reconstructing the Typical Colonial American in London in the Late Colonial Period," in *Old World, New World: America and Europe in the Age of Jefferson*, ed. Leonard J. Sadosky et al. (Charlottesville: U. of Virginia P, 2010), 32–61; Julie Flavell, *When London Was the Capital of America* (New Haven: Yale UP, 2010); and Susan Lindsey Lively, "Going Home: Americans in Britain, 1740–1776" (PhD diss., Harvard Univ., 1997), chap. 1. Lively documents three times as many Americans going to England in the 1760s as in the 1740s.

31 West to Shippen, 1 Sept. 1763, in Richardson, "West's Voyage to Italy," 23.

32 Daniel Defoe, *A Tour through the Whole Island of Great Britain*, ed. G. D. H. Cole and D. C. Browning (London: Dent; New York: Dutton, 1962), 323. See also Jerry White, *A Great and Monstrous Thing: London in the Eighteenth Century* (Cambridge: Harvard UP, 2013); and M. Dorothy George, *London Life in the Eighteenth Century* (New York: Harper & Row, 1965).

33 Cesar de Saussure, *A Foreign View of England in the Reigns of George I and George II: The Letters of Monsieur Cesar de Saussure to His Family*, trans. Madame Van Muyden (London: John Murray, 1902), 94–95, 169–171, quotation at 95.

34 *Spectator*, no. 69, 19 May 1711.

35 *London and Its Environs Described* (London, 1761), preface, n.p.

36 James Boswell, *Life of Johnson*, ed. R. W. Chapman (New York: Oxford UP, 2008), 859 (20 Sept. 1777).

37 Henry Trueman Wood, *A History of the Royal Society of Arts* (London: J. Murray, 1913), chaps. 1, 7. Quotations from *LEP*, 17 April 1760; see also *WEP*, 19 April, 8, 15 May 1760.

38 Society minutes quoted in Matthew Hargraves, *Candidates for Fame: The*

Society of Artists of Great Britain, 1760–1791 (New Haven: Yale UP, 2005), 26. The verse "Apollo and Albion" appears in the *Public Ledger*, 29 April 1760. For the royal visit to the exhibition, see ibid., 7 May 1760; and *LC*, 8 May 1760.

39 *SJC*, 14 May 1761; *LC*, 10 May 1763.

40 Hargraves, *Candidates for Fame*, 26–32.

41 Joshua Reynolds, "Discourse I, Delivered at the Opening of the Royal Academy, January 2, 1769," in Reynolds, *Discourses on Art*, ed. Robert R. Wark (New Haven: Yale UP, 1997), 13. On the arts in the wake of the Seven Years' War, see Douglas Fordham, *British Art and the Seven Years' War: Allegiance and Autonomy* (Philadelphia: U of Pennsylvania P, 2010); Hargraves, *Candidates for Fame*; and Holger Hoock, *The King's Artists: The Royal Academy of Arts and the Politics of British Culture, 1760–1840* (Oxford: Clarendon Press, 2003).

42 *PA*, 2 May 1764.

43 Allen to Benjamin Chew, 27 Jan. 1764, in "William Allen–Benjamin Chew Correspondence, 1763–1764," *PMHB* 90:2 (April 1966): 221.

44 Von Erffa and Staley, *Paintings of Benjamin West*, 534–35.

45 The French verses appeared in *PA*, 20 April 1764. Three days later, the paper published one English version and noted that the editors had "received several other Translations." On 25 April they published a Latin version, and promised not to "surfeit our Readers with too much on the same subject." That issue also contained a letter pointing out that the verses in question were a close paraphrase of an older poem addressed to the French poet Bernard le Bouyer de Fontenelle.

46 *PA*, 2 May 1764.

47 Flavell, *When London Was the Capital of America*, 165–83.

48 Catherine Molineux, "Pleasures of the Smoke: 'Black Virginians' in Georgian London's Tobacco Shops," *WMQ*, 3d ser., 64:2 (April. 2007): 327–76.

49 Henry Howard [attr.], *A New Humorous Song, on the Cherokee Chiefs Inscribed to the Ladies of Great Britain* (London, 1762). On the visit of the Cherokee delegation, see John Oliphant, "The Cherokee Embassy to London, 1762," *Journal of Imperial and Commonwealth History* 27:1 (Jan. 1999): 1–26. The rage for Indian prints dates back at least to 1710; see Eric Hinderaker, "The 'Four Indian Kings' and the Imaginative Construction of the First British Empire," *WMQ*, 3d ser., 53:3 (July 1996): 487–526. For the growth of Black London, see Flavell, *When London Was the Capital of America*, 27–61.

50 On the rise of America/Americans in print culture as a referent for North American provincials in the mid-eighteenth century, see the pioneering content analysis by Richard L. Merritt, *Symbols of American Community, 1735–1775* (New Haven: Yale UP, 1966).

51 A search of the Burney Collection of British Newspapers database for the year 1763 turns up 39 uses of "Americans," which break down as follows:

| QUALIFIERS/CONTEXTS | INSTANCES |
|---|---|
| Royal Americans (60th Regiment of Foot) | 20 |
| "The Americans" or "Americans" in the context of trade | 12 |
| "Savage" or "poor" Americans, or other ref. to indigenous | 3 |
| North Americans | 3 |
| "English Americans," as distinct from "savages" | 1 |

A search of the America's Historical Newspapers database for "Americans" in 1763 turns up a similar pattern among the 55 total usages for that year:

| QUALIFIERS/CONTEXTS | INSTANCES |
|---|---|
| Royal Americans (60th Regiment of Foot) | 51 |
| "The Americans" or "Americans" in the context of trade | 3 |
| "Savage" or "poor" Americans, or other ref. to indigenous | 1 |

In both databases, "American" yields larger numbers, typically in adjectival form, but follows similar patterns. "Americans" appears with greater frequency in both American and British prints a decade later, with 93 instances in the Burney Collection and 275 in America's Historical Newspapers.

52 Susan Rather also reads the label as a compliment; see "A Painter's Progress: Matthew Pratt and 'The American School,'" *Metropolitan Museum Journal* 28 (Jan. 1993): 178–79.

53 Pratt's manuscript autobiographical notes, reprinted in William Sawitzky, *Matthew Pratt, 1734–1805* (New York: New-York Historical Society, 1942), 19. On the students who worked with West in London, see Dorinda Evans, *Benjamin West and His American Students* (Washington, DC: National Portrait Gallery / Smithsonian Institution P, 1980), esp. 24–70.

54 Rather, "A Painter's Progress"; see also Carrie Rebora Barratt, "Inventing American Stories, 1765–1830," in *American Stories: Paintings of Everyday Life, 1765–1915*, ed. Barratt and H. Barbara Weinberg (New Haven: Yale UP / Metropolitan Museum of Art, 2009), 2–5.

55 Sawitzky, *Matthew Pratt*, 23.

56 Bernard to Richard Jackson, 7 Jan. 1764, in Colin Nicolson, ed., *The Papers of Francis Bernard: Governor of Colonial Massachusetts, 1760–69* (Boston: Colonial Society of Massachusetts, 2007), 2:29.

57 *BG*, 2, 16, 23 Jan. 1764.

58 JSC to [Charles Pelham?], 24 Jan. 1764, *CPL*, 29.

59 *BG*, 12 March 1764. Advertisements for traders removing their stock to the country appear in issues of the *BG* throughout March and April.

60 *BG*, 30 Jan. 1764.

61 Margaret Holyoke Mascarene to John Mascarene, 30 Jan. 1764, repr. in Francis Apthorp Foster, *The Burning of Harvard Hall, 1764, and Its Consequences* (Boston: J. Wilson and Son, UP, 1911), 3. On Holyoke's chair, see Jonathan Prown, "John Singleton Copley's Furniture and the Art of Invention," *American Furniture*, 2004, http://www.chipstone.org/html /publications/2004AF/Prown/2004Prownindex.html. Jules Prown dates the Holyoke portrait to ca. 1759–61 on stylistic grounds; *JSC*, 33–34.

62 "The Lamentation of Harvard," in Foster, *Burning of Harvard Hall*, 8–9.

63 *BG*, 6 Feb., 7 May 1764 (Sugar Act text). News of the native uprising now known as Pontiac's Rebellion ran in almost every issue of the newspaper through the year.

64 "Instructions for the Representatives," 24 May 1764, in *BTR, 1758–69*, 16:119–22, quotation at 121; see also Richard Archer, *As If an Enemy's Country: The British Occupation of Boston and the Origins of Revolution* (New York: Oxford UP, 2010), 1–19.

65 *BG*, 11 June 1764. George III was born on 4 June.

66 Bernard to John Pownall, 11 July 1764, *Papers of Francis Bernard*, 2:100.

67 James Otis, *The Rights of the British Colonies Asserted and Proved* (Boston, 1764), 24, 29. This was an explosive argument, but given Otis's "Violent & Vehement" temperament, Bernard found the pamphlet "more temperate & decent than was at first expected"; Bernard to John Pownall, 2 Aug. 1764, *Papers of Francis Bernard*, 2:111.

68 *BG*, 24 Sept. (leather garb), 13 Aug. 1764 (cheese).

69 *BG*, 1 Oct. 1764.

70 Estimates extrapolated from statistical work done by Prown; see P-*JSC*, 117–21. Prown's date categories are largely based on stylistic analysis. I have counted only dated portraits and, in instances where one of a marital pair is dated, its pendant.

71 P-*JSC*, 36–37; Paul Staiti, "Character and Class," in *JSC in America*, 53–78.

72 "Account of Sundries on Board Captain Tuckerman for N. Sparhawk," Nov. 1754, in Henry S. Burrage, "Colonel Nathaniel Sparhawk of Kittery," *Collections and Proceedings of the Maine Historical Society* 9:2 (1898), 242–43.

73 *JSC in America*, 203–5. Sparhawk's financial collapse in 1758 is noted in Burrage, "Colonel Nathaniel Sparhawk of Kittery," 250–51.

74 Ainslie to JSC, 12 Nov. 1764, *CPL*, 30–31.

75 JSC to Thomas Ainslie, 25 Feb. 1765, *CPL*, 32–33.

76 "Remarks on the Late Exhibitions at Spring-Gardens," *Gentleman's Magazine*, May 1764, p. 233.

77 HP to JSC, 22 Oct. 1771, *CPL*, 170.

78 *BPB*, 8 Feb. 1762.

79 Search for "London" in advertisements in newspapers published in Boston, ca. 1760–65, America's Historical Newspapers, accessed 18 Nov. 2014. Quotations from *BG*, 16, 30 Jan., 12 March 1764.

80 *Rowe*, 74, 75 (cold), 64 (black act); Arthur M. Schlesinger, *The Colonial Merchants and the American Revolution, 1763–1776* (New York: Columbia Univ., 1918), 57.

81 "Letters of James Otis, 1764, 1765," in *Proceedings of the Massachusetts Historical Society* 43, 3d ser., (1909): 205–7; and *Rowe*, 74. Francis Bernard (correctly) blamed the colony's lack of bankruptcy protections; see Bernard to Board of Trade, 8 April 1765, *Papers of Francis Bernard*, 2:236–37. Scott's stock is described in *BG*, 28 Jan. 1765; see also *BNL*, 19 April 1765; *BG*, 24 June 1765.

82 The Scollay portraits are signed and dated; Copley also did pastels after the oil versions in 1764. See P-*JSC*, 36–37. Prown dates the Scott portraits to ca. 1765 on stylistic grounds (P-*JSC*, 53), but it seems all but impossible that Copley painted the couple in the year of Scott's devastating failure.

83 Bernard to Board of Trade, 8 April 1765, *Papers of Francis Bernard*, 2:237, 241 n7.

84 *BEP*, 27 May 1765; *BPB*, 3 June 1765. See also Arthur M. Schlesinger, "The Colonial Newspapers and the Stamp Act," *New England Quarterly* 8:1 (March 1935): 63–83.

85 Edes & Gill, printers of the *BG*, published the text of the act as a pamphlet on June 24; see *BG* and *BEP*, 24 June 1765; and *BNL*, 27 June 1765. The schedule of duties can be found at http://avalon.law.yale.edu/18th_century /stamp_act_1765.asp. The best introduction remains Edmund S. Morgan and Helen M. Morgan, *The Stamp Act Crisis: Prologue to Revolution* (Chapel Hill: U of North Carolina P, 1953).

86 *BG*, 8 July 1765.

87 Bernard to John Pownall, 5 June 1765; Bernard to Board of Trade, 15 Aug. 1765, in *Papers of Francis Bernard*, 2:278, 280 n2, 301.

88 James Northcote to Samuel Northcote, 19 Dec. 1771, James Northcote Correspondence, letter 6, RAA; and Joshua Reynolds Sitter Books, 1757–90 (26 vols.), Joshua Reynolds Papers, ms. 610, RAA.

89 Lillian B. Miller et al., eds., *The Selected Papers of Charles Willson Peale and His Family* (New Haven: Yale UP, 1983), 3:173, 5:23.

90 JSC to Benjamin West, 12 Nov. 1766, *CPL*, 50.

91 JSC to [Captain R. G. Bruce], 10 Sept. 1765, *CPL*, 35–36. Copley said he

had sent the canvas "so soon" after finishing it as "to risque the picture"; he feared "the changing of the colours" before "the exhibition."

92 Captain Peter Traille to JSC, 7 March 1765, *CPL*, 34. Jennifer L. Roberts reveals the "formative powers of distance and delay" on the painting and its reception in London; see her *Transporting Visions: The Movement of Images in Early America* (Berkeley: U of California P, 2014), chap. 1, quotation at 15; and "Copley's Cargo: Boy with a Squirrel and the Dilemma of Transit," *American Art* 21:2 (Summer 2007): 20–41.

93 JSC to [Captain R. G. Bruce], 10 Sept. 1765, *CPL*, 35. For Hale's travails, see *Papers of Francis Bernard*, 2:212, 277; and Thomas C. Barrow, *Trade and Empire: The British Customs Service in Colonial America, 1660–1775* (Cambridge: Harvard UP, 1967), 186–99.

94 The *Boscawen* arrived in Boston on May 26; see *BPB*, 27 May 1765. It sailed for London on 10 Sept., and the newspapers noted that Hale was among the passengers; *BEP*, 16 Sept. 1765. Bruce typically sailed from London to Boston in late fall, then headed south to winter in Antigua, and returned to London in spring; see, e.g., *BPB*, 6 Feb. 1764 (departing to Antigua); *PA*, 17 June 1765 (bound for London); *LEP*, 4 Nov. 1766 (departing Deal for Boston). The likely commodities involved are English manufactures sold in Boston; Boston lumber and foodstuffs sold in Antigua to sugar planters to feed their enslaved workforces; with proceeds used to buy Indies sugar and molasses. I have not located a London address for Bruce. He was waiting for the painting, per J. Powell to JSC, 18 Oct. 1765, *CPL*, 37.

95 *BG*, 19 Aug. 1765; Thomas Hutchinson to Richard Jackson, 16 Aug. 1765, in John W. Tyler and Elizabeth Dubrulle, eds., *The Correspondence of Thomas Hutchinson*, vol. 1, *1740–1766* (Boston: Colonial Society of Massachusetts, 2014), 279.

96 Bernard to Board of Trade, 15 Aug. 1765, *Papers of Francis Bernard*, 2:301–2; Hutchinson to Richard Jackson, 16 Aug. 1765, *Correspondence of Thomas Hutchinson*, 1:279. John Rowe referred to "A great Number of people . . . many thousands," *Rowe*, 89–90. Current scholarly consensus places the crowds at 3,000–5,000 people.

97 Hutchinson to Richard Jackson, 16 Aug. 1765, *Correspondence of Thomas Hutchinson*, 1:279 (amazing mob); and *HMB*, 3:87 (forty or fifty).

98 *Correspondence of Thomas Hutchinson*, 1:280–81.

99 *BNL*, 5 Sept. 1765.

100 The rumored cost of Hallowell's house, at £2,000, was more than a Boston laborer earned in a lifetime; see *Papers of Francis Bernard* 2:319, 320 n5.

101 The attack on the painting was documented during a 1988 restoration. Conservators discovered five tears to the canvas, four on or near the face, "odd-

shaped gashes . . . consistent with bayonet or sword punctures"; Wendy M. Watson, *Altered States: Conservation, Analysis, and the Interpretation of Works of Art* (South Hadley, MA: Mount Holyoke College Art Museum, 1994), 56–59, quotation at 58. My thanks to Lauren Lessing of the Colby College Museum of Art for this source. The 1764 dating is my guess, based on the major life event of Hallowell's new "place" that year.

102 *BNL*, 5 Sept. 1765. On house attacks, see Robert Blair St. George, *Conversing by Signs: Poetics of Implication in Colonial New England Culture* (Chapel Hill: U of North Carolina P, 1998), 263–95.

103 Bernard to the Earl of Halifax, 31 Aug. 1765, *Papers of Francis Bernard*, 2:338–39.

104 *HMB*, 3:92. For the inventory of losses, see Hutchinson's "Application for Compensation," *Correspondence of Thomas Hutchinson*, 1:316–35.

105 JSC to R. G. Bruce, 10 Sept. 1765, *CPL*, 36; see also Bernard to Richard Jackson, 10 Sept. 1765, *Papers of Francis Bernard*, 2:356, 332.

106 Peter [Chardon] to JSC, 28 April 1766, *CPL*, 37–40. Internal cues belie the editors' attribution of this letter to Copley's stepnephew, Peter Pelham IV. Born in 1737, Chardon was about Copley's age. He lived in his father's mansion on Cambridge Street, with a substantial art collection, to which Copley referred in later letters; see *CPL*, 93, 250. Pelham calls Chardon "our once gay facetious and respectable Neighbor"; *CPL*, 311. Their proximity is confirmed by the Boston tax list of 1771, which places Copley's house no more than five doors away; Bettye Hobbs Pruitt, *The Massachusetts Tax Valuation List of 1771* (Boston: G. K. Hall, 1978), 28. For Chardon's biography see "Peter Chardon," *Sibley's*, 14:149–51.

107 JSC to Peter [Chardon Jr.], 12 Sept. 1766, *CPL*, 47. The news lag between Barbados and Boston was around five weeks. Chardon's letter could have taken longer, because a great fire consumed much of Bridgetown on 14 May 1766, about a fortnight after Chardon wrote. Correspondence may have been deranged—though the Boston papers ran news of the fire with the customary delay; see *BPB*, 16 June 1766. "Free limbs, unphysick'd health, due appetite, / Which no sauce else but Hunger may excite," was a familiar quotation from James Howell, *The Vote; or, A Poeme Royall* (London, 1642).

108 JSC to Peter [Chardon], 12 Sept. 1766, *CPL*, 47–48. Chardon had left Barbados for Dominica—where Copley's onetime sitter and Chardon's friend General George Scott was governor—before he could have received Copley's response. On 3 Oct. 1766, less than a month after Copley wrote to him, Chardon died; see *BPB*, 19 Jan. 1767.

CHAPTER FOUR: A SON OF BRITISH LIBERTY

1 JSC to Peter [Chardon], 12 Sept. 1766, *CPL*, 47–48.

2 Bruce's letter of 4 Aug. 1766 enclosed West's, *CPL*, 41–45, italics in original. Copley's response, dated 13 Oct. 1766, indicates he just received the letter; *CPL*, 49.

3 Richard Wendorf, *Sir Joshua Reynolds: The Painter in Society* (Cambridge: Harvard UP, 1996), chap. 1, esp. 53–57; Charles Robert Leslie and Tom Taylor, *Life and Times of Sir Joshua Reynolds: With Notices of Some of His Cotemporaries* (London: J. Murray, 1865), 1:102, 182–84, 222–25. In busy years Reynolds painted 120 or 150 sitters. Prown estimates that Copley "averaged about 24 currently known pictures a year" between 1762 and 1770; P-*JSC*, 129. Copley's sitter books have not survived. A bill from March 1765 documents a price of £11 4s. for a 40 × 50 inch portrait; *CPL*, 35. A full-length portrait of the Harvard College president Thomas Holyoke was priced at £22 8s.; P-*JSC*, 98. The prices Copley quoted for his New York patrons in 1771 were twice as high: "Whole Lengths 40 Guineas, half Length 20, ¼ peices or Busts 10"; JSC to Captain Stephen Kemble, n.d. 1771, *CPL*, 112–13.

4 R. G. Bruce to JSC, 4 Aug. 1766, *CPL*, 41–43. The painting was at Reynolds's in early June 1767; R. G. Bruce to JSC, 11 June 1767, *CPL*, 53. Later that month Bruce "removed" it "from Mr. Reynolds's to Mr. West's," where it would be more useful to Copley "as a Specimen" of his abilities; R. G. Bruce to JSC, 25 June 1767, *CPL*, 59.

5 *A Catalogue of the Pictures, Sculptures, Designs in Architecture, Models, Drawings, Prints, &c. Exhibited by the Society of Artists of Great-Britain . . . 1766. Being the Seventh Year of Their Exhibition* ([London], 1766), 4. West spelled "Copley" correctly, directing his letter to "Mr. William Copley, Painter, at Boston," CO 5/38, TNA-UK.

6 Benjamin West to William [*sic*] Copley, 4 Aug. 1766, *CPL*, 43–45.

7 JSC to Benjamin West, 13 Oct. 1766, *CPL*, 49.

8 *BG*, 18 Aug. 1766. On the rise of the Sons of Liberty, see Pauline Maier, *From Resistance to Revolution: Colonial Radicals and the Development of American Opposition to Britain, 1765–1776* (New York: Knopf, 1972), 77–112, 307.

9 JSC to West, 12 Nov. 1766, *CPL*, 50.

10 John M. Murrin, "A Roof without Walls: The Dilemma of American National Identity," in *Beyond Confederation: Origins of the Constitution and American National Identity*, ed. Richard R. Beeman et al. (Chapel Hill: U of North Carolina P, 1987), 340; see also H. James Henderson, *Party Politics in the Continental Congress* (New York: McGraw Hill, 1974), 11–18.

11 JSC to Benjamin West, 12 Nov. 1766, *CPL*, 51; JSC to [Bruce or West], ca. 1767, *CPL*, 65–66. On Copley's efforts to distance himself from the particularisms of trades like tailoring and shoemaking, see Susan Rather, "Carpenter, Tailor, Shoemaker, Artist: Copley and Portrait Painting around 1770," *Art Bulletin* 79:2 (June 1997): 269–90.

12 West to JSC, 4 Aug. 1766, *CPL*, 45; West to JSC, 20 June 1767, *CPL*, 58.

13 JSC to [Bruce or West], [late 1767], *CPL*, 66.

14 West to JSC, 4 Aug. 1766, *CPL*, 44.

15 JSC to West, 12 Nov. 1766, *CPL*, 50.

16 JSC to West, 13 Oct. 1766, *CPL*, 49.

17 JSC to West, 17 Jan. 1768, *CPL*, 68. This unidentified portrait is now lost.

18 JSC to [West or Bruce?], [1767?], *CPL*, 65.

19 The candidates would have been daughters of Copley's two surviving step-brothers, Peter Pelham's sons Peter (b. 1721) and Charles (b. 1722). Peter had moved to Virginia. Charles Pelham married in Feb. 1766, and his first child, Helena Pelham, was not born until 1767.

20 Copley's portrait of Mrs. John Powell Senior (Anna Dummer) is dated by an invoice of 17 April 1764; see Morrison H. Heckscher, "Copley's Picture Frames," in *JSC in America*, 145, 147. For the pendant pastels, see Anne Bolling Wheeler and Barbara Neville Parker, *John Singleton Copley: American Portraits in Oil, Pastel, and Miniature* (Boston: Museum of Fine Arts, 1938), 228.

21 J. Powell to JSC, 18 Oct. 1765, *CPL*, 37. For Powell's role in the Copley–West correspondence, see JSC to West, 13 Oct. 1766, *CPL*, 49; and JSC to West, 12 Nov. 1766, *CPL*, 50. Evidence that Powell's daughter was the subject comes from R. G. Bruce to JSC, 11 June 1767, *CPL*, 53. Susanna Powell was born in Sept. 1760; *Boston Births from A.D. 1700 to A.D. 1800*, vol. 24, Reports of the Record Commissioners of the City of Boston (Boston: Rockwell & Churchill, 1894), 299.

22 For the association of the breed with King Charles, see T. C. Turner, "The King Charles Spaniel," *Art & Life* 10:6 (June 1919): 332–35. On parrots and parakeets as symbols of the tropics, see Richard Verdi, *The Parrot in Art: From Dürer to Elizabeth Butterworth* (London: Scala Publishers / Barber Institute of Fine Arts, 2007), 19–30. Copley used a hummingbird and a King Charles spaniel in his 1758 portrait of the daughters of the Indies merchant and Boston's largest slaveholder, Isaac Royall, upon whose last name the dog could be seen as a pun.

23 JSC to West, 13 Oct. 1766, *CPL*, 49–50; R. G. Bruce to JSC, 11 June 1767, *CPL*, 53; *A Catalogue of the Pictures, Sculptures, Designs in Architecture, Models, Drawings, Prints, &c. Exhibited at the Great Room in Spring-Garden . . . by the Society of Artists of Great-Britain* ([London], 1767), 5.

24 C. W. Peale to John Beale Bordley, March 1767, in Lillian B. Miller et al., eds., *The Selected Papers of Charles Willson Peale and His Family* (New Haven: Yale UP, 1983), 1:47; see also 48–70. Before going to London, Peale had journeyed to New England, where he visited Smibert's collection and Copley's studio; ibid., 37–45.

25 Quoted in Carl Bridenbaugh, *Cities in Revolt: Urban Life in America, 1743–1776* (New York: Oxford UP, 1971), 281. For Barrell's failure, see *BEP*, 13 Aug. 1764; *BPB*, 3 Sept. 1764.

26 Barrell and Pierce married on 4 June 1764, just before his bankruptcy; *Boston Marriages from 1752 to 1809*, vol. 30, Records Relating to the Early History of Boston (Boston: Municipal Printing Office, 1903), 423.

27 Bruce to JSC, 4 Aug. 1766, *CPL*, 41–42; West to JSC, 4 Aug. 1766, *CPL*, 45; JSC to West, 12 Nov. 1766, *CPL*, 51. Copley had begun working in pastel as early as 1758; it was then a fashionable medium in London, with a vogue inspired by the tour of the Genevan artist Jean-Etienne Liotard. On Copley's pastels, see Marjorie Shelley, "Painting in Crayon: The Pastels of John Singleton Copley," in *JSC in America*, 127–41. On banyans, see Lovell, 99–102.

28 Bernard to John Pownall, 1 March, 13 April 1766, Colin Nicolson, ed., *The Papers of Francis Bernard: Governor of Colonial Massachusetts, 1760–69* (Boston: Colonial Society of Massachusetts, 2007), 3:105, 142.

29 *Massachusetts Gazette*, 22 May 1766. For Revere's obelisk, see Clarence S. Brigham, *Paul Revere's Engravings* (New York: Atheneum, 1969), 26–31. On parliamentary debates over the Stamp Act's repeal, see Edmund S. Morgan and Helen M. Morgan, *The Stamp Act Crisis: Prologue to Revolution* (Chapel Hill: U of North Carolina P, 1953), 261–81.

30 Douglass Adair and John A. Schultz, eds., *Peter Oliver's Origin & Progress of the American Rebellion: A Tory View* (Stanford, CA: Stanford UP, 1961), 56.

31 Samuel Eliot Morison, *Three Centuries of Harvard, 1636–1936* (Cambridge: Harvard UP, 1986), 21, 43.

32 Bernard to Board of Trade, 15 July 1765, in *Papers of Francis Bernard*, 3:289, see also 291 n10 and 16; Francis Apthorp Foster, *The Burning of Harvard Hall, 1764, and Its Consequences* (Boston: J. Wilson and Son, UP, 1911), 14–18.

33 Francis Blackburne, *Memoirs of Thomas Hollis, Esq. F.R. and A.S.S.* (London, 1780), 2:732, 735; Holyoke to Thomas Hollis, 9 July 1766, in Papers of Edward Holyoke, box 1, folder 10, Letter Book, 1766–67, folio 2v., Harvard Univ. Archives, UAI 15.870. Even the poor copy, by the Florentine painter and engraver Giovanni Battista Cipriani, was precious enough that Copley was reluctant to part with it; see Edward Holyoke to JSC, 31 Jan. 1767, *CPL*, 75. However unsuccessful, the *Hollis* portrait earned Copley more than double his usual fee; Loose receipt, "An 1766 Mr Hollis's picture" / "J. S. Copley's Bill," Harvard College Papers, 1st ser., UAI 5.100, vol. 2, 1764–85, 1793, Harvard Univ. Archives.

34 Harvard College Books, 1636–1827, VII, 160v. The picture was given to the college by Hancock's nephew John, a Harvard trustee. Thanks to Teri Hensick and Kate Smith at the Straus Center for Conservation and Technical

Studies of the Harvard Art Museums for sharing their analysis of X-rays and infrared photography of the *Thomas Hancock* portrait.

35 For the display and cabinetry, see Pierre Eugene du Simitiere Collection, Series VIII, Library Company of Philadelphia, 1412.Q.20j; for the Bernard portrait, see Harvard College Books,VII, 145r, 160v.

36 JSC to Benjamin West, 17 Jan. 1768, *CPL*, 67.

37 L. H. Butterfield, ed., *Diary and Autobiography of John Adams* (Cambridge: Harvard UP, 1961), 1:324 (11 Nov. 1766).

38 JSC to R. G. Bruce, 10 Sept. 1765, *CPL*, 36. Both the Howard and the Mayhew portraits can be dated to 1767, Howard via signature and Mayhew via receipt; P-*JSC*, 223. For Howard's return to the colonies, see Boyle's "Journal of Occurrences in Boston," *NEHGR* 84 (1930), 252; and Wheeler and Parker, *John Singleton Copley*, 114–15.

39 The dinner on 2 Dec. 1766 is described in *Rowe*, 116–17; see also 125–26. The guests included John Hancock, James Otis, and William Mollineux, the last allegedly responsible for the most frenzied of the Stamp Act looting, as well as Benjamin Hallowell, whose house (and Copley portrait) was attacked, and many other future loyalists.

40 The text of the Declaratory Act, 6 Geo. 3, c12, appeared in *BPB*, 26 May 1766; and can be found at http://avalon.law.yale.edu/18th_century /declaratory_act_1766.asp. See also Morgan and Morgan, *Stamp Act Crisis*, 268–91.

41 [Samuel Cooper], *The Crisis; or, A Full Defence of the Colonies* (London, 1766), 2 (emphasis in original). Cooper's pamphlet amplified an argument he made in the Boston press; "The Crisis," *BEP*, 18 Aug. 1766.

42 *Diary and Autobiography of John Adams*, 1:309 (26 April 1766).

43 [Cooper], *The Crisis*, 3, 8.

44 For the text of the Revenue Act, 7 Geo 3, 46, see http://avalon.law.yale. edu/18th_century/townsend_act_1767.asp. On its reception in Boston, see Richard Archer, *As If an Enemy's Country: The British Occupation of Boston and the Origins of Revolution* (New York: Oxford UP, 2010), 65–81.

45 *BEP*, 10 Aug. 1767.

46 Bernard to Shelburne, 24 Aug. 1767, *Papers of Francis Bernard*, 3:384. Rowe estimated that "about Sixty People Sons of Liberty" had gathered at the "Tree of Liberty" to mark the occasion; *Rowe*, 139.

47 *BG*, 17 Aug. 1767.

48 Bruce held his letter, written 11 June 1767, for West's letter dated 20 June 1767; *CPL*, 53. Parliament's final vote on the Townshend Acts came 26 June 1767.

49 Bruce to JSC, 11 June 1767, *CPL*, 55.

50 *A Critical Examination of the Pictures, Sculptures, Designs in Architecture, Models, Drawings, Prints . . .* (London, 1767), 7.

51 Bruce to JSC, 11 June 1767, *CPL*, 53, 54; Bruce to JSC, 25 June 1767, *CPL*, 59. The editor of the *CPL* notes that the words "Mr. Powel's vanity" had been erased almost completely. This would likely have been the work of the recipient, perhaps before he shared Bruce's letter with others in Boston, as was common practice.

52 Bruce to JSC, 11 June 1767, *CPL*, 54.

53 West to JSC, 20 June 1767, *CPL*, 56–57; see also Bruce to JSC, 25 June 1767, *CPL*, 59.

54 West to JSC, 20 June 1767, *CPL*, 57.

55 Bruce to JSC, 11 June 1767, *CPL*, 53–55; Bruce to JSC, 25 June 1767, *CPL*, 59–60. See also West to JSC, 20 June 1767, *CPL*, 58.

56 JSC to [West or Bruce?], [1767?], *CPL*, 65.

57 JSC to West, 28 Jan. 1768, *CPL*, 67; Francis M. Newton to William [*sic*] Copley, 3 Sept. 1766, *CPL*, 45–46. Newton's letter seems to have gotten held up in London. Captain Bruce enclosed it in his own of 11 June 1767, per Bruce to JSC, 25 June 1767, *CPL*, 59. West also sent Copley "a Copy of our Royal Charter and list of fellows" in his letter of 20 June 1767; *CPL*, 58. Copley's response notes that Newton's letter "did not come to hand till the 13th of Octr., 1767"; JSC to Francis M. Newton, 23 Nov. 1767, *CPL*, 63.

58 JSC to West, 17 Jan. 1768, *CPL*, 67; JSC to R. G. Bruce [ca. 17 Jan. 1768], *CPL*, 70.

59 JSC to Francis M. Newton, 23 Nov. 1767, *CPL*, 63.

60 JSC to [Bruce?], [late 1767], *CPL*, 64; JSC to [Bruce or West?], [late 1767], *CPL*, 66.

61 Bruce to JSC, 11 June 1767, *CPL*, 54.

62 George Livius to JSC, 3, 14 Sept. 1767, *CPL*, 61. On Copley's prices at the time, see P-*JSC*, 98–99. For the identification of Livius, see Walter A. Reichart, "An Unpublished Letter of Senator Ralph Izard to George Livius, Esq.," *South Carolina Historical and Genealogical Magazine* 41:1 (Jan. 1940): 34–38.

63 *Rowe*, 146 (20 Nov. 1767).

64 Bernard to Shelburne, 21 Sept. 1767, *Papers of Francis Bernard*, 3:409.

65 Broadside, *Whereas this province labours under a heavy debt, incurred in the course of the late war . . .* (Boston, 1767). The subscribed copy, recently discovered, is owned by Houghton Library of Harvard Univ., and can be seen online at http://nrs.harvard.edu/urn-3:FHCL. HOUGH:10873406. I am grateful for the crowd-sourced transcription undertaken by Dr. Samuel Foreman and a team of graduate assistants, including John Hannigan and Cassandra Berman. Bernard had wrongly

forecast that the boycott would attract few signatories; *Papers of Francis Bernard*, 3:420.

66 Adair and Schultz, *Peter Oliver's Origin*, 61.

67 *BG*, 15 Dec. 1766; *BEP*, 4 May 1767; and *BPB*, 19 Oct. 1767, among others.

68 Both Copley and Clarke used the Orange Tree Tavern, at the corner of Hanover and Queen Streets, as a reference point for their addresses: Samuel Fayerweather to JSC, 7 Jan. 1763, *CPL*, 28; and the notice to lease "a large House near the Orange-Tree . . . at present in the Occupation of Richard Clarke, Esq.," *BG*, 8 Sept. 1766. For Mary Clarke Barrett's death, see *BG*, 4 May 1764. For the birth and wedding dates of the Clarkes' twelve children, see "Richard Clarke," *Sibley's*, 8:562.

69 *A Journal of the Times*, 8 July 1769, Oliver Morton Dickerson, ed., *Boston under Military Rule (1768–1769) as Revealed in a Journal of the Times* (Boston: Chapman & Grimes, 1936), 115. On the nonimportation agreements, see Charles M. Andrews, "The Boston Merchants and the Non-Importation Agreement," in *Publications of the Colonial Society of Massachusetts*, vol. 19 (Boston, 1917), 159–259, esp. 191–98.

70 *Rowe*, 156–57 (18 March 1768). The circular letter of 11 Feb. 1768 can be found at http://avalon.law.yale.edu/18th_century/mass_circ_let_1768.asp.

71 Archer, *As If an Enemy's Country*, 85–95; *Rowe*, 165–71. Hillsborough deemed the letter "extraordinary & seditious"; Hillsborough to Gage, 23 April 1768, Clarence Edwin Carter, ed., *The Correspondence of General Thomas Gage* (New Haven: Yale UP, 1931), 2:66–67.

72 For Wilkes Barber as John Wilkes's namesake, see John Wilkes to Nathaniel Barber, 21 Sept. 1770, *CPL*, 95 and n1.

73 *Rowe*, 171–72 (1 Aug. 1768). On the bowl's iconography, see http://www.mfa.org/collections/object/sons-of-liberty-bowl-39072; and Jonathan Fairbanks, "Paul Revere and 1768: His Portrait and the Liberty Bowl," in *New England Silver & Silversmithing, 1620–1815*, ed. Jeannine J. Falino and Gerald W. R. Ward (Boston: Colonial Society of Massachusetts, 2001), 135–51.

74 Ethan W. Lasser, "Selling Silver: The Business of Copley's Paul Revere," *American Art* 26:3 (Sept. 2012): 27.

75 *P-JSC*, 122. The five portraits firmly datable to 1768 are *George Watson*, *John Amory* (discussed above), *Paul Revere*, *Rev. Myles Cooper*, and *Gen. Thomas Gage*. Prown assigns a larger number of portraits to the years 1768–70, though still well below the average of twenty-four pictures per year that he estimates for the period 1762–70 (*P-JSC*, 129).

76 On the portrait's staged naturalness, I have learned a great deal from Rebecca Zurier's unpublished essay, "Artifice as Evidence: John Singleton Copley's Portrait of Paul Revere."

77 Rather, "Carpenter, Tailor, Shoemaker, Artist," 282, 288; *JSC in America*, 248–49.

78 *BG*, 22 Aug. 1768, reprinted widely. See also "Boyle's Journal of Occurrences," 15 Aug. 1768, *NEHGR* 84:255. Both Copley and Revere joined the still-larger anniversary celebration in Dorchester in Aug. 1769; see [William Palfrey Jr.,] "An Alphabetical List of the Sons of Liberty Who Din'd at Liberty Tree, Dorchester," MHS Collections Online, http://www.masshist.org/database/doc-viewer.php?item_id=8.

79 Lasser, "Selling Silver"; and Rather, "Carpenter, Tailor, Shoemaker, Artist," 281–88.

80 Hillsborough to Gage, 11, 8 June 1768, *Correspondence of General Thomas Gage*, 2:69. Hillsborough's instructions preceded the *Liberty* riots by several days and would not have been received until much later.

81 Gage to Hillsborough, 28 June 1768; Gage to Barrington, 28 June 1768; *Correspondence of General Thomas Gage*, 1:182–183, 2:479–80.

82 Hillsborough to Gage, 30 July 1768, *Correspondence of General Thomas Gage*, 2:73.

83 Gage to Hillsborough, 26 Sept. 1768, *Correspondence of General Thomas Gage*, 1:196.

84 *Rowe*, 174 (9 Sept. 1768); Archer, *As If an Enemy's Country*, 98–100.

85 *Journal of the Times*, 28 Sept.–1 Oct. 1768, in Dickerson, *Boston under Military Rule*, 1–2. This digest of the occupation of Boston appeared first in the New York press and was reprinted in the *BEP*. These entries ran in the *New York Journal* on 13 Oct. and in Boston on 12 Dec. See also John Tudor, *Deacon Tudor's Diary . . . a Record of More or Less Important Events in Boston, from 1732 to 1793, by an Eye Witness*, ed. William Tudor (Boston: Wallace Spooner, 1896), 28.

86 For the women and children who arrived in Boston with the troops, see Serena R. Zabin, "An Intimate History of the Boston Massacre," unpublished conference paper, 2015.

87 See, e.g., *Rowe*, 177 (10 Oct. 1768).

88 Bernard to Barrington, 20 July 1768, *Papers of Francis Bernard*, 4:263–64.

89 *Journal of the Times*, 6 Oct. 1768, in Dickerson, *Boston under Military Rule*, 3. John Tudor echoed the *Journal* in his diary entry: "the picture of Governor Bd hanging in College Hall had a piece cut out of the Breast like a Heart & a note left, giving the Reason." Tudor, *Deacon Tudor's Diary*, 28.

90 Meeting of the President and Fellows of Harvard College, 25 Nov. 1768, Harvard College Books, VII, f. 184. Two prior meetings, on 14 and 19 Oct., do not mention the incident; ibid., ff. 183–84.

91 *Journal of the Times*, 14 March 1769, in Dickerson, *Boston under Military Rule*, 78.

92 Tudor, *Deacon Tudor's Diary*, 28–29 (15 Oct. 1768). The soldiers' "Good Appearance" was also noted in *Rowe*, 177 (15 Oct. 1768). The officers with Gage are listed in "Boyle's Journal of Occurrences in Boston," 15 Oct. 1768, *NEHGR* 84:256.

93 *Rowe*, 177 (16 Oct. 1768), 178 (23 Oct. 1768), 178–79 (1 Nov. 1768). For the baptism of Grenville Temple, see Andrew Oliver and James Bishop Peabody, eds., *The Records of Trinity Church, Boston, 1728–1830* (Boston: Colonial Society of Massachusetts, 1980), 524.

94 Captain John Small to JSC, 15 May 1770, *CPL*, 93. This is the only mention of a levee at Copley's. Small was a favorite of Gage's, who several times recommended his promotion; *Correspondence of General Thomas Gage*, 2:430, 431, 432, 446.

95 Gage to Hillsborough, 3 Nov. 1768, *Correspondence of General Thomas Gage*, 1:206. On military portraiture, see Mark Hallett, "Faces of War," in *Reynolds: Portraiture in Action* (New Haven: Yale UP, 2014), 164–91.

96 Captain John Small to JSC, 29 [Sept.?] 1769, *CPL*, 77; Captain John Small to JSC, 15 May 1770, *CPL*, 94.

97 JSC to West, 17 Jan. 1768, *CPL*, 68–69.

98 JSC to West[?], undated fragment, CO 5/38, f. 180v, TNA-UK; see also *CPL*, 66. The marginal notation "Rogers: Picture" suggests a date of late 1767 or early 1768.

CHAPTER FIVE: THE MARRIAGE PLOT

1 "Letter of Rev. Jonathan Mayhew to Richard Clarke, 1765," *NEHGR* 46:1 (Jan. 1892): 15–20.

2 *The Manifesto Church: Records of the Church in Brattle Square, Boston, with Lists of Communicants, Baptisms, Marriages and Funerals, 1699–1872* (Boston: Benevolent Fraternity of Churches, 1902), 444. The *Massachusetts Gazette*, 17 Nov. 1769, places the wedding in the evening.

3 *Rowe*, 149 (2 Feb. 1768). Rowe described a wedding at Trinity Church, where Mary Copley and Peter Pelham had been married, and where the Copleys would baptize their children and, presumably, worship.

4 "Richard Clarke," *Sibley's*, 8:552–53, 562. Clarke's sister Mary was married to Hutchinson's brother-in-law Peter Oliver.

5 Richard Clarke to Isaac Winslow Clarke, 21 June 1762, in Henry H. Edes, ed., "Selections from the Papers of Richard Clarke," *Colonial Society of Massachusetts Publications* 8 (1906): 80. Hannah Clarke, Sukey's eldest sister, married the merchant Henry Bromfield in 1762; Mary Clarke had wed the merchant Samuel Barrett in 1761. Sarah Clarke, Sukey's younger sister, married a powerful merchant, Philadelphia's Charles Startin, in 1771.

6 *BNL*, 23 April 1762.

7 *Rowe*, 129 (23 April 1767). In addition to painting Mary Clarke (d. 1764), Copley painted Peter and Andrew Oliver, husband and brother-in-law of Richard Clarke's sister Mary, ca. 1758–61; Henry Hill and his wife, kin to Elizabeth Winslow, ca. 1768–70; and Joshua Winslow, son of Elizabeth Winslow Clarke's brother, in 1763. See P-*JSC*, 150–51, 198–99. His portraits of Sukey's uncle Isaac Winslow and of Richard Clarke postdate the marriage.

8 John Trumbull, *The Autobiography of Colonel John Trumbull, Patriot-Artist, 1756–1843* (New Haven: Yale UP, 1953), 10–11.

9 Captain John Small to JSC, 15 May 1770, *CPL*, 93–94.

10 *The Clandestine Marriage, a Comedy. As It Is Acted at the Theatre Royal in Drury-Lane* (London, 1770); *The Forced Marriage, a Tragedy* (London, 1770). Numerous other titles on marriage were printed in Britain in the 1760s; see *Marriage a-La-Mode: A Comedy* (Dublin, 1763); *Matrimony Made Easy; or, A New Form of Marriage, Founded on the Principles and Practice of the Holy Patriarchs, and the Laws of God, and Nature . . .* (London, 1764); *Matrimony, a Novel; Containing a Series of Interesting Adventures* (London, 1766); *Isabella; or, The Fatal Marriage* (Dublin, 1769); and *Miscellaneous Dissertations on Marriage, Celibacy, Covetousness, Virtue, the Modern System of Education, &c. by John Dove* (London, 1769). Britain's Marriage Act of 1753 heightened literary attention to marriage plots.

11 John Johnson, *The Advantages and Disadvantages of the Marriage-State: As Enter'd into with Religious and Irreligious Persons*, 8th ed. (Boston, 1766).

12 Lovell, 54; see also 10–11.

13 *Massachusetts Gazette*, 17 Nov. 1764; *BEP*, 20 Nov. 1764; *BG*, 20 Nov. 1769; *Essex Gazette* (Salem), 21 Nov. 1769.

14 See esp. John Demos, *A Little Commonwealth: Family Life in Plymouth Colony* (New York: Oxford UP, 1970); Laurel Thatcher Ulrich, *Good Wives: Image and Reality in the Lives of Women in Northern New England, 1650–1750* (New York: Knopf, 1980); Lenore Davidoff and Catherine Hall, *Family Fortunes: Men and Women of the English Middle Class, 1780–1850* (Chicago: U of Chicago P, 1987); Jeanne Boydston, *Home and Work: Housework, Wages, and the Ideology of Labor in the Early Republic* (New York: Oxford UP, 1990); Sarah M. S. Pearsall, *Atlantic Families: Lives and Letters in the Later Eighteenth Century* (New York: Oxford UP, 2008).

15 JSC to SCC, 8 Oct. 1774, CFP-LoC.

16 *Massachusetts Gazette*, 17 Nov. 1769.

17 Daniel Scott Smith, "The Demographic History of Colonial New England," *Journal of Economic History* 32:1 (March 1972): 177.

18 JSC to Peter [Chardon], 12 Sept. 1766, *CPL*, 48.

19 Ibid., 47 (bondage); JSC to West, 17 Jan. 1768, *CPL*, 69 (tender); JSC to West, 24 Nov. 1770, *CPL*, 97–98.

20 Compare the *Susanna Clarke Copley* image to ca. 1767–70 pastels of young women, including *Mrs. Joseph Barrell* (Hannah Fitch), *Mrs. Elijah Vose* (Ruth Tufts), *Mrs. Edward Green* (Mary Storer), *Mrs. William Turner* (Ann Dumaresq), and *Mrs. Ebenezer Storer II* (Elizabeth Green), all in *JSC in America*, 127, 133, 143, 237, 243. Marjorie Shelley points to the pendant pair of Copley and Susanna Copley as evidence of the artist's "tremendous range in manipulating the texture of his crayons"; "Painting in Crayon: The Pastels of John Singleton Copley," *JSC in America*, 137. But the curatorial file at Winterthur suggests that the issue is condition rather than intention.

21 William Johnston to JSC, 4 May 1770, *CPL*, 92.

22 "Richard Clarke," *Sibley's*, 8:551–53; *Rowe*, 64, 70 (3 Dec. 1764).

23 *BNL*, 5 Sept. 1765, 16 Jan. 1766. For Adams's purchases, see Richard Clarke to John Adams, 11 Jan. and 16 March 1768, Richard Clarke and Sons Records, NEHGS, Mss. 1051, box 1, folder 2, ff. 78, 88–89.

24 Henry Bromfield to Richard Clarke, 18 Nov. 1768, BFP, ser. 1, box 1, folder 2.

25 *Rowe*, 183 (Feb. 9).

26 Gage to Hillsborough, 1 April 1769, Clarence Edwin Carter, ed., *The Correspondence of General Thomas Gage* (New Haven: Yale UP, 1931), 1:223; see also *HMB*, 3:157.

27 L. H. Butterfield, ed., *Diary and Autobiography of John Adams* (Cambridge: Harvard UP, 1961), 3:289–90; Richard Archer, *As If an Enemy's Country: The British Occupation of Boston and the Origins of Revolution* (New York: Oxford UP, 2010), 128–37. *Journal of the Times* reported low-level outrages almost daily; Oliver Morton Dickerson, ed., *Boston under Military Rule (1768–1769) as Revealed in a Journal of the Times* (Boston: Chapman & Grimes, 1936), 31, 34, 39–40, 42, 47, 53–54, 63, 79, 89, 90, 93–94, 105, 114.

28 Dickerson, *Boston under Military Rule*, 115–17.

29 *BG*, 7 Aug. 1769; see also "Boyle's Journal of Occurrences in Boston," *NEHGR* 84:259; *Rowe*, 190 (1 Aug. 1769); and Archer, *As If an Enemy's Country*, 140–41.

30 West to JSC, 20 Sept. 1768, *CPL*, 72–73.

31 Copley's recollection of the transaction is detailed in subsequent legal papers: "Deposition of John Singleton Copley," 22 Jan. 1812, HGOBP, box 1, folder 15a. Chardon was the second administrator appointed; see *BNL*, 3 March 1757; and *BEP*, 14 Nov. 1757.

32 Inventory of the Estate of Mr. Nathaniel Cunningham, Middlesex County Probate File Papers, 1648–1871, no. 5455, Archives of the Supreme Judicial Court, MassArchs; "An Exact Plan of Nath: Cunningham's Land, at Barton's Point," 14 Aug. 1767, CFP-LoC, folder 1.

33 *The Acts and Resolves, Public and Private, of the Province of the Massachusetts Bay*, vol. 18, *Resolves, Etc., 1765–1774* (Boston: Wright & Potter, 1912), 154.

34 For the prior litigation over "Bannister's Pastures," see Bannister et al. v. Cunningham, July 1750, Suffolk Files #66742; Bannister et al. v. Cunningham, Aug. 1750, Suffolk Files #67034; Bannister et al. v. Cunningham, Feb. 1754, Suffolk Files #72514, all MassArchs. The lawsuit against Copley's purchase initially named his tenant, Ephraim Fenno, as defendant. The tangled chain of custody is well laid out in the later "Deposition of Robert Treat Paine," 31 Jan. 1809, HGOBP, box 1, folder 15. For the deed "without warranty" see "Deposition of John Singleton Copley," 22 Jan. 1812, HGOBP. The Bannister heirs filed suit in the Suffolk Court of Common Pleas in March 1769. The record books for that court are missing for the years 1772–76, but Bannister, who lost the case, appealed to the Superior Court of Judicature in March 1770, referencing the earlier suit; see Bannister v. Fenno and Copley, Suffolk Files #10234, MassArchs.

35 "Deposition of John Singleton Copley," 22 Jan. 1812, HGOBP.

36 A guinea, named after the "Guinea trade" or transatlantic slave trade, was worth 21 shillings, or 5 percent more than a pound. Each gold guinea weighed about ¼ ounce.

37 JSC to Benjamin West, 17 Jan. 1768, *CPL*, 68.

38 JSC to [West or R. G. Bruce?] undated fragment, ca. 1767–68, *CPL*, 66.

39 JSC to West, 24 Nov. 1770, *CPL*, 97. Elizabeth Copley was born on 20 Nov. 1770 and baptized on 9 Dec. 1770. *The Greene Family in England and America: With Pedigrees* (Boston: privately printed, 1901), 56; Andrew Oliver and James Bishop Peabody, eds., *The Records of Trinity Church, Boston, 1728–1830* (Boston: Colonial Society of Massachusetts, 1980), 561.

40 *BEP*, 20 March 1769; *BTR, 1758–69*, 16:267. The history of the office appears in Eboranos [pseud.], *The History of the Ancient Office of Clerk of the Market of the King's Household; Its Authority and Usefulness* (London, 1737). For its duties in Boston, see *A Useful and Necessary Companion* (Boston, 1708), 78–80.

41 [William Palfrey Jr.,] "An Alphabetical List of the Sons of Liberty Who Din'd at Liberty Tree, Dorchester," MHS Collections Online, http://www.masshist.org /database/viewer.php?item_id=8&img_step=1&mode=large#page1; see also "Boyle's Journal of Occurrences," *NEHGR* 84:259; and *Rowe*, 191. Bernard's departure made the occasion especially festive, Richard Archer notes in *As If an Enemy's Country*, 142.

42 *BPB*, 14 Aug. 1769.

43 *Massachusetts Gazette*, 17 Aug. 1769; *Essex Gazette*, 22 Aug. 1769.

44 *Boston Chronicle*, 22 Jan. 1770, 9 Oct. 1769. On Mein's campaign to publicize the hypocrisy of the boycotters, see Archer, *As If an Enemy's Country*, 145–65.

45 Sarah Startin to Sarah Pearson, 4 Feb. 1786, BFP, box 1, folder 9.

46 Gardiner to Copley, 12 July 1770, Suffolk Deeds L117, f. 129, MassArchs; see also Allen Chamberlain, *Beacon Hill, Its Ancient Pastures and Early Mansions* (Boston: Houghton Mifflin, 1925), 50–56, 64–65; *P-JSC*, 63; and E. Alfred Jones, *The Loyalists of Massachusetts, Their Memorials, Petitions and Claims* (London: Saint Catherine Press, 1930), 140–42.

47 HP to Charles Pelham, 20 April 1771, CO 5/39 f. 22r, TNA-UK.

48 The first mention I have found of Mount Pleasant as a name for the estate appears in HP to JSC, 10 Sept. 1771, *CPL*, 155; see also 160 ("pleasant Mount"), 162, 177; and HP to JSC, 17 Nov. 1771, CO 5/39, ff. 125–26, TNA-UK.

49 On the Remick view and the Hancock property, see Lovell, 51–52, 199–200.

50 "An Act for Enquiring into the Rateable Estates of This Province," 5 July 1771, repr. in Bettye Hobbs Pruitt, *The Massachusetts Tax Valuation List of 1771* (Boston: G. K. Hall, 1978), xvii–xviii. Pruitt's transcription preserves the order of the original assessment schedules, which reflect assessors' footpaths. Copley's Cambridge Street neighbors can be seen on p. 28, and his Beacon Hill neighbors on p. 36. Copley was not assessed on the Common when the survey was taken, between 20 Aug. and 20 Sept. 1771. He and Sukey were then in New York City. Among his three houses on Beacon Street, only the oldest house, tenanted to Ephraim Fenno, was occupied and assessed. A new digital edition makes it possible to sort taxpayers by various criteria: "1771 Massachusetts Tax Inventory," http://sites.fas.harvard.edu/~hsb41/masstax/masstax.cgi. The history of New England and mid-Atlantic slavery in the colonial period is now undergoing intensive research. Important recent works include David Waldstreicher, *Runaway America: Benjamin Franklin, Slavery, and the American Revolution* (New York: Hill and Wang, 2004); Jill Lepore, *New York Burning: Liberty, Slavery, and Conspiracy in Eighteenth-Century Manhattan* (New York: Knopf, 2005); Margot Minardi, *Making Slavery History: Abolitionism and the Politics of Memory in Massachusetts* (New York: Oxford UP, 2010); and Wendy Warren, *New England Bound: Slavery and the Colonization of Early America* (New York: Norton / Liveright, 2016). Dissertations by Gloria Whiting (Harvard) and John Hannigan (Brandeis), will greatly add to our understanding of slavery in New England, and particularly in Boston.

51 Suffolk County Probates, 10609, 12389, MassArchs.

52 Henry Stedman Nourse, *History of the Town of Harvard, Massachusetts: 1732–1893* (Harvard, MA: W. Hapgood, 1894), 133; Daniel Denison Slade, "The Bromfield Family," *NEHGR* 26:1 (Jan. 1872): 40, 42.

53 *BG*, 16 Sept. 1765.

54 A search of the America's Historical Newspapers database for the years sur-
 rounding Copley's marriage on the term "Negro" yields hundreds of runaway
 and sales notices for black slaves in and around Boston.

55 On urban slavery and imperial fantasy, see Catherine Molineux, *Faces of
 Perfect Ebony: Encountering Atlantic Slavery in Imperial Britain* (Cambridge:
 Harvard UP, 2012); and Simon Gikandi, *Slavery and the Culture of Taste*
 (Princeton: Princeton UP, 2011).

56 The practice of giving slaves as wedding gifts is often noted and rarely ana-
 lyzed in the scholarly literature. Thomas Jefferson settled entire families upon
 his daughters; see "Marriage Settlement for Martha Jefferson," 21 Feb. 1790;
 and "Marriage Settlement for Mary Jefferson," 12 Oct. 1797, *The Papers of
 Thomas Jefferson Digital Edition*, ed. Barbara B. Oberg and J. Jefferson Looney
 (Charlottesville: U of Virginia P, Rotunda, 2008–15), http://rotunda.upress
 .virginia.edu/founders/TSJN-01-29-02-0437, and http://rotunda.upress
 .virginia.edu/founders/TSJN-01-16-02-0107, accessed 10 March 2015.

57 Alexandra A. Chan, *Slavery in the Age of Reason: Archaeology at a New England
 Farm* (Knoxville: U of Tennessee P, 2007); and C. S. Manegold, *Ten Hills
 Farm: The Forgotten History of Slavery in the North* (Princeton: Princeton
 UP, 2010). Nathaniel Sparhawk married Sir William Pepperrell's daughter
 Elizabeth. When Pepperrell died without male issue in 1759, his baronetcy
 descended through his daughter's line.

58 HP to JSC, 7 July 1771, *CPL*, 124; JSC to HP, 14 July 1771, *CPL*, 130. I
 assume he is talking about selling either the third and oldest house on Bea-
 con Hill, or the Cambridge Street house, with a plan to move Harry and his
 mother to Mount Pleasant.

59 *Manifesto Church*, 255. Only two other black Lucys, Lucy Vassall (pp. 117,
 209, 213) and Lucy Harris (268) are listed among the scores of women with
 that name in this group of records. That Copley was not assessed for the
 ownership of bondspeople aged fourteen to forty-five in the 1771 tax assess-
 ment further suggests that Lucy and Snap were under fourteen.

60 The name Snap is singular in the annals of New England slavery; no other
 bondsperson of that name turns up in the databases of the NEHGS, which
 aggregate New England church and vital records. "Snap" appears regularly in
 the ledgers of slaveholders in the British Caribbean, however. An Ancestry
 .com database digitizing records of the Office of Registry of Colonial Slaves
 and Slave Compensation Commission, Treasury Office 71, TNA-UK, con-
 tains thirty-two individuals named Snap, most born ca. 1760–80: *Slave Reg-
 isters of former British Colonial Dependencies, 1813–1834* [database online],
 Provo, UT, accessed 30 Jan. 2015. Most of these came from Jamaica; Clarke's
 Jamaica connections make this path likely for Snap Copley.

61 JSC to HP, 17 Aug. 1771, *CPL*, 142; HP to JSC, 25 Aug. 1771, *CPL*, 147;

HP to JSC, 8 Dec. 1771, CO 5/39, ff. 141–42, TNA-UK. See also HP to [Peggy McIlvaine?], 1 March 1770, *CPL*, 184; and HP to JSC, 17 Nov. 1771, CO 5/39, ff. 125–26, TNA-UK.

62 HP to Charles Pelham, 12 Nov. 1770, *CPL*, 96; see also Vincent Carretta, *Phillis Wheatley: Biography of a Genius in Bondage* (Athens: U of Georgia P, 2011), 18–23, 78.

63 Eric Slauter, "Looking for Scipio Moorhead: An 'African Painter' in Revolutionary North America," in *Slave Portraiture in the Atlantic World*, ed. Agnes Lugo-Ortiz and Angela Rosenthal (New York: Cambridge UP, 2013), 89–116.

64 Christian Barnes to Elizabeth Smith, 20 March 1770, Christian Barnes Papers, 1768–84, LoC, MMC-1785, ff. 38–40; Amelia Peck and Paula M. Bagger, "Prince Demah Barnes: Portraitist and Slave in Colonial Boston," *Antiques*, Feb. 2015, pp. 154–59.

65 Christian Barnes to Elizabeth Smith Inman, 9 March 1772, Christian Barnes Papers, ff. 84–85; *BNL*, 7 Jan. 1773; Peck and Bagger, "Prince Demah Barnes," 159 n11.

66 Slauter, "Looking for Scipio Moorhead," 109–10.

67 Samuel Johnson, *Taxation No Tyranny; An Answer to the Resolutions and Address of the American Congress* (London, 1775), 89. A Google n-gram search reveals that the metaphorical usage of "slavery" and "slaves" in American English more than doubled between 1765 and 1770, and would double again by 1774. Edmund S. Morgan famously called the connection between liberty and slavery "the American Paradox"; *American Slavery, American Freedom: The Ordeal of Colonial Virginia* (New York: Norton, 1975). Bernard Bailyn argued that the rebels' attachment to the metaphor of antislavery catalyzed abolitionist thought; *The Ideological Origins of the American Revolution* (Cambridge: Harvard UP, 1967), 230–46. Recent works have tended to make the trajectory more vexed. See esp. Christopher L. Brown, "The Problems of Slavery," in *The Oxford Handbook of the American Revolution*, ed. Edward G. Gray and Jane Kamensky (New York: Oxford UP, 2012), 427–46; and Malick W. Ghachem, "The Antislavery Script: Haiti's Place in the Narrative of the American Revolution," in *Scripting Revolution: A Historical Approach to the Comparative Study of Revolutions*, ed. Keith M. Baker and Dan Edelstein (Stanford, CA: Stanford UP, 2015), 148–65.

68 *BNL*, 11 Jan. 1770; see also Archer, *As If an Enemy's Country*, 166–81.

69 "Boyle's Journal of Occurrences," *NEHGR* 84:262 (22 Feb. 1770); *Diary and Autobiography of John Adams*, 1:349–350; see also *Rowe*, 197 (26 Feb. 1770).

70 *BEP*, 26 Feb. 1770.

71 "Extract of a Letter from Boston, dated March 19, 1770," *New-York Journal*,

12 April 1770. On what came to be known as the Boston Massacre, see esp. Hiller B. Zobel, *The Boston Massacre* (New York: Norton, 1970), 181–205.

72 *BTR, 1770–77*, 18:1–2.

73 Gage to Hillsborough, 10 April 1770, *Correspondence of General Thomas Gage*, 1:248–51, quotation at 249; Douglass Adair and John A. Schultz, eds., *Peter Oliver's Origin & Progress of the American Rebellion: A Tory View* (Stanford, CA: Stanford UP, 1961), 90–91. Gage also uses the word "mob" (or "mobs") seven times in his report. On words that name acts of war, see Jill Lepore, *The Name of War: King Philip's War and the Origins of American Identity* (New York: Knopf, 1998), ix–xxiii.

74 *BG*, 2 April 1770; HP to Charles Pelham, 17 Jan. 1770, *CPL*, 79.

75 Daniel Rea Jr., "A Bill for Printing," March 1770, *CPL*, 84. The watermark on the one surviving impression of Pelham's print shows the paper to be Dutch; Clarence S. Brigham, *Paul Revere's Engravings*, [rev. ed.] (New York: Atheneum, 1969), 54.

76 HP to Paul Revere, 29 March 1770, *CPL*, 83.

77 Brigham, *Revere's Engravings*, 52–78; Louise Phelps Kellogg, "The Paul Revere Print of the Boston Massacre," *Wisconsin Magazine of History* 1:4 (June 1918): 377–87.

78 HP to Charles Pelham, 1 May 1770, *CPL*, 87. Pelham sent two copies of his print with this letter to Charles in Newton. A search of America's Historical Newspapers and America's Historical Imprints turns up few references to "civil war" ca. 1770; Google n-grams confirms the very low incidence of "civil war" talk in American prints of the day.

79 The oft-repeated assertion that Adams "is represented at the meeting of the Council and the officers of the British army and navy, the day after the Boston Massacre," originated in a biography by Adams's great grandson; see William Vincent Wells, *The Life and Public Services of Samuel Adams, Being a Narrative of His Acts and Opinions, and of His Agency in Producing and Forwarding the American Revolution* (Boston: Little, Brown, 1865), 475–76.

80 *The Writings of Samuel Adams*, ed. Harry Alonzo Cushing (New York: Putnam, 1904), 1:1–2.

81 Wells, *Life and Public Services of Samuel Adams*, 475. Wells says the painting commemorated a rapprochement between Adams and the more moderate Hancock; see ibid., 343–44, 437–39. But the rift between Hancock and Adams was both shallow and short-lived, and the portrait could as easily have been painted before it started or after it was allegedly ended by the elections of 1772.

82 Isaac John Greenwood, *The Greenwood Family of Norwich, England in America*, ed. H. Minot Pitman and Mary M. Greenwood (Concord, NH: privately printed, 1934), esp. 61–63.

83 John Greenwood to JSC, 23 March 1770, *CPL*, 81–83.

84 JSC to John Greenwood, 25 Jan. 1771, *CPL*, 105; *JSC in America*, 269–71. Mary Charnock was born in March 1710; *Boston Births from A.D. 1700 to A.D. 1800*, vol. 24, Reports of the Record Commissioners of the City of Boston (Boston: Rockwell & Churchill, 1894), 66. Her third marriage, to Humphrey Devereux, took place in 1762; *Boston Marriages from 1752 to 1809*, vol. 30, Records Relating to the Early History of Boston (Boston: Municipal Printing Office, 1903), 47.

85 JSC to West, 24 Nov. 1770, *CPL*, 97.

86 *Boston Births, 1700–1800*, 312, 316, 320.

87 John Wilkes to Nathaniel Barber, 21 Sept. 1770, *CPL*, 95.

88 For Copley's political sentiments at the time, see his praise for Peale's allegorical print of William Pitt, whom Copley called "a great man . . . a true Patriot vindicatting the rights of mankind," in JSC to Peale, 17 Dec. 1770, *CPL*, 100.

89 JSC to West, 24 Nov. 1770, *CPL*, 98.

90 West to JSC, 16 June 1771, *CPL*, 116.

91 *LC*, 25 May 1769. News of Reynolds's knighthood, conferred in April 1769, appeared in the *Boston Chronicle*, 12 June 1769.

92 John Galt, *The Life, Studies, and Works of Benjamin West, Esq., President of the Royal Academy of London* (London: Printed for Cadell and Davies, 1820), 2:46–48.

93 Galt, *Life and Studies*, 2:49–50; *Craftman's Weekly* (UK), 25 May 1771.

94 On the reception of *The Death of General Wolfe*, see Emily Ballew Neff, "At the Wood's Edge: Benjamin West's 'The Death of Wolfe' and the Middle Ground," in *American Adversaries*, 64–103; and Helmut von Erffa and Allen Staley, *The Paintings of Benjamin West* (New Haven: Yale UP, 1986), 55–85.

95 JSC to Greenwood, 25 Jan. 1771, *CPL*, 105–6. News of West's triumph began to appear in American newspapers in Aug. 1771: see *BPB*, 12 Aug. 1771. But the ecstatic reception began before the spring exhibitions; see West to Peale, 21 June 1770, in Lillian B. Miller et al., eds., *The Selected Papers of Charles Willson Peale and His Family* (New Haven: Yale UP, 1983), 1:81. Peale may well have shared West's news with Copley when they exchanged letters in late 1770; see JSC to Charles Willson Peale, 17 Dec. 1770, *CPL*, 100–101, which references a letter from Peale to Copley dated 24 Nov.

96 *P-JSC*, 16–17; Susan Rather, "Carpenter, Tailor, Shoemaker, Artist: Copley and Portrait Painting around 1770," *Art Bulletin* 79:2 (June 1997): 273–74.

97 Joshua Reynolds, *Discourses on Art*, ed. Robert R. Wark (New Haven: Yale UP, 1997), 27. It is possible that a bookseller like the Anglophilic John Mein would have stocked Reynolds's annual lectures, or that somebody would have carried a copy to Copley. He had read them closely before writing to Harry,

"I would send you Sir Josha. Reynolds's Lectures *if I was sure you had not them*," JSC to HP, 17 Aug. 1774, *CPL*, 241, emphasis added.

CHAPTER SIX: THE TYRANNY OF LIBERTY

1 John Small to JSC, 15 May 1770, *CPL*, 94; see also Small to JSC, 29 Oct. 1769, *CPL*, 77–78.

2 JSC to Stephen Kemble, [20 March 1771?], *CPL*, 112–13.

3 HP to JSC, 11 July 1771, *CPL*, 126. On life in provincial New York, see Esther Singleton, *Social New York under the Georges 1714–1776* (New York: D. Appleton, 1902), pt. 4. For comparisons to Boston, see Gary B. Nash, *The Urban Crucible: Social Change, Political Consciousness, and the Origins of the American Revolution* (Cambridge: Harvard UP, 1979).

4 "List of Subscribers," 17 April 1771, *CPL*, 113–14. For Gage's residence see R. Alden John, *General Gage in America; Being Principally a History of His Role in the American Revolution* (Baton Rouge: Louisiana State UP, 1948), esp. 65–69, 193.

5 JSC to Stephen Kemble, [20 March 1771?], *CPL*, 112; Stephen Kemble to JSC, 17 April 1771, *CPL*, 113.

6 Articles of Agreement, 3 June 1771, Joy v. Copley, Suffolk County Court of Common Pleas, MassArchs.

7 *BSM, 1769–75*, 23:89.

8 JSC to HP, 16 June 1771, *CPL*, 116–18; see also HP to JSC, 11 July 1771, *CPL*, 126.

9 HP to JSC, 28 July 1771, *CPL*, 135; HP to JSC, 22 Oct. 1771, *CPL*, 172; HP to JSC, 17 July 1771, *CPL*, 128. For other mentions of Betsy during this separation, see *CPL*, 124, 126, 147, 151, 155, 162, 172, 176, 178, 184. For Mrs. Pelham's usual ill health, see HP to JSC, 23 June 1771, *CPL*, 121 ("very tolerable Health"); HP to JSC, 7 July 1771, *CPL*, 124 ("as well as . . ."); and *CPL*, 135, 145, 151, 154–55, 161, 171.

10 JSC to HP, 20 June 1771, *CPL*, 120; JSC to HP, 14 July 1771, *CPL*, 127; JSC to HP, 24 July 1771, *CPL*, 132; HP to JSC, 25 Aug. 1771, *CPL*, 145.

11 JSC to HP, 17 Oct. 1771, *CPL*, 168. Sukey's sister is misidentified by the editors as Mary Clarke Barrett, who in fact had died in 1764. Sukey mourned Elizabeth Watson Clarke, widow of her brother Edward Clarke; "Boyle's Journal of Occurrences," *NEHGR* 84:271.

12 HP to JSC, 11 July 1771, *CPL*, 127; HP to JSC, 23 July 1771, *CPL*, 123.

13 JSC to HP, 24 July 1771, *CPL*, 132.

14 HP to JSC, 25 Aug. 1771, *CPL*, 146.

15 HP to JSC, 28 July 1771, *CPL*, 135.

16 JSC to HP, 24 July 1771, *CPL*, 133.

17 HP to JSC, 25 Aug. 1771, *CPL*, 146; see also *CPL*, 132, 154, 172.

18 HP to [Peggy McIlvaine?], 1 March 1772, *CPL*, 184 ("abroad"); JSC to HP, 29 Sept. 1771, *CPL*, 165 ("Adieu"); JSC to HP, 12 Oct. 1771, *CPL*, 166 ("adiew"). By the sixteenth century, "abroad" carried two meanings: far from home and in foreign parts; *OED*.

19 JSC to HP, 20 June 1771, *CPL*, 120; JSC to HP, *CPL*, 14 July 1771, 126–28. Copley described the picture brought to his New York painting room as "Capt. Richards's' portrait (at Mr. Sherbrooks)." The subject has not been identified, but its presence in New York in 1771 makes it likely that Captain Richards was one of those who came to Boston with Gage.

20 JSC to HP, 24 July 1771, *CPL*, 133; JSC to HP, 17 Aug. 1771, *CPL*, 141; JSC to HP, 9 Sept. 1771, *CPL*, 152; JSC to HP, 6 Nov. 1771, *CPL*, 174.

21 JSC to HP, 20 Sept. 1771, *CPL*, 160–61; JSC to HP, 3 Aug. 1771, *CPL*, 136; JSC to HP, 6 Nov. 1771, *CPL*, 174; JSC to HP, 15 Dec. 1771, *CPL*, 179.

22 JSC to HP, 12 Oct. 1771, *CPL*, 166; JSC to HP, 6 Nov. 1771, *CPL*, 174.

23 John Montrésor and James Gabriel Montrésor, *The Montresor Journals*, ed. G. D. Scull, vol. 14, Collections of the New-York Historical Society (New York: N-YHS, 1882), 336, 369, 348, 357.

24 JSC to HP, 6 Nov. 1771, *CPL*, 174. On *Mrs. Thomas Gage* (Margaret Kemble) and the vogue for Turkish fantasy dress, see Carrie Rebora Barratt, *John Singleton Copley and Margaret Kemble Gage: Turkish Fashion in 18th-Century America* (San Diego: Putnam Foundation, 1998).

25 HP to JSC, 25 Aug. 1771, *CPL*, 147–48; HP to JSC, 11 July 1771, *CPL*, 126; see also HP to JSC, 28 July 1771, *CPL*, 134; HP to JSC, 24 Sept. 1771, *CPL*, 163. On bookkeeping, see *CPL*, 148, 153, 162, 165. Shipments of supplies: *CPL*, 138, 140–41, 147, 152, 155, 159, 162, 176.

26 JSC to HP, 29 Sept. 1771, *CPL*, 163–65; HP to JSC, 22 Oct. 1771, *CPL*, 170–71.

27 JSC to HP, 14 July 1771, *CPL*, 130–31.

28 HP to JSC, 28 July 1771, *CPL*, 134.

29 JSC to HP, 3 Aug. 1771, 136–37. On the piazza, see also *CPL*, 141–42, 147, 153–54, 156, 160, 162, 169, 175.

30 JSC to HP, 14 July 1771, *CPL*, 130–31; JSC to HP, 17 Aug. 1771, *CPL*, 142; JSC to HP, 20 Sept. 1771, *CPL*, 160.

31 HP to JSC, 25 Aug. 1771, *CPL*, 148.

32 JSC to HP, 3 Aug. 1771, *CPL*, 137; JSC to HP, 9 Sept. 1771, *CPL*, 153; HP to JSC, 24 Sept. 1771, *CPL*, 162.

33 HP to JSC, 2 Sept. 1771, *CPL*, 151; JSC to HP, 9 Sept. 1771, *CPL*, 152; HP to JSC, 10 Sept. 1771, *CPL*, 156; 28 Nov. 1771, *CPL*, 177; HP to [Peggy McIlvaine?], 1 March 1772, *CPL*, 184.

34 JSC to HP, 15 Dec. 1771, *CPL*, 179; *Rowe*, 225 (17 Feb. 1772). For their arrival in Boston, see HP to [Peggy McIlvaine?], 1 March 1772, *CPL*, 184.

On the resolution of Bannister's suit, see Bannister v. Fenno and Copley, Suffolk Files #10234, MassArchs.

35 Joy v. Copley, Suffolk County Court of Common Pleas, January Term, 1773, Docket No. 148, documents 4 & 5 (Writs of Attachment), and documents 7–11 (bills), MassArchs.

36 Benjamin Labaree, *The Boston Tea Party* (New York: Oxford UP, 1964), 42–50. Lord North had set in motion the reversal of the Townshend duties hours before the king's soldiers fired into the crowd on the other side of the ocean.

37 Hiller B. Zobel, *The Boston Massacre* (New York: Norton, 1970), 207–94, Quincy quotation at 279.

38 Ann Hulton to Mrs. Lightbody, 21 Dec. 1770, in [Ann Hulton,] *Letters of a Loyalist Lady, Being the Letters of Ann Hulton* (Cambridge: Harvard UP, 1927), 28; *Rowe*, 211–12 (18 Jan. 1771).

39 Gage to Lord Barrington, 3 July 1771, Clarence Edwin Carter, ed., *The Correspondence of General Thomas Gage* (New Haven: Yale UP, 1931), 2:583. For passing mentions of political affairs during Copley's New York trip, see *CPL*, 135, 157–58, and 178.

40 *BPB*, 22 July 1771. For plans to resume importation, see Richard Clarke to Isaac W. Clarke, 6 Sept. 1770, box 1, folder 4, Richard Clarke and Sons Records, NEHGS; Labaree, *Boston Tea Party*, 33–34. In 1770 and early 1771 the firm sold rice, sugar, and indigo; see, e.g., *BEP*, 5 March 1770, 25 March 1771; *BNL*, 15 March 1770; *BPB*, 21 May, 22 Oct. 1770.

41 Jared Sparks, ed., "Bennett's History of New England; Boston in 1740," *Proceedings of the Massachusetts Historical Society* 5 (Jan. 1861): 125–26. On tea, see Rodris Roth, "Tea-Drinking in Eighteenth-Century America: Its Etiquette and Equipage," in *Material Life in America, 1600–1860*, ed. Robert Blair St. George (Boston: Northeastern UP, 1988), 439–62; Beth Kowaleski-Wallace, "Tea, Gender, and Domesticity," *Studies in Eighteenth-Century Culture* 23 (1994): 131–45; and T. H. Breen, "'Baubles of Britain': The American and Consumer Revolutions of the Eighteenth Century," *Past & Present*, no. 119 (May 1988): 73–104.

42 Samuel Wharton, "Observations upon the Consumption of Teas in North America [January 1773]," *PMHB* 25:1 (1901): 139–41.

43 Carole Shammas, *The Pre-Industrial Consumer in England and America* (New York: Oxford UP, 1990), esp. 65–67, 183–86; Labaree, *Boston Tea Party*, 3–14, 331. Labaree estimates that three-quarters of the tea in America was smuggled.

44 *BG*, 3 Oct. 1768; *BNL*, 27 Oct. 1768.

45 Thomas Robie to Richard Clarke, 13 Jan. 1770, Miscellaneous Bound Mss., MHS.

46 Labaree, *Boston Tea Party*, 46, 50, 331. English tea exports to New England more than tripled between 1770 and 1771, from 85,935 lbs. to 282,857 lbs. For rates of consumption see Shammas, *Pre-Industrial Consumer*, 63–64.

47 *CPL*, 126, 130, 157, 158–59, 160, 179.

48 John Singleton Copley Jr. was born on 21 May 1772, and baptized on 9 June in Trinity Church; Dennis Lee, *Lord Lyndhurst: The Flexible Tory* (Niwot: UP of Colorado, 1994), 1; Andrew Oliver and James Bishop Peabody, eds., *The Records of Trinity Church, Boston, 1728–1830* (Boston: Colonial Society of Massachusetts, 1980), 563. Margaret Copley, the couple's third child, was born in Oct. 1773, which means that Sukey would have been pregnant when John Jr. was eight months old. Birth intervals of thirty months were common, though there is some indication that, by the end of the colonial period, elite women in port cities purposely concentrated childbearing; Susan E. Klepp, *Revolutionary Conceptions: Women, Fertility, and Family Limitation in America, 1760–1820* (Chapel Hill: U of North Carolina P, 2009), 21–55.

49 William Carson to JSC, 16 Aug. 1772, *CPL*, 188.

50 Lucy Clarke to Sally Clarke Bromfield, 5 Aug. 1772, BFP, box 1, folder 4.

51 Lucy Clarke to Isaac Winslow Clarke, May 1770, BFP, box 1, folder 3.

52 West to JSC, 6 Jan. 1773, *CPL*, 197; see also Jonathan Clarke to JSC, 20 Dec. 1772, *CPL*, 192. Copley's exhibition performances are cataloged as "A gentleman, half length," "Ditto, ditto," and "A lady, ditto," see *A Catalogue of the Pictures, Sculptures, Models, Designs in Architecture, Drawings, Prints, &c. Exhibited at Their New Room, near Exeter-Exchange, Strand, May the Thirteenth, 1772, by the Society of Artists of Great-Britain* (London, 1772), 6. One of the anonymous gentlemen was the portrait of Thomas Gage.

53 William Carson to JSC, 16 Aug. 1772, *CPL*, 187–88.

54 Jonathan Clarke to JSC, 20 Dec. 1772, *CPL*, 190–93. Clarke's letter references a now lost letter from Copley, dated 8 Nov. 1772, detailing the plan to sail. See also West to JSC, 6 Jan. 1773, *CPL*, 195–97.

55 Sarah Clarke Startin to Isaac W. Clarke, 6 Feb. 1773; Sarah Clarke Startin to Isaac W. Clarke, 27 April 1773, Miscellaneous Bound Mss., MHS. See also an undated draft from Henry Pelham to his "Aunt Singleton" (either his mother's brother's wife or her unmarried sister) in Ireland, ca. 1772, CO 5/39, ff. 150–51, TNA-UK, in which he says that Copley will journey "this fall or the next spring at latest."

56 *BTR, 1770–77*, 18:111, 126.

57 JSC to William Phillips, 23 June 1773, Suffolk Deeds, L124, f. 56. Copley added to Mount Pleasant earlier in the month, a strip of land stretching east to Hancock's boundary, for which he paid £90; John Williams to JSC, 2 June 1773, Suffolk Deeds, L126, ff. 19–20, MassArchs.

58 Klepp, *Revolutionary Conceptions*, 182–85.

59 On the Tea Act (13 George III ch 44), see Labaree, *Boston Tea Party*, 66–73, 84–87; *Massachusetts Gazette*, 21 June 1773; and *Massachusetts Spy*, 1 July 1773; *BPB*, 12 July 1773.

60 *HMB*, 3:303.

61 Jonathan Clarke to East India Company, 1 July 1773, repr. in Francis S. Drake, *Tea Leaves: Being a Collection of Letters and Documents Relating to the Shipment of Tea to the American Colonies in the Year 1773* (Boston: A. O. Crane, 1884), 209–11; see also 215, 224, 235, 237, 238, 243. The amount of Clarke's consignment is noted in John Bromfield to Henry Bromfield, 9 Aug. 1773, BFP, box 1, folder 4.

62 John Bromfield to Henry Bromfield, 9 Aug. 1773, BFP, box 1, folder 4; Henry Bromfield to John Bromfield, 4 Sept. 1773, quoted in Labaree, *Boston Tea Party*, 87–88.

63 *Records of Trinity Church*, 565. Mary was also the name of Richard Clarke's sister, married to Andrew Oliver.

64 *BG*, 18 Oct. 1773.

65 *BEP*, 25 Oct. 1773; also printed in *BNL*, 28 Oct. 1773. For Clarke's self-identification as "Z," and his intentions in publishing the article, see Richard Clarke to Abraham Dupuis, Nov. 1773, in Drake, *Tea Leaves*, 279–82.

66 Drake, *Tea Leaves*, 282–83; *Rowe*, 252 (2 Nov. 1773). On "O.C." see Alfred F. Young, *Liberty Tree: Ordinary People and the American Revolution* (New York: New York UP, 2006), 163–64.

67 *BNL*, 8 Nov. 1773; Richard Clarke to Abraham Dupuis, Nov. 1773, in Drake, *Tea Leaves*, 283–84.

68 *BG*, 8 Nov. 1773; Henry Bromfield to Sally Clarke Bromfield, 15 Nov. 1773, BFP, box 1, folder 4; Richard Clarke to Abraham Dupuis, Nov. 1773, in Drake, *Tea Leaves*, 285–86. The *Gazette* downplayed the violence of the affair, noting only that "the people . . . shewed some marks of their resentment, and then dispersed."

69 *BTR, 1770–77*, 18:141–46; and *BG*, 8 Nov. 1773.

70 Richard Clarke to Isaac W. Clarke, 21 June 1762, in Henry H. Edes, ed., "Selections from the Papers of Richard Clarke," *Colonial Society of Massachusetts Publications* 8 (1906): 79–80. On reputation as currency, see Craig Muldrew, *The Economy of Obligation: The Culture of Credit and Social Relations in Early Modern England* (New York: St. Martin's Press, 1998).

71 *BTR, 1770–77*, 18:146. Young's speech is reported in Henry Bromfield to Sally Clarke Bromfield, 15 Nov. 1773, BFP, box 1, folder 4.

72 HP to Charles Pelham, 5 Nov. 1773, *CPL*, 200–202.

73 William Paine to Isaac W. Clarke, 7 Nov. 1773, Miscellaneous Bound Mss., MHS; see also Labaree, *Boston Tea Party*, 107–25.

74 *BPB*, 22 Nov. 1773; *BNL*, 26 Nov. 1773. Compare to Richard Clarke's draft petition to the governor and council, 19 Nov. 1773, Richard Clarke Papers, 1763–75, box 2, folder 13, Henry Herbert Edes Collection, 1648–1917, MHS. Hutchinson's letters identify "one of Mr. Clarke's sons" as the shooter; "Richard Clarke," *Sibley's*, 8:557.

75 *BG*, 13 Dec. 1773. The diary of John Rowe, an owner of one of the tea ships, supports Clarke's account; see *Rowe*, 254 (18 Nov. 1773).

76 JSC to HP, 17 Aug. 1771, *CPL*, 142.

77 "To All Nations of Men," *Massachusetts Spy*, 18 Nov. 1773. The letter was understood to "justify the Murder or assassination" of the teamen; Neil Longley York, ed., *Henry Hulton and the American Revolution: An Outsider's Inside View* (Boston: Colonial Society of Massachusetts / UP of Virginia, 2010), 155–56. Massachusettensis was Daniel Leonard, who in 1774 parted company with the rebels, and saw his own house attacked in consequence; Carol Berkin, "Leonard, Daniel," *ANB Online*, Feb. 2000, http://www.anb .org/articles/01/01-00513.html. For Richard Clarke in Salem, see Clarke to Jonathan Clarke and Isaac W. Clarke, 23 Nov. 1773, Edes Collection, box 2, folder 13, MHS. Hulton places him in the castle on 28 Nov.

78 *BTR, 1770–77*, 18:148; Drake, *Tea Leaves*, 309–20. Among the members of the council present at those meetings, William Brattle, Samuel Danforth, John Erving, Isaac Royall, and John Winthrop had sat to Copley, as had Royall's daughters, Winthrop's wife and son, the wife of James Russell, and the father of James Otis.

79 *Rowe*, 255 (29 Nov. 1773); compare with Drake, *Tea Leaves*, 43.

80 An anonymous transcript of the meetings is reprinted in L. F. S. Upton, "Proceedings of Ye Body Respecting the Tea," *WMQ*, 3d ser., 22:2 (April 1965): 287–300, quotation at 290.

81 *HMB*, 3:310–11.

82 Upton, "Proceedings . . . Respecting the Tea," 290–91.

83 Ibid., 292; JSC to West, 24 Nov. 1770, *CPL*, 98 ("party spirit").

84 Copley's actions on the night of 29 Nov. are detailed in a note one of the consignees appended to the press clippings they sent to London; see Drake, *Tea Leaves*, 323. For the consignees at the castle, see *HMB*, 3:309.

85 The consignees' letter appears in Drake, *Tea Leaves*, 323–24, as well as in newspapers.

86 Upton, "Proceedings . . . Respecting the Tea," 292–93.

87 Douglass Adair and John A. Schultz, eds., *Peter Oliver's Origin & Progress of the American Rebellion: A Tory View* (Stanford, CA: Stanford UP, 1961), 39. Oliver describes the statement as "the Observation made by a celebrated Painter in *America*." Copley is the only possible choice. Related to the Clarkes, Copley was well known to Oliver, whom he had painted in minia-

ture in 1758 and somewhat later in oil; P-*JSC*, 225. The two traveled in the same circles in England ca. 1775–81, when Oliver's manuscript account was written. Moreover, there simply *was* no other celebrated American painter, in Boston or in London, who could possibly have made such a remark. Mather Brown, who came from a loyalist family, was born in 1761, and hardly "celebrated" even in 1781; during the events in Boston in 1773, he was twelve.

88 *BPB*, 6 Dec. 1773.

89 Upton, "Proceedings . . . Respecting the Tea," 294–95; contra *Rowe*, 256 (30 Nov. 1773). For the contrast between "the moderate part" and "those that have been most zealous," see Jonathan Clarke to Richard Clarke, 24–26 Nov. 1773, BFP, box 1, folder 4.

90 *Massachusetts Spy*, 2 Dec. 1773; Upton, "Proceedings . . . Respecting the Tea," 294–96.

91 JSC to Jonathan Clarke and Isaac W. Clarke, [1 Dec. 1773], *CPL*, 211–13.

92 L. H. Butterfield, ed., *Diary and Autobiography of John Adams* (Cambridge: Harvard UP, 1961), 2:85–86 (17 Dec. 1773).

93 Isaac W. Clarke to Henry Bromfield, 19 Dec. 1773, BFP, box 1, folder 4; Thomas Hutchinson Jr. to Elisha Hutchinson, 14 Dec. 1773, Hutchinson Family Correspondence, BL, Eg. 2569, ff. 56–57.

94 Handbill reprinted in "Richard Clarke," *Sibley's*, 8:559; see also *BG*, 17, 24 Jan., 28 March 1774.

95 *Diary and Autobiography of John Adams*, 2:92. The line appears to have been repeated to Adams by Eleazar Tyng, a Copley sitter; Tyng had heard it at Andrew Oliver's funeral, in which Adams rejoiced; ibid., 2:90.

96 Jonathan Clarke to Henry Bromfield, 19, 28 Jan. 1774, BFP, box 1, folder 5.

97 JSC to Richard Clarke, [ca. 15 Feb. 1774], *CPL*, 213–15.

98 *BG*, 14 March 1774; *Diary and Autobiography of John Adams*, 2:91. Prown estimates that Copley painted seventy-two pictures ca. 1771–74, of which thirty-seven were painted in New York, leaving only thirty-five pictures done in Boston over four years; P-*JSC*, 128–29.

99 Clarence S. Brigham, *Paul Revere's Engravings* (New York: Atheneum, 1969), 111–14.

100 JSC to Isaac W. Clarke, 26 April 1774, *CPL*, 217–18. Watson, whom Copley had painted in 1768, would be elevated in Aug. 1774 to the governor's council, appointed by royal writ or mandamus, an office much despised by the patriots, for it represented the negation of representative government. But that was not yet known.

101 JSC to Isaac W. Clarke, 26 April 1774, *CPL*, 218–19.

102 *Rowe*, 269–70 (10, 13, 17 May 1774).

103 Revere's engraving, copied from the *London Magazine*, April 1774, ran as

the frontispiece to the *Royal American Magazine* that June; Brigham, *Revere's Engravings*, 117–18.

104 "Address of the Merchants and Others of Boston to Gov. Hutchinson," reprinted in James H. Stark, *The Loyalists of Massachusetts and the Other Side of the American Revolution* (Boston: W. B. Clarke, 1910), 123–25. For the manner of its circulation, see *BG*, 30 May 1774; *BPB*, 23, 30 May 1774; *BEP*, 30 May 1774.

105 York, *Henry Hulton and the American Revolution*, 162.

106 *A True List of Those Persons Who Signed an Address to the Late Governor Hutchinson* ([Boston, 1774]). A notation on the copy at the MHS gives the date as 28 May. On government by committee, see Richard D. Brown, *Revolutionary Politics in Massachusetts: The Boston Committee of Correspondence and the Towns, 1772–1774* (Cambridge: Harvard UP, 1970).

CHAPTER SEVEN: LUXURY IN SEEING

1 All *BEP*, 13 June 1774; see also *BNL*, 9 June 1774.

2 *Rowe*, 273 (1 June 1774); Neil Longley York, *Henry Hulton and the American Revolution: An Outsider's Inside View* (Boston: Colonial Society of Massachusetts / UP of Virginia, 2010), 164.

3 JSC to SCC, 9 July 1774, *CPL*, 223–24.

4 Ibid. Clarke Copley was born on 13 Jan. 1775, which means Sukey conceived in late April. In HP to JSC, 19? Aug. 1774, CO 5/39, ff. 219–20, TNA-UK, Harry says that Sukey "frequently sees Polly," which indicates that the baby, like her siblings, was put out to nurse.

5 JSC to SCC, July 9, 1774, *CPL*, 223–24.

6 *Rowe*, 274 (10 June 1774).

7 JSC to SCC, July 9, 1774, *CPL*, 223.

8 JSC to SCC, 11 July 1774, CFP-LoC, folder 1.

9 JSC to HP, 11 July 1774, *CPL*, 225.

10 JSC to SCC, 11 July 1774; also JSC to HP, 11 July 1774, *CPL*, 225–26.

11 JSC to HP, 11 July 1774, *CPL*, 227.

12 JSC to HP, 17 Aug. 1774, *CPL*, 239.

13 JSC to HP, 5 Aug. 1774, *CPL*, 236.

14 JSC to SCC, 11 July 1774.

15 Ibid.; JSC to HP, 11 July 1774, *CPL*, 227.

16 JSC to HP, 11 July 1774, *CPL*, 226.

17 JSC to HP, 5 Aug. 1774, *CPL*, 236.

18 JSC to SCC, 21 July 1774, fragment, CFP-LoC, folder 1.

19 JSC to HP, 17, 5 Aug. 1774, *CPL*, 237–39. Hutchinson also made some effort to import a New England diet. The day before his dinner with Copley, he wrote to his son Thomas Jr., "Don't forget the Cranberries, at least six or

eight bushels . . . get the largest and fairest, and when they are come to their colour, and not too ripe"; *Hutchinson Diary*, 1:201.

20 JSC to HP, 11 July 1774, *CPL*, 226.

21 JSC to HP, 17 Aug. 1774, *CPL*, 238–39, 240, 241; JSC to HP, 2 Sept. 1774, *CPL*, 246.

22 *MC*, 26 May 1772.

23 JSC to HP, 17 Aug. 1774, *CPL*, 239–40.

24 Society of Artists of Great Britain, *A Catalogue of the Pictures, Sculptures, Models, Designs in Architecture, Drawings, Prints, &c. Exhibited by the Society of Artists of Great-Britain* (London, 1774), 8. For Carter's biography, see Deborah Graham-Vernon, "Carter, George," *ODNB Online*, 2004.

25 JSC to HP, 11 July 1774, *CPL*, 227; JSC to SCC, 21 July 1774, fragment.

26 Carter Diary, 29, 30 Aug. 1774; JSC to HP, 2 Sept. 1774, *CPL*, 242.

27 JSC to HP, 2 Sept. 1774, *CPL*, 242; Carter Diary, 1 Sept. 1774. See also JSC to MCP, 8 Sept. 1774, *CPL*, 254.

28 JSC to HP, 2 Sept. 1774, *CPL*, 245; Carter Diary, 6 Sept. 1774.

29 JSC to HP, 7 Sept. 1774, *CPL*, 247, 249–50; JSC to HP, 14 March 1775, *CPL*, 305.

30 JSC to HP, 7 Sept. 1774, *CPL*, 247, 250–51, 252; JSC to John Greenwood, 7 May 1775, CFP-LoC.

31 JSC to HP, 2 Sept. 1774, *CPL*, 244. Carter complained that the production contrived a sunny ending, with Orpheus and Eurydice in heaven; Carter Diary, 2 Sept. 1774.

32 JSC to MCP, 8 Sept. 1774, *CPL*, 254–55, 253; see also JSC to HP, 25 Sept. 1774, *CPL*, 262.

33 Carter Diary, 3 Sept., 12 Oct. 1774.

34 Letters signed "adieu": *CPL*, 245, 252, 260, 342, 344; CFP-LoC: 4 Nov., 4–17 Dec. 1774, [n.d.: Jan. 1775], 28 Jan., 9 June, 22 July 1775.

35 Carter Diary, 10, 14 Sept. 1774; JSC to SCC, 15 Sept. 1774, *CPL*, 257.

36 JSC to SCC, 15 Sept. 1774, *CPL*, 258; Carter Diary, 17 Sept. 1774.

37 JSC to MCP, 8 Sept. 1774, *CPL*, 253; JSC to SCC, 15 Sept. 1774, *CPL*, 259.

38 Carter Diary, 16 Sept. 1774.

39 Ibid., 16, 27 Sept. 1774.

40 Ibid., 27 Sept., 12, 9 Oct. 1774. Carter often portrays Copley stammering; see chap. 1, above.

41 Ibid., 16, 24, 20 Sept. 1774. For complaints that Copley was feminine, see also 16 Sept. 1774.

42 Ibid., 20 Sept. 1774.

43 Ibid., 28 Sept. 1774.

44 JSC to SCC, 15 Sept. 1774, *CPL*, 257; Ann Hulton to Mrs. Lightbody, Aug. 1772, in [Ann Hulton,] *Letters of a Loyalist Lady, Being the Letters of Ann*

Hulton (Cambridge: Harvard UP, 1927), 49–50. See also JSC to HP, 2 Sept. 1774, *CPL*, 244; JSC to HP, 25 Sept. 1774, *CPL*, 263.

45 For comparisons to Shandy, see Carter Diary, 12 Oct. 1774.

46 JSC to SCC, 17 Aug. 1774, CFP-LoC, folder 1.

47 JSC to MCP, 8 Sept. 1774, *CPL*, 255; JSC to SCC, 15 Sept. 1774, *CPL*, 256–57, 259–60.

48 JSC to SCC, 17 Aug., 8 Oct. 1774, CFP-LoC, folder 1.

49 JSC to SCC, 15 Sept. 1774, *CPL*, 260.

50 JSC to SCC, 8 Oct. 1774. He failed to meet with letters in Leghorn / Livorno.

51 Ibid.

52 Ibid.

53 JSC to SCC, 4 Nov. 1774, CFP-LoC, microfilm reel. For Smibert's copy of the Venus, see P-*JSC*, 18–19; Richard H. Saunders, *John Smibert: Colonial America's First Portrait Painter* (New Haven: Yale UP, 1995), 30–31.

54 JSC to SCC, 25 Oct. 1774, CFP-LoC, folder 1. It is not clear which Raphael or in what medium—or indeed whether it hung in Mount Pleasant or on Cambridge Street.

55 JSC to HP, 14 March 1775, *CPL*, 304; Saunders, *John Smibert*, 222.

56 Carter Diary, 23 Oct. 1774.

57 Izard to Edward Rutledge, 13 July 1774, in *Correspondence of Mr. Ralph Izard, of South Carolina, from the Year 1774 to 1804* (New York: C. S. Francis, 1844), 2; see also 15–18, 33, 35, 42. Lee and the Izards embarked on their tour together from London; see Richard Henry Lee and Arthur Lee, *Life of Arthur Lee, LL.D.* (Boston: Wells and Lilly, 1829), 262. They were in Florence on 18 Oct. 1774; Copley and Carter arrived there on 15 Oct.; JSC to SCC, 25 Oct. 1774. Later in his tour, Copley noted of Izard, "I had no acquaintance with him in America, but *at Florance he inquired for me and called to see me*," JSC to MCP, 25 June 1774, *CPL*, 330, emphasis added. For West's acquaintance with Izard, see *Correspondence of Mr. Ralph Izard*, 10.

58 Carter Diary, 23 Oct. 1774.

59 On American "independency" before 1775–76, see Benjamin H. Irvin, "Independence before and during the Revolution," in *The Oxford Handbook of the American Revolution*, ed. Edward G. Gray and Jane Kamensky (New York: Oxford UP, 2012), 139–58; and Craig Yirush, *Settlers, Liberty, and Empire: The Roots of Early American Political Theory, 1675–1775* (New York: Cambridge UP, 2011), esp. pt. 3.

60 Carter Diary, 21, 22 Oct. 1774.

61 Metcalfe Robinson Ms. letter, 1705, quoted in Jeremy Black, *The British Abroad: The Grand Tour in the Eighteenth Century* (New York: St. Martin's Press, 1992), 48.

62 John Galt, *The Life and Studies of Benjamin West, Esq., President of the Royal Academy of London, Prior to His Arrival in England* (London: Printed by Nicholls, Son, and Bentley, 1816), 1:92–93.

63 JSC to SCC, 25 Oct. 1774.

64 Carter Diary, 23 Oct. 1774.

65 Ibid.

66 John Morgan to James Byers, 24 Nov. 1773, *CPL*, 207; Dr. John Morgan to Abbé Peter Grant, 24 Nov. 1773, *CPL*, 209. On Grant as "l'Introduttore," see Clotilde Prunier, "Grant, Peter (1708–1784)," *ODNB Online*, 2004. On Byers, see Black, *British Abroad*, 49.

67 Carter Diary, 23 Oct. 1774; JSC to SCC, 25 Oct. 1774. The diary entry spans several days.

68 Carter Diary, interpolated letter dated 3 Nov. 1774.

69 JSC to SCC, 25 Oct. 1774; JSC to SCC, 4 Nov. 1774. I am estimating the date JSC received Harry's letter of 17 July 1774 (*CPL*, 228–33). Sukey's letters from Boston have been lost. On rumors that British warships had destroyed Boston, see T. H. Breen, *American Insurgents, American Patriots: The Revolution of the People* (New York: Hill and Wang, 2010), 128–59.

70 JSC to SCC, 25 Oct. 1775.

71 HP to JSC, 17 July 1774, *CPL*, 232–33.

72 JSC to SCC, 25 Oct. 1775; HP to JSC, 2 Nov. 1774, *CPL*, 266–67. Copley would not have received this letter for weeks after he wrote to Sukey on Nov. 4, but her 5 Sept. letter had contained the same news.

73 JSC to SCC, 4 Nov. 1774.

74 JSC to SCC, 25 Oct., 4 Nov. 1774. For the sending of the pigments to paint the houses, see JSC to HP, 5 Aug. 1774, *CPL*, 235.

75 JSC to SCC, 25 Oct. 1774.

76 JSC to SCC, 4 Nov. 1774.

77 JSC to SCC, 4–17 Dec. 1774, CFP-LoC, folder 1.

78 Ibid.

79 JSC to SCC, 9 June 1775, CFP-LoC, folder 1.

80 Maurice Andrieux, *Daily Life in Papal Rome in the Eighteenth Century* (London: Allen & Unwin, 1968), 1–25, 120–32; Brendan Cassidy, ed., *The Life & Letters of Gavin Hamilton (1723–1798): Artist & Art Dealer in Eighteenth-Century Rome* (London: Harvey Miller, 2011), esp. 1:274–317.

81 JSC to HP, 25 Sept. 1774, *CPL*, 262; see also Carter Diary, 22 Sept. 1774; Andrieux, *Daily Life in Papal Rome*, 186–87.

82 Location of Copley's rooms based on his comment, in JSC to SCC, 4–17 Dec. 1774, that his lodgings lay "opposite [Gavin Hamilton's] own house." Hamilton's showroom was in the Casa Moscatelli, on the Via del Corso, "verso Babuino." Cassidy, *Life & Letters of Gavin Hamilton*, 1:16.

83 JSC to SCC, 4–17 Dec. 1774. On the English see Brinsley Ford, "The Grand Tour," *Apollo* 114, no. 238 (Dec. 1981): esp. 396–97. Numbers of British (including American) and Irish travelers in Rome during Copley's trip computed via Grand Tour Explorer (https://grandtour.herokuapp.com/#/), developed by the Stanford Humanities Center. The tool allows multivariable searching and visualization of the data in John Ingamells, *A Dictionary of British and Irish Travellers in Italy, 1701–1800* (New Haven: Yale UP, 1997).

84 JSC to SCC, 4–17 Dec. 1774 (Carracci, Michelangelo); JSC to MCP, 25 June 1775, *CPL*, 332 (*Aurora*). On the fame of the *Aurora*, see María Dolores Sánchez-Jáuregui and Scott Wilcox, *The English Prize: The Capture of the Westmorland, an Episode of the Grand Tour* (New Haven: Yale UP, 2012), 64, 66–67, 199. Copley purchased a copy in watercolor for Thomas Palmer. For the *Transfiguration*, see JSC to SCC, 4 Nov. 1774 and Amory, 39. For Copley's continuing contact with Hamilton, see JSC to HP, 14 March 1775, *CPL*, 300. For the Izards, see JSC to MCP, 25 June 1775, *CPL*, 330 (quoted); JSC to SCC, 28 Jan. 1775; JSC to HP, 14 March 1775, *CPL*, 294, 295, 307; and JSC to SCC, 9 June 1775.

85 JSC to HP, 2 Sept. 1774, *CPL*, 245; see also 226. For sketches within letters see *CPL*, 234, 297 (both to Henry Pelham), and JSC to SCC, 28 Jan. 1775.

86 JSC to SCC, 4–17 Dec. 1774.

87 JSC to SCC, 2 July 1775, CFP-LoC, folder 1.

88 Ibid.

89 JSC to SCC, 28 Jan. 1775. Clarke Copley was born on 13 Jan.; see HP to JSC, 27 Jan. 1775, *CPL*, 285.

90 JSC to SCC, undated fragment [Jan.? 1775], CFP-LoC, folder 1.

91 R. Burr Litchfield, "Naples under the Bourbons: An Historical Overview," in *The Golden Age of Naples: Art and Civilization under the Bourbons, 1734–1805*, ed. Susan F. Rossen and Susan L. Caroselli (Detroit: Detroit Institute of Arts, 1981), 1–14.

92 JSC to SCC, 28 Jan. 1775.

93 Horace Walpole, ca. 1764, quoted in Geoffrey V. Morson, "Hamilton, Sir William (1731–1803)," *ODNB Online*, May 2009.

94 JSC to SCC, 9 June 1775.

95 JSC to SCC, 28 Jan. 1775. This notion of sites "untouched by time" was a fiction; Viccy Coltman, *Fabricating the Antique: Neoclassicism in Britain, 1760–1800* (Chicago: U of Chicago P, 2006), 97–111.

96 JSC to SCC, 28 Jan. 1775. Ingamells, *British and Irish Travellers*, via Grand Tour Explorer (https://grandtour.herokuapp.com/#/), reveals only 5 Brits in Paestum in 1774–75 (including Copley and Carter), among the 114 then in Italy. For the claim that Copley and the Izards were "the first Americans" to reach Paestum, see Maurie D. McInnis, "Cultural Politics, Colonial Crisis,

and Ancient Metaphor in John Singleton Copley's 'Mr. and Mrs. Ralph Izard,'" *Winterthur Portfolio* 34, no. 2/3 (July 1999): 90.

97 JSC to MCP, 25 June 1775, *CPL*, 329–30.

98 HP to JSC, 2 Nov. 1774, *CPL*, 267; HP to Charles Startin, 12 Dec. 1774, *CPL*, 279–80. For Harry's letter sent from Philadelphia see JSC to SCC, 28 Jan. 1775.

99 Izard to Henry Laurens, 18 Oct. 1774, *Correspondence of Mr. Ralph Izard*, 17; also 40, 43, 52.

100 JSC to SCC, 28 Jan. 1775.

101 JSC to SCC, 4–17 Dec. 1774.

102 JSC to HP, 14 March 1775, *CPL*, 295. Prown finds some evidence that Copley also worked on the now lost *Priam Beseeching Achilles for the Body of Hector* in Rome; P-*JSC*, 251.

103 McInnis, "Cultural Politics, Colonial Crisis."

104 JSC to HP, 14 March 1775, *CPL*, 300; JSC to HP, 25 June 1775, *CPL*, 340.

105 JSC to SCC, 4–17 Dec. 1774.

106 JSC to HP, 14 March 1774, *CPL*, 295, 296, 301. On the status of Raphael, see David Alan Brown, *Raphael and America* (Washington, DC: National Gallery of Art, 1983).

107 JSC to SCC, 4 Nov. 1774; and Amory, 39.

108 JSC to HP, 14 March 1775, *CPL*, 297–99.

109 Ibid., 299–300.

110 JSC to John Greenwood, 7 May 1775; JSC to SCC, 9 June 1775. The casts did not survive the trip; Amory, 54.

111 James Boswell, *Life of Johnson*, ed. R. W. Chapman (New York: Oxford UP, 2008), 742 (11 April 1776).

112 JSC to SCC, 9 June 1775; JSC to HP, 25 June 1775, *CPL*, 340.

113 JSC to HP, 14 March 1775, *CPL*, 304.

114 JSC to SCC, 4 Nov. 1774.

115 JSC to MCP, 25 June 1775, *CPL*, 329.

116 JSC to SCC, 9 June 1775; JSC to HP, 14 March 1775, *CPL*, 301.

117 HP to JSC, 27 Jan. 1775, *CPL*, 285, 286; HP to JSC, 16 Feb. 1775, *CPL*, 290. The letters went with Captain Robson, with whom Copley had sailed the year before; see *CPL*, 289.

118 JSC to HP, 14 March 1775, *CPL*, 301.

CHAPTER EIGHT: THE AMERICAN WAR

1 JSC to SCC, 2 July 1775, CFP-LoC, folder 1.

2 JSC to Mary Pelham, 25 June 1775, *CPL*, 328–29.

3 Ibid.; JSC to Ozias Humphry, 2 July 1775, Charles Henry Hart Autograph Collection, Smithsonian Institution; Archives of American Art, http://www

.aaa.si.edu/collections/viewer/john-singleton-copley-letter-tounidentified
-recipient-florence-italy-6897; JSC to SCC, 9, 19 June 1775, CFP-LoC,
folder 1. Copley's letter to Humphry is misdated, for it refers to news Copley
learned on July 22; see JSC to SCC, 28 July 1775, Dwight Collection, MHS.

4 JSC to MCP, 25 June 1775, *CPL*, 328, 331; JSC to SCC, 2 July 1775.

5 JSC to HP, 25 June 1775, *CPL*, 333–43.

6 HP to JSC, 2 Nov. 1774, *CPL*, 267; HP to JSC, 3 April 1775, *CPL*, 312. For
Boston Harbor empty, see *Rowe*, 275 (12 June 1774).

7 HP to MCP, 18 Nov. 1774, *CPL*, 272.

8 Neil Longley York, *Henry Hulton and the American Revolution: An Outsider's
Inside View* (Boston: Colonial Society of Massachusetts / UP of Virginia,
2010), 168–69; see also "Boyle's Journal of Occurrences in Boston," *NEHGR*
84 (1930): 381.

9 York, *Henry Hulton*, 178–79. For the committees of safety and inspection,
see T. H. Breen, *American Insurgents, American Patriots: The Revolution of the
People* (New York: Hill and Wang, 2010), 12–16, 207–40.

10 HP to JSC, 16 Feb. 1775, *CPL*, 291–92.

11 On the Revolution's impact on women's daily lives, see Mary Beth Norton,
*Liberty's Daughters: The Revolutionary Experience of American Women, 1750–
1800* (Boston: Little, Brown, 1980), esp. 195–227; and Sarah M. S. Pearsall,
"Women in the American Revolutionary War," in *The Oxford Handbook of the
American Revolution*, ed. Edward G. Gray and Jane Kamensky (New York:
Oxford UP, 2012), 273–90.

12 JSC to SCC, 4 Nov. 1774, CFP-LoC. Copley inquired after Snap in JSC
to MCP, 8 Sept. 1774, *CPL*, 256, and promised to "reward him" for good
behavior. Harry answered in HP to JSC, 3 April 1775, *CPL*, 312. Snap was
living with Copley's mother and brother on Cambridge Street. Readman
(also Redman, Readmond) was a Copley dependent as well, but his status—
servant, slave, or tenant farmer—is unclear. "I hope Readmond behaves well
& the Maids remember me to them in their respective places," Copley writes,
JSC to SCC, 17 Aug. 1774, CFP-LoC, folder 1; see also JSC to SCC, 11 July,
4 Nov. 1774, CFP-LoC; and HP to JSC, 17 July 1774, *CPL*, 231.

13 HP to JSC, 17 July 1774, *CPL*, 228–32; HP to JSC, 2 Nov. 1774, *CPL*,
267–68. For Copley's responses to the situation, see JSC to SCC, 25 Oct.,
4 Nov. 1774, 28 Jan. 1775, all CFP-LoC. Green's allegiance to the patriot
party is demonstrated by his appointment to town office in the late 1770s;
BTR, 1770–77, 18:261, 262, 264, 291, 296.

14 "Richard Clarke's account with John S. Copley," 17 May 1775, BFP, box
4, folder 8; see also Richard Clarke to Isaac Winslow Clarke, 9 Aug. 1774,
Robert Earle Moody, ed., *The Saltonstall Papers, 1607–1815* (Boston: MHS,
1972), 463–64.

15 HP to JSC, 3 April 1775, *CPL*, 310–11. He also related the deaths of Mary Clarke Oliver and the elder Peter Chardon.

16 "Sons of Anarchy" and "God of Order" in Peter Oliver to Polly Hutchinson, 26 May 1775, *Hutchinson Diary*, 1:457. For socializing among the Copley, Pelham, Clarke, Hutchinson, and Oliver families, see ibid., 458; HP to JSC, 3 April 1775, *CPL*, 312; and "Richard Clarke's account with John S. Copley," BFP, which tallies Lucy Clarke's loans to Peggy Hutchinson.

17 *Boyle's Journal of Occurrences in Boston*, *NEHGR* 85 (1931): 8.

18 HP to JSC, [May 1775], *CPL*, 317; HP to JSC, 16 May 1775, *CPL*, 322–25.

19 Richard Frothingham, *History of the Siege of Boston and the Battles of Lexington, Concord, and Bunker Hill* (Boston: Little, Brown, 1851), 91–120; Jacqueline Barbara Carr, *After the Siege: A Social History of Boston, 1775–1800* (Boston: Northeastern UP, 2005), 13–42.

20 HP to JSC, 16 May 1775, *CPL*, 324–25.

21 JSC to MCP, 25 June–1 July 1775, *CPL*, 328, 332. News of the skirmish arrived in London on 29 May 1775; *Hutchinson Diary*, 1:455–56.

22 JSC to SCC, 2 July 1775.

23 JSC to HP, 6 Aug. 1775, *CPL*, 348. For other references to the unfolding conflict as a civil war, see HP to John Singleton, 16 May 1775, *CPL*, 318; HP to JSC, 16 May 1775, *CPL*, 322; JSC to MCP, 25 June 1775, *CPL*, 328; JSC to Ozias Humphry, 2[8?] July 1775, Archives of American Art; HP to JSC, 10 Oct. 1775, *CPL*, 363. See also David Armitage, "Every Great Revolution Is a Civil War," in *Scripting Revolution*, ed. Keith Michael Baker and Dan Edelstein (Stanford, CA: Stanford UP, 2015), 57–68.

24 JSC to SCC, 2, 22 July 1775, CFP-LoC, folder 1; JSC to HP, 6 Aug. 1775, *CPL*, 348.

25 JSC to HP, 6 Aug. 1775, *CPL*, 348–49; JSC to SCC, 22 July 1775.

26 JSC to HP, 6 Aug. 1775; *CPL*, 349; JSC to MCP, 25 June–1 July 1775, *CPL*, 332.

27 JSC to HP, [15 July 1775], *CPL*, 343–44.

28 For concerns that letters would be opened, see *CPL*, 351, 352, 365, 366.

29 Richard D. Brown, "The Confiscation and Disposition of Loyalists' Estates in Suffolk County, Massachusetts," *WMQ*, 3d ser., 21:4 (Oct. 1964): 534–50.

30 JSC to SCC, 28 July 1775, Dwight Papers, MHS. The cost of the passage of "Mrs. Copley & her children & maids" appears in "Richard Clarke's account with John S. Copley," BFP. If the £70 were divided evenly, then Sukey would have brought three "maids." Servants and children may have been charged a lower tariff.

31 SCC to HP, 18, 21 Sept. 1775, *CPL*, 359.

32 Ibid.

33 *Hutchinson Diary*, 1:480–81. For the cabin passengers in the *Minerva*, see Katharine Greene Amory, *The Journal of Mrs. John Amory (Katharine Greene) 1775–1777: With Letters from Her Father, Rufus Greene, 1759–1777* (Boston: privately printed, 1923), 4. Greene lists eight adult civilians, in addition to the captain's wife and a navy lieutenant, and not including servants. Six of those eight (John Amory, Katherine Amory, Joseph Greene, Mary Greene, Samuel Quincy, and Isaac Smith Jr.) had sat to Copley.

34 JSC to SCC, 28 July 1775; JSC to SCC, 30 July 1775, CFP-LoC, folder 1; JSC to SCC, 22 July 1775.

35 JSC to SCC, 30 July 1775, CFP-LoC; Joseph Wright to Ozias Humphry, 24 July 1775, in William Bemrose, *The Life and Works of Joseph Wright, A.R.A., Commonly Called "Wright of Derby"* (London: Bemrose & Sons, 1885), 36; and JSC to HP, 22 Aug. 1775, *CPL*, 352–56. The next extant letter, from Cologne, is dated 23 Nov. 1775 and postmarked 30 Nov. 1775, CFP-LoC, microfilm. In it, Copley mentions having left Mannheim four days earlier, and Venice twelve days before that, or on 7 Nov. 1775. I have found no record of Copley's stint in Venice.

36 JSC to HP, 22 Aug. 1775, *CPL*, 353–54.

37 JSC to SCC, 22 July 1775.

38 JSC to HP, 22 Aug. 1775, *CPL*, 353.

39 JSC to SCC, 30 July 1775.

40 SCC to HP, 18 and 21 Sept. 1775, *CPL*, 357–59.

41 JSC to HP, 22 Aug. 1775, *CPL*, 353.

42 JSC to SCC, 2 July 1775.

43 The first day Copley can be placed in London with certainty is 23 Dec.; *Hutchinson Diary*, 1:586; see also Andrew Oliver, ed., *The Journal of Samuel Curwen, Loyalist* (Cambridge: Harvard UP, 1972), 100–101 (23 Dec. 1775). A misdating in an earlier version of Curwen's journal led Prown to conclude that Copley had reached London by Oct.; P-*JSC*, 258 n1. In fact, Curwen reported seeing *Mrs.* Copley on 11 Nov. 1775; see also *CPL*, 371. For Clarke's arrival, and the eagerness of New England exiles to hear news from him, see *Curwen Journal*, 102–3 (29–30 Dec. 1775).

44 P-*JSC*, 259–60.

45 *Curwen Journal*, 132–33 (1 April 1776). For comparisons of the paintings, see Jules Prown, "Benjamin West's Family Picture: A Nativity in Hammersmith," in Prown, *Art as Evidence: Writings on Art and Material Culture* (New Haven: Yale UP, 2001), 116–32.

46 *A Catalogue of the Pictures, Sculptures, Models, Designs in Architecture, Drawings, Prints, &c. Exhibited . . . by the Society of Artists of Great-Britain* (London, 1772), 6.

47 P-*JSC*, 360.

48 "The Painter's Mirror," no. IV, *MP*, 1 May 1777.

49 *The Exhibition of the Royal Academy, MDCCLXXVI* (London, 1776), 8.

50 JSC to HP, 6 Aug. 1775, *CPL*, 349.

51 HP to JSC, 19 Aug. 1775, *CPL*, 351 (fresh meat); HP to JSC, 27 Jan. 1776, *CPL*, 367–68; HP to JSC, 3 Sept. 1795, CFP-LoC, microfilm (railing).

52 JSC to Isaac Winslow, 3 March 1776, CFP-LoC, microfilm; petition of Mary Pelham, 22 Feb. 1779, Massachusetts Archives Collection, 1603–1799, vol. 185, f. 46, MassArchs.

53 HP to SCC, 23 July 1775, *CPL*, 346.

54 SCC to HP, 18 and 21 Sept. 1775, *CPL*, 360.

55 HP to JSC, 27 Jan. 1776, *CPL*, 364–66. A letter the previous fall related the sudden and shocking death of Lucy Clarke at the age of twenty-three; HP to JSC, 10 Oct. 1775, *CPL*, 360; see also *Essex Journal*, 22 Sept. 1775.

56 *The Nativity* remained in the Copley family for nearly a century, until 1864, when it was sold upon JSC Jr.'s death. It reemerged at auction in 1971, when it was initially thought to be the work of Benjamin West; *JSC in England*, 94–98. The identification of Sukey Copley as the model for the Madonna had long been ascribed to "family tradition"; P-*JSC*, 264. A Brandeis undergraduate, Daniele Dimitrova, used facial recognition technology as well as traditional stylistic analysis to confirm that the model was in fact Sukey; http://omeka.lts.brandeis.edu/exhibits/show/susanna_copley.

57 P-*JSC*, 260; Holger Hoock, *The King's Artists: The Royal Academy of Arts and the Politics of British Culture, 1760–1840* (Oxford: Clarendon Press, 2003), 30–34.

58 Janice Hadlow, *A Royal Experiment: The Private Life of King George III* (New York: Henry Holt, 2014), 182–207; and Jeremy Black, *George III: America's Last King* (New Haven: Yale UP, 2006), 144–61. Royal visits to the annual exhibitions are discussed in Hoock, *The King's Artists*, 174–78. Commentary on West's *Six Youngest Children* appeared in *MC*, 25 April 1777.

59 The print bears a date of 1 June 1779; British Museum, object 1875,0710.157. *The Nativity* was later the subject of scabrous criticism; P-*JSC*, 263–64.

60 *MC*, 26 April 1777.

61 A search of the Burney Collection of 17th- and 18th-century British Newspapers discovers 2,112 articles using the phrase "the American War" published between 1774 and 1783 (inclusive); Eighteenth-Century Collections Online turns up 685 long-form print titles within the same dates. On Britain and the American War, see, among others, Julie Flavell and Stephen Conway, eds., *Britain and America Go to War: The Impact of War and Warfare, 1755–1815* (Gainesville: UP of Florida, 2004); Stephen Conway, *The British Isles and the War of American Independence* (Oxford, UK: Oxford UP, 2000);

and H. T. Dickinson, ed., *Britain and the American Revolution* (New York: Addison Wesley Longman, 1998).

62 So great was the demand for images of American officers that printers rushed mezzotints to press before any genuine portraits had been seen in England; Wendy Wick Reaves, *George Washington: An American Icon: The Eighteenth-Century Graphic Portraits* (Washington, DC: Smithsonian Institution / National Portrait Gallery, 1982), 18–21. On mourning wear and the printshops, see Benjamin Waterhouse, "Autobiography, in the Hand of Louisa Lee Waterhouse," n.d., pp. 39–40; Waterhouse Family Papers, 1785–1836, Countway Medical Library, Harvard Univ.

63 For political tracts see *Curwen Journal*, 132 (1 April 1776), 133 (3 April 1776). The books referenced took opposite sides, one faulting the Americans, the other the ministry. See also *Hutchinson Diary*, 2:121 (23 Dec. 1776).

64 *Curwen Journal*, 110–12; "Refugees in London, 1775," *NEHGR* 3 (Jan. 1849): 82–83. Edward Oxnard's journal also indicates that "an American club" was newly convened in Feb. 1776; Edward S. Moseley, ed., "Edward Oxnard: A Sketch, with Abstracts from His Journal," *NEHGR* 26 (1872): 118.

65 *Curwen Journal*, 128 (22 March 1776); see also Moseley, "Oxnard Journal Extracts," 119 (22 Feb. 1776), 120 (2 May 1776), 121 (29 Oct. 1776), 254 (13 Dec. 1776). For other meetings, see *Curwen Journal*, 120, 122, 127, 134, 143, 156, 158, 317, 318. Attendance in the New England Club, also known as the Brompton Row Tory Club, began to peter out later in 1776; Mary Beth Norton, *The British-Americans: The Loyalist Exiles in England, 1774–1789* (Boston: Little, Brown, 1972), 76–77.

66 Clarke et al. to John Robinson, 12 July 1777, AO 13/75, f. 273, TNA-UK. Clarke always signs first.

67 Clarke to John Robinson, 24 Oct. 1777, AO 13/75, f. 275, TNA-UK.

68 AO 13/73, ff. 263–76; AO 13/75, ff. 263–69.

69 *The Nativity* (lot 62) and *The St. Jerome, after Correggio* (lot 82) were offered for sale in 1864; see P-*JSC*, 400–405; and *Catalogue of the Very Valuable Collection of Pictures of the Rt. Hon. Lord Lyndhurst, Deceased: Including Most of the Important Works of His Lordship's Father, That Distinguished Historical Painter, John Singleton Copley, R.A.* (London: Christie, Manson and Woods, 1864). *The Ascension* descended to JSC Jr. and then to Betsy Copley's daughter Martha Amory; http://www.mfa.org/collections/object/the-ascension-32172.

70 Izard to George Germain, CO 5/155, pt. 1, ff. 34–35; Maurie D. McInnis, ed., *In Pursuit of Refinement: Charlestonians Abroad, 1740–1860* (Columbia: U of South Carolina P, 1999), 116–19.

71 *Hutchinson Diary*, 2:121 (23 Dec. 1776); E. Alfred Jones, *The Loyalists of*

Massachusetts, Their Memorials, Petitions and Claims (London: Saint Catherine Press, 1930), 116–17.

72 Bernard spent much of the spring of 1776 in London; see *Curwen Journal*, 115 (15 Feb. 1776); and *Hutchinson Diary*, 1:72 (22 June 1776). So it is likely that Copley painted him during that interval. For Pepperrell, see ibid., 2:19, 21–22, 44; and Josiah P. Quincy, ed., "Diary of Samuel Quincy," *Proceedings of the Massachusetts Historical Society* 19 (1 Jan. 1881): 218; and HP to JSC, 27 Jan. 1776, *CPL*, 366. Pepperrell played a leading role in the later claims of the Massachusetts loyalists to the Loyalist Claims Commission; see Norton, *British-Americans*, 72–73, 124, 125, 162, 186, 240–41; and *Curwen Journal*, 776, 892, 893, 894, 895. Elizabeth Royall Pepperrell was not the only one of Boston's dead whom Copley's brush brought back to life in London; see P-*JSC*, 266–67.

73 Style and the age of the subjects have led art historians to surmise that *Benjamin West* was painted ca. 1776–80 and the oil sketch *Self Portrait* ca. 1776–84. See P-*JSC*, 264, 274; *JSC in England*, 136–38.

74 *MC*, 9 May 1777; see also 6 May 1777, and *MP*, 27 April 1777.

75 *LEP*, 13 Nov. 1776; see also *CPL*, 350–51, 356–57.

76 HP to SCC, 23 July 1775, *CPL*, 346–47; HP to JSC, 17 July 1774, *CPL*, 232. For similar sentiments by the Hutchinsons and Clarke, see *Hutchinson Diary*, 1:537 (22 Sept. 1775); see also *Curwen Journal*, 104 (30 Dec. 1775). On the dispiriting circumstances of the loyalists in London, see also Norton, *British-Americans*, 42–61.

77 Petition of Mary Pelham, 22 Feb. 1779, Massachusetts Archives Collection, vol. 185, f. 46, MassArchs; compare to "Deposition of John Singleton Copley," Jan. 1812, HGOBP, box 1, folder 15a.

78 *Hutchinson Diary*, 2:169–71. On Saratoga, see Piers Mackesy, *The War for America, 1775–1783* (Cambridge: Harvard UP, 1964), 121–46; Andrew Jackson O'Shaughnessy, *The Men Who Lost America: British Leadership, the American Revolution, and the Fate of the Empire* (New Haven: Yale UP, 2013), 124, 154–59.

79 Moseley, "Oxnard Journal Extracts," 259 (15 Jan. 1778).

80 *Independent Ledger* (Boston), 17 Aug. 1778; *MP*, 29 April 1777. For rumors of Spanish forces massing at Havana, see *PA*, 23 March 1778.

81 JSC to HP, 25 June 1775, *CPL*, 339.

82 L. F. S. Upton, "Watson, Sir Brook," in *Dictionary of Canadian Biography*, vol. 5 (University of Toronto/Université Laval, 2003), http://www .biographi.ca/en/bio/watson_brook_5E.html, accessed 7 April 2015. The name of the relative comes down as "Levens"; see John Clarence Webster, *Sir Brook Watson, Friend of the Loyalists, First Agent of New Brunswick in London* (Sackville, NB: Mount Allison Univ., 1924), 3–4. I have not

found a Levens, Levings, or Levins in Boston, but Samuel Leavens was a substantial enough Anglican merchant to donate £100 to the rebuilding of King's Chapel in 1747; Henry Wilder Foote, *Annals of King's Chapel from the Puritan Age of New England to the Present Day* (Boston: Little, Brown, 1896), 2:120. For the store on Belcher's Wharf, see *BPB*, 12 Dec. 1748.

83 John Robert McNeill, *Atlantic Empires of France and Spain: Louisbourg and Havana, 1700–1763* (Chapel Hill: U of North Carolina P, 1985), esp. 35–45, 85–92, 97–104, 154–79; Louis A. Pérez, *Cuba: Between Reform and Revolution*, 4th ed. (New York: Oxford UP, 2011), 38–55; and Brian Delay, "Watson and the Shark," in *The Familiar Made Strange: American Icons and Artifacts after the Transnational Turn*, ed. Brooke L. Blower and Mark Philip Bradley (Ithaca: Cornell UP, 2015), 9–20.

84 "Narrative, on which the very extraordinary picture now exhibiting at the Royal Academy, painted by Mr. Copley, and numbered 65, is founded," *GEP*, 28 April 1778. The article is unsigned but suggests the authorship of Copley and Watson; Ellen G. Miles et al., *American Paintings of the Eighteenth Century* (Washington, DC: National Gallery of Art, 1995), 54–69, esp. 56. The phrase "*Jaws of Death*" also appears in *PA*, 28 April 1778.

85 *London Gazetteer*, 23 June 1779.

86 Francis S. Drake, *Tea Leaves: Being a Collection of Letters and Documents Relating to the Shipment of Tea to the American Colonies in the Year 1773* (Boston: A. O. Crane, 1884), 202–3, 215, 222–23, 235, 237, 238, 260, 292–93. The Joshua Winslow who consigned the tea and the Joshua Winslow whom Watson knew in Nova Scotia in the 1750s were distantly related.

87 See chap. 2, above.

88 Miles et al., *American Paintings of the Eighteenth Century*, 63–64.

89 Jennifer L. Roberts, *Transporting Visions: The Movement of Images in Early America* (Berkeley: U of California P, 2014), 62–64; Emily Ballew Neff, "Like Gudgeons to a Worm: John Singleton Copley's 'Watson and the Shark' and the Cultures of Natural History," in *American Adversaries*, 176.

90 *General Advertiser*, 27 April 1778.

91 *SJC*, 28 April 1778; see also 30 April 1778.

92 The preparatory drawing, known as "The Rescue Group," can be viewed at http://www.dia.org/object-info/06800f7e-a860-4c9e-b752-4889589d9a8b .aspx?position=6. The study for the *Pepperrell Family* remains in private hands; P-*JSC*, 264–66 and plate 357.

93 *American Paintings in the Detroit Institute of Arts* (New York: Hudson Hills Press / Detroit Institute of Arts, 1991), 1:62–64; Miles et al., *American Paintings of the Eighteenth Century*, 62–65; *JSC in England*, 106; and Albert Boime, "Blacks in Shark-Infested Waters: Visual Encodings of Racism in

Copley and Homer," *Smithsonian Studies in American Art* 3:1 (Jan. 1989): 19–47.

94 In *Red Cross Knight* (1793), three Copley children smile with teeth showing, the daughters most overtly. Betsy Copley's teeth are revealed in *Elizabeth Copley (Mrs. Gardiner Greene)*, 1800–03; see chap. 11, below. The smile connects the figure to Dutch genre paintings of laughing servants, yet also evokes emotional intimacy; see Colin Jones, *The Smile Revolution in Eighteenth Century Paris* (Oxford, UK: Oxford UP, 2014).

95 *Catalogue of the Very Valuable Collection of Pictures of the Rt. Hon. Lord Lyndhurst, Deceased*, 7. For valuations noted in various surviving copies of the catalog, see P-*JSC*, 402.

96 Hutchinson's Boston household had included at least one "negro," most likely a slave, named Mark, whom Hutchinson took with him from Boston. Mark died en route, but there may have been other black men in Hutchinson's large London retinue, which by 1776 had swelled to twenty-six people; John W. Tyler and Elizabeth Dubrulle, eds., *The Correspondence of Thomas Hutchinson*, vol. 1, *1740–1766*, (Boston: Colonial Society of Massachusetts, 2014), 331; "Diary of Elisha Hutchinson, 1774–1788," ff. 9–10, BL, Egerton mss. 2669; and *Hutchinson Diary*, 2:71 (18 June 1776).

97 Amory, 69. For "maids," see "Richard Clarke's account with John S. Copley," 17 May 1775, BFP, box 4, folder 8.

98 *The Manifesto Church: Records of the Church in Brattle Square, Boston, with Lists of Communicants, Baptisms, Marriages and Funerals, 1699–1872* (Boston: Benevolent Fraternity of Churches, 1902), 255.

99 MCP to JSC, 23 Dec. 1780, CFP-LoC, folder 2.

100 Sharpe quoted in Christopher Leslie Brown, *Moral Capital: Foundations of British Abolitionism* (Chapel Hill: U of North Carolina P, 2006), 96; see also 95–101 on the ambiguous legacy of the *Somerset* case.

101 For a prediction that *Somerset* would occasion greater unrest than the Stamp Act, see *BPB*, 7 Sept. 1772.

102 On black London in the 1760s and 1770s, see Jerry White, *A Great and Monstrous Thing: London in the Eighteenth Century* (Cambridge: Harvard UP, 2013), 125–62; and Julie Flavell, *When London Was the Capital of America* (New Haven: Yale UP, 2010), 27–61.

103 David Bindman, "The Atlantic Triangle," in Bindman and Henry Louis Gates, eds., *The Image of the Black in Western Art*, vol. 4, *From the American Revolution to World War I*, pt. 1, *Slaves and Liberators*, new ed. (Cambridge: Harvard UP, 2012), 14. As Bindman points out, the "terms 'slave' and 'portrait' constitute together an oxymoron, a contradiction in terms, for a portrait . . . has as its defining purpose the affirmation of the sitter's subjectivity, autonomy, and integrity"; Bindman, "Subjectivity and Slavery in Portraiture:

From Courtly to Commercial Societies," in *Slave Portraiture in the Atlantic World*, ed. Agnes Lugo-Oritz and Angela Rosenthal (New York: Cambridge UP, 2013), 71–89, quotation at 75. See also Marcia Pointon, "Slavery and the Possibility of Portaiture," ibid., 42; and David Bindman, "Am I Not a Man and a Brother? British Art and Slavery in the Eighteenth Century," *RES: Anthropology and Aesthetics*, no. 26 (Autumn 1994): 68–82.

104 The subject of Reynolds's sketch was long identified as Francis Barber, a servant of Samuel Johnson's, but recent scholarship reveals a servant in the Reynolds household as the likelier sitter; Michael Bundock, "Searching for the Invisible Man: The Images of Francis Barber," in *Editing Lives: Essays in Contemporary Textual and Biographical Studies in Honor of O. M. Brack, Jr.*, ed. Jesse G. Swan (London: Rowman & Littlefield, 2013), 107–22. For Reynolds's black footman, see James Northcote, *Memoirs of Sir Joshua Reynolds . . . Late President of the Royal Academy* (Philadelphia: M. Carey & Son, 1817), 98–100. The politics of the 1770s also prompted the visits of celebrated native emissaries. The Mohawk leader Joseph Brandt was painted by George Romney (1776) and the Rhode Island-born Gilbert Stuart (1784). The Tahitian Omai, who arrived in London in 1774 with Cook's second voyage, was also portrayed several times, most famously by Joshua Reynolds.

105 Monica L. Miller, *Slaves to Fashion: Black Dandyism and the Styling of Black Diasporic Identity* (Durham, NC: Duke UP, 2010), chap. 1.

106 *BNL*, 3 May 1773, quoted in Vincent Carretta, *Phillis Wheatley: Biography of a Genius in Bondage* (Athens: U of Georgia P, 2011), 118, see also 96–99, 109–19, 128–29; David Waldstreicher, "The Wheatleyan Moment," *Early American Studies* 9:3 (Oct. 2011): 522–51. On Watson's coat of arms, see William Betham, *The Baronetage of England; or, The History of the English Baronets, and Such Baronets of Scotland, as Are of English Families* (London: Burrell and Bransby, 1805), 5:542.

107 Augustus Thorndike Perkins, *A Sketch of the Life and a List of Some of the Works of John Singleton Copley* (Boston: privately printed, 1873), 24.

108 See esp. Ann Uhry Abrams, "Politics, Prints, and John Singleton Copley's *Watson and the Shark*," *Art Bulletin* 61:2 (June 1979): 275. Abrams's reading rests on the presumption that Copley engraved an anti–Stamp Act cartoon, "The Deplorable State of America," an attribution that has since been convincingly refuted; see Paul Staiti, "Accounting for Copley," *JSC in America*, 50 n69. For other readings of the painting that focus on rupture, see Neff, "Like Gudgeons to a Worm"; Roberts, *Transporting Visions*, 55–67.

109 O'Shaughnessy, *Men Who Lost America*, 61–65.

110 *GEP*, 28 April 1778; *General Advertiser*, 27 April 1778, emphasis added.

111 *SJC*, 28 April 1778; *GEP*, 28 April 1778.

112 *MP*, 25 April 1778.

113	*SJC*, 28, 30 April 1778. By July, the "high rank in the art *Copley* has so suddenly achieved" made his omission from any discussion of the leading lights of the contemporary art scene appear glaring; see *MP*, 30 July 1778.

CHAPTER NINE: WAGING PEACE

1	Anthony Pasquin, *Memoirs of the Royal Academicians* (London, 1796), 136.

2	*MC*, 25 Nov. 1778.

3	P-*JSC*, 275. Copley received nine votes in 1779, and three in 1778. Royal Academy of Arts General Assembly Minutes, 1768–1796, 10 Feb. 1778, 9 Feb. 1779, RAA.

4	*General Advertiser*, 30 April 1779. *MP*, 26 April 1779, promises prints "about the middle of May"; on 18 June 1779 says "in a few days"; and on 9 July 1779 offers it for sale.

5	*MC*, 14 Feb. 1780.

6	*WEP*, 21 Nov. 1780. For another reference identifying Watson with the painting, rather than the reverse, see *SJC*, 17 June 1780.

7	The fragility of fame was a truism of the time; see James Boswell, *Life of Johnson*, ed. R. W. Chapman (New York: Oxford UP, 2008), 319, 924–25.

8	Roger Shanhagan [pseud.], *The Exhibition, or a Second Anticipation: Being Remarks on the Principal Works to Be Exhibited Next Month, at the Royal Academy* (London, 1779), 23 (Kauffman), 52 (Gainsborough), 29 (Reynolds), 30 (West); 46–49 (Copley, quoted). For the identification of Shanhagan, see Beverly Kay Brandt, *The Craftsman and the Critic: Defining Usefulness and Beauty in Arts and Crafts-Era Boston* (Amherst: U of Massachusetts P, 2009), 19, 315 n45. For notices of its publication in April 1779, see *Monthly Review; or, Literary Journal* (April 1779): 321, e.g.

9	Stella Tillyard, "'Paths of Glory': Fame and the Public in Eighteenth-Century London," in Martin Postle et al., *Joshua Reynolds: The Creation of Celebrity* (London: Tate Publishing, 2005), 61–69; and David H. Solkin, *Painting for Money: The Visual Arts and the Public Sphere in Eighteenth-Century England* (New Haven: Yale UP, 1993), esp. intro. and chap. 7.

10	American patrons who sat to Copley following *Watson* included the South Carolinian George Boone Roupell and John Loring of Boston, who had been given a captaincy in the Royal Navy. Both were exhibited at the Royal Academy in 1780. See Maurie D. McInnis, ed., *In Pursuit of Refinement: Charlestonians Abroad, 1740–1860* (Columbia: U of South Carolina P, 1999), 120–22; and E. Alfred Jones, *The Loyalists of Massachusetts, Their Memorials, Petitions and Claims* (London: Saint Catherine Press, 1930), 198–200.

11	*Hutchinson Diary*, 2:237 (1 Jan. 1779); Andrew Jackson O'Shaughnessy, *The Men Who Lost America: British Leadership, the American Revolution, and the Fate of the Empire* (New Haven: Yale UP, 2013), esp. 254.

12 John Charnock, *Biographia Navalis; or, Impartial Memoirs of the Lives and Characters of Officers of the Navy of Great Britain, from the Year 1660 to the Present Time* (London, 1794), 5:387–92. On Gayton's brutal tactics against the revolts of slaves of Hanover County, see Andrew Jackson O'Shaughnessy, *An Empire Divided: The American Revolution and the British Caribbean* (Philadelphia: U of Pennsylvania P, 2000), 151–52.

13 Ronald M. Sunter, "Montgomerie, Hugh, twelfth earl of Eglinton (1739–1819)," *ODNB Online*, 2004, http://www.oxforddnb.com/view/article/19061, accessed 8 May 2015. On Montgomerie's regiment in the American War, see Piers Mackesy, *The War for America, 1775–1783* (Cambridge: Harvard UP, 1964), 373–75.

14 *A Candid Review of the Exhibition (Being the Twelfth) of the Royal Academy, MDCCLXXX* (London, 1780), 26. See also *JSC in England*, 114–17; and Emily Ballew Neff, "At the Wood's Edge: Benjamin West's 'The Death of Wolfe' and the Middle Ground," in *American Adversaries*, 64–103.

15 *A Candid Review*, 11; John Murdoch, "Architecture and Experience: The Visitor and the Spaces of Somerset House, 1780–1790," in *Art on the Line: The Royal Academy Exhibitions at Somerset House, 1780–1836*, ed. David H. Solkin (New Haven: Yale UP, 2001), 9–22.

16 *A Candid Review*, 18 (West), 31 (Cook monument).

17 Rosie Dias, *Exhibiting Englishness: John Boydell's Shakespeare Gallery and the Formation of a National Aesthetic* (New Haven: Yale UP, 2013), 32–33; C. S. Matheson, "'A Shilling Well Laid Out': The Royal Academy's Early Public," in *Art on the Line*, 39–40.

18 *MP*, 15 May 1780; *PA*, 2 May 1780.

19 Record Books, RAA/ TRE/ 13/1/3 (1777–80), RAA. For the exhibition as a place of staring and receiving stares, see K. Dian Kriz, "'Stare Cases': Engendering the Public's Two Bodies at the Royal Academy of Arts," in *Art on the Line*, 54–63.

20 *A Candid Review*, 10–11, 28.

21 *Hutchinson Diary*, 2:149 (30 May 1777) (unnatural . . . war); *GEP*, 7 April 1778. Chatham's putative last words inveighed against American independence; Jeremy Black, *Pitt the Elder* (New York: Cambridge UP, 1992), 299.

22 *MP*, 2 June 1778. The funeral, culminating in Chatham's burial in the Abbey, took place a full month after his death; see *GEP*, 11 June 1778.

23 *MP*, 30 May 1778; see also *PA*, 12, 15, 20 May 1778.

24 *PA*, 23 May 1778; *LC*, 2 June 1778.

25 *SJC*, 5 Dec. 1778; *MC*, 2 Jan. 1779. "A Citizen" thought the competing sculptural design the better choice.

26 Horace Walpole, Book of Materials, 2:113, Lewis Walpole Library, Yale Univ. Walpole's comments are undated but appear on a page of notes with pasted clippings from 1784 and 1785. See also William S. Pressly, "The

Challenge of New Horizons: Copley's 'Rough and Perilous Asent,'" in *JSC in England*, 36–38; and Helmut von Erffa and Allen Staley, *The Paintings of Benjamin West* (New Haven: Yale UP, 1986), 65, 218.

27 *PA*, 13 March 1781.

28 Cuthbert Headlam, ed., *The Letters of Lady Harriot Eliot, 1766–1786* (Edinburgh: Printed by T. and A. Constable, 1914), 32.

29 Lord Mansfield sat two years later, the Earl of Bessborough in 1790, and Viscount Dudley in 1804; *JSC in England*, 50–53, 70, 164–66.

30 *GEP*, 30 Oct. 1779; see also *MP*, 1 Nov. 1779.

31 *MC*, 31 Dec. 1778, 2 Jan. 1779.

32 *MC*, 7, 15 Jan. 1779.

33 *MC*, 17 Dec. 1779. Earlier sketches included 30–35 figures; P-*JSC*, 280–82.

34 *MC*, 17 Dec. 1779. The monument still stands in London's Guildhall.

35 *LEP*, 18 April 1780; *PA*, 5 May 1780. Condensed versions of Copley's proposals also appeared in *MC*, 22 April 1780; and *London Courant*, 1 May 1780.

36 Samuel Curwen described the picture room on 19 Dec. 1780: Andrew Oliver, ed., *The Journal of Samuel Curwen, Loyalist* (Cambridge: Harvard UP, 1972), 2:701.

37 Susan Burney to Fanny Burney, 6 June 1780, Philip Olleson, ed., *The Journals and Letters of Susan Burney: Music and Society in Late Eighteenth-Century England* (Burlington, VT: Ashgate, 2012), 170; Amory, 102–3, see also 354. See also Thomas Holcroft, *A Plain and Succinct Narrative of the Late Riots and Disturbances in the Cities of London and Westminster and Borough of Southwark* (London, 1780), esp. 25–36; and Ian Haywood and John Seed, eds., *The Gordon Riots : Politics, Culture and Insurrection in Late Eighteenth-Century Britain* (New York: Cambridge UP, 2012).

38 *MC*, 27 Nov. 1780.

39 *Hutchinson Diary*, 2:291, 307, 335.

40 *MC*, 6 March 1781.

41 *Curwen Journal*, 2:740 (2 April 1781).

42 *MC*, 10 April 1781; *Description of Mr. Copley's Picture of the Death of the Late Earl of Chatham, Now Exhibiting at the Great Room, Spring-Gardens* (London, 1780); see also *MP*, 11 April 1781.

43 Chambers's letter, received between 10 April, when Copley's advertisement first ran, and 24 April, when the first of several responses was published, is printed in Allan Cunningham, *The Lives of the Most Eminent British Painters, Sculptors, and Architects* (1829; repr., New York: J & J Harper, 1834), 4:147. I have not located the original.

44 Joseph Addison, *The Spectator*, vol. 1 (London, 1744), 125–26; *London and Its Environs Described* (London, 1761), 6:215–16. See also Richard D. Altick, *The Shows of London* (Cambridge: Harvard UP, 1978), 56–57, 117–18.

45 N. Bailey, *The New Universal Etymological English Dictionary . . . To Which Is Added, a Dictionary of Cant Words*, 7th ed. (London, 1776), n.p.

46 *MP*, 24 April 1781; *MC*, 27 April 1781.

47 The academy distributed 61,500 catalogs for its 1780 exhibition and only 52,000 in 1781; revenues fell from £3,068 to £2,141. See RAA/ TRE/ 13/1/3 (1777–80); RAA/ TRE/ 13/1/4 (1781–86), RAA. The novelty of Somerset House elevated attendance in 1780; numbers began to rebound in 1782 but did not reach 1780 levels again.

48 *The Earwig; or, An Old Woman's Remarks on the Present Exhibition of Pictures of the Royal Academy . . . Dedicated to Sir Joshua Reynolds, R.A.* (London, 1781), 1–4. *The Earwig* was published on 1 May and provoked such vehement discussion that some painters considered a libel action; *MC*, 15 May 1781.

49 *MC*, 7 May 1781.

50 *London Courant*, 11 June 1781.

51 *Gazeteer*, 7 May 1781.

52 *London Courant*, 11 June 1781.

53 "On Mr. Copley's Picture," *MH*, 6 June 1781.

54 *London Courant*, 8 June 1781.

55 *PA*, 7 June 1781.

56 *PA*, 25 June 1781; *MC*, 3, 9, 16 July, 29 Aug. 1781; *MP*, 16 July 1781. The Royal Academy exhibition typically ran for a month, closing by early June.

57 *MH*, 30 April 1810. Prown identifies the satirist John Williams, who published as Anthony Pasquin, as the author of the verses; P-*JSC* 380 n23.

58 Copley's composition and staging borrow from the effects of waxworks and *tableaux vivants*, new genres of entertainment in the great theatrical metropolis; see Altick, *Shows of London*, 50–56, 332–49.

59 *London Courant*, 11 June 1781.

60 *SJC*, 12 June 1781.

61 Douglass Adair and John A. Schultz, eds., *Peter Oliver's Origin & Progress of the American Rebellion: A Tory View* (Stanford, CA: Stanford UP, 1961), 144.

62 MCP to JSC, 6 Feb. 1782, CFP-LoC, folder 2.

63 *Gazetteer*, 7 May 1781; *FD*, 5:1970 (30 Jan. 1803).

64 *MC*, 20, 21 June 1781; P-*JSC*, 288.

65 *PA*, 21 June 1781.

66 *MC*, 29 Aug. 1781; see also 27 July 1781. Sherwin had contrived a companion or competing project: a distaff Chatham, in which the beauties of Great Britain were arrayed around the infant Moses. See W. S. Lewis, ed., *The Yale Edition of Horace Walpole's Correspondence* (New Haven: Yale UP, 1937–), 29:185; P-*JSC*, 289 and n.

67 Walpole to William Mason, 7 May 1783, *Walpole Correspondence*, 29:299.

68 C. W. Peale to Benjamin West, 9 April 1783; West to Peale, 15 June 1783,

Lillian B. Miller et al., eds., *The Selected Papers of Charles Willson Peale and His Family* (New Haven: Yale UP, 1983), 1:387–88, 390–91. On Peale and the project of American art in the wake of the Revolution, see David C. Ward, *Charles Willson Peale: Art and Selfhood in the Early Republic* (Berkeley: U of California P, 2004); and Wendy Bellion, *Citizen Spectator: Art, Illusion, and Visual Perception in Early National America* (Chapel Hill: Omohundro Institute of Early American History and Culture / U of North Carolina P, 2011).

69 West to Peale, 15 June 1783, *Peale Family Papers*, 1:391. For West's studio as "principally filled with portraits of the King, Queen, and Royal Family," see *Hutchinson Diary*, 2:308–9 (9 July 1779).

70 J. Hector St. John de Crèvecoeur, *Letters from an American Farmer* (London, 1782), 51–52. Addressed to an English reader, Crèvecoeur's *Letters* went through multiple London printings in 1782, a second edition the following year, and was quickly reprinted in Belfast and Dublin. *Letters* was widely enough discussed to provoke a response: Samuel Ayscough, *Remarks on the Letters from an American Farmer; or, A Detection of the Errors of Mr. J. Hector St. John* (London, 1783).

71 *London Courant*, 12 Jan. 1782; *Gazetteer*, 25 Feb. 1782. For Green's Jan. 1781 print of Trumbull's *Washington*, see Wendy Wick Reaves, *George Washington, an American Icon: The Eighteenth-Century Graphic Portraits* (Washington, DC: Smithsonian Institution / National Portrait Gallery, 1982), 26–29.

72 Washington to JSC, 12 Dec. 1792, George Washington Papers, LoC, http://memory.loc.gov/cgi-bin/query/r?ammem/mgw:@field%28DOCID+@lit%28gw320201%29%29. There is no copy in the Copley Family Papers, though it could have been sold to an autograph collector.

73 Elisha Hutchinson Diary, in *Hutchinson Diary*, 2:309–10 (27 Aug. 1783, misdated 1781). By "rent," Hutchinson meant the kind of 99-year lease that characterized much English tenancy. Such leases could be sold; see SCC to GG, 1 Feb. 1816, CFP-MHS, box 2.

74 L. H. Butterfield, ed., *Diary and Autobiography of John Adams* (Cambridge: Harvard UP, 1961), 2:85–86 (17 Dec. 1773).

75 *World*, 28 March 1788. Adams considered the likeness too luxurious; *American Paintings at Harvard* (New Haven: Yale UP / Harvard Art Museums, 2008), 1:148–51.

76 *WEP*, 23 Nov. 1782; *A Key to the Craftsman* (London, 1731), 32.

77 John Adams to Richard Cranch, 4 July 1786, *Adams Papers Digital Editions*, MHS, http://www.masshist.org/publications/apde2/view?id=ADMS-04-07-02-0089.

78 JSC to Peter [Chardon Jr.], 12 Sept. 1766, *CPL*, 47.

79 *MP*, 14 Nov. 1786. On the series Stuart painted for Boydell, see Carrie

Rebora Barratt and Ellen G. Miles, *Gilbert Stuart* (New Haven: Yale UP / Metropolitan Museum of Art, 2004), 48–62.

80 Clare Williams, ed., *Sophie in London, 1786: Being the Diary of Sophie von La Roche* (London: J. Cape, 1933), 237. For Boydell's career, see Hermann Arnold Bruntjen, "John Boydell (1719–1804): A Study of Art Patronage and Publishing in Georgian London" (PhD diss., Stanford Univ., 1974), 7–68. Woollett's print of *The Death of General Wolfe* earned Boydell £15,000, and West as much as £23,000; ibid., 36; and James Clifton, "Reverberated Enjoyment: Prints, Printmakers, and Publishers in Late-Eighteenth-Century London," in *American Adversaries*, 50–61.

81 Bruntjen, "John Boydell," 205–7. As a member of the Court of Common Council, Boydell had endorsed Copley's proposal for the Chatham monument.

82 Undated letter to an unnamed Irish peer reprinted in P-*JSC*, 297. Copley's letter outlined his plan, never realized, to depict the investiture of the first Knights of the Order of Saint Patrick, which the king had created as a sop to the Anglo-Irish peers who had navigated the narrow straits of loyalty in an age of revolutionary upheaval.

83 *PA*, 28 Feb. 1782 ("great Style"). This new history was "bespoke" from the outset, a different model of patronage than *Chatham*; see *WEP*, 23 Nov. 1782.

84 *WEP*, 23 Nov. 1782.

85 *Glasgow Mercury*, 11 Jan. 1781; see also *LC*, 20 Jan. 1781; and *MH*, 10, 22, 30 Jan. 1781. Corbet's court-martial was closely followed; see *SJC*, 23 Jan. 1781; and *MH*, 4 June 1781. The most thorough modern account of the battle remains error riddled: Richard Mayne, *The Battle of Jersey* (London: Phillimore, 1981). Additional documentation is available in Philip John Ouless, *The Death of Major Frs. Peirson, 6th January, 1781; Being an Account of the Battle of Jersey* (St. Helier, Jersey: Le Lievre Brothers, 1881).

86 *LEP*, 24 Jan. 1781; see also *MH*, 10 Jan. 1781. Richard Saunders calls the contemporaneous writing on the battle "Frustratingly brief"; "Genius and Glory: John Singleton Copley's 'The Death of Major Peirson,'" *American Art Journal* 22:3 (Oct. 1990): 11, 33. Coverage in Scottish papers, which celebrated the bravery of the Highland regiment, was fuller. But, on the whole, scholars have greatly overstated the impact of the battle on the public mind.

87 At 92,000 sq cm, *Peirson* is 130 percent the size of *Chatham*, whose 70,680 sq cm area makes it 169 percent the size of *Watson*.

88 Abigail Adams to Mary Smith Cranch, 25 July 1784, *Adams Papers Digital Editions*, MHS, http://www.masshist.org/publications/apde2/view?id=ADMS-04-05-02-0204.

89 P-*JSC*, 303; Saunders, "Genius and Glory," 13–14. The battle prompted a

crude print entitled "The Glorious Defeat of the French Invaders on the Island of Jersey." Copley's painting, by contrast, promised "an exact view of that part of the town . . . where the battle was fought"; *Description of the Picture of the Death of Major Peirson, and the Defeat of the French Troops in the Island of Jersey, Painted by Mr. Copley, for Mr. Boydell* (London, 1784), 2.

90 The faithfulness of the record is trumpeted on the title page: *The Proceedings at Large on the Trial of Moses Corbet, Esq; Lieutenant Governor of Jersey . . . Taken in Short Hand, by W. Williamson, Short Hand Writer* (London, 1781).

91 Hemery and Harrison appear in Copley's key as numbers 8 and 10; *Description of the Picture of the Death of Major Peirson*, 2.

92 *P-JSC* reproduces seventeen studies for *Peirson*, figures 447–63. Richard Saunders adds two more; "Genius and Glory," 5 and 38 n3.

93 *Verses Written at Jersey, January 6. 1781* ([London?], 1781), 2–3, 4, 9.

94 This assertion appears, unsourced, in numerous writings about the black loyalist experience, and has found its way into several textbooks. See, e.g., Louise Downie and Doug Ford, *1781: The Battle of Jersey and The Death of Major Peirson* ([St. Helier]: Jersey Heritage, 2012), 51–52. Downie and Ford cite as evidence of this claim the website Black Loyalists of New Brunswick, whose entry on Copley and Pierson contains numerous errors: http:// preserve.lib.unb.ca/wayback/20141205155437/http://atlanticportal.hil.unb .ca/acva/blackloyalists/en/context/gallery/copley.html. Hundreds of black men fought under Dunmore's banner, wearing rough muslin shifts adorned with sashes emblazoned LIBERTY TO SLAVES. Some of the survivors were folded into the Queen's Rangers. There is vague resemblance between the servant's attire and the rangers' bottle-green field dress; Peter F. Copeland, "Lord Dunmore's Ethiopian Regiment," *Military Collector & Historian* 58:4 (Winter 2006): 208–15; James Hannay, *History of the Queen's Rangers* (Ottawa: Royal Society of Canada, 1909). The Royal Ethiopian Regiment deserves a book-length scholarly history.

95 The background of Christie's servants and the contours of his military career appear in their depositions at his wife's trial for adultery: *The Trial of Mrs. Eliz. Leslie Christie . . . Wife of James Christie, Esquire* (London, 1783), esp. 30–31. Allec testified that Christie's wife bade him to join the staff of her paramour, Joseph Baker, explaining that if he "stayed with her he must change his livery for the said Joseph Baker's livery"; ibid., 44. I am grateful to John Hannigan for discovering this text.

96 *Glasgow Mercury*, 18 Jan. 1781.

97 "A Short Account of the Transactions on the Island of Jersey . . . as given verbatim by Adjutant Harrison, of the 95th Regt, to Francis Peirson Esq. father of the late Major Peirson," reprinted in Société Jersiaise, *Annual Bulletins I–IX 1875–1884* (St. Helier, Jersey: Société Jersiaise / Labey et Blampied,

1897), 321. Harrison's account, from a now lost manuscript, does not seem to have appeared in print until the late nineteenth century; Saunders, "Genius and Glory," 32–33. But the account may well have circulated; it amplifies only slightly the letter printed in the *Glasgow Mercury*, 18 Jan. 1781. Harrison attended the court-martial and could have related the story to Copley then. Prown conflated Captain James Christie with James Christie the auctioneer, who lived near Copley in Leicester Square; P-*JSC*, 303–4.

98 *Description of the Picture of the Death of Major Peirson*, 1.

99 Saunders, "Genius and Glory," 32.

100 Boswell, *Life of Johnson*, 876 (23 Sept. 1777). For comparisons to other images of black servants and soldiers, see David Bindman and Henry Louis Gates, eds., *The Image of the Black in Western Art*, vol. 4, *From the American Revolution to World War I*, pt. 1, *Slaves and Liberators*, new ed. (Cambridge: Harvard UP, 2012), 11–96, esp. 22–24.

101 John Adams to Jonathan Dickinson Sargent, 17 Aug. 1776, *Adams Papers Digital Editions*, MHS, http://www.masshist.org/publications/apde2 /view?id=ADMS-06-04-02-0215. On the arming of slaves during the American Revolution, see Philip D. Morgan and Andrew Jackson O'Shaughnessy, "Arming Slaves in the American Revolution," in *Arming Slaves: From Classical Times to the Modern Age*, ed. Christopher L. Brown and Philip D. Morgan (New Haven: Yale UP, 2006), 180–208.

102 *General Advertiser*, 27 April 1778.

103 *Parker's General Advertiser*, 29 April 1783; see also *LC*, 29 April 1783; and *MC*, 29 April 1783; contra *PA*, 1 May 1783. For the controversy over the seated figure in *Chatham*, see *JSC in England*, 51–52.

104 *Hutchinson Diary*, 2:276 (29 Aug. 1779). See also Gene Adams, "Dido Elizabeth Belle: A Black Girl at Kenwood," *Camden History Review* 12 (n.d.): 1984; Carolyn Steedman, "Lord Mansfield's Women," *Past & Present*, no. 176 (Aug. 1, 2002): 105–43.

105 *MH*, 22 May 1784.

106 Copley's advertisement mentions only *Peirson* and *Chatham*, but *WEP*, 27 May 1784, notes that *The Boy and the Shark*—presumably the copy Copley had made for himself—was there as well. Compare to *MC*, 13 May, 19 July 1784; *MP*, 15 May, 23 June 1784.

107 *MP*, 26 April 1784, 14 Nov. 1786; *LC*, 24 June 1784. For the allegation that William Chambers's "illiberality" was again responsible for Copley's absence from the Royal Academy, see *SJC*, 24 April 1784. For the exhibition of *Peirson* as a "raree-show," see Peter Oliver Jr. to Elisha Hutchinson, 17 May 1784, Hutchinson Family Correspondence, vol. 2, folio 14r, BL, Egerton ms 2660. For the picture in Boydell's gallery, see *Sophie in London, 1786*, 238–39.

108 *GEP*, 27 May 1784.

109 *WEP*, 27 May 1784.

110 *Description of the Picture of the Death of Major Peirson*, 2.

111 *WEP*, 27 May 1784.

CHAPTER TEN: DAUGHTERS AND SONS

1 SCC to Sally Bromfield, 29 Oct. / 28 Nov. 1784, BFP, box 1, folder 8. Step-daughter to Sukey's sister Hannah, Sally was the Copleys' stepniece.

2 *GEP*, 16, 18 Sept. 1784; *MC*, 16, 17 Sept. 1784.

3 Walpole to Horace Mann, 25 July 1785, W. S. Lewis, ed., *The Yale Edition of Horace Walpole's Correspondence* (New Haven: Yale UP, 1937–), 25:596; and Paul Keen, "The 'Balloonomania': Science and Spectacle in 1780s England," *Eighteenth-Century Studies* 39:4 (July 2006): 507–35.

4 John Jeffries Diaries, 20 Nov., 8 Dec. 1784, 8 Feb. 1787; John Jeffries Papers, 1768–1963, ser. 2, 11.8, 11.13, Houghton Library, Harvard Univ.

5 *MP*, 17 Sept. 1784.

6 SCC to Sally Bromfield, 28 Jan. 1785, BFP, box 1, folder 9.

7 SCC to Sally Bromfield, 29 Oct. / 28 Nov. 1784, BFP, box 1, folder 8.

8 Michael A. McDonnell, "The Other Three-Fifths: Reconsidering the War for Independence and the American Revolution," conference paper delivered May 2013. On the peace, see Mary Beth Norton, *The British-Americans: The Loyalist Exiles in England, 1774–1789* (Boston: Little, Brown, 1972), 185–222; and Maya Jasanoff, *Liberty's Exiles: American Loyalists in the Revolutionary World* (New York: Knopf, 2011), 55–84.

9 Adams quoted in David E. Maas, *The Return of the Massachusetts Loyalists* (New York: Garland Press, 1989), 448. The transparency is described in *Salem Gazette*, 11 March 1784; see also the gallows and gibbet threatened in *BG*, 28 April 1783.

10 Andrew Oliver, ed., *The Journal of Samuel Curwen, Loyalist* (Cambridge: Harvard UP, 1972), 1015 (20 July 1784). Just 13 percent of loyalists from Boston returned; Maas, *Return of the Massachusetts Loyalists*, 492.

11 Sarah Startin to Sally Clarke, 24 Aug. 1783, BFP, box 1, folder 1.

12 On Harry Pelham's marriage, see Timothy Clayton, "Pelham, Peter (1695?–1751)," *ODNB Online*, Oct. 2006, which places the marriage in ca. 1778; and P-*JSC*, 265 n15, which places it in 1780–81. The latter appears correct; Mary Pelham had just learned of the wedding in MCP to JSC, 6 Feb. 1782, CFP-LoC, folder 1. Harry and his wife spent the winter of 1782 in London; John Jeffries Diary, 7, 11, 24, 27 Jan. 1782, Jeffries Papers, ser. 2, 11.6. In MCP to Sally Bromfield, 22 Sept. 1784, BFP, box 1, folder 8, Mary Pelham mentions that Harry sent her the inscription from his wife's tomb. On Castle Crine, see the Landed Estates Database, National University of Ireland, http://landedestates.nuigalway.ie/LandedEstates/jsp/estate-show.jsp?id=1913.

13 MCP to Copley Family, 3 Nov. 1779, CFP-LoC, folder 1.

14 MCP to JSC, 23 Dec. 1780, CFP-LoC, folder 2.

15 MCP to JSC, 6 Feb. 1782, CFP-LoC, folder 2.

16 Ibid.

17 *Independent Ledger*, 7 June 1784.

18 Curwen to Judge Jonathan Sewall, 2 Aug. 1785, *Curwen Journal*, 1035.

19 SCC to Sally Bromfield, 29 Oct. / 28 Nov. 1784, BFP, box 1, folder 8.

20 R. Campbell, *The London Tradesman* (London, 1747), 107, 100, 104.

21 JSC to SCC, 17 Aug. 1774, CFP-LoC, folder 1; see also JSC to HP, 5 Aug. 1774, *CPL*, 236.

22 For evidence that the painting was not commissioned, see P-*JSC*, 312–13 and n2. Martha Amory holds that West had recommended Copley for the portrait, though no other documentation supports this claim; Amory, 12–13.

23 Theodore Sizer, ed., *The Autobiography of Colonel John Trumbull, Patriot-Artist, 1756–1843* (New Haven: Yale UP, 1953), 84–87; Samuel Shoemaker, "A Pennsylvania Loyalist's Interview with George III," *PMHB* 2:1 (Jan. 1878): 36.

24 *FD*, 2:286–87; and John Wilson, "Hoppner, John (1758–1810), *ODNB Online*, May 2011. On Wright, see Wendy Bellion, "Patience Wright's Transatlantic Body," in *Shaping the Body Politic: Art and Political Formation in Early America*, ed. Maurie D. McInnis and Louis P. Nelson (Charlottesville: U of Virginia P, 2011), 15–47; and Charles Coleman Sellers, *Patience Wright, American Artist and Spy in George III's London* (Middletown, CT: Wesleyan UP, 1976).

25 *MP*, 13 July 1784; *Parker's General Advertiser*, 15 July 1784.

26 *PA*, 1 May 1783.

27 SCC to Sally Bromfield, 29 Oct. / 28 Nov. 1784, BFP, box 1, folder 8 (quoted); SCC to Daniel D. Rogers, 14 Oct. 1784. Abigail Bromfield Rogers, like Sally Bromfield, was the Copleys' stepniece.

28 "Diary of Samuel Shoemaker, Esquire, of Philadelphia," typescript at New-York Historical Society, 242 (quoted), 251–52 (4, 11 Oct. 1784).

29 Ibid., 246–51 (10 Oct. 1784).

30 SCC to Sally Bromfield, 29 Oct. / 28 Nov. 1784, BFP, box 1, folder 8.

31 William Dunlap, *History of the Rise and Progress of the Arts of Design in the United States*, ed. Alexander Wycoff (1834; repr., New York: Benjamin Blom, 1965), 1:144; see also Amory, 13.

32 Princess Mary, born April 1776, and Princess Sophia, born Nov. 1777, bracket the Oct. 1776 birth date of Mary Copley; Jonathan Copley was born in Feb. 1782 and Princess Amelia in Aug. 1783.

33 Mark Hallett, "'The Business of Criticism': The Press and the Royal Acad-

emy Exhibition in Eighteenth-Century London," in *Art on the Line: The Royal Academy Exhibitions at Somerset House, 1780–1836*, ed. David H. Solkin (New Haven: Yale UP, 2001), 65–73.

34 *MH*, 4 July 1785. On London painters' "flowing from all quarter to India," see Joseph Farington to Ozias Humphry, 27 Dec. 1785, Humphry Papers 3/95, RAA.

35 "Royal Academy Letters Passed between the Rev. Mr. Peters and Mr. Hoppner," *MP*, 4 July 1785.

36 Elizabeth West's Household Journal, ca. 1785–89, Archives of American Art, reel 4233, 16 Feb., 30 Dec. 1785.

37 *P-JSC*, 315–17; *JSC in England*, 155–58.

38 *MP*, 5 May 1785.

39 *PA*, 3 May 1785.

40 Anthony Pasquin, *Memoirs of the Royal Academicians* (London, 1796), 137; see also *MH*, 7 May, 3 June 1785.

41 *Catalogue of the Very Valuable Collection of Pictures of the Rt. Hon. Lord Lyndhurst, Deceased: Including Most of the Important Works of His Lordship's Father, That Distinguished Historical Painter, John Singleton Copley, R.A.* (London: Christie, Manson and Woods, 1864). Martha Amory said West's drawing hung in John Jr.'s "bed-room until the last day of his life"; Amory, 101.

42 MC to ECG, 3 April 1803, CFP-MHS, box 1. All further references to CFP-MHS in this chapter box 1 unless otherwise noted.

43 *Curwen Journal*, 2:759 (25 May 1781).

44 JSC to SCC, 9 July 1774, *CPL*, 224. See also JSC to SCC, 15 Sept. 1774, *CPL*, 260; and JSC to SCC, 2 July 1775, 11 July, 8, 25 Oct., 4 Nov., 4–17 Dec. 1774, 9 June 1775, all CFP-LoC, folder 1.

45 Elizabeth West's Household Journal, ca. 1785–89, 24 Oct., 9 Nov. 1785; George S. Steinman, *A History of Croydon* (London: Longman, Rees, 1833), 188; *Hutchinson Diary*, 2:364–65. On the illness, see John Berkenhout, *Symptomatology* (London, 1784), unpaginated, under "headache," "hoarseness," "rigor," and "throat."

46 Abigail Adams 2d to John Quincy Adams, 1 Feb. 1786, *Adams Papers Digital Editions*, MHS, http://www.masshist.org/publications/apde2/view?id=ADMS-04-07-02-0007#AFC07d009n47.

47 Richard Clarke to Elizabeth Bromfield, 15 April 1784, BFP, box 1, folder 8; Sarah Startin to Sarah Bromfield Pearson, 4–5 Feb. 1786, BFP, box 1, folder 9; see also SCC to Sarah Bromfield Pearson, 25 July 1786, ibid.

48 SCC to ECG, 23 Sept. 1811, CFP-MHS.

49 JSC Jr. to SCC, 26 Feb. 1791, LLP-GRO, DLY 1/4/1; Amory, 79.

50 MCP to Sarah Pearson, 7 April 1787, BFP, box 1, folder 10; SCC to ECG,

1 March 1803, CFP-MHS. For the children's sketches, see MCP to JSC, 3 Nov. 1779, CFP-LoC, folder 1; MCP to JSC, 8 Aug. 1781, CFP-LoC, folder 2. On drawing as a polite accomplishment, see Ann Bermingham, *Learning to Draw: Studies in the Cultural History of a Polite and Useful Art* (New Haven: Yale UP, 2000).

51 In 1787, John Jr., aged fifteen, and Mary, aged eleven, were "home for a few days . . . and are now returnd again to their schools"; MCP to Sarah Pearson, 7 April 1787, BFP, box 1, folder 10. Betsy, seventeen, was living at home.

52 SCC to ECG, 18 March 1802, CFP-MHS; see also *Curwen Journal*, 2:742 (6 April 1781).

53 Margaret Oliver Hutchinson to ECG, 3 July 1791; see also JSC Jr. to SCC, 4 Dec. 1789, LLP-GRO, DLY 1/3.

54 Jeffries Diary, 28 July 1786, 3 Aug. 1787; Jeffries Papers, ser. 2, 11.12, 11.13.

55 Mary Sword to ECG, 28 Jan. 1792 (quoted); see also the several letters from Mary Hutchinson Oliver to ECG dated 1791, and Augusta Thomas to ECG, 5 Oct. 1792, all in CFP-LoC, folder 2.

56 London *Star*, 26 Oct. 1791. The absence of Mary Copley from the retinue suggests that the trip to Bath was devoted to debuting Betsy.

57 JSC Jr. to SCC, 1790–91?, LLP-GRO, DLY 1/1/1. The Glamorgan Record Office dates this letter 1789?, but it is postmarked from Cambridge, which places it after July 1790.

58 JSC Jr. to SCC, 26 Feb. 1791, LLP-GRO, DLY 1/4/1; Dennis Lee, *Lord Lyndhurst: The Flexible Tory* (Niwot: UP of Colorado, 1994), 8–11.

59 JSC to MCP, 8 Sept. 1774, *CPL*, 255.

60 Mary Sword to ECG, 28 Jan. 1792, CFP-LoC, folder 2, suggests that the Copleys hosted such a gathering: "I hope to be favoured with an account of your Ball, where I should have been one of the Party."

61 *MC*, 30 May 1783. The paintings of Gibraltar appear in *The Exhibition of the Royal Academy, MDCCLXXXIII. The Fifteenth* (London, 1783), nos. 173, 228, 241, 262. The last was painted by West's son Raphael, and must have been in progress when West bid for the commission. On the popularity of the subject, see John Bonehill, "Exhibiting War: John Singleton Copley's The Siege of Gibraltar and the Staging of History," in *Conflicting Visions: War and Visual Culture in Britain and France, c. 1700–1830*, ed. John Bonehill and Geoff Quilley (Burlington, VT: Ashgate, 2005), esp. 141–45.

62 John Trumbull to Jonathan Trumbull, 27 Feb. 1787, quoted in *Trumbull Autobiography*, 148 n273.

63 P-*JSC*, 311–12.

64 *The Defeat of the Floating Batteries at Gibraltar* spans 410,091 sq cm, making it 880 percent the size of *Watson*, 480 percent that of *Chatham*, and 346 percent that of *Peirson*, which together have an area of 204,539 sq cm.

65 Thomas Frognall Dibdin, *Reminiscences of a Literary Life* (London: J. Major, 1836), 151. The date of Dibdin's visit is unclear. Born in 1776, he would have been very young at the beginning of Copley's work on *Gibraltar*. He placed the encounter shortly before the exhibition of John James Masquerier's picture of Napoleon, which took place in 1801, long after *Gibraltar* was installed in Guildhall. Sometime close to the painting's completion in 1791 seems likeliest.

66 Amory, 99–100. Copley's painting room lacked the grandeur of Benjamin West's soaring "great room"; see Kaylin H. Weber, "A Temple of History Painting: West's Newman Street Studio and Art Collection," in *American Adversaries*, 14–49.

67 *LC*, 3 Oct. 1786. John Bonehill argues that these and other articles were likely placed by Copley himself; Bonehill, "Exhibiting War," 145.

68 JSC Jr. to SCC, 4 Dec. 1789, LLP-GRO, DLY 1/3.

69 "Pictorial Bet," *Oracle*, 29 April 1791.

70 *LC*, 28 Aug. 1787; *World*, 24 Sept. 1788. On the massive adjustments to the planned composition, see P-*JSC*, 324–27.

71 *World and Fashionable Advertiser*, 30 Aug. 1787, listed the traveling party: "Mr. and Miss *Copley*, with Mr. *Green* jun. of Newman-street," probably the son of the engraver Valentine Green, who had engraved *Watson*. It is not clear when the Copleys returned from Hanover. A letter from JSC to Mercy Scollay dated 23 June 1788 (Miscellaneous Bound Mss., MHS) mentions the family's "sudden and unexpected Journey to Germany" and indicates that Scollay has been waiting for a response, making it likely that they had recently arrived back in London. A fragment documenting five days of the party's travel in Belgium and the Netherlands survives: "Diary of Copley from Sept. 1 to Sept. 5 of 1787," Manuscripts Department, Ch I 3.12, Boston Public Library; see also *American Paintings at Harvard* (New Haven: Yale UP / Harvard Art Museums, 2008), 154–55, 162–63.

72 Amory, 93–94.

73 *PA*, 7 June 1785. The *GEP* reported on 22 April 1786 that the *Chatham* subscription was "so full that not a print will reach the shops till fifteen hundred are thrown off."

74 *MH*, 23 March 1787.

75 *World*, 1 April 1791; *MC*, 28 April 1791.

76 Copley was anxious enough about the sums paid to engravers that he discussed it with John Jeffries; Jeffries Diary, 8 Feb. 1787, Jeffries Papers, ser. 2, 11.13. The delay of the *Chatham* prints was covered extensively; see *PA*, 28 March 1787; *MH*, 5 April 1787; *MC*, 12 June 1787; and *MP*, 3 Jan., 2 Feb. 1788, among others. James Heath's *Peirson* engraving, underwritten by John Boydell, was also slow to come to fruition; see *World*, 16 June 1789.

On Copley's trouble with engravers see P-*JSC*, 289–90; and James Clifton, "Reverberated Enjoyment: Prints, Printmakers, and Publishers in Late Eighteenth-Century London," in *American Adversaries*, 54–57.

77 *FD*, 1:261–62 (21 Nov. 1794).

78 Copley first discussed the large historical painting *Charles I Demanding . . . in the House of Commons* with John Boydell in 1781, and it was described in the *GEP*, 28 Oct. 1786, as "the chosen subject of Mr. Copley's pencil." He did not complete it until 1795; P-*JSC*, 343–50. Boydell also listed Copley among those who would paint for his Shakespeare Gallery; see *MH*, 21 Nov. 1786; and *SJC*, 7 Dec. 1786. On the Shakespeare Gallery, see Rosie Dias, *Exhibiting Englishness: John Boydell's Shakespeare Gallery and the Formation of a National Aesthetic* (New Haven: Yale UP, 2013).

79 The description of *Chatham* also included "the weight of the frame"; *A Catalogue of the Superlatively Fine Collection of Pictures, Late the Property of the Right Reverend Dr. Newton, Lord Bishop of Bristol, Dec. Likewise That Chef d'Oeuvre, Representing the Death of Chatham* (London, 1788), 16.

80 *World*, 10 April 1788.

81 Charles Pelham to Henry Bromfield Sr., 1 May 1789, BFP, box 1, folder 10. See also the funeral announcement in *BG*, 4 May 1789.

82 JSC to Mercy Scollay, 23 June 1788; JSC to Henry Bromfield, 20 Feb. 1792; both Miscellaneous Bound Mss., MHS.

83 Will and inventory of Mary Pelham, 11 May 1789, Suffolk Country Probates, 19268, MassArchs.

84 Margaret Oliver to ECG, 3 July 1791, CFP-LoC, folder 2.

85 JSC Jr. to SCC, n.d. [Nov. 1791], LLP-GRO, DLY 1/5.

86 *WEP*, 30 April 1791; *MP*, 3 May 1791; *PA*, 21 May 1791. On the king's illness, see Jeremy Black, *George III: America's Last King* (New Haven: Yale UP, 2006), 264–304.

87 *Diary or Woodfall's Register*, 10 June 1791; see also *LEP*, 8 June 1791.

88 *World*, 11 June 1791.

89 Paul K. Longmore, *The Invention of George Washington* (Berkeley: U of California P, 1988); and François Furstenberg, *In the Name of the Father: Washington's Legacy, Slavery, and the Making of a Nation* (New York: Penguin Press, 2006).

90 Margaret Oliver to ECG, 3 July 1791, CFP-LoC, folder 2.

91 Wordsworth's verses, written ca. 1799, first appeared in the *Friend* in 1809 as "The French Revolution as It Appeared to Enthusiasts at Its Commencement," and then were codified in *The Prelude*, bk. 10, ll. 693–97.

92 *SJC*, 11 June 1791. Copley remembered that the record-breaking attendance netted him £5,000, when in fact 60,000 visitors would have resulted in a *gross* income of £3,000; "Library of the Fine Arts; or Repertory of Painting, Sculpture, Architecture & Engraving" (Oct. 1832), 4:335. On panoramas

see Richard D. Altick, *The Shows of London* (Cambridge: Harvard UP, 1978), 128–40; and Bernard Comment, *The Painted Panorama*, rev. ed. (New York: H. N. Abrams, 2000).

93 *LC*, 18 Aug. 1791; *Evening Mail*, 19 Aug. 1791; *Star*, 18 Aug. 1791.

94 "Particulars Respecting the Late Unfortunate James Sutherland, Esq.," *Weekly Entertainer* 18, no. 448 (Aug. 29, 1791): esp. 206. Sutherland's pamphlet, *A Letter to the Electors of Great Britain* (London, 1791), went through several editions. See also *An Elegy on the Death of James Sutherland, Esq. By Eunohoo* (London, 1791), esp. 10–11. Copley's exhibition appears to have closed for a fortnight after the suicide; I have not found advertisements for *Gibraltar* between 17 Aug. and 1 Sept.

95 John Barrell, *Imagining the King's Death: Figurative Treason, Fantasies of Regicide, 1793–1796* (Oxford: Oxford UP, 2000), 554–57; Jenny Uglow, *In These Times: Living in Britain through Napoleon's Wars, 1793–1815* (New York: Farrar, Straus and Giroux, 2015), 139–50; *Debating the Revolution: Britain in the 1790s* (London: I. B. Tauris, 2006); and Frank Petersmark, "London Calling: The London Corresponding Society and the Ascension of Popular Politics" (PhD diss., Wayne State Univ., 2015).

96 P-*JSC*, 342–43.

97 Tim Clayton and Sheila O'Connell, *Bonaparte and the British: Prints and Propaganda in the Age of Napoleon* (London: British Museum Press, 2015).

98 SCC to Samuel Cabot, 29 March 1796, BFP, box 1, folder 12. Cabot (b. 1759) was married to the daughter of Sukey's short-lived sister Mary Clarke Barrett; he was also her distant cousin; L. Vernon Briggs, *History and Genealogy of the Cabot Family, 1475–1927* (Boston: C. E. Goodspeed, 1927), 194, 197–220.

99 Copy of the will of Richard Clarke, 11 Dec. 1794, BFP, box 4, folder 3; Henry Bromfield Jr. to Henry Bromfield Sr., 26–28 March, 21 Oct.–3 Nov. 1796, Henry Herbert Edes Collection, 1648–1917, MHS, box 2, folder 12. Clarke died on 27 Feb. 1795.

100 SCC to Samuel Cabot, 29 March 1796, BFP, box 1, folder 12.

101 *Argus of the Constitution*, 7 March 1792; *MH*, 16, 19 March 1792; see also *Star*, 29 Feb. 1792.

102 Bromley appended his letters to Copley, originally published in the *Morning Herald* in five installments in 1794, to vol. 2 of *A Philosophical and Critical History of the Fine Arts, Painting, Sculpture, and Architecture* (London, 1795), quotations at 2:xxxii, xxxv, xxxvi; see also P-*JSC*, 338 n6. Copley's suspicion that "West is at the bottom" of the matter appears in *FD*, 1:235 (18 Sept. 1794).

103 Emily Ballew Neff and Kaylin H. Weber, "Laying Siege: West, Copley, and the Battle of History Painting," in *American Adversaries*, esp. 222–30. Academy politics were increasingly vicious in the 1790s; Holger Hoock, *The King's*

Artists: The Royal Academy of Arts and the Politics of British Culture, 1760–1840 (Oxford: Clarendon Press, 2003), pt. 2.

104 Bromley, *History of the Fine Arts*, 2:xxxvi. These were familiar charges, and not entirely false; see, e.g., P-*JSC*, 333–34; and *WEP*, 15 Feb. 1794; *MP*, 22 April 1794; and *LC*, 5 June 1794.

105 Pasquin, *Memoirs of the Royal Academicians*, 138; and *MH*, 30 April 1810. For Pasquin as the author of the verses see P-*JSC*, 380 n29.

106 The encounter appears in bk. 1, canto 10, of *Faerie Queene*. West had painted *Fidelia and Speranza* two decades before; *JSC in England*, 167–69; Ellen G. Miles et al., *American Paintings of the Eighteenth Century* (Washington: National Gallery of Art, 1995), 76–81.

107 *London Packet*, 1 May 1793; *True Briton*, 1 May 1793.

108 Anna Quincy Lowell Waterston, "A Long Life: A Sketch of the Life of Elizabeth Copley Greene" (1886), in Francis Cabot Lowell, "A History of the Gardiner Greene Estate on Cotton Hill, Now Pemberton Square, Boston," ed. Winthrop S. Scudder, *Bostonian Society Publications* 12 (1915): 61.

109 MC to ECG, 4 March 1801, CFP-MHS; Mary Sword to ECG, 20 Feb. 1794, CFP-LoC, folder 2.

110 SCC to ECG, 12 Oct. 1803, CFP-MHS; *FD*, 6:2284 (29 March 1804). On the roles of Sukey, Mary, and Betsy in Copley's studio practice, see SCC to ECG, 20 Dec. 1800; SCC to ECG, 1 Feb. 1803, CFP-MHS.

111 John Quincy Adams diary 21, 17 Sept.–31 Oct. 1794, p. 52, *The Diaries of John Quincy Adams: A Digital Collection*, MHS, 2004, http://www.masshist .org/jqadiaries.

112 Henry Bromfield Jr. to Henry Bromfield Sr., 21 Oct.–3 Nov. 1796, Edes Collection, MHS, 2:12.

113 John Jeffries Diary, 8 Feb. 1787, Jeffries Papers, ser. 2, 11.13.

114 Pasquin, *Memoirs of the Royal Academicians*, 64. On the painting, exhibition, and reception of Copley's *Charles I Demanding in the House of Commons the Five Impeached Members*, see P-*JSC*, 343–50.

115 JSC Jr. to JSC, n.d. [Jan. 1794], LLP-GRO, DLY 1/9 and 1/8/1; *GEP*, 11 Nov. 1794. See also John Singleton Copley Lyndhurst and Theodore Martin, *A Life of Lord Lyndhurst from Letters and Papers in Possession of His Family* (London: J. Murray, 1883), 28–32; Lee, *Lord Lyndhurst*, 10–12.

116 JSC to Henry Bromfield, 20 Feb. 1792, Miscellaneous Bound Mss., MHS; JSC to William Phillips, 24 June 1773, Suffolk Deeds, L124, ff. 55–56, MassArchs.

117 JSC to Samuel Cabot, 3 March 1793, HGOBP, box 1, folder 5.

118 Ibid.; JSC to Samuel Cabot, 9 Nov. 1793, quoted in Allen Chamberlain, *Beacon Hill, Its Ancient Pastures and Early Mansions* (Boston: Houghton Mifflin, 1925), 68. The original of this letter appears lost.

119 JSC to Samuel Cabot, 3 March 1794, HGOBP, box 1, folder 5; Agreement between Samuel Cabot and the Mount Vernon Proprietors, 17 June 1795, HGOBP, box 2, folder 19; see also Chamberlain, *Beacon Hill*, esp. 59–60. Copley had painted Charles Bulfinch's mother, as well as older members of the Scollay and Otis families.

120 Gabriel Manigault to the Society of Charleston, 18 April 1794, quoted in Carrie Rebora Barratt and Ellen G. Miles, *Gilbert Stuart* (New Haven: Yale UP / Metropolitan Museum of Art, 2004), 104.

121 JSC to Samuel Cabot, 3 March 1794, HGOBP, box 1, folder 5. Compare to Mary Copley Pelham, Petition to the General Court, Feb. 1779, Massachusetts Archives Collection, vol. 185, f. 46, MassArchs. The suit between Richard Clarke and a Mr. Watson centered on the property that had devolved to Clarke's grandson Edward ("Neddy") Clarke; see Richard Clarke to Samuel Cabot, 25 July 1793, Samuel Cabot Papers, MHS, box 1, folder 3.

122 Agreement between Samuel Cabot and the Mount Vernon Proprietors, 17 June 1795, HGOBP, box 2, folder 19; see also the unexecuted deed from Copley to Mason & Otis, June 1795, ibid., folder 17.

123 James Scott to JSC, 7 Aug. 1795, Harrison Gray Otis Papers, MHS, microfilm ed., reel 2.

124 JSC to Samuel Cabot, 29 Aug. 1795, HGOBP, box 1, folder 5.

125 Ibid.. Born in 1753, Hull was still in Connecticut when Copley left Massachusetts. But he served in the Continental army with Colonel Henry Knox, and he and Knox were founding members of the Society of Cincinnatus; see Maria Campbell, *Revolutionary Services and Civil Life of General William Hull: Prepared from His Manuscripts* (New York: D. Appleton, 1848). Knox rented Copley's house in 1784; P-*JSC*, 341 n12. It is likely that Hull learned of the property through Knox. For his payment to Copley, see JSC Jr. to JSC, 27 Feb. 1796, CFP-LoC, microfilm.

126 Sizer, *Trumbull Autobiography*, 173; *FD*, 1:207 (1 July 1794).

127 *FD*, 2:402 (13 Nov. 1795); Mary Oliver to ECG, 2 Jan. 1796, CFP-LoC, folder 3.

128 JSC Jr. to ECG and MC, 21 Jan. 1796, repr. in Amory, 137–38 (Vixen, hurricane, cold); JSC Jr. to SCC, n.d. [Nov. 1795], LLP-GRO, DLY 1/13, 1/14, 1/15 (stiffish weather, good sailor); William Heath Bennet, *Select Biographical Sketches from the Note-Books of a Law Reporter* (London: G. Routledge, 1867), 179 (Volney).

129 JSC Jr. to JSC, 2 Jan. 1796, CFP-LoC, microfilm.

130 JSC Jr. to JSC, 27 Feb. 1796, CFP-LoC, microfilm; *Columbian Centinel*, 3 Aug. 1796; JSC Jr. to ECG and MC, 8 July 1796, CFP-LoC, folder 3. For the sale documents, see Agreement of Sale with John Singleton Copley, 24

Feb. 1796, HGOBP, box 1, folder 13a; and JSC to Jonathan Mason et al., 24 Feb. 1796, Suffolk Deeds, L182, ff. 184–97, MassArchs. Under the revised agreement, Copley could keep the money Hull had paid him.

131 JSC Jr. to JSC, 27 Feb. 1796.

132 JSC Jr. to JSC, 2 Jan. 1796; JSC Jr. to ECG and MC, 21 Feb. 1796, in Amory, 140 (original unlocated).

133 JSC Jr. to SCC, 20 April 1796, in Amory, 145; *FD*, 4:1411 (29 June 1800). The War of 1812 was, in fact, the conflict he foresaw.

134 Copley to Bellward, n.d. [June–July 1796], trans. and repr. in Bennet, *Select Biographical Sketches*, 186, italics in original.

135 Bennet, *Select Biographical Sketches*, 183, 186–88.

136 JSC Jr. to SCC, 22 Nov. 1796, LLP-GRO, 1/17/1; JSC Jr. to SCC, 2 Dec. 1796, LLP-GRO, 1/18/1.

137 JSC Jr. to Daniel D. Rogers, 3 Feb. 1797; see also Sarah Startin to Daniel D. Rogers, 25 Feb. 1796; both BFP, box 1, folder 12.

138 JSC Jr. to Sarah Startin, 20 July 1797, CFP-LoC, folder 3.

139 Sarah Startin to ECG, 16 Nov. 1798, CFP-LoC, folder 3.

CHAPTER ELEVEN: BETSY COPLEY'S SMILE

1 Gordon McMullan, *Shakespeare and the Idea of Late Writing: Authorship in the Proximity of Death* (Cambridge, UK: Cambridge UP, 2007), esp. chap. 3. The *OED* dates the application of "late" to artistic works to the mid-nineteenth century.

2 Anthony Pasquin, *Memoirs of the Royal Academicians* (London, 1796), 138.

3 Allen Chamberlain, *Beacon Hill, Its Ancient Pastures and Early Mansions* (Boston: Houghton Mifflin, 1925), 63–65; see also Jay Wickersham, "The Financial Misadventures of Charles Bulfinch," *New England Quarterly* 83:3 (Sept. 2010): esp. 436–39. Otis estimated that the Mount Vernon Proprietors paid over $40,000 for their purchases in 1795. Copley's acres accounted for the bulk of their land but fetched less than one-third of that amount.

4 Samuel Cabot to JSC, copies of letters dated 27 Sept. 1796, 24 Oct., 1 Nov. 1797, 15 Nov. 1795; Samuel Cabot Papers, MHS, box 1, folder 3. Cabot labeled these letters A, B, C, and D, suggesting exhibits in a legal action.

5 Christopher Gore et al. to Samuel Cabot, 30 Dec. 1796, Samuel Cabot Papers, MHS, box 1, folder 3. One signer, John Amory, had fled Boston on the *Minerva*, along with Sukey and the children; other Copley patrons among the letter's signatories include John Codman and Jonathan Jackson.

6 George Cabot to Samuel Cabot, 27 Nov. 1797; JSC to Samuel Cabot, 6 Nov., 5 Dec. 1797; all Samuel Cabot Papers, MHS, box 1, folder 4; Cabot to JSC, copies of letters dated 1 and 15 Nov. 1797, Samuel Cabot Papers, MHS, box 1, folder 3.

7 Sarah Startin to Samuel Cabot, 21 Nov. 1796, Samuel Cabot Papers, MHS, box 1, folder 3.

8 JSC held on to the signed quitclaim for more than two years: JSC to Jonathan Mason et al., signed 17 April 1797, not filed until 7 March 1799, Suffolk County Deeds, L191, ff. 167–68, MassArchs. For his continuing efforts to negotiate, see George Erving to JSC, 19 June 1799, CFP-LoC, microfilm.

9 JSC to Samuel Cabot, 30 Oct. 1797, Samuel Cabot Papers, MHS, box 1, folder 4.

10 Martin Rosenberg, "Raphael's Transfiguration and Napoleon's Cultural Politics," *Eighteenth-Century Studies* 19:2 (Dec. 1985): 180–205.

11 Copley wrote to Boydell on 25 Jan. 1799, repr. in P-*JSC*, 357–58. See also *Bell's Weekly Messenger*, 10 Feb. 1799. Copley presented the finished work for the committee's inspection in April; *London Packet*, 8 April 1799.

12 *Express and Evening Chronicle*, 26 May 1798. See also P-*JSC*, 357–58.

13 *WEP*, 8, 15 May 1798.

14 *MC*, 13 May 1799; see also *FD*, 2:346 (29 May 1795), reporting that Copley was "much disappointed" by the response to *Charles I*.

15 See, e.g., *MP*, 6 June 1799. The one-man, one-picture exhibit was no longer novel; Copley himself had used the once shocking gambit "frequently and successfully," as the *Observer* noted, 2 June 1799.

16 Exhibition brochure quoted in P-*JSC*, 358; "The British School of Engraving," *British Magazine* 2 (Oct. 1800), 335.

17 Jenny Uglow, *In These Times: Living in Britain through Napoleon's Wars, 1793–1815* (New York: Farrar, Straus and Giroux, 2015), 174, 235–40. Public interest in Nelson's portrait first spiked with the Battle of St. Vincent and reached frenzied proportion after the Battle of the Nile; see R. J. B. Walker, *The Nelson Portraits: An Iconography of Horatio, Viscount Nelson, K.B., Vice Admiral of the White* (London: Royal Naval Museum Publications, 1998), 33–72. Nelson credited Robert Barker's panorama for keeping his name in the headlines; see Richard D. Altick, *The Shows of London* (Cambridge: Harvard UP, 1978), 97, 136–37.

18 MC to ECC, 5 April 1805, CFP-MHS. All manuscript letters cited in this chapter are found in CFP-MHS, box 1 unless otherwise noted. For the funeral, see *MP*, 7, 9, 10 Jan. 1806; *MC*, 10 Jan. 1806.

19 Walker, *Nelson Portraits*, 159–91; Alison Yarrington, *The Commemoration of the Hero, 1800–1864: Monuments to the British Victors of the Napoleonic Wars* (New York: Garland, 1988).

20 *MP*, 15 Nov. 1805. Boydell also announced a competition for the best picture of the subject; *FD*, 7:2654 (4 Dec. 1805), 7:2689 (11 March 1806).

21 *FD*, 7:2670 (13 Jan. 1806).

22 SCC to ECG, 23 Aug. 1806. The letter makes clear that Copley's fall took

place before SCC's previous letter, sent 6 July. For West's *Death of Nelson*, see *FD*, 7:2782 (12 June 1806); see also 7:2694, 2776; Emily Ballew Neff and Kaylin H. Weber, "Laying Siege: West, Copley, and the Battle of History Painting," in *American Adversaries*, 230–31.

23 *FD*, 7:2721, 2788, 2799 (quoted); (16 April, 18, 28 June 1806). Copley hoped for 25 investors. He had envisioned but not executed a similar scheme eleven years earlier, to feature 500 bidders purchasing five-guinea tickets; see *FD*, 2:356 (17 June 1795).

24 *FD*, 7:2786 (17 June 1806).

25 Sukey noted the conjunction of the birthday and the wedding anniversary: SCC to ECG, 26 July 1802.

26 Francis Cabot Lowell, "A History of the Gardiner Greene Estate on Cotton Hill, Now Pemberton Square, Boston," ed. Winthrop S. Scudder, *Bostonian Society Publications* 12 (1915): 41. For Greene's migration, see *The Greene Family in England and America: With Pedigrees* (Boston: privately printed, 1901), 55–56, 69–71; "Letters to Gardiner Greene," *Proceedings of the Massachusetts Historical Society* 13 (June 1873): 56–62.

27 *Carte génerale & particulière de la Colonie d'Essequebe & Demerarie: située dans la Guiane, en Amérique . . . par le Major F. von Bouchenroeder* (Amsterdam, 1798).

28 The Guiana coast was the setting for one of the most sensational tracts of the day: John Gabriel Stedman, *Narrative, of a Five Years' Expedition; against the Revolted Negroes of Surinam, in Guiana, on the Wild Coast of South America; from the Year 1772, to 1777*, 2 vols. (London, 1796), which featured William Blake's incendiary images of the torture of slaves. On the early history of Demerara, see also Henry Bolingbroke, *A Voyage to the Demerary, Containing a Statistical Account of the Settlements There, and of Those on the Essequebo, the Berbice, and Other Contiguous Rivers of Guyana* (London: R. Phillips, 1807); James Rodway, *History of British Guiana, from the Year 1668 to the Present Time* (Georgetown, Demerara: J. Thomson, 1891); and Kit Candlin, *The Last Caribbean Frontier, 1795–1815* (Basingstoke, UK: Palgrave Macmillan, 2012), esp. chap. 2.

29 William Parkinson to Gardiner Greene, 17 Aug. 1795, in James Rodway, ed., "Four Old Letters from Demerara," *Timehri: The Journal of the Royal Agricultural and Commercial Society of British Guiana*, n.s., 8 (1894): 329.

30 Mary Greene Hubbard to Gardiner Greene, 17 May 1799, CFP-LoC, folder 3; *Greene Family in England and America*, 56. Austen completed the first draft of *Pride and Prejudice*, then titled *First Impressions*, by late 1797; David Gilson, *A Bibliography of Jane Austen* (New York: Oxford UP, 1982).

31 MC to ECG, 14 Jan. 1801.

32 P-*JSC*, 164–65, 224. In addition to the thirteen Greene family commissions

Prown documents, genealogical sources suggest that Copley also painted Greene's father, Benjamin; *Greene Family in England and America*, 53. The portrait of the young Gardiner Greene burned in 1872; Augustus Thorndike Perkins, "Sketch of Some of the Losses to the Departments of Literature and the Fine Arts, Occasioned by the Great Fire in Boston of 1872," *NEHGR* 27 (Oct. 1873): 370.

33 Katharine Greene Amory, *The Journal of Mrs. John Amory (Katharine Greene) 1775–1777: With Letters from Her Father, Rufus Greene, 1759–1777* (Boston: privately printed, 1923).

34 SCC to ECG, 23 Aug. 1800 ("maxim"); MC to ECG, 23 Aug. 1800 (critic); SCC to ECG, 3 Nov. 1800 ("red room"); MC to ECG, 4 March 1801 ("never procrastinate").

35 MC to ECG, 15 Oct. 1801.

36 The settlement is reported in *Columbian Centinel*, 2 Jan. 1832. Greene doubled the allowance upon his death.

37 JSC Jr. to ECG, 9 Aug. 1802. The phrasing echoes Mary Wollstonecraft, *A Vindication of the Rights of Woman* (London, 1792), 68, 99.

38 MC to ECG, 4 March 1801; MC to ECG, 23 Aug. 1800

39 Wollstonecraft, *Vindication of the Rights of Woman*, 355, 434.

40 John Hubbard to GG, 19 Aug. 1804; Inventory of Reliance Plantation, 2 May 1804, Hubbard-Greene Papers, MHS.

41 Quoted in Margot Minardi, *Making Slavery History: Abolitionism and the Politics of Memory in Massachusetts* (New York: Oxford UP, 2010), 13.

42 George Washington Doane, *A Sermon, Delivered at Trinity Church, December 23, 1832: On the Decease of Gardiner Greene, Esq.* (Boston: Crocker & Brewster, 1833), 9, 11, 13; Lowell, "History of the Gardiner Greene Estate," 41–42.

43 Sheba surfaces in the record when she returned to England in 1804: JSC Jr. to ECG, 17 Aug. 1804; SCC to ECG, 5 April 1806; MC to ECG, 5 April 1806; SCC to ECG, 23 Aug. 1806. She was at least nominally free by then and appears to have left the Greenes' service to marry: MC to ECG, 28 Jan. 1807. It is possible that Sheba was a servant or even former slave of the Copleys rather than of Greene; Martha Amory, who redacts all but one mention of Sheba from her loose adaptation of the family letters, refers to her as "a cook whom Mrs. Greene took with her from England," Amory, 261. On Sheba / Quasheba as an Akan or Coromantee "day name," see David DeCamp, "African Day-Names in Jamaica," *Language* 43:1 (March 1967): 139–49; Trevor G. Burnard, "Slave Naming Patterns: Onomastics and the Taxonomy of Race in Eighteenth-Century Jamaica," *Journal of Interdisciplinary History* 31:3 (2001): 325–46. The inventory of Reliance Plantation, 2 May 1804, Hubbard-Greene Papers, MHS, lists a female slave named Quashebo; the Ancestry.com data-

base *Slave Registers of Former British Colonial Dependencies, 1813–1834* lists over 400 others throughout the British Caribbean.

44 Doane, *A Sermon, Delivered at Trinity Church*, 19; Lowell, "History of the Gardiner Greene Estate," 44.

45 SCC to GG, 29 June 1802.

46 MC to ECG, 13 Aug. 1801. See also SCC to ECG, 11 May 1804, in which Sukey offers an "encomium on American Husbands." Betsy's stepdaughter engaged in matchmaking for John Jr. and Mary Copley; MC to ECG, 30 June 1802.

47 SCC to ECG, 10 Oct. 1800.

48 Jefferson to James Madison, 27 April 1809, Thomas Jefferson Papers, 1606–1827, LoC, ser. 1, http://hdl.loc.gov/loc.mss/mtj.mtjbib019928.

49 MC to ECG, 22 Oct. 1800.

50 SCC to ECG, 26 Feb. 1802; MC to ECG, 14 Jan. 1801. On Copley's reluctance to write, see also SCC to ECG, 20 Dec. 1800; JSC Jr. to GG, 22 Jan. 1801; and SCC to ECG, 3 March 1801.

51 SCC to ECG, 5 Oct. 1801 (peace); SCC to ECG, 18 March 1802 (health).

52 MC to ECG, 15 Oct. 1801; JSC Jr. to GG, 14 Oct. 1801.

53 MC to ECG, 30 June 1802; SCC to ECG, 23 June 1802.

54 SCC to ECG, 27 June 1803; SCC to ECG, 30 July 1803.

55 SCC to ECG, 12 Oct. 1803; *FD*, 6:2134 (29 Sept. 1803). New England's cold is a theme throughout the second Copley family correspondence, but see esp. SCC to ECG, 20 Feb. 1807.

56 SCC to ECG, 30 July, 12 Oct. 1803; see also MC to ECG, 31 July 1803.

57 MC to ECG, 24 Aug. 1803.

58 [John Singleton Copley Jr.,] *A Concise Vindication of the Conduct of the Five Suspended Members of the Council of the Royal Academy* (London: John Stockdale, 1804), 6; see also P-*JSC*, 365–72. Mary and Sukey downplayed the dispute: MC to ECG, 24 Aug. 1803; SCC to ECG, 29 Jan. 1804.

59 *FD*, 6:2161 (11 Nov. 1803).

60 "Mr. Copley" [1803], Joseph Farington Papers, ser. 1, item 4, RAA. The manuscript contains Farington's redundant pagination; quoted passages from p. 9 and three different versions of p. 16; *FD*, 6:2248 (21 Jan. 1804).

61 *FD*, 6:2207 (1 Jan. 1804). Mrs. West's verses also mentioned, more briefly, the other four dissenting council members.

62 Morse to his parents, 24 Aug. 1811, Edward Lind Morse, ed., *Samuel F. B. Morse; His Letters and Journals* (Boston: Houghton Mifflin, 1914), 44–45.

63 Morse to Mr. and Mrs. Jarvis, 17 Sept. 1811, *Samuel F. B. Morse Letters*, 47.

64 SCC to ECG, 28 July 1804; see also MC to ECG, 1 Sept. 1804.

65 MC to ECG, 17 Aug. 1805; see also JSC to GG, 12 Sept. 1805; JSC to Samuel Cabot, 12 Sept. 1805.

66 SCC to ECG, 20 Feb. 1807; cranberries and turkey in SCC to ECG, 2 Feb. 1807; salt fish in MC to ECG, 25 Feb. 1802; and SCC to ECG, 26 Feb. 1802.

67 SCC to ECG, 11 Dec. 1810, 23 Sept. 1811; "Deposition of John Singleton Copley," HGOBP, box 1, folder 15a.

68 *FD*, 11:4035, 4041–42 (21, 30 Nov. 1811); see also 10:3712 (17 Aug. 1810).

69 SCC to ECG, 2 July 1808.

70 SCC to ECG, 23 Aug. 1809; SCC to ECG, 10 April 1810.

71 "Exhibition of Paintings, Somerset-House," *Repository of Arts, Literature, Commerce, Manufactures, Fashions and Politics* 3:13 (June 1810): 366, 367. A traveler who saw Copley's picture pronounced it "certainly not good," adding, "West's is not better"; *Journal of a Tour and Residence in Great Britain: During the Years 1810 and 1811*, 2d ed. (Edinburgh: James Ballantyne, 1817), 164.

72 SCC to ECG, 23 Sept. 1811.

73 Lowell, "History of the Gardiner Greene Estate," quotation at 53. For the cows and the dog, see Martha Babcock Amory to Charles Amory, Nov. 1869, Charles Amory Family Papers, 1861–1942, MHS, folder 1. On William Vassall, whom Copley had painted with his youngest son ca. 1770–72, see *JSC in America*, 280–83.

74 Martha Babcock Amory to Charles Amory, Nov. 1869.

75 *Greene Family in England and America*, 71–75.

76 SCC to ECG, 27 June 1812.

77 Will of Gardiner Greene, 28 May 1828, probated 24 Dec. 1832, Suffolk County Probates, 30090; and Record Books, vol. 130, pt. 2, ff. 528–35; MassArchs. For the composition of the household, see federal census of 1810, Boston, Ward 7, Suffolk, MA, NARA-M252, roll 12, p. 365; see also federal census of 1820, Boston, Ward 7, Suffolk, MA, NARA-M33, roll 53, p. 89. The census takers consistently label Greene's black servants free, though the manumission in his will demonstrates that Harry was not formally so.

78 Martha Babcock Amory to Charles Amory, Nov. 1869.

79 Doane, *A Sermon, Delivered at Trinity Church*, 19; Lowell, "History of the Gardiner Greene Estate," 44.

80 Inventory of Gardiner Greene Estate, Suffolk Country Probates, 30090. The newspapers reported Harry's manumission extensively. Greene's bequest to him was substantially more than his onetime gift of $50 to each of his other four "domestics"; see *Columbian Centinnel*, 2 Jan. 1833.

81 *Liberator*, 22 Dec. 1832; *Columbian Centinel*, 2 Jan. 1833. See also the damning comments about Greene's generosity in *Norfolk Advertiser*, 12 Jan. 1833.

82 JSC to GG, 26 Nov. 1803.

83 JSC to GG, 19 June 1809.

84 JSC to GG, 9 June 1804, 31 Jan., 12 Sept. 1805, 2 Oct. 1811, 4 March, and, finally, 20 Aug. 1812, in Sukey Copley's hand.

85 JSC Jr. to GG, 30 May 1804.

86 *FD*, 6:2260, 2284 (3, 28 March 1804). For young Copley's rise to prominence through his defense of a Nottingham Luddite, see Dennis Lee, *Lord Lyndhurst: The Flexible Tory* (Niwot: UP of Colorado, 1994), 27–30. JSC Jr. had attained the rank of sargent-at-law when Copley died.

87 SCC to ECG, 23 Aug. 1800.

88 SCC to ECG, 1 Feb. 1803; on Betsy and "chat," see SCC to ECG, 18 March 1802. For portraits as second selves, see William Hazlitt, "On Sitting for One's Picture," in *The Plain Speaker: Opinions on Books, Men, and Things* (London: H. Colburn, 1826), 258–59.

89 MC to ECG, 18, 27 Aug., 9 Oct. 1815; CFP-MHS, box 2.

90 MC to ECG, 1, 9 Sept. 1815, CFP-MHS, box 2.

91 George S. Steinman, *A History of Croydon* (London: Longman, Rees, 1833), 85. Martha Amory says the vault was part of the tomb of the Hutchinson family; Amory, 320–21.

92 SCC to GG, 1 Feb. 1816, CFP-MHS, box 2.

EPILOGUE

1 JSC to SCC, 8 Oct. 1774, CFP-LoC.

2 Catalog for the Feb. 1820 print sale reproduced in P-*JSC*, 389–94.

3 "Account of an Interview with Mr. Stuart, 17 November 1810," Henry Pickering Papers, Phillips Library, Peabody Essex Museum, MSS 0.608. For Copley in nineteenth-century America, see Carrie Rebora, "Copley and Art History: The Study of America's First Old Master," in *JSC in America*, 3–23.

4 William Dunlap, *History of the Rise and Progress of the Arts of Design in the United States*, ed. Alexander Wycoff (1834; rptd., New York: Benjamin Blom, 1965), 1:116, 121–22, 127–29 (excerpts from Carter).

5 Allan Cunningham, *The Lives of the Most Eminent British Painters, Sculptors, and Architects* (London: J. Murray, 1829), 4:138–39. Cunningham's quotations from Carter's journal, which are fairly close paraphrases, appear on 4:142–44.

6 Dunlap, *Rise and Progress*, esp. 1:133–34, 137. See also Rebora, "Copley and Art History," 6; and Maura Lyons, *William Dunlap and the Construction of an American Art History* (Amherst: U of Massachusetts P, 2005).

7 Henry Tuckerman, *Book of the Artists* (New York: G. P. Putnam, 1867), 72, 8.

8 JSC to HP, 25 June 1775, *CPL*, 340. For Copley's elevation to the peerage, see Dennis Lee, *Lord Lyndhurst: The Flexible Tory* (Niwot: UP of Colorado, 1994), 56–59, 279 n33.

9 William Heath, "To Be Sold with His Engagements . . ." (London, 1829). British Museum print 1868,0808.9042.

10 Amory, 436.

11 Lee, *Lord Lyndhurst*, 260–62; Amanda Foreman, *A World on Fire: Britain's Crucial Role in the American Civil War* (New York: Random House, 2010).

12 *Catalogue of the Very Valuable Collection of Pictures of the Rt. Hon. Lord Lyndhurst, Deceased: Including Most of the Important Works of His Lordship's Father, That Distinguished Historical Painter, John Singleton Copley, R.A.* (London: Christie, Manson and Woods, 1864), 8. Annotated copy in the Royal Academy Archives, RA AND-3, ff. 91-92. Several other annotated copies of the catalog survive. Prown helpfully collates the annotations, which include notes on prices and buyers; *P-JSC*, 400–405.

13 "Curiosities of Longevity," *Nation*, 8 May 1866, 300-301; Anna Quincy Lowell Waterston, "A Long Life: A Sketch of the Life of Elizabeth Copley Greene" (1886), in Francis Cabot Lowell, "A History of the Gardiner Greene Estate on Cotton Hill, Now Pemberton Square, Boston," ed. Winthrop S. Scudder, *Bostonian Society Publications* 12 (1915): 57.

14 *List of Portraits in Memorial Hall* ([Cambridge, MA], [ca. 1875]). Copley's thirteen canvases account for nearly a quarter of the sixty-two works on the walls; R. B. Bernstein, *The Founding Fathers Reconsidered* (New York: Oxford UP, 2009), 3–6.

15 *Boston Daily Globe*, "Common Council," 16 Feb. 1863; Friends of Copley Square, "Copley Square: The Story of Boston's Art Square" (Boston: privately published, 2002). Martha Babcock Amory died in 1880; *The Domestic and Artistic Life* was published posthumously.

16 Stuart P. Feld / Hirschl & Adler to Grant Holcombe of the Timken, 18 Feb. 1984, object files, Timken Museum of Art, San Diego.

17 Cecil [?] to Nancy Ames Petersen, 11 May 1984, object files, Timken Museum of Art, San Diego.

18 "Timken Gallery Buys $1.4 Painting," *Los Angeles Times*, 18 April 1984; "Portrait of a Lady Returns: Copley Work to Be Sold," *New York Times*, 5 Jan. 1984.

19 JSC to HP, 6 Nov. 1771, *CPL*, 174.

20 Amy Galpin, ed., *Behold, America! Art of the United States from Three San Diego Museums* (San Diego: San Diego Museum of Art / Distributed Art Publishers, [2012]).

Index

Page numbers in *italics* refer to illustrations.
Page numbers beginning with 417 refer to endnotes.

Abigail Bromfield Rogers (Copley), 335, *335*, 401
Able Doctor, The; Or, America Swallow-ing the Bitter Draught (Revere), 219, *219*, 284
abolitionists, 378, 389, 396, 454
Acadians, deportation of, 52, 56, 58
Adams, Abigail, 318
Adams, John, 127, 128, 129, 136, 139, 149, 155, 156, 169, 204, 210, 215, 261, 313–15, 323, 455
Adams, John Quincy, 359
Adams, Samuel, 1, 174–75, *175*, 212–13, 217, *217*, 330, 365
Admiral Clark Gayton (Copley), 292, *293*
Admiral Duncan (Copley), 372–73
Advantages and Disadvantages of the Marriage-State . . . , 152
Africans and people of African descent:
 artistic depiction of, *281*, 282–85, *283*, 320–25, 327, 477
 biased perception of, 167, 282, 388
 in London, 285–86, 477
 as loyalists, 485
 in military service, 320–23, 485
 see also slavery; slaves, *specific individuals*
Ainslie, Thomas, 60–61, 71, 98

Aix-la-Chapelle, Treaty of, 36, 51
Allen, George, 37–38
Allen, Johnny, 81
Allen, William, 63, 65, 81, 88, 91, 192
America, provincial, 12, 80, 85, 128
 British identity of, 66, 74, 84, 116–17
 forward-looking character of, 40, 332
 growing sense of unity in, 116, 125, 141
 JSC's ambivalence about, 232–37
 JSC's praise of, 231, 233
 JSC's rejection of, 241–42, 252, 265, 362
 loyalist sentiment in, 116, 124–25, 141
"American," use and connotations of term, 89–91, 312, 436
American art, American artists:
 condescension toward, 112–13
 evolution of, 82, 116, 178, 181, 311–14, 362, 365, 395, 400–401
 JSC classed as, 1–8, 253, 276, 313–15, 394–95, 400–401
 limited education in, 44
 obstacles to, 92
 origin myths of, 17–18, 62–63
 predictions about, 50–51
 roots of, 26–28, 30
 subjects of, 313, 346, 351

American Magazine and Monthly Chronicle for the British Colonies, 65–66

American Revolution, 254–89, 295, 327
 aftermath of, 92, 330, 362–65
 in art, 320, 395
 as Britain's American War, 3, 272–274, 278
 Boston in, 95–96, 136–38, 141, 169, 194, 196–97, 247, 256, 259, 264, 279, 330
 British defeats in, 278–79, 292, 301
 centennial of, 399
 end of, 309–13, 330
 global theater of, 3, 278, 287, 292, 301, 309, 311, 321, 323, 324, 330, 386
 JSC's ambivalence about, 2–3, 8, 160, 175, 178, 235–37, 240–42, 275–76
 as JSC's context and subject, 333, 354
 onset of fighting in, 3, 258–62, 269
 patriots of, 1–2, 311
 prelude to, 135–46, 156, 169–75, 200–220, 221, 233, 235–37, 240–42, 245, 247, 255–59
 roots of, 53–54, 93–95, 100–101, 104–8, 116, 129
American School, The (Pratt), 92, *93*, 190
Amherst, Jeffrey, 56, 67
Amory, John, 137, 140, 263, 273, 376, 472
Amory, Katherine Greene, 263, 273, 376, 472
Amory, Martha Babcock Greene, 399, 499
Anatomical Drawings (Copley), 45–47, 71, 186

anatomy study of, 43–47
Anecdotes of Painting in England (Walpole), 98
Anglicans, 12–13, 24
animals, allegory and symbolism of, 104, 120
Anne, queen of England, 32
Apollo Belvedere, 82, 371
apprenticeships, 28–30, 41, 206
art collections, 26, 87, 125–26, 180, 192, 225, 228
Artist's Family, The (West), 268
Art of Painting and the Lives of the Painters, The (de Piles), 47–50, 63
art supplies, vendors of, 25–26
Ascension, The (Copley), 248–51, *250*, 259, 267, 271, 274, 281
Athenaeum Washington (Stuart), 395
Aurora'L (Reni), 243
Austen, Jane, 345, 376

Bacon, John, 298–99
Badger, Joseph, 7, 68
Baker, Joseph, 485
balloon flight, 328–33, *329*, 344, 353
Banks, Joseph, 114
Barbados, 108–10, 154, 183
Barber, Nathaniel, 139, 145, 178
Barber, Wilkes, 139, 145, 178
Barnes, Henry and Christian, 167–68
Barnes, Prince Demah, 167–68
Barrell, Hannah Fitch, *122*, 123
Barrell, Joseph, 122–23
Barrett, Mary Clarke, 136, 150, 151, 198, 493
Bartolozzi, Francesco, 310–11, 348
Bath, England, 344–45
Battle of the Boyne, The (West), 294
Beacon Hill, 158, 162, 175
"Behold America! Art of the United States" (exhibition), 401

Belcher, Abigail Allen, 61

Belcher, Jonathan and Mrs., 60–61

Benjamin Hallowell (Copley), *107*

Benjamin West (Copley), 275, *275*, 475

Benjamin West (Kauffman), *83*

Berkeley, George, 24, 25, 45, 50

Bernard, Francis, 74, 93, 94, 99, 101,
 105–7, 124–26, 135, 136, 139,
 143–45, 157, 275, 475

Betty Sally, 80–81, 432

Blackburn, Joseph, 41–42, 56, 60, 62,
 97

Blanchard, Jean-Pierre, 328

*Bloody Massacre Perpetrated on King-
 Street, The* (Revere), 171–75, *173*

Board of Customs Commissioners,
 129–30, 135, 169

Book of Anatomical Studies (Copley), *46*

Boscawen, 103, 108, 161, 439

Boston, 61, 74–75, 224, 244, 365
 active protests in, 104–9, 114, 127,
 138–39, 142, 143, 149, 169–75,
 189, 204–9
 in American Revolution, 95–96,
 136–38, 141, 169, 194, 196–97,
 247, 256, 259, 264, 279, 330
 art scene in, 24–25, 28, 30, 38,
 41, 43, 45, 47, 49, 113, 115, 117,
 125–26, 132, 134, 159, 228
 British blockade of, 219–20, 221,
 240
 British military occupation of, 143,
 145–46, 151, 156–57, 169–75, 184,
 219, 240, 245, 256, 258, 269
 British nature of, 18, 98–99
 Calvinist character of, 10–11, 20,
 30–31, 78, 184, 228–29
 as center of global trade, 9–10, 16
 economic downturns in, 12, 30, 52,
 77–79, 92–95, 99–100, 122
 fires in, 78–80, 94

JSC's career in, 93–110, 111–13

JSC's departure from, 3, 4, 252, 361

loyalist sentiment in, 124–25, 141,
 256–57, 259, 330

martial law in, 219–20, 221, 240

New York compared to, 183–84,
 186

political scene in, 124–25

prosperous times in, 16–17, 122,
 361–62, 364–65

rapid development of, 67–68

revolutionary sentiment in, 129,
 135–42, 149, 156, 160, 200–220,
 221–22, 240, 247, 252–53,
 255–59

Boston Massacre, 169–75, 179, 216,
 459
 trial, 194

Boston Port Bill, 218–19, 221, 277

Boston tea party, 3, 215–16, 236–37,
 261
 Parliamentary response to, 218–19

boycotts of British goods, 95–96,
 136–38, 141, 169, 194, 196–97,
 247, 256
 defiance of, 160–61, 169

Boydell, John, 300, 315–16, 372
 JSC's collaboration with, 318–19,
 325, 491, 492

Boylston, Nicholas, *123*, 124

Boy with a Flying Squirrel, A (Copley),
 103–4, *104*, 108, 110, 114, 116,
 117–19, 155, 161, 163, 291, 304,
 355, 392, 398

Brattle, William, 57–58, 59, 61

British Army, 74, 78
 Boston occupied by, 143, 145, 156,
 162, 183, 194, 221, 245
 military portraits of, 53–62, 386
 rioters vs., 169–75

British Coffee House, 99, 127

British empire, 7, 9, 17, 60, 76–77, 82, 142, 288, 309, 358, 375
 apogee of, 54, 278, 294
 art of, *see* English art, English artists
 challenges to, 278–279, 287, 292, 295, 301, 309; *see also* American Revolution
British Magazine, 373
Bromfield, Hannah Clarke, 150, 163, 198, 202, 221
Bromfield, Henry, 163, 202, 221, 262, 361
Bromfield, Thomas, 262, 265
Bromley, Robert, 356–57
Bruce, Captain R. G., 103, 112–14, 118, 123, 130–31, 183, 439
Bulfinch, Charles, 362
Burgoyne, John, 278–79, 292
Burke, Edmund, 114, 345, 360
Burney, Fanny and Charles, 114
Burton, Isaac, 320–22
Bute, Earl of, 105, 114

Cabot, Samuel, 354, 361–64, 493
 JSC's rift with, 370–71
Calvinism, 10–11
Cambridge University, Trinity College at, 345, 350, 360–61, 366, 367
Camperdown, Battle of, 372
Canada, 52, 55, 98, 331
Cardinal Bentivoglio (Van Dyck), 26
Caribbean, slavery in, 81, 109, 375–78, 387, 453, 498
Carson, William, 198–99
Carter, George, 254–55, 346
 as J. S.Copley's traveling companion, 226–29, 230, 233–39, 346, 396, 466, 468
 tensions and rift between JSC and, 230–31, 235–39, 243, 356, 396

Castle William, Boston harbor, 9, 58, 76, 142, 184, 189, 222
 British military and supporters evacuated to, 170, 195, 209–16, 218–19
"Catalogue of American Genius" (Jefferson), 315
Catholic Relief Act, 300–301
Catholics, 12–13, 227, 242
 bias against, 300–301
Cato (slave), 165–66, 185, 194, 198, 284
Chambers, William, 302–4, 486
Channel Islands, 316–17
Chardon, Peter, Jr., 108–9, 111–13, 153, 157, 440
Chardon, Peter, Sr., 157–59, 162, 199, 380, 440
Charitable Irish Society, 13, 20–21
Charles I, king of England, 218, 360
Charles I (Copley), 360, 373
Charles II, king of England, 120
Charles Pelham (Copley), *31*
Charlotte, queen of England, 124–25, 127, 195, 225, 271, 295, 334, 337, 350, 373
Chatham, William Pitt, Earl of, 66–67, 125, 141, 180, 186, 244, 309, 310, 456
 death of, 295, 305, 311
childbirth, 18, 331, 460
childhood mortality, 11–12, 14, 30, 334, 336, 343, 382, 393
Christ, as subject of art, 248–51, *250*, 270–71, *270*
Christie, James, 320–21, 485, 486
civilization, trope of westward progress of, 50–51, 80, 181
Civil War, English, 53, 360
Civil War, U.S., 388, 397–99
Clarke, Elizabeth Winslow, 150, 159, 449

Clarke, Isaac, 150, 206, 207, 209, 218, 265, 331

Clarke, Jonathan, 136, 149, 160, 199–200, 202, 207, 209, 213–16, 224, 226, 233, 252, 273, 327, 343

Clarke, Lucy, 198, 209, 217–18, 258

Clarke, Richard, 150, 154–56, 161, 195–97, 202, 265, 266–67, 330, 345–46, 354, 362, 449

estate of, 354–55, 360, 362

irascibility of, 342, 354

in London, 271–74, 276, 302, 313, 343

slaves sold by, 163–64

as tea consignee, 203–16, 219, 247, 273–74

Clarke mansion, vandalism to, 208–9, 258

Clerk of the Market, 159–60

Coercive (Intolerable) Acts, 218–19

coffee, tea vs., 195

Collection of Prints, Engraved from the Most Capital Paintings in England, A, 315

Colonel George Watson (Copley), *137,* 140, 400

Colonel John Montresor (Copley), 189–90, *190*

color:

attempts to describe, 228

JSC's use of, 34–35, 131–32

see also pigments; red

commerce:

American, 89–90

art and, 25–26

Boston as center of, 9–10

London as center of, 85

taxes on, *see* taxes

war as impetus to, 12, 16–27, 52–53, 55, 60, 64

communications:

delayed or lost, 76, 103, 108, 111–12, 118, 121, 130, 133, 178, 186, 233–34, 245, 255, 260, 263, 331–32, 432, 440, 467

letters as lifeline of, 223, 258, 331, 333, 344, 379, 399

Concord, battle of, 3, 54

Continence of Scipio (Poussin), 26

Cook, James, 294

Cooper, Samuel, 128, 129, 149, 170

Cooper, William, 31

Copley, Clarke, 252, 254, 263, 266, 269, 271

Copley, Elizabeth, *see* Greene, Elizabeth Copley

Copley, John Singleton:

as ambitious, 4–6, 18, 27, 32–33, 38, 40–41, 167–68, 178, 226, 232, 234, 248, 304–5, 334, 360

apolitical stance of, 244

birth of, 9–10, 13, 14, 18, 20, 28, 30, 83

in Boston tea controversy, 211–15

as cautious and tentative, 2–5, 17, 18, 38, 98, 109–10, 116, 120, 134–35, 148, 153–54, 175, 199, 222, 232

death of, 379, 392–93

in departure for Europe, 221–23

discontentment and bitterness of, 333, 369–73, 383, 384

early years of, 9–11, 13, 15–20, 22, 27–30, 62, 67, 70, 279, 392

family background of, 11–16, 20–22

financial struggles of, 224, 241, 248, 264, 274–75, 296–97, 299–300, 310, 342, 345–46, 348–50, 361, 374, 376, 387

as fretful, 132–33, 178, 222, 262–64

grandchildren of, 17, 284, 301, 343, 347, 388, 398, 399

Copley, John Singleton (*continued*)
 growing combativeness of, 356–57,
 369–71, 381–83
 as industrious and diligent, 31–32,
 38, 40–41, 59, 63, 66, 72, 73, 101,
 112, 188–89, 191, 198, 234, 255,
 372, 375, 385
 infirmities of, 333, 374, 379, 383–
 87, 390, 392
 as lacking in social sophistication,
 72–73, 230–32, 235–36, 238, 336,
 356, 374
 later years of, 369–93
 limited education of, 18, 21, 109
 as parsimonious, 193–94
 physical appearance of, 16, 72, 151,
 155
 property purchases of, 67–68,
 158–159, 175, 380, 384, 451; *see
 also* Mount Pleasant estate
 stammer of, 16, 211, 235–36, 360,
 420
 sword as prized possession of, 229,
 238, 251
 West and, *see* West, Benjamin
Copley, John Singleton, career and
 works of:
 acclaim for, 111–13, 147, 190, 197,
 198–99, 235, 238, 248, 251, 271,
 288–89, 290–92, 295, 297, 305–9,
 326–27, 333, 351
 advancement in, 58, 60–61, 96–98,
 122–24, 126, 146, 185, 251, 288–
 89, 290–92, 295, 305–6, 316–27,
 333–40, 355
 artist's process in, 249–50, 297–98,
 339, 347
 auctions of, 394–95, 398, 473
 in Boston, 93–110
 Boydell's collaboration with,
 316–27

decline of, 4, 339, 346, 355, 369,
 372–75, 379–81, 383–86, 394
detail in, 57–59, 120, 137, 140, 177,
 248, 293
early years of, 40–49, 56–58
as emigré in London, 225–26,
 265–89, 290–327
evolving skills of, 44–47, 59, 71–72,
 96–98, 122–23, 146, 248, 251, 391
fame of, 290–92, 295, 305–6, 309,
 327, 334, 347–48, 352, 355, 396
influences on, 3–4, 16, 23, 26,
 31–38, 41–42
legacy of, 394–401
letters of introduction for, 238, 251,
 347
London spring exhibition entries
 of, *see* exhibitions, London's spring
 season of
as means of support for, 6, 24–25,
 28, 32–33, 37, 67, 92, 109, 127,
 134, 146, 158–59, 167, 175, 185,
 188–89, 226, 248, 274–75, 296–
 97, 299, 310
negative critical reception of, 5, 113,
 115, 120, 126, 131–32, 159, 176,
 179, 190, 272, 282, 297, 305, 334,
 337, 338, 346, 352, 355, 356, 358,
 372–73, 385–86
output of, 6, 79, 96–97, 114, 185,
 188–89, 428, 441, 446, 463
posthumous assessment of, 394–401
promise and disappointment of,
 355, 393, 394
restored reputation of, 394–95,
 400–401
self-promotion strategies of, 145–
 46, 291, 295, 299–302, 334, 351,
 356–57, 373
as self-taught, 17–18, 42, 45–47
talent of, 7, 32–33, 66, 73

viewed as American artist, 1–8,
253, 276, 313–15
viewed as English artist, 1–8, 288–
89, 315–16
war as context for, 333, 354
see also specific paintings
Copley, John Singleton, married life,
153, 154, 157, 159–65, 170, 196,
202, 218, 269, 274, 327, 328, 332,
371, 452
in Boston political upheaval, 207–8
as London emigrés, 328–68
London reunion of, 265
New York trip of, 185–95, 200
period of geographical separation
in, 199–200, 221–53, 254–56
stresses and losses of, 342–43
wedding in, 136, 149, 151–53, 156,
161, 163, 168, 170, 174, 284, 324
Copley, John Singleton, Jr. "Jacky,"
222, 262–63, 265–67, 301, *327*,
333, 340–41, 346, 347, 350, 358–
59, 370, 379, 387, 399
aristocratic sentiments of, 360,
365–66, 377, 397
birth of, 197, 460
death of, 283, 398, 473
intellectual pursuits of, 345, 360–61
law career of, 380, 381, 389–90, 397
as Lord Lyndhurst, 397–98
political career of, 397–98
ultimate success of, 387, 389–90
U.S. tour of, 361, 364–68, 369, 371
Copley, Jonathan, 327, 333, 340–41,
343, 393
Copley, Mary "Polly," 202, 222, 254,
262–63, 265–67, 286, 301, 333,
344, 346, 358–59, 365, 370, 376,
379, 381, 387, 391, 392, 397
Copley, Mary Singleton, *see* Pelham,
Mary Singleton Copley

Copley, Richard, 11–15, 17, 18, 19, 21,
41, 53, 61, 142, 153, 354, 419
Copley, Sarah, 11–12
Copley, Susanna, 269–71, 301, 333,
340–41, *340*, 343, 383
Copley, Susanna Farnum Clarke
"Sukey," 266–68, 271, 275, 280,
309, 327, 328–30, 334, 336, 337,
341, 347–48, 354, 365, 366, 379,
384, 388, 390–92
appearance of, 154, 270, 473
arrival in London of, 262–64, 284,
376, 472
death of, 379, 397
family background and connections
of, 150, 160, 163, 218–19
JSC's correspondence with, 227,
232–33, 237, 239–42, 244, 245–
49, 251–52, 254, 255, 257, 260–61,
265, 467
JSC's courtship of, 150–51, 153
lifespan of, 333
married life of, *see* Copley, John
Singleton, married life
Mount Pleasant managed by, 257–58
at onset of Revolution, 259
pregnancies of, 159, 194, 197, 200,
202, 207, 222, 239, 245, 252, 269,
327, 333, 460
social life of, 197–98
wedding of, 136, 149, 151–53, 156,
161, 163, 168, 170, 174
Copley family, 216, *266*, 331–32, 399
as American emigrés in London,
328–68
financial concerns of, 5, 29, 30,
193–94, 393, 394
JSC's devotion to, 40–41, 53, 67,
148, 211, 222, 223, 246, 254, 263,
326–27, 333, 342, 358, 387–90,
392–93

Copley family (*continued*)
 as merchants, 10, 11, 14, 16, 21, 22,
 29
 migration to Boston of, 12, 14, 17
 portrayed in *Death of Major Pierson*,
 326–27
 slaves held by, 165–68, 185, 257,
 284, 324, 453, 470
Copley Family, The (Copley), 266–69,
 266, 271–72, 274, 283, 291, 300,
 391, 398
Corbet, Moyse, 316, 318, 321
Cotton Mather (Pelham), *19*
Crèvecoeur, J. Hector St. John de,
 312
Crisis, The (Cooper), 129, 149
*Critical Examination of the Pictures . . . ,
 A*, 131
Cromwell, Oliver, 12, 19, 204
Cunningham, Nathaniel, 157–58, 161
Curwen, Samuel, 266, 268, 273, 302,
 330, 332, 342, 472

Daniel Rogers (Copley), 133, 157
Dartmouth, 209–10
Dartmouth, Lord, 286
David, Jean-Louis, 371, 386
De Arte Graphica (Du Fresnoy), 47–48
Death of General Wolfe, The (West),
 179–80, *181*, 225, 279, 287–88,
 293, 315, 356, 374
Death of General Wolfe, The (Woollett
 after B. West), *181*
*Death of Lord Chatham in the House of
 Peers, The* (A. Williams after Cop-
 ley), *308*
Death of Major Peirson, The (Copley), 3,
 8, 316–27, *317*, *322*, 330, 333, 346,
 347, 354, 398, 486, 491
 study for, *326*
Death of Socrates, The (West), 64

Death of the Earl of Chatham, The
 (Copley), 295–309, *306*, 310–11,
 313, 316, 317–18, 325, 346, 347,
 348–49, 354, 360–61, 373, 374
DeBlois, Gilbert, 274–75
Declaration of Independence, 1, 2–3,
 323–24, 333, 346, 399
Declaratory Acts, 128, 129, 149
*Defeat of the Floating Batteries at
 Gibraltar, The* (Copley), 346–53,
 355, 372, 386, 491
Delaware tribe, 62–63, 67, 196
Demerara, G. Greene's plantations in,
 375, 378, 387, 498
de Piles, Roger, 47–50
*Destruction of the French Fleet at La
 Hogue, The* (West), 294
Devereux, Mrs. Humphrey Green-
 wood, 175–79, *177*, 178, 180–81,
 456
Devonshire, Georgiana, Duchess of,
 335
dissection, 43–44
dogs, 119–20, 166, 338, 364, 367
*Domestic and Artistic Life of John Sin-
 gleton Copley, The* (M. Amory),
 300–301
Dorothy Murray (Copley), 6–8, *7*
Du Fresnoy, Charles, 39–41, 44,
 47–50, 63

East India Company, 201–4, 209, 212,
 219, 221, 240, 274, 280
economy, war as impetus to, 12, 16–17,
 52–53, 55, 56, 61, 62, 64, 66, 78,
 81, 99, 139
Edes & Gill, 65, 173, 203
Edinburgh, 24–25
effigies, 105, 117, 138, 169
Elizabeth Copley Greene (Copley), 390–
 93, *391*, 400

English art, English artists, 42, 275–76, 285–86, 325
 evolution of, 49–51, 84, 86, 92, 98, 176, 181, 316, 373, 3347
 JSC viewed as, 1–8, 288–89, 315–16, 395
English Coffee House, 242, 244
engravings, 19, 22, 28, 29, 32, 63, 100, 126, 142, 251, 268, 304, 308
 advance payment for, 299–301, 310–11, 313
 of Boston map, 276, *277*
 copied from paintings, 24, 55, 226, 286, 299, 315–16, 348, 374, 386, 395, 443, 491
 of H. Pelham vs. Revere, 171–73, *172, 173,* 179
 political, 217, 219
 see also mezzotints
Enlightenment, 50, 71
Ensis (pseudonymous critic), 305, 307
Essay on the Theory of Painting (Richardson), 69
Europe:
 academic and artistic traditions of, 41, 49–50, 110, 117, 176, 251–52, 289, 401
 JSC's ambivalence about traveling to, 117, 121, 132, 134, 148, 154, 157, 175, 176, 182
 JSC's reaction to, 232–33
 in JSC's personal and artistic growth, 252, 264
 JSC's travels in, 221–56, 345, 361, 371
 leading artists of, 82–83
 ramifications of American Revolution in, 278
Evening Post, 317, 328
Evergreen (Demerara slave camp), 375, 377

Exhibition of the Royal Academy of Painting in the Year 1771, The, 272
exhibitions, London's spring season of, 86–89, 92, 98, 102–3, 146–47, 179, 225, 226–27, 292–95, 337, 346, 355, 358–59, 372, 381, 385, 456, 482
 JSC's challenge to, 302–5, 325
 JSC's entries in, 101–2, 108, 111, 114, 118–22, 130–31, 133, 157, 159, 169, 175, 177–78, 191, 198–99, 268, 271, 279, 288–89, 291, 293
 JSC's triumph at, 291–92

Faerie Queen (Spenser), 359
family pictures, as genre, 271, 381, 432
Faneuil Hall, 55, 170, 205, 210
Farington, Joseph, 348, 364, 374, 381, 384
Feke, Robert, 27–28, 30, 32, 34, 38, 41, 60
Fenno, Ephraim, 161, 257, 451, 452
Firle Place, 400–401
Florence, 26, 234–35, 247
Forge of Vulcan, The (Copley), 32
France, 227, 371
 in American Revolution, 278, 287, 323
 balloon flight to, 328–29
 Britain's ongoing conflicts with, 16–17, 36, 51, 66, 76, 273, 316, 321, 353, 354, 363, 364, 372, 380–381, 390; *see also specific wars*
Francis Bernard (Copley), 126
 vandalism of, 143–45, 157
Franklin, Benjamin, 40, 62, 64, 66, 286
Free Society of Artists, 179
French and Indian War, *see* Seven Years' War

French Revolution, 351–53, 361, 371–72

"Fruits of Arbitrary Power; or, the Bloody Massacre" (H. Pelham), 171–73, *172*

Gage, Margaret Kemble, 184–86, 190–91, *191*, 198, 400–401

Gage, General Thomas, 142–43, 145–48, *147*, 151, 156–57, 170, 183–84, 188, 189, 191–92, 195, 219, 259, 276

Gainsborough, Thomas, 286, 291, 292, 335, 401

Galatea (Copley), 32–35, 40, 45, 60, 64

Galt, John, xi, 82, 83

Garrick, David, 114, 180

Gayton, Clark, 292, *293*, 480

Gayton, Elizabeth Legge, 292, *293*

General Thomas Gage (Copley), 146–48, *147*

General Washington (V. Green), 313

genre paintings, 197, 227

Gentleman's Magazine, 98

George I, king of England, 18, 265–66

George II, king of England, 75, 76–78, 88, 271, 338, 386

George III, king of England, 83, 88, 95, 96–97, 124–25, 127, 141, 179, 180, 186, 295, 302, 312, 347, 350–52, 373, 381
 artists seeking patronage from, 334
 bouts of madness of, 350, 354
 children of, 271, 334–40, 350
 Copleys' audience with, 333–35
 coronation of, 77–79
 death of, 394
 as dismissive of JSC, 374–75

George IV, as prince of Wales, 385–86, *385*, 392, 398

George IV as Prince of Wales (Copley), 398

Germany, Copleys' trip to, 347–48, 491

Gibraltar, 80, 278, 346–53

Gordon, George, 300–301

grand tour, 83, 86, 176, 227, 242, 342, 361, 364–68, 468

Green, Valentine, 290, 313, 491

Greene, Elizabeth Copley "Betsy," 185, 187, 222, 262–63, 265–68, 301, 333, 344, 346, 347–48, 351, 358–59, 364, 365, 368, 385, 387, 390–93, *391*, 399
 birth of, 159, 197, 200
 children and stepchildren of, 388, 398
 death of, 398
 debut of, 344–45
 marriage of, 375, 378–79, 387, 390–91, 393, 398
 ultimate success of, 387–90
 U.S. residency of, 379, 392, 397, 398
 women's rights stance of, 377

Greene, Gardiner, 375, 376, 378–79, 387, 388–90, 393, 498, 499, 501

Greene, Harry (slave), 278, 388, 501

Greene, John Singleton Copley, 368

Greene, Joseph, 246, 263, 273, 376, 472

Greene, Mary, 263, 273, 376, 472

Greene, Susanna, 388

Greenfield (Demerara slave camp), 375, 377

Green Park, London, 36–37, 352, 372

Greenwood, John, 27–28, 30, 32, 34, 41, 175–77, 180–81, 183, 251, 268

Grenville, George, 105, 114, 145

Halifax, Nova Scotia, 60, 142, 156, 183

Hallowell, Benjamin, 106, *107*, 108, 439, 444

Halt—Dismount! (Remington), 400

Hamilton, Alexander, 26–27

Hamilton, Gavin, 82, 243, 248, 251, 315

Hamilton, William, 245–46

Hancock, John, 1, 2, 126, 127, 128, 136, 138, 139, 160, 161, 162, 174, 185, 197, 205, 210, 212, 214, 217, 236, 257, 362, 444, 455

Hancock, Thomas, 16–17, 52, 55–56, 60–61, 127

Handel, Georg Friedrich, 35–36, 77

hands, mastery in rendering of, 71–73, 177, 183, 372, 431

Harmony, 218

Harrison, Adjutant, 318, 321, 486

Harvard College, 65, 77, 109, 121, 143–45, 150, 151, 196, 266, 345, 399

Harvard College library, 45, 47 fire at, 94, 125–26, 144

Havana, 278–79, 288, 293, 318

Head of a Favourite Negro (Copley), 282–84, *283*

Heath, James, 325, 374, 491

Hemery, Clement, 318, 320

Henry Laurens (Copley), 313, 316

Henry Pelham (Copley), *102*, 177

Hillsborough, Lord, 142, 146, 156

History of the Fine Arts (Bromley), 356

History of the Rise and Progress of the Arts of Design in the United States (Dunlap), 396

history paintings:
in contemporary dress, 179–80, 225, 279, 325
as genre, 87, 174, 280, 372
nationalistic nature of, 294

Hogarth, William, 22, 41, 43, 88, 89, 265

Holyoke (Copley), 94

Hoppner, John, 334, 335, 338–39

House of Commons, 79, 290, 360, 372

House of Lords, 295

Howe, William, 276, 292

H.R.H. the Prince of Wales at a Review (Copley), 385–86, *385*, 392

Hubbard, John, 377–78

Hull, William, 363, 495

Hulton, Henry, 195, 220, 256

Humphry, Ozias, 39, 254, 315

Hutchinson, Elisha, xi, 160, 202, 204–5, 273, 313

Hutchinson, Thomas, 52, 74, 105–8, 127, 136, 150, 154, 157, 170, 174, 195, 201, 202, 210, 212, 214, 215, 216, 219–21, 224, 226, 256, 263, 273, 278, 280, 284, 292, 324, 343, 375

Hutchinson, Thomas, Jr., 160, 202, 204–5, 215, 218

Ignatius Sancho (Bartolozzi after Gainsborough), *285*, 286

India, 337–38, 358

Industry and Idleness (Hogarth), 41

Intolerable (Coercive) Acts, 218–19

Ireland, Irish, 11–13, 20–21, 24, 61, 94, 331, 396, 484

Italy, 267
JSC's decision to travel to, 199–200, 226
JSC's sojourn in, 39, 233–53, 254–65, 274
as seat of art and culture, 24, 35, 83, 166
West's sojourn in, 80–84, 88, 132, 192, 199

Izard, Alice Delancey, 235, 246–48, *249*, 268, 468

Izard, Ralph, 235, 243, 245–48, *249*, 268, 274, 284, 466, 468

Jackson, Sarah, 67–68
Jamaica, 95, 279, 292, 321, 387
Jefferson, Thomas, 315, 366, 379, 453
Jeffries, John, 328–29, 344
Jersey, Battle of, 321, 341
Jersey island, 316–18, 323, 485
John Adams (Copley), 313–14, *314*, 324, 399
John Amory (Copley), 137, 140
John and Sukey, 103
Johnson, Samuel, 54, 86, 114, 168, 251, 323, 478
Johnston, William, 49, 154
Joseph Mann (Copley), *35*
Joshua Winslow (Copley), *57*, 58, 71, 280
Joy, John, 185, 194

Kauffman, Angelica, 83, 291
Kemble, Stephen, 183, 185
King George's War, *see* War of Austrian Succession
King William's War, 294
Knatchbull, Edwin, 377, 379–81, 390
Kneller, Godfrey, 24, 42–43, 49

Lancaster, Pa., 63–64
Laocoön, 251, 281, 371
Last Judgment (Michelangelo), 360
Laurens, Henry, 313, 316
Letters from an American Farmer (Crèvecoeur), 312
levees, 145–46, 151
Lever, Ashton, 296
Lexington, battle of, 3, 54, 259, 260
Liberty, 138, 141–42
Liberty Bowl, 1, 139
Liberty Tree, 116, 117, 125, 130, 138, 141, 160, 168, 169, 204
Library of Congress, 399
Lillie, Theophillus, 169

"limner," use of term, 68–71
Lincoln, Abraham, 398
London, 84–92, 98–99, 210, 224, 311, 328, 365
 American emigrés in, 224, 226, 235, 262–63, 273–76, 278, 292, 344, 376, 475
 art scene in, 24, 42–43, 62, 86–88, 98, 101, 113, 147–48, 166, 168, 175–76, 179, 226, 387, 443
 intellectual scene in, 113–14
 JSC as emigré in, 265–89, 290–327, 472
 JSC's arrival in, 223–27
 perceived as "Home" by provincial Americans, 9, 83–84, 147–48, 175, 223, 242, 376, 434
 rivalry of American painters in, 334–40
 social and political unrest in, 351–54
 social scene in, 225, 334–35, 344–46
 spectacles of, 303, 306–9
 Sukey Copley's arrival in, 262–64
London and Its Environs Described, 85–86
London Book Store, 98–99, 131, 160
Louisbourg, British victories at, 17, 24, 36, 55, 56, 58, 61, 67, 97, 146, 419
Louis XIV, king of France, 386
Louis XVI, king of France, 278, 351–53, 361
Lovell, Margaretta, 152, 432
Loves of the Gods (Carracci), 243
Low Countries, 251, 347
Lucy (slave), 165–66, 185, 284, 453
Lunardi, Vincenzo, 328–33, 353

Madonna of Saint Jerome (Correggio), 254–55, *255*, 263, 267, 274, 371

Major George Scott (Copley), 58–59, *59*
Mann, Bethia Torrey, 32, *33*, 71
Mann, Joseph, 32–33, *33*
William Murray, Earl of Mansfield
 (Copley), 324–25
Mansfield, William Murray, Earl of,
 219, 284, 300, 305, 324
maps, 10, 89, 276, *277*
Marie-Antoinette, 351, 353
marriage:
 dowries in, 15, 161, 164, 165–66,
 185, 197, 359
 in literature and drama, 151–52
 of slaves, 165, 284
 social class and, 11, 97, 150, 153
marriage plot, 151–54, 200, 344–46,
 358–59, 368, 376, 378–79
marrying "up" and "down," 97, 153,
 154–56, 185
Mary, princess of England, 338
Mason, George, 68–69
Massachusetts, 10–11, 51–62, 116,
 171, 324, 328
Massachusetts Gazette, 153
Massachusetts Spy, 209
Mather, Cotton, *19*
Mayflower, 150
Mayhew, Jonathan, 127, 149, 155
memorial art, as genre, 295–97
merchants (New England):
 Clarke family as, 160–61, 163, 195,
 197, 201–7
 illicit trade by, 279–80
 slave-owning by, 10, 157–58, 162–63
 wealthy, 60, 123–24, 154, 157
Metamorphosis (Ovid), 33
mezzotints, 19–20, 27, 32, 100, 107,
 132, 271, 290, 299, 313, 315, 348,
 386
Michelangelo, 234, 244, 360
Mifflin, Mrs. Thomas, 73, 431

military portraits, as genre, 54–62, 75,
 88–89, 148, 184, 189, 280, 292,
 293, 337–38, 354, 372, 386, 474,
 479
Minerva, 263, 376, 472
miniatures, 60, 83, 105, 124, 126, 136,
 358, 430, 462–63
Miss Susanna Copley (West), *340*
mob rule:
 in Boston, 104–9, 114, 139, 169–75,
 189, 204–9, 213–14, 218, 256–57,
 444
 in London, 300–301, 354, 361
artists' models, modeling:
 dearth of, 118–19, 159, 178, 359
 nude, 225
 for portraits, *see* sittings
 sexual implications of, 43–44, 430
Mohawk tribe, 74, 82, 180, 196, 215,
 478
Molasses Act, 93
Monckton, Robert, 88, 280
Montgomerie (Copley), 293–94, 299
Montgomerie, Hugh, 292–93
Montresor, John, 189–90, *190*
Moorhead, Scipio, 167, 168
Morgan, John, 238
Mount Pleasant estate (Copley), 161–
 62, 165, 197, 218, 233, 244, 387,
 453, 460
 controversial sale of, 362–65, 369–
 71, 496
 damage to, 269, 361
 financial concerns about, 241, 248,
 257–58
 lawsuits over, 192, 194
 lien against, 361
 management issues of, 257–58,
 349–50
 remodeling of, 185, 189, 192–94, 209
 social life at, 197–98

Mount Vernon Proprietors, 362, 364–65, 370, 384, 496

Mr. and Mrs. Ralph Izard (Copley), 247–48, *249*, 268, 274

Mr. Samuel Adams (Revere after Copley), 217, *217*

Mrs. Clark Gayton (Copley), 292, *293*

Mrs. Humphrey Devereux (Copley), 177–79, *177*, 180–81

Mrs. John Singleton Copley (Copley), 154, *155*

Mrs. Joseph Barrell (Copley), *122*, 123

Mrs. Joseph Mann (Copley), 32, *33*, 71

Mrs. Thomas Gage (Copley), 190–91, *191*, 198, 268, 400–401

Murray, Dorothy, 6, *7*

mythology, as subject of art, 32–37

Naples, 244–46, 248

Napoleon I, emperor of France, 353, 371, 379, 380–81, 386, 392

Napoleon Crossing the Alps (David), 386

Napoleonic wars, 363, 364, 372, 380

Nathaniel Sparhawk (Copley), *96*, 97, 165

Nation, 398

Native Americans, 13, 82, 89, 293, 367
 displacement of, 12
 London perception of, 89–90
 pigment use by, 63
 portraits of, 82, 478
 in Seven Years' War, 63–64, 66–67
 as slaves, 162
 uprisings of, 94
 see also specific tribes

Nativity, The (Copley), 270–71, *270*, 274, 281, 340, 392, 473

Nelson, Horatio, 372, 373–74, 497

Nelson (West), 374

"New-Boston," 67–68, 79

New England Club, 273, 278

New England Coffee House, 223, 233

Newport, R.I., 30, 62, 108, 127, 198

New York, N.Y., 27, 62, 66, 147, 151, 202–3, 331, 362, 364, 367, 400
 Copleys' "summer abroad" in, 183–95, 199, 200, 256, 452

Nicholas Boylston (Copley), *124*

Nile, Battle of the, 372, 497

North, Lord, 196, 203, 284, 287, 459
 JSC's study for, *298*

North Briton No. 45 (Wilkes), 139

Nova Scotia, 56, 58, 60, 61, 103, 280

Oliver, Andrew, 60–61, 68, 78, 105–6, 108, 125, 150, 154, 216, 449

Oliver, Margaret, 350, 351, 364

Oliver, Peter, xi, 125, 136, 170, 212, 309, 449, 462–63

"On the Prospect of Planting Arts and Learning in America" (Berkeley), 50

Origin and Progress of the American Rebellion (Oliver), xi

O the Roast Beef of England (Hogarth), 227

Otis, James, 95, 99, 136, 139, 140, 175, 444

Paestum, 246, 468

Paine, Thomas, 345, 360

painting:
 copies of masterpieces, 254–55, 263, 274
 ethnographic accuracy in, 293
 hierarchy of genres of, 33, 47
 individual vs. typographical character depictions in, 281–82, 305, 309, 318, 321
 as "liberal" art, 33, 37–38, 66

original vs. prints and copies, 176, 228, 234, 243, 251

physical demands of, 27, 40, 333

prices and fees for, 114, 134–35, 141, 183, 299, 346, 374, 432, 441, 443

recipes and procedures of, 39–40

seasonal effect on, 6, 10, 101

size and scale in, 4, 118, 251, 266, 268, 271, 281, 297, 306, 317, 346–47, 350, 352, 369, 372, 398

as source of income, 6, 24–25, 28, 32–33, 37, 67, 92, 109, 127, 134, 146, 158–59, 167, 175, 185, 188–89, 226, 248, 274–75, 296–97, 299, 310, 342

treatises on, 45–50

panoramas, 352, 373

Paris, 274, 278, 351–53, 371, 397

JSC in, 227–29, 233

Paris, Treaty of, 84, 313, 330

Parliament, 116, 124, 125, 127, 296, 353

duties leveled by, 93–95, 196, 218–19

powers of, 128, 196

Parma, 255, 260, 263, 265, 267, 279

Pasquin, Anthony (John Williams), 357, 482

pastels, 60, 103, 118, 122–23, 135, 157, 167, 186, 234, 443

patriotism:

art and, 88

in Seven Years' War, 53–55

Paul Revere (Copley), 1, 4, 8, 139–41, *140*, 146, 251, 401

Peale, Charles Willson, 101, 121, 311–12, 371, 395, 456

Peale, Rembrandt, 73, 431

Peirson, Major Francis, 316–17, *317*, 321, *322*

Pelham, Charles, 21, 22, 28, 30, 31, *31*, 38, 40, 93–94, 150–51, 154, 166, 207, 259, 331, 348, 420, 421, 442

Pelham, Helena "Maria," 20–21, 29–30, 423, 442

Pelham, Henry "Harry," 6, 8, 22, 29, 67, 98, 109, 165–66, 170, 175, 222, 263, 269, 278, 318, 401, 487

artistic efforts of, 171–73, *172*, 191–92, 194, 226, 276–77, 331

depression of, 240–41, 259

JSC's correspondence with, 165–66, 186–87, 190, 192, 194, 199, 224, 226, 239–40, 246–53, 255–56, 261–62, 263, 279, 343

JSC's long-distance mentoring of, 226, 228, 234, 243, 255–56, 456–57

JSC's relationship with, 41, 53, 67, 79, 98, 110, 148, 159, 162, 261–63, 453

in London, 276–77

loyalist sentiment of, 206–7, 261–62, 276–77

in management of Mount Pleasant, 257–58

marriage of, 331, 487

as model for paintings, 101–4, *102*, *104*, 119, 177

in onset of Revolution, 259, 261–62

tension between JSC and, 187–88

Pelham, Mary Singleton Copley, 9–15, 17, 29–30, 109, 152, 171, 263, 269, 276–77, 324, 349, 350, 487

first marriage of, 11–15, 18, 20, 61, 142, 153

fragile health of, 6, 18, 186, 258, 331, 342, 349

genteel upbringing of, 11, 15–17, 153

Pelham, Mary Singleton Copley
 (*continued*)
 JSC's correspondence with, 229,
 252, 260, 261, 287, 309–10,
 331–32
 JSC's relationship with, 41, 47, 53,
 67, 79, 110, 148, 159, 162, 177,
 193–94, 221–22, 240, 269, 453
 second marriage of, 18–23, 27, 67
Pelham, Peter, Sr., 21–22, 29, 423, 442
Pelham, Peter, Jr., 18–24, 29, 32, 33,
 34, 35, 41, 45, 72, 420, 423, 442
 in collaboration with Smibert, 24,
 27–28, 55–56
 death of, 22, 29–30, 31, 41, 67, 72
 marriage of, 18–23, 27, 67
 various vocations of, 20, 22–26, 30,
 36, 47
Pelham, Peter, III, 18, 20, 22, 28, 420
Pelham, Thomas, 18, 22, 420, 421
Pelham, William, 22, 420, 423
Penn's Treaty with the Indians (West),
 293
Pennsylvania, 63–64, 67, 81, 84, 87,
 91, 116
Pepperrell, William, 55, 97, 165, 275,
 453, 475
Pepperrell Family, The (Copley), 282,
 288, 291
Philadelphia, Pa., 27, 30, 84, 91, 101,
 117, 121, 287, 311, 366, 400
 British capture of, 278, 336
 Harry Pelham's trip to, 256–57
 revolutionary sentiment in, 202–3
 West in, 62–66, 80–81, 92
pigments:
 in paint making, 29, 63, 101
 sale of, 25–26, 35, 55
 sources of, 4, 87, 138, 427
 tax on, 129, 135, 137–38
 toxicity of, 333

Piranesi, Giovanni, 251
Pitt, William, *see* Chatham, William
 Pitt, Earl of
*Plan of Boston in New England with its
 Environs, A* (H. Pelham), 276–77,
 277
Poems on Various Subjects (Wheatley),
 167
poetry, 64, 75, 166–67, 286
 painting and, 48, 319
Political Raree-Show, The, 303, *303*
politics:
 art and, 37, 60, 120, 127, 141, 173,
 178, 217–19, 248, 284, 288–89,
 352, 371
 Copleys and, 360, 365, 377
 suicide motivated by, 352–53
 in U.S., 365–66
 of wealth and commerce, 154–56,
 160–61, 195
Pope's Day, 205, 207
*Portrait of a Highland Officer, see
 Montgomerie*
portraits:
 of American emigrés, 292
 of couples, 60, 64, 99, 119, 122–23,
 154, 247–48, 292
 downturn in commissions for, 216
 elite subjects of, 23, 27, 28, 42, 53,
 60, 69, 78–79, 88, 92, 94, 106,
 122–24, 127, 139, 141, 162, 167,
 185, 292–93, 297, 388
 likeness as important to, 198–99,
 305, 392
 marriage, 152, 154
 military, 54–62, 75, 88–89, 148,
 184, 189, 280, 292, 293, 337–38,
 354, 372, 386, 474, 479
 models for, *see* sitters; sittings
 of Native Americans, 82, 478
 official, 60–62

pairing of youth and age in, 177–78

range of subjects in, 189

of royalty, 80, 97, 125, 295, 333–40, 374–75

self-, 49, 72, 83

sitting for, *see* sitters; sittings

various purposes of, 2, 4, 123, 395

see also miniatures; *specific genres and works*

Poussin, Nicolas, 35, 244, 248

poverty, in Boston, 30–31, 52, 78, 92–93

Powell, John, 119, 131

Powell, Susanna, 119, 131

Pratt, Matthew, 91–92, 190–91

Preston, Captain, 194, 216

privateers, 80–81

Protestant Association, 300

Prown, Jules, 24, 97, 139

Quakers, 63, 81, 84, 92

Quebec, British victory at, 74–75, 87, 88, 280, 288, 317

Quincy, Samuel, 194, 273, 472

Quinville Abbey, 11, 153

Racehorse, 76

Raphael, 35, 234, 243, 244, 248–52, 254, 270, 306, 371

raree-shows, 302, 303, 308, 325, 486

red, as imperial and military color, 53–56, 60–61, 77, 79, 87, 88, 127, 143, 184, 189, 240, 280

Red Cross Knight, The (Copley), 358, *359*, 393

Renaissance art, 24, 26, 43, 49, 50, 83, 234

Return of Neptune, The (Copley), 33–37, *37*, 40, 45, 51, 64

Revere, Paul, 1, 124, 136, 139–41, *140*, 142, 146, 168, 217, 219, 261

Henry Pelham's Boston Massacre engraving pirated by, 171–73, *173*, 194

Reynolds, Joshua, 70, 88, 101, 111–15, 117, 121, 123, 131–34, 146, 147, 179–80, 182, 225, 226, 248, 252, 265, *285*, 286, 292, 295, 315, 322, 335, 355, 431, 456, 478

Richard Clarke & Son, 155, 160–61, 195, 197, 198, 201–2, 206

Rights of the British Colonies Asserted and Proved, The (Otis), 95

riots:

in Boston, 104–9, 114, 127, 139, 149, 169–75, 205–9, 212, 444

fatalities in, 169–70

in London, 300–301, 354, 361

Rippon, 157

River Thames (Canaletto), *86*

Rogers, Abigail Bromfield, 335, *335*

Rogers, Daniel, 133, 157, 169

Rome:

British tourists in, 242–43

JSC's sojourn in, 234, 237–53, 254, 255, 259–60, 394, 468

as seat of art and culture, 26, 80–81, 85, 88, 91, 237

Romney, 138

Rowe, John, 99, 135, 138, 194, 204, 213, 219, 221

Royal Academicians (Bestland after H. Singleton), *357*

Royal Academicians (H. Singleton), 356, *357*

Royal Academy, Parma, 254

Royal Academy of the Arts, London, 147, 179, 182, 225, 268, 279, 280, 298, 302, 325, 337–38, 346, 358, 372, 380, 482, 486

factionalism in, 381–82, 493

JSC as associate member of, 271

Royal Academy of the Arts, London
(*continued*)
 JSC as member of, 290
 JSC's challenges to, 302–5, 307,
 355, 381–82
 new quarters of, 293–94, 302
Royal American Magazine, 217
Royal Americans, 91
Royal Ethiopian Regiment, 320
Royall, Isaac, 165, 282
Ruins, The; or, A Survey of the Revolu-
 tions of Empires (Volney), 364

Saint Dominigue, 323
Samuel Adams (Copley), 174–75, *175*,
 212, 399
Samuel and Eli (Copley), 295
Sancho, Ignatius, *285*, 286
Saratoga, British defeat at, 278–79
Sargent, Henry, 72–73, 431
satire, satirists, 36, 44, 291, 296, 304,
 306–7, 354, 357, 397, 482
Saul Reproved by Samuel (Copley), 372
Savage Warrior Taking Leave of His
 Family (West), 82
Scollay, John, 99, 211, 349
Scollay, Mercy, 349, 491
Scott, George, 58–60, *59*, 440
Scott, James, 362–63
sculpture, 26, 87, 186, 251, 334
 as memorial art, 297–99
Seaflower, 13
seasons, painting affected by, 6, 10,
 101, 133, 185, 188
sea travel:
 cost of, 262
 duration of, 221–23
 hardships and dangers of, 13, 21,
 61, 80–81, 227, 232, 364
 shipping art by, 102–3, 108, 111,
 121, 155, 161, 177, 190, 439

Seider, Christopher, 169
Self-portrait (West), *83*
Self-Portrait 1769 (Copley), *frontispiece*,
 154, *155*
Self-Portrait ca. 1780–84 (Copley),
 275-76, *275*
self-portraits, 49, 72, 83
Sentimental Journey through France and
 Italy (Sterne), 227
Seven Years' War (French and Indian
 War), 7, 51–75, 78, 81, 87, 88–90,
 116, 143, 146, 179, 183, 189, 276,
 280, 285, 294, 338, 372, 386
shark attack, 280–81, *281*, 287
Sharp, William, 348, 386
Shawnee tribe, 62–63, 67
Sheba (slave), 378, 499
Sherwin, John K., 300, 310, 482
Shippen, Joseph, 81, 84, 433
Shirley, William, 17, 27, 52, 55–56,
 58, 60
Shoemaker, Samuel, 336
Short Narrative of the Horrid Massacre
 in Boston, A, 173
Singleton, Henry, 356, 431
Singleton, John, 11, 15
sitters, 31, 42, 97, 122–24
 appealing to vanity of, 25, 29,
 97–98, 111
 relationship of artist to, 69–70, 133
sittings:
 discomforts of, 101, 118–19, 337,
 359, 431
 intimacy of, 6, 44, 70, 151, 430
 for JSC, 72–73
slave rebellions, 323, 376, 480
slavery, 5, 34, 377, 396, 452
 abolition of, 378, 389, 396, 398
 American paradox of liberty and,
 95, 168, 284, 286, 288, 323–24,
 366–67, 389, 454

art and, 323–25

black families separated by, 164

in Boston, 12, 44, 162–68, 387, 453, 477

in Britain, 284–85, 477

in Caribbean, 81, 109, 323, 375–78, 387, 498

opposition to, 95, 168, 284–85, 288, 323–24, 351, 454

slaves, 13, 60, 90, 97, 107, 257, 282, 284

abuse of, 375, 480, 498

cultural and artistic pursuits of, 166–68, 286

liberated, 168, 286, 320, 388, 499

marriage of, 165, 284

as nursemaids, 197

as property, 157–58, 162–65, 168, 286, 349, 378, 453

social mobility of, 40

urban labor of, 163–64

slave trade, 10, 163, 280

Small, John, 146, 147, 151, 183, 263

smallpox, 12, 72, 93–94, 239

Smibert, John, 23–28, 30, 32, 33–35, 38, 41–43, 45, 47, 50, 51, 55–56, 60, 68, 72, 88, 97, 146, 234

Smith, William, 64–66, 81

smuggling, 53, 138, 199, 280

Snap (slave), 165–66, 185, 198, 257, 269, 284, 349, 453, 470

social status:

American vs. British, 232

in Boston, 22–23, 52, 150, 198

JSC's striving for, 5–6, 67–68, 72, 167–68, 193, 233, 340, 3887

marriage and, 151–56, 359, 376

in Rome, 242

slaves and servants as indicators of, 164, 166, 168, 320

upward mobility in, 40

social season (London), 87, 344–46

Society of Artists of Great Britain, 88, 102–3, 119, 130, 198, 226–27, 304

competition for, 179, 268

Copley as member of, 133–35

Soldier Exhorted to Courage, The (Morrill), 53

Somerset House, 293–94, 302, 304, 338, 346, 374

Somerset v. Stuart, 284–85, 324

Sons of Liberty, 116, 125, 127, 138, 139, 141, 155, 160, 189, 199, 202, 207, 261

Spain, 278–79, 292, 346, 353

Sparhawk, Nathaniel, *96*, 97, 165, 453

Spectator, The, 303

Staiti, Paul, 97

Stamp Act, 95, 99–101, 135

protests against, 104–8, 114, 116, 127–28, 141, 160, 189, 444, 478

repeal of, 124–25, 127–29, 138, 168–69, 189

Startin, Sarah Clarke, 161, 257, 330–31, 367–68, 371

state portraits, 313–14

Sterne, Lawrence, 114, 227

Story, William, 106, 108

Stuart, Gilbert, 44, 315, 325, 362, 364, 371, 395

Stubbs, George, 387

stuttering (Copley's), 16, 211, 360, 420

Carter's mocking of, 235–36

Sugar Act, 95, 99, 100, 155

sugar trade, 81, 93–94, 109, 199

Clarke family in, 154–56

suicide, politically motivated, 352–53

Sundry Rules and Directions for Drawing Up a Regiment (Brattle), 57

Suriname, 30, 175
Sutherland, James, 352–53

taxation:
 on art supplies, 129, 135
 on Boston trade, 93–95, 99, 129–30
 boycotts as response to, 95, 135–38
 on land, 96
 without Parliamentary representa-
 tion, 128–30, 168, 196
 see also specific acts
Taxation No Tyranny (Johnson), 168
tea:
 dumping of, 215–16, 218–19, 236–
 37, 261
 political implications of, 143, 155, 161,
 196–97, 200–220, 247, 258, 284
 social associations of, 195–96, 198
Tea Act, 200–202, 280
 protest against, 202–3
Thames, 85, 103, 294
Thomas, 221–23
Thomas Hancock (Copley), 126
Thomas Hollis (Copley), 125–26
Three Youngest Daughters of George III,
 The (Copley), 337–39, *338*, 346
Times, The (Hogarth), 89, *90*
toasts, political, 116, 127–28, 130, 139,
 141, 160, 323
Tories, threats to, 256–57, 262
Townshend, Charles, 129
Townshend Acts, 129–30, 135–36,
 169, 194, 201, 202, 203, 209, 459
 boycott in protest of, 135–38, 194,
 196–97
Trafalgar, Battle of, 373, 386
Traille, Peter, 103
Transfiguration (Raphael), 243, 249,
 252, 254, 306, 371
transparencies, 216–17
True Briton, 358

Trumbull, John, 151, 311, 313, 334,
 346, 356, 363–64, 371, 395
Tuckerman, Henry, 396–97

United States:
 centennial of, 17
 cultural growth of, 395
 founding of, 3, 295, 301, 311–13,
 330
 G. Greene family's return to, 379
 JSC Jr.'s tour of, 362, 364–68, 369,
 371, 379
 as land of opportunity and innova-
 tion, 367, 369, 397
 return of loyalist emigrés to, 330
 westward expansion of, 379, 400
 wilderness territories of, 367

Van Der Gracht, Jacob, 45
Venice, 251, 263, 265, 472
Venus and Cupid (Copley), 341, *341*, 393
Venus and Cupid (Titian), 26
Venus de' Medici, 26, 45, 82, 234
 measured study of (Copley), *46*
Verplanck, Gulian, 245
"Verses Written at Jersey, January 6,
 1781," 319–20
Vesalius, Andreas, 45
View of the Town of Boston, A (Revere),
 143, *144*
Vincent Lunardi's Aerial Ascent from the
 Artillery Ground, *329*
Vindication of the Rights of Woman, A
 (Wollstonecraft), 377
Volney, Comte de, 364

Waldo, Samuel, 97
 land grants of, 13–15, 61, 419
Walpole, Horace, 98, 296, 311, 328
War of 1812, 383, 395
 prediction of, 366

War of Austrian Succession (King George's War), 15, 16–17, 36, 51–53, 55, 279, 354, 419
Warren, Joseph, 1, 204
Warren, Mercy Otis, 1–2
Washington, D. C., building of, 366–67
Washington, George, 269, 273, 309, 311–12, 330, 351, 362, 366, 371, 395
Waterloo, Battle of, 392
Watson, Brook, 278–80, *281*, 286–89, 396
Watson, George, 137, *137*, 140, 218
Watson and the Shark (Copley), 280–83, *281*, 286–89, 290, 292, 295, 299, 300, 313, 317, 346, 347, 354, 491
 Death of Major Pierson compared to, 317, 320, 322, 325
weddings, 149
Wedgwood, Joshia, 323
Welsteed, William, 32, 107–8
West, Benjamin, xi, *84*, 191, 211, 237, 248, 262, 275–76, *275*, 287–88, 290, 307, 334–35, 337, 339, 346, 357, 384, 385, 390, 430, 473
 acclaim for, 88, 98, 176, 180–81, 456
 in America, 62–66
 as "American Raphael," 82, 89, 91, 117, 166, 176, 180, 224, 238, 279, 433
 "American" style of, 312–15
 cosmopolitan transformation of, 83, 91–92, 176, 224–25
 death of, 393, 394
 ethnographic paintings of, 293
 in Europe, 80–84, 87, 132, 237
 as History Painter to the King, 180, 224, 276, 334–35

innovation of, 179–80, 225, 279
 JSC compared to, 62–64, 383, 393
 JSC's friendship with, 268, 296, 338
 JSC's meeting with, 224–25
 JSC's rift with, 356–57, 381, 382–83, 493
 JSC supported and mentored by, 103, 112–18, 121, 130, 133–34, 147–48, 154, 156, 177–79, 183, 192, 198–99, 226, 235, 252
 London career of, 88–92, 98, 111, 113, 132, 179–82, 224, 271, 275, 294, 296, 383, 396, 456
 as mentor to aspiring painters, 91–92, 121, 311–12, 336, 383
 negative criticism of, 89, 91
 physical appearance of, 72
 as Royal Academy president, 355, 381
 rustic persona of, 62–64, 82, 91, 117, 176, 224
West, Elizabeth, 343, 382–83
West, Raphael, 91, 490
Westminster Abbey, 77, 86, 296
Wheatley, Phillis, 166–67, 286
Wilkes, John, 139, 141, 178
William Welsteed (Copley), 32, 107–8
Windsor Castle, 224, 334, 339, 356, 382
Winslow, John, 56, 60
Winslow, Joshua, 56–57, *57*, 59, 60, 71, 78, 280, 449
Wolfe, James, 74, 88, 179–80, *181*, 189, 279, 280, 294, 317
Wollaston, John, 62, 64–65
Wollstonecraft, Mary, 377
women:
 as artists, 44
 domestic role of, 156–57, 164–65, 187, 257–58, 344, 358

women (*continued*)
 in male-dominated society, 15, 152, 161
 marriage as goal of, 151–54, 200, 344–46, 358–59, 368, 376, 380, 387
 as models, 44
 in protests, 136
 as slaves, 163, 166
 societal restraints on, 11, 15, 44, 120, 150, 164, 166, 344, 377, 399
 tea and, 195–96
women's rights, 377
Woollett, William, *181*, 315

Wordsworth, William, 352
Wright, Joseph, 115, 254, 315

"Yankee Doodle," satire based on, 307, 357
Young, Thomas, 206, 212
Young Black, A (Reynolds), 285–86, *285*
Young Lady with a Bird and A Dog (Copley), 119–22, *120*, 131–33, 176, 297, 400

"Z" (Richard Clarke pseudonym), 203–4, 208
Zephyr, 364